MEASURING HEAVEN

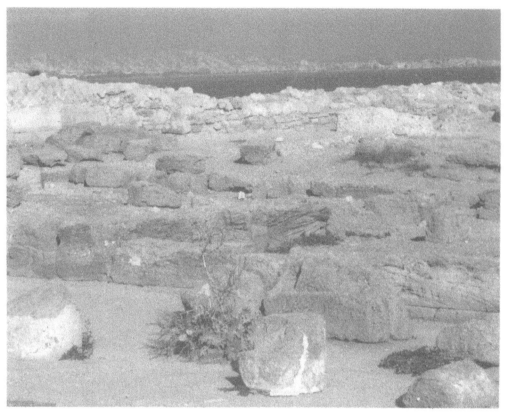

View of Crotone, Calabria, home of Pythagoras and site of his teaching. The ruins of the sixth-century Greek city are in the foreground; the medieval city of Croton is in the background. Photo by Judy Bonderman

MEASURING HEAVEN

∴

Pythagoras

and His Influence

on Thought and Art in

Antiquity and the Middle Ages

CHRISTIANE L. JOOST-GAUGIER

CORNELL UNIVERSITY PRESS

Ithaca and London

First published 2006 by Cornell University Press
First printing, Cornell Paperbacks, 2007

Printed in the United States of America

Library of Congress Cataloging-in-Publication Data

Joost-Gaugier, Christiane L.
 Measuring heaven : Pythagoras and his influence on thought and art in antiquity and the Middle Ages / Christiane L. Joost-Gaugier.
 p. cm.
 Includes bibliographical references and index.
 ISBN-13: 978-0-8014-4396-1 (cloth : alk. paper)
 ISBN-13: 978-0-8014-7409-5 (pbk. : alk. paper)
 1. Art and philosophy. 2. Architecture and philosophy. 3. Pythagoras and Pythagorean school—Influence. 4. Philosophy, Ancient—Influence.
 I. Title.
N61.J66 2006
701'.05—dc22 2005025053

Cornell University Press strives to use environmentally responsible suppliers and materials to the fullest extent possible in the publishing of its books. Such materials include vegetable-based, low-VOC inks and acid-free papers that are recycled, totally chlorine-free, or partly composed of nonwood fibers. For further information, visit our website at www.cornellpress.cornell.edu.

Cloth printing 10 9 8 7 6 5 4 3 2 1
Paperback printing 10 9 8 7 6 5 4 3 2 1

▲

Pittagora

volse che tutte

fossero d'una nobilitade,

non solamente le umane,

ma con le umane quelle de li animali bruti

e de le piante, e le forme de le minere; e disse

che tutta la differenza è de le corpora e de le forme.

—Dante, *Convivio*, IV.xxi.3

CONTENTS

List of Illustrations ix
Acknowledgments xi

Introduction 1

PART I. PYTHAGORAS — MAN AND LEGEND 9

1. **Pythagoras in the Greek World** 11
 The Beginnings: The Sixth Century BC 12
 The Reputation of Pythagoras in the Fifth Century BC 14
 The Critical Fortune of Pythagoras from the Fourth
 to the Second Century BC 17

2. **Pythagoras in the Roman World** 25
 The First Century BC: Pythagoras Mythologized 25
 The First and Second Centuries AD: The *Vir Sagacis Animi*
 Revered 30

3. **Pythagoras in the Late Pagan and Early Christian Worlds** 44
 The Third and Fourth Centuries: The Divine Pythagoras
 as Apollo Reincarnated 44
 Pythagoras Remembered in the Fifth and Sixth Centuries 58

4. **Pythagoras in Medieval Memory** 66

PART II. PYTHAGOREAN THOUGHT 77

5. **Pythagoreanism in Greek and Roman Antiquity** 79
 Sappho: The First Pythagorean? 80
 The Culture of Early Pythagoreanism 83

6. Neopythagoreanism in the Late Pagan and Early
 Christian Worlds 101

 The Revival of Pythagoreanism in the First Century AD:
 Arithmology and Arithmosophy 102
 The Dissemination of Neopythagoreanism after the First Century 106
 The Druids and Pythagoreanism 112

7. The Middle Ages: A New Pythagoreanism 116

 Rules for Conduct in the Pythagorean/Christian World 117
 The Enduring Classical Conception of Number 117
 The New Enthusiasm for Numerical Organization in Learning 121
 Number in Daily Life: Magic, Medicine, and Alchemy 127

PART III. PYTHAGOREANISM IN ART AND ARCHITECTURE 135

8. Pythagoreanism in Ancient Art and Architecture 137

 Antique Images of Pythagoras 138
 Possible Pythagorean Impulses in Classical Antiquity 148
 The Iconography of Apollo in Roman Art and Architecture
 and Its Pythagorean Connections 150

9. The Oldest Surviving Pythagorean Building and Its Significance 154

10. The Pythagoreanism of Hadrian's Pantheon 166

11. Pythagoreanism in Medieval Art 182

 Medieval Images of Pythagoras 182
 The Dodecahedron in Early Medieval Art: Cosmos and Number 203
 The Pythagorean Sphere in Later Medieval Art: Cosmos
 and Number 209
 The Pythagorean Y as a Symbol of Choice 215

12. Sacred Siting: The Pythagorean Heritage of Medieval
 Ecclesiastical Architecture 222

 The Basilical Origins of the Medieval Church 224
 Concepts of Order in the Gothic Cathedral 228

13. Conclusions 246

Notes 259
Bibliography 327
Index 355

ILLUSTRATIONS

Frontispiece. View of Crotone, Calabria, home of Pythagoras ii

1. Portrait of Pythagoras, coin from Abdera, ca. 430–425 BC 139
2. Portrait of Pythagoras, coin from Abdera, ca. 430–425 BC 139
3. Portraits of Pythagoras and Apollo-Helios, contorniate, date unknown 141
4. Portrait of Pythagoras, shield, early fifth century AD 142
5. Portrait of Pythagoras, herm, date unknown 144
6. Portrait of Pythagoras, herm, date unknown 145
7. Portrait of Pythagoras, date unknown 146
8. Portrait of Pythagoras, mosaic, late fourth century AD 147
9. Ruins of the Temple of Apollo at Punta Alice, and Greek ruins near the site of the Sanctuary of Apollo at Croton, sixth century BC 149
10. Subterranean Basilica at Porta Maggiore, interior view to apse 155
11. Subterranean Basilica at Porta Maggiore, plan 157
12. Subterranean Basilica at Porta Maggiore, interior view 160
13. Subterranean Basilica at Porta Maggiore, view of apse 163
14. Pantheon, AD 120–27 168
15. Pantheon, interior view showing oculus and ribs 169
16. Pantheon, view of facade and pronaos 170
17. Pantheon, plan 171
18. Pantheon, interior showing (modern) attic 173
19. Pantheon, frontal view of facade 175
20. Blacksmith's shop and Pythagoras, early twelfth century 184–85
21. Pythagoras, twelfth century 186
22. The *Harmony of the Spheres* with Pythagoras, Arion, and Orpheus, late twelfth century 187
23. Music and Pythagoras, Dialectic and Aristotle, ca. 1146–60, royal portal, Cathedral of Notre-Dame, Chartres 188
24. Pythagoras, detail from royal portal, Cathedral of Notre-Dame, Chartres 189
25. Boethius and Pythagoras, and Plato and Nicomachus, from Boethius, *De musica,* twelfth century 192

26. Pythagoras, detail, from Boethius, *De musica* 193
27. Music with Pythagoras, ca. 1225–30 194
28. Pythagoras at the blacksmith's shop, and two musicians with
 monochord and harp, ca. 1225–30 195
29. Cathedral of Clermont-Ferrand, north transept portal, ca. 1290 196
30. Cathedral of Clermont-Ferrand, north transept portal,
 Seven Liberal Arts 197
31. Pythagoras, early fourteenth century 198
32. Capitello dei Sapienti, 1344, Venice, Palazzo Ducale 200
33. Pythagoras, detail from Capitello dei Sapienti 201
34. Andrea di Bonaiuto, *Allegory of the Catholic Religion with Saint
 Thomas Aquinas and the Liberal Arts,* 1360s, Florence, Sta.
 Maria Novella 202
35. Arithmetic and Pythagoras, detail from Andrea di Bonaiuto,
 Allegory of the Catholic Religion 203
36. Bronze dodecahedron, ca. third–fourth centuries AD 204
37. Bronze dodecahedron, ca. third–fourth centuries AD 204
38. Bronze dodecahedron, ca. third–fourth centuries AD 204
39. Pythagorean Sphere, ninth century 210
40. Pythagorean Sphere, tenth century 212
41. Pythagorean Sphere, eleventh century 213
42. Pythagorean Sphere, ca. 1120 214
43. Pythagorean Sphere, fourteenth century 216
44. Pythagorean Spheres, early fifteenth century 217
45. *Temptation,* Clermont-Ferrand, Notre-Dame du Port,
 ambulatory capital, late twelfth century 218
46. *Temptation,* ca. 1190 220
47. *Adam and Eve Admonished by God,* ca. 1190 221
48. St. Sernin, Toulouse, chevet 228
49. Cathedral of Santiago de Compostela, plan 229
50. Abbey Church, Fontenay, plan 230
51. Cathedral of Notre-Dame, Chartres, plan 232
52. Cathedral of St. Julien, Le Mans, chevet 235
53. Cathedral of Notre-Dame, Paris, interior 238
54. San Nicola di Trullas, Semestene (Sardinia), plan 239
55. Cathedral of Notre-Dame, Chartres, west facade 242
56. *Mystical Paradise,* ca. 1170–85 243

Acknowledgments

Many people have asked me, "Don't we already know everything there is to know about Pythagoras?" That question I answer with this book. One thing I learned in the process of writing it is that much more remains to be discovered; in this sense this book is only a beginning. But propitious beginnings are closely tied to the largesse of one's colleagues, readers, and friends.

In this respect, I owe a special debt to many people who helped me with their superior knowledge of difficult subjects or passages, or their bibliographical expertise, or their linguistic skills, or simply their patient, practical advice. Although any inattentive lapses or errors that remain are my own, I have many people to thank for the benefit of their inspirational and unstinting support.

My most grateful thanks are extended to the libraries in which I worked and to their staffs, who helped me in ways big and small. These include the Houghton and Widener libraries at Harvard University, the Bibliothèque Nationale at Paris, the Biblioteca Apostolica Vaticana, the Dumbarton Oaks Byzantine Library, the Folger Library, the Library of Congress, the Library of the National Gallery of Art in Washington, the National Library of Medicine in Bethesda, the libraries at the University of Maryland College Park, the Morgan Library, and the Kunsthistorisches Institut in Florence. Special thanks are due to the entire staff of the Museo Archeologico at Crotone for their assistance in every imaginable way. Virtually everyone at the National Gallery of Art Library was personally helpful in an enormous variety of ways.

I am also very grateful to those who were willing to take on the exacting and demanding work of helping and guiding me through the various mazes I encountered. Above all, Carolyn Tuttle, who was my Latin muse, rescued me from my own barbaric translations. My first reader was George Hersey, from whose positive ideas and encouragement I benefited enormously. Francisco LaRubia-Prado and Riccardo Polloni were helpful in an endless list of imaginative ways. With his unerring eye, Stephen Kurtz uncovered a number of linguistic infelicities. Judy Bonderman deserves special thanks for having been my accomplice and photographer on a safari to Pythagoras's home country, southern Calabria and Lucania, where while enduring "il grande blackout," we were rewarded by the discovery of the Barolo of southern Italy, Cirò Ris-

erva, made in Pythagoras's home town. Allan Foy sharpened his mathematical skills to include the conundrums of Pythagorean arithmetic, while Ginevra Kornbluth introduced me to the mysterious dodecahedrons of the Gallo-Roman world. To Arielle Saiber and Corinna Rossi, who read this work carefully when it was in its infancy and gave me the benefit of their learned, positive, and helpful comments, I express my vivid appreciation.

Special thanks are due to Alvin Burts for the drawing on page 35, to Irene van Rossum and Dominique Surh for their roles as deeply valued interlocutors, and to Józef Grabski for sponsoring my first thoughts on the Pantheon.

For many other forms of help, encouragement, and good faith without which I could not have completed this volume, I take great pleasure in thanking Fatih Onur, Joscelyn Godwin, R. R. R. Smith, Catherine and Georges Richard, Don Raffaele Farina, James Morris, Stefano de Caro, Paul Magdalino, Caroline Karpinsky, Sharon Gerstel, Michael T. Davis, Carolyn Valone, Massimo Rassu, Filomena Tosto, Marika Scarpelli, Steven Mansbach, Gerard Bonneaud, Alice-Mary Talbot, Ron Costell, Flaminio Lucchini, and Anita B. Jones. Last but not least, long ago, when this volume was but a gleam in my eye and I hoped to offer a seminar on Pythagoras at my university in order to elicit more and deeper interest in Pythagoras, Michael J. B. Allen, John Bussanich, and Evangelos Coutsias were inspirationally supportive. This was the first step.

It has been a privilege to work with Bernhard Kendler, executive editor at Cornell University Press; time and again he has been resourceful and perspicacious. To Kathryn Gohl, who was Cornell's insightful copy editor, I express my special gratitude as I do also to Candace Akins, who oversaw the editing with grace and humor, and to Roger Haydon, whose patience and imagination brought the project together. I am especially honored and pleased that this press, which has published several of the works that were important for this book, was willing to bet on Pythagoras.

MEASURING HEAVEN

INTRODUCTION

This book describes a tradition of thought and belief considerably older than Christianity. It attempts to show how, across the span of more than one and a half millennia, this tradition's influence in the Western world helped shape perceptions among practitioners in the sciences, humanities, medicine, and the law and, as well, inspire architects, painters, and sculptors.

Pythagoras as a father of Western thought comparable to Plato and Aristotle is the unavoidable subtext of this book. Beyond his academic value as a great mind, Pythagoras is also in many ways utterly relevant to our times. Although most people know little about him (he lived long ago, and he had something to do with the triangle), Pythagoras is at the very foundation of contemporary culture. His relevance is, in fact, more multifaceted than that of either Plato (who historically was believed to be a follower of Pythagoras) or Aristotle (who was a student of Plato's). He is important not only for mainstream scholarship and culture but also for many patterns of belief and behavior that are based on perceptive knowledges that contribute to the enrichment of our complex social fabric. Many elements of modern-day alternative culture (such as peace, concord, meditation, frugality, harmony, vegetarianism, reincarnation, and astrology) are to be found in this worldview that has very ancient roots.

Pythagoras is particularly fascinating because he is the most "literalized" author of Antiquity. Like Christ, he did not write anything, but many people wrote things attributed to or about him. He was in the imagination of genera-

tion after generation of Western intellectuals as well as common folk, and they created Pythagoras in the image of their own times. In this sense, he is the most imagined author of Antiquity and a prophet for our time. Ultimately, understanding the development of Pythagoras, his following, and his influence helps us to understand ourselves, our world, and our universe. We can understand ourselves and our historical roots better when we realize a diachronic development from this most important thinker of Antiquity. This setting shows how Pythagoras became so assimilated into the history of our thought that many of his ideas (imaginary or not) have become part of the collective consciousness of our culture.

▲

The starting point for this book was my realization that a famous group of paintings created by Raphael early in the sixteenth century (his frescoes for the private library of Pope Julius II) contained thematic material that could not readily be understood in terms of conventional Christian and classical iconography.[1] I gradually came to recognize that the constellation of historical and mythical personages Raphael chose to present in those frescoes reflected his familiarity with a set of ideas that first took coherent form in the sixth century BC and were elaborated during later Antiquity into an intellectual tradition that remained surprisingly vigorous in the Middle Ages and experienced a lively resurgence in the Renaissance. Although that tradition may in its beginnings have inherited elements of preexisting Orphic beliefs, and although it certainly underwent some later shaping by Plato, its founding and its central ideas are firmly and plausibly ascribed to the Greek sage Pythagoras.

As I began to trace the history of those ideas from Pythagoras's time forward, I became convinced that Raphael was not unique in drawing inspiration from them—that many buildings, paintings, and sculptures from Antiquity through the Middle Ages and well into the Renaissance would have been created differently or not at all had their authors not been exposed, directly or indirectly, to Pythagorean ideology and doctrines. Only two of the many examples that I cite in this book follow. As early as the middle of the fifth century BC, less than a century after Pythagoras's lifetime, a variety of portraits of him appeared on Greek coins circulated in Asia Minor, an honor extremely unusual, if not unique, in that period for a personage neither royal nor divine. In the city of Byzantium, over six hundred years later, the Roman emperor Septimius Severus commissioned the creation of a statue gallery depicting gods and famous men. The representation of Pythagoras in that gallery caught the imagination of Christodorus, a fifth-century writer, who said of it, "methinks with his pure eyes he was measuring Heaven alone."[2] At that time, Pythagoras had been dead about seven hundred years. Even after the passage of another millennium, Pythagoras and events from his life would still be considered worthy of depiction.[3]

▲

Pythagoreans were famously preoccupied with numeric principles and their application not only to arithmetic but also to cosmology ("measuring heaven"), geometry, harmony, divination, and other fields. Less well understood heretofore has been the fact that that preoccupation, and other aspects of the intellectual tradition we call Pythagoreanism, influenced the design of works of visual art over a period of many centuries. This book is an initial attempt at outlining the history of such influence from the sixth century BC, when Pythagorean ideology emerged, to the fourteenth century AD, when it had come to be a major factor in Western culture.

The freshness of the topic has its frustrations as well. To identify Pythagorean influence in the art of various periods, we must be aware of what was known or perceived at those particular times in the vast territory treated in this book (ranging from England to the Arab world) regarding Pythagoras himself, his teachings, and the lives and teachings of those who carried on the tradition that bore his name. Because it has not previously been attempted, establishing even the rudiments of such a chronology has required an unexpectedly intensive and laborious new review of primary sources.

To say this is not to deny the abundance or quality of modern academic research on the origins and development of the Pythagorean tradition. Philosophers, philologists, classicists, musicologists, mathematicians, anthropologists, astronomers, and historians of science have produced studies that illuminate, some in admirable detail, those aspects of that tradition that are of interest to their particular disciplines. Examples of the virtues of the monodisciplinary approach include Thomas Heath, *A History of Greek Mathematics* (1921), which establishes the twentieth-century conventional wisdom concerning the mathematics of Pythagoras; Walter Burkert, *Lore and Science in Ancient Pythagoreanism* (1962), a work of cultural anthropology debunking, for the benefit of specialists able to study its many citations in original Greek, the idea that Pythagoras was a mathematician; Flora R. Levin, *The Manual of Harmonics of Nicomachus the Pythagorean* (1994), a detailed introduction to a first-century AD work on Pythagorean theories of musical harmony; and Charles H. Kahn, *Pythagoras and the Pythagoreans: A Brief History* (1999), which, as promised in the title, briefly traces the influence of Pythagoras and Pythagoreanism, primarily as it concerns philosophy, forward to modern times. Such specialized studies are not without their risks, however.[4] Nor does a work exist at this time that traces the significance of Pythagoras, even for one discipline, for the Middle Ages.[5]

However, for Pythagoras himself, his immediate followers, and those who in later centuries called themselves Pythagoreans, the boundaries between scientific, religious, and philosophical fields appeared less sharp than they do to most modern thinkers. Indeed, much of the appeal of Pythagorean thought for

those it influenced seems to have been the essential unity it found in a complex, sometimes mysterious, world. The compartmentalized scholarly diligence of the modern world risks underemphasizing that unity. We can learn to see the history of art and architecture through Pythagorean eyes only by reaching beyond the borders of individual academic fields, by looking holistically at the literary evidence as it developed in tandem with the visual arts. Several scholars in the past century have pointed the way.

Cornelia de Vogel's research from the 1950s on, although its primary focus was on Greek philosophical history, was exemplary in accepting the inseparability of the philosophical and mystical aspects of Pythagorean thought.[6] She admiringly acknowledged the late nineteenth-century work of François Lenormant, not himself a philosopher, who had proposed that the great originality of Pythagoreanism lay in its having been both practical and theoretical—two opposing tendencies that required constant reconciliation.[7]

The highly original writings of Franz Cumont in the first half of the twentieth century explored the credibility of ancient traditions about Pythagoras's wisdom having Oriental roots and suggested that doctrines attributed to Pythagoras were permeated with themes originating in Chaldea, Persia, and Egypt.[8] These suggestions were substantiated in the 1990s by Peter Kingsley, who showed that Pythagorean teachings derived from the East, and, after leaving an extraordinary imprint on Western civilization, they returned to the East.[9] A different kind of "Eastern" connection was proposed by Isidore Lévy, who in the 1920s and 1930s reached provocative conclusions about substantive and historical parallels in Antiquity between Pythagoreanism and Judaism.[10]

In brilliant midcentury studies of the climate of thought in the early Roman Empire, Jérôme Carcopino traced mutual influences between Neopythagoreanism and early Christianity, while Jean Gagé made it clear that worship of the Greek god Apollo, who was closely associated with Pythagoras, played a role similarly important.[11] In the 1990s Paul Zanker brought expertise in classical history and art history together to explore classical concepts of intellectuality in relation to portrayals of intellectuals.[12]

Most important as models for the present study are the contributions of S. K. Heninger Jr. and George L. Hersey. Motivated by a realization that much late medieval and Renaissance literature was written by and for people imbued with the Pythagorean notion of belonging to an intricately designed, harmonious, and hierarchical universe inherited from Antiquity, Heninger published in 1974 and 1977 a pair of near-encyclopedic accounts of the Pythagorean worldview as it was manifested in Renaissance poetry.[13] In an inventive 1976 study of the architecture of the Renaissance palace, Hersey proposed that Italian architects, inspired by Pythagorean concepts of the cube, embarked on a deliberate program of applying such concepts to ennoble domestic architecture.[14] This original work in essence opened the door to considerations of Pythagorean influence in the history of art in general.

▲

The interdisciplinary approach that has inspired this book is an important step toward fuller understanding of the influence of Pythagorean thought. Something more is needed, though, to address the numerous uncertainties that remain, notwithstanding many generations of research regarding even embarrassingly simple questions: Who was Pythagoras? (a philosopher? a sage? a scientist? a charlatan? a legend?) How did his ideas develop? To what extent were they original? What did they owe to influences from foreign cultures? What doctrines did he himself teach and to whom did he teach them? What was the nature of the Pythagorean cult or cults active in his lifetime and in the first few centuries after his death? Who were the Pythagoreans, then and later? What beliefs characterized the versions of Pythagoreanism current in 500 BC, AD 500, AD 1000, and the centuries between? How and where did differences evolve?

Answers to such questions, to the extent that they are available, have been based mostly on a diverse and inconsistent array of documents created centuries after the time of the early Pythagoreans. These documents undoubtedly mingle some accurate information with guesswork, embellishment, slander, and hagiography; surviving contemporary evidence is extremely limited, consisting for the most part of fragments quoted by later authors. Pythagoras himself may, like Socrates, have written nothing; certainly no writings attributable to him survive, and by most accounts his teachings were transmitted orally and secretively in enigmatic forms designed to perplex the uninitiated.

As a way of making it possible to draw sensible conclusions from this heterogeneous documentary record, I propose—rather than pursuing the nearly impossible goal of establishing rigorously verifiable "truth" about Pythagoras, his teachings, and his followers—to study the chronological development of *perceptions* about these topics, a relatively tractable task. An intellectual history so conceived appears more relevant to questions of Pythagorean influence on the arts, since it was presumably in the perceptions current in their own times that architects, painters, and sculptors found their inspiration.

Choosing to approach the biographical background as a history of Pythagoras's reputation, rather than of Pythagoras as an individual historical figure, frees us from the necessity of constantly and competitively weighing the plausibility of reports about him. It also enables us to consider a greater number of ancient sources than are cited in any work on Pythagoras known to me. Many of these sources are relatively little read and familiar only to specialists. Assembling them together and describing their contents in a language free from jargon help us to understand the coherent picture that is formed from their combination. Ascertaining, for example, whether or not Pythagoras discovered the familiar hypotenuse theorem attributed to him by geometry textbooks, whether or not he learned wisdom from Egyptian and Zoroastrian priests or allowed sacrifices to the gods as an exception to his injunctions

against killing animals—even, for that matter, whether or not he was the miracle-working immortal son of the god Apollo—will not be so important in our search for influences in art and architecture as recognizing that Pythagoras's legend at various stages included all these claims and many more.

It is similarly irrelevant, once we shift our focus from "fact" to perception, whether or not it was Pythagoras himself who developed the concepts of harmony, proportion, form, and order that were labeled Pythagorean in Antiquity and later centuries. What is relevant is that eminent ancient authorities believed this to be true, and that their beliefs were incorporated into the Pythagoreanism inherited by future generations.

▲

The tradition of thought whose influence I trace in this way appears to have begun in the sixth century BC as a syncretic science-religion built around a loosely related set of notions—including vegetarianism, simplicity of dress, hygiene, moral instruction, musical harmony, metempsychosis (or transmigration of the soul, which at death is believed to pass from one body to another, thus being reincarnated), cosmic order, and theories of number. It is important to understand that number did not have the same meaning for Pythagoreans as it does for modern mathematicians. Pythagoreans thought of numbers as having warmth (in that they had function, personality, sex, symbolism, and ethical implications that, relating to the human condition, helped to explain the universe), whereas in modern mathematics they are cold (being merely abstract units or integers).

Above all, the followers of Pythagoras were known for their connection of numbers with philosophical ideas, in ways that strike modern observers as combining both practical and mystical elements. On the one hand, their use of number as an organizing principle for scientific inquiry has left its mark on the world of academic learning to this day. Modern curricula have their historical roots in those of the medieval schools, whose fundamental and prestigious core courses, the quadrivium, had originally been defined in Pythagorean terms: arithmetic studied the meaning of number for its inspirational power, geometry the relationship of number to shape and substance, music the arrangement of number in sound and harmony, and astronomy the governing role of number in space and motion. On the other hand, Pythagoras and his immediate followers were said to have attributed near-magical powers to numbers, such as, for example, four and ten. The sum of the first four integers (one, two, three, and four) is ten, a number whose "perfection" for Pythagoreans symbolized the universe and was manifested in the *tetraktys,* a triangular array of marks that symbolize Pythagoreanism as the cross symbolizes Christianity and the six-pointed star has in modern times come to symbolize Judaism.[15]

In the centuries after Pythagoras's lifetime the beliefs and teachings attributed to him gained growing acceptance, in part through their association with the teachings of Plato, whose *Timaeus* asserted that number is a universal and

divine principle that explains and governs all things. Later Pythagoreans for this reason regarded Plato as a follower of Pythagoras. Whether or not this was literally true, the compatibility of the two sets of doctrines worked to the advantage of both, and the extensive influence of Plato's works made him one of the most famous "Pythagoreans" of Antiquity.

Despite this infusion of prestige, a millennium after the death of its founder Pythagoreanism as an active movement had begun to fade, reaching a nadir in the sixth century AD when Justinian closed the Greek Academy at Athens. Nevertheless, Pythagorean ways of thought survived into the following centuries and indeed gained strength, permitting them to exert strong intellectual as well as popular influences in the high Middle Ages. Thus did interest in Pythagoras and his doctrines continue throughout medieval times. This survival can be attributed in part to continuing interest in the *Timaeus* and to the popularity of late Antique authors such as Macrobius and Boethius, but as will be seen in these pages, the still-to-be-explored activity of other thinkers undoubtedly played a role as well.

▲

This book brings information from all aspects of Pythagorean studies to bear on the question of how the Pythagorean legacy manifested itself in the visual arts and how the meaning of a work of art can be sought in its geometrical, proportional, or numerical characteristics. The text is divided into three parts. The first consists of chapters that compose a biography of the reputation of Pythagoras as it developed through the centuries of Antiquity and the Middle Ages. The second creates a history of the development of the ideas associated with him and those who considered themselves his followers; the third considers in some detail not only representations of Pythagoras himself but examples drawn from the visual arts and architecture that appear to have been inspired or influenced by Pythagoras and the tradition associated with his name.

Part I is further divided into four chronologically arranged chapters that focus on Pythagoras the man and the legend. These consider the diverse and often fragmentary surviving accounts of Pythagoras's life and the ideas attributed to him personally (rather than to later followers), as they unfolded and grew between the sixth century BC and the fourteenth century AD into a rich and relatively consistent "biography." Part II (chaps. 5–7) directs attention to Pythagorean thought, that is, to what became of Pythagoras's ideas in the hands of others. It traces the development of doctrines and ideas associated with his admirers from the time of the sage's earliest followers, through ever-widening circles of interest and influence over the next millennia and a half, to the devotion of late medieval intellectuals to a cosmic view of world order and harmony that they imbibed from Pythagorean authors of late Antiquity and the early Middle Ages. Part III (chaps. 8–12) explores how Pythagorean concepts of subject matter, form, and proportion were reflected in the commis-

sioning, design, and creation of architecture and the visual arts in Antiquity and the Middle Ages, and what meaning such works held for "initiated" viewers. A concluding chapter evaluates the significance of Pythagoras for the history of ideas and for the history of art and architecture by summarizing the ways in which the ideas associated with him were a significant phenomenon in the history of Western civilization and the unique role they played in the creation of new visual concepts. The idea of achieving modernity by looking back to Antiquity would climax during the Renaissance, when two-thousand-year-old Pythagorean concepts would be seized on by new generations of artists and patrons as, paradoxically, a program for making works of art intellectually "modern."

Paralleling these visual expositions of Pythagorean themes through the centuries is a persistent tradition of portraiture, never before studied as a whole, depicting Pythagoras himself. Beginning with naturalistic likenesses created close in time to the sage's own lifetime, these images evolved through a wide variety of idealized representations that continued throughout medieval times. They underline the consistent importance of Pythagoras and his doctrines from Antiquity through the thirteenth and fourteenth centuries, when the Middle Ages slowly but relentlessly transformed themselves into the Renaissance.

▲

This volume is the first to treat comprehensively the history of the influence of this one man on virtually all branches of knowledge. No earlier work either of Pythagoras the man or of Pythagoreanism has addressed so broad an array of themes or endeavored to bring together its diverse threads and trace them through Antiquity and the Middle Ages. I recognize that to attempt this inquiry is to venture into a number of fields in which others are more expert than I. However, I am emboldened by the clear need for such a multidisciplinary approach and by my sense that the wait for a scholar fully qualified in all the appropriate fields would be a very long one indeed.

The aims of this book are limited to illuminating a relatively unfamiliar tradition of thought; to showing how its influence, centered on the dim memory of a single personality, lingered on for close to twenty centuries; to demonstrating that it represents a central aspect in the transmission and interpretation of the heritage of classical Antiquity; and to suggesting a new approach for studying works of art and architecture. These aims also include paving the way for a subsequent volume in which I plan to show how Pythagoras and Pythagoreanism captured the interest of the Renaissance. I shall be gratified if the present book succeeds in serving as a foundation and a catalyst for inquiries by other scholars into further parallels between the history of ideas and the history of the visual arts.

PYTHAGORAS—
MAN AND LEGEND

PYTHAGORAS
IN THE GREEK WORLD

Considering that Pythagoras was one of the most influential minds in the history of thought, remarkably little certain contemporary information has come down to us about his life and his teachings. Nothing written by him survives. All of the relatively meager biographic details we have come from writers who, in the centuries after his death, mentioned him or compiled accounts based on oral traditions and written materials that have long since vanished.

That said, there is no good reason to disbelieve ancient testimony that Pythagoras was born in the early sixth century BC on Samos, easternmost of the Greek islands, just off the coast of Ephesus in Asia Minor (modern-day Turkey). Foreign traders congregated on Samos to exchange goods and, undoubtedly, cultural traditions between the Oriental world to the east—Chaldea, Syria, and Babylonia—and the Greek world to the west.[1] This made Samos an important link between the early Greeks and the Persians during the era leading up to their wars in the following century.[2]

Ancient tradition also tells us that, as an adult, Pythagoras emigrated to a small Greek colony called Croton (or Kroton), in Magna Grecia on the Ionian Sea near the southern tip of Italy. Today the Italian town of Crotone, in Calabria, is near the remains of the ancient Greek settlement of Croton (see frontispiece) reputedly founded in the eighth century BC by the hunchback Myscellus. Croton was famous for its Olympic athletes, warriors, and medical doctors as well as for a particularly sumptuous temple dedicated to Hera, only

one column of which survives. Its fame in subsequent ages grew out of its as-
sociation with Pythagoras.[3]

The Beginnings: The Sixth Century BC

The oldest surviving description of Pythagoras was written by Xenophanes of
Colophon (near the present-day city of Ismir in Turkey), a sixth-century poet
who settled in Magna Grecia, not far from Croton. The fact that he lived close
to Croton at the time Pythagoras was there makes plausible the suggestion of
Heraclitus of Ephesus, another contemporary who may also have known
Pythagoras personally, that Xenophanes and Pythagoras were acquainted.[4]
The plausibility is enhanced by surviving fragments of poems in which Xeno-
phanes expresses belief in a single "cause" that regulates the universe, a belief
that will be seen, in the following chapters, to be associated with Pythagoras.
This belief contrasts with the pantheon of anthropomorphic gods described by
earlier authors such as Homer and Hesiod and, as such, resembles the
"monotheistic" views that later authors would suggest was an important com-
ponent of the thought of Pythagoras, which was centered on one god, Apollo.[5]

Xenophanes' description of Pythagoras takes the form of a short poetic
fable:

> Pythagoras and the Dog
> They say that once he passed by as a dog was being beaten, and pitying it
> spoke as follows, "Stop, and beat it not; for the soul is that of a friend; I
> know it, for I heard it speak."[6]

Whimsical or cryptic (or even satirical) though these words may appear, they
come from a contemporary who likely knew Pythagoras personally and so are
worth careful attention. Xenophanes attributes three key beliefs to Pythagoras:
(1) human beings have souls (a belief not widely held in his time); (2) the soul
is immortal; and (3) at death it passes or migrates from one being to another (a
belief known as transmigration of the soul, because the soul is reincarnated
into another being, or metempsychosis).[7] In recording Pythagoras's apparent
belief that a dog could be worthy of housing a human soul, the poetic fable
just quoted provides a possible explanation of the compassion for animals that
later came to be regarded as a Pythagorean characteristic.

Another contemporary and a possible acquaintance of Pythagoras, a med-
ical doctor of Croton named Alcmaeon, has left us a fragment suggesting sev-
eral of his friends may have known his fellow townsman Pythagoras.[8] Aristotle
later hinted that Alcmaeon may have known Pythagoras personally.[9] The sim-
ilarity of Alcmaeon's views to those of Pythagoras were, Aristotle tells us, to be
found in Alcmaeon's assertion that all things are balanced "in pairs." Most
subsequent commentators have concurred in these judgments by Aristotle.[10]
Not surprising, given that Alcmaeon was a medical man, is that most of the
surviving fragments connected with him concern health. In one of these, Alc-

maeon expresses the view that good health consists in the balancing of oppo-
sites and the avoidance of excess. His conclusion that good health is the pro-
portionate blending of qualities constitutes the first suggestion that the con-
cepts of harmony and proportion might be derived from the teachings of
Pythagoras. Nor is it surprising that, as a probable friend of Pythagoras's, Alc-
maeon believed in the immortality of the soul.[11]

A third contemporary who has left behind words implying probable first-
hand acquaintance with Pythagoras is Pherecydes of Syros.[12] The tomb of this
sixth-century mythographer was reportedly inscribed as follows: "The end of
all wisdom is in me. If aught befall me, tell my Pythagoras that he is the first of
all in the land of Hellas. In speaking thus I do not lie."[13] These somewhat mys-
tical sentences, whether written by Pherecydes himself before his death or by
an obituarist, suggest that Pythagoras was both famous in his own time and
well acquainted with Pherecydes. Later writers in fact identify Pherecydes as
Pythagoras's teacher, and legends circulating in later Antiquity attribute the
same miraculous deeds to both.[14]

The late sixth-century BC scientific philosopher Heraclitus of Ephesus, who
lived across a few miles of water from the birthplace of Pythagoras and whose
lifespan may have overlapped his,[15] accused Pythagoras of trickery and
"quackery" in his research. Contemptuously dismissing the work of this
"Prince of Cheats," Heraclitus says: "Pythagoras, son of Mnesarchus, prac-
ticed inquiry more than any other man, and selecting from these writings he
manufactured a wisdom for himself—much learning, artful knavery."[16] This
fragment was an important, though ambiguous, piece of evidence in a long-
standing ancient and medieval controversy over whether Pythagoras commit-
ted any of his teachings to writing. Diogenes Laertius, the scholar who pre-
served the fragment in about the third century AD, considered it an
unequivocal statement that Heraclitus knew Pythagoras as the author of writ-
ten works. Heraclitus's words can also be interpreted, however, as a curmud-
geonly accusation that Pythagoras, portrayed as a bumbling know-it-all, con-
cocted a philosophy by culling passages from the writings of others.[17]

In a pithier fragment, Heraclitus again disparages Pythagoras's overly broad
interests: "Much learning does not teach sense—otherwise it would have taught
Hesiod and Pythagoras."[18] A notorious misanthrope with what appears to have
been a particular antipathy toward Pythagoras, Heraclitus manages, at any
rate, to pass on one piece of new information: the name of Pythagoras's father,
Mnesarchus. In addition, his account of Pythagoras's prolific scholarship might
well, despite the sneering tone, be taken as praise. Heraclitus's disparaging re-
marks about the excessive breadth of Pythagoras's learning may be a complaint
about his perceived "mysticism"[19] or they may simply reflect a local rivalry—
possibly even a good-natured one—between the two men or between their
neighboring homelands. It could, however, also be an expression of a more sub-
stantive disagreement: Heraclitus believed that the universe naturally tended
toward an all-pervading harmony, whereas Pythagoras (as first suggested by

Alcmaeon and gradually developed in later accounts) appears to have seen the harmony of the universe as the result of the balancing of pairs of opposites.[20]

▲

Thus the oldest knowledge we have of Pythagoras, the fragmentary evidence supplied by fellow Greeks, contributes significant information about him: His father was Mnesarchus; he believed that men have souls that are immortal and that transmigrate to new bodies when former bodies die; he was sympathetic to animals and believed that they, like men, could harbor souls; he had disciples in Croton, at least one of whom—probably because of Pythagoras's teaching—attached importance to the pairing of opposites; and he was famous in his own time as a polymath. Although at least one of his contemporaries seems to have considered him a charlatan, he had to acknowledge that Pythagoras was an avid researcher. Although Pythagoras was associated with writings, it is not clear that the writings were his own.

The Reputation of Pythagoras in the Fifth Century BC

The first mention of Pythagoras in surviving works by Greek fifth-century writers is by Ion of Chios (ca. 480–ca. 421 BC),[21] whose *Triagmoi,* now known only through fragments, exalts the mystic powers of the number three (the triad) and is considered by many to reflect Pythagorean ideas. According to one of the fragments, preserved some six centuries later by Diogenes Laertius, Pythagoras ascribed to Orpheus some poems that he himself had written.[22] Like the Heraclitean fragment discussed earlier (also preserved by Diogenes Laertius), this one suggests but by no means confirms that Pythagoras committed some of his thoughts to writing; it also suggests some connection between Pythagoras and Orphic beliefs. In a lengthier fragment, eulogizing the philosopher Pherecydes, Ion suggests his admiration for Pythagoras:

> Thus he, excelling in courage and also in honour, even after death possesses in his soul a pleasant life—if indeed Pythagoras is truly wise, who above all men learned and gained knowledge.[23]

These lines make it clear that by this time Pythagoras had become a quotable sage, an authority remembered in particular for his belief in metempsychosis.

Empedocles (ca. 493–ca. 432 BC) wrote one surviving verse, which, although it does not name Pythagoras, has been interpreted by both ancient tradition and modern scholars as a reference to him:[24]

> Among them was a man of immense knowledge
> who had obtained the greatest wealth of mind,
> an exceptional master of every kind of wise work.
> For when he stretched out with all his mind
> he easily saw each and every thing
> in ten or twenty human generations.[25]

This fragment, recorded in late Antiquity by Porphyry, does not identify the context of Empedocles' encomium. Surely, though, it reveals the fervor of Empedocles for the range of Pythagoras's knowledge, brilliance, and wisdom. Likely, "every kind of wise work" that Empedocles attributes to Pythagoras suggests, again, that Pythagoras was regarded (or indeed known) in his time through his writings. It also suggests that the ideas of Pythagoras were neither exclusively rational nor exclusively mystical. Certainly it gives the impression that Pythagoras was a highly regarded authority on a multitude of topics.

Empedocles lived at Acragas (modern Agrigento) in Sicily, not far from southern Italy, and later tradition associates him with Pythagoras—possibly even as his pupil, although there is no evidence for this.[26] In a broader sense, it is not at all implausible that Empedocles breathed an atmosphere of Pythagorean ideas as he developed his own philosophy and mode of life. The four-element cosmology posited by Empedocles was, for example, widely thought in Antiquity to reflect the tetrad of Pythagoras. Empedocles clearly admired the subject of his poem (most likely Pythagoras). According to ancient tradition he too, like Pythagoras, came to be regarded as a sage. As Heraclitus and Ion have suggested and Empedocles underlines, Pythagoras may not have been admired exclusively for his rationality but also, even at this early time, for magic and miracle working. Perhaps following in the footsteps of Pythagoras, Empedocles also came to be associated with magic and miracles, as well as with belief in immortality.[27] According to the most famous of the legends about his death, Empedocles immolated himself by leaping into the erupting Mount Etna; miraculously, his bronze sandal survived, suggesting that he had achieved godlike immortality.[28]

The writings of Empedocles also provide the oldest surviving evidence regarding dietary prohibitions ascribed to Pythagoras. Empedocles urged his followers to abstain from eating living creatures, since their bodies are the inheritors of human souls. This belief echoes the admonition contained in the earliest record of Pythagoras himself, that of Xenophanes discussed earlier. Empedocles reasoned that if human beings kill and eat animals (even for religious ritual purposes, since edible parts of the sacrificed animal were consumed by worshippers), they are killing their own kin:

A father lifts his son who has changed his shape
and slaughters him as he prays, the fool,
 while he cries pitifully,
beseeching his sacrificer. But he, deaf to his cries,
slaughters him in the halls and prepares a foul feast
in the same way a son takes his father,
 children their mother:
they bereave them of life and eat their dear flesh.[29]

In another fragment Empedocles advises his own followers not to eat beans.[30] Although he does not cite Pythagoras's authority for this prohibition, later ancient authors do.

From the fifth-century historian Herodotus (ca. 484–ca. 420 BC) we have the most concise early description of Pythagoras. Herodotus called Pythagoras, whom he confirms to have been the son of Mnesarchus, "one of the greatest" of Greek teachers and says that he taught his followers the doctrine of immortality. Herodotus also relates information he says was transmitted to him by the Pontic Greeks, concerning a freed slave of Pythagoras's named Salmoxis. After returning to his home territory in Thrace, Salmoxis, who had been exposed to Pythagoras's doctrines, ordered the construction of an underground chamber, where he lived in hiding. After three years he emerged, claiming to have risen from the dead, and persuaded some of his fellow countrymen to believe that he was immortal. As I discuss in chapter 3, a similar story was told of Pythagoras himself several centuries later.[31]

Writing near the turn of the fourth century BC, Isocrates (436–338 BC) adds new information to the biography of Pythagoras. In one of his works, the *Busiris,* named after a legendary king of Egypt, Isocrates ascribes some of Pythagoras's success in attracting Greek followers to his having traveled to Egypt and brought back religious knowledge:

> On a visit to Egypt he [Pythagoras of Samos] became a student of the religion of the people, and was first to bring to the Greeks all philosophy, and more conspicuously than others he seriously interested himself in sacrifices and in ceremonial purity, since he believed that even if he should gain thereby no greater reward from the gods, among men, at any rate, his reputation would be greatly enhanced. And this indeed happened to him. For so greatly did he surpass all others in reputation that all the younger men desired to be his pupils, and their elders were more pleased to see their sons staying in his company than attending to their private affairs. And these reports we cannot disbelieve; for even now persons who profess to be followers of his teaching are more admired when silent than are those who have the greatest renown for eloquence.[32]

Isocrates' account is packed with new information. His commentary provides the first surviving testimony about a trip by Pythagoras to Egypt, something that Herodotus did not mention.[33] Although the education of Pythagoras in Egypt is considered legendary by some modern scholars, what is important here of course is that the words of Isocrates provide the oldest testimony that this perception existed in his time. This new "fact" would be well remembered as the memory of Pythagoras developed over the centuries. Although Isocrates' references to "ceremonial purity" may refer to an unwillingness to eat the flesh of animals, he does not explicitly say this. Isocrates also is the first to affirm specifically that Pythagoras was a teacher; his reputation, says Isocrates, was so excellent that he was surrounded by many eager pupils. That his teachings may have had moral overtones is suggested by Isocrates' reference to the parental approval of Pythagoras's relationships with their sons. Last but not least, Isocrates is the first to mention the "silence" practiced by the followers of Pythagoras's teaching.

Although this claim may have been little more than a fairly standard rhetorical figure (placing a higher value on the silence of the wise than on the eloquence of those without wisdom), the works of later authors pursue the concept that Pythagoras and his followers practiced, or were believed to have practiced—a quasi-monastic silence. This practice was eventually perceived, rightly or wrongly, as less a matter of individual spiritual self-discipline than a deliberate protection of the arcana of Pythagoras's sect from outsiders.

The theme of secrecy emerges more clearly in a letter written by Lysis of Tarentum (whose dates are unknown but who probably flourished in the late fifth century BC). According to Lysis, Pythagoras had a daughter named Damo to whom he entrusted his "commentaries" (not further specified), instructing her not to divulge them to any outsider. Although she might have profited handsomely, Lysis says, she kept her father's secrets because they were "more important than gold."[34] It should be noted that Lysis's reference to "commentaries" suggests that Pythagoras left writings.

▲

Summarizing the development of Pythagoras's biography in the century following his death, we find several new elements. Among these perhaps the most important are Pythagoras's fame as a teacher—the "greatest" of all Greek teachers—his promulgation of the doctrine of immortality, and his reputation as a great mind noted for his wisdom. Other important new ideas that emerged in the fifth century BC relate to his supposed education in Egypt, and to the silence and secrecy practiced by him and his disciples. The latter implies that the teachings of Pythagoras were available only to initiates. We also learn that he had a daughter, and we learn her name. She protected his "commentaries" from the public, which suggests that writings existed and that they were secret. Legends connecting Pythagoras with miracles had become current. For the first time, we learn of the association of Pythagoras with taboos on the eating of animal flesh and beans.

Throughout this century the luster of Pythagoras's great wisdom and humanity and his reputation as a sage, first expressed in his own time, remain untarnished and unchanged. Thus does the ancient tradition about Pythagoras take form in the century following his death.

The Critical Fortune of Pythagoras from the Fourth to the Second Century BC

As we enter the fourth century BC, we encounter many famous philosophers who, though some would be considered Pythagoreans by later writers, have left us little information about Pythagoras, now dead for over one hundred years. Their writings suggest that a number of key texts about Pythagoras from this period are lost to us. These writings also suggest that myths had begun to emerge about the already legendary sage. The most famous of these philosophers—including Archytas of Tarentum (who lived in the first half of

the century), Plato (ca. 429–347 BC), and Aristotle (384–322 BC)—are discussed briefly here and again in chapter 5, which considers Pythagoreanism in Antiquity.

Despite the influence Pythagoreanism appears to have exerted on him, Archytas of Tarentum, in the surviving fragments of his writings, has nothing specific to contribute about the life of the wise man from Samos. Plato only mentions Pythagoras by name once, when he tells his readers that Pythagoras was particularly loved as an educational leader.[35] However, one contemporary known to both Archytas and Plato, Eudoxus of Cnidus (ca. 409–356 BC), a noted mathematician and astronomer of his time who set forth the theory that concentric planetary spheres revolve around the earth, offers some information about the life of Pythagoras. From surviving extracts of his *Description of the Earth,* preserved in the works of later writers, we glean that he considered Pythagoras to be one who paid assiduous attention to the practice of ceremonial "purity," a term first mentioned by Isocrates. Eudoxus explains the practice of purity: Not only did Pythagoras abstain from animal food, but he was repelled by all forms of killing and bloodshed. Pythagoras went so far, Eudoxus informs us, as to shun contact with hunters and butchers.[36]

It was during this time that Andron of Ephesus, a writer active around 400 BC, claimed to have a collection of the prophecies of Pythagoras. This claim is reported by the early Christian scholar Eusebius of Caesarea, who says that one of these prophecies was stolen from Andron.[37] It constitutes the first claim that in the fourth century BC, Pythagoras was regarded as a prophet.

The two mentions of Pythagoras in Aristotle's surviving works (*Metaphysics* I.v.7 and *Magna moralia* 1182a.11–12) do not add to our knowledge about the life or career of Pythagoras. Later writers, however, preserved some fragments of Aristotle's lost works from which we can ascertain some extremely valuable new information.

In one such work, an important text titled *On the Pythagoreans* (transcribed in part by a certain Apollonius two centuries later and widely known in later Antiquity), Aristotle praised Pythagoras as a mathematician who had a particular interest in numbers. He also recounted stories indicating that Pythagoras was known to his contemporaries as a worker of miracles. These included correctly predicting that a white bear would appear and die at a certain time; biting and killing a poisonous snake that had just bitten him; being greeted by name ("Hail, Pythagoras!") by a river as he was about to cross it; appearing simultaneously in Croton and Metapontum, two cities many miles apart; accurately predicting, before the arrival of a cargo ship at Metapontum, that it contained a corpse; and, most memorably, standing up before the audience in a public place and revealing that he had a thigh made of gold.[38]

A fragment from another lost work by Aristotle informs us that Pythagoras paid special attention to the worship of Apollo. Elsewhere Aristotle tells us that the people of Croton addressed Pythagoras as Apollo Hyperboreus. Together, these constitute the first known references to a connection between

Pythagoras and Apollo—one that would be further explored by Diogenes Laertius (who had access to this work) six centuries later.[39]

In the work of Aristoxenus of Tarentum (Taras, present-day Taranto), a pupil of Aristotle who was born in southern Italy in about 365 BC and who was renowned for his writings on harmony and musical theory, we encounter new information about Pythagoras. Most likely it was meticulously obtained, given Aristoxenus's scholarly character, from sources—including oral tradition—that do not survive or are unknown to us.[40] Aristoxenus was the author of the earliest biography of Pythagoras from which any material has survived, a work titled *Pythagoras and His Associates* (now lost), as well as other works on Pythagorean matters and practices.[41] Surviving fragments from these writings by Aristoxenus offer new insights into the life of the by now legendary polymath.

Perhaps the most important new information these works contain is a chronology: Pythagoras was forty years told, Aristoxenus says, when the advent of the tyranny of Polycrates in Samos impelled him to leave for Italy. This information enabled Apollodorus of Athens, a learned scholar of the second century BC, to estimate that Pythagoras was born around 570 BC and emigrated to Croton in about 531 BC. Further, Aristoxenus tells us that Mnesarchus, the father of Pythagoras, was an artist, an engraver of gems. Aristoxenus also is the first to suggest that Pythagoras was not born in Samos but in Tuscany. He also was the first to suggest that Pythagoras traveled to Chaldea, a land whose inhabitants were known for their skills in prophecy,[42] to study with Zoroaster. When Pherecydes (Pythagoras's teacher) became ill, Aristoxenus adds, it was Pythagoras who buried him on Delos.[43] In contrast to what previous writers have told us, Aristoxenus testifies that beans were a favorite food of Pythagoras because of their purgative characteristics:

> Pythagoras esteemed the bean above all other vegetables;
> For he said that it was both soothing and laxative—
> That is why he made particular use of it.[44]

Pythagoras did not altogether abstain from meat, Aristoxenus says, since young pigs and goats formed part of his diet.[45]

We also learn from the testimony of this scholarly peripatetic that late in life Pythagoras was driven out of Croton, along with his associates and followers, by a local tyrant named Cylon; and that Pythagoras sought refuge in Metapontum (or Metapontium, present-day Metaponto), a city near Aristoxenus's home in Taranto, north of Croton in the nearby province of Lucania, where he died. The story of Pythagoras's flight from Croton would be corroborated in the second century BC by Polybius, who asserted that the principal building used by Pythagoras and his followers was burned down, causing a revolution.[46] Possibly the most far-reaching thing we learn from Aristoxenus comes, however, from a now-lost treatise he wrote on arithmetic. A surviving fragment of this work informs us that Pythagoras was famous above all others

for the study of number, for he "extolled and promoted the study of numbers more than anyone, diverting it from mercantile practice, and comparing everything to numbers."[47] Aristoxenus may be regarded as a well-qualified authority on Pythagoras not only for the scholarly precision with which he wrote but also because he was apparently familiar with Pythagoras, who, though already semi-legendary in his time, had lived in the neighboring cities of Croton and Metapontum. Because Aristoxenus is believed to have received his first musical instruction from his father, who could have been influenced by Pythagoras's disciples, it is reasonable to assume that Aristoxenus had some direct knowledge about Pythagoras.

Contemporaneous with Aristoxenus were Lyco of Troas, a peripatetic who discussed Pythagoras in a work now completely lost, and Heraclides Ponticus, who is thought to have been a student of Plato's nephew, Speusippus, in the Old Academy at Athens.[48] Surviving fragments from Heraclides' late fourth-century BC dialogues attribute to Pythagoras the coining of the word *philosophy*. They also add new complications to the topic of what if any dietary restrictions Pythagoras advocated. Empedocles had issued prohibitions, widely agreed in Antiquity to have originated with Pythagoras, against the eating of meat and beans; Aristoxenus had said just the opposite with respect to Pythagoras. Heraclides explains that Pythagoras's ban on meat eating was not absolute; he also suggests that the taboo on beans was based on the belief that a bean, if covered with dung for forty days, comes to resemble a man. From Heraclides we also learn that Pythagoras claimed to be able to remember at least four previous lives, in one of which he was a Trojan named Euphorbus who had lost his shield to Menelaus in battle.[49] Heraclides' account constitutes the most specific early attribution of supernatural powers (reincarnation) to Pythagoras.

Surviving fragments from the original and prolific third-century poet Callimachus of Cyrene (ca. 305–ca. 240 BC) mention Pythagoras several times, not always by that name, suggesting, as Heraclides had, his various reincarnations. Callimachus credits Pythagoras with discoveries concerning circles and "unequal-sided triangles"—corroborating the statements of Aristotle and Aristoxenus about Pythagoras's mathematical interests.[50] Callimachus also enters the debate over Pythagorean dietary restrictions (disagreeing with his near-contemporary Aristoxenus but agreeing with Empedocles): he tells us that Pythagoras taught men "to abstain from eating living things" but notes that this command was not obeyed by everyone.[51] Callimachus also admonishes his readers to "keep hands off the beans, a vexatious food, I too command as Pythagoras ordered."[52]

Thus it appears that by the third century, great interest had developed on the subject of Pythagoras and diet. Empedocles had suggested that Pythagoras ate neither meat nor beans and warned his followers to stay away from beans. Eudoxus had essentially repeated this, while Callimachus had suggested it was to be interpreted as an order of Pythagoras himself. Aristoxenus had main-

tained the opposite. (According to the second-century AD Roman essayist Aulus Gellius, these opposing views were based on a misunderstanding of Empedocles, who was speaking symbolically rather than literally. Beans resemble testicles, so in counseling men to stay away from beans Empedocles actually meant to warn them to avoid sexual excess.)[53] The active interest and vivid debate on this subject were to be overshadowed by more substantive additions to the biography of Pythagoras.

In a late third-century BC fragment, Timon of Phliasios, a dancer and skeptical philosopher, lampooned Pythagoras in the following words: "Down to a juggler's level he sinks with his cheating devices, laying his nets for men, Pythagoras, lover of bombast."[54] Timon's verse suggests the existence, in the third century BC, both of a tradition that Pythagoras had been a miracle worker and of an undercurrent of suspicion—possibly surviving from the time of Heraclitus—that saw in the miracle stories (such as, for example, Pythagoras's display of his golden thigh) nothing but conjurors' tricks.

Another late third-century writer, Hippobotus, contributes some biographical detail not contained in surviving earlier sources: Pythagoras had a wife named Theano who bore him a son named Telanges. According to Hippobotus, Telanges succeeded his father, thus inheriting his father's disciples and promulgating his father's doctrine, possibly becoming, as Hippobotus suggests, the teacher of Empedocles.[55]

Fragments from the work of Dicaearchus (active ca. 336–296 BC), a learned Greek historical author and biographer, tell us that Pythagoras taught the people of Croton to abandon their luxurious ways (which gave rise to the "disease" of self-indulgence) and pursue simplicity. This message, Dicaearchus says, was well received: the government of Croton invited Pythagoras to provide instruction to the youth of the city. Dicaearchus described Pythagoras as a man of remarkable powers and experience whose manner was "graceful and harmonious."[56]

Continued—indeed, increasing—interest in Pythagoras at this time, more than two hundred years after his death, is demonstrated by the appearance of at least two new biographies to join the previous century's pioneering work by Aristoxenus. One of these biographies, by the historian Neanthes of Cyzicus (exact dates uncertain), adds another few points to the traditional background of Pythagoras. According to Neanthes, Pythagoras's father, Mnesarchus, was a rich merchant rather than an artist. Originally a citizen of Tyre in Phoenicia, Mnesarchus sent his son to study under Chaldean masters there.[57] Neanthes is not the first writer to attribute some of the wisdom of Pythagoras to exotic sources. Isocrates, it will be remembered, reported a trip by Pythagoras to Egypt, while Aristoxenus had claimed that Pythagoras had studied in Chaldea with Zoroaster himself. Ancient opinion, however, was not unanimous on the subject of Pythagoras's education: a biography by Neanthes' contemporary Satyrus Ponticus says that Pythagoras went to Delos to study with Pherecydes.[58] The Oriental education of Pythagoras was to become a well-established

and steadily growing part of his traditional biography in the centuries that followed. In modern times both Cumont and Kingsley have provided significant corroboration by demonstrating Near Eastern origins for many Pythagorean (and Empedoclean) doctrines.[59]

Several writers around this time, including both Neanthes and Satyrus, describe the last days of Pythagoras. According to Neanthes, Pythagoras and forty of his disciples (all except Lysis and Archippos) died a tragic death when Pythagoras's house in Metapontum was set afire. According to Satyrus, although his enemies set fire to his house in Metapontum, Pythagoras escaped with the assistance of his disciples. Satyrus and Dicaearchus both say that Pythagoras died of starvation in Metapontum, although in Dicaearchus's version he was a fugitive from his enemies, whereas in Satyrus's version he starved himself deliberately out of grief over the death of his teacher Pherecydes. In contrast, the third-century BC biographer Hermippus of Smyrna asserts that Pythagoras was killed by enemy soldiers because he refused to escape via a route that would have required him to trample a field of beans.[60] Despite the great variance among these accounts, they are in agreement that Pythagoras and his followers were persecuted and that a sense of chaos and tragedy likely accompanied the sage's death.

This perceived tragedy may have been viewed as an apotheosis by those who believed an apparent miracle also reported by Hermippus. According to this story (which resembles the one told by Herodotus of Pythagoras's former slave Salmoxis), earlier in his stay in Italy Pythagoras constructed an underground apartment, where he disappeared for a considerable time. When he reappeared, looking like a skeleton, he announced that he had been to Hades; his disciples greeted him as one risen from the dead and considered him divine.[61]

Hermippus also introduces a new subject—that Pythagoras inherited ideas from Judaism. In a vast work about famous lawgivers and philosophers (which may have included a chapter on Pythagoras), Hermippus claimed that the philosophy Pythagoras brought to the Greeks originated with the Jews and that Pythagoras appropriated Jewish doctrines.[62]

Politically eventful as it was, with the founding of the Hellenistic kingdoms and the early expansion of Rome, the second century BC saw no new biographies of Pythagoras on the scale of those written by Aristoxenus, Neanthes, and Satyrus in the preceding two hundred years. There did appear, however, an interesting elaboration of the theme, first voiced by Hermippus in the third century, of Jewish influence on Pythagoras. Aristobulus, a distinguished Jewish intellectual active in Alexandria around 180–145 BC, writes that both Pythagoras and Plato borrowed from a purported early version of the Old Testament and incorporated its doctrines into their systems of belief. Indeed he claims that Pythagoras (as well as Socrates and Plato) followed Moses and copied him in "every" way—a claim with which the modern scholar Isidore Lévy takes issue, holding that the contrary was true, that is, that Alexandrian

Judaism was "pythagorized," in other words, that the fiction of Moses came to be based on the fiction of Pythagoras. Aristobulus also, in discussing the institution of the Sabbath, compares the number seven, around which he says that all living things revolve, to the sun that directs the seven planets.[63] Similar veneration of the number seven had been expressed by the fifth-century BC lyric poet Pindar (whose poems speak of the number as dedicated to Apollo) and would be expressed again by the first-century AD Jewish philosopher Philo of Alexandria. (The probable Pythagorean connections of both Pindar and Philo are discussed in chapters 5 and 6.) The idea that Pythagoras was a student of Hebraic culture, which as we have seen dates from at least the third century BC, persisted into later Antiquity and would surface again, with surprising vigor, a millennium later when a number of Renaissance scholars would maintain that Pythagoras was a disciple of Moses.

▲

Thus on the eve of Rome's rapid ascent to world mastery, a fairly consistent Greek picture of Pythagoras has taken shape: sage and polymath, born in about 570 BC probably on the island of Samos, but perhaps in Tuscany. He was the son of a gem engraver or a rich merchant from Tyre. In about 531 BC Pythagoras moved to Croton, where he came to be widely known as a thinker and teacher. Late in life, persecuted by a tyrannical government in Croton, he moved to Metapontum, where he died, evidently as a result of further persecution (although accounts differ as to the exact manner of his death). No texts or descriptions remain to us of any writings he may have produced, but Pythagoras was unequivocally identified in Antiquity as the promulgator of a coherent body of wisdom on topics such as arithmetic (both mathematics and number), harmony, music, order, and the cosmos. It was believed, not unanimously, that he left writings and that he was a prophet.

Pythagoras is credited with coining the term *philosophy* to describe his inquiries into these topics. He believed in immortality and metempsychosis, and as a corollary he was particularly kind to animals. Some or all of his ideas may, according to various sources, have been acquired by him from Hebrew, Egyptian, or Chaldean teachers (possibly even Zoroaster himself). He attracted a body of followers in part because of his philosophical ideas, but also in part because of his reputation as a magician and the suggestion of his divinity. The latter was exhibited through his association with Apollo, his special attributes (such as his golden thigh), and his special powers (such as resurrection from the dead and reincarnation in different forms). The doctrines he taught apparently included dietary restrictions (he was widely—but not unanimously—believed to abstain from eating meat or beans) and the practice of silence. Pythagoras had a wife and two children, both of whom carried on his teachings, including a code of secrecy, after his death. Although so judicious a historian as Aristotle took the many miracle stories about Pythagoras seriously enough to compile and publish them, others in Antiquity (notably Pythago-

ras's near contemporary Heraclitus of Ephesus) saw him as something of a charlatan, whose learning was broad but shallow, and who used trickery to persuade gullible audiences that he had miraculous powers—a view that may have been, as I suggested earlier, motivated by rivalry.

Even the briefest overview of how the "biography" of Pythagoras came into being in Greek Antiquity must take note of the fact that numerous accounts of Pythagoras's life by pre-Roman Greek authors are lost to us. These authors include Xenophillus (whose dates and works are unknown), Democritus of Abdera, Aristotle, Aristoxenus, Heraclides Ponticus, Dicaearchus, Hermippus of Smyrna, Hippobotus, and probably also Aristophon.[64] Fortunately, these "lost texts" were still available in later Antiquity. Writers such as Diogenes Laertius, Porphyry, and Iamblichus made extensive use of them in compiling their own biographies of Pythagoras, which are discussed in chapter 3. Parts of two especially valuable third-century BC works on Pythagoras, by Neanthes of Cyzicus and Satyrus, were preserved in this way. Neanthes, for example, is cited several times by Porphyry and also (as Isidore Lévy has shown) quoted without attribution by Diogenes Laertius.[65]

Despite the inevitable loss of documents through the centuries, from what has been preserved it seems clear that by the last century BC Greeks everywhere had come to regard Pythagoras as the thinker of greatest consequence in the early intellectual history of their nation.

PYTHAGORAS
IN THE ROMAN WORLD

Rather than withering away as the Hellenistic kingdoms yielded power to Rome around the end of the pre-Christian era, Greek culture flourished and expanded its sphere of influence to new regions and new audiences—most notably to Rome itself, where thoughtful literati found much to admire and emulate in the lore of their Mediterranean neighbor. Prominent among the traditions that philhellene Romans enthusiastically responded to and assimilated into their own culture were the life and teachings of the wise man of Croton. Latin and Greek writers in this era, drawing on (and preserving some passages from) a wide variety of older works that have since been lost, made significant additions to the traditional biography of Pythagoras. With the supply of potentially corroboratable narratives and recollections having by that time apparently been tapped close to exhaustion, these additions extended the biography in mystical, even supernatural, directions. Thus Pythagoras came increasingly to be regarded as having had magical powers over nature. Uncomfortable though our less credulous century may be with such material, it helped ensure that the memory of Pythagoras, having already persisted for five hundred years, would gain new vigor and continue to exert significant influence in European culture for another millennium and a half.

The First Century BC: Pythagoras Mythologized

Encyclopedic histories were a popular late-Hellenistic medium for the transmission of Greek thought to its Roman inheritors. One such compilation, and

the most extensively preserved Greek history from Antiquity, is the *Biblio-theke historika* (*Library*) of Diodorus Siculus (fl. ca. 60–21 BC), a Greek from Sicily who settled in Rome. Writing for a Greco-Roman audience, Diodorus expands on the biography of Pythagoras as it was known through the surviv-ing works of the earlier Greek writers. For example, Diodorus echoes Di-caearchus, who reported three centuries earlier that Pythagoras converted men from their love of extravagance and luxury and taught them to live a simple life. However, Diodorus's is the earliest surviving account to elaborate on what this "simple life" entailed: Pythagoras persuaded his followers to eat only uncooked food and drink only water and to refrain, especially in summer, from the pleasures of love because they defiled the body. He required his fol-lowers to wear white garments, Diodorus says, and to pray on behalf of the imprudent. Diodorus also repeats the story Heraclides had told about Pythagoras claiming to have recognized a particular shield as having belonged to him in a previous incarnation when he was the Dardanian warrior Euphor-bus. In what may be the most extravagant praise of Pythagoras anyone had yet recorded, Diodorus asserts that Pythagoras was considered a god in his own time: "every day almost the entire city turned to him, as to a god present among them, and all men ran in crowds to hear him. . . . he received at the hands of the inhabitants of Croton honours the equal of those accorded to the gods."[1] Going a step further, Diodorus deduces from the reputation of Numa Pompilius for goodness and wisdom that this early and most revered king of Rome had been a pupil of Pythagoras.[2]

Other first-century BC writers were quick to point out the anachronism in-volved in imagining Numa as Pythagoras's student. The great orator and statesman Cicero (Marcus Tullius Cicero, 106–43 BC) established a definitive chronology showing that Pythagoras lived after Numa.[3] The celebrated Latin historian Livy (Titus Livius, ca. 59 BC–ca. AD 17) concurred.[4] However, Livy's immense compilation on the history of Rome (*Ab urbe condita*) goes on from there to observe that the claim that Pythagoras had been Numa's teacher, un-true though it was, was so widely believed as to be worth taking note of.[5]

The connection of Numa Pompilius with Pythagoras and Croton was also challenged by Dionysius of Halicarnassus, a later contemporary (ca. 50 BC–ca. AD 30).[6] Dionysius exemplifies the influence and inspiration of Greek culture and ideas that were very much alive at the time he was a leading intellectual in Rome—to which he granted the ultimate compliment by calling it a Greek city. However, even so pro-Greek a writer pointed out the awkward fact that, wise though he was, Numa lived a full four generations before Pythagoras and thus could not have acquired that wisdom from him; nor could Numa have been a student in Croton, since he had already been king in Rome four years when Croton was founded.[7] This suggests that Diodorus's report demonstrated a sentimental inclination on the part of the Romans to link the wisdom of their beloved early king with that of the prestigious Greek sage.

▲

Preeminent among the Latin authors of the first century BC was Cicero, whose broad learning and prolific writings did much to make the reputation and teachings of Pythagoras accessible both in his own era and for centuries to come. He wrote at a time when a native Greek tradition of cosmological inquiry going back to Empedocles, Philolaus, and Aristotle in the fifth and fourth centuries was coming into contact with intellectual elements that were being acquired by the Romans from the Eastern cultures that had been conquered by the Macedonians.[8] The resulting synthesis of Oriental religion, magic, and science was, as Cumont has shown, particularly attractive to the Romans,[9] and most certainly to Cicero.

Again and again in his works Cicero uses the historical Pythagoras as an emblem of this holistic mode of thought. He extols the "supreme wisdom" and learning of Pythagoras.[10] He also echoes Heraclides Ponticus in crediting Pythagoras as the coiner of the term *philosophy*, "love of wisdom."[11] Pythagoras, Cicero says, brought together disparate views and disparate people in order to enrich and unify public and private life as well as the internal life of the soul.[12] He was a builder of community, equality, and justice and thus, Cicero suggests, brought harmony into the world. Cicero also tells us, as Xenophanes had said five centuries previously, that Pythagoras taught that the soul is eternal. He also says that Pythagoras practiced augury and divination.[13] Cicero takes special note of Pythagoras's refusal, even at the altar of Apollo of Delos, to slaughter a living animal, preferring instead to worship with bloodless sacrifices (flour and cakes, according to Aristotle).[14] Cicero repeats what has by now become fairly standard information about Pythagoras's secretiveness,[15] but he offers a new explanation for his prohibition against beans: according to "respectable authorities," Cicero says, its purpose was to prepare the body for sound sleep and trustworthy dreams.[16]

Following but extending the accounts of earlier writers, Cicero portrays Pythagoras as one who traveled to the "ends of the earth" in pursuit of his passion for knowledge.[17] He walked throughout Egypt in search of learning and visited Persia as well, just as two centuries later Plato—who according to Cicero was a Pythagorean and deliberately followed in the footsteps of Pythagoras—was to travel to Egypt and Sicily.[18] (Writing a few years after Cicero and possibly using different sources, the Greek geographer Strabo similarly maintains that Pythagoras had studied in "Egypt and Babylon.")[19] As depicted by Cicero, Pythagoras has become an "illustrious predecessor" to all men of wisdom, a saintlike example whose learning, teaching, and personal influence penetrated the world "far and wide."[20] In effect, Cicero suggests, Pythagoras had come to be a divine authority invoked by learned men to obviate any need for further discussion on any given subject.[21] Cicero describes a pilgrimage he himself made to Metapontum to see Pythagoras's chair and the house where

Pythagoras "breathed his last breath" (allegedly still in existence in spite of the city's destruction by Hannibal two centuries before Cicero's visit; this in turn suggests the possibility that out of respect for Pythagoras, Hannibal spared his house from destruction).[22] This testimony is the first we have suggesting that artifacts connected with Pythagoras had become sacred relics and his house a shrine.

So keen was Cicero's interest in the personality and teachings of Pythagoras that the main character in the great Ciceronian dialogue *De re publica* (*On the State*) serves in part as a vehicle for introducing key concepts believed to have been taught by the sage. In the first five books of the work the virtuous Roman statesman Scipio Africanus the Younger discusses with his associates what constitutes just government. In the sixth book, Scipio recounts a dream in which he was shown the structure and workings of the universe. Although elsewhere Cicero expounds on Pythagoras's fame as a mathematician and his view that number—manifested through arithmetic, geometry, and harmony—affects all branches of knowledge and is the supreme governing principle of the cosmos, here he makes those abstractions concrete and visible.[23]

In his dream, Scipio's guide (his late adoptive grandfather) tells him that there is life after death and introduces him to the "perfect" numbers seven and eight (numbers whose meanings were attributed by contemporary Greek mathematicians to Pythagoras). He goes on to show Scipio the nine spheres that make up the universe. Eight of them, he says, revolve at extremely high speeds, emitting seven tones that form an extraordinarily harmonious musical chord. This chord is inaudible to humans, but they nevertheless try to imitate it with the seven strings of the lyre and in song.[24]

This description is the earliest known of the harmony of the spheres, a concept related to ideas first put forward by Philolaus and Aristoxenus and elaborated by Plato, which came to be recognized by later authors as the invention of Pythagoras. The perpetually harmonious tones portrayed by Cicero as resulting from the motions of the spheres provided an appropriate musical backdrop to Scipio's contemplation of the immortality of his soul.[25] This theme, no doubt enthusiastically received by Christians, may have helped ensure long-lasting popularity for the *Somnium Scipionis* (*Scipio's Dream*) portion of the *De re publica*, while the rest of the dialogue was lost until Renaissance times.[26] The survival of the *Somnium Scipionis* as an independent work in the medieval world was due in large part to an impressive *Commentary* that Macrobius wrote on it in late Antiquity. As a result, the *Somnium Scipionis* had an important influence on philosophic writing throughout the Middle Ages and into the Renaissance.

Different Roman writers found different inspirations in the various doctrines associated with Pythagoras. Whereas Cicero in the *Somnium Scipionis* saw numbers as governing the "symphony" of the heavens, his contemporary Varro (Marcus Terentius Varro, 116–27 BC), a learned scholar of Latin literature and antiquities, found the same principles at work on a much smaller

scale. In a work titled *Tuberone* (now lost but known through excerpts quoted two centuries later by the Roman grammarian Censorinus), Varro attributed to Pythagoras the view that during the gestation of each human fetus the seed is transformed into blood, the blood into flesh, and the flesh into human form, each within a certain number of days, and that these numbers form patterns resembling the numerical patterns that underlie musical consonances. Varro also claims that Pythagoras believed that two types of human fetus exist: one requiring seven months to form and one requiring ten.[27]

Varro's focus on embryology contrasts with the more abstract mathematical approach to Pythagoras's teachings taken by Vitruvius (Vitruvius Pollio), a late first-century BC Roman architect-engineer who would be much admired in the Renaissance for *De architectura,* the only treatise on architecture to survive from Antiquity.[28] This work, which was dedicated to Augustus Caesar, the first Roman emperor, explicitly expresses its author's high regard for Pythagoras and his "divine inspiration." For Vitruvius, who likely had in mind the imperial project to rule the world, Pythagoras is a learned man whose influence extended to "all nations."[29] Vitruvius is more specific than any previous writer about Pythagoras's mathematical contributions. He speaks approvingly of various teachings of Pythagoras, especially those concerning the mystic power of the number four (the tetrad) as manifested in, for example, the four elements.[30] He also says that Pythagoras wrote books that discussed the importance of the cube; this statement constitutes the first unambiguous surviving claim that Pythagoras wrote "books."[31] Most intriguingly, Vitruvius provides the oldest surviving testimony linking Pythagoras's name with the geometrical proof now known as the Pythagorean theorem (but published by Euclid in about 300 BC without attribution to Pythagoras), according to which the square of the hypotenuse of a right triangle is equal to the sum of the squares of the other two sides (that is, $c^2 = a^2 + b^2$). Pythagoras discovered this fact, Vitruvius says, through the inspiration of the Muses.[32] He finds the discovery praiseworthy because it enables a carpenter to construct right angles (a set of steps, for example) by using simple building materials—a practical application of an abstruse mathematical truth. Vitruvius does not cite any documentary evidence for crediting Pythagoras with this discovery, which suggests he is recording oral traditions current among contemporary Pythagoreans (who, as Cicero tells us, claimed that their ideas came directly from the master, thus allowing authority to prevail over reason: "Ipse dixit" or "He himself said that").[33] If indeed Vitruvius (and not some other person, unknown to us) was the first to publish the name of Pythagoras in association with this theorem, it could be that he repeated an association he had read in an older source, or that the association was newly made in his time. More will be said later about Vitruvius's relationship to the Pythagorean movement of his time.

The continuing evolution of Pythagoras's biography reached a new milestone of sorts around the end of the first century BC, when the great poet Ovid (Publius Ovidius Naso, 43 BC–AD 17) made him a key character in his master-

piece, the *Metamorphoses.* The fifteenth and concluding book of this mytho-historical panorama in verse is built around an intense discourse on vegetari-anism and metempsychosis delivered by a Samos-born resident of Croton who is not named but who can only be Pythagoras. For this character these two topics are closely related. Not only is it cruel and unholy, he says, to indulge our "savage teeth" by eating the flesh of slaughtered animals when the earth is blessed with acorns, milk, honey, and fruits, but because our souls pass "from and into the bodies of beasts," it is like eating our own friends and neighbors.[34]

Ovid's Pythagoras figure also, at great length, praises the tetrad as the sym-bol of order in the universe.[35] Here Pythagoras proudly cites the god Apollo himself as the source of his inspiration. This personal identification with Apollo later leads Ovid's Pythagoras to discuss miracles and the roles of Apollo and the laurel tree in soothing human troubles and gaining immortality for mankind.[36] He also refers to the use of herbs and medicine to allay the suf-ferings of death.[37] This passage is the earliest known attribution to Pythagoras of an interest in medicine and may account in part for Apollo's being regarded in Italy as a healer.

Toward the end of the century and the beginning of the next we receive cor-roboration, in the work of Celsus (Aulus Cornelius Celsus, d. ca. AD 37), of Pythagoras's reputation as a physician. In a surviving encyclopedia of medi-cine, Celsus cites Pythagoras as the most celebrated of the philosophers who came to be experts in medicine.[38]

Thus by the end of the pre-Christian era the memory of Pythagoras, much enlarged and expanded from its original Greek sources, appears to have been an established element of Roman intellectual culture. Writing early in the next century, the encylopedist Pliny the Elder (Gaius Plinius Secundus, AD 23–79) credits Pythagoras with a great astronomical discovery, the planet Venus. He also claims that Pythagoras studied magic and taught it openly. One of the ex-amples he provides of Pythagoras's practice of magic involves his discovery of a "wondrous" plant that magically congeals water. On the medicinal side of magic, Pythagoras was especially interested in the squill plant, about which, Pliny says, he wrote a book. Pliny supplies us with the best brief summary of how the Roman world saw Pythagoras at this time: he was a "vir sagacis animi," a "wise genius."[39]

The First and Second Centuries AD: The *Vir Sagacis Animi* Revered

Admiration of Pythagoras is elevated still further in a series of letters attrib-uted to Apollonius of Tyana (a city in Cappadocia near the Euphrates), a cele-brated miracle worker and sage in the first half of the first century AD, who wrote a now-lost biography of Pythagoras and whose Pythagoreanism is dis-cussed in chapter 6. Apollonius's letters, which circulated in late Antiquity and were collected by the emperor Hadrian, shed new light on the evolving image of Pythagoras.[40] In several of the eighty-five surviving letters, Pythagoras is eu-

logized as a universal genius intermediate between god and man—a supernatural king, or a divinity, *daimon*.[41] One of the letters appears to corroborate Ovid's portrayal of Pythagoras as interested in medicine: Pythagoras, Apollonius says, praised the practice of medicine as the most "divine" occupation. (There is, however, no mention of Pythagoras in the surviving medical writings of Galen, a contemporary of Apollonius, or in those of Galen's predecessor Hippocrates. This may be because Pythagoras's "medical" interests were seen as concentrating more on spiritual or moral therapy for the soul than on the treatment of physical ailments.)[42] In another letter Apollonius acknowledges the conflicts among the many then-current oral and written stories about Pythagoras, but he says this is no cause for skepticism: "we need not be surprised, seeing that even concerning God himself men's accounts differ from one another."[43]

The view of Pythagoras as divine and thus deserving of reverence is expressed several times by Valerius Maximus, an early first-century Roman historian whose works would survive many editions in medieval and Renaissance times. According to Valerius, Pythagoras traveled in both Egypt and Persia before settling in the south of Italy, when he had achieved the "most perfect wisdom." He studied the motions of the stars and the courses of the planets and was so revered that human beings could not debate or question his words. Sites associated with him (such as the house in which he died, to which Cicero had made a pilgrimage in the preceding century) had indeed, Valerius affirms, become sacred shrines.[44]

Meanwhile, a contemporary Roman historian, Pompeius Trogus (Pompeius Trogus Justinius, fl. ca. first century AD), presented a different view of Pythagoras. In writing about the cities of Magna Grecia, he pointed out the great influence of Pythagoras for southern Italy, especially for Croton. According to his testimony, the teachings of Pythagoras were not so much esoteric as practical. Pythagoras did not address a special school, or intellectuals in particular, but the people as a whole. He taught the people of Croton to abandon their lives of luxury and to chose virtue and sobriety, and thus to find their appropriate place in the cosmos.[45]

A dramatic episode portraying Pythagoras as a healer of spiritual ailments appears in the *Institutio oratoria* (*On the Training of an Orator*), the masterwork of the famous rhetorician and teacher Quintilian (Marcus Fabius Quintilianus, ca. AD 35–ca. AD 95). In discussing how boys should be instructed in music, he provides an account of how Pythagoras once rescued a decent family from an "outrageous act" (undoubtedly rape) about to be committed by a group of young men who were being "led astray by their passions." Diagnosing the youths' frenzy as arising from inflammatory flute music, Pythagoras persuaded the flutist to change to a solemn "spondaic" beat, thereby calming the youths, saving the day, and proving the power of music to heal the soul.[46] This theme would resurface and be further developed four centuries later in the work of Boethius.

It was a contemporary of Quintilian, Martial (Marcus Valerius Martialis, ca. AD 38–ca. 104), who provides us with the oldest surviving information about Pythagoras's appearance. Martial mentions the Greek sage once in his *Epigrams*, saying that he had a long beard.[47]

Writing toward the end of the first century AD, Antonius Diogenes, a writer of tales of thrilling adventure, broadens still further the already prodigious erudition with which Pythagoras had come to be credited. According to his *On the Incredible Things beyond Thule*, Pythagoras studied not only with the Egyptians (as Isocrates had claimed), the Chaldeans (as Aristoxenus had claimed), and the Hebrews (as Hermippus of Smyrna had claimed), but also with the Arabs. From the Hebrews, Antonius appears to be the first to assert, Pythagoras learned the art of interpreting dreams. Implausible though this ever-expanding multicultural education may appear from our remote vantage point, it was to be taken quite seriously by the studious and scholarly third-century author Porphyry (whose biography of Pythagoras, discussed in chap. 3, would accept Antonius's statement as fact and elaborate on it).[48] From time to time after this, and especially during the Renaissance, Pythagoras would be described as a student of Egyptian, Chaldean, Arabic, and Hebrew learning.

Contemporary with these views of Pythagoras as a widely traveled, near-supernatural mystic and healer is that found in the work of Nicomachus of Gerasa (fl. AD 50–150), a celebrated Greek mathematician of Syrian origin whose interest in Pythagoras was focused on his pioneering role in the development of arithmetic and his promulgation of a quasi-religion dominated by mathematics (or arithmology, that is, an arithmetic in which the numbers are imbued with religious significance). Although Nicomachus's texts appear to have been, for the most part, compilations of now-lost earlier works, they are important on the one hand because they constitute the most elaborately conceived surviving writings from his time or before on Pythagoras's arithmetic, and on the other because they were copied, imitated, and used for instructional purposes throughout late Antiquity, the Middle Ages, and well into the Renaissance.[49] Nicomachus, who traveled widely throughout the Roman Empire, was a self-described Pythagorean. Although his *Life of Pythagoras* has not survived, the fact that he bothered to compile such a historical work suggests that interest in Pythagoras was high at this time.

Nicomachus is best known to us for his mathematical works, which include an *Introduction to Geometry* (now lost); an *Introduction to Harmonics* (now lost, whether or not it was ever completed); the *Theologoumena arithmeticae* (*Theology of Arithmetic*), a work on the Pythagorean doctrine of number, parts of which have survived through extracts and restatements in the works of later authors, such as Photius and Pseudo-Iamblichus (discussed in chap. 7 because they do not mention Pythagoras directly); an *Introduction to Arithmetic*; and a *Manual of Harmonics*. Both the *Introduction to Arithmetic* and the *Manual of Harmonics* survive in their entirety. Laced with homage to the

master, they constitute the best early sources on Pythagoras's mathematical and harmonic doctrines.[50]

Nicomachus begins the *Introduction to Arithmetic* by crediting Pythagoras with having persuaded his contemporaries and succeeding generations to apply the word *wisdom* only to the knowledge of eternal truths of the sort sought by science and philosophy. Nicomachus then demonstrates, using deductive reasoning and quotations from Plato, that wisdom is to be attained through four varieties of scientific endeavor: arithmetic, geometry, music, and astronomy (the future quadrivium; a later writer, Boethius, would borrow this concept from Nicomachus and so name it). Further, according to Nicomachus, one of these four, arithmetic, underlies the other three—and thus serves as the foundation of all wisdom. As the highest mathematical science, arithmetic is the source of consummate knowledge, and number its most important offspring. The science of arithmetic is, the reader gathers, influenced by the number three. What follows is a fairly systematically presented compendium of handy facts about numbers and their relationships to each other. The sequence of topics Nicomachus addresses includes the division of all numbers into even and odd; the division of all even numbers into powers of two (2, 4, 8, 16, and so on) and numbers whose factors include odd numbers; the division of all odd numbers into primes (3, 5, 7, 11, and so on); composites (numbers produced by multiplying two or more smaller numbers); methods for finding common factors between two numbers; the classification of all composite numbers as "superabundant," "deficient," or "perfect," based on whether they are less than, greater than, or equal to the sum of their factors; and the construction of various sorts of multiplication tables, which as Nicomachus points out can be both practical and aesthetically pleasing.[51]

Having established these basics (in at least some of which he was anticipated by Euclid) and convinced his readers that the universe is organized according to number, Nicomachus proceeds in the second half of the *Introduction to Arithmetic* to develop from them a kind of three-dimensional geometry based on various numerical relationships. A triangle, the simplest plane figure, can be created based on any of a series of what Nicomachus calls "triangular" numbers: 1, 3 (the sum of all the integers smaller than 3), 6 (the sum of all integers smaller than 4), 10 (the sum of all integers smaller than 5), 15, 21, 28, and so on. A square can be created based on any "square" number (from the series 1, 4, 9, 16, 25, and so on). Nicomachus further defines a number series for pentagons (1, 5, 12, 22, 35, 51, and so on) and a series for hexagons (1, 6, 15, 28, 45, 66, and so on), and then goes on to describe series that can be used to generate polygons of any number of sides. Nicomachus applies analogous reasoning to develop number series representing solid figures: pyramids (with triangles, squares, and other polygons as bases), cubes, parallelepipeds of various proportions, spheres, and irregularly shaped "wedges."[52]

What he has done, Nicomachus reminds his readers, is to take the measure

of the universe by using a mathematical toolkit that ultimately derives from two simple concepts: unity/odd numbers and duality/even numbers. In this sense the monad refers to "sameness" or permanence (or God), while the dyad refers to "otherness" or transitoriness (or matter).[53] While God is the cause of unchanging truth and unification, matter is the cause of things changing and separating. According to Nicomachus's view, their relationship is dynamic because they necessarily coexist in that they are mutually present. This system was, he says, adopted by Plato and similar to Philolaus's view of the limited and the unlimited. Both are balanced contraries that can be found in the universe as well as in number. As interacting opposites, they are bound together with a mean term that produces mediation or reconciliation.[54] This concept corresponds exactly, he points out, to the view of Pythagoras and other ancient philosophers that the beginnings of all things lie in sameness and otherness. In demonstrating the mechanics of the reconciliation of opposites and its goal, harmony, he explains:

> That we may be clearly persuaded of what is being said, namely that things are made up of warring and opposite elements and have in all likelihood taken on harmony—and harmony always arises from opposites, for harmony is the unification of the diverse and the reconciliation of the contrary-minded.

The remarkable regularities that can be generated by meshing an odd-number-based series with an even-number-based series, he says, should lead us to admire

> their mutual friendship and their cooperation to produce and perfect the remaining forms, to the end that we may with probability conceive that also in the nature of the universe from some such source as this a similar thing was brought about by universal providence.[55]

The final chapters of the *Introduction to Arithmetic* discuss in some detail the numerical proportions underlying three types of series (arithmetic, geometric, and harmonic) that Nicomachus says were known to Pythagoras, Plato, and Aristotle; these types touch lightly on seven additional types more recently recognized, bringing the total up to the "perfect" Pythagorean number ten. Nicomachus's references to Pythagoras in these chapters stop short of effusiveness but nevertheless make it clear that he regards Pythagoras as something like a godfather to, if not the inventor of, the entire field of mathematics he describes.[56]

The title page of the *Manual of Harmonics* proclaims its author to be "Nicomachus of Gerasa, the Pythagorean."[57] What follows amounts to an elaboration, in twelve brief and often cryptic chapters, of assertions Nicomachus made early on in his *Introduction to Arithmetic* that music, like astronomy, is a science inspired by Pythagoras and rooted in mathematics, and that "the motions of the stars [astronomy] have a perfectly melodious harmony [music]."[58]

Nicomachus begins by defining music. As opposed to speech, which is sound generated throughout a range and not limited to specific pitches, music is composed of discrete tones separated by fixed intervals. He attributes this definition to "the Pythagoreans"—exhibiting, perhaps, more loyalty than accuracy, since it appears to have originated with Aristotle's pupil Aristoxenus.[59] Nicomachus next considers the nature of the system of fixed pitches within which music operates. The traditional scale at the time of Pythagoras contained seven notes whose names Nicomachus associates with the presumed distance from Earth of the seven anciently recognized geocentric "planets." Saturn (Kronos), the farthest and slowest moving, corresponds to and generates the lowest note of the scale, inaudible to human ears; next farthest is Jupiter (Zeus), followed by Mars (Ares), the Sun (Helios), Mercury (Hermes), Venus (Aphrodite), and the nearby Moon (Selene), which travels the fastest and corresponds to the highest note.[60]

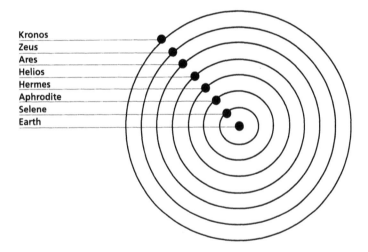

This scheme, based on the scale, is comparable but by no means identical to Cicero's "music of the spheres," which took the form of a chord. In Nicomachus's scheme, musical instruments generate the various pitches of the scale in accordance with numerically describable attributes: the length and tautness of vibrating strings and the length and diameter of wind instruments determine how quickly or slowly air will vibrate and thus how high or low a note will be produced.[61] Pythagoras, Nicomachus says, revolutionized music by applying his understanding of these numerical relationships to redesign the traditional seven-string lyre. By re-tuning certain strings and adding an eighth, he enabled the instrument to produce "the most satisfying consonance," namely, the octave, with minimal disruption to the tonalities his contemporaries were accustomed to hearing.[62]

Nicomachus explains Pythagoras's familiarity with these numerical princi-
ples by recounting an anecdote that was to fascinate readers down through the
centuries: One day, while deeply immersed in trying to conceive a mechanical
means for analyzing musical sounds, Pythagoras happened to walk past a
blacksmith's shop and, "by divine chance," heard perfect octaves, fourths, and
fifths in the clanging of the hammers against the anvils. "Elated . . . since it
was as if his purpose was being divinely accomplished," he carried out a series
of experiments, first with the hammers and anvils in the smithy, later with a
homemade string instrument, and still later with a variety of common string,
percussion, and wind instruments.[63] The result, described by Nicomachus at
length, was a "consistent and unchanging" set of relationships between the di-
mensions of the instruments and the tones they produced. The ability to ex-
press these relationships numerically made it possible, Nicomachus says, for
Pythagoras to analyze in detail not only familiar diatonic scales but also chro-
matic and enharmonic intervals that can be generated within the same pitch
range. Nicomachus uses the closing chapters of his brief work to outline a
comprehensive theory of music, promising to follow this with a more detailed
treatment, to be called the *Introduction to Harmonics*. If this larger book was
actually written, it has been lost.[64]

As the modern scholar Flora Levin has pointed out, the theory Nicomachus
presents is substantially the same as that set forth 450 years earlier by Aristox-
enus in his *Harmonic Elements*. However, while it highlights those aspects
compatible with Pythagoras's numerical concepts, it glosses over the inconven-
ient fact that not all the notes of the diatonic scale, let alone of the chromatic
scale, can be produced by strictly Pythagorean methods.[65]

The unique contribution of Nicomachus is his enrichment of Pythagoras's
biography with a description of his arithmetical system and accounts of his
musicological researches, including the "harmonious blacksmith" story.
Whether the now-lost sources Nicomachus relied on were authentic or apoc-
ryphal, these stories were enthusiastically accepted and built upon by future
writers, including Macrobius, Boethius, Porphyry, Iamblichus, Chalcidius, and
Isidore of Seville, all of whom are discussed later in the volume.[66]

A probable contemporary of Nicomachus was Aëtius (whose exact dates
are unknown), an eclectic anthologist and writer on mathematical and philo-
sophical topics. In a little-known but important compilation titled the *Placita
philosophorum* (*Opinions of the Philosophers*), preserved in an Arabic trans-
lation, Aëtius reveals his respect for the authority of Pythagoras. He notes par-
ticularly those parts of Pythagoras's mathematical thinking that would take on
mystical characteristics in later Pythagoreanism: Pythagoras identified the
monad (the number one) with God, and taught his followers that the tetraktys
constituted the source and the root of all nature. Probably quoting a now-lost
work by Theophrastus, a pupil of Aristotle, Aëtius explains that Pythagoras
identified geometrical origins for the constituents of the physical universe: four
of the five regular polyhedrons (the triangular pyramid, the cube, the octahe-

dron, and the icosahedron) gave rise to the four elements (fire, earth, air, and water, respectively), and the fifth (the dodecahedron) gave rise to the sphere that encloses the universe. That sphere was of particular importance to Pythagoras. He was the first to call the universe *kosmos,* in recognition of its orderliness, which he explained; he taught that it was made up of the four elements, that it contained all time, and that it was divided into five circles or zones, one of which was the zodiac.[67]

Pythagoras and his followers are mentioned often in the wide-ranging works of the famous Plutarch of Chaeronea (ca. AD 50–ca. 120). Whether or not Plutarch was formally affiliated with the followers of Pythagoras in his day, his writing shows sympathetic familiarity with their teachings, and even six hundred years after Pythagoras's death, his writings enrich the biographical record with details not preserved by any earlier, surviving writer. It is probably impossible to determine just how much of his contribution was based on since-lost authentic documents, but even if it includes legendary components, it is relevant to the continuing influence of Pythagorean thought in the centuries to come because Plutarch's works were widely known.

In what may be the earliest attempt to trace specific doctrines to the Near Eastern sojourns traditionally ascribed to Pythagoras, Plutarch suggests the possibility that Pythagoras's numerological, dietary, and other teachings had Egyptian origins. He says, in an essay about the Egyptian gods, that "the wisest of the Greeks" (Solon, Thales, Plato, Eudoxus, Pythagoras, and perhaps Lycurgus) had traveled to Egypt and spent time with its priests. According to Plutarch, Pythagoras in particular developed a close relationship with Oenuphis and other priests, admiring and emulating them.[68] In the Pythagorean association of certain numbers with certain Greek gods (Apollo is one, Athena is seven, and Poseidon eight), he finds echoes of Egyptian numerological beliefs.[69] Plutarch is also fascinated by, and detects Egyptian influence in, Pythagoras's habit of encapsulating wisdom in enigmatic or abstruse sayings.[70] Plutarch even deduces, from information he claims to have found in Herodotus, that Pythagoras's supposed antipathy toward beans might have been learned from the Egyptians.[71]

Another theory about Pythagoras's background noted by Plutarch, and without comment other than the observation that it does not necessarily conflict with the Egyptian-wisdom story, is the claim of Etruscan Pythagoreans that the sage was born and educated in their country rather than in Samos.[72]

Plutarch adds detail to earlier accounts of Pythagoras as a mathematician: Pythagoras invented a way of estimating an immeasurable quantity based on its relationships to known quantities. (The height of the gigantic Heracles cannot be directly measured, for example, but Pythagoras's method allows it to be calculated, based on the assumption that it is greater than the height of an average man and by use of the same ratio that a six-hundred-pace running track allegedly laid out by Heracles at Pisa is longer than a six-hundred-pace running track laid out by ordinary men.)[73] Pythagoras also originated at least two important geometrical proofs: the now-famous hypotenuse theorem (which, as

noted earlier in this chapter, was apparently first associated with his name by Vitruvius a century before Plutarch) and an even more ingenious one showing that from any two (rectilinear) figures a third can be constructed matching one in shape and the other in area.[74]

Plutarch echoes assertions of earlier writers (in particular, one he attributes to Apollodorus of Athens) that Pythagoras was so pleased with these geometrical discoveries that he sacrificed an ox in thanks to the gods.[75] Plutarch does not dwell, however, on the apparent contradiction between this story and the conventional view of Pythagoras's teachings, which he also reports: that the soul is immortal and can migrate from humans to animals, so therefore animals must be treated humanely, and it is wrong to slaughter and eat them.[76] In other writings, in fact, Plutarch adds details to the conventional view. In teaching abstention from meat, Pythagoras was not expressing a new revelation; instead he was reviving a doctrine that had been taught by "wise men of old" but forgotten by gluttonous generations.[77] Pythagoras, Plutarch says, carried his beliefs to the point of buying and releasing birds and fish caught by others.[78]

Notwithstanding his generally pro-Pythagoras attitude, Plutarch does not seem reluctant to report derogatory biographical incidents or unflattering evaluations of Pythagoras recorded by earlier writers. While he recounts with no apparent skepticism stories about Pythagoras being the teacher of Numa Pompilius, or his charming an eagle out of the sky with "certain cries," or his having a golden thigh, Plutarch readily lets us know that there were those who found Pythagoras distinctly inferior to Socrates as a man of vision.[79] It was Plutarch who preserved Timon of Phliasios's satirical description of Pythagoras (cited in chap. 1) as a charlatan who cheated men with juggler-like tricks.[80] A character in a dialogue by Plutarch accuses Pythagoras and his followers of having reduced philosophy to superstition rather than reason.[81] Most startling of all, perhaps, is Plutarch's allegation that Pythagoras learned to deliver personal criticism privately when a student he had publicly scolded committed suicide.[82]

On the whole, though, the Pythagoras portrayed by Plutarch is an admirable figure. He wrote nothing, Plutarch says, but is no less great for that—for neither did Socrates.[83] Pythagoras was above all a teacher of virtue, whose doctrines ranged from prosaic maxims (wonder at nothing; avoid indiscriminately acquiring friends; wait five years before imposing newfound "wisdom" on others) to grand cosmological and moral theories.[84] Pythagoras believed, for example, that the soul includes both rational and irrational elements, and that music, which determines the revolution of the universe and must be judged by the mind rather than by the ear, can encourage virtue by taming the irrational parts of the soul.[85] "Perfectly right action," Plutarch says, depends on a combination of innate goodness, learning, and constant practice; this threefold combination was perfectly achieved in the souls of "all who have attained an ever-living fame," in particular three men who are "celebrated among all mankind": Socrates, Plato, and Pythagoras.[86]

A similarly ambivalent but ultimately favorable view of Pythagoras was expressed by Lucian of Samosata (born ca. AD 120 on the far eastern edge of the Roman Empire in what is now Syria), whose entertaining Greek-language writings in many genres remained popular into the seventeenth century.[87] Like Plutarch, Lucian finds the five-year silence that Pythagoras imposed on his pupils a curiosity meriting uncritical mention.[88] He is, however, moved to ridicule the golden thigh Pythagoras was alleged by various ancient authors to have displayed to impress potential followers. In a satirical work titled *Dialogues of the Dead* he has Pythagoras admit that he no longer possesses such a thigh.[89] He goes further in a polemic against a local cult leader of his own day (*Alexander the False Prophet*): the pompous target of his satire flaunts a "golden" thigh, which is exposed as an illusion created by use of a gilded leather wrapping. Asked by two "learned idiots" whether Alexander is a reincarnation of Pythagoras, a judge rules that he cannot be, because Pythagoras was a good man and truly divine.[90] Elsewhere Lucian reaffirms the divinity of Pythagoras.[91]

A closely contemporary Latin writer whose mentions of Pythagoras exhibit a mixture of irreverence and respect comparable to Lucian's was Apuleius (Lucius Apuleius of Madaura, born AD 123; Madaura was a city in Africa). Apuleius, whose travels took him from Carthage to Athens to Rome before he settled in Africa, was and is most famous for a picaresque romance titled the *Metamorphoses* (more commonly, *The Golden Ass*). The first-person narrator, a young man who has by inadvertent magic been transformed into a donkey, recounts a purification ritual he performed at the seashore: in obedience to the "divine" decree of Pythagoras, he ritualistically plunged his head into the water seven times.[92] In a more serious vein, Apuleius is reported, with uncertain sourcing, to have produced now-lost Latin translations of the Pythagorean mathematical writings of Nicomachus.[93] He also created a work called *Florida*—a compendium of oratorical set-pieces he used in his profession as an itinerant teacher of rhetoric—which includes a summary of the life of Pythagoras as it was understood in his time. This summary expands the corpus of biographical material in two respects. It describes Pythagoras as performing music on the lyre, rather than merely experimenting with the mechanisms by which lyre strings produce tones; also, it expands Pythagoras's peripatetic education to include contacts not only with wise men in Egypt, Persia, and Chaldea (as described by earlier writers) but also with two Indian sects, the Brahmans and the Hindu gymnosophists. Apuleius credits Pythagoras's great wisdom in part to the learning he acquired in all these distant lands. In a dazzling demonstration of seven centuries of hindsight, Apuleius observes that Pythagoras had an excellent build, that is, that he was very "handsome."[94]

Another early second-century writer, Theon of Smyrna (fl. ca. AD 120–140; Smyrna was a city of Asia Minor now Izmù in Turkey), is more interested in Pythagoras's contributions to mathematics than in his character or philosophical beliefs. Theon's only extant composition, a work on number, music the-

ory, and astronomy, attributes to Pythagoras the discovery of laws of plane-
tary motion: "Pythagoras . . . was the first to understand that the planets move
according to a regulated revolution, simple and equal."[95] He also echoes Nico-
machus in attributing to Pythagoras the numerical laws of musical conso-
nances.[96] Most important for Theon was the discovery, attributed by him to
Pythagoras, of the tetraktys, an array of ten dots or other marks that must be
arranged (so that the counting is evident, $1 + 2 + 3 + 4$) in the shape of an equi-
lateral triangle in order to demonstrate the universality and completeness of
the number ten. Fitted together harmoniously, they appear so:

```
        •

      •   •

    •   •   •

  •   •   •   •
```

The equilateral triangle thus symbolically illustrates various arithmetical prop-
erties of the numbers four and ten, and through them various mystic principles
that govern the universe.[97] Theon devotes an entire chapter to explicating how
every aspect of the universe manifests itself through a fourfold division, called
a quaternary. In addition to the four elements and the four seasons there are
four ages of man (childhood, adolescence, maturity, and old age), four levels
of society (man, the family, the village, and the city), four faculties of judgment
(thought, sensation, opinion, and feeling), and so on. There are eleven quater-
naries altogether, Theon says, all contained in and symbolized by Pythagoras's
tetraktys, which he says is the holy emblem on which his followers swore their
oaths. Theon devotes a further chapter to the number ten (which is "perfect"
because it is the sum of the first four digits) and its manifestations in the arith-
metical, geometrical, and harmonic unity of the universe.[98]

Writing later in the second century, Numenius of Apamea, a philosopher
from Syria about whom little would be known were it not for the importance
with which he was viewed by later pagan and Christian authors (several of
whom specifically referred to him as a Pythagorean), has more to say. In a
book, now known only in fragments, that discussed what he viewed as dissen-
sion between the older philosophers, he lays even more stress than Apuleius
had on the exotic education that he thinks helped shape Pythagoras's thinking.
Pythagoras was great and powerful, Numenius says, at least in part because of
his precepts, which (echoing Cicero's comments of two centuries before) were
later to be adopted by Plato. They incorporated everything Pythagoras had
learned from the Egyptians, the Brahmans, the Magi, and the Jews.[99] Nume-
nius takes particular note of the various similarities he saw between
Pythagorean practices and those of the Persian priestly elite known as the
Magi: worship of the four elements, divination, dressing in white, and vegetar-

ianism. Numenius also claims to have read works written by Pythagoras him-
self that discuss the immortality of the soul; attribute the sustenance of unborn
souls to milk provided by the Milky Way (thus when they fall to earth, milk is
their first nourishment); equate the monad (the concept of one, or unity) with
God; and say that God alone has the power to counteract Nature.[100]

Pythagoras continues to be a topic of interest to Pausanias and other au-
thors later in the second century, but with two exceptions, none of them added
significantly to the biographical tradition about him.[101]

In *Against the Arithmeticians* (ca. 200), the philosopher and medical doctor
Sextus Empiricus admiringly recapitulates what Theon of Smyrna had written
about the relationship of the tetraktys pattern to the "perfect" number ten and
the perfect harmony with which the universe is governed. The discovery of
such power in arithmetic leads Sextus to conclude that even though Pythago-
ras was known to have been human, he must in reality have been a god.[102]

For the Christian writer Clement of Alexandria (b. ca. 150), it would pre-
sumably have been blasphemy to attribute divinity to Pythagoras. His exten-
sive knowledge of Greek literature led him to believe that Pythagoras may
have been born in Tuscany rather than in Samos, depending (he says) on
whether one follows Hippobotus or Aristoxenus. He found the teachings of
Pythagoras so persuasive that he was inspired to borrow their terminology for
use in Christian contexts. Clement's Hellenism permitted him to believe that
the union of many into one (like Pythagoras's monad) results in a divine har-
mony comparable to the harmonious unity that results when one teacher (now
"The Word," or Christ, rather than Pythagoras) is followed.[103] He was partic-
ularly delighted with Pythagoras for having declared that "God is one."[104] Ex-
pressing his admiration for the Greek sage, who he called "Pythagoras the
Great," Clement described harmony as dependent on the proportions of num-
ber and geometrical ratios. Pythagoras was inspired by the Jews, if not by
Ezekiel himself, Clement speculates. He was especially taken with what
Clement terms the clemency of Pythagoras toward the humblest of animals,
baby lambs, which suggested to Clement a prefiguration of Christ.[105] This con-
vert to Christianity and teacher in Alexandria has high praise for Pythagoras
as a guide to holy life: "In my view, Pythagoras of Samos understood virtue
well because he said 'When you have done wrong, scold yourself; when you
have done right, rejoice.' "[106]

A close Christian contemporary of Clement's, Hippolytus, bishop of Rome
(ca. 170–235), knew a great deal about the teachings of Pythagoras and spoke
about them with respect. His *Philosophumena* (*The Refutation of All Here-
sies*) outlines the life of Pythagoras and explains that his philosophy was a
"mixture" of astronomy, geometry, music, and arithmetic (thus suggesting the
future quadrivium). He also lauds Pythagoras as having been the first to bring
to Greece, from Egypt, knowledge of arithmetic and geometry. He says that
Plato's *Timaeus* "entirely" follows the teachings of Pythagoras in that it has
much to say about the role of the symbolism of numbers in making the world

intelligible. Although he disagrees with Pythagoras's view of the transmigration of souls, he admires Pythagoras's morality in promoting the unity of friendship over discord.[107]

▲

Launched by Cicero, Ovid, and other writers in the first century BC, the Roman-era enrichment of Pythagoras's biography and reputation was vigorously continued by the Greek and Latin writers of the first two centuries AD. Pliny assures us that, as Heraclitus had first suggested, Pythagoras practiced magic. For the first time, we learn—from Diodorus Siculus, Martial, and Apuleius writing roughly five centuries after Pythagoras's time—something about the physical appearance of Pythagoras: he dressed in white, and he had a long beard. Apuleius adds that he was very handsome. In contrast, Pythagoras's thought is discussed in fairly convincing detail, particularly by Plutarch and Nicomachus. Together they imagined a mathematician and an experimental scientist interested in geometry, astronomy, and acoustics for their own sake and for the explanation of cosmic phenomena as well as for their potential practical use in society. Along these lines, Vitruvius was persuaded of Pythagoras's special interest in the number four and maintained that Pythagoras had written on the cube. At the same time, the hagiographic element in Pythagoras studies remained lively, with increasing emphasis on portraying him as the founder of a cult with special rituals, dress, and dietary restrictions. As in earlier centuries some writers (such as Apollonius of Tyana and Sextus Empiricus) were seemingly intent on moving him farther along the promotion path from sage to miracle worker to divinity, whereas others (like Lucian and Apuleius) permitted themselves to retain a touch of skepticism along with their admiration.

The amalgamation of these two biographical strains took place for the most part during the early Roman centuries. It was perhaps this very amalgamation that extended Pythagoras's reputation and influence for another millennium and a half, when he could easily have faded out of memory as one more failed shaman or proto-scientist, interesting only to antiquarian specialists. Evidence suggests that during the early Roman period Pythagoras was regarded as having been a highly influential educator whose devotion to the practical goals of virtue and sobriety made him a political force in southern Italy. The readers who shared the fascination of Plutarch and other writers with Pythagoras's reputed exotic travels and the mystical sayings attributed to him; the students who laboriously worked their way through the expositions of Nicomachus and Theon in the border zone between mathematics and numerology; and the pilgrims who (as Cicero and Valerius Maximus tell us) visited the house in Metapontum where Pythagoras was reputed to have died—all undoubtedly included both the superstitious and the rationally philosophical. Together they provided a fertile intellectual climate for the preservation and expansion of Pythagoras's thoughts on the interrelationships between harmony in the cos-

mos, harmony in society, and the power of number. These interrelationships were visually represented in a symbology that would carry the influence of Pythagoras well into the Renaissance: the balancing of contraries set forth by Nicomachus; the "holy tetraktys" described by Theon of Smyrna; performance on the seven-string lyre as explained by Nicomachus and Apuleius; the association of Apollo with the music of the lyre (which, according to ancient Homeric tradition, was invented by the god Hermes, who shared it with Apollo);[108] and the music of the spheres with its seven-tone harmonious chord described by Cicero. Thus the legacy of Pythagoras included both taking the measure of the heavens and teaching people to take their appropriate place in the cosmos.

PYTHAGORAS
IN THE LATE PAGAN AND
EARLY CHRISTIAN WORLDS

By the dawn of the third century, the writing of history, following the example of Marcus Varro, Cornelius Nepos, and Suetonius, had come increasingly to be centered on the lives and activities of Roman emperors.[1] Pythagoras, however, would not be forgotten. On the contrary, this century and especially the next saw an efflorescence of activity inspired by the memory of the sage of Croton. Those who memorialized Pythagoras included Christians as well as pagans, and Romans as well as Greeks from the "new Rome," Constantinople.[2] Many Romans wrote about him in Greek, the acknowledged language of the erudite; among those regarded as followers of Pythagoras, though now dead, was a Roman Jew who lived in Egypt and wrote in Greek.[3] As the third century unfolded into the fourth, the supernatural elements that had been incorporated into Roman conceptions of Pythagoras since the days of the Republic were to become increasingly prominent, further enriching the extraordinary legend of a virtuous wizard noted for his holiness, preeminent as a philosopher, and revered as a harmonizer of mankind.

The Third and Fourth Centuries: The Divine Pythagoras as Apollo Reincarnated

One writer who stood apart from the trend toward nationalistic Roman historiography was Philostratus (Flavius Philostratus, b. ca. 170), two of whose major works were a compelling biography of the early first-century Anatolian

Greek mystic Apollonius of Tyana and a collection of Apollonius's letters (discussed in chap. 2).[4] Philostratus seems to have aimed at defending his subject's reputation against accusations of having been a charlatan.

It is striking that the strategy he chose in his *Life of Apollonius* was to stress parallels between Pythagoras's life and that of Apollonius, who (Philostratus tells us) lived through multiple incarnations and refused to wear clothing made from animals or to stain sacrificial altars with the blood of animals—preferring instead to wear cotton or linen and to honor the gods with offerings of honey cake and frankincense. Apollonius's birth was marked by portents suggesting divinity, Philostratus says, and at the end of his life he ascended to heaven. Like Pythagoras, Philostratus's Apollonius traveled to exotic lands (Egypt, Persia, and points farther east), practiced silence, kept to an ascetic diet (eating no animal flesh and drinking only water), and worked miracles. In effect, Philostratus is using his biography of this Pythagorean missionary as a way of retelling the story of Pythagoras himself. Although the work is cast so as to focus on the sanctity of Apollonius rather than on his wisdom, it leaves no doubt that he was, like Pythagoras, a great sage. The climax of Philostratus's work is Apollonius's ascension to heaven—an event doubtless intended to carry the parallel with the now "divine" mystic Pythagoras a step further, but also evoking overtones of early Christianity. Thus, through this vivid and dramatic picture of the wise Apollonius journeying eastward with his bare feet, long hair, and white garments, a compelling picture of a second Pythagoras is suggested.[5]

Quite a different view of Pythagoras is presented in *The Lives and Opinions of Eminent Philosophers,* a work most likely dating to the early third century.[6] Its author, who called himself Diogenes Laertius, was probably not a philosopher himself; he was, however, a thoughtful scholar who studied what must have been a vast collection of Greek works in order to assemble his historical biographies. His account of Pythagoras must be taken seriously not only because he records the contents of writings on Pythagoras that have been lost between his day and ours but also because this, his major work, had the good fortune to survive into medieval and Renaissance times. It became a very popular text among Italian humanists, who drew from it a vision of Pythagoras that was to be profoundly influential in their time.[7]

Although Diogenes Laertius largely repeats and consolidates the corpus of Greek knowledge about Pythagoras, he introduces some new elements. Notably, he takes the position that Pythagoras played a crucial role in the development of Greek speculative thought in that he countered Thales of Miletus's "Ionian" school of philosophy by establishing an "Italian" school that lasted until the time of Epicurus.[8]

Diogenes Laertius accepts the traditional identification of Samos as Pythagoras's home in his youth but records an alternative account that made Pythagoras a Tyrrhenian by birth and named as his father, rather than Mnesarchus, a man called Marmacus. More significantly, Diogenes Laertius says

that it was on the island of Lesbos that Pythagoras studied with Pherecydes and that he later studied in Samos with a man named Hermodamas.[9] Diogenes Laertius also enriches the list of "foreign lands" where Pythagoras acquired his learning: in addition to Egypt and Persia (where he learned much from the Chaldeans and the Magi), Pythagoras also studied in Crete.[10] Pythagoras's household, besides the slave Salmoxis mentioned by Herodotus, included two brothers, named Eunomus and Tyrrhenus.[11] In Croton Pythagoras had three hundred followers, Diogenes Laertius informs us, and together they governed the state by constitutional law of their own invention.[12]

First described by Aristotle and reiterated by Cicero, the connection between Pythagoras and Apollo is elaborated by Diogenes Laertius. Another of Diogenes' sources on this subject, Aristippus, was older than Plato, and his comments show that the connection between Pythagoras and Apollo dates at least back to the late fifth century BC. Not only was Apollo's the only altar at which Pythagoras worshipped, but the very name, *Pyth-agoras,* comes from the Pythian oracle (of Apollo), and it was in a temple of Apollo that Pythagoras identified the shield he had lost to Menelaus in a previous life, when he was the warrior Euphorbus.[13] Pythagoras's disciples even mistook him, Diogenes Laertius relates, for the god Apollo; the proof of this unusual relationship was his thigh of gold which could be seen when he undressed.[14] A musician and the discoverer of the mathematical principles that underlay musical intervals, Pythagoras urged his disciples to sing to the accompaniment of the lyre—the instrument, as mentioned earlier, associated with Apollo from the earliest times. In informing us that Pythagoras regarded the monad (the indivisible unity) as the "principle of all things," Diogenes Laertius is surely referring to Pythagoras's worship of Apollo, a reference that would have been apparent to his readers. Plato had established for the ancient world the Greek etymology of the god's name: as he explained in the *Cratylus, a-pollo* means "without multiplicity," in other words, the single one or "mover-together" (harmonizer). This meaning was well known to Nicomachus, Numenius, and Plutarch, and as well to Plotinus.[15]

Another area of new information provided by Diogenes Laertius concerns the writings of Pythagoras. He says definitively that Pythagoras wrote three treatises (all of which were purchased, he claims, by Plato): *On Nature, On Education,* and *On Statesmanship.* Diogenes Laertius also names seven other treatises and poems, citing without any particular endorsement the assertions of various earlier authors that Pythagoras wrote them and additional similar works; he says that two other works often attributed to Pythagoras were actually written by others.[16]

Speaking scornfully of those who claim that Pythagoras left no writings, Diogenes Laertius quotes the opening words of *On Nature* and summarizes some of the contents of all three treatises. They contain, he says, a number of rules and maxims. These include some previously cited by Plutarch but also some additional ones, such as "Don't urinate facing the sun." This maxim,

taken literally, simply calls for due respect to be paid to the sun, but for Pythagoras this may well have been interlocked with a sense of respect due to Apollo, or to Apollo's instrument, the lyre. In this connection it is worth noting that a cult of the sun was founded early in the third century by followers of the first-century BC scientist-philosopher Posidonius, a Pythagorean who described the "world soul" and was probably the person who inspired Cicero's discussion of harmony in the *Somnium Scipionis*.[17] Other topics Diogenes Laertius says are covered in Pythagoras's books include drinking (which he says Pythagoras called a "trap") and the importance of the tetrad. Also on this theme, Diogenes Laertius explains that Pythagoras divided man's life into four quarters corresponding to the four seasons, which in turn are associated with the four elements.[18]

According to the account of Diogenes Laertius, the rule of silence imposed by Pythagoras required five years, during which his disciples could not speak and were required to listen to his discourses without seeing him; upon successfully passing an examination, they were admitted to his company and to his house. He was so admired, we are told by Diogenes Laertius, that his disciples were called prophets and his voice was considered that of God.[19] Pythagoras, Diogenes Laertius reports, divided man's life into four quarters of twenty years each. Thus a man spent twenty years as a boy, twenty years as a youth (the time of his education), twenty years as a young man, and twenty as an old man. From him we learn that Pythagoras took divination very seriously; we also learn something new about Pythagoras's appearance: dressed in white, he was majestic and commanding.

Although Diogenes Laertius has comparatively little to say about Pythagoras as a mathematician, he acknowledges his authority in geometry and numbers and (like Vitruvius and Plutarch) attributes to him the hypotenuse theorem, citing a certain Apollodorus as his source. He also describes Pythagoras's particular interest in the sphere, which for him was not only the most beautiful of all solids but also the shape of the universe, which held the earth at its center. It was Pythagoras, Diogenes Laertius says, who was the first to suggest that the earth is a sphere.[20] He also devotes some attention to Pythagoras's concept of harmony. It is a virtue whose major components are concord and equality, he says; it results from winning the soul, which has three parts, from evil over to good.[21]

Diogenes Laertius reports that his researches uncovered three differing descriptions of Pythagoras's death. No matter which is believed, he notes, it is clear that Pythagoras lived to be eighty. Afterward, he adds, the house of Pythagoras at Metapontum (apparently the house to which Cicero had made a pilgrimage and which Valerius Maximus had noted was a shrine) was converted into a temple of Demeter.[22] Pythagoras proved his divinity to his followers, Diogenes Laertius informs us, by miraculous signs such as his golden thigh, which, rather than showing it off as Aristotle and Plutarch had reported, he casually revealed so that some of his disciples might catch a glimpse of it

when he was disrobing. Another way in which Pythagoras proved his divinity, according to Diogenes Laertius, was by descending into Hades and returning after an extended stay, causing his followers to weep and hail him as divine— a feat not unlike a resurrection, for which Diogenes Laertius's source was the third-century BC writer Hermippus.[23]

Another compiler also active in the early third century, a cultivated Hellene Roman from Praeneste named Aelian (Claudius Aelianus, ca. 170–ca. 235), provides us with some new insights on Pythagoras.[24] Written in Greek for educated readers who wanted to know more about history, Aelian's *Varia historia* discusses the intellectual activity of philosophers, citing information from (now mostly lost) older sources. The exemplary philosopher, Aelian informs his readers, is one who learned at the feet of Pythagoras. He says Pythagoras claimed an ancestry superior to that of ordinary mortals and lists miraculous signs—including the golden thigh—that support the claim. Pythagoras's words were never questioned, Aelian says, because they were oracles of God. He taught, Aelian adds, among other things, that the mallow plant is sacred, that number is the source of all wisdom, that earthquakes are caused by assemblies of the dead, and that rainbows are the light of the sun. When Pythagoras traveled he told his audiences he was not a teacher but a healer.[25]

It is from Aelian that we learn about the illness from which Pythagoras's teacher Pherecydes died: he suffered first from hot sweats, then from malignant sores, and finally from an invasion of lice that caused his flesh to dissolve and rot. Pythagoras, who cared for him, was his wisest pupil. Aelian also discusses Pythagoras's customary dress. Like earlier writers, he describes the clothing as white, but he adds two new features: a golden garland around the head and trousers. Implicitly, this corroborates stories about Pythagoras's Persian education, since (as Kingsley points out) Greeks did not wear trousers but Persians did.[26] Nor does Aelian omit reference to the ethical and spiritual teachings of Pythagoras: the two most blessed gifts from the gods to humankind were truthfulness and good works. Nothing could better comfort a dying man, Aelian speculates, than the thought of meeting the great sage from Samos in the next life.[27]

The next major additions to the life of Pythagoras appear in a *Life of Pythagoras,* which is all that survives of a general history of philosophy written by the prolific Roman Syrian Porphyry of Tyre (ca. 232–ca. 305). An erudite philosopher and student of religion, Porphyry produced over seventy works, including an edition of Plotinus's *Enneads,* a third-century work discussed in chapter 6.[28] Like his probably older contemporary Diogenes Laertius, but with even more diligence, Porphyry displays his extensive literary knowledge by naming the sources of his assertions about Pythagoras. (Although, as discussed later in this chapter, Diogenes Laertius cites slightly more sources, Porphyry's citations tend to be more scholarly and painstaking.) This adds to our knowledge of works that were known to the Greek-speaking

Roman world but have since perished, and it suggests the possibility that some scholars felt a need to "legitimize" through historical authorities a Pythagoras whose story was in some danger of becoming regarded as an exotic legend.

Porphyry introduces new information about Pythagoras's associates. Although previous writers had identified Mnesarchus as Pythagoras's father and Pherecydes as his teacher, Porphyry, in agreement with Diogenes Laertius, names Pythagoras's teacher in Samos as Hermodamas. He also adds the name of Pythagoras's mother, Pythais. Most dramatically, Porphyry tells us that according to Apollonius of Tyana's now-lost biography, the true father of Pythagoras was the god Apollo, who impregnated Pythais with Mnesarchus's knowledge if not consent.[29]

Being Apollo's son made it natural that Pythagoras should play Apollo's instrument, the lyre, and sing along with it as well; Porphyry tells us that this was the case. He also reports that Pythagoras went to Delphi to visit the tomb of Apollo and found it in a place called the tripod. This sacred spot had received its name because it commemorated the spot where Apollo was mourned by the three daughters of a man named Triopas. This place-name may explain the connection, made from later Antiquity into the Renaissance, between Apollo and the triangle. Elsewhere Porphyry says that the triad symbolizes perfection. These pervasive references to the number three connect Porphyry's biographical writings about Pythagoras with earlier Pythagorean literature concerning the triangle and Plotinus's citing of the triangle as an example of "multiplicity in one" that is discussed later.[30]

The purported link between Apollo and Pythagoras reaches its most dramatic expression in Porphyry's version of the golden thigh story. Not only was Pythagoras Apollo's son, he says, and not only did he visit Apollo's tomb at Delphi, but Pythagoras revealed his golden thigh to a priest of Apollo to demonstrate that he was himself the god of the Hyperboreans.[31]

Regarding the education of Pythagoras, Porphyry explains that Pythagoras studied with the Egyptians, who taught him geometry (and treated him exceptionally well, sending him to the most ancient and revered priests in various cities); the Phoenicians, who taught him numbers; the Chaldeans, who taught him astronomy; the Magi in Persia, who taught him that the body of God is symbolized by light; and the Hebrews. In Babylon, Porphyry says, Pythagoras went to see Zoroaster "the Chaldean," who "purified" him and taught him the path to purity. Although Porphyry does not cite his source for this more detailed version of the Zoroastrian encounter first reported by Aristoxenus some centuries before (see chap. 1), the modern authors Joseph Bidez and Franz Cumont speculate that the ultimate source must have been Aristoxenus. Because Babylon was the center of scientific and religious study in the fourth century BC, such a notion would have been impressive to Aristoxenus's Greek audience—who might well also have assumed that it was from Zoroaster that Pythagoras learned "divine powers," that is to say, magic. Porphyry's account

goes on to describe how, after this education, Pythagoras traveled throughout Sicily and Magna Grecia (southern Italy), introducing freedom, forcing the abdication of tyrants, and doing good works.[32]

Porphyry provides the most specific description yet of the Samian sage's appearance and mode of life, supplementing brief references by Martial to his long beard, by Apuleius to his dressing in white, by Dicaearchus to his graceful and harmonious manner, by Diogenes Laertius to his dignified bearing, and by Aelian to his wearing a golden garland and trousers. Pythagoras was tall and handsome, says Porphyry, and graceful in both speech and gesture. His hearing and eyesight were exquisitely accurate. He ate honey for breakfast and bread and boiled herbs for dinner, sometimes varying these with poppy and sesame seeds, dried raisins, daffodil petals, and cream. He liked to take walks, especially in quiet and beautiful places such as sacred groves. His students included not only men but also women and boys. He loved his friends and cared for them if they were ill. He could cure the sick by singing. His repertory included special songs that could banish thoughts of sorrow, anger, and lust. Besides playing the lyre and singing along with it, Pythagoras was fond of dancing, which he believed helped make the body agile.[33]

It is on the subject of miracles that Porphyry waxes most eloquent. He tells of Pythagoras whispering in an ox's ear to dissuade it from its regular diet of beans in the pasture, of predicting the exact number of fish that fishermen would find they had caught in their net, and of discovering a divine child who could look at the sun without blinking, as well as other events in which Pythagoras banished pestilence, chased away winds and hail, and calmed turbulent waters. These miracles were recognized by Pythagoras's followers, Porphyry assures us, as a sure sign of his divinity.[34] Such marvelous events were possible in large part, he says, because of Pythagoras's extraordinary skill at expressing himself through rhythm and incantation, a skill that grew out of his ability to hear the music of the spheres (the concordant tones made by the seven planets—Mercury, Venus, Mars, Jupiter, Saturn, the Sun, and the Moon—as they whirled around the earth) and understand the harmony of the universe. This ability was reflected in his reverence for the nine Muses, seven of whom corresponded to the seven planets. Ultimately, Pythagoras's extraordinary sense of harmony and order allowed him to contemplate both the corporeal and the incorporeal.[35]

Among the latter were, Porphyry tells us, the mathematical sciences in which Pythagoras excelled. He devoted himself to numbers and their symbolism, understanding their meanings and their relationships to each other and to the rest of the universe. Supremely important to Pythagoras, says Porphyry, were the monad, which symbolizes unity and harmony, and the decad, which symbolizes the interrelationships in the universe. The visual symbol of the powers of the decad is the tetraktys, which Porphyry also tells us that Pythagoras's followers used in the swearing of oaths, calling on Pythagoras as their witness. Porphyry affirms that Pythagoras discovered the hypotenuse theorem

named after him; he explains that the "ox" he sacrificed in celebration (referred to by Plutarch and others) was actually a bovine effigy made of barley.[36]

Porphyry adds two new alternative accounts of the death of Pythagoras to those noted by Neanthes, Hermippus, and Diogenes Laertius. In one version, Pythagoras died of starvation after fleeing from Croton to Metapontum. In the other, Pythagoras died of grief to see his friends burning in the conflagration of their meeting house. In any case, according to Porphyry, Pythagoras's secrets died with him because he left no writings.[37] This conclusion, which directly contradicts that reached by Porphyry's near-contemporary Diogenes Laertius, may have resulted from a greater interest on Porphyry's part in Pythagoras as a miracle worker than as a wise scholar; on the other hand, it may reflect disparities among the research materials available to the two men. Between them Porphyry and Diogenes Laertius draw on the writings of thirty-four authorities (sixteen cited by Diogenes Laertius, eleven by Porphyry, and seven by both men).[38] This rich and varied literature—mostly written in Greek and mostly now lost—undoubtedly contributed to the persistence into late Antiquity of uncertainty about whether Pythagoras committed his beliefs to writing.

The lively third-century atmosphere of biographical interest in Pythagoras manifested itself next in the work of a famous follower of Porphyry's, Iamblichus of Chalcis in Syria (ca. 250–ca. 325). Iamblichus was less fastidious than his immediate predecessors about citing his sources, naming only a few and omitting credit for other authors he used extensively.[39] Compared to Diogenes Laertius and Porphyry, Iamblichus tends to be ambivalent and vague about documenting what information he has derived from previous learned sources. In particular he drew entire passages from Porphyry and Nicomachus of Gerasa without always acknowledging his debt to them.[40] Iamblichus's main accomplishment was a ten-volume encyclopedic work covering Pythagorean philosophy, theology, geometry, music, and astronomy, as well as the life of Pythagoras and a description of early Pythagoreanism. (The division into ten volumes may well have been intended to recall the "perfection" of the number ten demonstrated by the tetraktys.)[41] Although the work was largely dismembered in the centuries after the death of Iamblichus, the first four books survived. Of these book I, *On the Pythagorean Way of Life,* combines biographic and historical material about Pythagoras; it is now commonly referred to as the *Vita Pythagorica* (*Life of Pythagoras*). Knowledge of it was to survive through the Middle Ages, while it came to be widely known in Renaissance times. Books II, III, and IV, known through manuscripts and less available to posterity, are concerned with philosophy, mathematics, and arithmetic. The fifth, sixth, and seventh books, on physics, ethics, and theology, are known through the descriptions of a later Byzantine scholar, Michael Psellus, who is discussed in chapter 7. The last three books, which were concerned with geometry, music, and astronomy, are entirely lost.[42] As the only book that describes Pythagoras, book I is the subject of consideration here.

Although Iamblichus's writings have been disparaged in the past because he

was a practitioner of theurgy (a ritualistic supplication of divine intervention through incantations), his *Vita Pythagorica* is of great importance. It is the longest extant biography of Pythagoras from Antiquity and was highly influential from medieval times into the Renaissance.[43] Good reason exists to suppose that Iamblichus's interest in Pythagoras derived not only from his having studied with the earlier third-century Syrian philosopher Anatolius (who was probably a mathematician and Christian bishop) as well as with Porphyry, but also from his aspiration to become known as a miracle worker in the tradition of Pythagoras, Empedocles, and Apollonius of Tyana. Iamblichus was not a compelling writer (as readers as early as his first biographer, Eunapius, have acknowledged), and he may well have pursued a reputation for "marvelous works" as partial compensation for this shortcoming. In this he seems to have been successful: Eunapius assures us that multitudes flocked to Iamblichus because of his great learning and his inspirational, virtually "divine" message.[44]

It is this quality of religiosity that sets Iamblichus's biography of Pythagoras apart from the others. His uppermost aim appears to have been moralistic rather than academic—to describe the divine wisdom of Pythagoras in a way that emphasizes and extols the good example he projected to his audience. As Cornelia de Vogel points out, Iamblichus laid great stress on Pythagoras's intention that audiences should not just hear words but become personally involved, even to the point of changing their behavior or way of life.[45] Thus Iamblichus presents Pythagoras as an ethical reformer who appealed to the development of personal character: a divinely inspired teacher, idealized and highly moralistic, who put personal piety, brotherly love, temperance, conjugal fidelity, and shared possessions—all examples of communal harmony—above all else and turned the multitudes whom he addressed into his first practitioners. Pythagoras was a god (Apollo), Iamblichus says, sent to earth to teach the worthy (those who observed the required rules of silence and understood his aphoristic utterances) how to raise themselves to share in his divine status. Relying, he says, on Aristotle's account of early Pythagorean teachings that characterizes Pythagoras as a being midway between gods and men, he assures his readers that the divine Pythagoras will reward their piety with divine guidance. He credits Pythagoras with teaching humans not only the true and detailed workings of the universe but also the correct path to virtuous living.[46]

The vita of Iamblichus opens with an elaborate account of the divine birth of Pythagoras, whose soul was miraculously sent to humankind by Apollo. Iamblichus stops just short of saying that Pythagoras was Apollo reincarnated. Instead, he lets others say this: poets say he is the son of Apollo; most people believed he was the son of a god; he had a godlike appearance; people treated him like a god; he was the most "godlike" of all mortals. In gratitude for the birth of his "stepson," Mnesarchus built a temple to Apollo on Samos, where his family had come to settle after Pythagoras's birth in Sidon in Phoenicia. There,

Pythagoras grew up surpassing in beauty all persons known to history, and in good fortune most worthy of a god. . . . and while still a very young man, full of courtesy and modesty, he was well thought of even by the eldest citizens. Everyone turned to look on seeing him or hearing his voice, and anyone he looked at was struck with admiration, so it was quite understandable that most people were convinced he was the son of a god. . . . He regulated his life by worship, study and a well-chosen regime; his soul was in balance and his body controlled, his speech and action showed an inimitable serenity and calm; no anger, mockery, envy, aggression or any other perturbation or rash impulse, took hold of him. It was as if a benevolent spirit had come to stay in Samos. . . . he would become the most godlike of mortals, surpassing all others in wisdom.[47]

Thus even during his youth, according to Iamblichus, Pythagoras was celebrated as divine. Later, Pythagoras would "prove," according to this account, that he was truly a god by revealing his golden thigh to a priest of Apollo, who perceived that he was no ordinary mortal and presented him with an arrow (an attribute of Apollo): "privately [he] took Abaris aside and showed him his golden thigh, as a token that he was not deceived."[48] As though to dispel any doubts among his readers, Iamblichus later confirms this miracle:

It is widely known that he showed his golden thigh to Abaris the Hyperborean, who had guessed that he was Apollo of the Hyperboreans. . . . They say he was Hyperborean Apollo, and their proofs are that in standing up in a contest he showed his golden thigh.[49]

This is essentially the same golden thigh story told by Porphyry, with some additions, including a description of the circumstances shaping Pythagoras's act and the name of the priest, for which Iamblichus's source is unknown.

Indeed, Iamblichus informs us, during his lifetime Pythagoras imitated the oracles of Apollo by speaking in enigmas. He expressed judgment in such a way that those present were convinced he was Apollo. In his lifetime he was never addressed by his proper name but rather by the name "the Divine."[50] He was called Pythian Apollo, a reference to Apollo's having killed the monster Pytho while a baby and reflecting the derivation of his name, *Pyth-agoras*; he was also called Hyperborean Apollo and Apollo the Healer. Pythagoras once explained, Iamblichus informs us, that as a god he was required to be obedient to his father, a senior god, in whose honor the Olympics had been founded.[51] Thus is it clear that although Iamblichus may have refrained, for religious reasons, from declaring outright that Pythagoras was the son of Apollo, he certainly makes this "fact" clear through the words he attributes to the characters in his drama, including its protagonist.

Iamblichus's information about the education of Pythagoras somewhat overlaps that of his predecessors but also adds new elements. Pythagoras's early learning, we are now told, was divided between Pherecydes, Anaximander, and Thales. Thus from Samos, where he was known as "the long-haired

young man," he went to Miletus and Priene. After a voyage to Phoenicia, which included a visit to Sidon (his birthplace, according to Iamblichus), he was advised to go to Egypt, where he could study the Egyptian mysteries and enhance his divinity. Upon his arrival in Egypt, an altar was built for him and offerings were made in acknowledgment of his divinity. In Egypt he was recognized by the priests, who saw his superhuman character, as the most "godlike" of mortals, for he surpassed all others in wisdom. From there he traveled to Babylon to study mathematics and music with the Magi. When his education was complete, at the age of fifty-six, Pythagoras returned to Samos.

There his teaching career began with a single young pupil whom he was obliged at first to pay to study with him. Finding this arrangement less than satisfactory, Pythagoras visited the altar of Apollo at Delos and, subsequently, all his oracles in Crete and Sparta, eventually choosing to settle in Croton.[52]

While Iamblichus's description of the youth and education of Pythagoras for the most part resembles what had been established in previous tradition, it introduces a significant new aspect. For Iamblichus as for his predecessors, Pythagoras's emerging divinity is derived from his incarnation as the son of Apollo. But the beauty, wisdom, and benevolence attributed by Iamblichus to this "youthful Apollo" suggest that the role and character of Apollo himself had come to be viewed differently in Pythagoras's lifetime than had been the case only a few centuries earlier. The evolution from the pre-Pythagoras Apollo (the vengeful, sharp-shooting deity who appears in Homer) to the Apollo whom Pythagoras is said to resemble (the god of civilization and certainly the god familiar to Iamblichus) is perhaps heralded by presentations of the god in the poetry of Pindar (who is discussed as a Pythagorean in chap. 5).

Iamblichus describes the arrival of Pythagoras in Croton as the arrival of a god. Pythagoras performed miracles, and the natives expressed their honor and gratitude for his presence by flocking to listen to him. He assured the young boys of Croton that Apollo was the guardian of their city, and he advised the elders of the city to build a temple to the Muses in honor of the concord and harmony that were established because of his presence in the city. The Muses, he explained, were unified by their perfect harmony and concord. Their inspiration was, he held, the primary influence for social harmony and concord in private life. Similarly, the Muses had an animating effect on the study of the heavens, which, because the stars are in their courses, constitute a perfect example of harmonious and measured order.[53]

The rest of Iamblichus's work is essentially devoted to describing the teachings of Pythagoras. He colors the now-standard elements of Pythagoras's teaching—silence (or the "subjugation" of the tongue), piety, communal sharing, abstinence from meat and beans, self-control—with new details in order to better illustrate his divinity. According to the teachings of Pythagoras, just as gods were more worthy of deference than men, the east was more important than the west for the sunrise is more honored than sunset and dawn is more

honored than evening. In his divine wisdom, Pythagoras felt free to structure the lives of his followers. He required monogamy from them and spoke to the issue from the temple of his father, Apollo, at Croton. Friendship, he taught, is exemplary of reconciliation between people. Moderation of human passion is an important method to balance opposites or to find a central path between two extremes. Mutuality and justice are virtues that produce equality. For Pythagoras, the principle of justice is basic to all human activity. Justice is the reciprocal, or balanced, relationship of equals. When exercised correctly, justice is also symmetrical because it produces the same result on two sides. So also moderation is the reconciling element between two opposites. Pythagoras also functioned as a teacher of political science, for he taught his followers the rules of good management, legal writing, and administration of the community.[54]

In stressing the morality of Pythagoras's teaching, Iamblichus suggests that Pythagoras was sent to earth to teach human beings how to live and to provide them with specific moral and spiritual training. For example, whereas Diogenes Laertius had first commented that Pythagoras advised moderation in drinking, Iamblichus informs us that he ordered his followers to abstain from wine except in connection with sacrificial rituals because it leads to immorality.[55] In ordering abstention from mallows as well as other foods it is clear that, according to Iamblichus, Pythagoras required his followers to recuse themselves from partaking in everything that constituted an obstacle to attaining purity of the soul, including paying attention to their stomachs.[56] His moral discourses so impressed his followers that, convinced of his divinity, they changed their lifestyles. Indeed, to ensure that his readers understood the divinity of Pythagoras and his mission, Iamblichus reminds us of the numerous miracles associated with Pythagoras. These demonstrate his power over animals, over the elements, and over people.[57]

While these miracles underline the divinity of Pythagoras and demonstrate the godlike power of his voice, Iamblichus is not inattentive to the issue of the writings of Pythagoras. These, Iamblichus reports, were "encyclopedic." Demonstrating Pythagoras's wisdom, they are concerned with all human knowledge. They cover physics, logic, ethics, and the other sciences. Pythagoras also authored a treatise titled *On the Gods,* a sacred discourse not among the works by him listed by Diogenes Laertius.[58]

Iamblichus is particularly attentive to the efforts of Pythagoras to instill in men the many values of music. A form of purification Pythagoras advocated involved playing and singing to the music of the lyre. A special arrangement was prescribed in which the person playing the lyre was seated in the center of a circle; around him the singers were arranged so that they could, in singing with his accompaniment, express harmony and rhythm. Although Iamblichus does not say this arrangement was meant to suggest enigmatically a cosmological symbol such as the planets and fixed stars rotating around a central fire

and creating cosmic harmony, it appears likely when taken into account with his other comments. Iamblichus refers to Pythagoras's description of heaven as circular, articulated by stars that move through their courses in the rational order and harmony of the universe. In singing together in unison the Muses reflect through their music the harmony and measured order of the universe. For Pythagoras, Iamblichus notes, music exemplified harmony, proportion, and harmonic progression.[59] To demonstrate this important point, he repeats Nicomachus of Gerasa's story of how the ringing hammers of a blacksmith inspired Pythagoras to carry out experiments in order to learn the mathematical principles underlying the musical intervals.[60] Iamblichus's Pythagoras also teaches us that music may be used, like food, to promote good (moral) health. Thus there is appropriate music to sing when rising and other music to sing when retiring. Music may also be useful for curing passions of the body and inducing moral behavior that is good for the soul. Good music, then, like dietetics and incantations, is good medicine. The music of the lyre, which Pythagoras played elegantly, Iamblichus says, is especially beneficial.[61]

Although Iamblichus stresses Pythagoras's interest in mathematics, he has little new information to provide on this subject. He informs us that Pythagoreans swore by invoking the "discoverer of the tetraktys" and that Pythagoras taught his listeners that the worship of the gods is enhanced by invoking number and geometry. Apollo, for example, is symbolized (as Porphyry had first suggested) by the tripod, a three-legged stand that was also a manifestation of the triangle.[62]

Iamblichus describes at great length the process Pythagoras conceived for admission to his school (which appears to have been much more selective than the lectures Iamblichus says Pythagoras delivered to "multitudes"). This process involved interviews, trials, tests, observation, and a final examination before a candidate could be accepted to receive his doctrines. Iamblichus also lists some injunctions established by Pythagoras for the initiated that have not been cited by previous authors. These include a prohibition on wearing black or brown clothing in a temple (colors that symbolized sluggishness) and a regulation requiring his followers to enter temples from the right and exit them from the left.[63] The many rules and injunctions that Pythagoras required of those who "listened" to him and became his followers were calculated, according to the account of Iamblichus, to teach them good moral example, which would be passed on to humankind. Thus could his followers live in harmony, love each other, and share with each other in establishing true equality and harmony. Personal harmony thereby became a reflection of the greater cosmic laws of equilibrium and harmony that he, "the Divine," had discovered. Not surprisingly, since Pythagoras—who Iamblichus says lived to be a hundred years old—was the second Apollo, or Apollo on earth, his followers were required by him, Iamblichus concedes in his conclusion, to adore the rising sun.[64]

From the Roman provincial capital of Palestine, Eusebius of Caesarea (ca. 260–ca. 340), a scholarly Christian bishop trained in the tradition of Alexandria, gives us an early Christian perspective on the memory of Pythagoras in the fourth century, when the new Christian order was developing against the background of old imperial Rome.[65] Eusebius's *Ecclesiastical History* commends Philo of Alexandria (who is discussed as a Pythagorean in chap. 7) for his zealous study and imitation of Pythagoras, which Eusebius says included keeping silence for five years.[66] In another work, Eusebius compares Pythagoras with Moses and in so doing reveals a perhaps more than passing acquaintance with Jewish Pythagoreanism. Eusebius also acknowledges that Pythagoras was highly regarded for his wisdom and honored for his restraint and orderly moderation—so much so, Eusebius asserts, that he served as example to Plato.[67] In several passages from his *Contra Hieroclem,* Eusebius praises Pythagoras's rule of silence, his frugality, his "extraordinary" uprightness, and his admirable teachings.[68] In his *Chronicle,* a work transmitted to the medieval world in the form of translations and epitomes, Eusebius expresses his respect for Pherecydes, who was known to him as the teacher of Pythagoras. He also dates the acme of Pythagoras's activity as the sixty-second Olympiad, or about 532–529 BC, a dating that suggests it was derived from the computation of Apollodorus (based on, as described in chap. 1, information provided by Aristoxenus).[69]

Although these mentions do not contribute new information to the biography of Pythagoras, they are nonetheless important because they show that among the earliest Christian scholars there was a significant level of esteem for Pythagoras as the Christian tradition began to extricate itself from the dense web of interplicated classical and Hebraic traditions in which it was born, and from its struggles with the many various syncretic religions (such as Orphic and Gnostic cults) pervading the Mediterranean basin.[70] It also confirms what we already know from the biographies of Diogenes Laertius, Porphyry, and Iamblichus, which is that despite differences in detail there existed a strong tradition, or a mainstream, of biographical literature about the extraordinary sage from Samos.[71]

Other fourth-century Christians were equally aware (and equally respectful) of the memory of Pythagoras. Although he does not include a vita of Pythagoras in his *De viris illustribus,* Saint Jerome (ca. 348–420), perhaps the most distinguished of the early Christian scholars and certainly the most "classical" in terms of his writing, was well acquainted with the reputation of Pythagoras.[72] It could be that his attraction to the ascetic life, which led Jerome to travel to Syria, Egypt, and Palestine and to settle in Bethlehem, where he founded a community, was inspired in part by the example of Pythagoras. One of Jerome's letters speaks of his regard for the wisdom of Pythagoras, while another appears to credit Pythagoras for his belief, which he suggests was inherited by Christianity, in the immortality of the soul:

That immortality of the soul, and its existence after the dissolution of the body, which Pythagoras dreamed . . . , is now the common philosophy of Indian and Persian, Egyptian and Goth. The savage Bessians and their host of skin-clad tribes, who used to offer human sacrifice to the dead, have now dissolved their rough discord into the sweet music of the Cross, and the whole world with one voice cries out, "Christ."[73]

A third letter refers to something new: the choice of two roads, good and evil, symbolized by the Greek letter upsilon (Y). This was, according to Saint Jerome, the invention of Pythagoras. Choosing the correct road early on, Jerome implies, will lead a child to obtain wisdom as an adult.[74]

The "letter of Pythagoras" (upsilon or Y) also became a popular theme elsewhere in the waning years of the Roman empire. The Gallic poet Ausonius (d. ca. 395), who lived most of his life in Trèves (now Trier), demonstrated his familiarity with it in a letter to his nephew: Ausonius reproves him for not having kept to the "right" path in the choice offered by Pythagoras, thus losing his chance to succeed his uncle as a teacher of literature.[75] In his *Eclogues,* Ausonius (a less-than-fervent Christian) refers to the destruction of the community established by Pythagoras as an inevitable consequence of the pure lifestyle he preached.[76]

Thus it is clear that the continuing enthusiasm for developing the biography of Pythagoras in the third and fourth centuries belonged primarily to pagan scholars; however, at the same time it is equally clear that among the earliest Christian writers also, Pythagoras was held in high esteem. Nor was the Christian respect for the celebrated sage of Croton limited to the first centuries of Christianity.

Pythagoras Remembered in the Fifth and Sixth Centuries

Although Saint Augustine, bishop of Hippo (354–430), an independent thinker with a classical education, appears to have been profoundly influenced by numbers that he used (without crediting Pythagoras) to express exegetical notions, he has little new to contribute to the biography of Pythagoras.[77] If anything, what his remarks about Pythagoras tell us is that aside from the fact that he rejects the concept of transmigration of the soul (in the discussion he does not name Pythagoras), he has a significant respect for Pythagoras as a man of great wisdom.[78]

In his masterpiece, *De civitate Dei* (*The City of God*), completed in about 426, Augustine cites Pythagoras's notions about the divinity of numbers and refers to his interest in divination. He stresses Pythagoras's devotion to philosophy, his modesty, and his invention of the word *philosopher* to denote a lover of wisdom. Augustine refers to the great renown of the followers of Pythagoras in Italy and agrees that Plato's travels in Egypt must have been influenced by those of his great predecessor. He pays passing respect to Pythagoras as the

possible originator of his own ideas (which to some extent depend on Platonism) about God and the blessedness of the eternal life he promises. In listing great philosophers of the past, he has genuine praise for the eminence of the first man on his list, Pythagoras of Samos.[79]

In *De Trinitate* (*On the Trinity*), Augustine compliments the wise Pythagoras for the example he provided in calling himself a lover of wisdom (rather than a sage). As his reputation developed, Augustine suggests, so also did the use of the word *philosopher*. In another passage, while refusing to believe the allegation that Pythagoras claimed to have experienced other lives, he stoutly defends Pythagoras's good name.[80]

Thus does the biography of Pythagoras, in the many forms he must have been acquainted with, live on in the thinking of Augustine, a theologian who was to have remarkable prestige in medieval and Renaissance times. Although Augustine's influence on his famous pupil Paulus Orosius was considerable, Orosius does not discuss the famous sage from Samos in his most important work, the *Historiarum adversus paganos* (*Histories against the Pagans*)—surely because of his disdain for the classical past.[81]

Perhaps like Saint Augustine an African but unlike him an advocate of paganism, Macrobius (ca. 360–ca. 420) compiled writings that were based on the classical past and especially on Latin writers such as Cicero and Virgil.[82] Both his *Commentary on the Dream of Scipio* and *Saturnalia* are important documents of the early fifth century not only because as compilations they exemplify the diffusion and, some might hold, the corruption of Greek ideas, but more so because these works—which survived into medieval times, when they became very popular—were responsible for keeping alive certain ideas about classical philosophy and science throughout the Middle Ages.[83] Both works mention Pythagoras.

Although they do not contribute any new information to the biography of Pythagoras, what these works say is of great significance because of the influence they exerted. In the *Commentary* Macrobius tells us that Pythagoras was a religious man, that his followers invoked his name in their oaths as the discoverer of the tetraktys, and that he studied the heavens. It was, according to Macrobius, Pythagoras who was responsible for the idea that the soul represents harmony, and indeed, he who invented the musical harmony based on the concord of tones, a harmony reflected in that of stringed instruments played with a plectrum (the lyre). Last but not least, Macrobius credits Pythagoras with being extremely skillful in his reasoning, exemplary in his learning, and profound in his thinking.[84] In its single mention of Pythagoras, the *Saturnalia* adds a reference to the enthusiasm of Pythagoras for numbers.[85]

It is, however, for his exposition of Pythagorean ideas in the *Commentary*—which made the *Dream of Scipio* famous throughout the Middle Ages while the other chapters of Cicero's *De re publica* languished in oblivion—that Macrobius is most important. Thanks to Macrobius's discussion of Pythagoras's numerical ratios of musical concords, the cosmological concept of the harmony of

the spheres survived from classical Antiquity into the Middle Ages and Renaissance.

In the vast anthology of excerpts and citations he collected from earlier writers, Iohann Stobaeus, a Greek early fifth-century compiler about whose life we know little, includes "adages" of Pythagoras.[86] Among these are "*Enkrateia* [continence or self-restraint] is the master of the greatest bodily strength and wealth," and "To die is much better than to wreck the soul through lack of self-control."[87] These sayings indicate that the reputation of Pythagoras as a moral authority continued to be strong in the fifth century, providing a parallel though very different thread to that of the genius of numbers and music that Macrobius was developing. Stobaeus also has something to say about numbers, however, for he tells us that Pythagoras gave personal names to numbers. Among these, he named the number one (the monad) "Apollo" and the number seven (the heptad) "Athena."[88]

A similar thread is followed at around the same time by Hierocles of Alexandria, a scholar from the School of Alexandria who appears to have had a particular interest in Pythagoreanism in addition to Platonism. Hierocles wrote a commentary on seventy hexameter lines that were preserved by the followers of Pythagoras and attributed to the sage himself. (The existence of this poem cannot be confirmed before the fifth century; it may have some connection with a poem titled *On the Mysteries,* which Diogenes Laertius says was extant in his day and falsely attributed to Pythagoras.)[89] The poem, a collection of rules of life and behavior, is compared by Hierocles to gold, the purest metal, and is known as the *Golden Verses of Pythagoras,* or *Carmin aureum.*[90] It focuses on the concept of human order and its corollary universal harmony. The verses include, in addition to two references to the requirement to revere the tetraktys, admonitions to be clean, to avoid luxury and forbidden foods, and to have faith in the immortality of the soul. The practical philosophy they suggest is that a good human being who leads an orderly life can hope to attain the harmony of divinity, the ultimate in orderliness. Although the origin of these verses is shrouded in mystery, the attention paid them by Hierocles shows that in the fifth century it was believed, even among scholars at Alexandria, that they were traceable, directly or indirectly, to Pythagoras himself. The "golden verses" would come to be well known in Arabic as well as in Western medieval and Renaissance tradition.

An important contemporary of Hierocles of Alexandria was Martianus Capella, an imaginative raconteur from fifth-century Carthage. Composed in about 430, his *De nuptiis Philologiae et Mercurii (The Marriage of Philology and Mercury)* is a fascinating compendium that introduces the Seven Liberal Arts. Set into the fantastic scene of an imaginary marriage that unites the seven under the authority of Apollo, the golden-haired god of Parnassus, together with the Muses, produces the symphony of notes and chords that makes up perfect harmony.[91] One of the actors in this drama is none other than Pythagoras. He is present to pronounce the power of the decad, the perfection of the

number ten in the tetraktys, which sets the proportions of the musical har-
monies. As the Seven Liberal Arts are introduced, Pythagoras is the chaperone
and patron of the extraordinary figure of Arithmetic, a striking woman clad in
golden dress with ten rays emanating from her head. When Pythagoras follows
the regal figure of Arithmetic and stands by her side, Martianus uses the scene
as an opportunity to expound the virtues and magical properties of each of the
numbers that makes up the decad. Subsequently, Pythagoras is joined by Plato,
and together in the presence of all the gods at this celebratory and regal setting
they expound the *Timaeus,* which confirms the long-standing undercurrent in
Antiquity that the *Timaeus* is a Pythagorean work. An astronomical note is in-
terjected as the figure of Astronomy expresses infinite gratitude to Pythagoras
for having discovered the planet Venus. The last of the wedding guests is also
the most important: the figure of Harmony is introduced by Apollo. Harmony
carries a shield composed of the encompassing circles of the seven planets. As
she paces to the music of stringed instruments, a symphony of concordant
tones rises from her shield. To the accompaniment of the lyre, she describes the
reconciliation of opposites obtained by the marriage of lower and higher
chords as they are joined in the middle by the intermediary bond of a tone they
both share.[92] Thus, imagined by Pythagoras and orchestrated by the god
Apollo whose golden hair symbolizes the flaming rays of the sun, the Seven
Liberal Arts are brought together in a resplendent and extraordinary perfect
harmony in the setting of a heavenly wedding.

Martianus was to remain one of the most popular writers in Europe
through medieval times and into the Renaissance for his fantasy on the learned
arts that explained the quadrivium, which together with grammar, rhetoric,
and logic, composed the Seven Liberal Arts ($3 + 4 = 7$).[93] Although the group-
ing of arithmetic, geometry, music, and astronomy had been recognized since
these disciplines were first brought together by the Pythagorean Archytas in
the fourth century BC, who was followed by Plato and Nicomachus and
Boethius, it appears that the Seven Liberal Arts were first described by Varro
(who, it will be remembered, had a special devotion to the number seven and
who had a Pythagorean burial) in the first century BC. Varro's description of
the *artes liberales* was most likely a source for Martianus's bizarre allegory.
(The term *quadrivium* would become standard from early medieval times,
after its use by Boethius, who would explain the primacy of arithmetic as a dis-
cipline useful for the other three, whereas the term *trivium* would be intro-
duced later.)

Proclus Diadochus (ca. 410–85), a prodigiously gifted and erudite intellec-
tual from Constantinople, used his position as head of the Platonic Academy
at Athens during much of the fifth century to pay continued tribute to
Pythagoras.[94] Known as the Prince of Sciences, Proclus was inspired by
Iamblichus. It is not surprising to learn, from his disciple and biographer Mar-
inus of Samaria, that, like Pythagoras and Iamblichus, he lived a life attended
by portents and miracles; at his birth in Constantinople, for example, he was

personally welcomed into the world by the goddess Athena. Also like Pythagoras, he had a special relation to Apollo: before going to Alexandria for his education, he was raised in a town that was dedicated to Apollo. Like Pythagoras, he abstained from meat and lived the life of a blessed and holy man who attended to humanity with sympathy and virtue. In a dream, his biographer reports, Proclus was convinced that his soul was that of Nicomachus, reincarnated.[95] Not only is this a Pythagorean dream in that it infers transmigration, but it also pays tribute to the great fame of Nicomachus.

It was Proclus who established for the Middle Ages and the Renaissance, when his works would become well known, what was self-evident to his predecessors and contemporaries in Antiquity, that Plato was a Pythagorean. Proclus begins his most important work, the *Platonic Theology,* by specifying that Pythagoras was the first to learn the secrets of the gods (the doctrine of harmony) and that Plato inherited this secret science from Pythagorean (and Orphic) writings. By discovering how the mathematical sciences, particularly geometry and harmony, underlie the workings of the universe, Pythagoras prepared the way for Plato's revelation of divine truth.[96] Thus, as the modern scholar Dominic O'Meara points out, does Plato's theology, or science of the divine, take its inspiration from Pythagoras.[97] Pythagoras was the pathfinder, the discoverer, whose revelations of the divinely inspired truths of mathematics and harmony led to the learning of Plato, which explained the truths of the universe hidden in the divine intellect.

In other works by Proclus, such as the *Commentary on the Timaeus* and the *Commentary on Euclid,* which discuss the science of mathematics, he pays special attention to geometry because, even over arithmetic, its visual images give perceptible knowledge to the soul. As he states early on in the *Platonic Theology,* although Pythagoras is his ultimate authority in this area as well, Plato is his central authority (and his central interest). Thus the shining light of Pythagoras appears to have become somewhat dimmed (outshone by that of Plato) in fifth-century Athens. Although Proclus is believed by some to have written a commentary on the *Golden Verses,* which occasioned a medieval Arabic commentary (as discussed in chap. 4), there is no proof that the work was his.[98]

Despite the turbulent times in which he lived, when the Roman Empire had all but collapsed under the pressure of successive waves of invasions from the north and east, and despite the personal anguish that he suffered in the last years preceding his execution, the learned Roman Boethius Severus (ca. 475–ca. 525) paid tribute to the memory of Pythagoras in two of his major surviving works, both of which came to be of major importance for the Middle Ages and Renaissance.[99]

In the *De institutione arithmetica,* a work that provided Latin scholars with the vocabulary of mathematics as presented four centuries before in Greek by Nicomachus, Boethius recognizes Pythagoras as the ultimate authority on arithmetical learning. Pythagoras, according to Boethius, is the first to have

achieved the highest perfection in wisdom, or philosophy, and it is from his in-
fluence, Boethius asserts, that the quadrivium derives.[100] As the foundation of
the four sciences making up the quadrivium, without which the other three
(geometry, music, and astronomy) could not exist, arithmetic is the most im-
portant. According to Boethius, it was Pythagoras, followed by his zealous stu-
dent Plato, and Aristotle after him, who pointed to the avenues of knowl-
edge—arithmetic, geometric, and harmonic—and it was Pythagoras who
discovered the perfection of the number ten.[101] Further, Boethius informs his
readers, arithmetic as discovered by Pythagoras is the science of number that
lays the foundation for understanding the divine mathematics of creation and
the principles of harmony that govern all order in the universe. Like the four-
fold quadrivium, which is the road to divine wisdom and philosophical truth,
all things are based on the four elements, and it is these that establish propor-
tion and the harmonic mean.[102] The importance of this work, which is based
on that of Nicomachus, cannot be underestimated because it came to be the
basic text in western Europe for the study of arithmetic through medieval
times and into the Renaissance.

In the *De institutione musica,* Boethius follows through by placing cosmic
music at the top of the three categories of music he distinguishes (cosmic,
human, and instrumental). In its larger sense, cosmic harmony refers to bring-
ing together in equilibrium the four elements that together form the harmonic
structure of the celestial world. Despite the loss of the last books of this work,
it is clear from the surviving portion of his text that Boethius was indebted to
Macrobius and Nicomachus. Boethius makes it plain, from the beginning, that
Pythagoras is his ultimate authority. After an argument that recalls the com-
ments of Stobaeus, Boethius maintains in the opening section of this text that
Pythagoras could inspire *enkrateia,* or continence, with music. This he ex-
plains: While Pythagoras was contemplating the course of the stars, an intoxi-
cated Taorminian youth who had been listening to the "Phrygian" tempo was
pursuing a harlot who was in the home of a rival lover. In his anger the youth
was threatening to burn down the house. Through the power of music (specif-
ically, the spondee) Pythagoras was able to render the youth mild and in con-
trol of himself. In the same vein, Boethius reports a story similar to one we first
learned from Quintilian: When some intoxicated youths were allowing them-
selves to become incited, through the sounds of the flute, to break down the
doors of a home where chaste women lived, Pythagoras advised the flute
player to change the mode of the music and to play instead a spondee; at the
sound of the solemn and heavy religious music, the raging wantonness of the
youths subsided. Thus were Porphyry's and Iamblichus's claims—that
Pythagoras believed music could cure illness and adjust the soul, restoring its
harmonious balance—"proven" in the description of Boethius.[103]

Although Boethius's works on geometry and astronomy are, to the extent
they were completed, lost to us, these recommendations are compatible with
the argument of Lady Wisdom in *The Consolation of Philosophy,* that hu-

mankind must seek the highest good. Indeed, Boethius's single mention of Pythagoras in that work is exhortative; he was inspired every day by Pythagoras's words "Follow God"—a concept most likely inspired by Aristoxenus.[104]

▲

Thus have we seen that a distinct reverence for Pythagoras persuaded writers of the third century to discover new materials that enhanced the divinity of their hero. Through their song, the Muses, who accompanied Apollo, revealed the harmony of the universe; the Seven Liberal Arts symbolized this harmony; and the reconciliation of opposites relied on moderation in both the cosmological and the personal sense. Pythagoras's physical attributes were discussed in more detail than previously. From Diogenes Laertius we learn that he was majestic; Porphyry tells us he was tall, graceful, and handsome, and that his hearing and eyesight were exquisitely accurate. Aelian describes him as dressed in white, crowned with a golden garland, and wearing trousers. Iamblichus tells us Pythagoras had long hair (in addition to the long beard previously mentioned by Martial) and surpassed in beauty all other living beings. The detailed descriptions of Iamblichus allow us to visualize Pythagoras giving moralizing speeches to spellbound crowds of his followers at Croton. We also see him as an arbiter of the law and an inspiration for freedom to those under the shackles of tyranny. The accumulation of miracles, signs, and wondrous stories associated with Pythagoras by Iamblichus suggests that Pythagoras had privileged access to truths hidden in secrecy, mystery, and enigma. For Iamblichus Pythagoras had a privileged access to god, for he had a divine origin and mission on earth: he was Apollo incarnate. Thus was established a renewed importance for the sun, the dawn, and the east, including the practice of adoring the rising sun.

The eager amassing of biographical data on Pythagoras that characterized the third-century biographies of Pythagoras faded somewhat in the fourth and fifth centuries: the biographical tradition for Pythagoras had essentially ended with Iamblichus. After his death the lively interest in and devotion to the mystical Pythagoras evolved into a somewhat more passive but enduring respect for the inventor of philosophy. This invention was interpreted in different ways. For Proclus, as for Macrobius before him, the learning of Pythagoras was basic to the study of arithmetic and to its application in studying the function of the universe, whereas for Hierocles the example of Pythagoras had the very practical value of application: it was useful for teaching people to live a well-ordered life. Both, in their own ways, aimed at harmony. These avenues were not mutually exclusive. For Boethius, reverence for Pythagoras was based on both his intellectuality and his moral example. Not only did Pythagoras's invention of the science of number give men the tools to measure heaven and comprehend the harmony that governs the universe; beyond that, through its expression in music, it could bestow order on life and cure body and soul of illness.

Thus had a four-sided mostly Greek debate about Pythagoras emerged. Was

he, as Aelian and Porphyry now suggested, the genius who discovered the relationship of number to God and to the cosmos because he was himself a god? Or was he the profoundly religious man perceived by Iamblichus, preaching personal holiness and communal love? Or was he, as Dicaearchus and Pompeius Trogus had suggested before them, a very practical-minded person who taught common people how to lead well-ordered lives? Or was he, as Heraclitus deridingly put it, long before that, and as Pliny later more respectfully agreed, a magician? These differing views available in the Roman world, which often deferred to Greeks in matters of culture, were inherited and absorbed in the late pagan and early Christian worlds, where conflicts between ancient magic and modern science did not exist. Indeed the very survival of these different ideas and legends about Pythagoras and their deep interplication in the thought of writers such as Boethius would appear to emphasize the authenticity of the "story" of Pythagoras as a complex web of elaborate rationalizations that came to be woven over the increasingly distant memory of a now legendary god-man.

Long before the reigns of the last Roman emperors, and although the pursuit of learning in the empire continued, the abundant production of significant original literary works that had characterized the Augustan period appears to have subsided. In 529, within a few years after the execution of Boethius at Pavia, the Emperor Justinian closed the Platonic Academy at Athens.[105] The emperor's action, no doubt influenced by the sometimes militant anti-Christianity of the brilliant Proclus and other pagan scholars, resulted in a hiatus in the study of Pythagoras and an attenuation of his influence, although it could not stop the pursuit of classical learning. Pythagoreanism, which as we shall see had in the meantime developed into the equivalent of a "scholarly religion," suffered but did not die. As for Pythagoras, his memory would stay very much alive in a Christian world.

PYTHAGORAS
IN MEDIEVAL MEMORY

.
. .
. . . .

Even as Justinian was attempting to suppress pagan learning, Neoplatonist scholars such as Simplicius of Cilicia (fl. ca. 500–540) in Athens and his contemporary Olympiodorus of Alexandria (fl. early sixth century) were actively engaged in keeping the tradition of Greek thought alive.[1] Simplicius, whose learned commentaries on Aristotle (relying in good part on his hero the "divine Iamblichus" and works he imagined to be by Archytas) would be known into the Renaissance, certainly considered Platonism to include the legacy of Pythagoras along with that of Aristotle. Olympiodorus worked with more freedom in Egypt; in the course of attempting to refocus the attention of intellectuals on Plato himself, Olympiodorus, like Pythagoras, absorbed mathematics, medicine, and political and moral thought into the fabric of philosophy. Nor was Iamblichus's attempt, in Syria, to revive the importance of the teachings of the divine Pythagoras for Platonism forgotten. Although Iamblichus had been dead almost two centuries, his legacy was in significant part preserved by Proclus, Stobaeus, and other late Antique anthologists. Thus were the intellectual traditions of the Greek academy and the memory of Greek culture—including its fascination with Pythagoras—renewed and debated by pagan philosophers in Greece, Egypt, and Syria, who did not forget the works of Plato, Aristotle, Plutarch, Nicomachus, and others, and who were conscious of if not accommodating to the emerging Christian outlook. It was during this time that a number of important early medieval literary collections, whose holdings would preserve a large variety of classical texts, were formed.[2]

Among the Aristotelian and Platonic texts known in early medieval times, Plato's *Timaeus* was the most important. Not only had Cicero written a commentary on it (dedicated to Nigidius Figulus) in the first century BC, but Porphyry too, in the third century, had written a commentary on it. The *Timaeus* was, however, primarily known in medieval times through a fourth-century translation and commentary by the Christian writer Chalcidius.[3] Meanwhile, the figure of the idealistic vegetarian Pythagoras made famous in Ovid's *Metamorphoses*, a work that not only survived but was widely read in medieval times,[4] began to fade. The curiosity of the growing Christian community was concentrated in the direction of self-definition and disentangling itself from the web of pagan traditions from which it had emerged. Thus the discovery of information about Pythagoras was no longer to be a priority for emerging medieval writers. This is not, however, to say that he was forgotten. On the contrary.

As monasteries began to develop in the sixth century, they became centers of learning that exerted a tremendous influence and formed the foundation of medieval intellectual life.[5] In this world, Pythagoras's love of wisdom and his renown were not forgotten; nor was the fact that Saint Augustine had ranked him as the first of the great philosophers of the past. From Clement of Alexandria they had learned of Pythagoras's devotion to one god. From Saint Jerome they acquired respect for Pythagoras as the first to discover the immortality of the soul. Those developing the emerging Christian theology in the monasteries also came to be attracted to works by late pagan authors. Through Macrobius's *Commentary on the Dream of Scipio,* a work that was to exert a tremendous influence beginning in the sixth century,[6] theologians learned that Pythagoras was a religious man, the creator of the science of harmony, and the discoverer of the meaning of numbers. Similarly, the authority of Martianus Capella's *Marriage of Philology and Mercury,* which presented Pythagoras as the father of arithmetic and of the symbolic properties of number as well as an interlocutor for astronomy, was also well known to medieval monks. Proclus too was widely respected; through him it was known that Plato followed in the footsteps of Pythagoras, and thus was the science of the divine inspired by Pythagoras. Although possibly a Christian, Boethius, widely celebrated in the Middle Ages as the greatest philosopher since Aristotle and as a saintly martyr, had espoused the Greek classical tradition. He had demonstrated the morality of Pythagoras as well as his importance for number and music.[7]

Although many literary works of the sixth century are poorly known to us, the works of Cassiodorus (Magnus Aurelius Cassiodorus, Senator, 479–575), a learned scholar, politician, and monk who was interested in preserving and cultivating classical literature for the Church, show that he inherited his predecessor Boethius's belief that Pythagoras was the inventor of the discipline of mathematics. In the *Institutiones divinarum et saecularium litterarum* (*Instruction in Christian and Secular Literature*), an erudite and influential guide for the education of monks, he describes a course of study in the liberal arts

and sciences for which pagan scholarship is fundamental. In this bibliographical guide he reports that Pythagoras was well known at the time for his discovery that all things were created by God according to proportion and could be measured and understood in terms of number. Indeed he says that among his contemporaries, many, following Pythagoras, held the science of numbers to be the fountain and mother of everything.[8]

This variegated background of pagan and Christian sources was not lost on Isidore, bishop of Seville (ca. 602–36), who in the following century, through his library, writings, and influence, played a major part in the preservation of late Antique knowledge and its dissemination in the Middle Ages.[9] In perhaps the greatest of his compilations, a twenty-book *Etymologiae* that would be widely known through medieval and Renaissance times, the authoritative Christian bishop passes on a number of important points that inspired his enormous respect for Pythagoras. Isidore was at pains to explain the metaphor of the Greek letter Y, which (as Saint Jerome had first suggested and the Roman poet Ausonius had echoed in the fourth century) encouraged individuals to choose the difficult life of goodness and virtue over the easy one of ruin and destruction, as an invention of Pythagoras. At the same time, he admires Pythagoras for his invention of the "discipline" of number and arithmetic, which, Isidore explains, was known to his world through Nicomachus, Apuleius, and Boethius.[10] His chapter on arithmetic shows that he knew well the *Introduction to Arithmetic* by the then "great master" of arithmetic, Nicomachus (who, as discussed in chap. 2, attributes the wonders of arithmetic to Pythagoras), as well as the *Institutiones* of Cassiodorus discussed above. It was Pythagoras, Isidore says, who discovered that the universe is constituted from numbers.

Isidore relates that the Greeks regarded Pythagoras as the one who, from the sound of hammers and heart beats, discovered the principles of music. On the other hand, he discusses the seven strings of the lyre and the lyre's relation to cosmic harmony without crediting Pythagoras, which suggests that by now this information had become common knowledge. Pythagoras was wise in both divine and human matters, he maintains. He was the inventor of philosophy, and his doctrines were wise for they influenced not only Plato but also Cicero, Virgil, and other great writers of Antiquity. Indeed, in describing the island of Samos, Isidore says it was famous in his time for two reasons: as the home of the Samian sibyl and as that of Pythagoras.[11] In combination, these observations suggest that Isidore was one of the first to regard the reputation of Pythagoras as one that integrated ethics, morality, religion, and mathematics.

Two centuries later, in the Byzantine world of the East, another admirer of Pythagoras made a major contribution to the preservation of his memory. The celebrated ninth-century scholar Photius was patriarch of Constantinople, a city whose various libraries were remarkable for the sheer bulk of classical texts they held.[12] With the aim of helping Christians appreciate the heritage of the ancient world, Photius produced the *Bibliotheca,* an erudite compendium

of critiques and extracts from nearly three hundred books he had read, many of them now lost. One of these books was an ancient biography of Pythagoras, which Photius himself owned and from which he drew material that he used to stress the dependence of Plato and Archytas on Pythagoras. Photius does not identify this biography by title or author, but the fact that it appears to have been based at least in part on Aristotle's lost work *On the Pythagoreans* suggests that its author had direct access to that work. Photius's précis of the biography records the names of Pythagoras's wife and children and says that Pythagoras lived to be 104. Pythagoras, according to the biography, was a prophet who attributed great significance to number and used it to organize knowledge about natural phenomena: he identified twelve colors and seven tastes recognized by four senses that are activated in the human head, and he posited that humans possess eight organs of knowledge and three types of docility. Pythagoras also taught that in heaven there were twelve orders and three levels. The anonymous biographer went on to write of the importance of the monad, the dyad, and the tetraktys to Pythagoras, and especially of the great importance he placed on the power, size, and influence of the sun; man, Pythagoras taught, was a microcosm of the universe illuminated by the sun. According to this biography, Pythagoras was a prognosticator, and all his predictions materialized. Like him, his followers also practiced the art of prognostication. His influence was especially felt by Plato, who was his ninth successor (that is, after Archytas) and whose teachings, including those on the immortality of the soul, were based on those of Pythagoras.[13]

The contents of this biography, valuable though they are, are perhaps equaled in significance by the fact that so distinguished a Christian primate as Photius considered the teachings of this pagan sage, who lived over a thousand years before him, sufficiently important to preserve for the edification of his fellow Christians in the ninth century.

▲

Little new activity on behalf of Pythagoras is known to have taken place in the tenth and eleventh centuries, although his reputation lived on through the very popular works of others, including Ovid, Martianus Capella, Boethius, and perhaps most importantly, Macrobius. There is no doubt that, certified by such eminent Christians as Clement of Alexandria, Eusebius, Saint Augustine, and Saint Jerome, as well as Cassiodorus (not to mention Isidore of Seville) in the Latin world and Proclus in the Greek world, Pythagoras was remembered as one of the greatest representatives of the wisdom of Antiquity.

An epitaph, composed anonymously in about 1095 for the tomb of an Italian ecclesiastic known to us only as Guido, lists the "prophets" and "teachers" who were his favorite authors: Pythagoras, Socrates, Plato, Cicero, and Virgil. This epitaph merits attention not just because Guido was a Christian and a representative of the Church but because it shows that even a low-level ecclesiastic whose complete name is unknown to us could be interested in demon-

strating erudition in the wisdom of Antiquity as exemplified by his admiration of Pythagoras.[14] In a similar vein, popular treatises that paid tribute to ancient knowledge remembered Pythagoras. He is praised, for example, in the (Provençal) *Bible Guiot* along with Plato, Aristotle, Virgil, Cicero, and Ovid.[15]

An eleventh-century manuscript that contains the translation of a commentary, thought at the time to be by Proclus, on the *Golden Verses* believed to have been written by Pythagoras, demonstrates that in the Arabic as well as in the Christian world, scholars were familiar with the biography and example of Pythagoras. Titled *Book of Medical and Philosophical Gists and Fruits,* this manuscript, preserved in the Escorial Library, is only one of many known Arabic versions of this text. Following an introductory biography of Pythagoras that describes his virgin birth, his education and wisdom, and his veneration of one god, the commentary describes how God may be glorified through the virtuous lives of good men. Whether or not the commentary was composed by Proclus, this text was popular in Baghdad and elsewhere in the Arabic world, which shows that Pythagoras was well known not only to Christians but also to Muslims in medieval times. Its pedagogic tone indicates that the doctrines of Pythagoras were considered valuable guidelines useful for the (monotheistic) worship of Allah.[16]

Another such text, which offered to Muslims the translation into Arabic of a commentary on the *Golden Verses,* this one supposedly written by Iamblichus, is little known to Western scholars. It speaks of souls as wise and divine beings, the hierarchy of souls, man's duty to God, the importance of number, "theological" arithmetic, and the revolutions of the heavens.[17]

Thus was Pythagoras regarded by both Christians and Muslims during the tenth and eleventh centuries as a towering example of moral authority as well as a prestigious ancient sage who made the universe comprehensible to man through the symbolism of number. He knew the road to heaven because he knew, in essence, how to measure heaven.

▲

Pythagoras was well remembered by the scholars of Chartres, who occupied a place of preeminence in the intellectual life of the twelfth and early thirteenth centuries and who esteemed the works of Plato, especially the *Timaeus.* The most famous of these scholars was Thierry of Chartres (d. ca. 1150), a philosopher with a particular interest in mathematics. In one of his commentaries on Boethius he pays homage to Pythagoras as the founder of philosophy. He lauds Pythagoras for his modesty in claiming to be a mere lover of wisdom rather than one who had attained it.[18]

Among his disciples was the theologian and philosopher William of Conches (ca. 1080–ca. 1160). Almost all the works of William deal with the cosmology that he admired in Plato's *Timaeus.* In explaining that the influence of Pythagoras on Plato lay in the importance of number, he describes Plato as a follower of Pythagoras. According to William, Pythagoras maintained that

number has a life of its own and no creature can exist without it.[19] William also shows that the concept of the tetraktys was well known to the medieval world. He explains that Pythagoras devised the tetraktys because he had discovered the power of the number four and the first four numbers that were reflected cosmologically in the four elements.[20]

In a well-known and influential work known as the *Didascalicon* (*A Guide to the Arts*), composed in Paris during the 1120s, Hugh of St. Victor (ca. 1100–1141) sought to define all areas of human knowledge, and in so doing could not resist praising Pythagoras. Not only was Pythagoras, for him, the one who discovered philosophy, but Pythagoras yearned for the truth and made of philosophy the discipline of things that "truly" exist. Pythagoras was also, he reminds his readers, the inventor of arithmetic, and his followers in this realm were Nicomachus, Apuleius, and Boethius. Hugh further enriches the biography of Pythagoras by telling his readers that Pythagoras wrote a book concerning the teaching of the quadrivium (which Hugh calls the *Matentetradem*), a work unknown to us. He also discusses the hidden meaning discovered by Pythagoras in the Greek letter Y. According to the Greeks, Hugh continues, it was Pythagoras who invented music. Pythagoras, he adds, so revered the number seven that no pupil was permitted to question his statements for seven years in honor of the Seven Liberal Arts. Accordingly, it was the Seven Liberal Arts that made men truly learned.[21]

Thus enriched by surviving late Antique works, the influential masters of twelfth-century France well remembered Pythagoras as the thirteenth century opened. Although, with the exception of Hugh of St. Victor's claim that Pythagoras had written a work on the quadrivium, they did not contribute anything "new" to his biography, these learned men most certainly kept his memory alive as the one who had discovered the importance of number, who was a master of arithmetic, a preeminent philosopher, and an arbiter of morality. More is said about their Pythagoreanism in chapter 7.

▲

Even the triumph of scholasticism in the thirteenth and fourteenth centuries did not overshadow the memory of the sages of Antiquity, including Pythagoras, who continued to be known through the works of Boethius and others. While at the University of Paris, the bulwark of scholastic orthodoxy, Saint Thomas Aquinas directed his attention to Aristotle—allowing the latter to overshadow the role of his teacher Plato, whose *Timaeus* had been so important for medieval scholars and scientists. Meanwhile, humanist movements began to grow elsewhere, and particularly in Italy. Here schools that were supported either by individuals or by town governments (communes) began to develop. In these schools one of the basic subjects taught was mathematics.[22] The new humanism, was, however, focused on the study of Greek and Latin classics. The quest for ancient texts came to be a passion, especially for Italian *eruditi,* who began to develop a concept of history for which Antiquity was

fundamental. To feed this passion, book hunting experienced a resurgence that was to continue into the Renaissance. In this late medieval world, Pythagoras was highly appreciated, most visibly by Dante and Petrarch, but also by other scholars, such as the cosmopolitan English cleric Walter Burley, whose contributions to Pythagorean studies have not yet been appreciated by modern writers.

Dante (Dante Alighieri, 1265–1321) refers to Pythagoras eight times. In the *Convivio* (*The Banquet*)—a tribute, composed in about 1305–8, to universal knowledge as a reflection of divine wisdom—he invokes the authority of Pythagoras in describing the meaning of science. For Pythagoras, he says, all is number, and it is number that regulates the universe and explains all natural things.[23] Dante reminds his readers that it was Pythagoras who discovered and named philosophy.[24] He explains Pythagoras's concept of the universe as a sphere that turns from west to east, causing the sun to revolve around it and thus being alternately visible and invisible. In discussing the modifications of this idea of geocentricity proposed by Plato and Aristotle, he affirms that Pythagoras was the first great authority on the order of the universe. Yet he also notes the humility of this distinguished mind in reporting that when asked if he was known as a wise man Pythagoras replied that he was not wise but a lover of wisdom.[25] Perhaps it was under the influence of Pythagoras that Dante mapped out the various levels of the heavenly hierarchy—ten in all, although Dante does not mention the Pythagorean "perfection" of the number.

For Dante Pythagoras was also a model of practical life and virtue. He cites Pythagoras's emphasis on friendship as the source of communal concord. He is moved by Pythagoras's love of humanity and suggests it as an argument in favor of an ideal universal state. Although, he explains, some philosophers such as Plato held that souls had different levels of nobility, depending on the nobility of the stars from which they issued, Pythagoras maintained that all souls were of equal nobility. Pythagoras also regarded the souls of animals and plants, Dante adds, finding the same nobility in all of them.[26] Dante's words on this subject form the dedicatory epigraph of this book.

In the *De monarchia,* a work devoted to present arguments for the necessity of an independent universal state under the guidance of Rome while independent of the Church, Dante points out the idealism of Pythagoras's view of concord and his belief in the importance of unity as opposed to plurality. The result, Dante agrees admiringly, is concord and harmony, which are based on unity. In a shorter work, Dante refers to Pythagoras as a prophet.[27] Thus did Dante, who would be enormously influential in late medieval and Renaissance times, look to Pythagoras as an example in matters of philosophy, mathematics, astronomy, politics, and morality.

A younger contemporary of Dante's, the English scholar Walter Burley (Gualterus Burlaeus, or Walter de Burleigh, 1275–ca. 1345), did something that had not, to our knowledge, been done in centuries: he wrote an original biography of Pythagoras. Burley, who began life as a diocesan priest in En-

gland and later taught at the universities of Oxford and Paris, also serving as a diplomat at the papal court at Avignon and eventually settling in Italy, completed his *De vita et moribus philosophorum e poetarum* (*The Life and Character of Philosophers and Poets*) in about 1340. This small volume contains the biographies of 119 philosophers and poets, including a long one (in comparison to the others) on Pythagoras.

Burley's vita of Pythagoras is of great importance not only because it is original to the medieval world, but also because in its length and contents it shows that scholars like Burley knew a good deal about Pythagoras from Antique authors. Although the only sources he cites are Timaeus (presumably Timaeus of Tauromenium, writer on southern Italy), Cicero, Nicomachus, Apuleius, Valerius Maximus, Boethius, and Saint Augustine, one passage suggests Burley's familiarity with another author: he says that after Pythagoras's death his house became a temple, a "fact" first reported by Diogenes Laertius (although before him Cicero had said he visited Pythagoras's house, which he seemed to regard as a shrine). The earliest surviving complete Latin version of Diogenes Laertius dates from nearly a century after Burley's death, which suggests that an earlier partial or complete translation may have been available to him and his younger contemporary Petrarch, who also knew about the house-to-temple conversion. The two scholars were almost surely acquainted, since Burley spent the last years of his life, the period when he appears to have composed his work, in southern France and northern Italy; it is tempting to speculate that the two shared information as well as enthusiasm about Pythagoras.[28]

Burley's vita recounts the education of Pythagoras, first in Egypt and later in Babylonia, before going on to describe his invention of philosophy and his social, intellectual, and religious doctrines. These included the desirability of shunning luxury and living a frugal life, the importance of number (preserved for posterity, Burley says, by Nicomachus), and the concept of the soul and its eternal life after the death of the body. Pythagoras lived in a community of like-minded people, Burley tells us, and taught temperance and mutual love, both through exemplary sermons and through enigmatic utterances that were understood by his collaborators and followers. Pythagoras studied nature and meditated daily. His wisdom was famous throughout the Greek world and inherited by the Roman world. Indeed, he was venerated by the ancients. Evidence of the respect for his authority in Magna Grecia lay in the fact that scholars such as Archytus of Tarentum came to Metapontum to study with him.

This authoritative biography of Pythagoras by a noted Christian cleric, scholar, and diplomat did not go unnoticed. Although Burley's ideas have been insufficiently studied and discussed by most modern scholars, they must have been well known in his time and after his death. The more than one hundred surviving manuscripts of his *De vita et moribus philosophorum et poetarum* testify to his renown. The fact that none of these is in an English hand indicates that the work was especially popular on the Continent. Indeed it was to

appear in numerous printed editions after the invention of printing in the fif-
teenth century.[29]

Although he felt a strong aversion to the scholastic movement, Petrarch
(Francesco Petrarca, 1304–1374), a devout Christian with a strong instinct for
the significance of classical texts, points to Pythagoras as the first philosopher
and the one whose example can lead us to God. Petrarch knew a great deal
about Pythagoras and admired him immensely. He contrasts "idle" philoso-
phers with a Pythagoras who sounds virtually Christlike:

> Blind and deaf as they are, they do not even listen to Pythagoras, the most
> ancient of all natural philosophers, who asserts that "it is the virtue and
> power of God alone to achieve easily what Nature cannot, since He is more
> potent and efficient than any virtue or power, and since it is from Him that
> Nature borrows her powers." No wonder they do not listen to Christ, the
> Apostles and the Doctors of the Church, all of whom they despise; I only
> wonder why they do not listen to this philosopher or why they despise him.
> We have no right to suspect that these great judges of others have not read
> these words. However it may be that they actually have not read them. Then
> let them read them in the second book of the commentary which Chalcidius
> wrote on Plato's *Timaeus,* if any shame is left with them.[30]

In the *Triumph of Fame III* Petrarch praises Pythagoras for his humility in
applying the word *philosopher* to himself; in the *De viris illustribus (Lives of
Famous Men)* he reports that the legend that Pythagoras was the teacher of
Rome's beloved King Numa Pompilius still survived in his time. Although Pe-
trarch appears to sympathize with this idea, he explains that time and geogra-
phy refute it.[31] In one of his minor poems, Petrarch refers to the "Y of
Pythagoras," which was well known to his predecessors Saint Jerome and Au-
sonius: "What is it," he asks, "that compels men, at the *bivium* [crossroads] of
the old man of Samos, to deviate to the left side and to hold the right path in
such contempt?"[32]

This concept was so important to Petrarch that he mentions it at least three
times in the *Familiarium rerum libri (The Book of Familiar Things,* his col-
lected letters). In one letter he tells a friend he has chosen the left road of
Pythagoras, while in another he writes about an adolescent boy who is in peril
because he has not chosen the prudent path as defined by Pythagoras. In the
third he says that it was Pythagoras who hammered out that letter (the Y) so
useful for life.[33] In the *De vita solitaria (On the Contemplative Life),* a pane-
gyric on the life of solitude, he states explicitly, this time without referring to
Pythagoras, that his protagonist found himself "in bivio," at the crossroads.[34]

Petrarch frequently mentions Pythagoras in letters to other correspondents
as well, mentioning his "great talents" and the "fact" that from him and his
teacher Pherecydes was derived the later wisdom of "Socrates and all the So-
cratics and Plato himself, the greatest man who produced the most brilliant

work." Another letter describes the travels of the "famosiorque" (renowned) Pythagoras, who as Petrarch understands from Cicero traveled on foot throughout Egypt and Persia, where his ardent love of wisdom led him to study with the Magi. Having once left home, Petrarch notes, Pythagoras never returned.[35]

Although another letter described Pythagoras as a man of keen talents, Petrarch, as a Christian, expresses his disapproval of the doctrine of metempsychosis: "Hence that ridiculous 'rolling about' [transmigration] of souls passing through many and various bodies and the philosopher testifying to being reborn from the soldier of the Trojan war Euphorbus." This notion was, in Petrarch's words, "insaniam" [an insanity]. The passage continues by eulogizing Pythagoras as a man of every possible talent, eminent character, and the most supreme propriety. For these reasons, Petrarch reports, Pythagoras received highest honors not only from his contemporaries in life but after death from the gods. Petrarch also notes that the house of Pythagoras was transformed, after his death, into a temple—which suggests that, like Walter Burley, Petrarch may have had access to fragments of the work of Diogenes Laertius.[36]

Among Petrarch's other mentions of Pythagoras in the *Familiarium rerum libri* is one that links his "doctrine" to that of Plato. This doctrine, Petrarch says, was obtained first in Egypt, was brought to Italy, and then was poured forth into "the whole world." In a later letter Petrarch praises the greatest men of Antiquity—Plato, Pythagoras, Aristotle, and Varro, in that order. In another he equates the authority of Pythagoras and Plato on the one hand with that of Saint Peter and the Church on the other. Pythagoras, he says, did not fear work. Through their travels and their work, Pythagoras and Plato were the most illustrious of philosophers.[37]

Even in a tour guide that he dashed off in three days for Christians planning pilgrimages to the Holy Land, Petrarch found occasion to mention Pythagoras (and no other philosopher). The 1358 *Itinerarium de Janua usque in Hierusalem et Alexandriam* (*Journey from Genoa to Jerusalem and Alexandria*) describes the island of Samos as the home of the wonderful Pythagoras, who invented philosophy and left Samos in order to bring philosophy to Italy.[38]

Perhaps it was the influence of Petrarch that inspired one of his Paduan contemporaries, Marchettus, an obscure writer of treatises on music, to declare, in one of his major works, that Pythagoras was the inventor of music. This led him to discuss the diapason, diapente, and diafesseron, varieties of harmonious concord that, in the Renaissance, would be associated with Pythagoras.[39]

There was, too, a lighter side to the appreciation of Pythagoras in these years. A French thirteenth-century poem, *The Romance of the Rose*, well remembers Pythagoras as an author, and specifically as the author of the *Golden Verses*: "Pythagoras himself tells you, if you have seen his book called the *Golden Verses*, esteemed for its sayings, 'When you depart from the body, you

will move freely into a holy atmosphere and will leave humanity to live in pure deity.' "[40]

▲

Well known to intellectuals through the Antique texts of Plato, Aristotle, Plutarch, Cicero, Ovid, Nicomachus, Macrobius, Martianus Capella, Boethius, and many others, the image of the brilliant yet humble sage from Samos had been slowly reconstructed through medieval times, when he was admired by many influential Christian scholars from Cassiodorus to Petrarch. His admirers were to be found in Spain and England as well as France, Italy, Constantinople, and the Arab world.

It does not appear, contrary to what some have suggested, that the idea of Pythagoras takes on a new form during these centuries.[41] The old Pythagoras had never died—although scholastic theology had tended to overlook him in its anxiety to "Christianize" Aristotle—and by the end of the Middle Ages the emerging Italian humanism, which greatly respected Pythagoras, began to overcome the concerns of the scholastics and to pave the way for what would be an exciting resurgence of interest in him in the Renaissance.

This is not to say that interest in Pythagoras was limited to the admiration and respect of learned Christian (and Arab) writers who were especially interested in his cosmology, in which the sun was of great importance. Connected with this admiration and respect for a great sage and religious precursor of the now-distant past, new forms of Pythagoreanism that had begun to develop in early medieval times disseminated into a fantastic array of beliefs and rituals that would be widespread by the fourteenth century. Often ascribed to Pythagoras himself, these included a variety of magical practices such as recondite numerology, divination, prophecies, incantations, geomancy (a connection by lines, through elaborate tables, of events and persons to astrological constellations), and alchemy. Superstitious esteem for certain occult characteristics of natural objects, resulting from the study of celestial spheres, the powers of planets, the influence of stars, magical cures, medicinal herbs, and the transmutation of minerals, was often associated either directly or indirectly with the cult of Pythagoras. Even so great an ecclesiastical scholar as Albertus Magnus deemed these studies "experimental."[42] The development and dissemination of this Pythagorean cultism, which had its own effects on the history of art, is discussed in chapters 7 and 11.

PART II

PYTHAGOREAN
THOUGHT

PYTHAGOREANISM
IN GREEK AND ROMAN
ANTIQUITY

Many modern writers have struggled to characterize early Pythagoreanism. The numerous difficulties, most of them insoluble, connected with reconstructing the society or community that Pythagoras founded and its early dissemination of his teachings are based on the assumption that Pythagoreans practiced secrecy as well as silence, on the probability that what documents and writings existed are for the most part lost, and on the fact that those that do survive to any great extent are of much later date. Coming from different disciplines, many of those who have attempted to bring intelligible order to this movement (mostly philosophers) have worked from the perspective of their own disciplines. From their work we have learned a great deal, yet all their studies have been quite different and, for the most part, quite specialized.[1] Most of their studies are concerned with pursuing a particular aspect of early Pythagoreanism—characterizing its philosophical ideology, or explaining the peculiarities of its interest in mathematics, or describing its rules of morality and behavior.

Few of these writers have attempted to follow the concurrent, and sometimes convergent, multiple threads of Pythagoreanism, especially insofar as they cross the boundaries of the separated disciplines of modern times. This chapter follows Pythagoreanism in general as a loosely constructed "movement" that did not necessarily distinguish between scientific and mystical concerns. In it I organize extant information into a chronological outline of some of the major and perhaps not-so-major events that mark the movement's de-

velopment. My goal is to follow the history of the devotees of Pythagoras, their ideas, and the dissemination and influence of their ideas on the developing Western world.

▲

To describe the earliest formation of the society (or sect) of Pythagoras is an impossible task. Not only is there a lack of recorded information from this time but also the little information we have about the founding of a "school" by Pythagoras comes from late sources and may therefore be incomplete, incorrect, or legendary. Our knowledge of the names of those who were in direct contact with Pythagoras and of those who carried on his teachings after his death comes to us only through authors such as Diogenes Laertius, Porphyry, and Iamblichus.[2] Although they wrote some eight hundred years after Pythagoras's lifetime, they had access to the texts of earlier scholars that are now lost to us. Thus there is no compelling reason to doubt their assertions that for at least two hundred years after the sage's death, his teachings and methods were carried on by communities (or "schools") that had originated with him. We know next to nothing about these communities except for what is recorded by these much later authors.

My goal in the pages that follow is to suggest, in the absence of surviving writings by Pythagoras himself, the method of transmission of his teachings and to follow the dispersal of those who continued to study or impart his wisdom and precepts. I also outline the dissemination of Pythagoras's ideas and practices as they came to be perceived by others, forming a very diversified fabric—partly intellectual, partly ritualistic, and accompanied by a lifestyle with social and mystical characteristics that came to be known as Pythagorean.

Sappho: The First Pythagorean?

The earliest acquaintance with Pythagoras's ideas is suggested by the poetry of an older contemporary of his who was born on an island just north of Samos: Lesbos. Coincidentally, this island was identified by Diogenes Laertius's sources as the place where Pythagoras had studied with Pherecydes.

Little is known about the life of Sappho of Lesbos; however, she had much more in common with Pythagoras than merely coming from a neighboring island that he may have visited or even inhabited. A strong Antique tradition associates Sappho with the lyre. Relying on older writers such as Duris of Samos (Pythagoras's birthplace) and Aristoxenus, Plutarch credited Sappho with being the inventor of the Mixolydian or "tragic" (passionate) mode of accompanying poems with the music of the lyre.[3] Originally the lyre had three strings, but as the instrument developed, the number was increased to four and gradually to more, until in the sixth or fifth century BC (roughly the time of Pythagoras) the number was brought to seven, the same number that was

known in Roman versions of the instrument.[4] Sappho invented her sublime harmonies on the Aeolian lyre, which was distinguished by its large, graceful, curved shape; its strings were plucked with the fingers.[5] Pythagoras too played the lyre, which he appreciated for the harmony it produces. Numerous Greek sources tell us that it was reputed to be his favorite instrument. Not only did he sing accompanied by the lyre, he also (as later sources tell us) danced to its music.

It is not surprising to learn from another Antique source of the tradition that Sappho, like Pythagoras, had a special relation to Apollo. We have testimony from as far back as the fourth century BC, in the poetry of Menander (ca. 342–290 BC), that the "Lady of Leukas"—already legendary in his time, he says—was Sappho. She leapt from the Leucadian Cliff (a spectacular perpendicular cliff overlooking the sea at Cape Leukatas), Menander tells us, in the precinct of Apollo.[6] In the *Heroides,* Ovid describes Sappho's predicament as she prepares for her famous leap, which was occasioned by her sadness over the loss of the beautiful young Phaon. As she contemplates suicide, she is very much aware of her surroundings. At the top of this cliff stood a temple dedicated to Apollo: "There Phoebus from on high looks down on the whole wide stretch of sea."[7] Praising Phoebus in the light of the new sun (dawn), she dedicates her leap to Apollo and promises her lyre to him (who will save her and give her the gift of immortality):

> Do thou . . . place thy pinions beneath me, lest I die and bring reproach on the Leucadian wave! Then will I consecrate to Phoebus my shell, our common boon, and under it shall be writ one verse, and a second, "Sappho the Singer, O Phoebus, hath gratefully brought Thee a zither [lyre, cithara] token well suited to me, token well suited to Thee."[8]

In dedicating her leap to Apollo, Sappho expresses her belief that Apollo will allow her to return to life—or rather, give her the gift of immortality. The Temple of Apollo Leukatas, from which Sappho flung herself, is described by a contemporary of Ovid, Strabo. Strabo explains that it was an old custom of the Leucadians, every year at the time of the sacrifice to Apollo, to throw someone over the cliff—to be rescued by boats waiting below, enacting a kind of fable of immortality.[9] Thus Sappho suggests in her poem, which would be revived and amplified by Angelo Poliziano in the Renaissance, that immortality is the gift of divinity. In modern times, Jérôme Carcopino has suggested that Sappho's love for Phaon was transformed into divine love as Phaon was transmuted hypostatically into Apollo, representing a Pythagorean eschatology, that is, belief in a world beyond mortal existence.[10] Carcopino was not the first to think of Sappho as Pythagorean. In ancient Rome, as we shall see in chapter 9, a fresco in a Pythagorean precinct depicted Sappho's leap and thus underlines what Sappho's biography beguilingly suggests—that she was connected with the great sage from Samos.

Sappho's yearning for immortality sets her apart, so far as we can tell, from

the thoughts of preceding poets regarding the subject of death. Surviving poems by earlier poets speak, with fatalistic acceptance, of death as a final event. Consider the words of Mimnermus (active ca. 630 BC):

> We are like the leaves which the flowery season of spring brings forth. . . . And when the end of their season passes by, straightaway death is better than life.[11]

and those of Simonides (ca. 556–466 BC):

> Men's strength is slight, their plans impossible; within their brief lifetime toil upon toil, and death hangs inescapable over all alike: an equal portion is allotted to good men and to bad.[12]

Sappho was different. She was the first to suggest that humans might aspire to immortality in the remembrance of others:

> But when you die you will lie there, and afterwards there will never be any recollection of you or any longing for you since you have no share in the roses of Pieria; unseen in the house of Hades where, flown from our midst, you will go to and fro among the shadowy corpses.[13]

Sappho seems to be thinking more specifically of herself in these shorter fragments:

<div style="text-align:center">

Yes
they gave me
true success
the golden
Muses
And once dead
I shall not be forgotten

</div>

and

<div style="text-align:center">

Many have been cheated by oblivion
But by good judges
None:
And afterwards, I say,
I shall be remembered
Certainly by some[14]

</div>

Even so familiar a piece as her poem about the apple beyond the reach of the pickers can be viewed in this light:

<div style="text-align:center">

Like the last red apple
Sweet and high:
High as the topmost twigs,
Which the apple-pickers missed—
O no, not missed
But found beyond their fingertips[15]

</div>

A comment by Aristotle suggests that Sappho's antipathy toward death was part of her legend in Antiquity: "Sappho says that death is an evil; the gods have so decided, otherwise they would die."[16] Taken together with the idealism expressed in her poetry, this attitude toward death supports·the suggestion first made by Carcopino that Sappho was in the "orbit" of Pythagoras.

Believed to have been born about 612 BC, Sappho would have been close to forty as of the birth date calculated for Pythagoras by Aristoxenus and his pupil Apollodorus of Athens. This means that if Diogenes Laertius's information about Pythagoras having studied on Lesbos in his youth was correct, Sappho and Pythagoras could have been acquainted, or certainly—given their mutual interests—could have been aware of each other. Such a link would not be surprising, considering the ample tradition, noted in the previous chapters, that Pythagoras was notably divine in his youth, that he supported female intellectuality and education, and that he had female followers. Although none of this conclusively shows that Sappho was the "first Pythagorean," it is certainly plausible that she could have been one of the first to be touched by his influence. And it is worth noting that Pliny's first-century AD account of an aphrodisiac plant links Sappho, her lover Phaon, and the Pythagoreans.[17]

The Culture of Early Pythagoreanism

Assuming the tradition is authentic that early on Pythagoras himself founded a "school," we find that the school appears to have been characterized by both contradiction and continuity. The characterization may be difficult for modern readers to imagine because it assumed the view that mathematics, cosmology, and religion together formed an incorporated and consolidated subject matter, while at the same time it compelled its followers to show devotion and respect through their secrecy and obedience to rules. Assuming this diversity was the main feature of Pythagoras's teaching, we find that when repeated and cast into the framework of ritualistic behavior, it perpetuated a tradition that was inherently non-orthodox.

A perfect example of this non-orthodoxy is Hippasus of Metapontum. About him we know little other than (from several later sources) that he was a member of Pythagoras's original "colony" or "group" and that he appears to have been associated, perhaps together with Heraclitus, with the idea that the first principle of the universe was fire. He is perhaps also connected with the earliest discussion of a "central fire" in the substrate of the earth. On one occasion at least, his revelation of one of Pythagoras's mathematical secrets is reported to have occasioned his punishment by the school. On another, he appears to have defied the rules set by Pythagoras. Thus he acquired the reputation of a dissident within the group.[18]

Aristeas, the son of Damophon of Croton, provides a different kind of example. He blended in so well that we know almost nothing about him. He is noted by Iamblichus as being the acknowledged successor to Pythagoras, the

one who administered Pythagoras's school, married his widow, and educated his children. However, Iamblichus may have confounded Aristeas of Croton with the celebrated Aristeas of Proconnesus, who through miracles—including one at Metapontum—spread the cult of Apollo.[19]

It was Pindar (518–438 BC), born during the lifetime of Pythagoras and known as the greatest lyric poet of ancient Greece, who forever changed the cult of Apollo and his personification from the avenging and terrifying deity of the Homeric myths, who through the violence of his arrows expressed his anger toward men, to the god who made music that cured the ills of humankind and soothed the souls of men.[20] No doubt the greatest invention of Pindar, beyond the splendor of his language and imagery and the versatility of his techniques, was his idea of Apollo as the great unifier and benefactor of humankind. Not only did the divine beauty of Apollo inspire the athlete with the force and courage to achieve victory, but this victory symbolized that of man, who was enabled to become a civilized being through the radiant gifts of Apollo.

For Pindar, Apollo is the origin and symbol of civilization. Pindar discovered the intelligence and grace of Apollo and endowed him with the exalted position of redeemer. Through Apollo, in his "reincarnation" as the Delphic ideal, the civilizing arts were taught to man. Thus humankind learned to function according to moral law based on the advice of Apollo. Far from fearing the shooting arrows of an avenging angry god, humankind was now urged to seek counsel and moderation in life.

Indeed, Pindar's verses sing the praises of the music of Apollo—music that gives rhythm and regularity to a world that lives in a well-ordered way and according to the law. Through Pindar's song, the primitive god evolved into a resplendent and perfect divine being who bestowed gifts to man, including not only music but also immortality. Apollo rules over the world from the sun, which is the monad, as is his own name (a–pollo, "without multiplicity").[21] Pindar praises the "golden light" of the sun and describes it as Apollo's glory shining down over the earth.[22] As the sun maintains order in the heavens, Apollo's music distributes peace and order on earth. Even the warlike Zeus is spellbound and tempered by the music of Apollo.[23]

Pindar's homage to Apollo was expressed through the music of the lyre, which he, as well as Apollo (and Pythagoras) played. Again and again, the spiritual power of its music is set forth by Pindar. For example, the first *Pythian Ode* describes the peace, harmony, order, and regularity evoked by the phraseology of the "golden" lyre.[24] This narrative is very different from that of the subsequent lines, which describe the chaos, destruction, and horror of the eruption of Mount Etna, which had occurred just before Pindar's visit to Sicily. He appears to see the devastation first hand, for he describes it as a monster belching fountains of fire, rivers of lava, and torrents of smoke. Pindar's visit to Sicily raises the possibility that he was connected with or personally knew Empedocles (whose likely ties to Pythagoras are discussed in chap. 1). Empedocles would die in an eruption of this volcano in 432 BC.

The golden lyre of Apollo, Pindar tells us, had seven strings, and through its music Apollo's harmony of the universe was expressed.[25] Pindar is the first to assert this idea, which will later be regarded as Pythagorean in the works of Plato, Cicero, and Macrobius. The significance of the seven strings of Pindar's lyre invites us to consider the beguiling Greek literary tradition that Apollo was born on the seventh day of the month, a tradition connecting the number seven with Apollo, which must have been of great importance. The principal feast days of Apollo fell on the seventh of any given month.[26] Soon after Pindar's time, Aeschylus would refer to Apollo as the "Commander of the Sevens."[27] And Plutarch would later affirm that the number seven is consecrated to Apollo.[28] The greatest gift Apollo could bestow on those who expressed piety to him was, according to Pindar, to be given the honor of dying on the seventh day of the month.[29] This honor was to be bestowed in the most supreme way on Plato, who not only was born on the seventh day of the month now considered to be May but died on the same day he was born.

Pindar's special attachment to the sublime god of order and divine harmony was expressed in his visits to Apollo's shrine, the same shrine that Pythagoras visited.[30] And Pindar exults in the fact that his own birthday occurred at the time of the celebration of the Pythian festival at Delphi, an annual festival in honor of Pythian Apollo, the god after whom "Pyth-agoras" was named.[31] Like Sappho, Pindar believed in immortality as the gift of divinity and in the rewards that awaited mankind after death.[32] For Pindar, Apollo's gift of music to humankind included the spirit of harmony on earth, peace, obedience to law, and the healing and saving arts, all of which offered a change in the Greek outlook on harmony and peace in the universe and were in accord with the traditions associated with the life of Pythagoras. Little wonder, then, that Plutarch and Clement of Alexandria would link Pindar with Pythagoras.[33]

Parmenides of Elea (b. ca. 515 BC), a contemporary of Pindar's and a historical figure admired by Plato, was known in his time as a Pythagorean, a description that has puzzled some modern writers. However, the surviving fragments of a long didactic poem believed to be his support his identification with the Pythagorean movement in southern Italy where he lived. One of these recommends restraint in daily life, while another describes man's obligation to choose between two paths, one of carelessness and the other of virtue, a choice that would later be symbolized by the Greek letter Y, which would come to be known in late Antiquity and medieval times as the Pythagorean Y. Parmenides' references to the perfection of the sphere, to the importance of justice, and to finding the middle ground (or reconciliation) between two opposites recall doctrines that were associated with Pythagoras. Whenever he refers to opposites, Parmenides finds his way to the middle ground between them, suggesting that the balancing of extremes leads to proportionality. His phraseology is often difficult to understand: in addressing this peculiarity of his poetry, he tells his readers that he is using a "deceitful arrangement of words." Most

likely, he is not lying, as some have suggested, but rather speaking in enigmas, which would constitute another of his many Pythagorean characteristics.[34]

If the dates we currently assign to Empedocles are correct (ca. 493–ca. 432 BC), his life could have overlapped with that of Pythagoras if in fact Pythagoras lived to be ninety or one hundred, as Iamblichus was to claim in the third century AD. Still, Empedocles would have been a child when Pythagoras died. Thus is it not likely that he was a student of Pythagoras, as Timaeus of Tauromenium (ca. 356—260 BC), a Greek historian who emphasized Sicilian events and persons, suggests. This claim of a historical relation between Empedocles and Pythagoras was to be repeated by Diogenes Laertius and Iamblichus.[35] Nonetheless Empedocles provides the first example of a philosopher-scientist who was closely attached to the recent memory of Pythagoras and who became the founder, or first propagator, of a doctrine that came to be called Pythagorean. In early Antiquity it was generally held that Empedocles was expressing the ideas of Pythagoras when, as a sage who taught through oracles, he explicated the fundamental importance of the four elements for the cosmology of the universe. The striking concept he offered of the four elements that, as a tetrad, regulate the universe and are the source of all unity, which in turn is complemented by harmony, goodness, and love, suggests that the influence of Pythagoras on him was great.[36] As noted in chapter 1 of this volume, fragments of Empedocles' works reveal that he shared many beliefs with Pythagoras, including those concerned with immortality, kinship with nature, transmigration of the soul, and the "consciousness" that all things possessed.[37] They also show Empedocles' belief in a *harmonia* established by the balancing of opposed but equal elements.[38] He also shared with Pythagoras, according to the testimony of later authors, the divinely ordained prestige of being a miracle worker, a physician or healer, and a diviner. Diogenes Laertius reports, for example, that he kept a woman who was in a trance alive for thirty days, though she had no pulse. Empedocles also shared with Pythagoras a special reverence for Apollo as the sun god as well as certain practical habits, including abstention from beans and flesh.[39] He shared this reverence with Pindar, who was his contemporary and whom he may have personally known since he appears to have visited Greece to present recitals at the Olympic games.

Among the teachings attributed to Empedocles, perhaps the most perplexing is that of the fire at the center of the earth. As Kingsley deduces, this belief was probably a reference to a source of light much like the sun.[40] In evoking the underworld, where he thought this fire was located, Empedocles appears to have been referring to the region of Hades, the same place Pythagoras was believed to have visited, as Hermippus reported in the third century BC and Diogenes Laertius would elaborate five centuries later. That Pythagoras survived this journey proved his divinity, or "resurrection." One of many later Antique writers who connects Pythagoras and Empedocles is Lucian, who, in *The Dialogues of the Dead,* links the golden thigh that Pythagoras displayed with the bronze sandal that Empedocles left behind when he perished in the eruption of Mount Etna in 432 BC.[41]

Thus this earliest chapter of Pythagoreanism invites us into a world of complexity that eventually becomes far more diversified as it is fractured into many different threads or avenues. At this early stage the legends associated with Empedocles and Pythagoras overlap to the point of possible confusion. The miraculous survival of Empedocles' bronze sandal, intact, from the raging fire of Mount Etna proved his divinity and provided a parallel not only to Pythagoras's visit to Hades but also to the story of Pythagoras's golden thigh.[42]

The life of the Greek historian Herodotus, who probably was only slightly younger than Empedocles, has no known connection with that of Pythagoras.[43] Evidently an outsider, he is the first to use the word *Pythagorean* to denote followers of Pythagoras, and his comments constitute the oldest extant mention of such a sect or organized group. In the course of a travelogue about Egypt, he says that the Egyptians wear loose white woolen mantles as outer garments but observe a taboo against bringing wool into temples or being buried in wool. He notes that various religious groups in Greece observe a similar rule but stresses that the rule was originally "Egyptian and Pythagorean."[44]

Whether or not Philolaus of Croton called or considered himself a Pythagorean we may never know, but it appears to be likely. He was born about 470 BC in Pythagoras's hometown. If the 570 BC birth date estimated for Pythagoras by Apollodorus is correct, even the great longevity claimed for Pythagoras by his ancient biographers would not have allowed the two men to know each other personally. Nonetheless, virtually all later commentators in Antiquity—Nicomachus of Gerasa, Plutarch, Lucian, Cassiodorus, Stobaeus, Boethius Severus, Macrobius, and many others—called him Philolaus the Pythagorean.[45] A character in a Plutarch dialogue claims that Philolaus was not only a disciple of Pythagoras but also was present at the conflagration of the first Pythagorean headquarters at Metapontum. According to an early Roman writer of works on literary history, Philolaus was the first "publisher" of the works of Pythagoras, which he titled *On Nature*.[46] Given this widely shared perception in Antiquity, Philolaus's surviving fragments must be regarded as among the earliest, if not the very first, documents of what came to be perceived as Pythagoreanism.

Although previously considered spurious, these writings are now, thanks to the work of Carl Huffman, generally accepted as genuine.[47] Although they do not mention Pythagoras by name, they certainly put forward, and quite clearly, ideas that will be regarded by virtually all later writers of Antiquity as those of Pythagoras. The most important of the Philolaus fragments consist, coincidentally, in a series of passages from a lost work called *On Nature* (or *On the World*), which address "the limited" and "the unlimited"—two opposing elements that can be brought into balance or agreement by *harmonia*. Harmony in nature, Philolaus says, results from the unification of "limiters" (possibly odd numbers) with "unlimiteds" (possibly even numbers) in the sphere that is the universe.[48] A longer fragment says that the harmony inherent in nature grows out of a process (*harmonia*) of mutual adjustment of oppo-

sites.[49] This is the oldest surviving clear description of the Pythagorean concept of reconciling opposites in order to produce unity.

Philolaus also proclaims the importance of number for the aggregate of all things in the universe:

> And all the things that are known have a number—
> For without this nothing could be thought of or known.[50]

It is through the study of number and its concomitant, proportion, he suggests, that the cosmos can be comprehended and the measure of the heavens taken. Philolaus assigns importance to the five regular geometric solids, describing the cube as the most perfect harmonic form because its sides are in perfect harmony. He discusses types of number (odd, even, and even-odd) and the shapes they signify. He speaks, as well, about the importance of musical tones and the musical scale, and explains that harmony governs all. Last but not least, he mentions "the hearth," a fire at the center of the cosmos around which the earth revolves.[51]

The Philolaus texts, dating from late in the fifth century BC, are the earliest surviving writings to ascribe cosmological significance to music and number and to hold that the earth revolves around a central fire. Although it is conceivable that these ideas did not become part of Pythagorean doctrine until they had been articulated by Philolaus, the unanimous belief in Antiquity that Philolaus was a follower of Pythagoras makes it more plausible to regard his writing as reflecting the actual early teachings of the Pythagorean school. In any case, Philolaus is the earliest author known to have put forth a series of interrelated philosophical concepts about the cosmic roles of number and balance that later would be described in great detail (by Nicomachus of Gerasa) as those of Pythagoras himself.[52]

Although he was one of the most influential of the pre-Socratic philosophers, none of the writings of the prolific scholar Democritus of Abdera (ca. 460—ca. 357 BC) survive intact. However, we know from later sources that he was a Pythagorean and the author of a work, perhaps a biography (now lost in its entirety), which was known for its praise of Pythagoras. As well, the repertoire of his writings strongly suggests Pythagorean concerns. Cosmology, virtue, geometry, ethics, numbers, astronomy, harmony, prognostication, diet, medicine, and painting are primary among the subjects listed for the more than seventy volumes he purportedly wrote. It is often thought that the antagonism of his opponents (such as the somewhat younger Plato) was instrumental in preventing the dissemination of the works of this great scholar, whose theory of the atom would inspire the work of Epicurus.[53]

The early fourth-century BC philosopher and statesman Archytas of Tarentum was widely renowned in Antiquity as Archytas the Pythagorean. Many of the extant fragmentary writings formerly attributed to him are now regarded as spurious.[54] Of the genuine fragments, all are on mathematical subjects. One, from a work titled *On Mathematics,* is the first to clearly enunciate the

concept of the quadrivium. In speaking about the speed of the stars and their risings and settings, Archytas says that such knowledge is obtained through the study of geometry, arithmetic, astronomy, and music. He adds that the relationship between these studies is as close as that among sisters. This description of the quadrivium by the Pythagorean Archytas is the oldest extant written image we have of it. It was well known to Nicomachus of Gerasa, who, in the first century AD, would quote from this work in his *Introduction to Arithmetic,* a work dedicated, as we have seen, to the explication of the mathematical teachings of Pythagoras. Another passage describes the arithmetic, geometric, and harmonic as the three "means" in music.[55] Archytas is believed to have carried on the work of Pythagoras not only in the field of mathematics but also in the areas of politics and lifestyle.

Although little is known about him today, Archytas was well regarded in Antiquity. As the ruler of Tarentum, he was noted for his mildness and tolerant guidance. Aristoxenus wrote that Archytas was so admired he was reelected seven times.[56] The respect attached to Archytas in his own time is perhaps best reflected in the fact that he and Plato corresponded. One occasion centered on Archytas's obtaining four works by a Pythagorean author from Magna Grecia, Ocellus. Eventually, when Plato visited Italy, the two presumably met. First Cicero, and then Valerius Maximus in his *Facta et dicta memorabilia* (*Memorable Doings and Sayings*), explained that Plato had gone to Italy expressly to learn the precepts and doctrines of Pythagoras from Archytas at Tarentum in order to acquire the abundance of learning necessary for his teaching. It appears that Plato met Archytas on the first of his three visits to Italy, in about 388–387 BC.[57]

One contemporary of Archytas, Lysis of Tarentum, was mentioned in chapter 1 as an early source of information about the family of Pythagoras. He is believed by some Antique writers (for example, Hermippus) to have been closely connected with the school Pythagoras established. These writers suggest that Lysis collected notes that he treasured from secret meetings of the Pythagorean community. According to their reports, he excoriated those who attempted to reveal the secrets of Pythagorean initiation as being impious to the divine precepts of the master. Likewise he criticized the new wave of Sophism for attempting to displace Pythagoreanism by influencing the young with its "pretended" divine doctrines.[58]

Although a military commander, Lysis's pupil Epaminondas of Thebes (d. 362 BC) was respected for his exemplary and virtuous character (which Diodorus Siculus attributes to his being a Pythagorean). He was also known for sharing his possessions with his friends, for helping those in need, and for playing the lyre. Unfortunately, little else is known about him.[59]

According to Aristoxenus, the school established by Pythagoras had begun to die out, albeit "with dignity," during the fifth century BC. Pythagorean fellowships, particularly in the big cites, shrank as enthusiasm for Pythagorean studies waned under the pressures of hostility. This situation appears to have

persisted for centuries, for Nicomachus says that in his time (the late first century AD) Pythagoreans were ridiculed and attacked and their homes set on fire—possibly, according to Apollonius, because other people resented their distinguished knowledge. The reports of Aristoxenus, Nicomachus, and Apollonius were assembled in the third century AD by Iamblichus, who suggests that this backlash against Pythagoreans, combined with their vow of silence, led to the disappearance of Pythagorean learning except for what was preserved in writing by a few solitary people. These reports and others assembled by Iamblichus suggest that the original active communities established by Pythagoras himself had by the late fifth century BC faded or even disappeared as a result of purges or persecution, and that this persecution continued, albeit in a milder vein, through the fourth century BC and until about the first century AD.[60]

The persecution of Pythagoreans in Plato's time, the fourth century BC, may to some extent account for the curious near-total absence in his writings of explicit reference to Pythagoras and his teachings, although on one occasion he does say that Pythagoreans were, in his view, "distinguished" for their way of life.[61] The doubts some modern writers have expressed respecting the extent to which Plato was influenced by Pythagoreans pale in light of the fact that Aristotle, who as a pupil of Plato's was in a position to know best, held that Plato's teaching "resembled" that of the Pythagoreans.[62] In addition, virtually all writers from Cicero on through the Renaissance considered Plato a Pythagorean. Later Antique writers considered Plato's *Timaeus*, above all, a Pythagorean work for it attempted to give an account of the divine creation of the universe as a sphere whose structure incorporated the four elements (first described by Empedocles), symbolized by the five regular solids first described by Philolaus. Famous throughout Antiquity, this account was to be translated by Cicero in the first century BC, by Porphyry in the third century AD, and by Chalcidius in the fourth century, and it would be the subject of an important commentary by Proclus Diadochus in the fifth century. Ultimately it would exert an exceptional and continuous influence on European thought from medieval through Renaissance times. The Antique perception of Plato as a Pythagorean may well have been reinforced by the numerological significance of his birth and death dates.[63]

It is logical to suppose that the cosmological and mathematical discoveries and studies credited to Pythagoras and his followers would have attracted Plato, and that his three journeys to southern Italy and Sicily (where, as noted earlier, he probably met Archytas of Tarentum) were for better acquainting himself with Pythagorean philosophy. His having to travel so far to find the "learning" he was seeking may have been a consequence of the persecution and dispersal of the Pythagorean communities; the oppression suffered by the Pythagoreans may also explain Plato's reluctance to "own up" to Pythagoras and Pythagoreanism in his writings.

As noted in chapter 1, Plato contributed little information to the biography

of Pythagoras in his writings. Although he mentions individual members of the "school" in his dialogues and seems to have special regard for the views of several Pythagoreans, including Timaeus (of Locri) and Parmenides, he has little of a historic nature to say about them. Yet his works came to be regarded by later Antique writers as deeply imbued with Pythagoreanism, so much so that Pythagoreans (those who continued to follow the precepts and doctrines of Pythagoras) and Neoplatonists (a nineteenth-century term for those who followed Plato) came to be so interconnected that it is frequently impossible to separate them. Just as Plato may have refrained from mentioning Pythagoras or Pythagoreans by name out of prudence, it may be that for the relatively few Pythagoreans who escaped the persecutions Platonism served as a safe haven.

Although Plato does not reveal any specific information that might suggest a "dependence" on a philosophical position other than his own (such as that of the followers of Pythagoras), if we read between the lines that articulate some of his most significant thoughts, we can understand the closeness of his relation to Pythagoreanism. In conceiving of the soul as immortal, transcending the body, he showed his dependence on Pythagorean tradition. In proposing that astronomy, which depends on the eyes, and harmony, which depends on the ears, are kindred sciences, he suggested their interrelationship as the "harmony of the spheres," a harmony first noted by Philolaus. Speaking of the interrelationship between music and astronomy, Plato says that the Pythagoreans insist on it, and he agrees with them.[64] This passage from *The Republic* allows Plato to pursue the matter further in a later discussion on the orbital motion of the planets and the "concord" they produce from the single harmony they simultaneously exude.[65] The importance of number, which leads to the understanding of "truths," and ultimately directs the elevation of the soul, is at the root of Plato's thoughts concerning cosmic harmony. It is this generalized praise of number, led by the monad, or unity, that leads to the contemplation of the entire natural world, a world in which everything can be measured or explained in mathematical terms. Indeed, says Plato, he who never looks for number in anything will never be counted among the wise.[66]

It is particularly his interest in mathematics and astronomy, which for Plato are inseparable and exemplify order, that links him to the "scientific" aspect of Pythagoreanism. In the *Timaeus,* a work named after Timaeus of Locri, a famous Pythagorean who becomes the spokesman of Plato's ideas, Plato describes the relations between numbers and things by use of mathematical terms that refer to harmony and proportion. The scope of his speculations is then developed into an extraordinary description of the construction of the universe as a single harmonious structure imagined by the "one," or "single cause," who, guided by his goodness, imposes order on the four elements that make up all things in the universe. Each of the four elements has its own numerical constituency and is symbolized by one of the five solid geometrical forms. Basic to the composition of all geometrical forms is the triangle. Plato supposes that all forms can be broken down into their constituent triangles. He explains that

the construction of the most stable solid figure, the cube, which he assigns to represent earth, is based on the collaboration of triangles that form the squares, which in turn form the respective faces of the cube.[67] In combination, the elements establish a numerical harmony that becomes the source of all material phenomena because their motion is perpetual. Man fits into this cosmic order because his soul is composed of the same substance as the souls of the stars. Thus are knowledge, order, and harmony achieved in a divinely ordered Cosmos, which in turn becomes an inspiration for the immortal soul or the path to the attainment of virtue.[68] Plato's scheme—in which the immortal soul exists in a spherical universe based on solids, which consist in and can disintegrate into triangles—is based on the order of number, which suggests Pythagorean concepts as does his notion of cosmic harmony. In the *Gorgias* Plato affirms that the world can function only because it is made of order, and order leads to goodness, which is a model, he explains, for moral life.[69]

The importance of number is such, according to his *Epinomis,* that it is a necessity that enables humankind to understand goodness and harmony. It is also, as Plato suggests in *The Laws,* useful for symbolizing social order. In this work, which discusses that subject—a concept linked with Pythagoras throughout Antiquity—Plato pays tribute to two of the most important numbers associated with Pythagoras. The work is divided into ten books, the number signified by the tetraktys. Furthermore, at his enigmatic best in practicing the Pythagorean doctrine of obscurity, Plato makes the curious suggestion that his ideal community should have five thousand and forty citizens. The number is the result of successively multiplying all the integers that make up the number seven ($1 \times 2 \times 3 \times 4 \times 5 \times 6 \times 7 = 5040$), a number that signified Pythagoras's cosmology as discussed by Aristobulus, Cicero, and others in Antiquity.[70]

In one of his letters, Plato acknowledges his acquaintance with "Pythagorean works," for he offers to send a collection of them to the tyrant of Syracuse.[71] Even if he was referring, in this vague phrase, to his own works and not to the works of others, this statement would support the many claims made throughout Antiquity of his association with Pythagorean thought.

Plato's regard for Pythagorean concepts was continued in the work of his nephew, Speusippus (ca. 407–339 BC), who accompanied him on at least one of his trips to Italy and who later succeeded him as head of the Old Academy, a position Speusippus held from 347 BC until his death.[72] Little is known about the life of Speusippus save for the fact that he was a zealous advocate, in the words of Iamblichus, of the "teachings of the Pythagoreans, and especially . . . [of] the writings of Philolaus."[73] The most famous of his works, of which Diogenes Laertius lists thirty,[74] was titled *On the Pythagorean Numbers,* the first half of which, it appears, treated numbers, surfaces, and figures on the basis of the writings of Philolaus "the Pythagorean" and the *Timaeus* of his (Pythagorean) uncle, Plato. The second half was devoted to the decad, which he proclaimed was not only the basis of all cosmological order and cos-

mic events but also contained all the multiples and ratios imaginable, the most naturally complete pattern in the universe:

> Ten is a perfect number, and it is both right and according to Nature that we Greeks and all men arrive at this number in all kinds of ways when we count, though we make no effort to do so; for it has many special properties which a number thus perfect ought to have, while there are many characteristics which, while not special to it, are necessary to its perfection.[75]

Its display (the tetraktys), he demonstrated, is incorporated in the triangle and the pyramid. Although Speusippus's works are lost, this mathematical treatise came to be known to the Renaissance world (and to us) through various fragments quoted by later authors, including Boethius. Chapter 6 of this volume discusses a lengthy extract published in a famous work titled *Theology of Arithmetic* (which was spuriously attributed to Iamblichus).

Another person who accompanied Plato on at least one of his trips to Italy was Xenocrates (396–314 BC). Xenocrates too followed Plato, after the death of Speusippus, as head of the Old Academy. He too wrote on the Pythagoreans and on numbers, as well as on a bouquet of other "Pythagorean" subjects, including wisdom, virtue, the soul, astronomy, friendship, contraries, concord, mathematics, and geometry. Important and learned as we are told he was, the Pythagoreanism of Xenocrates must remain a subject of conjecture, for all his writings have perished.[76]

What clearly emerges from the above, however, is that from the time of Plato through that of Xenocrates, the Old Academy at Athens was imbued with the study of Pythagorean form and number. This is significant even though, or perhaps because, Plato did not impose any particular doctrine on his pupils. Given the undoubted prestige associated with being head of the Academy, the holding of the position by a succession of men interested in Pythagorean number theory affirms that, as many Antique authors suggest, Pythagorean "mathematics" had an important influence on Platonism and also that there was in some sense a coming together of Pythagoreans and Platonists. It is thus hardly surprising that Aristotle, who set up his own school in the Lyceum of Athens in 335 BC while Xenocrates was presiding over the Academy, found Pythagoreanism a sufficiently fascinating subject to research and write a book on the subject.

Aristotle is of fundamental importance for Pythagoreanism not only because of this book (now essentially lost), but also because it is from the occasional discussions and casual remarks he makes in a number of his surviving works that we derive much of our knowledge about the fourth-century BC diffusion of Pythagoreanism that he witnessed, thus making him a contemporary authority. Perhaps it was the very diversity of Pythagorean interests that inspired him to research their history and beliefs. Among these, it appears to have been their scientific involvement that most interested Aristotle.[77]

Although in his own writings on mathematics (which are few) Aristotle does not discuss the Pythagoreans, he acknowledges their preeminence in stating that the Pythagoreans were "the first" to devote themselves to the study of mathematics. He appears to be well versed in Pythagorean/Platonic numerology, for he describes arithmetic as concerned with the meaning of odd and even numbers (as first described by Philolaus). He also refers to the preeminence of the square and the cube in the study of arithmetic and acknowledges Plato's recognition of the importance of the number ten. Alluding to the tetraktys, he describes the decad as a "complete thing," suggesting his appreciation of Pythagoreanism.[78]

That Aristotle attached substantial importance to Pythagorean philosophy becomes patently clear through his comments in the *Metaphysics*. Not only were the Pythagoreans the first to develop the science of mathematics, but it was they who through its study developed its principles. Of these, number was the most important. He describes the primacy of number for Pythagoreans, who have, he says, constructed a whole universe of numbers. Pythagoreans also equate number, he tells us, with existing things, and interpret things as though they were numbers.[79] His tone becomes skeptical, however, when he refers to the importance of individual numbers for Pythagoreans. He suggests that the concept of the number seven referring to such special things as seven strings, seven vowels, seven heroes, seven stars, or "seven anything else" is arcane. So also, he adds, justice cannot be represented by two even numbers.[80] He also voices skepticism about some Pythagorean mathematical views, for example, those on the character of infinity and the behavior of the void. These disagreements are expressed in such a way as to suggest that though he disagreed with some details, he had considerable respect for the principles of Pythagorean mathematics and took it seriously, regarding it as sufficiently complicated to merit discussion and disputation.[81] Elsewhere, however, he expressed his agreement with the role of contrariety and the (Pythagorean) opposites.[82]

Referring to Alcmaeon of Croton (the medical doctor who likely knew Pythagoras in person), Aristotle asserts that either he personally conceived the table of opposites, or contraries, or he took it from the original group around Pythagoras, of which he was a member. Aristotle suspects the latter, for he describes Alcmaeon as vague, whereas the Pythagoreans, according to him, were more precise; they clearly recognized the number and character of contraries. After all, he tells us, it was Pythagoras himself who first clearly defined contraries.[83]

Aristotle credits the Pythagoreans as a source of knowledge and learning in matters of astronomy and the natural sciences. This is clear from his various references to their views on comets, the Milky Way, thunder, and the like.[84] It is even clear in *De caelo,* where Aristotle describes a spherical universe in which everything, including the sublunary regions composed of the four elements, are in motion. Although his formulation of this concept must have de-

pended to some extent at least on Plato's *Timaeus,* the source of his interest in it goes back further. It was the Pythagoreans, he says, who first described heaven. It was they who first described the trinity by maintaining that the number three is the beginning, middle, and end of everything as well as the whole. Their belief in the motion of the fixed stars from east to west was based on the idea of spherical motion.[85] But it is in chapter 9 of book II of this work that Aristotle takes on a most serious Pythagorean issue, the harmony of the spheres. First he explains it as the concordant sound generated by the motion of the planets in relation to their size and speed, based on the intervals between them and the correspondence of these intervals to the notes of the octave. Though brilliantly formulated, Aristotle concedes, it cannot be true because stars do not move spontaneously. Thus he is compelled to disagree with the Pythagorean postulate that the planetary bodies move in perfect harmony on their own accord.

In *De caelo* Aristotle also describes the Pythagorean belief that the center of the earth contains a great fire around which the earth travels. He recognizes that the determination of whether and how the earth rotates and what the relation of this rotation might be to a "center" is crucial to understanding the problem posed by the Pythagoreans regarding the concept of day and night.[86]

Again and again, especially in discussing unity and being, Aristotle links Plato and Speusippus with the Pythagoreans.[87] Their common way of thinking, he implies, favors the idea of concords and contraries that, balancing each other, establish the basic principles of unity in the universe.[88] However, he admits, perhaps referring to the use of enigma, that Pythagoreans employ a more "abstruse" language.[89]

While Aristotle disagrees with Pythagoras's numerical approach to explaining virtue, he admires him for being the first to lay down practical guidance for virtuous living, which was to influence subsequent generations of Pythagoreans. Their admiration of virtue, Aristotle says, was seen in their doctrines of Good as unity and Justice as reciprocity.[90] Similarly, although Aristotle finds some Pythagorean concepts about the soul unpersuasive, particularly the doctrine of transmigration, he shares their view of the soul's importance.[91] Aristotle also dissented from the Pythagoreans on some scientific points, such as their belief that some animals are nourished by smell.[92]

The loss of Aristotle's work *On the Pythagoreans* is only in small part compensated by the citations of later authors, who may have learned some of its contents from his pupil Aristoxenus. Diogenes Laertius, Porphyry, and Iamblichus all refer to Aristotle as one of their sources for Pythagorean precepts, secrecy, and rules of life. Their citations of Aristoxenus refer in particular to his explanations of the Pythagorean idea of purification of the soul. Aristoxenus said Pythagoreans were required in daily life to aim at being in accord with the divine, that is, to "follow God," an exhortation that, as seen in chapter 3, Boethius attributed to Pythagoras himself.[93]

Because Aristoxenus had been a pupil of Xenophillus, a Pythagorean, be-

fore he engaged in study with Aristotle, and because he wrote a now-lost biography of Pythagoras, it is tempting to wonder if the strong inspiration that prompted him to write his major works on harmonics, rhythm, and music arose from the concept of the harmony of the spheres.[94] Given the very fragmentary preservation of his writings, this cannot be determined, but certainly it would appear he was a Pythagorean before becoming a Peripatetic.

Following the considerable attention focused on Pythagorean values by the great fourth-century BC philosophers of Athens, Pythagoreanism appears to have slipped out of the spotlight in the third and second centuries BC. One notable exception appears in the works of the poet Theocritus (ca. 300–ca. 260 BC), a Syracusan who was familiar with Magna Grecia (or southern Italy): "Thou'rt like one of your Pythagoreaners that came t'other day, pale faced and never a shoe to's foot; hailed from Athens, he said."[95] One could wish that Theocritus had written more in this charming vein (he notes that his barefoot character loved his dish of porridge), but even such a brief glimpse through the eyes of a poet usefully supplements the intellectual view presented by Aristotle with a vivid picture of how ancient Pythagoreans appeared to their contemporaries as people. Also worth noting is how widely these ascetic wanderers circulated: in this instance, to southern Italy all the way from Athens.

Thus it appears that by the end of the fourth century BC, the term *Pythagorean* referred to two different groups of individuals—those who, like Archytas, Plato, and Aristotle, had scientific interests, and those who were ascetic wanderers. Although some scholars have drawn a distinction between the two,[96] it is not inappropriate to speculate that, given the by-now traditionally broad latitude of Pythagorean interests, these aspects may not have been incompatible. In this sense, although the obsession of Middle Comedy authors for contemporary manners resulted in their mocking Pythagoreans for their "different" appearance,[97] those who appeared to be different may have been but one of many strands, or branches, of Pythagoreans with various interests that already existed and not a new development in the fourth century. Nor was the "scientific" strand the only alternative to the barefoot itinerants, who may have had an intellectual or religious character in that science and religion were not so distinct in ancient Greece as they are today.

Diodorus Siculus offers testimony that the "barefoot itinerants" were not always objects of ridicule. He describes the devotion of Pythagorean friends who assisted each other by sharing their property and their money, and by assuming legal liability for each other. Diodorus speaks with admiration of Pythagorean loyalty and constancy. The mystery of their devotion, he was convinced, was due to their secrecy. He also describes their reverence for justice as well as the Pythagorean insistence on exercising their memory and sharpening their senses to keep their judgment clear; before rising each day they reviewed the activities of the preceding several days. They also devised, he reports, a method of exercising self-control by preparing a banquet and then walking away from it. He describes as well ordered and admirable their choice of a

simple life that avoids extravagance as well as the luxury of cooked food. Their clothing was always white and clean, he informs us, a symbol of the undefiled soul.[98]

These virtuous individuals revered the gods and surveyed the heavens in order to understand their orderly layout, function, and arrangement. This last characteristic shows that to Diodorus these groups combined civic, religious, and scientific concerns. It also suggests that for them science and religion were the same. Diodorus's contemporary Strabo observed large numbers of Pythagoreans in cities such as Croton, although he has little to say about their behavior or beliefs.[99]

The second century BC sees the appearance and subsequent development of Jewish Pythagoreanism. Although we lack sufficient knowledge concerning the origins of this strand of Pythagoreanism, it appears that it took root at this time in the Jewish community at Alexandria. Of this "new" group of Pythagoreans, Aristobulus is the best-known early exponent. His work, which attempted to show that Pythagoras had borrowed from the Old Testament, created a background for Hellenistic Jews to become connected to Greek tradition, thus forming a "sect." In concert with early Jewish Gnostic writings in Palestine, this tradition would lay the groundwork for further developments, including the birth, in the following centuries, of Kabbalah, or "received tradition." Based on a combination of mystical and numerical elements, such as the seven heavens, the seven temples, and ten as the principle of all things, the Kabbalah would flourish in medieval times and endure to be a subject of great fascination in the Renaissance. Meanwhile, the relation between Jewish and Greek thought in the century following Aristobulus is exemplified in the writings of Josephus and especially of Philo, possibly including the Book of Wisdom, which is discussed in the next chapter.[100]

Not only did Cicero observe Pythagoreans, but he had Pythagorean friends. Although we cannot say definitively that he belonged to the sect, his sympathy with Pythagoreanism is clear: as we have seen earlier, he bestows exceptional praise on the learned polymath from Samos in many of his works, and his *Somnium Scipionis* demonstrates the cosmology thought to have been invented by Pythagoras. Cicero's Pythagorean tendencies appear even more emphatically in his project—albeit unfinished—to translate Plato's *Timaeus* (regarded in Antiquity as a Pythagorean work) from Greek into Latin. As though to make his feelings explicit, he dedicated this work to the Pythagorean astrologer Nigidius Figulus (d. 45 BC), his dearest friend. The dedication praises Nigidius for being in the vanguard of Pythagoreanism and having kept it alive in Rome.[101] Elsewhere in his writings Cicero asserts that he would give all his possessions to Nigidius, who was not only the most esteemed of his friends but incomparably the most learned, wise, and virtuous man in Rome.[102]

Cicero provides a clue as to why Nigidius struggled to keep Pythagoreanism alive in Rome. Elsewhere he remarks that in "olden" days, Italy was crowded with Pythagoreans who had mastered the arts of building communities, and he

describes these men as very accomplished. Many of them were men of great fame and weighty influence. They were men of great wisdom, indeed, lovers of wisdom, and they were very much admired.[103] However, it would seem, times had changed, for there were no longer so many Pythagoreans in Italy in the first century BC. Using the present tense, Cicero describes his Pythagorean contemporaries as holding that number is the basic principle of mathematics as well as the source of the universe. Although he refers to their practice of secrecy and to their abstention from beans because, he explains, beans caused flatulence and interrupted dreams, his deep admiration for Pythagoreanism is clear.[104]

Varro, Cicero's contemporary, also appears to have been well acquainted with Pythagorean ideas, particularly in the realm of numerology. His now-lost *Hebdomades,* a collection of the biographies of famous men, contained seven hundred lives composed in sets of seven. Varro attributed particular importance to the number seven, Aulus Gellius informs us, by citing its influence on the heavens, the zodiac, the solstices, fetal development, and the growth and development of human beings. He cited the importance of this number for medicine in that physicians used music performed on the seven-string lyre to regulate the flow of blood. Varro also recognized the importance of this number in specific historical ways (for example, in describing the seven sages) as well as in theoretical ways (for example, in citing the number of days involved in the monthly journey, or revolution, of the moon as four times seven, or twenty-eight).[105] Such views strongly suggest that Varro may well have been a Pythagorean. Indeed this is ensured in the words of Pliny the Elder, who informs us that Varro was buried "in the Pythagorean style," that is, in leaves of myrtle, olive, and black poplar.[106]

Not only did Vitruvius, as an architect-engineer of Augustan Rome, express admiration for Pythagoras, as mentioned in chapter 2, but his *De architectura* shows that he was a Pythagorean. In addition to the esteem he accords the cube, which as a perfect geometrical shape, composed of six faces, or sides, he describes as divine.[107] He also expresses admiration for "perfect" numbers. For him, six and ten are both perfect numbers, the latter because it represents the sum of $1 + 2 + 3 + 4$ (the tetraktys). Thus, not surprisingly, his treatise—the only extant one of its kind from Antiquity—is divided into ten books. In describing temples, he holds that sixteen is the most perfect number for their articulation.[108] In line with his devotion to Apollo, Vitruvius recommends that temples face the east, the direction of the rising sun.[109] He also introduces the idea of architectural proportion, which for him was certainly related to music. George Hersey has demonstrated the Pythagoreanism of Vitruvius by showing that his systems of design and proportion are based on the cube as the source of all number and life and the harmony of cubic principles. These principles signify a hierarchy of meaning based on the numerical description of a building that was transmitted to the Renaissance when a revival of interest in Vitruvius occurred.[110] Because of its specialized nature, and because it looks back on

Hellenic ideals, Vitruvius's text is primarily theoretical and does not contribute to our practical knowledge about Pythagoreans in the Rome of his time.

The very fact that Vitruvius looks back to Greek examples as he formulates his Pythagorean ideas seems to underline Cicero's implied lament about the decline of Pythagoreanism in Rome, which required the efforts of Nigidius to keep it alive.

▲

Despite the persecution of early Pythagoreans even during the lifetime of their master, and despite the fading of the "school" that Aristoxenus noted around the beginning of the fourth century BC, Pythagorean ideas were the fundamental inspiration for the "mathematical" philosophy of the Athenian Academy, which promoted above all number theory and the five geometrical solids; consequently, the Pythagorean movement was somewhat rejuvenated by the Academy's high esteem. The mathematical ideas, however, were but one aspect of a multilevel way of thinking that included active practices such as communal living, self-mastery, piety, conformity to specific standards of moral behavior, and abstinence from fleshly foods. While Pythagoreanism may have been respected by some academicians on purely intellectual grounds, it appears for others to have addressed a broader range of concerns. Archytas, for example, although famous for solving arithmetical and harmonic problems, was also a practical man with a reputation for leading a simple life and ruling his city with justice and tolerance. Plato too may fall into this category: although we may never know for certain that this great intellectual was a vegetarian, his omission of meat from the various foods he recommends throughout *The Republic*— rice, honey, nuts—suggests that he may have been one. The early Platonists, especially Speusippus and Xenocrates, embraced Pythagorean concepts so freely (especially number and the harmony of the spheres, that is, the interplication of mathematics, astronomy, geometry, and music) that it would be no exaggeration to say that Platonic philosophy had begun to merge with Pythagoreanism. Even Aristotle, despite the brilliance and depth of his intellectual interests in science and philosophy, expressed great respect for Pythagoreanism, and his *De caelo* developed out of an interest in measuring the heavens—an interest comparable in depth to that of the Pythagoreans themselves.

We can imagine cities in which Pythagorean groups, dressed in white and leading their well-ordered lives, participated in political life through their moral teachings, a characteristic that may have led to their oppression. In the case of Roman Pythagoreans, it appears that their burials were ritually distinguished from those of others by the ceremonial addition of myrtle, olive, and black poplar leaves. Among individual Pythagoreans, some were no doubt intellectuals ("philosophers"), while others were more devoted to leading a life of simplicity and virtue ("barefoot itinerants"). Aristoxenus suggests that the boundary between such groups was not sharp. These extremes also allowed the development of "branches" of Pythagoreanism, such as the Jewish Pythagore-

anism founded in Alexandria during the second century. Although some modern writers have supposed that Pythagoreanism was divided into two completely opposed groups, there is little evidence to support this notion.[111]

The resurgence and renewed popularity of Pythagoreanism from the mid-fourth century to the second century BC in the face of continued persecution appears to have been followed, as the republic came to an end, by a time in which Pythagoreanism began to die out. Cicero, who would be much admired in the Renaissance, looks back on Plato's Pythagoreanism with admiration; he remembers the cities of "the past" as crowded with Pythagoreans and admires his best friend for doing all he can to keep Pythagoreanism alive in Rome. Later in the first century BC, Vitruvius, who would also come to be a hero of the Renaissance, captures the fundamental value of Pythagorean ideas by also looking back. Thus would it seem that in the Augustan age, Pythagoreanism was about to disappear into the mists of legend.

NEOPYTHAGOREANISM
IN THE LATE PAGAN
AND EARLY CHRISTIAN WORLDS

Just as Pythagoreanism seemed to be fading out, in the late first century BC and the early first century AD, a revival occurred. It was at about this time that Ovid was incorporating into his *Metamorphoses* the long speech of Pythagoras advocating humane treatment of animals and abstention from meat. Ovid's contemporaries were interested in other strands of the Pythagorean legacy as well, such as the immortality of the soul, the symbolism of numbers, and the relation of man to the cosmos.

Many of those who participated in this Pythagorean revival, which has come to be called Neopythagoreanism, were Platonists who had strong Pythagorean interests because they believed that the legacy of Pythagoras lay behind Plato's stature as a philosopher and his eminence as a teacher. Thus they represented broader interests than did Cicero's friend Nigidius Figulus, who appears to have been primarily concerned with reviving Pythagoreanism in its own right. By the third century AD, mutual influences between Neopythagoreans and Neoplatonists, which had been building over some time, would become a major element of the intellectual climate.[1] Many of those interested in Greek philosophy and ideas in the (now) Romanized world could certainly see Pythagoreanism as a basis of thought and behavior, within the broader parameters of Platonism and its quest for absolute knowledge. Although this partial merging of two major currents of thought took place some time after Cicero's death, to some extent it can be traced to his writings, par-

ticularly his insistence that Plato went to Italy to learn all he could about
Pythagoreanism.

The Revival of Pythagoreanism in the First Century AD: Arithmology and Arithmosophy

Philo of Alexandria (ca. 30 BC–ca. AD 44), a Hellenized Jew with a deep inter-
est in Plato and Pythagoras, was one such person who regarded Greek philos-
ophy as a basis of thought. His voluminous works influenced late Antique
writers such as Plotinus and Saint Augustine. The influence of Philo would ex-
tend still further when he was "rediscovered" in the Renaissance. He may also
have been the author of the Book of Wisdom (or Wisdom of Solomon), a book
of Old Testament Apocrypha that appears to have been composed during his
lifetime. In this work, which shows the influence of Greek thought, he focuses
on the immortality of the soul. However, he clearly states the importance of
number: "Thou [God] has ordered all things in number, weight, and mea-
sure."[2] Among the many subjects Philo writes about in the works known to be
by him are universal harmony, the concord that is produced by musical conso-
nances, harmonic proportion, and the reconciliation of contraries. He also ad-
dresses such practical subjects as virtuous behavior and temperance in food
and drink.[3] Philo's works show a profound debt to Pythagorean arithmology
(the use of the symbolism of numbers derived from arithmetic in order to
demonstrate abstract ideas relating to the universe created by God, or, num-
bers imbued with religious import). They are replete with number symbolism,
which he uses as a tool in describing such varied subjects as the universe,
Noah's ark, the tabernacle and ark of Moses, man's duty to God, and the ages
and condition of man. Continuing the work of his predecessors, Philo elabo-
rates the concept of contraries in terms of odd and even numbers, "male" and
"female" numbers, as well as equal and unequal numbers.

Philo has special praise for the "perfect" number four, whose "vast impor-
tance" and peculiar power he expounds as the source of eternal order in the
world; this number may be, he explains, represented by the solid form of the
pyramid.[4] Another perfect number is six, which, being both male and female,
symbolizes productivity.[5] The sacred number seven, however, is according to
Philo the most revered of all numbers. It has been studied by mathematicians,
he assures us, because it refers to the planets as the sphere of fixed stars in
heaven. From the heavens its influence extends to all visible existence in the
universe. From the universe, it affects science, astronomy, and music. This
most honored of numbers was transformed into the holiest day of the week by
Moses, who exonerated not only servants but even cattle from work on that
day. Moses also paid tribute to this number, Philo tells us, by illuminating the
tabernacle, which he had built on the mount, with a seven-branched candle-
stick representing the divine music of the planets. The most perfect expression
of the sacred number seven, Philo says, is the seven-string lyre, the instrument

that transmits the symphony of the planets.[6] But the most supremely perfect and the most "complete" number is ten, whose virtues he expounds at great length in De decalogo, a work on the Mosaic law. He describes the virtues of this number, the sum of the first four integers, as infinite (though he does not specifically mention the tetraktys).[7] Philo reserves his most enthusiastic praise for the monad, the only number perfect in power and thus the number that connotes God.

Philo's life of Moses (Vita Mosis) describes the birth, education, and travels of Moses, who, as a gifted child learned in arithmetic, geometry, rhythm, and harmony, grew up to practice exemplary self-restraint, temperance, frugality, simplicity, and justice and to become both a divine being and a sage (not unlike the early "biography" of Pythagoras). Philo imagines Moses as not only the greatest philosopher but the "original" philosopher, and he perhaps intentionally uses Pythagorean language to challenge Pythagoras's own preeminence.[8] For Philo Moses is a prototypical mystic as well as an example to his disciples. In this he resembles Pythagoras, a coincidence noted by the modern scholar Isidore Lévy, who found similarity in their "legends."[9]

Philo's language suggests the interlocking of arithmetic and theology in an impressive array of Pythagorean mystagogy, which is far more developed than what we know of the views first proposed by another Alexandrian Jew, his predecessor Aristobulus, as discussed in chapter 1. Thus it was appropriate for his near contemporary, the early Christian Church father Clement of Alexandria, to acknowledge him as "Philo the Pythagorean."[10] Philo's combined interests in science and religion provide but one example that at least some Pythagoreans pursued, even as intellectuals, more than one strand of the very deeply interplicated (in the Antique sense), or diversified (in the twentieth-century sense), Pythagorean culture.

Seneca (Lucius Anneus Seneca, 4 BC–AD 65) provides another example of the enthusiasm for different strands of Pythagoreanism. Speaking as an intellectual, Seneca admits in one of his letters the ardent zeal he had for Pythagoreanism, especially in his youth. It was from the peripatetic philosopher Sotion, he tells us, that he received his inspiration. Sotion explained to him the various reasons for abstaining from animal food for reasons ranging from the disapproval of luxury to those involving belief in transmigration of the soul. As a philosopher, Seneca says, he felt comfortable with this practice; he adds that his father, who detested philosophy, encouraged him to renounce this practice.[11]

It was during the lifetime of Philo and Seneca that Apollonius of Tyana lived (his presumed writings were discussed in chap. 2). If the monumental biography Philostratus later wrote to remember him by resembles reality, then Apollonius was similarly inclined toward Pythagoreanism, however more dramatically. As a divinely inspired sage, Apollonius abstained from wine and marriage as well as from meat, which gave him the reputation of a mystic. That he wore shoes of bark, or went barefoot, and that he practiced silence

and let his hair grow long, wearing only white linen, enhanced his reputation for sanctity and holiness. At a time when Christianity was taking its first steps, this wonder-working mystical sage of the first century AD whose life was devoted to the expression of purity attracted the admiration, as Philostratus suggests, of many.[12]

Because he collected the letters of Apollonius of Tyana and preserved them in his palace together with the most "complete and pure" philosophical text, "the tenets of Pythagoras," it is not surprising to learn that the Emperor Hadrian (Publius Aelius Hadrianus, AD 76–138) was a Pythagorean.[13] A lover of Greek culture who spent most of his life in Syria, Hadrian took pleasure in wearing a beard (uncommon for Roman emperors of his time) as evidence of his Hellenic inclinations. He was a devotee of the sun and a believer in divination; he was also an architect, and counted mathematicians (who in first-century Rome were also astrologers) among his friends. A surviving poem that Hadrian wrote in anticipation of his death is dedicated to his "little" soul: it has been the guest of his body, he says, and is about to fly away. Hadrian's view of the soul resembles that expressed by Jewish Gnostics of this time, which was also likely influenced by Pythagoreanism; they regarded the soul as ascending from earth, through the spheres of the planets, to its divine home.[14]

We have no information that suggests Pliny the Elder, Hadrian's older contemporary, was a Pythagorean, but his admiring description of how the seven tones emitted by the planets create a universal harmony is worth noting. As mentioned in chapter 2, he tells us this harmony was discovered by the "wise genius," Pythagoras.[15]

Nicomachus of Gerasa too was a contemporary of Hadrian. Although the subject matter of his *Introduction to Arithmetic* was credited by Nicomachus to Pythagoras himself, this work of arithmosophy (the science of arithmetic) also serves as an excellent example of first-century Neopythagoreanism. By according a prominent place to the works of Plato—particularly the *Timaeus*—in the development of Pythagorean arithmetic into his exposition, Nicomachus thus identifies Platonism with Pythagoreanism and suggests that Pythagoreanism had become a kind of universal language.[16]

In another work, the *Theology of Arithmetic,* Nicomachus does not mention Pythagoras directly but nevertheless makes his Pythagoreanism felt. The theme of this now-lost book, as it was meticulously summarized in the ninth century by the learned Byzantine patriarch Photius, is the divinity of number.[17] Nicomachus asserts that number is the fundamental basis of order in the universe, and by extension that the entire cosmos is inevitably composed of meaningful qualities signified by number. Number thus "divulges" the plan of the Divine Craftsman, and the study of it is imbued with religious import that surpasses the aims of arithmosophy and enters the realm of arithmology. Arithmology assumes that arithmetic is God's wisdom, and that brings its practitioner closer to God.

In this work by Nicomachus the properties of the first ten numbers, from

unity (the monad) to ten (the decad), are described. The monad is identified with God, the sun, or Apollo, while the dyad represents multiplicity, or the opposite of the monad; these then signify, according to Nicomachus, sameness and otherness. The triad is the first true number because it has a beginning, a middle, and an end—thus introducing the idea of the mean. The tetrad is associated with the square; it merits particular attention because it is both the sum and the product of two dyads, and because the sum of the first four integers is the decad (a relationship represented by the tetraktys). Because of these remarkable properties, four is the number that signifies harmony for Pythagoreans. The pentad is to be admired because it is half of ten, as well as being the sum of the dyad (the first even number) and the triad (the first odd number, since Pythagoreans did not consider the monad a number). The hexad is "perfect" because it is both the sum and the product of the first three integers; it is also the product of the dyad and the triad. The heptad was revered by Pythagoreans more than any other number not only because of its manifestation in the seven whirling spheres that make up the universe but also because it has neither factors nor products within the decad. Eight is the first cube; nine is the "boundary" number because it is the last number before ten; and ten, the most perfect of all numbers, signifies the entire cosmos.[18]

Nicomachus's argument incorporates the Pythagorean doctrine (first known through Philolaus) that number is fundamental to the universe, but he goes further, presenting number as the creation of the divine mind; this concept shows the strong influence of Plato's *Timaeus*. The mystical and complex analyses with which Nicomachus supports his presentation suggest that for him the real triumph of Pythagoreanism was in the divine ability of numbers to reveal the working method of God. Concerning these methods, the erudite Byzantine scholar Photius would later comment, "So it is necessary, it would seem, to spend and expend a whole life for the sake of this theological juggling with numbers, and to be a sober philosopher in mathematics in order to be able to talk consummate nonsense."[19] Nevertheless, the influence of Nicomachus's *Theology of Arithmetic* would remain powerful into Renaissance times, with the help of two later works, *On the Decad* by Anatolius of Laodicea and *The Theology of Arithmetic* by an unidentified author known as Pseudo-Iamblichus.

Plutarch, whose contributions to the biography of Pythagoras have already been discussed, also added to our knowledge of Neopythagoreanism in a broader historical sense. A contemporary of Hadrian and Nicomachus, he confirms the persecution of Pythagoreans, who he says were, before his time, driven out of various cities.[20] However, that his writings contain numerous reference to Pythagoreans and Pythagoreanism suggests that, notwithstanding his suggestions to the contrary, Pythagorean communities continued to exist in his time and that he had ample acquaintance with them. Although we do not know that he was a Pythagorean himself, he appears to have had substantial sympathy for, as well as knowledge about, Pythagorean practices and beliefs

for he describes them as "noble." Among these is the custom of joining right hands and embracing each other before the sun goes down each day—a most "admirable" practice, Plutarch notes. Pythagoreans also, he tells us, shake their bed clothes on arising. They avoid fish and swallows. Plutarch expresses enthusiasm for various Pythagorean teachings, especially the one that concerns the influence of music on the symmetry and order that govern the universe.[21]

Plutarch records various Pythagorean rules and maxims that he found useful for educating children and for acquiring and keeping friends. He also explains various numerical meanings that were in use by Pythagoreans of his time: for example, the number one as symbolizing the special reverence accorded Apollo as the perfect unity; the number four as referring to the first solid form, or the cube; the number five as signifying marriage and, because it is the harmony of two and three, a number that represents Apollo; and the number seven as sacred to Apollo. He makes a point of noting that the Pythagorean love of harmony is expressed through the lyre. In fact, we learn from Plutarch that Pythagoreans played the lyre before going to sleep at night in order to quell the emotional turmoil of the day and to calm the irrational feelings of the soul.[22] For the first time, we learn—from Plutarch—of something that Pythagoreans abominated (besides sin and luxury): the number seventeen. So also we learn of their superstitions. Among these, the square and equality were good whereas the oblong and the dark were bad. Others included taking care never to cross the left leg over the right and not to choose the even number instead of the odd.[23] In discussing Pythagorean worship, Plutarch reminds us that it was important for worshippers not to turn their backs to the sun; Pythagorean temples face the east and the sun, he asserts, to enable the worshipper to face the sun. This statement would corroborate the advice of Vitruvius, who was a Pythagorean, that temples (in general) must face the east.[24]

The renewed activity of Pythagoreanism of the first century AD, articulated by Platonic concepts, shows that Pythagoreanism was not only alive but particularly vigorous during this time. Indeed, during the next centuries Neopythagoreanism would continue to develop in a variety of interplicated ways.

The Dissemination of Neopythagoreanism after the First Century

As we have seen, Pythagoras's teachings about a single God who supervised the universe and was the Father of all creation won the praise of the Christian Clement of Alexandria. Clement's moral writings suggest that he was inspired by Pythagorean moires, as known through the *Golden Verses,* which were widely circulated in late Antiquity. Thus we find Clement imagining the order and harmony that would result if Christians were clean in thought, deed, and personal habit, avoided luxury and pursued frugality, practiced self-control both of the tongue and of the body as a whole, shunned jewelry and ornaments, and took food sparingly. Although the injunctions put forward in his

guide to Christian ethics do not specifically condemn meat, they suggest that meat triggers carnal and destructive behavior.[25] The nature of Clement's writings, which are clearly didactic, suggests that he viewed Christianity as a school in which all pupils are equal and can be taught to advance toward God; perhaps he was recalling (or imitating) the example of Pythagorean schools.

Clement's second-century contemporary, Lucian of Samosata, seems to take a more worldly view in deriding the wise men (perhaps Pythagoreans, he suggests) who are called "holy." He ridicules one such Pythagorean for his long hair and the solemn face he puts on before telling his "lies" and "prodigious tales."[26] In a more serious vein, Lucian refers to the silence, or as he refers to it, the "truce of the tongue," practiced by Pythagoreans. He informs us that at this time the pentagram, which symbolized health, served as the emblem of Pythagoreanism because it was constituted of a triple intersecting triangle.[27] Aelian too, it appears, knew quite a bit about Pythagoreans, for while referring in one place to their interest in medicine, in another he describes the technique of a certain Clinias, a Pythagorean. This man, he explains, routinely calmed himself by tuning and playing his lyre whenever he sensed his temper approaching an unmanageable stage. In this way, he was able to subdue his wrath.[28]

The importance of music to Pythagorean thought is underlined in the comments of Saint Justin Martyr, the outstanding Christian apologist of the second century, who notes his frustration with the high standards of Pythagorean education. Because, in order to comprehend Pythagorean philosophy, he was required to demonstrate competence (which he did not have) in music, astronomy, and geometry, his hopes of becoming a Pythagorean were, he says, shattered.[29]

Later in the same century and early in the next, shortly after Theon of Smyrna published his *Mathematics Useful for the Study of Plato* discussed previously for its contributions to the biography of Pythagoras, the arithmologist Anatolius—probably the same Anatolius who was the teacher of Iamblichus and also the future bishop of Laodicea (a city in Asia Minor)—was at work. Although his exact dates are unknown, Bishop Anatolius's successor, Eusebius of Caesarea, described him as an illustrious scholar who had not only reached the pinnacle of studies in arithmetic, geometry, astronomy, and the other sciences but had also served as a diplomat. Anatolius concentrated his studies on establishing a date for Easter on the basis of that of Passover and the astronomical calendar, a search for mathematical exactitude that was to continue through the Renaissance. In addition, says Eusebius, Anatolius found time to praise the perfection of the number ten in a book called *On the Decad*. Like comparable works by Vitruvius, Theon of Smyrna, and Iamblichus, the text was presented in ten chapters.[30] Anatolius's text was important to later mathematicians of the third century and, through them, to the Renaissance.[31] Anatolius declared that it was the Pythagoreans who first gave the name "mathematics" to the combined sciences of geometry and arithmetic.[32]

This little work discusses in turn the particular beauties of each of the first ten integers, starting with perfect unity (the monad, which, he says the Pythagoreans called "intellect"), proceeding through six (also described as a "perfect" number), and ultimately reaching ten (the decad, which is the perfection of all numbers in the universe). He outlines magical properties that Pythagoreans see in the number seven: the sum of the first seven integers is twenty-eight, which is the symbol of the lunar month; and the seventh member of a series in which each new number is produced by doubling the previous number (starting with one) is sixty-four, the first number that is both a square and a cube. Other proofs of the magic of the number seven can be found, he explains, in such wonders as the human body, where the face, for example, has two eyes, two ears, two nostrils, and a mouth.[33] This rather standard Pythagorean recitation is part of a "decadic" literature that had evolved since the time of Nicomachus. The fact that Anatolius was a Christian is important, for it indicates that such speculation was not restricted to pagan intellectuals.

That Pythagoreans did not restrict their interests to arithmetical considerations is clear from a description of Pythagorean beliefs by Diogenes Laertius. According to him, Pythagoreans believed that the glittering particles of dust that dance in sunbeams are souls descending from the gases above, borne on the wings of light. Thus they concluded that the air was full of souls that descend to earth and reascend after death back into the sky. Cumont interprets this belief as connected with the fields of Elysium, where a happy afterlife awaits the blessed.[34] This is not unlike Pindar's suggestion that heroes become godlike in the immortality they can expect after death. Moreover, it is clear that by this time committed intellectuals could also be religiously inspired, taboo-observing Pythagoreans.

One example of such an intellectual from this time is Plotinus (205–270). Although, as mentioned previously, he was an influential Roman intellectual and author of the *Enneads,* a series of important philosophical essays that inspired Porphyry to collect them and write his biography, Plotinus practiced his Pythagoreanism in a religious way. He was celibate, owned no property, and was a vegetarian. He was modest in his eating and drinking habits and slept little. Despite his passion for the intellectual life, he took the time to arbitrate disputes and to pay close attention to the values of friendship. He attempted to found a new commune on the site of a former Pythagorean one.[35] He has little to contribute in the way of information on the Pythagoreanism of others in his time, except for the fact that he evidently was well versed in the use of enigma: "All teems with symbol," he says; "the wise man is the man who in any one thing can read another."[36] In many ways, if ever there was a consummate Pythagorean who was noted for his intellectual as well as for his moral and religious qualities, it was Plotinus.

Nonetheless Iamblichus, writing in the same century, appears to make a distinction between those who were Pythagoras's merely intellectual followers ("hearers") and those who not only studied Pythagorean philosophy but were

fully committed to the Pythagorean communal life and rules of conduct ("students").[37] These lifestyle distinctions, he implies in the *Vita Pythagorica,* remained unchanged in his time.

In *Vita Pythagorica* Iamblichus describes Pythagorean daily routine and rituals. These included morning walks, a period of study, care of the body, daily bathing, frugal lifestyle, a well-ordered diet, the practice of self-control and silence, the wearing of white clothing, and the use of white linen bedclothes. Pythagoreans were enjoined from hunting or killing any living thing as well as from allowing conflict to disturb their friendships. The most important cure for problems lay in the playing of music, which, imitating the harmony of the universe, encouraged concord. Pythagoreans, he continues, are always concerned with proportion, which they obtain through regulating their lives. This includes the practice of justice and the exhortation to avoid aggression and all superfluous material desires as well as the observation of secrecy. All these tenets were couched in the form of enigmatic symbols and riddles.[38] These eulogized the Islands of the Blessed (the sun and the moon), the Oracle at Delphi (the tetraktys), the Wisest Thing (number), and the Most Beautiful Thing (harmony).[39] Because Pythagoras had assured his followers his divine power was that of the sun, his followers arose before sunrise to pray to the rising sun.[40]

The two books that followed the *Vita Pythagorica* in Iamblichus's ten-book encyclopedia of Pythagoreanism describe the progression of the initiate (one who studies philosophy and mathematics in the Pythagorean way), in stages, from the general to the ultimate and specific knowledge of the most perfect wisdom. In this intellectual journey, order prevails everywhere. The fourth book, whose subject is arithmetic, in essence reproduces Nicomachus's *Introduction to Arithmetic.* Although this recapitulation indicates the fame of Nicomachus as an arithmetician and the high esteem Iamblichus had of his work, it also makes clear that Nicomachus was regarded, a century and a half after his death, as the ultimate Pythagorean arithmetician. The effulgent praise of Iamblichus for the purity of Nicomachus's scientific achievement suggests that Nicomachus embodies the highest Pythagorean virtues. Although they are known only through the later description of the Byzantine scholar Michael Psellus, books V, VI, and VII appear to have discussed the method and meaning of numbers and groups of numbers. They also proposed that the universe is structured by physical concepts that derive their properties and behavior from arithmetical numbers, and that the principles of ethics are furnished by numbers. In summary, the general plan of Iamblichus's ten-volume encyclopedia was to put forward, from his Syrian viewpoint—which tended to emphasize the mystical—the importance of Pythagoras and his doctrines for the third century.[41]

Considering the minimal attention he paid to mathematics in the *Vita Pythagorica* and the elaboration with which he treated mathematics in the other books of his encyclopedia, it is difficult to believe that Iamblichus also wrote the very practical little manual known as *Theology of Arithmetic* that is

attributed to him.[42] Whoever its author (frequently called Pseudo-Iamblichus) was, he followed the Pythagorean plan and interpretations of Nicomachus and Anatolius, while quoting extensively from Speusippus. The result was the longest work on the symbolism of number that survives from Antiquity. In describing the qualities of the first ten numbers, its abstract arithmological language inspires the reader to understand the laws that govern the universe. The climactic passage in this treatise occurs in the discussion of the number ten, which, we are informed, is God's measure for all things and the basis of Pythagorean "theology" because it is based on the concept of God's arrangement of all the components of the universe and the heavens. Attached to this section is a long passage elaborating the reasons for the "perfection" of this number, quoting extensively from Plato's nephew Speusippus, who, as noted earlier, had written a work titled *On the Pythagorean Numbers* in which the number ten was praised above all others.[43]

While Pythagorean arithmetical interests appear to have diminished in the fourth century, familiarity with Pythagoreans continues to be noted. Saint Basil (ca. 330–79) refers to their enthusiasm for the *quaternion,* or tetraktys. His contemporary, Saint Jerome (who was an admirer of Pythagoras), appears to have been more stimulated by them. He strongly suggests he had Pythagorean leanings. His many letters focus on teaching rules of conduct to his various acquaintances (mostly women, whom he regarded, perhaps, as more educable in this respect). His stature as a great intellectual notwithstanding, he advocates frugality and disdain for money, communal sharing, silence, adherence to rules of moral behavior, attention to rules of dress, temperance, moderation between extremes, piety, early rising (and singing), and fasting. He finds numerous occasions to criticize those who eat too much and recommends that they adopt a vegetarian diet. Meat inflames the body and leads to carnal behavior, he suggests. Saint Jerome sums it up by saying, "You should know that nothing is so good for young Christians as a diet of herbs."[44]

Although not a Christian, the Emperor Julian (331–63), who was especially devoted to Plato and Iamblichus, considered himself a Pythagorean. He considered Pythagoras a god; also, he expressed his particular attachment to the sun, which since later Roman times could be Helios, who rode in a chariot like Apollo, and with whom Julian was sometimes identified. Julian's long description of Helios as the mediator and unifier (or "the middle") suggests that Pythagorean admiration for the mean between two extremes was an idea of Eastern origin.[45] Later in the century, Eunapius composed his *Lives of the Philosophers,* a work that attempts to document the lives of many of those who paid homage and respect to Pythagoras in terms of their ideas or lifestyle—including Plotinus, Porphyry, Iamblichus, and others.[46]

The fifth and sixth centuries suggest that the major trend during this time was the compilation of arithmetical cosmographies based on the Pythagorean legacy of the symbolism of numbers. Both Macrobius and Boethius were likely

Neopythagoreans, for in addition to their praise for Pythagoras, they favored Pythagorean concepts.

Macrobius's expansion of Cicero's description of the universe bears many similarities to the information found in Vitruvius, Theon of Smyrna, Nicomachus, Porphyry, Martianus Capella, and others. The earth is spherical and located in the center of a universe delineated by seven planets, which in their fast rotation produce a concordant hum inaudible to humans, the "music of the spheres." The Milky Way intersects the zodiac and provides the essential nourishment (milk) for the souls of those who reside in the heavens while waiting to pass through the spheres and take up residence in a human body. Macrobius offers a detailed account of the downward journey of souls. He attempts to demonstrate that the sun, with its radiance, not only moderates and regulates the universe but also functions as its mind and leader. Macrobius demonstrates the validity of Cicero's assertion that the remote stars are much larger than the earth by showing that they are larger than the sun, which in turn is larger than the (relatively infinitesimal) earth. Numbers are the fundamental property of the universe and, as such, reflect the Creator's divine plan. Not only can they be perceived arithmetically, through lines (as in the triangle), but also geometrically (as in the pyramid). It was the Pythagoreans who explained the meaning of number. The number eight, for example, signifies Justice because not only is it the product of equal numbers but it is the first number than can be divided into two equal parts and then again. Through the number seven, which merits his special attention as the one that signifies the harmony of the spheres, Macrobius reaches the subject of the numerical ratios of musical concords. The properties of the sacred tetraktys are fundamental to his ideas, thus underlining his devotion to Pythagorean thought.[47]

The same Neopythagorean themes—the importance of numbers, numerical ratios, and the harmony of the spheres—are pursued by Boethius. Like his predecessors, who can be traced back to Philolaus, he opens his *De institutione arithmetica* with the assertion that everything in the universe springs from the four elements.[48] Likewise the academic quadrivium (as first described by Archytas the Pythagorean) consists, for Boethius, of four disciplines (arithmetic, music, geometry, and astronomy), the most fundamental of the Seven Liberal Arts. Relying on Plato's *Timaeus,* Nicomachus, Porphyry, and other Pythagoreans, he postulates that harmony is reached through renouncing dissident elements and explains that its result is proportionality.[49] In advocating the (Pythagorean) practice of beginning each day with singing, he suggests a connection between cosmic, geometric, and human harmony that links him to Pythagoreanism.[50]

Both Macrobius and Boethius attempted, in their turbulent historical times, to bring order to wisdom. This sense of order was well known and highly regarded in medieval times and during much of the Renaissance. Through the works of these two men especially, the Pythagorean tradition would be kept alive long after the world of Antiquity had given way to the Middle Ages.

The Druids and Pythagoreanism

No one knew Gallo-Roman France better than Julius Caesar (100–44 BC). Not only did he conquer this area but, as an astute observer of the peoples he conquered, he took the trouble to record his observations. In his memoirs, Caesar tells us that in Gaul there existed two classes of persons: the common folk, who were uneducated and little more than slaves, and the powerful nobles, who were in large part the Druids, that is to say, elite members of the Celtic tribe that had migrated to Gaul from Italy two centuries previously. Caesar's account of the Druids emphasizes their sociojudicial functions. As an educated superior class, they functioned as judges, and in this capacity they decided all kinds of quarrels, from the smallest personal problems to the gravest intertribal disputes. Their jurisdiction extended throughout the state. They also functioned, Caesar explains, as religious officials. They had, he continued, political functions as well as strong philosophical interests. Above all, he emphasizes, they were teachers and educators. Young men—that is, the future nobles—gathered about them to obtain their education. In the Druidic schools, instruction lasted for twenty years. Initiates were taught to practice secrecy rather than to commit their knowledge to writing. They were taught to cultivate the memory and, as well, to practice silence. The most important of all their doctrines concerned the immortality of the soul and its transmigration after death. In addition, the Druids had important interests in cosmology, and they studied the stars and their movements, the universe, the earth, and the order of nature. All in all, they were very different, Caesar observes, from the Germans.[51] Certainly this difference lay, as the modern historian of the Gauls, Camille Jullian, observes, in the fact that they remembered their ancestors in the classical world, a world that was still very much alive in their day. Their special interest in number and their respect for the number ten, on which their money was based, reinforces this continuity.[52]

Diodorus Siculus, another contemporary, has more to say. He agrees that the Gauls spoke in riddles; he also emphasizes the learnedness of their elite class, the Druids, and refers to them as "philosophers." They believed men have immortal souls, he says, and that the souls transmigrate. Furthermore, he tells us, they liked poetry and music. And they played lyres. His account stresses their skill in the practice of divination. Diodorus adds what might, by now, seem the obvious: "the belief of Pythagoras prevails among them."[53]

A clue as to how the Druids might have become associated with Pythagoreanism is provided by a predecessor of Diodorus's. Writing several centuries before the Druids established themselves in France, Polybius describes the Celts in Etruria, a part of Italy that Plutarch had associated with Pythagoras. (In the next century, Clement of Alexandria would describe Pythagoras as a Tuscan.) According to Polybius, it was this Celtic tribe that was driven north of the Alps by the Romans.[54] The history of the Gauls in Italy is described in great detail by Livy and would be elaborately corroborated in the first century AD by the

Roman historian Valerius Maximus, who, as a contemporary of the Gauls, described them as having Greek origins before their arrival in Italy, when they were subjugated by Hannibal and driven to the north (perhaps connected with their persecution). He too noted their belief in the immortality of the soul and maintained that it came from Pythagoras.[55]

Cicero exchanged views with a celebrated Druid (Divitacus), who visited Rome in his time, and who Cicero regarded as an expert auger.[56] A contemporary of Cicero, Posidonius, knew that the Druids practiced divination and said they also practiced medicine.[57] In a geographical survey of the inhabited world of his time, the first-century AD writer Pomponius Mela describes the Druids as masters of wisdom. They were, he says, philosophers who claimed to understand the size and shape of the earth and the universe and its celestial movements (that is, they "measured heaven"). He emphasizes the reputation and respect the Druids had as teachers in special schools hidden in caves, where the doctrines of the immortality of the soul and its transmigration were taught. They expressed their piety to divine will and practiced divination and medicine.[58] Writing not long afterward, Pliny refers to the Druidic physicians as having such excellent reputations that outsiders studied with them.[59] In the next century Strabo essentially confirms this description, as does a noted convert to Christianity, Clement of Alexandria. Both regard their Druid contemporaries as an educated aristocracy noted for their study of philosophy. Associating them with Pythagoreanism, Clement emphasizes that in his time they were major authorities on philosophy. He went so far as to cite an earlier source that claimed Pythagoras had studied with the Druids. He also seems at home with the idea that as Pythagoreans they could predict the future. It is thus clear that in the second century AD, that is, in Gallo-Roman times, the Gauls—and specifically the Druids—were regarded as Pythagoreans.[60]

By the early third century, Bishop Hippolytus of Rome singled out the Druids as examples of Pythagorean philosophers. He supposes that their ancestors had been the students of Salmoxis, the slave of Pythagoras. When they went to Gaul, he explains, they brought with them the philosophy of Pythagoras. Speaking of his own time and as a contemporary of the Druids, he says: "The Celts glorify the Druids as prophets and as knowing the future because they foretell . . . some things by the ciphers and numbers of the Pythagorean art."[61]

Writing in the same century, Diogenes Laertius also appears to have been familiar with Druidic practice. Because he refers to the Druids (who were also his contemporaries) as philosophers, it is not unlikely that at least some of them knew Greek.[62] Diogenes says that the Druids uttered their philosophy in the form of riddles, urging men to practice piety and to abstain from wrongdoing. His comments make it clear that he regards the Druids as magi, as did Pliny before him.[63] The Druids practice divination and forecast the future, Diogenes tells us, and they believe the air is full of shapes replete with vapor and mists. Their dress is white, and their food is vegetables, cheese, and bread.

This picture of Druids is completed by other ancient authors, who are unanimous in assuring us that the Druids were known to their contemporaries in the Roman world as philosophers, educators, judges, theologians, astronomers, physicians, and prophets.[64]

The ever-increasing power of the Romans eventually led to the downfall of the Druidic order during the early centuries AD. However, before this was accomplished with finality (the great invasions of the Franks began in the third century, although a fourth-century poem by Ausonius affirms that the Druids were still known in his time), Druidic practices likely lingered on in secret or in more isolated areas during the centuries of the Druids' persecution and the political turmoil that took place in Gaul before the Frankish empire was established.[65]

▲

Thus as Christianity came to be established, the various people and groups claiming to be Pythagorean lacked a single dogma—although they all incorporated, in various ways, theological and cosmological ideas in their expressions of the order in the universe. It appears that the Pythagorean schools, which promoted various combinations of scientific research, theology, and purity, although at first unified and later separated into various strands following the example of the one believed to have been founded by Pythagoras himself, had disappeared. However, it is possible that some elements of these survived in the educational program of Druidic schools, which appears to have been transferred from Greece to Italy to France.

Dispersed as they came to be, Pythagoreans continued to survive, primarily in the western part of the Greco-Roman world, although a significant tradition of Pythagoreanism was connected with Syria. As they scattered, however, Pythagoreans did not vanish. In their worship many of them continued to face the sun and to pray looking toward the east. They continued, as can be seen in the case of the Druids, to speak in riddles and to observe—despite their teaching obligations—silence, as well as to function as cosmological savants, judges, physicians, and prognosticators. At the same time, some of the strongest proponents of the Pythagorean philosophy of cosmology and numbers (Macrobius and Boethius) lived in these overlapping times of late paganism and early Christianity; it is to them that we owe what came to be, in medieval times, the new significance of number, which was reflected in parallel developments in Christianity and Judaism. As the last great systematizer of Greek thought in the Byzantine world, Proclus cannot be forgotten in this context. It was he, who believed himself to be Nicomachus reborn, who had established for the Middle Ages the importance of Pythagoras for Plato. Thus by default he was also important for the development of the *élan vital*, or forceful impulse, of Pythagoreanism at this time.

The fundamental quality of numbers was harmony, and harmony reflected the divine intelligence. Thus number became, for latter-day Pythagoreans es-

pecially, through the works of Nicomachus, the source of symbolism as well as of extending substance and shape into harmony and proportion. The harmony of numbers took the form of geometrical relations, which demonstrated proportions that are akin to musical harmony, which in turn could be felt throughout the earth, which was a sphere, and the heavens, which were the firmament. Together these comprised the cosmos. For Pythagoreans this well-ordered system could be expressed in the connection among the planets, which revolve at different speeds in the sky at varying distances from the center (which for some was a fire and for others the earthly sphere), and compared to the vibration of strings, thus composing the music of the spheres. Just as number unifies the quadrivium, first described by the Pythagorean Archytas in Antiquity and redefined by Boethius (as the sciences of arithmetic, geometry, astronomy, and harmony), so the music of the spheres unifies the cosmos and the soul of man. Regardless of the various strands of thought into which Neopythagoreanism disintegrated by the sixth century, these ideas would continue to have a life of their own in medieval times.

THE MIDDLE AGES
A New Pythagoreanism

The history of medieval Pythagoreanism has never been written. Although it is true that the demise of the Pythagorean schools in late Antiquity marked the end of a long chapter in intellectual history, the approval of Pythagorean moral and ethical values by the militantly emergent Christian Church (Saints Augustine and Jerome, Bishop Hippolytus, and Clement of Alexandria, for example) allowed, if not encouraged, Pythagoreanism to remain active in the work and teachings of Christian thinkers. At the same time the idea that numbers alone could account for the forms and relationships of nature and the harmonies and proportions of the universe, which lay at the heart of Pythagorean thought in Antiquity, was adopted in early Christian thought. This notion persisted into the Middle Ages, when it flourished in new ways. In the world of scholarship, numerical concepts—which were considered to be scientific as well as divine—were applied to the codification of knowledge and the organization of learning. The same concepts also gained astonishing popular currency as they were adopted by practitioners of magic, medicine, and alchemy. These developments took place not only in Christian Europe but also in the Islamic and Greco-Jewish cultures of the southern and eastern Mediterranean. Under this vast umbrella, the reach of Pythagoreanism was, if anything, vastly greater during medieval times than it had been in late Antiquity.

Rules for Conduct in the Pythagorean/Christian World

An interesting illustration of how Pythagorean moral and ethical teachings were assimilated into early Christianity can be seen in the history of a collection of ethical aphorisms called the *Sextou gnomai* (*Sentences of Sextus*). This text, which existed in some form at least as early as the second century AD, achieved considerable popularity that lasted throughout the Middle Ages.

Of the Sextus who originally compiled it little is known other than that he was regarded by the scholarly Saint Jerome (as well as the somewhat less reliable Iamblichus before him) as a Pythagorean ("Sextus Pythagoricus"). Many of the 451 sayings in the extant collection in fact resemble the Pythagorean aphorisms cited by Plutarch in the second century, whose direct descendants were contained in the so-called *Golden Verses of Pythagoras* that would appear in the productions of late Antique writers of the fifth century. Sextus's *Sentences* included, for example, injunctions to love the truth, to avoid polluting the body with pleasure, to shun flatterers, to let one's tongue be harnessed by one's mind, and to anticipate death (and an afterlife) with joy rather than fear.[1]

As the *Sentences* gained popularity, however, the collection took on an increasingly Christian flavor, to the point that despite its apparent "pagan" origin, some monastic orders (such as that of Saint Benedict) adopted it as an authoritative encapsulation of Christian doctrine.[2] In effect, during the first centuries of the first millennium AD, the ethical principles of Pythagoreanism came to be fused with and became indistinguishable from those of Christianity, in much the same way that Pythagorean and Neoplatonic cosmologies had blended into each other as the millennium had began.

The appearance of the Pythagorean *Golden Verses* in fifth-century Alexandria could have signified a resurgence of a separate Pythagorean tradition, but in fact the two documents did not compete. Similar in both content and form, they followed remarkably parallel courses in later centuries. The *Sentences of Sextus* was translated into Syriac, Latin, and Arabic (the written language of Jews as well as Muslims) and became for the Latin world a guide to daily life that was appreciated, studied, and preserved from Britain to Mesopotamia. The analogous *Golden Verses*, discussed in chapters 3 and 4, also had a long life in the Latin medieval west and became known in the Muslim world through Arabic translations in the eleventh and twelfth centuries.

The Enduring Classical Conception of Number

As we have seen, Antique interest in the mystical and cosmological symbolism Pythagoreans attributed to numbers reached a high point in the first-century AD treatises of Philo and Nicomachus and was sustained through the writings of such later mathematicians as Theon of Smyrna, Anatolius, and Pseudo-Iamblichus. Behind the work of all these authors lay Plato's most Pythagorean

text, the *Timaeus,* the importance of which for the Middle Ages cannot be overemphasized.[3] The numerical explanations of the proportion and harmony that govern the universe set forth in the *Timaeus* would permeate the thought of learned men throughout the Middle Ages and ensure the survival of Pythagorean thought, even if it had not been known in other ways. Exegeses of the work proliferated, studying in ever-increasing detail the symmetry and harmony with which Plato's (and therefore Pythagoras's) geometer-God had arranged the cosmos, and pondering how this knowledge might be applied to life. This great current of thought would culminate in the work of the French cathedral schools in the late eleventh, twelfth, and early thirteenth centuries and, as discussed in chapter 12, in the design of the French cathedral itself. By that time Pythagorean numerological concepts, whether or not recognized as such, would have become a universal language for the expression of the intellectual issues of the day.

▲

Shortly after the closing of the Platonic school at Athens, a highly original Christianized form of Platonism made its debut in the Greek-speaking world sometime around AD 500. Its manifesto took the form of four books incorrectly attributed at the time to Dionysius the Areopagite, a first-century Christian convert mentioned in the Bible: *Peri tes ouranias hierarchias* (*The Celestial Hierarchy*), *Peri tes ekklesiastikes hierarchias* (*The Ecclesiastical Hierarchy*), *Peri theion onomaton* (*On Divine Names*), and *Peri mystikes theologias* (*The Mystical Theology*). In these books Pseudo-Dionysius, as the unknown author has traditionally come to be called, proposed a bold fusion of Platonism and Christianity to explain the relationships among celestial beings, humans, God, and the universe.[4] At the heart of this explanation was number. *The Celestial Hierarchy* sets forth Pseudo-Dionysius's overall system: The universe, patterned after the divine intellect of a Platonic god, consists of three levels, the highest of which is Heaven. Heaven consists of twelve orders (four triads, or sets of three); nine levels of celestial beings (angels, ranked in three triads) mediate between God in Heaven and man on Earth. *The Ecclesiastical Hierarchy* further develops the ubiquity of threefold divisions in the universe; it also stresses the importance of sunlight, which lights up the universe and thus symbolizes or even proves the presence of God. These books were enormously influential throughout the Middle Ages, not only in the Byzantine world where they first appeared but also in the Latin world, for which they were translated in the ninth century.[5] It seems likely that the "twelve orders of heaven" found in Pythagoras's teaching by the anonymous biographer quoted in the masterwork of the ninth-century Byzantine patriarch Photius (as discussed in chap. 4) reflects the influence of Pseudo-Dionysius.[6] As late as the thirteenth century the important astronomer and mathematician John of Sacrobosco credited Dionysius "Ariopagita" in a work discussing the twelve signs of the zodiac, the seven climates, and the divisions of the sphere of the universe.[7]

Through the influence of Pseudo-Dionysius on authors such as Photius, John of Sacrobosco, and many others, the Pythagorean strain in Platonism was used to Christianize Plato, by means of number symbolism to link the geometrical Platonic cosmology with the Christian understanding of God's divine plan for his universe. This high regard for Pseudo-Dionysius persisted into the late Middle Ages (Dante, for example, praised him as an "astonishing mortal who pondered the celestial realms") and on into the Renaissance, when the great Florentine philosopher Marsilio Ficino would make new translations of his work.[8]

The seventh-century Christian bishop Isidore of Seville was well read in the sciences, but he felt far less sympathy with the Euclidean notion of building knowledge through deductive proofs than with the Pythagorean vision of a universe governed by the mystical properties of certain key numbers. Isidore's definition of arithmetic was based on Nicomachus, whose claim to be the direct heir of Pythagoras's arithmetic Isidore accepted, as had Cassiodorus and Boethius before him. As the beneficiary of this tradition, Isidore repeatedly propounds the importance of numbers in all his works, especially in the most significant of them, the *Etymologiae (Etymologies)*. He even carries Pythagorean arithmetic one step further by studying the etymology of the name of each number.[9]

The forty-eight books of Isidore's treatise *De natura rerum (On Nature)*, which describes the world from organizational, literary, and scientific viewpoints, are essentially based on conceptions of number. Of basic importance are the seven days of the week (the hebdomada), the twelve months, and the four seasons. Spring is born, Isidore tells us, on the eighth day after the kalends of March and lasts ninety-one days; summer begins on the ninth day after the kalends of June and lasts ninety-two days, and so on. Diagrams showing wheels that incorporate fours, sevens, and twelves are among the many that appear in various editions of his text. Isidore refers to the five "circles" of the Earth, which he compares with the five fingers of the human hand. The four elements are demonstrated by the cube and the heavens by the circle. The seven planets are paralleled by the seven phases of the moon and the seven gifts of the Holy Ghost. Similarly, Isidore's medical writings define, among other things, the four humors, the five senses, the six ages, and the three kinds of death. Most interesting, perhaps, is Bishop Isidore's attribution of the discovery of the art of medicine to Apollo.[10]

Another subject to which Isidore gave thoughtful consideration was how priests should dress:

> The whiteness of garments is especially approved, since . . . [it] is the most pleasing of all virtues to God. . . . For he says, "let your garments always be white," and the priests of the Lord were clothed in linen clothing for the sake of excellence. . . . Which among cloths is as pure as linen, to which whiteness is increased by frequent washing whereas with silken cloths the whiteness seems to be more darkened from washing? You should understand that purity of mind is nowhere where infidelity flourishes.[11]

This passage, viewed in light of the Pythagorean leanings demonstrated in Isidore's treatise on nature, suggests that he was familiar with, and admired, Pythagorean dress codes. It even suggests that the idea of white linen as the fabric most appropriately suited for divine uses entered Christian liturgical practice through the influence of Isidore's interest and preexisting Pythagorean avenues.

▲

The preservation of Plato's work as a foundation of Western thought was a long-term, multicultural enterprise. Byzantine libraries played a vital role in safeguarding thirty-six Platonic dialogues for the Middle Ages, and translators in the Arab and Jewish worlds were active in producing texts of the *Timaeus* and various commentaries on it. It was especially at the School of Chartres in the twelfth century, however, that the study of Plato gave rise to an independent body of literature explicating the glory of God as it was reflected in the orderliness of the universe. The writings of such intellectuals as Thierry of Chartres and William of Conches (both discussed in chap. 4), as well as Bernard of Chartres (d. ca. 1130) and Alexander Neckham (1157–1217), display not only their admiration of Plato's *Timaeus* but also their familiarity with the works of other classical authors who discuss Pythagoreanism (such as Cicero, Ovid, and Pliny). Their enthusiasm for these works enabled them to perceive the importance of mathematics as a key to understanding astronomy and nature.[12] Thierry of Chartres made it clear that only by mastering mathematics might a scholar truly understand the account of the Creation in the *Book of Genesis*.[13]

In his *Commentary on the Timaeus,* William of Conches cited Plato as an important Pythagorean, thus making it clear that Plato was understood, in the twelfth century as always, to be a Pythagorean.[14] From Plato he drew the conclusion that God acted as a craftsman when he designed the universe, a view of God that would survive into the Renaissance. Though his *Philosophiae mundi* elaborates on the four elements, it has little to say about Pythagoreanism per se.[15]

Plato, however, was not the only source of Pythagorean numerology known to the Middle Ages. Aside from Boethius's *De arithmetica,* which relied heavily on Nicomachus and which was extremely well known in the West, the work of Nicomachus himself was well known to the Greek, Latin, and Arabic worlds. In the ninth century, for example, Arabic translations from the Greek of Nicomachus's *Introduction to Arithmetic* and other Greek mathematical texts were known. Many of these works were retranslated from Arabic into Latin by authors such as Gerard of Cremona, thus becoming part of the medieval Latin tradition. The Pythagorean theorem was also known in Arabic transcriptions from this time.[16]

Writers in the Latin world demonstrated, in a variety of ways, their familiarity with Pythagoreanism: An anonymous poet from Chartres specifically described one of his pupils as "holding Pythagorean beliefs."[17] Similarly, an anony-

mous thirteenth-century commentator on the *De sphaera mundi* (*The Sphere*) of Sacrobosco takes the trouble to mention that in his time Pythagoreans defended the application of justice uniformly to everyone rather than allowing it to be a tool of the rich.[18] Throughout his work, Sacrobosco shows his personal familiarity with Pythagorean numerology and its application to cosmography.

On the other hand, it might be said that writers such as Hugh of St. Victor (who as we saw in chap. 4 very much admired Pythagoras) were not merely knowledgeable about the authority of number but obviously smitten by it. In addition, although not mentioning it by name, Hugh appears to have found Pythagoreanism, in general, to be alluring:

> I set problems of numbers; I drew figures on the pavement with charcoal, and with the figure before me, I demonstrated the different qualities of the obtuse, the acute, and the right angle, and also of the square. Often I watched out the nocturnal horoscope through winter nights. Often I strung my harp that I might perceive the different sounds.[19]

In praising the number four (the basis of the tetraktys), he said it described the soul and the body. His description of the body makes his Pythagoreanism clear in that his explanation is entirely in terms of number. "The power of number," he explains, "is this—that all things have been formed in its likeness."[20]

Although not demonstrating any specific new developments in Pythagoreanism, such examples as these show that scholars and scientists assumed Pythagorean meanings of number even if they did not call themselves Pythagoreans. Clearly, Pythagorean doctrines had left their mark in a steady stream of scholarship during the Middle Ages, culminating in the twelfth century when interest in Plato and his *Timaeus* was particularly active. In the fourteenth century, Walter Burley demonstrated an active interest in Pythagorean concepts in his *Expositio super primo et secundo perihermeneias* (*Description of the First and Second Books of Aristotle's Interpretations*). This work contains ten diagrams of contrarieties set in tetragonal formats. In another work, Burley compliments Boethius for having shown that in the realm of numbers all knowledge is fixed and permanent insofar as it concerns the universe, while in the realm of the senses, everything fluctuates.[21]

At the same time, it must be acknowledged that not all scholastics shared these Pythagorean or Platonic enthusiasms. The learned Dominican Albertus Magnus (ca. 1206–80), for example, reproved the Pythagoreans of his time for believing that nature could only be explained in terms of number.[22]

The New Enthusiasm for Numerical Organization in Learning

As described in chapter 3, the concept of the quadrivium originated in the fourth century BC with Archytas the Pythagorean; it became a familiar aspect of academic thought in Antiquity. In the fifth century, Proclus described it as Pythagorean ("Pythagoreans considered all mathematical science to be divided

into four parts, ... arithmetic, ... music, ... geometry, ... spherics [astronomy]").[23] It was certainly developed in the works of Boethius, who, relying on Nicomachus, had explained to his sixth-century and future audiences the importance of the fourfold path, which leads to the attainment of knowledge. Thus, although arithmetic appears to have outshone the others in importance in that it was useful in the other three disciplines, arithmetic, music, geometry, and astronomy had come to be essential to the practical curriculum in medieval schools and universities. In the twelfth century, Hugh of St. Victor credited Pythagoras with having written a book on the quadrivium, as mentioned in chapter 4.

The relationship between the four quadrivial arts was, if anything, consolidated by music, which stressed the role of harmony.[24] Although it most likely has roots in the triadic thinking expressed by both Plato and Aristotle, its complement, the trivium, which included grammar, rhetoric, and dialectic, does not appear to have developed as a discipline until the ninth century. After that time both the quadrivium and the trivium came to be commonly taught in all schools and formed part of the curriculum in the emerging universities of Europe.

Together these formed the Seven Liberal Arts, which had been demonstrated in the dazzling display of Martianus Capella's fifth-century creation, *The Marriage of Philology and Mercury*. In this work, the reader was led to the climactic conclusion that it was impossible to attain perfect knowledge without following the boulevard of wisdom created by this agglomeration of complementary disciplines whose number was seven, the most revered of Pythagoreans. In later medieval times, Thierry of Chartres would propose, in his *Heptateuchon* (*Seven Books*), that the Virgin Mary was the patroness of the Seven Liberal Arts, which embodied all human wisdom.[25] In a text on the seven days of creation, Thierry proposes a highly original cosmology that employs numbers as the explanation for all cosmic development, that is to say, "the creation of numbers is the creation of things." These numbers, he explains in admirable Pythagorean language, ultimately lead to unity and harmony.[26] Thierry even explains the concept of the Trinity in a way that can only be described as Pythagorean: between Equality and Unity there exists Connectiveness, and because these three concepts proceed from each other they incorporate the Father, the Son, and the Holy Spirit in a single reality.[27]

Numbers were also useful, at this time, for learning about virtue and vice. Thus the seven deadly sins formed a coherently related group of vices, whereas the seven virtues, buttressed by the seven gifts of the Holy Spirit, denoted the opposite. Seven, if its components three and four are multiplied, leads to twelve, the number that signifies not only the zodiacal signs but also the Apostles. Groups of four identified not only the elements but also the seasons, the Evangelists, the doctors of the Church, the cardinal virtues, the rivers of Paradise, and the major prophets. Numerological correspondences were instructional and formed an easily remembered system of coordinates, as did the

Trinity.[28] Perhaps most basic of all, to Christians as well as to Jews, was the number ten, which was embodied in the ten commandments. Although such numbers are not denoted in the literature of the time as Pythagorean, they correspond with numbers that were of particular significance to Pythagoreans. The numbers also appear to have been imbued in popular and religious culture that fell under the spell of the continued popularity of such literary works as those of Boethius and Martianus Capella.

▲

The symbolism of numbers was important in the Byzantine world as well. Michael Psellus (1018–78), an influential professor of philosophy, scholar of encyclopedic learning, and practitioner of occult sciences in Constantinople, was, in this sense, an ardent Pythagorean. This he demonstrated in a treatise on theology in which he discusses the symbolic meaning of numbers, reserving his greatest praise for the number seven because God created the world in seven days. Seeing Plato as the inheritor of Pythagoras's number mysticism, he suggests that Plato came close to being a Christian because he saw the truth in the mystical view of theology he presented in the *Timaeus*. In other discussions of number, Psellus speaks of guarding a Pythagorean secret, and he appears to attribute an arithmetical invention of Diophantus (a third-century Greek mathematician from Alexandria) to Pythagoras.[29]

Psellus's Pythagoreanism was also evident in his attempts to reconstitute Iamblichus's third-century ten-book encyclopedia on Pythagoreanism. His excerpts of books V, VI, and VII, which he studied from an ancient source that has since disappeared, permit us to know something of the content of Iamblichus's description of Pythagorean physics, ethics, and theology. They also show his devotion, as a member of the Byzantine court, not only to Pythagoras but also to Iamblichus. Psellus is among the first scholars known to have possessed a manuscript of the purported works by a mythical figure thought to have been a contemporary of Moses, Hermes Trismegistus (Hermes "thrice-greatest"). This was a concoction of theological, philosophical, and occult writings that were imagined to be genuinely ancient although they appear to have been a product of later centuries. In these Hermetic texts, which proliferated during late medieval and early Renaissance times, Pythagoras is cited for his abilities in magic. Psellus's manuscript would eventually find its way to Italy during the Renaissance and would be the one used by the Italian Renaissance philosopher Ficino for his Latin translation of this revered work, which by Renaissance times had come to be regarded as paralleling the revealed wisdom of the Bible.[30]

In the world of Byzantine music, numbers were important as well. In a work titled *Harmonics,* Manuel Bryennius (a music theorist from a famous family in Constantinople, active ca. 1300) lauded the doctrines of the ancients, which, as he saw it, originated in the works of Pythagoras, Aristoxenus, and Nicomachus. His musical canon was based on the use of number, especially the octave, in order to attain perfect harmony. Inherent in the consonance of inter-

vals perfect harmony had been discovered, Manuel relates, by Pythagoras, who reinstated the lyre, an instrument that according to him had been invented in Egypt by Terpander and passed on to Orpheus, who in turn had introduced Pythagoras to it. Manuel discusses the importance of the number seven for the lyre (and cosmic harmony), as well as the importance of the number four, which reflects, he says, the four elements out of which the universe is composed.[31] He chastises the "uncouth" people of his own time, who have forgotten the great scientists of Antiquity who directed mankind to the "perfect way"; but the work of Manuel Bryennius was considered important by posterity, for it was known in the Renaissance.

A Byzantine contemporary of Manuel Bryennius, the mathematician George Pachymeres (1242–ca. 1316), was apparently also drawn to Pythagoreanism. His major work, the *Quadrivium,* which must have been important for it is known in a large number of manuscripts, follows from the long tradition begun by Archytas (the disciple of Pythagoras) and continued by Boethius in closely connecting arithmetic, music, geometry, and astronomy. This work includes long quotes from Nicomachus's *Introduction to Arithmetic* and *Theology of Arithmetic.* The latter work he surely knew through the description Photius had left of it in the ninth century.[32] Following his long and scholarly discussion of arithmetic, he discusses music—beginning with the music of the spheres. The fourteenth-century Byzantine astronomer Theodore Metochites (d. 1332), who was a Platonist, must have known Plato's major work, the *Timaeus,* as a Pythagorean work; he quoted extensively from this work.[33]

Farther to the east, while the world of Islam exhibited strong interests in arithmetic, its primary focus appears to have been to solve practical problems of daily life (taxation, measurement, buying and selling, estimating agricultural values, and other such business applications). However, Islamic arithmeticians also exhibited an interest in Pythagorean concepts, which formed part of their classical intellectual inheritance. This interest is reflected, for example, in the work of Abu'l-Wafa' (940–98), who is known to the scholarly world for his contributions to astronomy and trigonometry. His discussion of multiplication and division, in a volume on arithmetic written for business administrators, shows that he knew well the work of Nicomachus.[34] For Islamic mathematicians, however, whose primary arithmetical systems were based on finger reckoning and Hindu arithmetic, the idea that relations between numbers and geometrical forms might be symbolic must have seemed beyond the realm of day-to-day business necessities. The view that music, because it was based on number, was a branch of mathematics provided an arcane sideline to the practical applications of algebra and geometry, which dominated Muslim mathematical activity.[35]

▲

Jewish interest in numerical organization was of much greater importance for it permeated the development of Kabbalah (or "Received Tradition"), an

esoteric religious "doctrine" that, somewhat as was the case with Pythagore-
anism, was essentially unwritten, especially in its earlier manifestations, and
handed down to initiates in the form of a variety of texts and sayings. Al-
though, as we now know, the idea that Pythagoras was connected with Ju-
daism dates from Hermippus in the third century BC and was further devel-
oped by Aristobulus in the following century, it was not until the first century
AD that, in the works of Philo of Alexandria, a Jewish Pythagoreanism was de-
veloped. Philo's fascination with number, especially in his exegeses of the Cre-
ation and the Decalogue, equipped his readers to understand the mysteries of
heaven and earth and the manifest superiority of God (whose divine mind as
the Monad, or the unique One, was the creator of all number, of which seven
was the most divine and ten the most supremely perfect).

Notwithstanding the learned works of the modern scholar Gershom Sc-
holem on the history of Kabbalah, the links of its early development in relation
to Pythagoreanism have never been traced.[36] Its leading figures, especially
those between the fourth and eighth centuries, are unknown. Nonetheless it
appears likely that its early development—from its roots in Jewish esotericism
and mysticism of the first century AD, which were kept alive in small learned
circles, into the medieval Kabbalah, which was largely focused on the cosmo-
logical scheme of the creation—was related to the dissemination of Pythagore-
anism.

As in Plato's *Timaeus* the early Kabbalist tradition worried over the soul's
fate after death. The scheme of rewards and punishments it developed in-
cluded a belief that allowed for souls of the good to have a better life and those
of the bad to be reincarnated into inferior beings. Indeed, metempsychosis is
mentioned in about 1300 by Menahem of Recanati as a form of divine retri-
bution. Thus did Jewish mystical doctrine acknowledge the idea of "voyages,"
if not transmigration, of souls, a concept that was also known in the Arab
world.[37] In addition it was imbued with Pythagorean numerical theory. Per-
haps the most basic aspect of this development was in the Kabbalists' recogni-
tion of ten principles (or "emanations") of all things, known as *sefiroth*, at-
tained through thirty-two paths of divine wisdom or Sophia.[38] The importance
of the number four, acknowledged by early Christian scholars as the fourfold
division of Mosaic Law, also became basic to Kabbalistic thought as it devel-
oped in the Middle Ages.[39] Kabbalistic cosmological schemes, which postu-
lated the four elements as the basic mystery of all things, appear to be descen-
dants of the concepts of early Greek Pythagorean philosophers such as
Philolaus and Empedocles.[40] These four levels of classifications of religious
meaning were popularized through the Zohar (a thirteenth-century commen-
tary on the Pentateuch, reputed to have originated in the second century, that
came to be incorporated into the Kabbalah). Inherent in these were other
groups of four, such as the four winds, the four metals, and the four basic
worlds. They also described seven heavens and the seven palaces through
which the initiated must travel before achieving the sight of God.

The arithmology of the Kabbalah was not unlike the number mysticism that was growing up in the Christian medieval world. Numerical designations such as those described above referred to a vast system of esoteric teachings, which constituted the heart of the Kabbalah and were developed especially in Spain and southern France in the eleventh, twelfth, and thirteenth centuries.

Perhaps the most famous, if not the greatest, Kabbalist of the Middle Ages was Moyses of Cordova, known as Moses Maimonides (1135–1204), a learned rabbi and physician who spent most of his life in Cairo studying Plato's relation to the Old Testament.[41] Even in his lifetime, and certainly in the century after his death (the thirteenth), his works came to be known, through Latin translations, to the Christian world. The most famous of these was the *Guide for the Perplexed,* a text first published in 1190 in Egypt.[42] This work contains a subtext of numerical organization and, perhaps most importantly, describes the ultimate significance of the number four as the Tetragrammaton, the four unutterable Hebrew letters that refer to the name of God.[43]

▲

Although the enthusiasm for the symbolic and mystical application of number was widespread in the Middle Ages, these centuries were not without a tradition of profound scholarship in pure mathematics. In this respect, the life and works of Leonardo of Pisa, commonly known as Fibonacci (ca. 1170–ca. 1250), serve as a supreme example of mathematical work, which, though grounded in the Pythagorean tradition of perfect numbers and odd and even numbers, was astoundingly innovative and creative. Educated, by his own description, in Egypt, Syria, Greece, and Sicily (not unlike the education ascribed by tradition to Pythagoras), Fibonacci learned Hindu, Arabic, and Greek methodologies that, together with Arabic numbers (which replaced Roman numerals), he introduced to Italy.[44]

Written in 1225, his *Liber quadratorum,* a text that uses number theory derived from the tradition of Nicomachus, set forth his observation that square numbers always arise through the addition of consecutive odd numbers starting with unity (the monad). On the basis of this observation, he developed a method of generating sets of three square numbers that satisfied the relationship first attributed to Pythagoras by Vitruvius that $a^2 + b^2 = c^2$ where $a, b,$ and c represent the sides of a right triangle. This and other works of his would be revered in the Renaissance, when it was translated into Italian by a Master Benedetto and especially admired by Luca Pacioli.[45]

Thus the enthusiasm for numerical organization, traceable essentially to the Pythagorean works of Plato, Nicomachus, and Philo, developed especially among Christian and Jewish mystics into a number mysticism that imbued the organization of religious learning much as numbers had become for secular learning authoritative symbols, if not archetypal examples, of cosmological principles that regulated the universe. At the same time, a tradition of pure mathematics, based on Nicomachean number theory, survived in the work of Fibonacci.

Number in Daily Life: Magic, Medicine, and Alchemy

Apart from the respect for classical and late Antique authors that underlined their continuing respect for Pythagoras and his teachings, medieval people fabricated a world of "essences." Both Christians (in the notion of *essentia,* a concept used by Saint Thomas Aquinas) and Jews (in the Kabbalah) perceived all things as having inner, or hidden, qualities. So also, in the world of numerology, were certain numbers assigned values, far beyond the calculatory roles assigned to them (by Nicomachus and others) according to their "essence," or mysterious power. Just as intellectual ideas had been seen as opposites that when balanced created unity, these essences came to be regarded as having magical qualities that also required balancing. Thus was medieval magic based on the manipulation of numbers (which could, for example, be lucky or unlucky) and essences (which could, for example, be moist or dry), both of which were inherent in all objects.

The concept that numbers and objects of nature possessed marvelous virtues is not a creation of the medieval world; rather it represents a continuation and acceleration of ideas that were deeply rooted in Antiquity, as, for example, Pliny made clear.[46] Both Ovid and Celsus had portrayed Pythagoras as a physician.[47] For medieval people, however, these ideas led to magical practices in medicine that were interrelated with parallel practices in divination and astrology. They led as well to an acceleration of interest in another field with Antique roots, alchemy.[48] All these were associated with Pythagoras. The widespread nature of these practices suggests that Pythagoreanism, no longer practiced as a "pagan" cult, had so imbued itself in the popular imagination (which, in turn, was based on the popular memory of one of the great practitioners of ancient wisdom) that it had become a normal way of life. This would have effects, as will be seen in chapter 11, on visual imagery throughout the Middle Ages.

▲

From Heraclitus to Aristotle to Pliny to Porphyry to Iamblichus, a subthread attributing magical powers to Pythagoras had always existed. This "divine" characteristic was passed on to his followers. Pliny had listed some of the marvelous virtues that Pythagoreans had ascribed to herbs and plants. Among these were their power to freeze water, their ability to invoke spirits, their aptitude to urge the guilty to confess, and their capacity to impart the gift of divination or prognostication.[49] In the West, Hippolytus, who knew well the teachings of Pythagoras, had suggested that in his time (the early third century) Pythagorean ideas were connected with occult practices.[50] In the East, in the Byzantine world, Pythagoreans were well known for their powers of prognostication. Writing in the early eighth century, the Greek Father Saint John of Damascus claimed it was a practice that Pythagoreans had learned from the Jews.[51] But because Saint Jerome had credited Pythagoras with discovery of

the belief in the immortality of the soul, and because Pythagoras had been well received by other influential Christians, his teachings could be readily accepted. Thus could "new" forms of Pythagoreanism, acceptable to Christianity, permeate all aspects of medieval life.

This is most readily seen in a variety of medical texts known from the fourth through the fourteenth centuries, although their prevalence is most conspicuous from the ninth through the eleventh. The magical use of number for prognostication is prominent in all these texts. Because the calculations were based on a circle divided in half horizontally, into which were inscribed a series of relevant numbers, this method of medical practice, or divination, came to be known as the Sphere of Pythagoras.

Also known as the Sphere of Apuleius (Apuleius, it will be remembered, was a Pythagorean of the second century AD), the Sphere of Pythagoras was a magical device for determining, through an arithmetical method, the outcome of any given illness or the desirability of treatment. The calculations contained in these spheres (whose images are discussed in chap. 11) were always very similar. They were based on dividing the numerical equivalent of the patient's first name (based on the assumption that to each letter of the alphabet was attached a number) by a number corresponding to the lunar month, usually 30 but sometimes 28. Essentially formulaic in nature, the accompanying texts read (with minor variations) much like the following example:

> The Sphere of Pythagoras predicts life and death. Learn under which day of the moon the patient fell ill and his given name. Divide the numerical value of both by the thirty days of the moon and search in the sphere. If the result is found among the numbers in the upper part of the sphere, the patient will live; if it is found in the lower part, he will die.[52]

Research has shown that the Sphere of Pythagoras was used by physicians (it is most commonly found in medical manuscripts) for treating patients and for determining if procedures such as venesection (bloodletting) should take place. It also is known in nonmedical literature that would have been available to laymen, missals for example. It was apparently also used for fixing the dates of festivals. Last but not least, it was used by priests, who consulted the magical sphere to determine if the time had come to administer extreme unction.[53] The medical literature of the thirteenth and fourteenth centuries testifies to the continued popularity of these concepts in later medieval practice. Arnaldo de Villanova (d. 1311), a learned physician who wrote on medicine, astrology, and theology, gives, for example, careful instructions for determining the advisability of performing certain medical procedures according to the phases of the moon.[54]

Other medieval medical manuscripts having to do with the magic of healing and divination speak of "Egyptian days," or unlucky days, during which illness or disaster could befall a person. The text of one such manuscript, dating from the ninth or tenth century, reads:

The Egyptian days, which must be observed each year, are beginning. One must not travel, walk, or plant in the vineyard. They do not follow reason. No person should undertake any work that needs to be finished. No people or cattle are in any way or by any necessity allowed to let blood. Nor may many other things be done. Times for these extend between the following: [dates are provided]. If a male or female is born during these days, he or she will die painfully, with hard labor; and if one has drunk a lot of water during these days, he will die before fifteen days.

It is followed by:

If you wish to know about an inconclusive matter of any sort whatever . . . [through this] you will learn about the calculation of Pythagoras about such a matter, about any case you wish to know, such as whether an event will be a misfortune or success.[55]

Although these "dog days" were widely observed in the ninth, tenth, eleventh, and twelfth centuries, the work of Arnaldo de Villanova exemplifies the continued popularity, into the thirteenth century, of the taboo on Egyptian Days. Arnaldo advises physicians to take into account the location and conjunctions of the moon and to strictly avoid bloodletting, cauterization, surgical procedures, and the administration of drugs during these days.[56]

Similar manuscripts that have to do with comparing opposite qualities of natural objects (such as the four temperatures, ages, winds, elements, humors) are associated with divination based on the interpretations of the macrocosm and the microcosm; others have to do with studying impending events through the twelve signs of the zodiac in relation to the human body. Although they are not directly associated with Pythagoras, the symbolism of number is clear in all of them. In one the monad is surrounded by the twelve signs of the zodiac and the four seasons; as the monad, the center represents not Apollo but Christ wearing a twelve-pointed halo.[57] In a treatise on the uses of wine, Arnaldo de Villanova pays attention to the balancing of opposites and its resulting unity. Wine, he says, which is hot and dry, mixes well with its opposite, water, which is cold and humid. The result is a tempered substance, or concord, that is very wholesome and to be recommended by physicians.[58] The concept of the creation of equilibrium through the balancing of contraries forms the centerpiece of a little medical manual published in the late thirteenth century by Ramón Llull (or Lulle), a noted Catalan physician. Although he does not mention Pythagoreanism as such, his language is recognizable to those familiar with Pythagoreanism. The number four is basic to all nature and therefore to all treatment. Diseases must be treated by treating each disease with its contrary. Thus will it be "neutralized." The symbolism of number can be translated into a symbolism of letters of the alphabet, which in various mixtures of four can be useful to physicians in determining cures and treatments.[59]

Closely allied to the art of divination was that of geomancy, which assisted

the believer to avoid peril or to test the efficacy of the influence of the moon. Some editions of an eleventh-century geomantic text contained, as the modern scholar Lynn Thorndike has observed, portraits of Pythagoras.[60] Typically, their contents focused on the magic of number—the infallibility of the number seven for lot casting, for example, or twenty-eight subjects of inquiry (life and death, marriage, imprisonment, wealth, and such), which correspond to the days of each moon. Often they were ascribed to Pythagoras. In other geomantic manuscripts, sixteen (a perfect Pythagorean number) questions are arranged in rows opposed to sixteen columns headed by sixteen possible pairs of letters. Another mode of geomantic divination can be found in a text bluntly titled *Prenostica pitagorice* (*Pythagorean Prediction*). The inquirer is here referred to tables of birds that correspond to possible answers to questions of daily life.[61] The learned thirteenth-century Dominican encyclopedist Vincent of Beauvais (ca. 1190–ca. 1264) describes a "cure" for bad dreams (sprinkle the sleeping patient with the blood of the hoopoe bird), which he attributes to a book allegedly written by Pythagoras himself.[62]

Such a learned mathematician as Robert Grosseteste, a great English scholar and ecclesiastic of the thirteenth century, took note of the fact that $1 + 2 + 3 + 4 = 10$, another "perfect" number not unfamiliar to Pythagoreans of Antiquity; he also demonstrated how mathematics might serve astrology in helping people to cure disease, plant vegetables, predict the weather, and transmute minerals. In the same century Gilbert of England, a distinguished mathematician, explained the "Pythagorean" doctrine that the soul is number and that the functions of the intellect can be described as the first four numbers.[63]

The powers of certain numbers and their relations to the influence of the stars were argued passionately and at length by Peter of Abano (b. 1250), a celebrated medical doctor and philosopher trained in Constantinople, whose works would be published throughout the Renaissance and were well known to the Florentine intellectual Pico della Mirandola. In his major work, the *Conciliator differentiarvm philosophorvm* (*The Reconciliation of Diverse Philosophies*), not only does he display his astrological skills but he also provides complicated recipes, based on magical numerical/astrological formulas, for the treatment of various medical problems. Bringing together medicine, astrology, philosophy, and magic, he recommends incantations, the construction of horoscopes, the measuring of the age of the fetus at birth, and the study of the disposition of the stars at the time of its birth. He attributes these to the doctrines of Pythagoras. His Pythagoreanism is also expressed in his linking together of arithmetic, music, and harmony—the inventions of Pythagoras, he says, developed by Macrobius and Boethius. He explains that medical doctors must understand numbers and fractions to calculate the critical days of illnesses (as in the Pythagorean sphere).[64]

Such knowledge was not cultivated only by Christians. In the Arabic world too these arcane topics and the foreign—mainly Greek—texts that expounded

on them drew considerable attention, especially from the ninth through the twelfth centuries. One tenth-century Arabic medical doctor, borrowing heavily from Porphyry, wrote a book on the importance of "Fitsagouras," in which he claimed that Pythagoras was the author not only of the *Golden Verses* but also of a treatise on arithmetic, a medical work on sleep and wakefulness, and various letters.[65] There also exists an enormous Jewish literature, which aside from arithmetical and geomantic works includes illustrated astronomical and astrological tracts that explain how the stars and planets are to be consulted in devising incantations as well as in drawing up natal horoscopes and other prognostications.[66] The role of incantation in both Jewish and Christian arcane writings is strikingly similar to that of prayer in the mainstream of the two religions, and it is increasingly clear that Pythagorean and Pythagorean-inspired mysticism was a significant element in each of the strands that made up Western medieval culture.

▲

Another form of magic associated with medieval Pythagoreanism was alchemy, the search for a means (such as the elusive "philosopher's stone") of transmuting base substances into silver and gold.[67] Although its beliefs and practices can be traced back at least as far as the mystical philosophical schools of the early centuries AD, this arcane art gained new energy, along with its Arabic name, in the Middle Ages. As early as the ninth century, Arabic·alchemical treatises proliferated, especially in Baghdad, and were spuriously ascribed to the Persian prophet Zoroaster, the legendary Egyptian alchemist and mystic Hermes Trismegistus, and Pythagoras.[68] As Latin versions of these treatises, particularly the Hermetic texts, became available in Europe, they spurred intense interest and experimentation.

This alchemical literature—which focuses on such subjects as the powers of the seven planets, the seven rings of the seven planets, the twenty-eight "mansions" of the moon, and the magical properties of stones—has a noticeable Pythagorean flavor. Pythagorean influence becomes explicit with the twelfth-century appearance in Europe of a text, probably translated from Arabic, titled *Turba philosophorum* (*Assembly of Philosophers*) and attributed to an otherwise unknown author named Arisleus.[69] The assembly, convened by Pythagoras ("the Master") himself, includes Anaximander, Anaxagoras, Plato, and Socrates, among other eminent authorities, and issues seventy-two "dicta" ranging from pronouncements on how the four elements formed the earth to detailed recipes for alchemical transmutations.[70]

Many of the dicta begin with the words "Pythagoras saith," including one that appears to claim that the book was written by a committee headed by Pythagoras.[71] This text contrasts somewhat with the claims of Arisleus, also contained in the book, that he himself is the author. Arisleus further claims to be a descendant of Pythagoras, "the greatest master of all wisdom" (aside from Hermes Trismegistus), who was the chief prophet of Italy and who

taught to the Greeks the Indian and Babylonian secrets of transmuting matter. On the basis of some curious spellings of chemical terms and Greek proper names, modern scholars have speculated that the Arisleus who wrote the *Turba* was not Greek but an Arab or (perhaps more likely, based on the book's claim that Moses was a great alchemist) a Jew.[72]

The *Turba* appears not to have been taken too seriously by major scholars like Albertus Magnus, Arnaldo de Villanova, and Ramón Llull, who were interested in alchemy but may well have considered the *Turba* a mélange of corrupted Greek alchemical notions in pseudo-Pythagorean dress. However, its influence on lesser-known philosophers, scientists, chemists, ceramists, pharmacists, physicians, and metallurgists—the mainstream of the Latin West— was immense. The book's date is uncertain, but it appears that glosses and extracts from it may have been known in the West for centuries before the complete text became available (in two Latin versions) in the twelfth century. In the thirteenth century alchemy had become so important a topic of intellectual discourse that Vincent of Beauvais, despite his lack of expertise in the subject, felt it necessary to devote a full chapter of his encyclopedia of the natural sciences to it. The extraordinary importance of the *Turba* for late medieval alchemy is indicated by the appearance of a series of Latin commentaries (such as the *Allegoriae sapientium supra librum Turba*) and emulative works (such as a series of fourteenth-century texts collectively titled *Rosarius* and an anonymous 1399 treatise on alchemy called *Phoenix,* both of which pay homage to Pythagoras). Clearly, by the fourteenth century the *Turba* had become the centerpiece of an entire literary industry that would live on well into the fifteenth century and later.[73]

▲

Thus did the medieval world offer important new avenues for Pythagoreanism, which brought together a collective Christian, Arab, and Jewish imagination—including not only western Europe but also Byzantium and northern Africa—which would serve as a legacy for the Renaissance.

Not only were Pythagorean moral values absorbed into the popular culture of Christianity but also number came to play a basic role in understanding the order and harmony of the universe. Although this role was derived from Pythagorean sources, its theological relevance made it increasingly worthy of respect in the world of medieval scholarship. Not only philosophical scholars but also mathematicians, astronomers, and music theorists paid their respects to Pythagoreanism in the Pythagorean tendencies they exhibited. Such scholars were known not only in the West but also in the Byzantine and Arabic worlds. Knowledge of Pythagorean arithmetic certainly figured in mathematical currents and scientific exchanges between these areas, no matter how vast the distance, especially until the fall of Baghdad to the Mongols in the thirteenth century.

One may wonder if there existed outright rejections, or negative reactions,

to Pythagorean thought in the Middle Ages. If indeed they appeared, they are not obvious in the works that have been considered here. Rather the opposite seems to have been the case, that is, that because Pythagorean ideas were respectfully if not enthusiastically transmitted by Christian thinkers from Clement of Alexandria, Saints Augustine and Jerome, and Bishop Isidore of Seville onward, these ideas came to be not only accepted but transformed into the new language of Christianity, that is, Christianized. In this new linguistic realm, many of the "old" ideas continued to have a life of their own, as the modern writer David Fideler has pointed out, in terms such as *celestial harmony* and the significance of number as a cosmic paradigm.[74] If some medieval thinkers, such as those in the School of Chartres, were more enthusiastic about Pythagoras, this was due in part to their enthusiasm for Plato's *Timaeus,* which was universally regarded as a Pythagorean work. Even those writers who were more interested in Aristotle, such as Albertus Magnus and Thomas Aquinas, did not reject Pythagoras, for Aristotle had in general approved of him too.[75] Even though they quibbled at times with Boethius's discussions of Pythagorean number, the views they expressed respected Boethius and his greatest gift to the Middle Ages, the (Pythagorean) quadrivium.

Paradoxically, this widespread respectability for Pythagoras in the medieval world allowed the doctrines of Pythagoreanism to become a stimulus for the ingenuity of its superstitions. Corrupted or not, ideas and concepts that had their roots in the Pythagoreanism of Antiquity as well as in Druidism became so embedded in medieval thinking that, it appears, they penetrated all aspects of daily life. The significance of these ideas shows that Pythagoreanism, in a dazzling array of new and varied forms, saturated medieval culture at both the intellectual and popular levels. This saturation is reflected, as seen in chapters 11 and 12, in a variety of ways in the visual arts.

PART III

PYTHAGOREANISM IN ART AND ARCHITECTURE

PYTHAGOREANISM
IN ANCIENT ART
AND ARCHITECTURE

From the time of Timaeus of Tauromenium, the first historian of Magna Gre-cia, to that of Pompeius Trogus, and to that of Porphyry, a steady stream of testimony associates Pythagoras with southern Italy. As we have seen in earlier chapters, that testimony consistently informs us that Pythagoras's role as an educator and preacher to the people of Croton and the rest of southern Italy made him an important socio-politico-religious figure in Magna Grecia. In-deed, if Porphyry's third-century AD observation is to be believed, it was fol-lowers of Pythagoras who originally established the Greek colonies in south-ern Italy.[1] Pythagoras's influence in the centuries after his death and his continued veneration by his followers are reflected in a consistent tradition of portraits in both Greek and Roman sculpture. This influence has also been corroborated by recent archaeological finds.[2]

At least as early as the time of Aristotle, the worship of Apollo was closely associated with Pythagoras. The spread of the cult of Apollo from its native Greece to southern Italy parallels the simultaneous spread of the influence of Pythagoras. Thus Pythagoras's legacy in southern Italy included not only the reformatory spirit that taught people to live restrained and virtuous lives, but also his injunction to worship one god, Apollo. As we have seen in earlier chapters, by late Antiquity the most fervent followers of Pythagoras had come to regard him as the son of Apollo and thus a deity in his own right, meriting not just veneration but something approaching ritualized worship. In this chapter I propose that Pythagoreans, moving beyond the tradition of repre-

senting him in portraits, began to develop a religious architecture that incorporated various iconographic and symbolic elements of their doctrines. Using the very limited extant evidence, we look at the various ways in which Pythagoreanism appears to have influenced and inspired artists and architects in Antiquity.

Antique Images of Pythagoras

Few Greek portraits of Pythagoras have survived, but those few have much in common. The earliest and probably best authenticated appear on two silver tetradrachma coins, one now in the Cabinet des Médailles at Paris (fig. 1) and the other now in the Gulbenkian collection at Lisbon (fig. 2). Both coins were minted at the Greek city of Abdera in northern Asia Minor about 430–425 BC, some seventy years after Pythagoras's death.[3] Like most Abderan coins from the sixth, fifth, and fourth centuries BC, these two are stamped on the reverse with the name of the magistrate during whose term they were issued, and with an emblem or logo associated with that magistrate. The emblems stamped by most magistrates of the period are simple figures such as rams' heads, amphorae, or lyres; in a few cases the chosen emblem is associated with the magistrate's name in a kind of visual pun. (The coins issued by a fifth-century magistrate named Dionysas, for example, bore on their obverse a stylized portrait of the god Dionysius.)

The Paris and Lisbon tetradrachmae, which were issued by a magistrate named Pythagores, appear to fall into this latter category. Each shows a wavy-haired, short-bearded man with high cheekbones and a prominent nose—an image almost certainly not that of the magistrate himself but instead a portrait of Pythagoras, which the magistrate seems to have adopted as a kind of self-congratulatory emblem exploiting the similarity between his name and that of the famous sage. The facial features of the two portraits (which point in opposite directions) are similar enough to suggest that they could have been based, directly or indirectly, on the same image—possibly even a statue of Pythagoras created from life by one of his contemporaries but since lost. Both of these coins show the portrait head set within a square, which in turn is set within the circular shape of the whole. Although the idea of inscribing a square within a circle first appears here in connection with Pythagoras, it was to be published (together with its corollary, the circle within the square) by Euclid in about 300 BC and appears to have resurfaced in later Pythagorean writings that relate the tetrad to the sphere.[4] This formula will reappear in buildings associated with Pythagoreanism, starting with the Pantheon, which is discussed in chapter 10.

It is remarkable, but perhaps not astonishing, that the memory of Pythagoras should have been so powerful in Abdera. Abdera was the birthplace of the influential Pythagorean philosopher Democritus, who was alive in 430 BC, and whose writings, as described in chapter 5, included a now-lost work on Pythago-

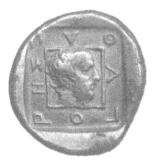

Figure 1. Portrait of Pythagoras, coin from Abdera, verso, ca. 430–425 BC. Bibliothèque Nationale de France, Paris. Photo courtesy of Bibliothèque Nationale

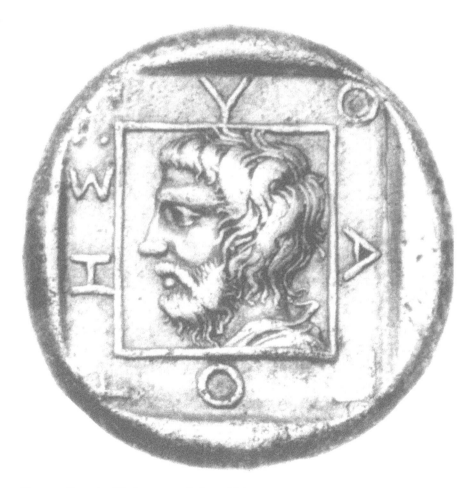

Figure 2. Portrait of Pythagoras, coin from Abdera, verso, ca. 430–425 BC. Gulbenkian Museum, Lisbon. Photo courtesy of Gulbenkian Museum

ras;[5] also, the chief deity of Abdera was Apollo, the one god Pythagoras reportedly worshipped.

Surviving inscribed Greek portraits of Pythagoras also include a number of bronze coins minted at Samos during the Roman imperial period, which show the full figure. Those in the best condition (despite a great deal of surface wear) include one now in the Brera Gallery at Milan (perhaps dating from the second century AD), which represents Pythagoras standing and wearing a himation, a characteristic ancient Greek garment worn draped loosely over one shoulder. He carries a scepter in his right hand and points to a sphere mounted on a stand, which suggests that he is represented in the act of teaching about the universe. Another, at the British Museum in London and of unknown date shows Pythagoras seated, partially covered with a mantle that leaves him nude from the waist up, similarly pointing with his right hand to a sphere mounted on a stand. Both these examples appear to show the philosopher sporting the same short curly hair and short beard as on the Abdera coins.[6] An inscribed contorniate now in the Bibliothèque Nationale in Paris (fig. 3A), whose surface is unfortunately very worn, shows a bearded Pythagoras, also full bodied and wearing a thin garment, in a seated position with one hand on his lap and the other raised to his chin; he appears to be contemplating something that can no longer be seen. Of particular interest is the fact that this portrait of Pythagoras is on the reverse side of this medal, while its obverse is dedicated to a representation of Apollo-Helios with seven rays emanating from his head (fig. 3B). Although it is of uncertain date and may have been made later, perhaps in the fourth century AD, the portrait type appears to be generally similar to those of the other coins described.[7]

A distinctly more impressive representation of Pythagoras appears in an inscribed marble shield-portrait from late Greek Antiquity that was discovered in the late 1980s in the excavations of Aphrodisias (fig. 4).[8] This type of portrait includes a bust set in a tondo, from which the image appears to lean out, suggesting it was made to be seen from below. This image constitutes the first sculptured portrait of Pythagoras, aside from those on coins, to be identified with certainty. Although the technique of this sculpture has helped archaeologists to date it from the early fifth century AD, its form suggests that it was modeled on a late classical example. Compared with the smaller images, this early fifth-century figure has a majestic appearance: it is a frontal bust portrait, with the head slightly averted and projecting from the circular frame on which his name is inscribed. The face appears alert, suggesting acute mental activity. The abundant long hair of Pythagoras is slightly curly and held in place by a headband or fillet. A long and curly—but thick—beard covers his chin, while a thick moustache covers his upper lip. His face is long and modulated, characterized by high cheek bones and a contracted jaw; his shoulders are covered by a garment.

This portrait, which has been studied by archaeologist R. R. R. Smith, is one of eleven shield-portraits found in the debris of a sumptuous building

Figure 3. (A) Portrait of Pythagoras, contorniate, verso; and (B) Apollo-Helios, recto, date unknown. Bibliothèque Nationale de France, Paris. Photo courtesy of Bibliothèque Nationale

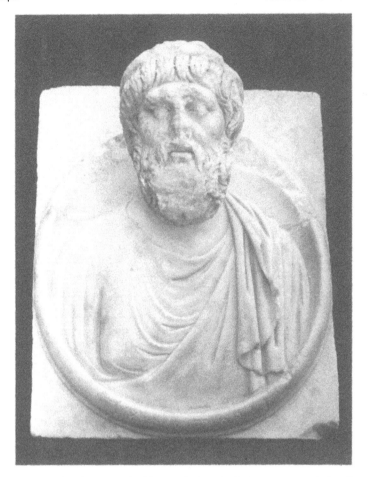

Figure 4. Portrait of Pythagoras, shield, inscribed, early fifth century AD. Aphrodisias Museum, Geyre. Photo courtesy of New York University Excavations at Aphrodisias

complex that may have been, as Smith suggests, an academy or school of philosophy that specialized in Neoplatonic learning. That some of the other images found in the same group (Socrates, Aristotle, Alexander the Great, although Plato is missing) were famous teachers and their pupils supports this possibility. The representation of both Pythagoras and Apollonius of Tyana in this small but prestigious series underlines the Neoplatonic character of the group.[9] That these portraits were found in the ruins of a richly decorated structure and that they are shield-portraits which were placed high up on a wall indicate that they had, as Smith points out, an honorific significance as images of immortals of high culture. The use of the fillet, commonly worn by poets and not by philosophers, on Pythagoras's portrait likely suggests, as Smith observes, the mystical aspect of his teachings. The inclusion of Pindar in

this group lends added support to the suggestion (made in chap. 6) that Pindar was a Pythagorean.

These inscribed Greek images suggest that a coherent tradition for the representation of Pythagoras existed in Greece from classical times to late Antiquity. This tradition showed him—whether sitting, standing, or in bust form—bareheaded and with thick short curly hair and a short curly beard. In addition to bearing these inscribed images of Pythagoras, all posthumous, some Greek coins from classical times display emblems, such as the seven-string lyre and the tripod (the three-legged stand that was the sacred symbol of Apollo), which are probably Pythagorean.[10]

A Roman tradition of sculptured portraits of Pythagoras was established early and lasted several centuries. In about the fourth century BC, the Senate decreed that a statue of Pythagoras should be set up in the center of the city.[11] Early in the second century AD the emperor Hadrian, who, as described in chapter 6 was a Pythagorean, commissioned a herm of Pythagoras to adorn the grand central piazza of his magnificent country villa at Tivoli.[12] These sculptures no longer exist, but a variety of other Roman images that do survive have been thought by some to represent Pythagoras.

These extant images include two marble portrait herms, now at the Museo Capitolino in Rome, one of a turban-wearing youngish man with a smooth, narrow face (the nose is a modern restoration) and a long, thin beard (fig. 5), and the other a copy of a fourth-century BC Greek image, now a somewhat weathered representation of a tired-looking older man with short curly hair and a curly pointed beard (fig. 6).[13] A marble bust in the Museo Archeologico at Ostia shows a young man with a squarish face, short hair (wreathed), and a very short beard;[14] one in the Musées Royaux d'Art et d'Histoire at Brussels shows a handsome young man with short hair and a short beard. The latter has been thought to represent Pythagoras because the pedestal underneath the head contains an inscribed Y.[15] However, because the pedestal appears to be a later addition, this inscription must be discounted.

A bronze bust, now in the Museo Archeologico Nazionale at Naples, represents a virile-looking, square-faced man with curly hair and a short beard, furrowed forehead, and turban-hat (fig. 7).[16] Some have argued that because this figure wears a turban he must be Pythagoras.[17] However, the face is completely different from that of the other turbaned figure (fig. 5), as is the turban (or hat). The fact that no Greek precedent showing Pythagoras wearing a turban or hat is known to us also argues against presuming that this bust is that of Pythagoras. More to the point, ancient authors (as noted in previous chapters) tell us Pythagoras was handsome, and that he wore white clothing and trousers; there is no known description of him wearing a turban. Thus, although a turban might have been chosen to indicate some Eastern connection of an individual, it is not a known attribute that would identify Pythagoras as opposed to any other figure of the late Hellenistic world, when, given that Eastern connections were well established, the turban was not a rarity. In fact,

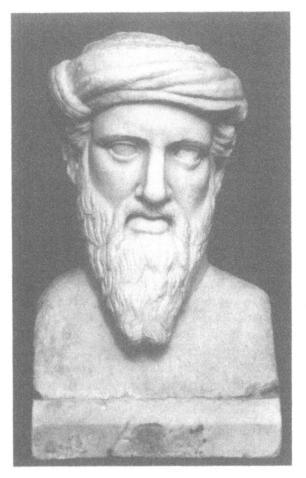

Figure 5. Portrait of Pythagoras, herm, date unknown. Museo Capitolino, Rome. Photo courtesy of Archivio Fotografico dei Musei Capitolini

all these busts are uninscribed and essentially undated. All are modern attributions.

That Romans were still interested in portraying Pythagoras as late as the early third century AD is known from the fifth-century description by Christodorus of Thebes in Egypt of the celebrated gymnasium of Zeuxippos, built in the early third century AD by the emperor Septimius Severus in the ancient city of Byzantium. Among the eighty bronze statues that Christodorus lists (all lost in a fire shortly after he wrote), one represented Pythagoras: "There stood, too, Pythagoras the Samian sage, but he seemed to dwell in Olympus, and did violence to the nature of the bronze, overflowing with intellectual thought, for methinks with his pure eyes he was measuring Heaven

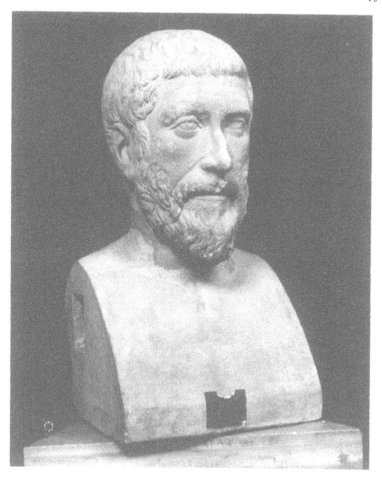

Figure 6. Portrait of Pythagoras, herm, date unknown. Museo Capitolino, Rome. Photo courtesy of Alinari (Anderson)

alone."[18] Other statues in the gallery included characters from Homer; the god Apollo in particular, who was very favorable to Troy in the *Iliad,* was represented three times. This Homeric emphasis suggests that the program of this gymnasium may have been at least in part Pythagorean. (In this context it should be remembered that Pythagoras himself claimed to have lived a former life as Homer's Dardanian/Trojan warrior Euphorbus) It may be relevant that Septimius Severus's wife, Julia Domna, included in her circle of intellectual friends the writer Philostratus, whose immortal biography of Apollonius of Tyana (in which Apollonius was cast as a second Pythagoras) was written at her request.

Although its date is not known, another epigram describing an unknown

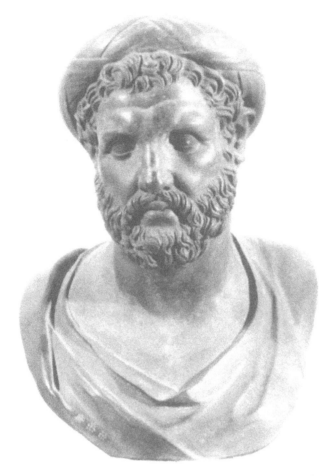

Figure 7. Portrait of Pythagoras, date unknown. Museo Archeologico Nazionale, Naples. Photo courtesy of Soprintendenza per i Beni Archeologici delle province di Napoli e Caserta

statue of Pythagoras may refer to the same one at Zeuxippos. This description, by a certain Julianus Prefect of Egypt, reads: "The sculptor wished to portray not that Pythagoras who explained the versatile nature of numbers, but Pythagoras in discreet silence. Perhaps he has hidden within the statue the voice that he could have rendered if he chose."[19] Like the one of Christodorus, this epigram emphasizes the mystical character of Pythagoras as opposed to his mathematical attributes.

An inscribed late fourth-century AD Roman floor mosaic from a library in the Greek city of Lyrbe, now in the museum at Antalya (in Turkey), exhibits the characteristics noted in the Greek examples. It shows a frontal bust image of Pythagoras wearing a himation (fig. 8). Framed by thick short hair and a

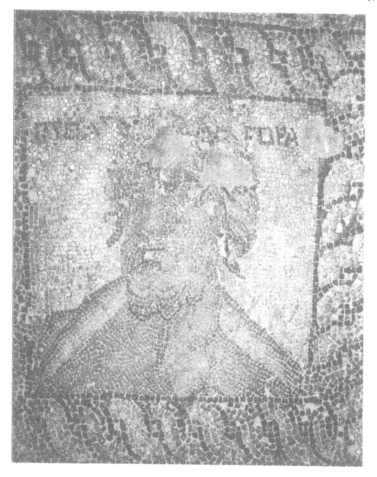

Figure 8. Portrait of Pythagoras, mosaic, inscribed, late fourth century AD. Museum, Antalya. Photo by Fatih Onur

short beard, his long, narrow face has generalized Greek features, while its expression, with eyes cast upward as though attentive to a speaker on high, suggests he is undergoing a mystical experience. Found in the ruins of an agora, this mosaic featured the seven wise men and nine philosophers, one of whom was Pythagoras (another was his teacher, Pherecydes), individually portrayed in separate rectangular formats, surrounding a centerpiece representing Homer, the Iliad, and the Odyssey.[20]

As in Greece, a tradition for the representation of Pythagoras certainly existed in Rome, with examples—unfortunately now lost—documented from the fourth century BC to the third century AD. The extant Roman images have been identified only tentatively, and relatively recently, with Pythagoras. How-

ever, their dissimilarity to each other (in contrast to the mutual similarity of the extant inscribed Greek images) suggests that the tradition for portraying him in Roman art may have had no fixed models or iconography.

Possible Pythagorean Impulses in Classical Antiquity

Not every town or city in classical Greece had a temple dedicated to Apollo. However, if we are to trust Iamblichus, the tradition that connects Pythagoras with temples dedicated to Apollo is an old one. According to Iamblichus, Pythagoras's putative father, Mnesarchus, celebrated the sage's birth by building on the island of Samos a temple dedicated to Apollo, Pythagoras's "true" father. This temple would therefore date from the early sixth century BC, although it has not been identified with any of the temples known from archaeological evidence to have been built on Samos during what was then a period of intense building activity.[21]

In Metapontum, once a powerful city but now an isolated site of ruins, surviving evidence suggests that two now-lost sixth-century BC Doric temples were dedicated to Apollo. One is known to archaeologists as Temple B, the other as the temple of Apollo Licio. The existence of two temples dedicated to Apollo in one town is unusual; the importance of Apollo for Metapontum is underlined by literary and archaeological testimony. Herodotus describes a *manteion,* or monument and altar, dedicated to Apollo by Aristeas in the agora of Metapontum. Remains of this altar lie in the southwest corner of the agora. In addition, numerous bronze laurel (the tree sacred to Apollo) leaves have been found in the area. Further evidence that the cult of Apollo was well developed in this locality can be found in the coinage of Metapontum, which includes fifth-century representations of Apollo before an altar, holding a branch of laurel.[22] That these two temples were built, possibly during Pythagoras's lifetime, in Metapontum, the place where Pythagoras lived and taught after his escape from Croton, offers strong evidence that it was the influence of Pythagoras that brought the worship of Apollo to Magna Grecia, that is, to southern Italy.

In the district of Croton (where Apollo was also an important deity and where numerous coins showing the Delphic tripod associated with him were issued), three other sixth-century centers for the worship of Apollo existed. A great Sanctuary of Apollo was located thirty kilometers north of the city at Krimisa (modern Cirò Marina), on a promontory now known as Punta Alice. Originally built as a small temple, the sanctuary was greatly expanded later in the sixth century as can be deduced from its surviving foundations (fig. 9A). Its location close to the sea suggests that here the god served as a guardian of navigation. Numerous statues of Apollo, large and small, have been found at this site.[23] In Croton proper, a temple of the Muses (the protectors of concord and the companions of Apollo) and another temple to Apollo himself once existed (fig. 9B). These were believed to have been personally ordered by Pythagoras.

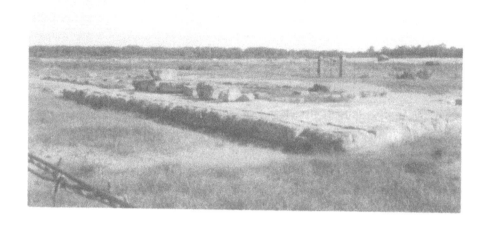

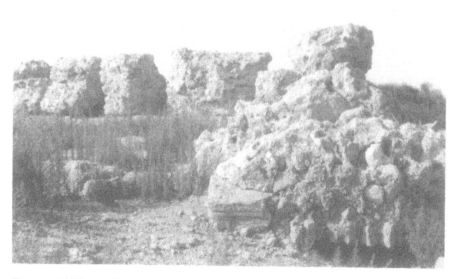

Figure 9. (*A*) Punta Alice (Cirò Marina), near Croton, ruins of the Temple of Apollo, sixth century BC; and (*B*) Croton, Greek ruins near the site of the Sanctuary of Apollo, sixth century BC. Photos by Judy Bonderman

The latter temple was apparently known to Aristotle, who informs us that a sanctuary to Apollo, known as the Apollonium, existed in the town.[24]

Although all these temples have essentially perished, it is surely significant that during the century when Pythagoras lived temples to Apollo are known to have existed in all the places where he resided and taught (Samos, Metapontum, and Croton). This further supports the suggestion that it was his influence that brought the worship of Apollo to Magna Grecia, that is, to southern Italy. In addition, the history of Italic oracles suggests that Apollo was known in Etruria during this time.[25] This may account in part for the ancient speculation recorded by Plutarch that Pythagoras might have been born in Etruria.

The Iconography of Apollo in Roman Art and Architecture and Its Pythagorean Connections

The original settlement on the Palatine was known as *Roma quadrata* and comprised four parts related to a center, or *mundus*. It is tempting to think that this organization may have reflected a predetermined geometry such as that later advocated by Pythagoreans, for example, Vitruvius. However, this is not the case: surviving evidence suggests that the four parts of archaic Rome were loosely connected regions rather than geometrically determined divisions relating to a square.[26]

Still, there is reason to believe that the influence of Pythagoreanism was felt in the religious and cultural iconography of ancient Roman buildings. As we have seen, Apollo was believed in Greek Antiquity to be the only god to whom Pythagoras sacrificed; in later Antiquity it came to be believed that Pythagoras was in fact an incarnation of Apollo. Thus there may well be a Pythagorean significance to the construction of Rome's first temple dedicated to Apollo, which took place as early as 431 BC.

Because Apollo was regarded as a "foreign" deity in Rome, this temple was built outside the official city boundary, the wall constructed a century earlier by Servius Tullius, Rome's second "founder" and sixth king.[27] The site was in the Campus Martius, just behind the future location of the Theater of Marcellus. Although little is known about the design of the temple, its history (it was built to thank the god for the end of a plague outbreak that had ravaged the city in 433 BC) and its name (the temple of Apollo Medicus) suggest that the induction of this Greek god into the Roman pantheon was precipitated by a Roman perception of him as a healer. Further, the dedication of this temple demonstrates that at least some Romans were already worshippers of Apollo at the time of the plague.[28]

Evidence indicates that indeed the cult of Apollo was well known in Rome before the building of the first temple dedicated to him. As early as the fifth and fourth centuries BC, the Roman oligarchy sought advice from Apollo's oracles.[29] Livy describes a (victorious) meeting of the consuls of Rome in 449 BC in a place then known as Apollo's Precinct.[30] It was at Apollo's command that,

during the Samnite wars in the fourth century BC, the Romans erected the above-mentioned statue of Pythagoras on the *comitium*, the center of public assembly in the city. Pliny informs us that through the Pythian oracle Apollo advised the senators of the city to erect this sculpture because Pythagoras was the wisest of all Greeks.[31] Writing three centuries later, Pliny expresses his amazement that in commissioning this statue the senators of Rome rated Pythagoras even above Socrates (who is sometimes cited as a protégé of Apollo). These examples show that Apollo was esteemed as an oracular god early on in ancient Rome and that in Roman thought he was connected with Pythagoras.

Cicero tells us that devotion to Apollo was known in Rome at least from the fifth century BC; he also makes it clear that in his time Apollo was regarded as the sun god and that his name referred to the abjuration of multiplicity.[32] Games dedicated to Apollo are also known to have existed in ancient Rome.[33] This shows that his cult was popular among plebeians and expressed in public style, which is underlined by the development of *ludi Apollinares*. Games in honor of Apollo are known to have existed in Rome before their official institution in the third century BC.

Apollo was honored in other ways by the ancient Romans. Livy cites him as one of the six deities chosen to be honored in a ceremony known as the Lectisternia by Romans in 399 BC, through the provision of luxurious couches intended for their relaxation.[34] A few years later, he tells us, the famous Roman general Marcus Furius Camillus led his troops to battle and to the capture of Veii, the wealthiest of Etruscan cities, inspired by the "holy breath" of Pythian Apollo. To celebrate this victory, the Romans sent a magnificent golden bowl to Apollo's sanctuary at Delphi.[35]

Shortly thereafter, Livy continues, after having made peace with Caere (Cerveteri), the Romans dedicated a second temple to Apollo. Because it was built after the ravages of a war, it is possible that this temple too was dedicated to Apollo Medicus. Livy does not tell us for sure; however, he mentions that among its priests were both patricians and plebeians.[36]

The independent development of Apollo on Italian soil may explain his peculiar, non-Hellenic, role as Apollo Medicus, a role that had been proclaimed in the iconography of the first temple dedicated to his honor in the city. According to Livy's explanation, this temple was dedicated to Apollo by the consul Julius himself on behalf of the public health of the city.[37] The role of Apollo as *medicus* reappears in 180 BC, when, with the cessation of an outbreak of plague that had ravaged Rome, the magistrates of the city ordered a series of golden statues intended as supplication to Apollo.[38] The modern scholar Jean Gagé shows that this idea of Apollo as god/medical doctor developed into a strong tradition starting in the fifth century BC in the cities of Latium (the area surrounding Rome) and those along the banks of the Tiber, which periodically suffered fever-borne illnesses and the plague. Gagé emphasizes that the mystical practices of Pythagoreanism played a major role in the diffusion and develop-

ment of the Roman Apollo. He shows that the earliest expressions of the worship of Apollo in Rome were connected with the infiltration of Pythagorean ideas, enthusiasm for which inspired early Romans to believe, in retrospect, the dogma reported by Livy, Cicero, Plutarch, and others (even if they personally disagreed with it), that Pythagoras had been the teacher of their beloved King Numa, the first to revere Apollo.[39] The linking of Apollo with Pythagoras as an inspiration in the iconography of Roman culture and architecture may account for Ovid's later association of Pythagoras with Apollo's curative role and the field of medicine in general, as well as the views of Apollonius of Tyana and Quintilian that Pythagoras was especially gifted at soothing the troubles of man (as discussed in chap. 2). Less formidable than he was in Greece, the Roman Apollo thus played a socially cathartic role in Rome, where he was accepted by all classes of Roman society.

A third temple to Apollo, known for its remarkable luxury, was built on the Palatine Hill as part of the emperor's own palace by Augustus Caesar in about 36 BC. To obtain funding for the golden tripods (the symbol of Apollo) with which he decorated this temple, Augustus ordered the melting down of a large number of silver statues. The site for this white marble temple was purportedly identified by the god himself with a bolt of magical lightning. A magnificent library, the Bibliotheca Apollinis, was constructed by Augustus alongside the temple and dedicated to Apollo.[40] Also during Augustus's reign, in about 20 BC, Rome's first temple to this god was rebuilt. Known at the time as the Temple of Apollo Sosianus (after its builder), its prestige was so great as to merit the transportation of a special cult statue of Apollo from Seleucia, in Phoenicia, for its sanctuary.[41]

Augustus further demonstrated his piety toward Apollo by commissioning a statue of the god to be placed on a public street of the capital.[42] Even more impressive was the scandal Augustus provoked in the capital by appearing at a banquet dressed as Apollo, thus implying, as the citizenry of Rome well noted at the time, that "Caesar is Apollo."[43] This connection was made even more poignant in a story reported by Suetonius concerning the divine paternity of Augustus. According to this account, Augustus was miraculously conceived in the temple of Apollo and the moment of his birth miraculously announced in the Roman senate by Nigidius Figulus, the Pythagorean astrologer discussed in chapter 5 who was so admired by Cicero. After Augustus's birth, his father dreamed that the sun had risen between his wife's thighs.[44] A few days later, the infant Augustus, who had been lost, was found with his face turned toward the rising sun. Although such signs might suggest a half brother–like relationship between Augustus and Pythagoras, Suetonius's vita of Augustus does not mention the sage or describe the emperor as a Pythagorean. Suetonius does, however, report several curious facts with suggestive Pythagorean implications: Augustus was an abstemious drinker who slept seven hours every night; and he had a "constellation" of seven birthmarks on the front of his torso.[45]

Augustus's sympathy with Pythagoreanism is suggested in the design he cre-

ated in 28 BC for an immense mausoleum for himself and his family. In effect an artificial *tumulus* of cylindrical shape, constructed of earth, and faced with marble around its rectangular base (which has completely disappeared), its interior walls formed a plan that radiated outward from the center, symbolically linking it to the topography of the surrounding city and suggesting a Pythagorean system of cosmogony in which the celestial bodies circle around a central fire.[46] Access to a corridor leading to the concentric divisions of the huge circular interior was restricted; it could be entered only through a small portico, which appears to have been preceded by a rectangular porch.[47]

Augustus's devotion to Apollo was inherited by his successor Tiberius (AD 14–37), who brought an enormous statue of the god from Syracuse to the library of a new temple he built, and by Caligula (AD 37–41), who built a temple dedicated to Apollo at Ephesus. It was perhaps Nero (AD 54–68) whose worship of Apollo was the most marked of all the Roman emperors. The extraordinary pomp with which he worshipped at the Palatine Temple of Apollo as well as his personal association with the sun god as a chariot rider are described by Suetonius.[48] Nero thereby became an Apollonian prince as the idea of a solar theology established itself during the empire. Thus Apollo, who had originally been a god for all classes in Rome, and whose first temple was built outside the city walls, gradually developed into the most important imperial deity.[49]

▲

There is a consistent tradition, however modest in terms of surviving examples, for the representation of Pythagoras in both Greek and Roman Antiquity from the fifth century BC to the fifth century AD. That he was represented on coins in Greek cities early on, before other philosophers, serves to certify the unique status he enjoyed at that time as a man of wisdom. The sentimental inclination of the Romans to link the wisdom of their beloved first king with that of the prestigious Greek sage reaffirms their affection for Pythagoras, whom Ovid regarded as a healer, and for his father-god Apollo, who was early on regarded as a healer in Rome. Undoubtedly many examples demonstrating remembrance of Pythagoras and the continuation of his inspiring influence have been lost. (One such example may have been the Septizodium,[50] a monumental Roman building thought to have honored the seven planets; it was built by Septimius Severus, who, as noted earlier, was at least in touch with Pythagoreanism.) Nevertheless, the message of the surviving evidence is clear: the worship of the foreign deity Apollo, who was in charge of the light of the sun and the music of heaven, appears to have come to Magna Grecia during the lifetime of Pythagoras and to have become especially important in those areas frequented by him and his followers, that is to say, southern Italy. Ultimately the worship of Apollo was to triumph in Rome, and it was in Rome that the earliest Pythagorean place of worship known to us so far was built.

The Oldest Surviving
Pythagorean Building
and Its Significance

.·.
. · .
. . . .

Just before the beginning of the first century AD, Cicero's friend Nigidius Figu-lus had revived interest in the philosophy of Pythagoras. During the first years of the new century Ovid had given a long account of Pythagoras that was to popularize him for future generations and centuries. By the middle of the first century AD, in the reign of Nero, Apollonius of Tyana brought further atten-tion to Pythagoras not only through the example of his own life but also in his purported writings (which were later collected by Hadrian). Although it seems that the appearance and development of the cult of Apollo in Italy was the re-sult of the influence of Pythagoreanism, the Greek temple was not designed to accommodate worshippers in an interior space. Indeed, we have, until now, no information on gathering places that focused on interior spaces in which faith-ful members of this sect might meet and perform their ritualistic obligations to each other and to their divine founder.

▲

It was during the reign of Nero that a unique edifice, and one without known precedent, was constructed in Rome. Now recognized as the oldest surviving Pythagorean structure, this large and remarkable building, known as the Subterranean Basilica at Porta Maggiore, is thought by archaeologists to date from about AD 45 to 54 (fig. 10).[1] Constructed just outside the Porta Maggiore, which was erected in AD 52 by Claudius, its location and under-ground nature suggest a clandestine activity that could not have been allowed

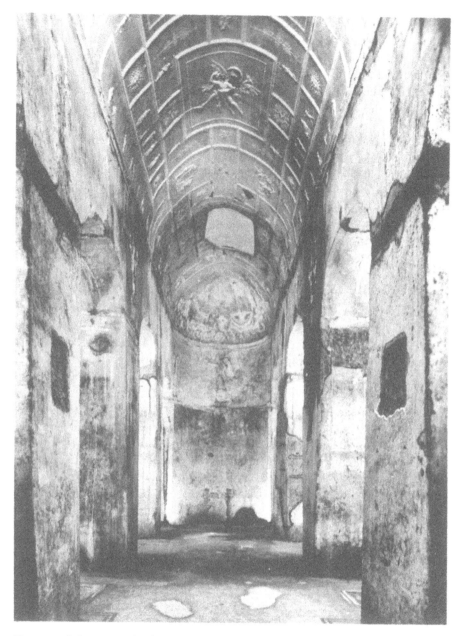

Figure 10. Subterranean Basilica at Porta Maggiore, Rome, ca. AD 45–54, interior view to apse. Photo courtesy of Archive of the American Academy in Rome and Fototeca Unione

within the city walls. That it served a religious purpose is evident from the re-
mains of a *cathedra* (celebrant's throne) ornamented with stucco *orante* (fig-
ures with arms outstretched in attitudes of prayer), as well as from the remains
of an interior sacrificial altar and of the sacrifice itself. Remains of pig bones,
discerned in the debris of the altar, are consistent with the then-current notion
that Pythagoras allowed such sacrifices as an exception to his ban on sacrific-
ing animals.[2]

The plan of this building constitutes the earliest known instance of the
adaptation of the Roman basilica plan for religious purposes (fig. 11). A
square atrium leads directly into a large rectangular interior space, which is di-
vided by two sets of three piers into a nave and two aisles that parallel it on ei-
ther side. The two flanking aisles terminate in flat walls, while the nave extends
from the atrium to a semicircular apse, which housed the altar. The location of
the apse directly opposite the entrance allows for the spectator's view, immedi-
ately upon encountering the space, to proceed directly to the altar. The longi-
tudinal axis of this view runs from the entrance in the west to the apse in the
east. Evidence indicates that the altar was composed of a horizontal slab rest-
ing on two posts. Above, the interior space is entirely vaulted—the nave and
side aisles with long barrel vaults, and the atrium with four small transverse
barrel vaults in a cradled arrangement. All of these characteristics are now as-
sociated with Christian worship; however, this sumptuous vaulted structure,
articulated with reliefs and mosaic floors, was designed and built long before
the Christians began to build their first rudimentary churches.

This basilica is particularly remarkable in two respects. First, it was pur-
posefully constructed deep underground, with its system of vaulting designed
to direct the weight of the overhead soil to the outer walls of the building. Sec-
ond, its primary source of illumination was natural light entering from above
through a circular hole, or oculus, located in the atrium. The natural lighting
appears, from the evidence of socles, to have been supplemented by cande-
labra, which hung from the arches formed by the piers.[3]

Paradoxically, in Antiquity the underworld was believed to be a source of
light, through the agency of Apollo, since it gave birth and a resting place to
the sun each day. The Pythagorean idea of "descending to the divine" was to
be inherited, as Kingsley has shown, by Christians and Jewish mystics.[4] It is
thus possible that this underground space where people gathered was intended
for "healing" and was dedicated to Apollo. Most likely, its oculus, the single,
monadic aperture through which light penetrated the interior, symbolized
Apollo. Indeed, as is discussed below, a "miracle" of Apollo is represented
over the altar.

In a brilliant analysis, Carcopino demonstrated that the distinctive qualities
of this building conform to the characteristics of Pythagorean worship and
liturgy as described by Pythagoras's late biographers Diogenes Laertius, Por-
phyry, and, especially, Iamblichus, all of whom claimed to have obtained their
information from earlier sources.

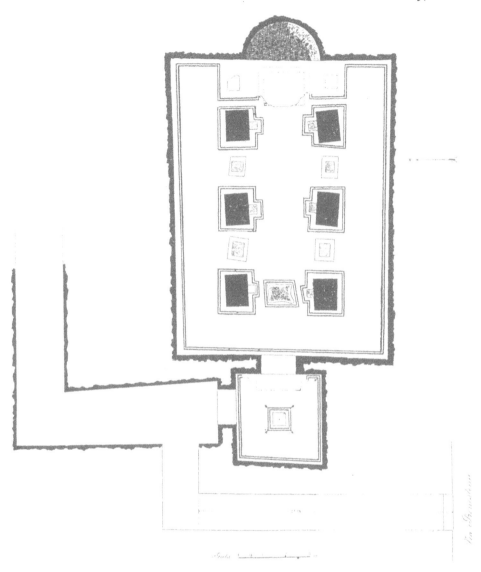

Figure 11. Subterranean Basilica at Porta Maggiore, plan. From Goffredo Bendinelli, *Il monumento sotteraneo di Porta Maggiore in Roma* (Rome, 1927)

The location of this basilica in what was then a countryside retreat outside the *pomerium* (the center of Rome) suggests, Carcopino explains, a specially chosen location that signals the teachings of Pythagoras. Pythagoras's biographers describe him and his disciples meditating in the solitude of gardens, where, removed from the tumult of city life, the faithful could take walks and engage in contemplation.[5]

The idea of building the basilica entirely underground no doubt in part re-

flects the secretiveness that had characterized Pythagoreanism since its incep-
tion, as well as the persecution Pythagoreans endured in the later centuries of
Antiquity, that is, in times that could be remembered. Carcopino, however,
finds it significant for another reason as well. He argues persuasively that it
likely also refers to the stories told of Pythagoras sequestering himself in a cave
of his own construction and later emerging into the daylight, and that it sym-
bolizes his descent into Hades, followed by his resurrection, which demon-
strated his divine nature.[6] Pythagoras also, Porphyry points out, met his
friends in caves, and while in Samos he constructed a subterranean grotto,
where he meditated at night and studied philosophy. He was also believed to
have descended into a secret cave while visiting Crete.[7] Such anecdotes, to-
gether with the underground construction of this basilica and its illumination
by a single beam of natural light from the outside world, suggest Pythagorean
preferences for a dark or underground location where mysteries might be con-
templated in anticipation of the ascent of the soul into the light of celestial im-
mortality.

The single shaft of light that entered the nave of the basilica from the atrium
a considerable distance away may well be related, Carcopino suggests, to the
slanting, spectral light that illuminated the underground space described by
Plato in book VII of *The Republic*.[8] Plato's parable pictured men as prisoners
in a cave (the visible world), where they could, with appropriate guidance and
great effort, learn to deduce the true nature of the world from shadows cast on
a wall in front of them by a source of light above and behind them. Long be-
fore Plato, Homer (with whom Pythagoras had connected himself by virtue of
claiming that he, Pythagoras, had previously been Euphorbus, a character in
the *Iliad*) had used the cave as a symbol of the cosmos, where divinity might be
sought. Empedocles too had seen in the cave a cosmic power that guides
souls.[9] Long after the time of Plato, Porphyry was struck with such imagery,
which he explained was originally a Pythagorean idea. Speaking of caves as
symbolic of invisible powers, he said that caves and caverns were sacred places
and images of the cosmos: "It was under these influences, I think, that the
Pythagoreans, and Plato after them, called the Cosmos a cave or grotto."[10]
Clearly, to the biographers of Pythagoras, worship in Pythagorean shrines was
intimately related to the indispensable presence of light: "Do not discuss
Pythagorean matters without a light."[11] Stucco decorations throughout the
basilica, representing candelabra, appear to confirm the importance of light to
Pythagorean worship.

The orientation of the basilica, with the apse in the east and the atrium in
the west, contrasts with that of Greek temples. In them, according to Por-
phyry, the statues and entrances face the east, and those who enter look
toward the west when they stand before the cult statues to make offerings.[12]
This reversal of existing convention was probably deliberately chosen by the
Pythagoreans to signify their respect for the rising sun as symbolic of their di-
vinity and their obedience to the injunction of their faith not to turn their

backs to the sun ("Pythagoreans . . . would watch for sunrise to pray to the sun as it rose"). The setting sun was also significant for Pythagoreans; they associated it with study and meditation. Diogenes Laertius and Iamblichus report that at Croton Pythagoras taught in the early evening, after the sun had begun its descent.[13]

Even the layout of the entrance leading into the basilica is evocative of Pythagorean ritual. According to Iamblichus Pythagoras had recommended narrow paths in preference to busy streets: "Leave the highway and use the footpaths."[14] Homer had suggested that the proper way to approach a cave was to descend on a path, and Porphyry had stipulated that the appropriate place for the descending path was along the northern side of the cave.[15] Accordingly, the basilica is entered via a narrow passageway that descends downward along the northern edge of the building. Reaching bottom at the northwest corner of the atrium, the path turns sharply south, into the "cosmic cavern," where worshippers were appropriately surrounded and engulfed by the celestial light of salvation.

Directly ahead of them in the atrium was a small pool in which they could symbolically cleanse and purify themselves with water before entering the basilica. The pool also served another function: Pythagoras had instructed his disciples, Iamblichus reports, to enter a sacred space on the right and to exit it on the left.[16] Carcopino suggests that this principle accounts for the innovative addition, in this structure built for religious purposes, of two side aisles to the nave. Blocked by the pool from approaching the altar directly, the faithful were forced to enter by walking up one of the side aisles (presumably the right) and exit by walking down the other (the left).[17]

Once they were settled inside the sanctuary, the site of worship (fig. 12), the faithful took a libation from a full cup as prelude to the sacrifice. This event was the most solemn moment in the liturgy and required the complete concentration of the participant.[18] After the sacrifice was completed, the faithful enjoyed a communal meal with bread, wine, cakes, vegetables, and, sometimes, meat. For this convivial occasion, the participants, dressed in clean white linen, sat at tables in the basilica. Although these tables no longer exist, evidence from imprints suggests that four large marble tables were installed in the central area below the candelabra. These were presumably for the leaders of the sect, with smaller movable tables provided to accommodate the faithful. After the evening celebratory meal, the sect concluded the liturgical event with readings from ritualistic texts.[19]

Number symbolism appears to have been an important feature of the Subterranean Basilica, suggesting that those who designed it were up-to-date on the evolving philosophical interests of Pythagoreans. As described in chapter 6, it was in the first century AD that number symbolism began to play an important role in Pythagorean literature. Philo, who defined in numerical terms all matter created by god in organizing the universe, died in AD 45—about the time the basilica was being constructed—and the work of Anatolius, Nico-

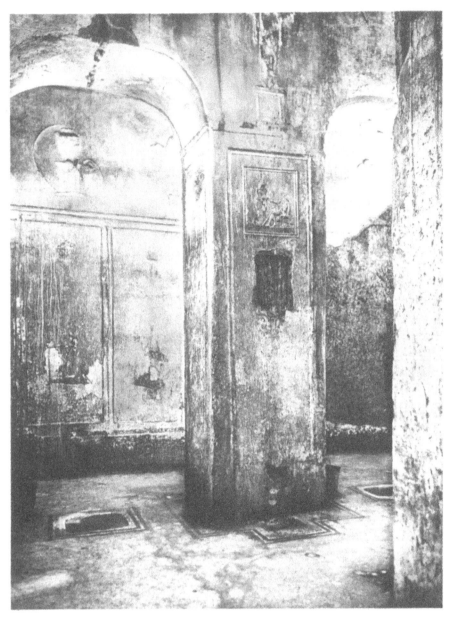

Figure 12. Subterranean Basilica at Porta Maggiore, interior view. Photo courtesy of Alinari

machus, Theon of Smyrna, and others over the next century would dramatically demonstrate continuing strong Pythagorean interest in numerological topics.

Carcopino's reconstruction of the connection between Pythagorean liturgy and the archaeological evidence of the basilica strongly supports the thesis that number symbolism was an important part of its planning and function. He notes that the large marble tables installed in the sanctuary were four in number, echoing the many fourfold subdivisions of the universe that are encapsulated in the tetraktys. (The important number four, the tetrad, also shows up as the number of cradled vaults in the atrium.) Each table seated seven persons, another extremely important Pythagorean number, which symbolized the celestial harmonies of the cosmos. Carcopino notes that according to Iamblichus, Pythagoreans honored the number ten by never arranging themselves in groups (for example, at table) larger than that number. The sanctuary thus provided seating for twenty-eight senior members of the sect, a number especially important because it was the sum of all the integers up to and including seven.[20] Fragments of three portraits, possibly depicting the founding disciples of the sect in Rome, survive on the interior piers of the basilica. On the basis of their location on the piers, archaeologists have determined that there were originally twelve portraits.[21] Twelve was another important number for Pythagoreans, being the number of signs in the zodiac and the number of pentagons constituting the dodecahedron, which, according to Plato, outlined the celestial sphere.[22]

In addition to these manifestations of the numbers four, seven, twelve, and twenty-eight noted by Carcopino, the structure of the basilica also incorporates emphasis on other important Pythagorean numbers. The monad appears in the form of the single oculus, which, representing the light of the sun, was the symbol of Apollo. The three aisles leading to the oneness of Apollo (the altar) suggest the three parts of the soul defined by Pythagoras and the paternal relation of Apollo, who rescues souls, to the congregation. Three is also the number of interior piers on each side of the nave. The total number of piers is six, the hexad, the first perfect number (equal to the product of its factors), which represents reconciliation and serves as the basis of all concord.[23] The decorations around the square holy water pool consist in four palmette motifs, each of which has six leaves.

We appear to be on solid ground in deducing from surviving evidence that the basilica was designed to express arithmological principles, and although some of the number symbolism it incorporated may be beyond reconstruction, there is reason to hope that further study of surviving evidence will significantly extend our understanding of how Pythagorean concerns were embodied in this extraordinary building.

The program of stucco reliefs that covered the interior walls of the basilica give further evidence of Pythagorean objectives in the building's design. As has been demonstrated by both Cumont and Carcopino, on the basis of their

analyses of surviving iconographical data, the sixty-five scenes on the interior walls and vaults proclaimed Pythagorean themes, including immortality of the soul, austerity of lifestyle, mitigation of the senses, and preparation for death and eternal bliss.[24] Covered with landscape scenes containing birds, flowers, and other naturalistic subjects, the *basamento* reliefs supported this iconography in suggesting the Elysian fields of the life hereafter.

The focus of the decorative scheme of this sanctuary was in the monumental apse in the east, which, despite its ruined state, dominates the spectator's attention upon entering the basilica from the west (fig. 13). Here Sappho is represented, holding her lyre to her breast and taking her suicidal leap, from the Leucadian Cliff and the Temple of Apollo, into the sea—that is, toward the altar below. Apollo, the god of Leucadia and of Pythagoras, to whom she dedicated her leap and her lyre, is positioned below, holding in his left hand the bow with which he plays the (seven-string) lyre, while he extends his right hand in a gesture of protection—or benediction—and assurance that he will rescue her and transport her to the land of the sun. Thus is Sappho's immortality assured.

The iconography of the apse of the Basilica at Porta Maggiore, with Sappho's leap taking place in the "land" of the rising sun as its centerpiece, has been brilliantly explicated by a number of scholars as an expression of Pythagorean eschatology. Carcopino's 1923 work substantiated Cumont's 1918 suggestion that the space was designed for this purpose,[25] and in 1929 an insightful analysis by the paleographer and philologist Pierre Boyancé further validated this thesis by tracing ancient linkages connecting Sappho, Apollo, the Pythagoreans, and the Subterranean Basilica. Boyancé points out the remarkable coincidence that Leucadia, the name of the cliff from which Sappho took her leap, is also the Greek name of a plant believed in Antiquity to have magical powers.[26] He goes on to note Pliny's assertions that the leucadia plant was what caused Sappho's infatuation with Phaon and that Pythagoreans were highly interested in the plant.[27] Just below the great apsidal scene is a smaller one representing Apotheosis of Victory: it is a raised stucco image, flanked by *orante* figures, representing a woman holding a crown and a palm. This linkage of the two images confirms that Sappho's leap is not her personal drama alone but an emblem of apotheosis. Boyancé concludes that the placement of these two images in this most important location in the entire building embodied a secret language that would have been understood by Pythagoreans as conveying their divine master's view of women as an instrument of divinity.[28]

A most striking feature of this building, which has not been previously noted, lies in the fact that the pavement mosaic is, with the exception of its borders, entirely white. So also are the interior walls, and their decorative stucco reliefs, entirely white. White was well known, by the first century AD, as the preferred "color" of Pythagoreans. With its white interior space, this building evokes a fully developed religious architectural type, built to last as its vaulting—sufficiently strong as to have resisted the rumbling of trains over-

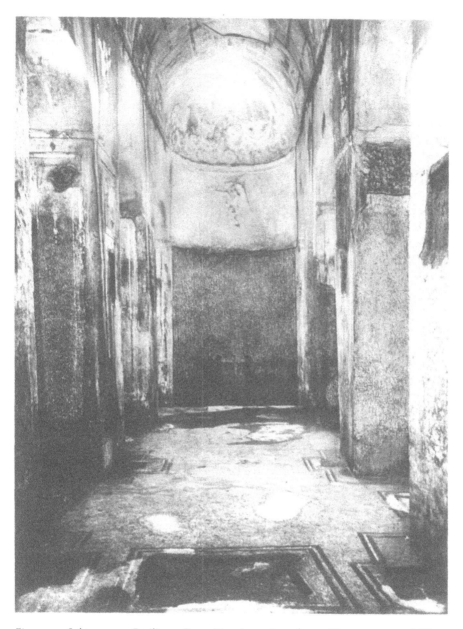

Figure 13. Subterranean Basilica at Porta Maggiore, view of apse. Photo courtesy of Alinari

head for a century—suggests. It also evokes the plan, orientation, and system of decoration of the future basilicas to be built by another sect in ascendance at this time, the Christians.

▲

The ultimate triumph of Apollo as a "naturalized citizen" of Rome coincides with the appearance of a type of religious architecture, in the Subterranean Basilica at Porta Maggiore, that suggests Pythagoreanism had developed a liturgy that required an interior space in which the faithful could gather. That liturgy led to the creation, for the benefit of its instructed audience, who believed in an incarnation of the divine and the eternal life of the soul, of a unique and original interior space that directed them to face the east when worshipping Apollo. References to Apollo as a source of light and depictions of his achievements demonstrate that the worship was focused on one god. Assisted by the symbolic use of number, Pythagorean concepts were articulated in a language that was clear to the initiated. In the atmosphere of contemporaneously emerging Christianity, inspirational concepts such as immortality, the power of numbers, and the elevation of an ascetic and pure man to divine status which he shared with his father-god would not be lost.

The discovery of this original and essentially intact building in 1917 suggested stunning consequences that have not yet been fully appreciated. Its exceptional architectural importance derives not only from its being the only Pythagorean structure so far known to survive, but also from the light it sheds on the early development of Christian architecture. The conventional supposition has been that it was the Christians who, after their religion was legalized early in the fourth century, adapted the plan of the Roman basilica into a religious structure in which side aisles flank a central nave that establishes the horizontal axis from entrance to apse.[29] Instead, this architectural innovation (along with the new notion of placing the apse in the east and the entrance in the west) now appears to have been made by Pythagorean initiates, independent of other cultic structures that did not share this particular plan, at least as early as the first century AD, when Christian worship was still being conducted clandestinely in private homes.[30] The sumptuous realization of the underground basilica, with vaulted ceilings above and marble tables positioned on mosaic pavement below—not to mention the elaborate program of stucco reliefs covering the surfaces and concentrating on the apse behind the altar—suggests that this building may have evolved from more rudimentary predecessors. This in turn suggests that during the early decades of the Roman Empire, considerable cultural influence was exerted by an older spiritual movement (Pythagoreanism, which, aside from Pythagoras's example, may have preferred because of continued persecution to build places of worship underground), because it had the blessings of a long Antique tradition, on a younger one (Christianity). This theme is one that continues in medieval ecclesiastical architecture, as is discussed in chapter 12.

Nor were Christian churches the only structures that showed such influ-ence: the peculiar illumination of this Pythagorean place of worship, with a single shaft of light entering through an open oculus, would be repeated soon after in the Pantheon, a temple built by Rome's only known Pythagorean em-peror, Hadrian.

THE PYTHAGOREANISM OF
HADRIAN'S PANTHEON

Perhaps the grandest temple ever built is the Pantheon in Rome (fig. 14). Not only is it distinct from other Roman temples, but it is certainly the most original of all of them. There is nothing like it in Vitruvius's description of established circular temple types, composed in the late first century BC.[1] Yet the purpose for which it was originally built has not come down to us. Indeed, the name Pantheon came to be applied to it later. Its meaning remains elusive.

Built by Hadrian between AD 118 and 125 and remarkably well preserved, this structure is neither a freestanding building nor a rectangular one, as were most other Roman temples. Nor is the building's design based on a formula of columniation. Hadrian's originality in adjusting a massive circular walled temple with a lofty dome to a rectangular porch has often been noted.[2] The highly centralized interior has a vertical axis and is aligned with the four cardinal directions. The originality of the structure did not, however, end here. As in the Subterranean Basilica at Porta Maggiore, light enters the building through a single source, the open oculus above (fig. 15). Such a significant number of other Pythagorean references characterize its originality as to suggest that Hadrian, who is reputed to have planned the structure himself and who had strong interests in mathematics, intended it to reflect current Pythagorean interests in arithmology. These are exemplified in the work of Nicomachus of Gerasa, Hadrian's contemporary and possible acquaintance.[3] The novelty of these concepts and their implications for unraveling the mystery concerning the original purpose of this exceptional building are the subject of this chapter.

▲

Five marble steps lead from the forecourt of the Pantheon up to its sixteen-column porch, or pronaos, which supports a high triangular pediment (fig. 16).[4] The pronaos leads to a triple barrel-vaulted entrance reminiscent of a basilica in that the central vault leads (like a nave) into the interior, while the side arches terminate in small apses.[5] A great cylinder rises from the circular foundation (not built on the foundation of any preexisting building) and supports the largest domed rotunda ever built, equal in height and radius to the cylinder below. The exterior of the dome was originally covered with glittering gold in the form of gilded bronze tiles,[6] while its interior is marked off by coffers that are aligned horizontally and vertically over the sloping surface, which culminates in an oculus of unprecedented dimension. Centrally located, over the interior space and poised over the central circle in the pavement below, the single source of light for the entire building was originally crowned with an elaborate bronze, most likely also gilded, cornice. Although the building has suffered some damage and loss, and although the ground level surrounding it has risen since it was built, on the whole it has survived miraculously intact, most likely because of its transformation, in 609, into a Christian church.

The Pantheon tells us a good deal about Hadrian that has not been considered important in previous discussions of it. Because this temple came to be dedicated to all the gods (*pantheon*), some scholars have speculated that what it meant to Hadrian and to Rome could be deduced by determining which statues of which gods appeared there, and in what order. This approach, however, has not yielded satisfactory results. One reason lies in the fact that when Hadrian was made emperor, a dramatized poem was presented, and recorded on papyrus, in which the main character, the divine Apollo, appeared on stage and proclaimed in an oracle that his son Hadrian had just been made emperor. Keeping this unusual event in mind, whereby an emperor is deified by a god proclaiming to be his divine father before that emperor even accedes to the throne, it is perhaps reasonable to suppose that Hadrian was more closely engaged with Apollo (the single god worshipped by Pythagoras) than with a pantheon of gods in general.

In looking at Hadrian's unusual temple through Pythagorean eyes, a different interpretation of it emerges. Given the secretiveness of Pythagoreans and their practice of transmitting ideas orally, it is difficult to point with certainty to the precise sources for Hadrian's extraordinary conflation of the idea of the cosmos with that of the sphere. Nevertheless, several observations concerning the design of the Pantheon suggest that the ingenuity of Pythagorean arithmology as it was understood at this time influenced his thinking.

The circular plan, central axis, and hemispherical character of its dome, as well as the structure's alignment with the four cardinal directions, clearly suggest a preoccupation with order and cosmology. As we have seen, Pythagoras himself was widely known by this time to have shared this preoccupation. It

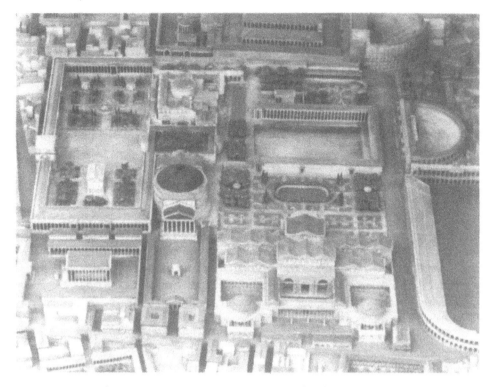

Figure 14. Pantheon, Rome, AD 120–27. Reconstruction by Flaminio Lucchini. Photo from Flaminio Lucchini, *Pantheon* (Rome, 1996)

was also known that he held the sphere in reverence. These views were fundamental to Plato's most Pythagorean work, the *Timaeus*.

The rotunda, the central and most important part of the cosmological design, is dominated by a tremendous oculus, the sole source of an illumination that streams down into the space and spreads throughout the building (fig. 15). The oculus, a relatively new constructional device at this time,[7] allows for the sun to spread its rays over the vast interior space below, an effect that might well be associated with the sun god. The device, particularly in the domain of a temple, suggests an appropriate medium for an emperor—who not only regarded himself as the son of this god but who was known as a Grecophile—to express the supreme authority of this most Greek of all the gods. Apollo was symbolized by the monad (viewed by Pythagoreans as the essence of perfect unity and order because of its indivisibility), as the contemporary work of Nicomachus and near-contemporary work of Numenius and Plutarch proclaimed.[8] As noted in chapter 3, Plato's *Cratylus* had reinforced the link between the monad and Apollo by etymologizing *a–pollo* as "without multiplicity," a concept well known to Nicomachus.[9]

Radiating from the oculus are twenty-eight massive ribs that articulate the

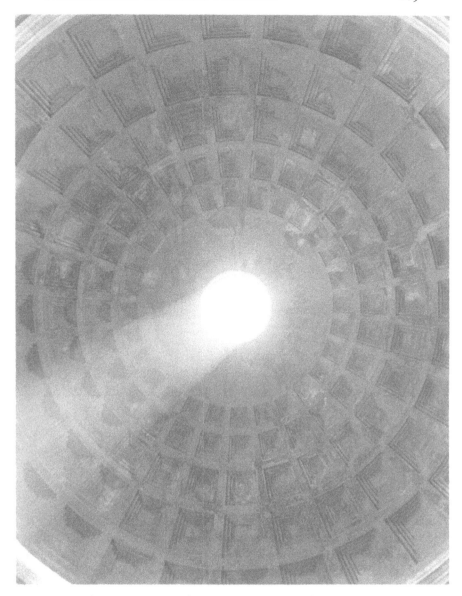

Figure 15. Pantheon, interior view showing oculus and ribs. Photo by Robert Reck

interior of the vast cupola. For Pythagoreans, twenty-eight, the number of days in the lunar month, symbolized the moon. In this context it was, as Michael Allen has recently shown, the final hidden part of the "fatal" number put forward by Plato in book VIII of *The Republic* for calculating auspicious dates to conceive children.[10]

Concentric around the oculus and intersecting the ribs are five coffered

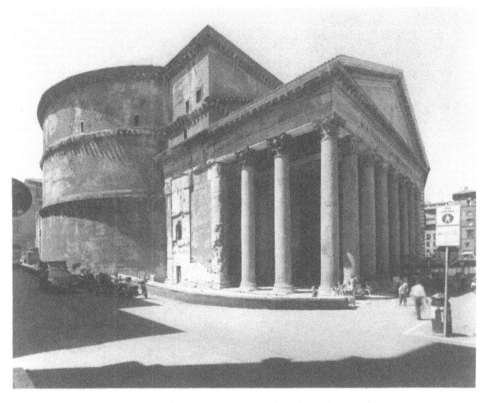

Figure 16. Pantheon, view of facade and pronaos. Photo by Robert Reck

rings whose relationship with both one (the sun) and twenty-eight (the moon) suggests a highly unusual combination by Antique standards. The number five—being the sum of two, the first even number (considered female by Pythagoreans), and three, the first odd (male) number—combined both sexes. The number five was therefore known through Aristotle (an acknowledged expert in Pythagoreanism) and Anatolius (claimed by Pythagoreans as a fellow believer), as well as through Plutarch, as the "marriage" or "wedding" number.[11] The domed rotunda—which forms the height and heart of the structure around and below which everything else is carefully organized—thus would appear to symbolize the dominant theme of the marriage, or accord, between the sun and the moon.

Cut into the cylinder wall of the supporting structure below the dome are three semicircular and four trapezoidal niches, for a total of seven large aediculae suitable for sculptures (fig. 17). The numbers three, four, and seven are full of Pythagorean significance.[12] Three was considered an ideal number since, having a beginning, a middle, and an end, it signified totality.[13] In addition, three is the smallest number of points that can define a plane figure: the triangle, which

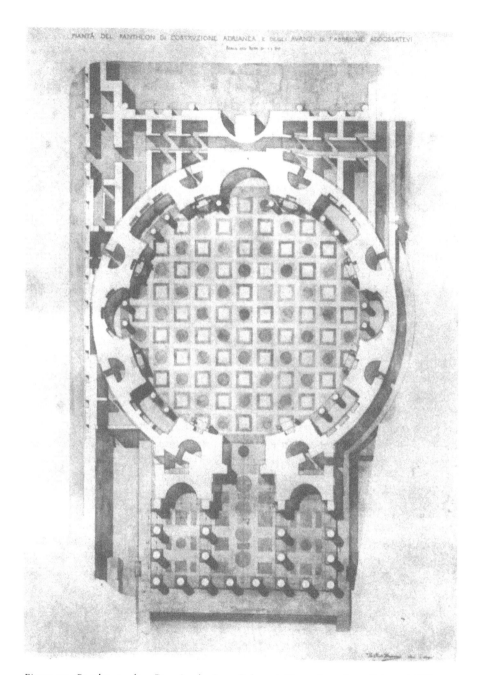

Figure 17. Pantheon, plan. Drawing by Luca Beltrami. Photo from Luca Beltrami, *Il Pantheon* (Milan, 1898)

Pythagoreans associated with Apollo. The three semicircular niches of the rotunda form an equilateral triangle whose apex lies in the niche opposite the entrance, the apse where Hadrian sat enthroned as judge—cast, geometrically, in the role of Apollo.[14] Four, the first square number, symbolized many things to Pythagoreans, as Nicomachus and Theon of Smyrna, both Pythagoreans, explained—primarily, perhaps, the four seasons and the four elements. Pythagoreans held the quaternary (the tetraktys, based on the number four) in highest esteem because it incorporates "the entire nature of the universe."[15] According to Pythagorean cosmology, the numbers three and four together represent the cosmos and the key to the universe: three, the mean between two extremes, unfolds into four, the first number to produce a solid form.[16]

The sum, seven, was of great interest through Antiquity but was of special interest to Pythagoreans from the time of Plato's *Timaeus*. Particularly noteworthy in this regard were Cicero's *Somnium Scipionis*, which linked the seven-string lyre with the number of the planets and thus with the order of the cosmos, and the works of Hadrian's near contemporary Philo, which identified seven as the most revered of all numbers. Apollo's birthday was celebrated on the seventh of each month. The sequence from the monad to the heptad ($1 + 2 + 3 + 4 + 5 + 6 + 7$) totals twenty-eight, the number of dividing ribs above; the seventh number in a series that starts from the monad and proceeds by doubling ($1, 2, 4, 8, 16, 32, 64$) is sixty-four, the number of pilasters that originally articulated the intermediate, or attic, level below in preparation for the springing of the dome above (fig. 18).[17]

Pythagoreans regarded sixty-four as the great unifying number not only because it was the first number that is both a square and a cube, but also because it was the product of eight (octaves) times eight (octaves).[18] Sixty-four ($4 \times 4 \times 4$) is also a "circular" cube—that is, it ends with the same digit (4) as the number whose cube it is.[19] One of the great themes of Pythagorean geometry was the attempt to square the circle.[20] Although Hadrian's design does not directly address this (insoluble) problem in the attic story, his use of the number sixty-four, plus several other features to be discussed below, suggests that he was fascinated by the relationships between the circle and the square, and that he may have hoped that his building would, in some Pythagorean sense, reconcile the two figures.

Eight smaller aediculae, placed in the piers, are evenly spaced between the seven "cosmic" ones (fig. 17). For Pythagoreans the number eight symbolized egalitarian justice. Justice was in fact one of their names for it, because it is the first number divisible into two equal even numbers that can each be further divided into two equal even numbers.[21] Thus was the number eight also associated with harmony, as noted in the contemporary writings of Nicomachus, who described how Pythagoras achieved new consonances by adding an eighth string (the octave) to the traditional seven-string lyre.[22]

The total number of segments in the perimeter of the rotunda, then, counting the entrance opening, is sixteen. For Pythagoreans, sixteen was another

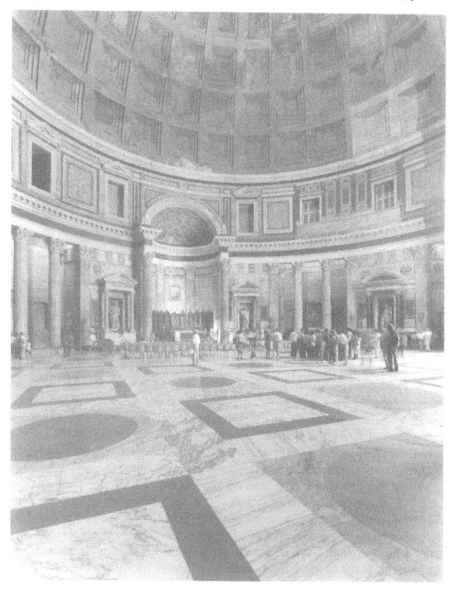

Figure 18. Pantheon, interior showing (modern) attic. Photo by Robert Reck

number with great significance. Vitruvius, a Pythagorean, had recently noted it was ideal for articulating temples. In addition to being the double of the Justice octave, it was the product of four (the smallest number that can define a three-dimensional figure) times four; it was also the intermediate step in the multiplication process leading from four to its "circular cube," sixty-four ($4 \times 4 = 16$; $16 \times 4 = 64$). These multiple numerical symmetries make sixteen an ex-

cellent number of elements to incorporate in a design that focuses on the perfectly symmetrical circle.

Thus when we look at the pavement of the rotunda (which, damaged in a flood in 1598 and not repaired until the nineteenth century, can be presumed to have followed the original design), it is not surprising to find a design composed exclusively of squares inscribed within squares and circles inscribed within squares, all within the larger circle of the whole (fig. 18).[23] These may well be related to the historical zest of Greek mathematicians for "rectifying," or squaring, the circle. Although many Greeks had pondered this problem, especially between the fifth century BC and the time of Archimedes in the third century BC, it was apparently claimed by Sextus Pythagoricus in the first century AD, shortly before the building of the Pantheon, that this problem had been solved in the Pythagorean school.[24] Whether or not it is true that Pythagoreans had "solved" this problem, what is important here is the fact that at the time the Pantheon was designed, this mathematical conundrum was believed by Pythagoreans to be particularly precious to their tradition.

On a larger scale, the circle of the rotunda can be contained within a square. The same pattern appears in three dimensions as well. Looking at the elevation of the building, we can imagine the dome extended, by an inverted duplicate joining it from below, into a perfect sphere. That imagined sphere can in turn be inscribed into an imagined cube—a shape that, as Vitruvius pointed out shortly before this building was designed, was of great importance to the Pythagoreans.[25] Thus the circle and square, as well as the sphere and the cube, together exert a strong presence in the plan and elevation of this building. Such square and circle interlockings are reminiscent of the Pythagorean connection of the sphere with the cube as well as of the settings of the earliest images of Pythagoras (in the coins from Abdera described previously) in squares that are inscribed within the circular shapes of the coins.

Often thought to be unrelated to the main body of the building, the pronaos, or porch, is in fact arithmetically linked to the interior space. It consists of sixteen Corinthian columns (fig. 16). Sixteen was the perfect number, according to the contemporary Pythagorean Vitruvius, for the articulation of a temple. Eight columns, half of sixteen, are presented in the temple front façade (fig. 19). Since the number eight symbolized Justice for the Pythagoreans, the number of externally visible columns proclaims that this sacred building also had judicial functions, as we know it did. Eight more columns are placed in a $2 \times 2 = 4 = 2 + 2$ array to either side of the entrance passageway. These symmetries—eight columns in front, eight in back, eight to the left, eight to the right—emphasize in Pythagorean terms (justice is equal on two sides) the balance and equality of the law, the embracer of all harmonies.[26] The entrance to the pronaos consists of five steps, which is not conventional in a Roman temple, where the number of steps was not specified and could vary greatly. Viewed as the "marriage" number, however, the five horizontal steps that introduce, from the exterior, the beholder to this sacred space are equivalent to

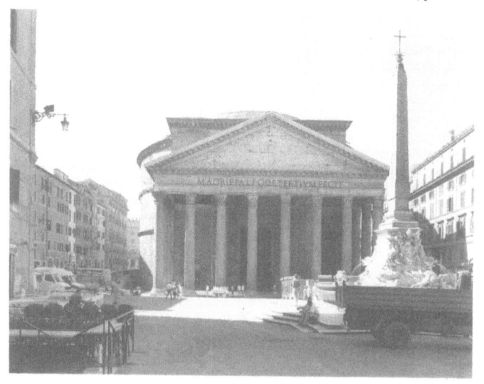

Figure 19. Pantheon, frontal view of facade. Photo by Robert Reck

the five horizontal ribs that articulate it in the interior, thus balancing and harmonizing exterior and interior as well as underlining the marriage theme.

Not enough of the lore of Pythagorean arithmetic has survived to enable us to analyze all its manifestations in the Pantheon, but it is clear that the numerological arrangement of the architectural elements of the Pantheon was designed to incorporate numbers ideal for symbolizing cosmological concepts as well as those considered "perfect" by Pythagoreans. Perhaps the most important of the latter is sixteen, the total number of aediculae of the circular interior plan and the number of freestanding columns at the entrance. According to Anatolius, the number sixteen is perfect because it is, uniquely, the area (4×4) and the perimeter ($4 + 4 + 4 + 4$) of a square whose side is four units long. Further, sixteen is "evenly even"—that is, when divided by two the result is an even number; this applies even to half of sixteen, as shown in the way the eight inner columns of the pronaos are arranged into two sets of four columns. Sixteen is also perfect in that it is the sum of the divisors of twelve, another number highly regarded by Pythagoreans: $1 + 2 + 3 + 4 + 6 = 16$. Finally, sixteen, as the double of eight, partakes of and enhances the properties of that number, which include security, harmony, and therefore justice. Another perfect num-

ber is twenty-eight, the number of coffers hovering overhead in the rotunda. Anatolius explains its perfection as arising from its dependency on the number four: the four weeks of the moon times its seven appearances or phases (crescent, half, three-quarter, full, three-quarter, half, crescent) equal twenty-eight. Further evidence that twenty-eight is perfect lies in the fact that it is the sum of all numbers up to seven ($1 + 2 + 3 + 4 + 5 + 6 + 7 = 28$).[27]

Anatolius received his information from "earlier" Pythagoreans,[28] according to Pseudo-Iamblichus's third-century *Theology of Arithmetic*, which itself depends in large part on the *Introduction to Arithmetic* by Hadrian's contemporary, the outstanding mathematician Nicomachus of Gerasa. Pseudo-Iamblichus reminds us of the traditional numerological identities recorded by Nicomachus: one is the sun, five is marriage, seven is the number of planetary spheres, and eight is panharmonic justice.[29] Nicomachus's fame as a mathematician and one adept in the mystique of numbers, thus honored by Pseudo-Iamblichus, was still so great two centuries later that Proclus believed himself to be Nicomachus reincarnated.[30]

Our fragmentary information about Nicomachus (who was alive around the beginning of the second century but whose birth and death dates are unknown) offers no compelling case for his having been directly connected with the design of the Pantheon. However, as a well-known, well-traveled Greek mathematician from Syria, a country in which Hadrian had spent considerable time and served as governor just before building the Pantheon, it is not unreasonable to wonder whether Nicomachus might have been consulted by Hadrian. Hadrian was fluent in Greek and admired Greek culture; he prided himself on the number and variety of his learned friends; he thought of himself as an architect and had strong interests in arithmetic, geometry, and astrology (which Vitruvius tells us were prerequisites for the study of architecture at that time).[31] It may be relevant that Nicomachus dedicated his *Manual of Harmonics* to "Your Noble Majesty," an unnamed lady of exalted rank.[32] We know Nicomachus mingled with the upper classes in the Roman world of his time; we also know (from Philostratus, who lived shortly after Hadrian) that Hadrian was given to Pythagoreanism for he had a collection of the tenets of Pythagoras, which he kept in a secret place together with a collection of the letters of Apollonius of Tyana.[33] It is tantalizing and tempting to speculate that the unidentified addressee of Nicomachus's famous dedication might have been the empress Plotina, the wife of Trajan, who became Hadrian's adoptive mother, protector, and advocate—and with whom some believe Hadrian may have been in love.[34]

The Pantheon was only one of many buildings that Hadrian commissioned in Rome, Greece, Syria, North Africa, and Gaul during his reign, but the dominating Pythagoreanism of this extraordinary structure sets it apart from the others, although we know that Hadrian commissioned a sculpture of Pythagoras for the grand central piazza of his villa at Tivoli. The work incorporates key elements of Pythagorean cosmology (in the conjunction of sun and moon,

which dominates a perfect sphere that represents the universe). We may well wonder what could have motivated Hadrian to undertake such a grandiose, complex, and unique project. Three early biographies of Hadrian provide some clues.

The account of Hadrian's life provided in the *Roman History* of Dio Cassius (Cassius Dio Cocceianus, fl. ca. AD 194–ca. 235) is replete with references to extraordinary dreams that motivated Hadrian and to his interests in astrology, divination, and magic.[35] On one of his trips to Greece, Hadrian was admitted to the highest grade at the Eleusinian Mysteries. He was very interested, Dio tells us, in literature, painting, and architecture.[36] The biography of Hadrian that appears in the *Scriptores historiae augustae,* thought to have been written by Spartianus (Aelius Spartianus, ca. fourth century), has more to say. Hadrian took prophecies and omens seriously and related these to his rise to power and fame. He consulted oracles (although he was thought by the Roman people to have written some of them himself) and astrologers; indeed, his granduncle was a master of astrology, and Hadrian himself was extremely proficient at it, to the point that he kept journals even to the hour of his death. Among his friends were astrologers, musicians, and geometricians, and he himself was expert in arithmetic and geometry (in Rome astrologers were called mathematicians, because mathematics was important for the construction of horoscopes).[37] Hadrian's death was foreshadowed by portentous events.[38] Spartianus supports Philostratus's statement that Hadrian owned Pythagorean writings and adds that he cultivated Pythagorean interests; he believed that the soul was immortal and that the universe was regulated by laws of harmony and arithmetic.[39] This image of Hadrian survives in a later biography of Hadrian by Aurelius Victor (Sextus Aurelius Victor, fl. ca. AD 390).[40]

No doubt for Hadrian, who was known in his own time as a Grecophile,[41] Pythagoreanism was an esoteric form of Greek learning that appealed to his passion for arithmetic as well as to his interests in cosmic order and universal harmony. Also appealing to him must have been the idea of emulating some of his predecessors, who thought of themselves as deified supreme beings. A precedent for this way of thinking was known in ancient Persia and Chaldea as well as in Rome, where it was connected with astrologers, many of whom came from the East.[42] Nero, for example, is known to have consulted astrologers; thus was he inspired to present himself as the incarnation of the sun god, in order to ensure his celestial immortality as a cosmocrator who, from his cosmic dome, sets the lower planets in motion and directs the order of the world below.[43]

▲

Recalling Greek precedent for solar temples and certainly symbolizing the Pythagorean unitary nature of Apollo as the sun,[44] the oculus of the Pantheon may be interpreted as a visible sign of the immortality of Hadrian himself. Indeed there is further good reason for this suggestion.

According to an Egyptian papyrus fragment of uncertain authorship published separately by two modern scholars, Hadrian's succession to the imperial throne (resentfully regarded by the Romans as resulting from Plotina's manipulation) was announced by Apollo himself in the previously mentioned dramatic presentation on the very day that Hadrian's predecessor, Trajan, died: "I, Phoebus, have just risen with Trajan on a chariot drawn by white horses and I . . . announce that a new prince, Hadrian, has made all things subject to his deified father."[45] Thus was Hadrian's accession sanctioned by the sun, the supreme Pythagorean god, and Hadrian himself deified as the god's representative who reigns on earth.[46] Though it is not unimaginable that Hadrian wrote the document himself, this oracle corresponds to a natal horoscope reportedly made by Hadrian's great uncle, the master astrologer Aelius Hadrianus, prophesying that his newborn grandnephew would rule the world.[47] This recently identified horoscope predicts the birth of an illustrious son who would punish many (as Hadrian did) and whose birth would be subject to the influence of the moon. Taken together, the Apollo proclamation and the natal horoscope suggest that Hadrian would naturally have a particular devotion to the sun (Apollo) and the moon.[48]

More important still, Hadrian's own horoscope is known with absolute certainty, and as the longest surviving exposition of its kind, it has been published several times with extensive commentaries by scholars of classical astrology.[49] Its longest section is devoted to explaining the imperial destiny of Hadrian on the basis of the position of the seven planets (including the sun and the moon) at the time of his birth. The calculated configuration shows the sun and the moon "in conjunction," that is, in the same house of the zodiac, along with all five of the nonluminary planets. This highly unusual configuration signified that the person born at that time (Hadrian) was destined to become the ruler of the world.[50] The horoscope goes on to offer specific predictions about Hadrian's future life and refers to the Pythagorean doctrine that identified the sun and the moon as the guarantors of immortality.[51]

Assuming that Hadrian received this type of horoscope from his great uncle or from another astrologer/mathematician, we may now understand some of the otherwise obscure comments made by Spartianus, who tells us that when Hadrian went to Sicily (in about 126, he climbed Mount Etna to view the sunrise.[52] Later, while in Syria, Hadrian climbed Mount Asius by night to see the sunrise from its summit. There he sacrificed to the sun, and the sacrifice was miraculously attended by a storm in which a flash of lightning struck the victim.[53] Nor is it surprising, in this light, to learn that after consecrating a monumental statue to the sun, Hadrian planned to make a companion piece dedicated to the moon.[54]

Hadrian's awareness of the astrological "conjunction" that took place at his birth no doubt explains not only his special devotion to sun and moon but also the importance he placed on his birthday. Although he is said to have refused to attend circus games at most times, Hadrian made a special exception to cel-

ebrate his birthday.[55] Dio Cassius tells us that for this purpose Hadrian staged grand spectacles, free to the people of Rome, and Spartianus describes gladiatorial combats that lasted for six days in honor of the birthday.[56] Several omens around the time of his last birthday foreshadowed his death: a ring and a head covering that he was wearing fell away from him of their own accord, and an unidentified person came into the Senate wailing incomprehensibly, so disconcerting Hadrian that he inadvertently spoke of "my death" when he had intended to say "my son's death."[57]

Hadrian's biographers insist on his consuming ambition. Dio tells us this ambition was insatiable and that Hadrian wished to surpass everyone in everything.[58] Spartianus elaborates: Hadrian thought so well of himself that he allowed [or encouraged?] the Athenians to build an altar to him; he consecrated temples and cities to himself; he wrote an autobiography and distributed it for publication.[59] Hadrian's Greek subjects deified him at his request, and oracles were given through him.[60]

According to Spartianus, Hadrian even ordered that the Roman people celebrate the ninth day of August each year, the anniversary of his receipt of the news of his predecessor Trajan's death.[61] Although it seems improbable that Hadrian wished people to rejoice in his predecessor's death, more than likely he intended to remind them that both the prophecy about his imperial birth and Apollo's proclamation of his ascension had been fulfilled—an appropriate occasion for celebration.

Hadrian's biographers are dubious about his elevation to the rank of emperor, which was highly irregular, and they all suspect foul play. Trajan had died suddenly without a legal successor. Hadrian, who was in Syria at the time, sent the Senate a carefully worded letter noting that the state could not be without an emperor and claiming that his troops had made him emperor by acclamation.[62] The Senate, the only body authorized to confer the *imperium*, never formally granted it to Hadrian, but he was able to make his de facto command of the empire permanent—probably, according to the biographers, in large part because of the considerable influence wielded by Plotina on his behalf.[63] Rather than returning promptly to Rome to assume the throne, Hadrian remained away for a full year, an act of arrogance that earned him the lifelong hatred of the Roman people and so alienated the Senate that it tried after his death to revoke his deification.[64]

It was to a hostile Rome that Hadrian finally returned. Although he evaded a plot to murder him, the hostility increased when he put four men of consular rank to death. At this point, Hadrian began to use every means to gain popularity, including the remission of debts, assistance to public officials, and special allowances and donations to many individuals and causes.[65]

These crucial two years, before Hadrian was to absent himself for another seven, are precisely the period during which the Pantheon was designed. No better symbol of Hadrian's imperial power and majesty could have been created than this temple, where he exerted his administrative and judicial pow-

ers—a temple whose design "married" the monad with the number twenty-eight to symbolize the conjunction of sun and moon that marked his nativity and proclaimed his destiny to rule the world. Most likely the great oculus was surrounded, in the upper zone of the dome's interior, by a painted belt representing the zodiac at the time of his natal horoscope and giving additional emphasis to the prophetic conjunction that made his birth a special occasion for the world.

Hadrian's efforts to glorify himself, exert his all-consuming ambition, and legitimize his reign as a sovereign god in the hostile and suspicious political climate of Rome were wide-ranging. The most effective of them—certainly more so than the mere words of the autobiography he distributed—was his use of architectural symbolism to express his claimed relationship with Apollo, his divine "father," oracular enunciator, and protector. Plato had suggested that gods are conceived on dates determined by "a perfect number" and that mortals fall short of divinity to the extent that their dates of conception differ from that perfection.[66] What way of conveying Hadrian's message could have been more powerful than the esoteric language of Apollo's oracle expressed in the cosmic harmony and numerological symbolism of Pythagorean arithmology? This language would have been understood by educated Romans of his time and would, no doubt, have been more effective than a mere sculpture. When he sat in the apse of the Pantheon to perform his judicial role, Hadrian occupied the apex of the triangle and thus "became" Apollo. In the authority of a spectacular golden temple whose glittering golden dome (perhaps crowned with a quadriga displaying Hadrian as Apollo)[67] could be seen throughout the city, Hadrian's solar immortality as king of the universe was guaranteed forever. Indeed, no matter what the Roman Senate thought, Hadrian would be a god after his death because he had been one since his birth.

▲

Thus does the Pantheon, with its sphericity, cosmological orientation, and numerical symbolism, suggest Pythagorean language and concepts as they were known in Rome of the first and second centuries AD. The design of this building, architecturally dominated by the monad, shows clear signs of having been dedicated to one god, Apollo, who was the announcer, protector, and divine father of Hadrian. There can be no doubt that the light that enters the building through the oculus is more than "playful," as it has sometimes been considered. At the very least it represents the power of Apollo; additional study may well demonstrate that the light was meant to illuminate specific portions of the interior at specific times of the day and year, further enhancing the glory of Hadrian, who, like his Greek idol Pythagoras, was also the son of Apollo. Seen in this way, the purpose for the highly original form and design of the so-called Pantheon becomes clear.

Having arrived in southern Italy most likely as a Pythagorean import, Apollo became not only a naturalized Roman but a divine father to Roman

emperors, as he had been to Pythagoras, teaching them to enhance their power and prestige through enigmatic symbolism. Although few if any emperors other than Hadrian were formal Pythagoreans, the concepts of the esoteric language connected with the sun god were undoubtedly widely known and perhaps employed in other Roman structures yet to be discovered by us.

CHAPTER 11

Pythagoreanism
in Medieval Art

Long after the Roman Empire had crumbled under the pressures of migrational raids from the east and the north and Islam had begun its relentless advance in the Mediterranean basin, Europe began to take on the form by which we know it today. By Carolingian times (eighth and ninth centuries), the ancient cities and towns, which had been continuously inhabited, had been evangelized to form a civilization that was fundamentally Christian. The developing life blood of these Christian communities was accompanied by needs that could be, and were, fulfilled in the visual arts. These included the reappearance of monumental sculpture as well as the development of the book, or codex, which replaced the ancient scroll. The relation of these to the continuing and ever-changing interest in Pythagoras and Pythagoreanism is discussed in this chapter. These needs also included liturgical developments that were reflected in an efflorescence of architectural activity, whose relation to Pythagoreanism is considered in chapter 12.

Medieval Images of Pythagoras

Because, being essentially abstract and nonfigurative, early medieval art was not primarily occupied with representation, we should not expect to find portraits, or even idealized portraits, during this time. Even so the images of Romanesque art (roughly from the tenth into the twelfth century) employed the reemerging human figure primarily, if not exclusively, to demonstrate the

182

Christian iconography that was steadily being developed. In this world, it appears, there was no room for Pythagoras or any other Antique heroes in the pedagogically oriented decorations on the walls of cathedrals, parish churches, and monasteries.

Pythagoras first appears in a pair of pen-and-ink drawings in a German early twelfth-century manuscript devoted to the theory and practice of music (fig. 20).[1] Dressed in a toga and holding in his left hand a sword while he gestures authoritatively with his right hand, Pythagoras (whose name is inscribed above) looks much like a Roman soldier. The pen drawing, whose contours are reinforced with color, shows him with dark hair and a dark short-cut beard. Although he is isolated against the neutral background of the page, opposite him, on another folio, is represented a blacksmith's shop with five workers hammering what must be harmonious tunes, for one of them turns to Pythagoras. Pythagoras is turned toward the shop as though to suggest he is listening. His size, which is much greater than that of the other five men, suggests his greater importance. This representation of Pythagoras shows that Nicomachus's story of the harmonious blacksmith was known in Germany in about 1100, the approximate date of this manuscript.

About midcentury he appears, very differently, in a Latin manuscript, perhaps French, now in Paris (fig. 21). Seated on a cushion and described with calligraphic lines, the beardless and youthful sage is engaged in writing a book. He holds the codex in his left hand while, with his right, he dips his writing instrument into a horn of ink. Isolated and silhouetted against the white background of the parchment, his figure is contained by a double circle in which his name is inscribed. The fact that he is shown writing signals that Pythagoras was believed, in medieval times, to have written books, whereas the fact that the figure is inscribed in a circle suggests that he was known for his cosmographical ideas, such as the harmony of the spheres if not for his love of the circle.[2]

Later in the twelfth century, another French artist had a very different idea of Pythagoras (fig. 22). Using a circular format to suggest the cosmos, this unknown artist represented Pythagoras, together with Arion (whose music charmed the sailors who wanted to kill him) and Orpheus (who played the lyre), supervising the Harmony of the Spheres.[3] The three figures, whose names are inscribed, are arranged in the center of the inner circle, while around them are displayed the nine muses as planets. On the far outside, the four winds, which are coordinated by the central figure of Air, suggest the rotation of the universe. Although Arion appears to be resting from his music making and Orpheus reclines, Pythagoras is very active. Doing three things at once—balancing a monochord on his lap, and holding a stick in his right hand (an obscured area of the drawing) and a hammer in his left—he directs the harmonious equilibrium of the cosmos. Young, beardless, and barefoot, he appears to be boyish. He is, as before, fitted into the composition against a neutral background.

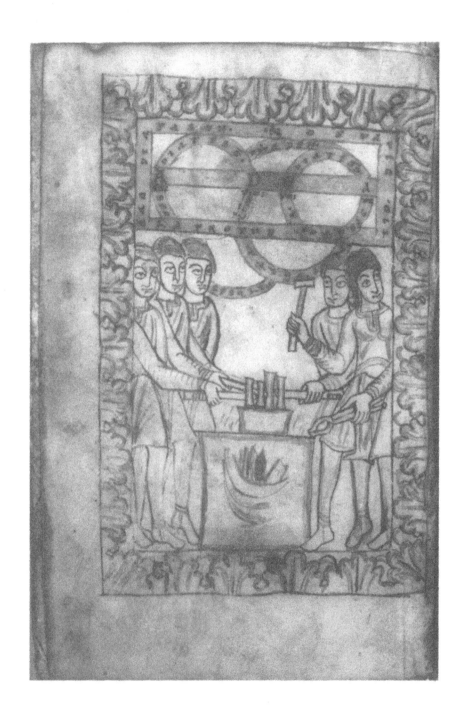

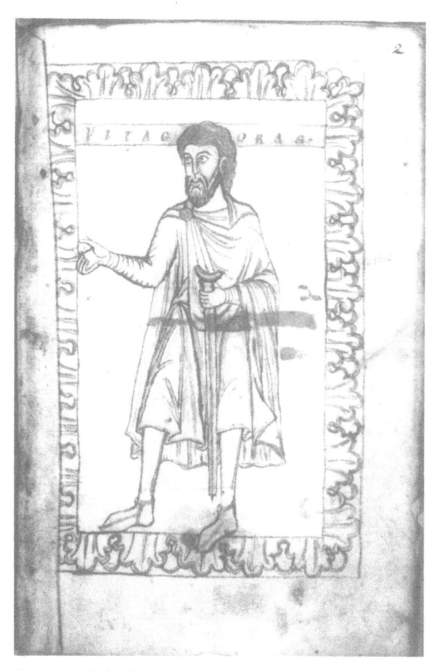

Figure 20. (*A*) Blacksmith's shop; and (*B*) Pythagoras. From *Cod.Gud.Lat.8*, fols. iv and 2r (from Cod.Guelf 334/Gud.Lat.), early twelfth century, Herzog August Bibliothek Wolfenbüttel. Photo courtesy of Herzog August Bibliothek

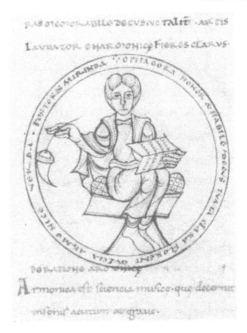

Figure 21. Pythagoras. From *Ms.Lat.7211*, fol. 133v, twelfth century, Bibliothèque Nationale de France, Paris. Photo courtesy of Bibliothèque Nationale

The significance of Pythagoras for the field of "portraiture" in the twelfth century is, however, clear, decisive, and dramatic at Chartres. Carved into the bottom of the inner archivolt of the south (or right) door of the royal portal of the facade of the Cathedral of Notre-Dame at Chartres (figs. 23 and 24), Pythagoras is shown hunched over and devoting his deepest concentration to his work. The figure above him, representing Music as one of the Seven Liberal Arts, signifies that his attention is directed toward a musical project. Holding a tool in his left hand and making a careful adjustment with his right, he appears to be tuning a string (no longer visible) that is attached to a boxlike instrument, probably a monochord,[4] which is somewhat different from the seven-string lyre that the figure of Music above him holds. The figure of Pythagoras is organized compositionally so as to fit into a comprehensive setting that includes a well-equipped workshop, in which tools hang on the wall and which suggests a space allowing him to sit on his decorated cushion and work at his desk.

The setting that frames Pythagoras here is but one sign of the new naturalism that the emerging Gothic style brought with it. The figure has little of the distortions and contortions that were familiar in the earlier—exclusively religious—figures of Romanesque sculpture. Nor is it compressed as a decoration on the surface of the wall. The figure is now liberated from the background so

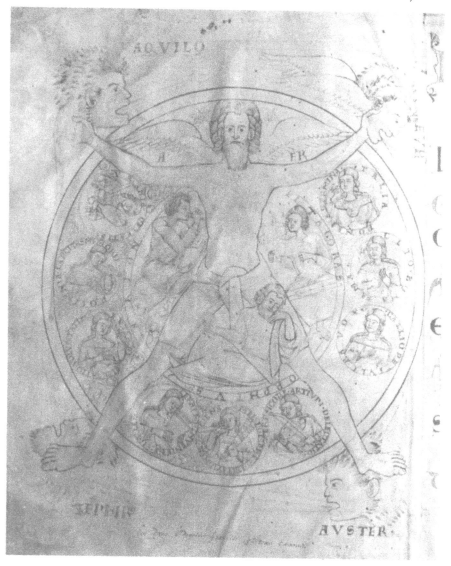

Figure 22. The *Harmony of the Spheres* with Pythagoras, Arion, and Orpheus. From *Ms.672*, fol. 1v, late twelfth century, Bibliothèque Municipale de Reims. Photo courtesy of Bibliothèque Municipale de Reims

as to appear to be somewhat rounded and set into a readable space. Its proportions are natural and the drapery deeply and variously grooved so as to suggest the volume of the body that exists beneath it. Indeed, the hunch of his back and the gesture of his hands suggest the deep emotional intensity that is also part of the naturalism of this Pythagoras.

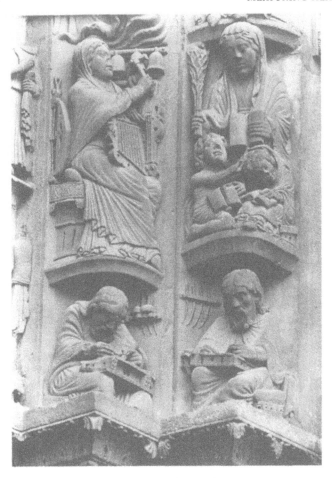

Figure 23. Music and Pythagoras, Dialectic and Aristotle, ca. 1146–60. From west front, royal portal, right door, Cathedral of Notre-Dame, Chartres. Photo courtesy of Bildarchiv Foto Marburg (Art Resource, NY)

The drapery that covers his body suggests that the unknown sculptor who carved this image directly on the stone of the archivolts was attempting to clothe Pythagoras in idealized Antique dress—in this case a kind of Roman toga with decorated hems. The sculptor gave Pythagoras a well-coiffed moustache and beard, as well as a mane of straight hair that is parted in the center and falls over his shoulders. Together the style and iconography of this figure indicate that it was carved, as was the entire portal, in the mid-twelfth century (about 1146–60).

This period corresponds precisely with the moment in time when the teachings of the School of Chartres reached the high point of their development. Whoever planned this portal took care to show not only the required Christian

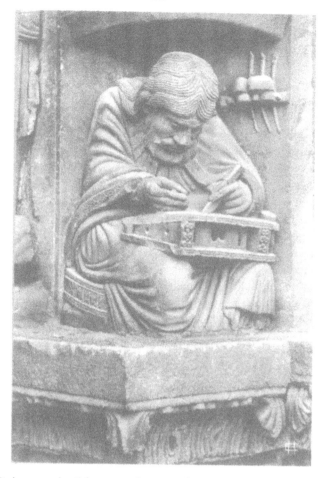

Figure 24. Pythagoras, detail from west front, royal portal, right door, Cathedral of Notre-Dame, Chartres. Photo by Etienne Houvet, in *An Illustrated Monograph of Chartres Cathedral* (Chartres, 1930) (courtesy of Washington National Gallery)

subject matter but also the ancient knowledge—in this case, the Seven Liberal Arts, each represented by a philosopher who excelled in that art—that, according to the masters of Chartres, had led to Christian concepts. By his thoughts and work, each ancient philosopher contributed to the substance of the discipline that he is associated with. Thus does Music (with Pythagoras as its representative) show exactly what the schoolmasters were teaching at this time: the Seven Liberal Arts were of the greatest importance for higher education; only through their study could men hope to be truly wise and understand theological truths. As an example of human wisdom, Pythagoras is inextricably bound to the focus of the portal's tympanum—the infant Christ, who, in the way he is held by his mother the Madonna, is divine wisdom incarnate.

Thus does the infant Christ as Logos become, as the modern scholar Adolf Katzenellenbogen has shown, the wisdom of the Lord. And thus do the Seven Liberal Arts and their representatives (including Pythagoras) become the instruments of the Lord.[5]

It was Boethius who first introduced, in his discussion of the Seven Liberal Arts, the idea that human wisdom aims to understand divine wisdom. Boethius considered the great minds of the pagan past, including Pythagoras, as those who were the first to direct their work, in the different disciplines of the Liberal Arts, toward understanding divine wisdom. The importance of Boethius, who would continue to be important even for Saint Thomas Aquinas in the next century,[6] for the program of the royal portal at Chartres is signified by the fact that Boethius was chosen to represent Arithmetic, while Pythagoras (Boethius's idol for Arithmetic as well as for Music) was chosen to represent Music. The concepts of Boethius were important for the twelfth-century masters of Chartres, who studied him and wrote commentaries on his works. Hugh of St. Victor emphasized the Seven Liberal Arts as a prerequisite for attaining perfection. William of Conches, who was particularly interested in arithmetic and geometry, regarded them as essential for understanding God. And Thierry of Chartres had just, at the time the royal portal was designed, completed his great work on the Seven Liberal Arts, the *Heptateuchon*. This coincidence suggests, as Katzenellenbogen did not hesitate to propose, that it was the influence of Thierry of Chartres, who happened to be chancellor of the School of Chartres until his death in 1150, that was responsible for the idea that the Seven Liberal Arts and their representatives, including Pythagoras, might be appropriate for the program of the royal portal when the west facade was designed.[7]

Although he does not resemble in any way Antique images of Pythagoras, which were surely unknown to the stone carvers at Chartres, this image of a contemplative sage shows how deeply respected Pythagoras was during medieval times, especially in the twelfth century. It also indicates that he could be connected with Christian theology because the most eminent theologians, having the greatest confidence in him, thought he deserved to be.

The appearance of Pythagoras at Chartres marks his debut in representations of the Seven Liberal Arts in the medieval visual arts. Although the arts had been represented before, they were apparently alone and without representative pagan philosophers.[8] The image also constitutes a first in terms of the history of his portraiture. Until now we have seen Pythagoras only as an isolated figure, or as a bust portrait, whereas here he is represented in a naturalistic setting as a human being engaged intellectually, physically, and spiritually in one of the activities for which he had become so famous. His relation to the figure of Musica, above him in the archivolt, is emphasized by Musica being represented as tapping on bells while accompanied by two string instruments, a harp and a lyre.[9]

A similar arrangement, perhaps based on the example of Chartres, can be seen in the south transept portal of St. Froilán in the thirteenth-century Cathedral of León in Spain. Here in the central of three archivolts, the Seven Liberal Arts are represented to the left, balanced by the Seven Virtues to the right. The figure representing Music, a seated, robed man who plays the lyre with a plectrum, appears to be Pythagoras.[10]

Contemporary with the representation of Pythagoras at Chartres is one in an English manuscript of ca. 1160 that reproduces Boethius's *De institutione musica* (figs. 25 and 26).[11] As was the case at Chartres, here Pythagoras is connected with Boethius. This time the affiliation is unmistakable. Pythagoras is represented directly opposite Boethius in the upper part of a folio that, divided into four approximately equal quarters, contains well-known Pythagoreans: Pythagoras himself (upper right), Boethius (upper left), Plato (lower left), and Nicomachus (lower right). All are identified by accompanying inscriptions. The fact that Plato looks Christlike and Boethius resembles a version of King David, while Nicomachus brings to mind an evangelizing apostle, suggests that in this case the artist, not as naturalistic as the sculptor at Chartres, was relying on formulaic images of Christian heroes. But, as we shall see below, Pythagoras is different.

This miniature shows the various methods used by these four philosophers to make their contributions to knowledge. Plato and Nicomachus exchange gestures, as though engaged in active conversation, while a more contemplative Boethius considers the tone emitted by the monochord on his lap. Pythagoras is, however, the most extroverted of the lot. Seated in a chair somewhat like an enthroned evangelist, he turns his head toward the eight bells above him while striking one of them with a little hammer, which he holds in his right hand. Grasping a pair of scales in his left hand, he looks up, an expression of bemused and interested curiosity on his face, to listen to the relationship between the tones as he strikes each bell. Pythagoras is thus shown together with his paraphernalia in the act of experimentation. The marginal inscriptions around him inform the viewer that Pythagoras is seeking to discover the secrets of the physical world. Although the focus of the folio is to compare the contributions of each of these four Antique philosophers to the discipline of music, Pythagoras is, perhaps, the most curiously interesting.

For one thing, in this portrayal Pythagoras is very young. As the "oldest" philosopher, it is odd to see, for the first time, a representation of Pythagoras as a slim and beardless young dandy. Despite its stylization, or patterning, the figure is original in other ways. Pythagoras cocks his head as he strikes and listens; also he is active: he does two things at once, using his scales to balance weights while engaged in tapping the bells above with his hammer. An extra hammer lies at his feet, just in case. His legs are bare beneath the dress he wears, which is decorated with pom-poms at the hemline. His man-

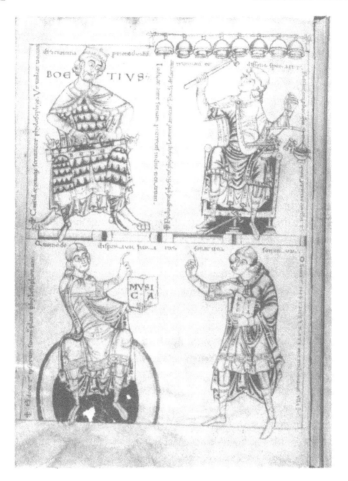

Figure 25. Boethius and Pythagoras (*above*); Plato and Nicomachus (*below*). From Boethius, *De musica, Ms.Ii.3.12,* fol. 61v. ca. 1160, University Library, Cambridge. Photo by permission of the Syndics of Cambridge University Library

tle is attached with a jeweled fibula, while his feet are shod in elegant high boots.

For the author (and the audience) of this miniature, Pythagoras is—despite his youthful appearance—one of the great sages, and his method, being experimental, is different from that of the other sages in whose company he is represented. The artist has depicted him by using the ingenious new visual language of gesture.

A slightly later image of Pythagoras survives in a pair of drawings from a German codex of about 1225–30 (whose subjects included the Seven Liberal Arts and seven pairs of Antique authors) from the Cloister of Aldersbach.[12] In one (fig. 27) Pythagoras is pictured together with a female figure who, representing music, holds a monochord. Together the two make up a full folio illu-

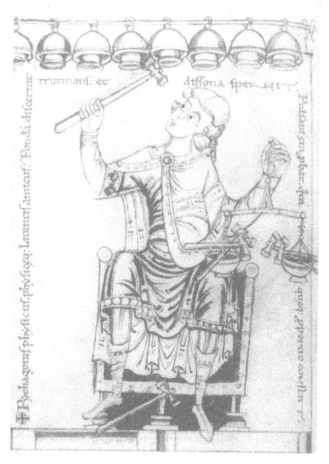

Figure 26. Pythagoras, detail. From Boethius, *De musica, Ms.Ii.3.12,* fol. 61v., University Library, Cambridge. Photo by permission of the Syndics of Cambridge University Library

mination, complete with inscriptions identifying the two. Of the two figures, both elongated and highly stylized, Pythagoras is the greater in size, suggesting his greater importance. He is dressed like a (Christian) bishop, wearing a pointed hat and luxurious vestment, both decorated with jewels. He also wears a beard proportionately much longer than his short hair. His pointed slippers are jeweled. In his hands he holds a scroll (with mysterious lettering, possibly an attempt at Greek) much in the manner of an old testament prophet. The charming smile he directs to Music suggests a personality full of wit and inspiration.

In the other (fig. 28), Pythagoras, whose name is inscribed as in figure 27 by the same artist, is pictured on one side of a brick wall, listening to the sounds of hammers coming from the other side. There, inside, a blacksmith

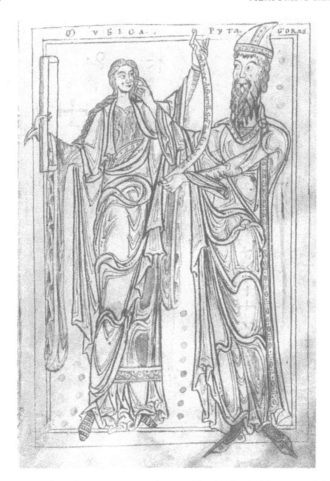

Figure 27. Music with Pythagoras. From Kloster Aldersbach, *Cod.lat.2599*, fol. 103r, ca. 1225–30, Staatsbibliothek, Munich. Photo courtesy of Bildarchiv Foto Marburg (Art Resource, NY)

and his two assistants pound on a block of hot metal. Dressed in the same ecclesiastical regalia as in the other miniature, Pythagoras is the largest of the four figures, again indicating his superior importance. Below this scene, two figures are shown playing, respectively, the monochord and the harp (the figure playing the harp is probably David; the identity of the other is unclear), while between them a lyre and its plectrum (or bow) hang in midair. This miniature obviously refers to the story of Pythagoras and the harmonious blacksmith, indicating that Nicomachus's story was well known in the thirteenth century to the monks in this German monastery, who very likely were acquainted with it through its dissemination by Boethius or a later scholar influenced by him.

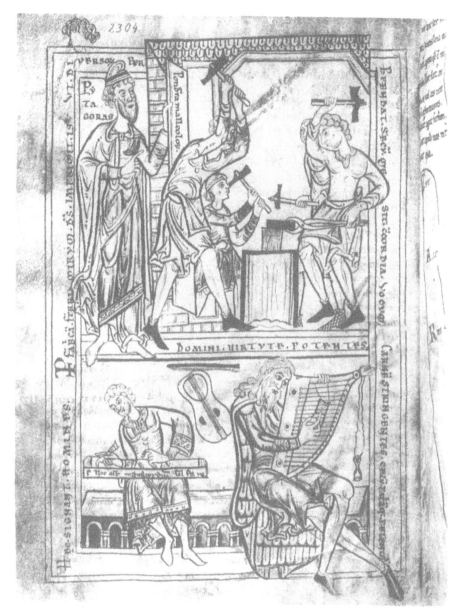

Figure 28. Pythagoras at the blacksmith's shop (*above*), and two musicians with monochord and harp (David?), with lyre (*below*). From Kloster Aldersbach, *Cod.lat.2599,* fol. 96v, ca. 1225–30, Staatsbibliothek, Munich. Photo courtesy of Bildarchiv Foto Marburg (Art Resource, NY)

Figure 29. Cathedral of Clermont-Ferrand, north transept portal, ca. 1290. Photo courtesy of Bildarchiv Foto Marburg (Art Resource, NY)

Another original interpretation of Pythagoras can be seen in a representation of him in a lobe of the sexfoil of the gable in the north transept facade of the Cathedral of Clermont-Ferrand (figs. 29 and 30). In this sculpture, which can be dated about 1290,[13] a seated and crowned Pythagoras is joined by Aristotle, Cicero, Priscianus, Ptolemy, and Boethius, who represent six of the Liberal Arts in the lobes of the sexfoil, while Euclid, representing geometry, is in its center. Here the sages are represented without the usual female symbols of the Liberal Arts. Instead, they are accompanied by small symbols of the arts. Representing music, Pythagoras (positioned at ten o'clock in the design) is striking a set of bells with his hammer. The crowns the figures wear on their heads suggest, according to the eminent French art

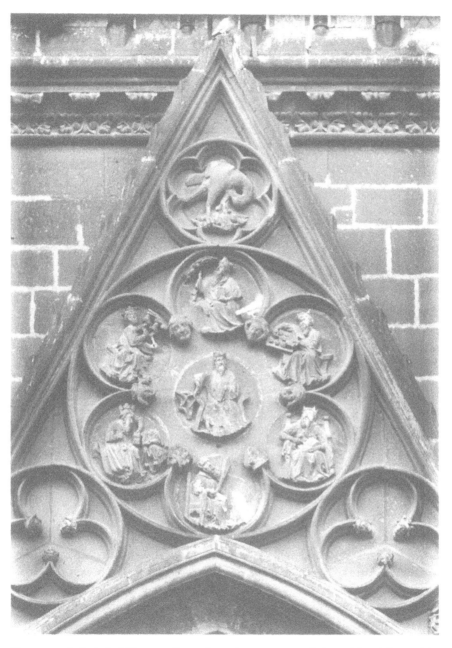

Figure 30. Cathedral of Clermont-Ferrand, north transept portal, Seven Liberal Arts (with Pythagoras at ten o'clock). Photo courtesy of Bildarchiv Foto Marburg (Art Resource, NY)

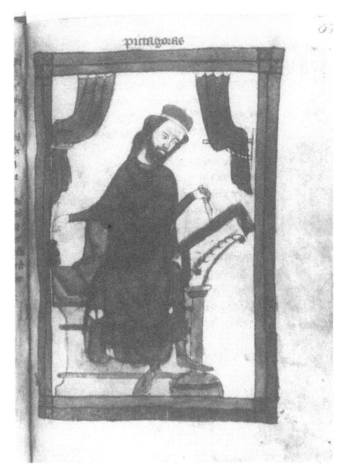

Figure 31. Pythagoras. From *Ms.Digby.46,* fol. 52r, early fourteenth century, Bodleian Library, Oxford. Photo courtesy of Bodleian Library, University of Oxford

historian Emile Mâle, the majesty that the subject of the arts evoked in the thirteenth century.[14] Although the appearance of Pythagoras as a protagonist of the Liberal Arts in Clermont was surely in accord with intellectual developments disseminating from Chartres, the appearance of Pythagoras and his famous philosopher friends in a relatively isolated city in the center of France, which, lacking a comparable intellectual tradition steeped in classical Antiquity was involved in a variety of territorial and civic disputes at this time, is indeed curious.[15] It is suggested later in this chapter that Pythagoras may have been a mythical hero in this region and that, where Druids once reigned, knowledge of Greek philosophers was well established in local traditions.

Wearing a dark pointed beret on his head, a brightly colored Pythagoras is seated at a clerical writing desk in an inscribed early fourteenth-century manuscript now in the Bodleian Library at Oxford (fig. 31).[16] His long dark hair cascades over his shoulders while his dark beard and moustache are trimmed; his left foot rests on a cushion. The figure is shown, between two parted curtains, doing two things at once: his right hand dips his writing instrument into an inkwell, indicating he was regarded as a writer, while his left hand holds a knife to the bookstand (which may be a monochord he is adjusting) in front of him. This pensive Pythagoras tilts his head wistfully to the left while he contemplates the action of his left hand. A portrait of Pythagoras was appropriate to this manuscript, which appears, due to the representation of Pythagoras as an intellectual, to be connected with the School of Chartres. In fact, its text reproduces the twelfth-century *Experimentarius,* a work on geomancy and astrology for which Bernard Silvester of Tours, an associate of Thierry of Chartres, is believed to have written the preface.[17]

At least a century later, Pythagoras was included as one of the seven sages of Antiquity, represented together with Solomon as the incarnation of wisdom, on a capital (ca. 1344) from the lower level of the south facade of the Palazzo Ducale at Venice (figs. 32 and 33). According to inscriptions above the capital, the others included with him are Priscianus (representing grammar), Aristotle (representing dialectic), Cicero (representing rhetoric), Euclid (representing geometry), Tubalcain (representing music), and Ptolemy (representing astrology). This assures us that Pythagoras, whose inscription is partially obliterated (PITAG——) and whose head is obliterated, represents arithmetic.[18] He is shown seated contemplating a tablet on his lap and counting four flat round objects, perhaps coins or the counters of an abacus. On the tablet appears the number (or numbers) 1344, which is thought to represent the date of completion of this particular series of capitals.[19] The modern scholar Paolo d'Ancona suggests these sages were specially chosen to be protectors of the disciplines of the trivium and the quadrivium.[20] Each of these figures is represented as a small draped man, seated or standing, inserted between the foliated acanthus leaves of the capital. Thus in mid-fourteenth-century Venice, the sages represented the Liberal Arts directly and without an intervening female figure. (Normally the latter were used alone to represent the Seven Liberal Arts, as were those in a bronze candleholder of ca. 1200 in the Duomo of Milan, in the pedestal of the pulpit of Nicolo Pisano in the duomo at Siena made later in the same century, in that of the pulpit of Giovanni Pisano in the duomo at Pisa, in the stone panels of the Fontana Maggiore at Perugia, in the reliefs of Andrea Pisano for the campanile of the duomo at Florence, in the funeral monument of Robert of Anjou in the Church of Santa Chiara at Naples, and elsewhere.)[21] That Pythagoras was revered in the Middle Ages for his double glory as the inventor of two of the disciplines of the Liberal Arts is indicated by the fact that here in Venice he

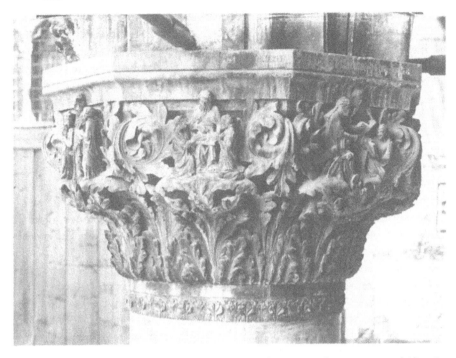

Figure 32. Capitello dei Sapienti, 1344, Palazzo Ducale, Venice. Photo courtesy of Alinari

represents arithmetic, while elsewhere, as in Chartres and Clermont-Ferrand, he represents music.

In the impressive Dominican chapter-room (known as the Spanish Chapel) of Sta. Maria Novella at Florence, Pythagoras takes his place in the first monumental painted series of the Seven Liberal Arts (fig. 34). Included in this ambitious fourteenth-century fresco executed in the late 1360s by a Florentine follower of Giotto named Andrea di Bonaiuto (Andrea da Firenze),[22] the Liberal Arts are ranged below Saint Thomas Aquinas, who is enthroned with figures from the Old and New Testaments. In the Liberal Arts series the female symbols of the arts are enthroned, while, seated at their feet, the philosophical representatives of the disciplines symbolically gesture. Here we find Pythagoras associated with arithmetic (fig. 35). Seated below the figure of Arithmetic and dressed in a heavy cloak that covers a white tunic, Pythagoras grasps a book in his left hand. This image suggests he was regarded as an author. His right is raised in a gesture of benediction, suggesting his authoritative status as the inventor of arithmetic. He wears a close-fitting black cap that reveals a symmetrically constructed face. His long white beard is evenly divided to either side, while he stares, hypnotically, straight ahead, a distinctly more formal and stern image than that of the charming and gracious youth of the eleventh-century manuscript discussed earlier.

Figure 33. Pythagoras. Detail from Capitello dei Sapienti, Palazzo Ducale, Venice. Photo courtesy of Venezia Direzione Centrale Beni e Attività Culturali

▲

Although surely not comprising a complete album of examples of the representation of Pythagoras in medieval times, these images tell us some important things about the ways in which Pythagoras was remembered in the Middle Ages. It appears that from about the twelfth century on, Pythagoras was represented not only in architectural decoration of religious and civic buildings but in manuscript illumination, religious and civic sculpture, and monumental painting. Images of him existed in France, England, Germany, and Italy. Most often he is represented in connection with the Seven Liberal Arts, sometimes as a representative of music (as at Chartres, where scholars knew him through their avid studies of Boethius, who was revered by them as the ancestor of the Scholastics in the classical world) and sometimes as a representative of arithmetic (as at Florence, where Martianus Capella's less austere recollections of Antiquity were, as everywhere else, strong throughout medieval times). There is no canon for his physical appearance: he is old or young, bearded or unbearded, active or contemplative. Although the continuing and apparently widespread nature of the dissemination of his image suggests his multifaceted importance in the medieval world, he was clearly respected equally by clerical and civic authorities. Thus did Pythagoras himself express his authority in the medieval world.

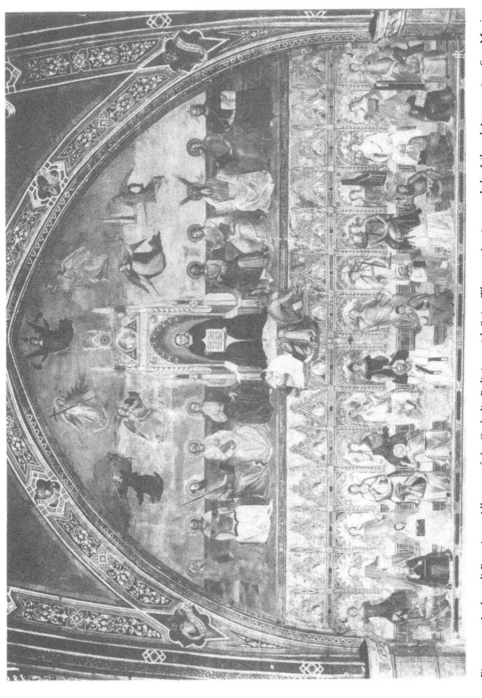

Figure 34. Andrea di Bonaiuto, *Allegory of the Catholic Religion with Saint Thomas Aquinas and the Liberal Arts,* 1360s, Sta. Maria Novella, Spanish Chapel, Florence. Photo courtesy of Alinari (Brogi)

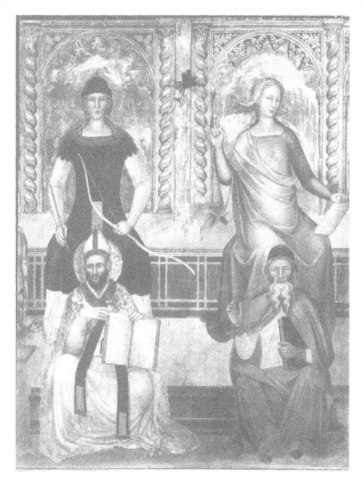

Figure 35. Arithmetic and Pythagoras (on right). Detail from Andrea di Bonaiuto, *Allegory of the Catholic Religion*, Sta. Maria Novella, Spanish Chapel, Florence. Photo courtesy of Alinari (Brogi)

The Dodecahedron in Early Medieval Art: Cosmos and Number

Shortly after the construction of the underground Pythagorean basilica at Porta Maggiore, at about the time the *Sentences* of Sextus the Pythagorean were beginning the wide dissemination they enjoyed during medieval times, Gallia Transalpina (the future France) came under the dominion of Rome as a result of the Gallic wars conducted by Julius Caesar. In the centuries after Caesar's conquest, Gaul would slowly become romanized until the kingdom of the Franks began to form under the Merovingian dynasty in the fifth century (AD), bringing Roman rule to an end. To the archaeology of this Gallo-Roman period belongs a series of curious geometrical objects, all of which appear to date

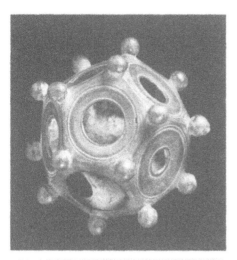

Figure 36. Bronze dodecahedron, ca. third–fourth centuries AD. Musée Romain, Avenches. Photo copyright Musée Romain d'Avenches

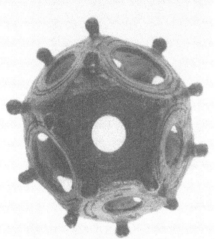

Figure 37. Bronze dodecahedron, ca. third–fourth centuries AD. Musée Archéologique, Strasbourg. Photo courtesy of Musée Archéologique de Strasbourg

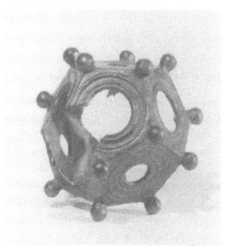

Figure 38. Bronze dodecahedron, ca. third–fourth centuries AD. Musée Archéologique, Strasbourg. Photo courtesy of Musée Archéologique de Strasbourg

from about the second through about the fourth centuries, and all of which bear precisely the same formulaic Pythagorean traits.

Found in Gallo-Roman sites identifiable by accompanying coinage, pottery, and other archaeological objects, primarily in central France, these enigmatic objects are all small polyhedrons made according to a specific formula (figs. 36–38).[23] Each of the approximately eighty examples known today is a spherical dodecahedron.

In every case, the twelve parts of the dodecahedron are articulated by twelve circular openings to the hollow interior of the sphere. Each opening is decorated with carefully incised lines forming a pentagon; thus each dodecahedron displays twelve pentagons. In all cases, each of the angles formed by the adjoining points of the pentagons is decorated with a small slightly flattened ball.[24]

Some diversity exists in the size and weight of these mysterious bronze objects. Although some are slightly larger and others slightly smaller, their average diameter is about 65 millimeters (about three inches), or about the size of a large apple. Although at least one is known to weigh as much as a kilo and another as little as 35 grams, the weight of these objects is most often close to 200 grams. Their physical dimensions suggest that these objects were not only precious but also portable.

With the exception of one constructed in silver, all these objects are constructed of carefully worked bronze, a material that, well known to the Greeks and Romans as well as to Celtic tribes, was superior to iron and reserved for special decorative use in migrational art of this period. In many areas this strong and enduring alloy, which when new gleamed with highlights, had sacred connotations and magical powers.[25] The use of this material thus suggests that these enigmatic objects were not intended for casual use but rather that they were precious, designed to be enduring, and perhaps served magical purposes.

Replete with hypotheses, the literature on them has not convinced us that they served any utilitarian purpose among the many that have been considered—including arms decoration, attachment for a scepter, a light fixture, or a type of bowling ball.[26] Not only does the bronze material in itself argue against a utilitarian function, but so also does its complicated form, which is distinctly mathematical and includes hollow as well as solid areas. Particularly puzzling to those who have studied these bronze dodecahedrons are the twenty little balls that decorate every angle formed by the pentagons.

Virtually every study has considered the possibility that these mysterious bronze objects may have served a religious purpose for which the geometry of the sphere, articulated as a dodecahedron, and its twelve component pentagons and twelve apertures were for some unknown reason important. Although it is tempting to imagine their purpose was religious, this idea is extremely unlikely, given that not one of these items was discovered in the interior of a sanctuary.

Although some of the specimens have been discovered in fragmentary state, most have been found whole and without wear on any parts of the surface. Nor have any traces of use or abuse been found on the objects.[27] This underscores the probability that they served a cultish purpose, connected with magic and, most likely, prognostication, rather than a practical purpose.

▲

The dodecahedron was well known in the classical world. Philolaus, the earliest known Pythagorean philosopher, who, as discussed in chapter 5 was reputed in Antiquity to have published the doctrines of Pythagoras, held that earth, being a sphere, was the fifth of the five regular convex solids, which were the pyramid, the cube, the octahedron, the icosahedron, and the dodecahedron.[28] Subsequently, in works that had a wide dissemination in Antiquity, Plato published the dodecahedron as the fifth of what came to be known as the Platonic solids, each of which could be circumscribed by a sphere. The dodecahedron represents, he explains, the cosmos. According to the *Timaeus,* regarded in late Antiquity and throughout the Middle Ages as his most Pythagorean work, the original dodecahedron was a structure used by God as his inspiration when he shaped the universe.[29] In the *Phaedo,* Plato elucidated: "The real earth viewed from above is supposed to look like one of these balls made of twelve pieces of skin, variegated and marked out in different colors."[30] The sphericity of the earth was further articulated, he explained, by "many hollow places all round the earth . . . in which the water, mist and air have collected . . . [and] are continually draining in the hollow places of the earth. We do not realize that we are living in its hollows but assume we are living on the earth's surface."[31] While we walk on the earth, he seems to say, we see it as it is, but if we were to look down on it from above, we would see it differently: "Such is the nature of the earth. . . . All over its surface there are many hollow regions . . . through which, from one basin to another, there flows a great volume of water, fire and mud."[32] Their movement, he explains, is caused by the oscillation of the earth, which forces the movement of fire, water, and mud through its cavities, which pierce through the earth from one side to the other.[33] During Gallo-Roman times, Plato's *Timaeus* was of particular interest. Translations and commentaries on it were made by writers as celebrated as Cicero, Porphyry, and Chalcidius.

Shortly after Plato's time, Euclid described the dodecahedron as being formed of equilateral and equiangular pentagons.[34] He would be followed by Aëtius, who was the first to attribute the concept that the universe is a dodecahedron to Pythagoras. Pythagoras proclaimed, Aëtius explains, that the five solids have mathematical significance in the following way: the cube gave birth to the earth, the pyramid to fire, the octahedron to air, the icosahedron to water, and the dodecahedron to the sphere of the universe.[35]

When Diogenes Laertius wrote his *Lives* shortly thereafter, he listed as com-

mon knowledge the five regular solids, attributing to Pythagoras the idea that
the four elements combined form the sphere (represented by the dodecahe-
dron). Pythagoras particularly loved the sphere, he tells us, and he was the first
to call the earth spherical.[36] Soon after, Iamblichus certified twice that it was
indeed Pythagoras who had been the first to construct the sphere and that he
had done it from twelve pentagons. This secret was so revered among
Pythagoreans, Iamblichus informs us, that when it was violated by Hippasus,
the latter was punished by being drowned at sea for his impiety in revealing
it.[37] Thus does the dodecahedron formed from twelve pentagons appear to
have been well known in later Antiquity and Gallo-Roman times as a secret
Pythagorean invention.

The pentagon and its corollary, the pentagram, were necessary to the con-
struction of the dodecahedron, and they were regarded as Pythagorean sym-
bols of health.[38] The first to tell us this was Lucian, who knew Gaul firsthand,
for he traveled there. He testifies, in the second century AD, that the pentagram
(which is derived from the pentagon) was the secret symbol signifying health
among Pythagoreans.[39] In connecting the dodecahedron of Antiquity with the
twelve zodiacal signs, the twelve months, and the twelve world spheres of Pla-
tonic discourse, the modern scholar Michael Allen suggests that these refer-
ences must have been familiar to Gallo-Roman seers and those interested in
cosmological discourse and divination.[40] From the time of Cicero in the first
century BC, Pythagoras had been credited with divination and, from the time
of Pliny the Elder in the first century AD (if not by Aristotle and Heraclitus long
before), with the practice of magic. Given this background, such a precious
and portable Pythagorean object as the bronze dodecahedron suggests a con-
nection between cosmology, health, and divination. Perhaps now we are in a
better position to speculate why.

▲

In the world of the Druids, the wise men of Gaul, human destiny was an im-
portant concern. As teachers, philosophers, physicians, and judges, the Druids
formed the sacerdotal class among the Gauls. As priestly educators, they spoke
in obscure enigmas, taught in dark places, played the lyre, and respected the
numerical language of Pythagoras. Above all they were famous for prognosti-
cation. They knew how to foretell historical events as well as how to announce
life and death.[41] Antique accounts emphasize the monopoly of the Gauls on
the most advanced forms of augury and divination. Even if it is not certain that
the Druids had devised a calendar, their cosmological interests inspired them
to calculate time and space. Incorporating ideas about the unity of social, po-
litical, intellectual, and religious mores, their cosmological doctrines, which
were transmitted secretly and characterized by a reluctance to put things in
writing, focused on the immortality of the soul, which, after passing through
finite time, would experience infinite time.[42] These doctrines correspond with

those of late Antique Pythagoreanism. So also does their interest in the healing arts. This interest is suggested by the intrinsic presence of the pentagon in every surviving example of these bronze dodecahedrons. Coincidentally, Diodorus Siculus praises the skill of the Druids in bronze working. Bronze is, he says, wrought by them in the most unusual ways to create fantastic shapes. Their bronze helmets, for example, are, he says, decorated with large projecting forms.[43]

It seems an inescapable conclusion that these evidently precious objects were Druidic prognostication devices whose purpose was to calculate the outcome of disease, life, and death as well as the advisability of medical procedures. Composed of twelve parts and articulated with an equal number of cavernous hollows through which, as described by Plato and Diogenes Laertius, vapors and mists might be imagined to flow (or through which actual water and mud might be flushed), such objects would have allowed the Druids to function, as the Christian bishop Hippolytus described them, as prophets who could foretell the future according to the "Pythagorean art." Pliny gives us a clue respecting the use of such objects. He describes a Druidic object that looked like a cosmic egg or snake's egg—a round object about the size of an apple, full of cuplike hollows—as an amulet.[44] While in this particular case he is not describing a dodecahedron (although the snake may also refer to health or medicine), he suggests that similar objects were used, perhaps in secret, for divination or augury.

Without intending to, Emile Mâle gives us a clue that would further clarify this interpretation. In describing the figure of Arithmetic in the Cathedral at Laon, Mâle identifies the little balls held between the fingers of this figure as the balls of an abacus used in making arithmetical calculations. Elsewhere too, he saw these balls in conjunction with images of Arithmetic.[45] The number of balls on the bronze dodecahedrons is always the same, twenty, thus suggesting a numerological symbology. According to Diogenes Laertius, who wrote at approximately the same time these objects were being made, it was believed in his time that Pythagoras had divided man's life into four quarters: twenty years as a boy, twenty years as a youth (the time of their education; in this connection it is useful to remember that Druidic youths were educated for a period of twenty years), twenty as a young man, and twenty as an old man.[46]

This concept suggests that the twenty balls placed on each point of the pentagon may have been specifically designed to take into account the age of a person in predicting the outcome of disease or the necessity for incantations— a notion that fits very well with the idea of medical practice of prognostication in which we know the Druids excelled. Iamblichus, a contemporary of the Druids, says that Pythagoreans thought little of drugs and rejected surgery and cauterization, preferring to use incantations and divination to treat illness.[47]

This interpretation of the three-dimensional wise men's dodecahedrons with their arithmetical balls and pentagons as precious objects used by Druidic

Pythagorean philosopher-physicians for medical prognostication fits with the emphasis that contemporaries placed on the Druidic practice of divination and its connection with medicine. It also suggests that, translated into the memory of later centuries after their presumable prohibition during the third and fourth centuries AD, when the Druids were persecuted and eventually became extinct, these objects became drawings of circles—or Pythagorean Spheres— by which, as we know through medieval manuscript illustration, similar calculations could be made.

This hypothesis offers a possible explanation as to why representations of Pythagoras and his philosopher colleagues should have been chosen to represent the Liberal Arts in settings such as the cathedrals of Clermont—an area that was not Christianized until the mid-third century (by Saint Austremoine of Gaul)—and Chartres, which was built over a Druidic religious structure.[48] Traditions of Pythagorean Druidic philosophers were strong in France, where the largest concentrations of bronze dodecahedrons happen to have been found. Perhaps well entrenched in local tradition, Pythagoras was a mythical hero in Druidic France. Indeed when the Druids disappeared, these mytho-cosmological images of the universe disappeared as well. In the Renaissance, which remembered the Druids as Pythagoreans, the "cosmic" dodecahedron would reemerge as a solid of great interest to Pythagorean mathematicians.

The Pythagorean Sphere in Later Medieval Art: Cosmos and Number

The idea that the monadic physical universe that underlay scientific thinking could, through the cosmological schemata it invited, have a medical application is suggested by the bronze dodecahedrons. Just as these seem to have disappeared, in about the third or fourth century, a new spherical object, likely related to the Druidic practice of seeing cosmology in terms of its human consequences, began to appear in early medieval manuscripts.[49] Because these illustrated spheres were accompanied by a written text, their purpose has not remained as mysterious as has that of the bronze dodecahedrons. These are the Pythagorean Spheres, whose uniform texts were discussed in chapter 7.

A potent device, the Sphere of Pythagoras was essentially a diagram that incorporated the numerical table used for calculating whether the patient or person in danger would live or die, or the wisdom of undertaking certain specified medical procedures. Thus was it a magical device used for divination of impending events that had to do, most commonly, with health matters. Because it is found in medical manuscripts, this magical device clearly was used by physicians. However, the fact that it is also known in nonmedical books, such as missals, suggests that it was also used by nonphysicians—for example, priests who could consult such a sphere while in the process of deliberating the wisdom of administering extreme unction.[50]

Figure 39. Pythagorean Sphere. From *Ms.Lat.11411*, fol. 99, ninth century, Bibliothèque Nationale de France, Paris. Photo courtesy of Bibliothèque Nationale

This idea of a magical sphere appears to be the descendant of a Greco-Egyptian design known as the Sphere of Petosiris, which, in its oldest surviving version (fourth century AD), was attributed to Democritus of Abdera, who it will be remembered was an important admirer of Pythagoras in Antiquity.[51] When the term was translated from Greek into Latin in about the sixth century, the device came to be known as the Sphere of Pythagoras or the Sphere of Apuleius.

One of the oldest of the surviving examples of the Pythagorean Sphere is found in a ninth-century manuscript now in the Bibliothèque Nationale at Paris (fig. 39), which displays a sphere roughly drawn by hand. The sphere is divided horizontally into an upper and lower part, with each part divided into three.[52] The resulting six sections show an arrangement of roman numerals (I, II, III, VII, VIIII in the first section, XI, XIII, XIIII, XVI, XVII, XVIII in the second, and so on) between 1 and 30, the number of days in the month, which refer to the "lucky" days (since they are on top). Those below, representing the "unlucky" days of the month, start with V, VI, VIII, XII, then XV, XVIII, XXI, XXIIII, and so on. Some numbers (between 1 and 30) do not occur at all, while others occur twice. The numerical value of individual letters of the alphabet (permitting a physician to compose a patient's name) is arranged in the margins to right and left of the sphere. The text above proclaims the usual message as discussed in chapter 7. The sphere occupies the lower third of the folio and is clearly meant to be coordinated with the text above so that together they form a composite image.

An early tenth-century codex at St. Gall shows a double circle divided vertically into two hemicycles. The numbers are written in the margins that form the circle and in the dividing line that bisects the circle.[53] In another early example, from a tenth-century codex in the Archivio Capitolare at Vercelli, the sphere is divided in half horizontally.[54] The numbers in one half are the lucky numbers that indicate life, while those in the other half are the unlucky ones that indicate death is imminent. The verso of the folio on which this sphere is illustrated contains a recipe for curing a person possessed by a demon. A potion was to be made from mistletoe (interestingly, a plant revered by the Druids, who were now presumably extinct) and holy water and administered with the urine of a virgin goat. Throughout his life, the victim was not permitted to drink again from a glass or to eat goat meat, lentils, certain fish, or bread baked on Sunday.[55]

A manuscript from the latter part of the same century, now in the Bibliothèque Nationale at Paris (fig. 40), shows a perfectly drawn sphere whose circumference is articulated by three circles. The sphere is divided by two horizontal bars.[56] It is set into a square with three of its corners articulated by six lines while the fourth is crosshatched. To the left is the alphabet, accompanied by the numerical value assigned to each letter. Above and below the horizontal bars, numbers appear. Some of the series are the same while others are different from those described in the previous manuscript. Again, the text is

Figure 40. Pythagorean Sphere. From *N.Acq.Lat.1616,* fol. 7v, tenth century, Bibliothèque Nationale de France, Paris. Photo courtesy of Bibliothèque Nationale

arranged in coordination with the image; this time the image is in the center, with text above and below to form a completed composition on the folio.

An example of a Pythagorean Sphere from the eleventh century, now in Orléans but originally from St. Benoît sur Loire (fig. 41), appears, despite its fragmentary condition, to be very much like the others.[57] It is composed of a double circle surrounding the interior "sphere," which contains the magic numbers that lead to *vita* or *mors,* the words inscribed above and below, respectively. That this

Figure 41. Pythagorean Sphere. From *Ms.276*, fol. 129, eleventh century, Bibliothèque Municipale, Orléans. Photo courtesy of Bibliothèque Municipale d'Orléans

example appears to have lacked an explanatory accompanying text suggests that it may have originally been a portable vellum that was later inserted into a book.

A twelfth-century folio completed in 1120, from a manuscript now in the University Library at Ghent, provides another example of the Pythagorean Sphere (fig. 42).[58] A triple circle forms the boundaries of a sphere which is articulated with bright red bars framing an X in the center, around which are arranged, in upper and lower registers, numbers that are slightly different from those noted previously, although they are arranged in similar series. In this case, the numerical equivalents of the letters of the alphabet are incorporated into the circle rather than placed outside it in order to form margins, which allows the sphere to take up the entire width of the folio. Text appears above and below, while the sphere is centrally located on the folio.

Figure 42. Pythagorean Sphere. From *Liber Floridus of Lambert of Saint-Omer, Ms.92,* fol. 26r., ca. 1120, Universiteitsbibliotheek, Ghent. Photo courtesy of Ghent University Library

Among the many other known manuscripts representing the Sphere of Pythagoras from the twelfth through the fourteenth centuries are two examples now in the Bodleian Library at Oxford. The first (fig. 43), dating from the fourteenth century, represents a sphere to which have been added eight semicircles, to form a design somewhat like the petals of a flower.[59] In the center is located a smaller circle in which the name of the sick person can be inserted numerically. Surrounding that is a larger circle (bisected by a dividing line) that lists numbers above and below, while the letters of the alphabet and their respective numerical values are arranged in subsequent circles forming the perimeter of the design. This design is larger than its predecessors, taking up almost the entire folio. The second, dating from the early fifteenth century, contains a pair of Pythagorean Spheres (fig. 44).[60] Both of these show a triple sphere that, bisected horizontally, contains a table of numbers above and below, while the letters of the alphabet and their numerical equivalents are displayed in the peripheral circles. In each case, the sphere takes up more than half the folio in relation to the accompanying text.

These examples show clearly that the Pythagorean Sphere, first presented in about the fourth century, was well known and in constant use from the ninth to the fifteenth centuries.[61] These designs were easily used. All one had to do was to add the numerical value of the letters of the sick person's first name, followed by the number of the day on which he or she fell ill. The total was divided by thirty, the number of days in the month, and the result fell either in the upper or the lower half of the sphere. All the Pythagorean Spheres have certain things in common. For example, the circle is the unit of design for all of them. The numbers above the dividing line (that is, those denoting life) tend to be arranged in three groups based on the number ten: 1–10; the teens, 11–20; and the twenties, 20–30; the numbers below appear to be unrelated to the number ten. Also, the numbers above are always in order (1, 2, 3, etc.), while the numbers below are out of order. Most interesting is the fact that there are more lucky numbers (above the line) than unlucky numbers (those below the line), suggesting a kind of underlying optimism.

The idea of connecting Pythagoras's assistance to mankind with the sphere was well noted not only in the bronze dodecahedron of Gallo-Roman times but as well in the contemporary writings of Iamblichus. Iamblichus referred to the sphere (of Pythagoras) as a "divine receptacle" and a "unity" that is the principle of the universe; in addition, he affirmed that Pythagoras cured disease by incantations.[62] Thus does the Pythagoreanism of these spheres appear to be likely.

The Pythagorean Y as a Symbol of Choice

An area of possible Pythagorean influence in medieval art is related to the continuing interest in morality and virtue, spurred by such Pythagorean works as

Figure 43. Pythagorean Sphere. From *Ms.Digby.46*, fol. 106b, fourteenth century, Bodleian Library, Oxford. Photo courtesy of Bodleian Library, University of Oxford.

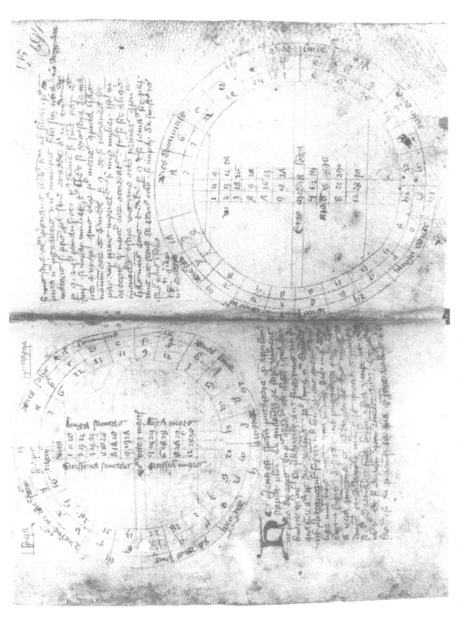

Figure 44. Pythagorean Spheres. From *Ms.Digby.29*, fols. 193v and 194r, early fifteenth century, Bodleian Library, Oxford. Photo courtesy of Bodleian Library, University of Oxford

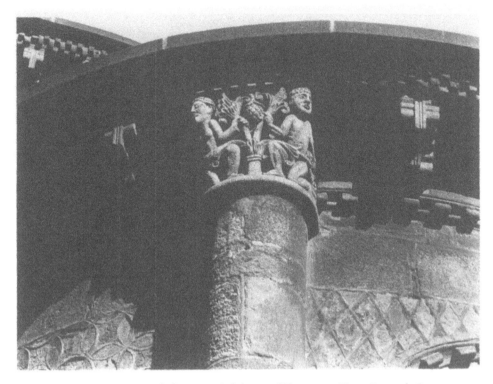

Figure 45. Temptation, ambulatory capital, late twelfth century. Notre-Dame du Port, Clermont-Ferrand. Photo courtesy of Bildarchiv Foto Marburg (Art Resource, NY)

the *Golden Verses*, by now traditionally believed to have been composed by Pythagoras himself, and the *Sentences* of Sextus, a work that had a long life throughout the Middle Ages. These topics are strongly suggested by the representation of Adam and Eve separated by a tree that has the form of a Y, recalling the famous Pythagorean Y, which both Saint Jerome and Ausonius had described as indicating the alternate paths of good and evil.

In a French late twelfth-century capital from the ambulatory of the Romanesque church of Notre-Dame du Port in Clermont-Ferrand,[63] we see Adam and Eve to either side of a tree that is divided in half above its trunk—clearly suggesting not the usual symbolic single tree but a divided tree (fig. 45). Because Adam and Eve are here represented in an early moment before the Temptation and before the picking of the fruit, it can be assumed that the Y here suggests exactly what Saint Jerome and Ausonius had explained, a choice between two paths, or between right and wrong. In fact, Saint Jerome himself had suggested a connection between the Pythagorean Y and original sin.[64] As noted earlier, Pythagorean influence may have been strong in central France due to Druidic influence.

Indeed the Carolingian scholar Remigius of Auxerre (ca. 841–910), an influential teacher and proto-humanist who taught in Burgundy, to the north of Clermont, twice described the Pythagorean Y in a famous commentary he wrote on Martianus Capella. Referring to Martianus's description of Philology taking "the letter" regarded by Pythagoras as representing the ambiguity of morality,[65] Remigius describes a fork that represents the moral difference in a splitting of paths, which was in accord, he says, with the teachings of Pythagoras. In another place Remigius explains that the letter Y, which begins with a stem and splits into a fork and which derives from the doctrine of Pythagoras, allows a person to choose a good or a bad path.[66] This concept may be traced to the comment of an earlier medieval writer, Servius, writing about Virgil's *Aeneid*. Servius had described a tree in the woods that Aeneas encountered upon entering Hades as having the shape of a Y.[67] This form provides a clear precedent for the sculptural image of the divided tree described earlier. Although because he wrote commentaries on Boethius as well as on Martianus Capella, Remigius may have been a Pythagorean, he is at the very least an excellent example of a ninth-century writer from central France through whose work or influence the significance of the Pythagorean Y would have been well known in the area. During the very century in which the sculpture at Clermont-Ferrand was executed, Hugh of St. Victor praised the letter Y as that of Pythagoras, and Petrach was to describe it—with admiration—in later medieval times.

Other examples of Adam and Eve to either side of a tree that resembles a Y are known in central France, the Île-de-France, and the Rhineland area of Germany. An example similar to that at Clermont, and also dating from the twelfth century, occurs in an ambulatory capital in St. Benoît sur Loire. This is, perhaps coincidentally, the same place from which an example of the Pythagorean Sphere (discussed above, now in Orléans) came. A scene representing the Temptation in a capital from the twelfth-century cathedral of St. Martin d'Ainay at Lyon includes a similarly split tree. Another example may be found at Paris, where Adam and Eve are represented on either side of a split tree in the central portal of the west facade of the Cathedral of Notre-Dame, likewise designed in the late twelfth century. A twelfth-century German manuscript confirms the significance of the Pythagorean Y: one scene, representing the Temptation, shows a tree clearly divided in two at the top, its parts issuing from a single root, while another miniature by the same artist, showing God admonishing Adam and Eve (who are no longer engaged in the act of deciding, for they have already acted), shows a normal, unified tree (cf. figs. 46 and 47).

▲

The examples described in this chapter reflect the extraordinary popularity of Pythagoras throughout medieval times. This book does not constitute a

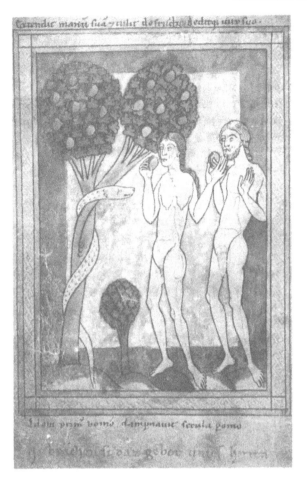

Figure 46. Temptation. From *Cod. Lat.935* (*Prayerbook of Saint Hildegard*), fol. 4v, ca. 1190 (from Middle Rhineland), Staatsbibliothek, Munich. Photo courtesy of Bildarchiv Foto Marburg (Art Resource, NY)

complete catalogue of images, but it appears clear that more inscribed images of Pythagoras survive from the Middle Ages than from Antiquity. These images also tell us about the importance of Pythagorean notions of cosmos and number in medieval times. From them it is clear that Pythagoreanism did not regard numbers in the cold, impartial manner of modern mathematicians. For those who followed Pythagorean numerology, as medieval intellectuals and physicians had been urged to do by Boethius, Macrobius, Isidore of Seville, and others so mystically inclined, numbers were a dynamic form of energy that impacted life and death. The sphere was always the unity, or the monad that signified the cosmos, and the numbers that decorated it or that were contained within it were "good" or they were "bad," like virtues and vices, and not unlike the Pythagorean Y, which also appears to have inspired works of art.

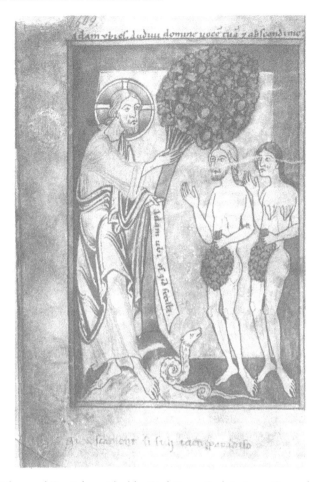

Figure 47. Adam and Eve Admonished by God. From *Cod. Lat.935 (Prayerbook of Saint Hildegard)*, fol. 5v, ca. 1190 (from Middle Rhineland), Staatsbibliothek, Munich. Photo courtesy of Bildarchiv Foto Marburg (Art Resource, NY)

As for the Pythagorean Sphere itself, even so exemplary an early Christian as Clement of Alexandria had acknowledged that Pythagoras, who he regarded as a harbinger of Christian ideas, was associated with the art of prophecy. The attribution of magical powers to the sphere is but a reflection of the old idea of the attribution of magical powers to Pythagoras himself, who was a "divine" man who performed miracles and who had a golden thigh. Although medieval physicians had lost interest in the golden thigh, if indeed they knew about it, they certainly knew about the magic that numbers could work, and its cosmological connections. Besides, they were the beneficiaries of Pythagoras's work as a physician.

SACRED SITING

The Pythagorean Heritage of
Medieval Ecclesiastical Architecture

∴∴

As the classical world began its slow transformation into the Middle Ages, ecclesiastical architecture aimed to support the growing strength of Christianity by initially providing a makeshift space in which small congregations might worship. This space eventually came to be articulated as an elaborate structure that had celestial aspirations in honor of Christ, who—not unlike Pythagoras in Antiquity—was not only a holy man but the divine son of God.[1] As Christian church architecture evolved into the great cathedrals of Gothic Europe, more complex liturgical needs accompanied the increasing ambition for the acquisition of relics. The ever grander structures that succeeded solidified the preeminence of Christianity and made the formalized worship of Christ accessible to huge pilgrimaging populations of the faithful as well as to the emerging cities of Europe. For these structures, the language of Pythagoras appears to have been, at least in part, very appropriate.

The dynamic creativity that was engaged in developing and building the Gothic cathedral was phenomenologically intellectual as well as psychological. The self-contained cosmology of the divine world imagined in these structures, centering in the east or altar end, required not only theological inspiration but also mathematical and musical applications, qualities in which Pythagoras had, it was believed by then, excelled. The liturgy was enriched by the influence of music, which was in large part dependent on the *Harmonic Elements* of the ancient Pythagorean-peripatetic Aristoxenus. The principles and theo-

rems he presented in this work had partially survived and were known in man-
uscript form, which were esteemed and reproduced in the twelfth, thirteenth,
and fourteenth centuries.[2] The texts stressed the value of the voice, the con-
struction of melody, and the diatonic scale, all of which brought Pythagorean
ratios to bear on the plain-song of the church.

Well known in the Middle Ages as a Pythagorean, Plato had shown in his
influential *Timaeus* that the mind of the philosopher was dependent on that of
God, because it is God who bestows human reason upon mankind, enabling
humanity to make sense of the universe. The arrangement of the cosmos fol-
lows an order in which symmetry and harmony could be expressed in an in-
spirational universal language, for God had, as William of Conches deduced
from Plato, acted as a craftsman in designing the universe.[3] The closer man-
kind comes to acquiring wisdom, Plato suggested, the closer it comes to God.
Correspondingly, medieval thinkers deduced, the more mankind is distracted
by material factors, the farther it moves away from God. Pythagoras, too, had
urged his followers to shun materialism and cultivate frugality in their quest
for piety.

Thus did Christians, in constructing their view of the celestial harmonies of
the cosmos as reflected in the Gothic cathedral, idealize order, ritual, asceti-
cism, abstinence, mystery, symbol, singing, and worship at bloodless altars.
Too, their human souls were worthy of being saved, that is, raised to the level
of the divine. In addition, number could serve to guide, inspire, and energize
architecture, allowing it to symbolize theological truths. All these concepts
were rooted in the cosmology of Pythagorean Antiquity. The qualities of num-
ber and the relation of number to the harmony of the world, passed on
through the works of Boethius, Martianus Capella, Macrobius, Simplicius,
Cassiodorus, Dionysius the Areopagite, Isidore of Seville, and others, were
transmitted and transmuted by intellectuals through theological concepts,
while for many of the faithful they survived as the language of divination, in-
cantations, and alchemy.

This chapter suggests some ways in which the idealized edifice of Christian-
ity is related to Pythagorean ideas that had been stamped with approval by the
Church Fathers—especially Saint Augustine and Saint Jerome—as well as by
the influential Christian scholar Clement of Alexandria and the learned bish-
ops Cassiodorus and Isidore of Seville. Many of these ideas had never died.
Pythagorean concepts of order, number, and, above all, cosmology, though
perhaps not always recognized as such, appear to have had a long life as inspi-
ration for the structural methodology of Christian worship. As numerological
and symbolic elements they were incorporated into medieval church architec-
ture as it developed over a millennium. The apogee of interest in these concepts
would be reached in the self-conscious architecture of the Italian Renaissance,
when the doctrine of the harmony of the universe would become a preferred
doctrine.

The Basilical Origins of the Medieval Church

The most distinctive features of the Pythagorean Basilica at Porta Maggiore were, as we have seen, its oblong rectangular plan preceded by a perpendicular narthex in which was located a pool of holy water for ritual purification before entrance into the basilica; its division of the interior space into a nave and side aisles, which provided a longitudinal, or horizontal, axis directed toward the altar; and its semicircular, semidomed apse, which, terminating from the nave, was located in the east. This sanctuary, the most holy part of the building, demonstrated in its decoration the role of Apollo as redeemer, for it was through him that Sappho's soul was rescued for eternal life. This image constituted the most significant symbolic decoration of the entire building. Its eastward orientation corresponds with what Vitruvius (a Pythagorean) had insisted on and Plutarch, Iamblichus, and others were shortly to reaffirm, that the cosmographical orientation toward the rising sun was of primary importance for Pythagorean worship.[4] The nave was separated from the side aisles by a series of upright elements (piers) that provided a horizontal axis, and from the apse by a large triumphal arch that framed the altar. These elements, in combination different from those of Roman mithraea and other cult structures as known in the Hellenistic, Egyptian, and Roman worlds,[5] all came to be embraced by the Christian church.

This heritage was, however, not realized at once. It is by now well established that early Christians first worshipped in private homes (the *domus ecclesiae*), where they gathered in small groups and received hospitality, and later, as catacomb cemeteries developed after the third century, in underground catacomb chapels where they feasted and prayed.[6] Perhaps the concept of feasting in an underground holy place gave them common cause with Pythagoreans, who, as indicated by the archaeology of the Basilica at Porta Maggiore, had feasted and worshipped underground. Although the central act that defined worship for Christians was, at first, an actual meal, it eventually came to be transformed into symbolic ritual.[7]

Precisely when Christians began to adapt and transform private houses and mansions donated to them into ecclesiastical structures, or churches, is unknown. However, perhaps the earliest example is well known to us as San Giovanni in Laterano, or the Cathedral of Rome (the Lateran).[8] Begun in 312–13 by Constantine himself, this church was built over a small house and a large mansion. Although subsequently much altered, the original church was very large, with a nave and two side aisles to either side. The entire width of the building was preceded by a narthex, and the nave terminated in a semicircular apse.

Other fourth-century churches followed in this arrangement, including the large independently constructed San Paolo fuori le Mura, reportedly also built by Constantine in 314–55. A yet larger, perhaps also Constantinian, building, San Pietro (St. Peter's), adopted the same example, although it was raised over

the tomb of Saint Peter and directly upon a large necropolis area. This lofty basilica (as in the Lateran and San Paolo fuori le Mura, constituted of a nave flanked by two side aisles to either side) was preceded by a large atrium and terminated in an apse. It featured the first transept, or transverse element (situated between the altar and the nave), an element rarely present in contemporary basilicas that originated probably to serve as a sacristy or custodial space.

Additional Christian churches built in fourth-century Rome include Sant'Agnese fuori le Mura, SS. Marcellino e Pietro in Via Labicana, SS. Nero ed Achilleo in Via Ardeatina, San Sebastiano, and San Valentino, which were all built over catacombs or developed from a series of antecedent mausolea. Another group, which were adapted from or constructed over preexisting Roman buildings include Sta. Cecilia in Trastevere, San Clemente, Sta. Croce in Gerusalemme, San Marcello al Corso, San Marco, Sta. Maria in Trastevere, SS. Nero ed Achilleo near the Baths of Caracalla, San Pietro in Vincoli, and Sta. Pudenziana. Three of these (Sant'Agnese fuori le Mura, Sta. Croce in Gerusalemme, and SS. Marcellino e Pietro in Via Labicana) were reportedly founded by Constantine. The many-times-rebuilt large basilica of Sta. Maria Maggiore was also founded during this century. As originally constructed, over a cemetery, it did not have the transept (added in the thirteenth century) that forms a part of the present structure.

All of these earliest churches built in Rome during the fourth century, either by Constantine or his successors, share the basilica plan—composed of a nave, flanking aisles, and a semicircular apse—that would become standard in the Christian world. However, the orientation of these early basilicas is not uniform. Built over preexisting structures, most of the Constantinian basilicas of Rome had apses facing west, north, or south. Only four of all these earliest Roman churches, including one built in the fifth century (SS. Quirico e Giulitta), have the apse in the east. This feature is remarkable when we consider that the eastern apse, as first seen in the Basilica at Porta Maggiore, will become the standard in later medieval churches and will be designated the "east end."

From the historical point of view, these four eastern-oriented churches have one thing in common: they were the only structures not adapted to the exigencies of a preexisting site. They were built ex novo. Among the four, San Paulo fuori le Mura, though surrounded by hillsides containing mausolea, was constructed on a flat plain. San Pietro in Vincoli, though built on a site where earlier structures had existed, was begun only after those buildings were demolished. Sta. Croce in Gerusalemme, whose substructure was also completely destroyed, was built as a new church. The church of SS. Quirico e Giulitta, whose apse points due east, was erected ex novo on its own foundations.

The evidence suggests that in the case of the adaptative church, built over catacombs or other preexisting structures, Early Christians were constrained, in their efforts to build efficiently and quickly, to adapt what was there. Either it was not possible or it was not practical to fix the apse in the ideal location. Given the freedom to design a new church, their impulse was to locate the apse in the east.

The siting of the apses of the churches created ex novo corresponds with that of the apse, or the sanctuary, in the Pythagorean Basilica at Porta Maggiore. Participants were required here to face the east (and the rising sun) while offering prayer and worship, which differs from the conventions of Greek temples.[9] The monumental apse, focused from the nave and viewed through the triumphal arch, contained in its semidome the most exalted thematic material of the interior. As worshippers concentrated on the sacrifice that took place on the altar in front of the apse, their backs were to the west, which was associated with study and meditation.

Many scholars have pondered the pagan ancestors of the early Christian basilica, and their suggestions credit a variety of sources, including the Roman private house, the Roman law court, Roman exedrae or outdoor garden niches, and the Egyptian hypostyle hall as it had evolved into the rectangular Greek temple, each of which exhibited some characteristic of the future church. These alternatives led to the inevitable conclusion that the early Christian basilica derived from the pagan Roman basilica type.[10] That the Pythagorean Basilica at Porta Maggiore contains in itself all the essential elements found in the early Christian basilica has been, however, curiously ignored, despite Christians having shared much with Pythagoreans—for example, persecution—and despite influential early Christian leaders having admired Pythagoras and Pythagoreanism. For early Christians as for Pythagoreans, richness was concentrated in the interior space, while the exterior, and even the entrance, was unremarkable and unornamented. The primary elements of the new religious basilica type, as they arose (conjoined from the beginning) and were established in Christian houses of worship, came to be basic to the development of medieval ecclesiastical architecture in the West. Although other Pythagorean religious buildings are not known at this time, good reason exists to believe that the underlying substructure of some Gothic cathedrals, such as that at Chartres, was Pythagorean. In the particular case of Chartres, the later churches built over it all preserved its eastern apse.

▲

As it developed in Romanesque Europe from the eighth to the twelfth centuries, the Christian church continued in general to exhibit all the basilical features I have described. Although architects worked toward enlarged structures and new treatments of wall divisions, the Christian "norm"—the general building type and plan—was set.[11] Barrel-vaulting, which had earlier appeared in the architecture of the Subterranean Basilica at Porta Maggiore, became standard in Romanesque basilicas and was well developed in, for example, the great and influential eleventh-century church of St. Pierre at Cluny (now destroyed).[12] Too, many churches had nartheces or atria where, as in the Basilica at Porta Maggiore, holy water was contained in either a pool or a fountain. A transept, which gave the plan the shape of the cross, came to be standard. This plan, known as the Latin cross (because one arm was longer than the others),

had a fourfold division—the three arms of the cross plus the apse, which invariably framed the high altar. These were inextricably bound together at its heart, a crossing that, in plan, had the shape of a square. The interiors of these Romanesque churches formed horizontal, rectilinear masses arranged according to a canon of proportions that had been inherited from the early Christian basilicas. A most important early example was the eighth-century monastery church of St. Denis, near Paris.[13] Also, as in the Basilica at Porta Maggiore, the emphasis was on the dark interior of the church, with concentrated lighting focused downward from small clerestory windows above rather than entering from windows at the worshipper's level. Almost invariably, the worshipper faced toward the altar in the east.

Some have suggested that the placing of the altar in the east proceeded from a regulation in the fourth-century *Apostolic Constitutions,* a collection of independent treatises on forms of worship and discipline that would be condemned in 692. This text was, however, little known even to the Greek world where it originated. In the West during the Middle Ages it was entirely unrecognized.[14] The idea of an eastern altar, however, survived in the words of Isidore of Seville, who, it will be recalled, was well connected with Roman Antiquity and a sympathetic descendent of Pythagoreanism. When speaking of the templum, or sanctuary, of the church, he stipulated that it should be located in the east and be complemented at its "back" by the west. Thus the sides of the church should face north and south.[15] Although a medieval explanation for the slight deviations of apses from due east is unknown, modern research suggests that the precise east–west axis was determined by the position of the sun on the feast day of the patron of each particular church.[16]

During the Romanesque period, especially in the eleventh and twelfth centuries, the apse had a spectacular development. Radiating chapels were added to it to house treasured relics and to provide burial places, and an ambulatory to provide access to them. Developed primarily in France, the chapels, or apsidioles, became an elaborate composite known as the chevet.[17] The resulting complex (as, for example, at St. Sernin at Toulouse [fig. 48]), became the most boldly articulated part of the Romanesque church. It faced, almost invariably, eastward, and not only in France (as for example St. Etienne at Caen) but elsewhere (as at the Church of the Apostles at Cologne in Germany, or the Cathedral of Santiago de Compostela in Spain [fig. 49]). Even where the elaborate chevet was not deemed appropriate—primarily in the strictly planned Cistercian churches, such as the twelfth-century Burgundian Abbey at Fontenay (fig. 50)—the apse faced the east.[18] Despite the fact that only the early Christian churches in Italy that were built ex novo had the apse in the east, the "east end" became, it appears, standard in Romanesque practice there as well. Sta. Tecla (the predecessor of Milan Cathedral), San Nazaro, Sant'Ambrogio, and San Simpliciano, all in Milan, San Michele at Pavia, and the Byzantine Basilica of San Marco at Venice are but a few examples. No doubt the idea that apses—the sacred sanctuaries of churches that were visited by relic-venerating

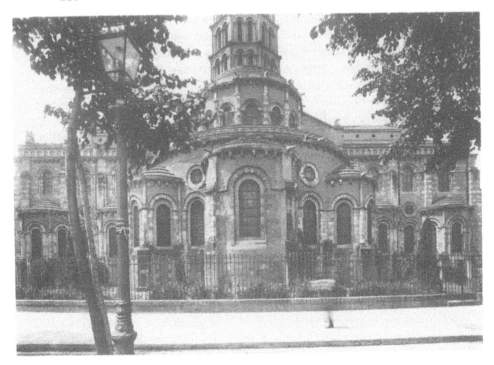

Figure 48. St. Sernin of Toulouse, 1077–1119, chevet. Photo courtesy of Bildarchiv Foto Marburg (Art Resource, NY)

pilgrims who undertook hazardous trips throughout Europe to worship in them—belonged in the east had not only endured but indeed become established.

Concepts of Order in the Gothic Cathedral

The authority of the "east end" came to be a dominant concept in the order of Gothic ecclesiastical architecture, which matured as the cities in western and central Europe burgeoned. In this well-ordered architecture, the first rays of light appeared over the altar each day. The eastern light flooding the sanctuary through stained glass windows in the full light of day became the divine light of Christ. Abbot Suger of St. Denis (1081–1151), one of the three who together conceived and built the first Gothic sanctuaries in the Île-de-France and the only one of the collaborators who left a detailed account of his intentions,[19] proudly describes the heavenly light illuminating his altar, causing it to "shine with the wonderful and uninterrupted light of most luminous windows." Also under its spell glistened the wealth of gold and precious gems with which he decorated his altar.[20] He reported that a refined gold was specially chosen to create a resplendent place "radiant as the sun."[21] His new chevet, he

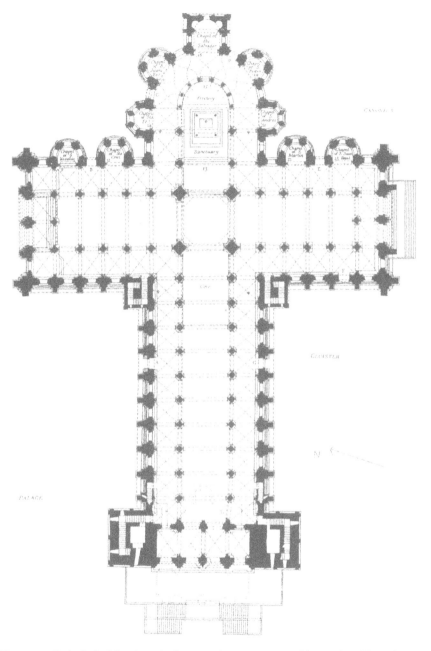

Figure 49. Cathedral of Santiago de Compostela, 813–1122 and later, plan. Photo from Kenneth J. Conant, *The Early Architectural History of the Cathedral of Santiago de Compostela* (Cambridge, MA, 1926)

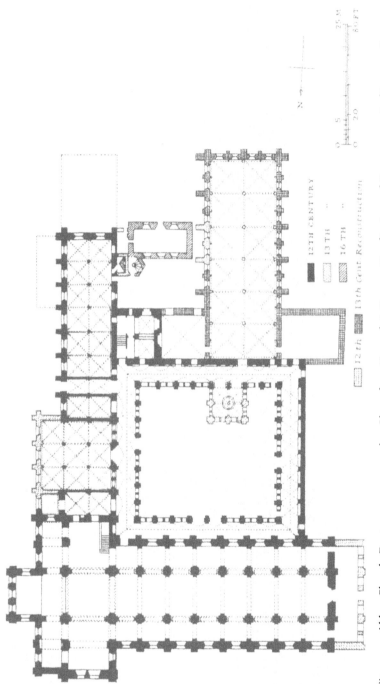

Figure 50. Abbey Church, Fontenay, 1139–47, plan. Photo from Kenneth J. Conant, *Carolingian and Romanesque Architecture, 800–1200* (Harmondsworth and Baltimore, 1959) (by permission of Yale University Press)

explained, was designed to be the most magnificent of places to which the viewer, coming from the entrance in the west, was lured, being "urged onward from the material to the immaterial."[22]

By the time of Suger's writing in the twelfth century, the tradition of the sanctuary as the city of God, or of a re-created Jerusalem, had long been established.[23] This ideal would become increasingly vivid as, at the height of the crusades, Christian interests were focused eastward. Although he does not say it in so many words, Suger appears to have had such a vision of the holy place as the New Jerusalem not only for the apse itself but, by extension, for his entire masterpiece. Practical issues preoccupied him (for example, finding the workmen and materials, selecting the timbers). Yet what most clearly emanates from his account is his purpose—to build something so new and so perfect that it would be unambiguously a Celestial City. Its center would be his altar, resplendent with gold, silver, and precious stones. His language speaks of the picture he had in mind, something not of this world but a celestial vision such as that imagined by Saint John on Patmos, as recounted in the book of Revelation.[24] Inasmuch as pilgrims journeyed to the East to visit Jerusalem, the east-facing apse was also well in accord with the cosmological relation of the Western church to the city of Christian dreams.[25]

The Pythagorean thread persisted in a corollary way. As established long before in the Basilica at Porta Maggiore, the apse continued to be mystically and liturgically the place in which the most holy subject of the entire church was depicted. In this monumental and glowing setting, Christ or his mother, the saviors of mankind, are represented in a language that is not of this world but designed to help the faithful understand the immortal life that awaits them once they have entered the heavenly sanctuary. Indeed the book of Revelation explained that the "new Jerusalem," a city made of gold and adorned with precious stones and translucent glass, would be the place where God puts an end to death and gives new life.[26] Perhaps the precious significance of the altar's iconography explains why it was normal practice to begin the building of Gothic churches from the east end.[27]

In following the thread of the eastern apse and its mystical subject matter from the Pythagorean Basilica at Porta Maggiore to Gothic architecture, the case of the Cathedral of Notre-Dame at Chartres provides an important chapter (fig. 51). Contrary to the assertions of some modern authors, the origins of Chartres Cathedral are not "lost in the mists of time."[28] The oldest known churches on this site were built over a large Gallo-Roman religious building. They were a series of pre-Norman churches that predated the great church designed by Abbot Fulbert in 1020–28, which, excepting the west end, perished in a fire in 1194. The original Gallo-Roman building, however, is not entirely lost.

Of this structure, traces, incorporated in the substructure of the Gothic cathedral, remain. These suggest that it enclosed a rectangular space with a nave leading to a sanctuary in the east. Its successors, the two early churches constructed after the conversion of the local Gallic Druids to Christianity by

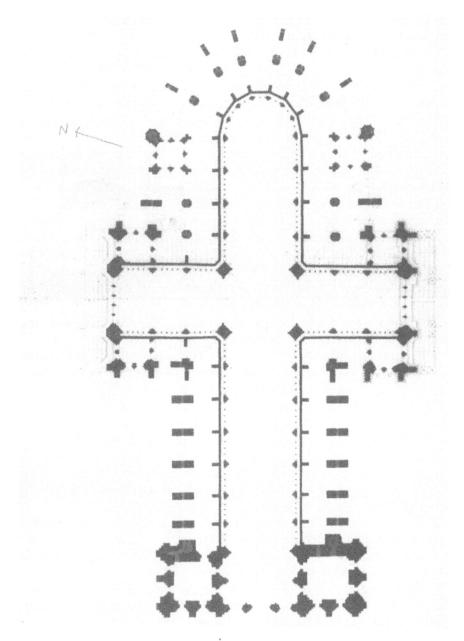

N↑

Figure 51. Cathedral of Notre-Dame, Chartres, ca. fourth century–1220, plan. Photo courtesy of Bildarchiv Foto Marburg (Art Resource, NY)

Saints Savinien and Pontenien (reputed to have been active in the second cen-
tury), shared an apse that, built over the Gallo-Roman sanctuary, pointed east-
ward.[29]

Although no details are known to us respecting the original sanctuary,
what appears to have been the case is that as in Rome, early Christians in
Chartres used an existing pagan building, which was adapted to become the
first church. What is of special interest at Chartres is the probability that the
original sanctuary was a Pythagorean basilica, perhaps not unlike the one at
Porta Maggiore. Julius Caesar gives us good reason to offer such a historical
speculation. In describing the Druids (who, as discussed in chaps. 7 and 11
were regarded as Pythagoreans by Christian and pagan contemporaries alike),
Caesar informs us that they made an annual pilgrimage to Chartres, which
they regarded as the center of Gaul, to hold a conclave and, in this consecrated
place, to make their most important decisions.[30] Other ancient authors cor-
roborate Caesar's information respecting the location of this Druidic tribe, the
Carnutes, whose capital was called Autricum by the Romans (later to be
known as Chartres).[31]

The consecrated place in the capital of Gallic Druidism came to be the site
not only of the Druidic sanctuary but of a long line of holy buildings. All of
these shared a rectangular plan with the entrance in the west and the altar in
the east. Older writers speculated, doubtless on the basis of local tradition be-
cause the archaeological evidence had long since disappeared, that the original
structure was vaulted, paneled with marble slabs, and lit by shafts of light.[32] In
this case, as at Porta Maggiore, light (here in the form of several shafts rather
than one) would have penetrated the interior space from above, forming a
precedent to the clerestory.[33] A continuity from "paganism" (or Pythagore-
anism) to Christianity as the Druidic altar became the Christian altar is sug-
gested by the fact that according to tradition the crypt of the present cathedral,
where Christians presumably first assembled, was called Notre-Dame-sous-
Terre (Notre-Dame under ground). Although we may never know for certain,
it is tempting to think that this long-standing cultic association of Chartres
with Pythagoreanism was not forgotten during medieval times, when as we
have seen in previous chapters Pythagoras and his purported doctrines were al-
ways important, especially at Chartres. Indeed it appears to have inspired its
intellectuals to be the first to honor Pythagoras in the royal portal of their
cathedral (fig. 24).

It is also tempting to think that because Chartres was a capital of Druidism
(that is, of Pythagoreanism), tradition there was strong during Carolingian
and early Romanesque times for the survival of Pythagorean ideas. This tradi-
tion is exemplified in the work of Remigius of Auxerre, whose birthplace, Aux-
erre, was part of the territory of Autricum and lay to the north of Clermont-
Ferrand. This protohumanist ninth-century scholar knew well and appreciated
the doctrines of Pythagoreanism; his discourse on the Pythagorean Y was dis-

cussed in chapter 11. Surely well known to his tenth-century successors, the first humanists at Chartres, were his famous commentaries on Martianus Capella and Boethius.[34]

Although the diaphanous nature and extreme verticalism aimed at by the creators of the Abbey Church of St. Denis and the Cathedral of Chartres were not shared by all other major cathedrals and basilicas inaugurated in the thirteenth century in France, Germany, Italy, Spain, England, Austria, the Low Countries, and Czechoslovakia, the "eastness" of the east end was generally common to them all. These buildings included, among many others, such different structural types as the early Cathedral of Sens (1140–1200), the Cathedral of Rouen (1200–1230), the Cathedral of Notre-Dame at Paris (1163–1250), as well as the Cathedral of Amiens (1220–70), the Cathedral of Toledo (1227–1493), the Basilica of Sant'Antonio at Padua (1232–1307), Westminster Abbey (1245–1519), the Cathedral of Strasbourg (1245–95), the Cathedral of Beauvais (1247–84), the Cathedral of Cologne (1248–nineteenth century), the Cathedral of Clermont-Ferrand (1250–86), the Cathedral of Siena (1250–1322), Regensburg Cathedral (1275–1390), Albi Cathedral (1282–1390), the Cathedral of Florence (1296–1462), St. Stephen's Cathedral in Vienna (1304–1460), the Cathedral of Notre-Dame in Antwerp (1352–fifteenth century), and Prague Cathedral (fourteenth–fifteenth centuries). The Gothic eastward-facing apse created (in 1217–54) for the Romanesque cathedral at Le Mans was especially daring and spectacular, spreading its complex system of flying buttresses outward and downward, like a waterfall cascading over the sloping hillside that overlooks the city (fig. 52).

The orientation of the Christian ecclesiastical structure from the rising sun (the altar in the east) to the setting sun (the facade in the west), a practice that had not been universal in early Christian days, was thus developed and disseminated during medieval times to the point that it became not just standard but authoritative. In the thirteenth century, the French-born bishop Gulielmus Durandus (1220–96), a papal chaplain and professor of canon law, speaks of this rule in the imperative: "The foundations must be so contrived as that the Head of the Church may point due East."[35] We must, he emphasizes, pray toward the east because Solomon recommended it in the Book of Wisdom.[36] Indeed, the Book of Wisdom recommends prayer toward the east: "We must rise before the sun to give you thanks and pray to you as daylight dawns."[37] However it is important to keep in mind that this work, thought in medieval times to have been written by Solomon, is now regarded (as discussed in chaps. 5 and 6) as a Pythagorean work of the first century AD, probably composed by Philo himself. Although the practice of building the apse in the east would not always continue to be honored in later centuries, its development in medieval architecture embodies a cosmological orientation that, reflected also in liturgical practice and interior adornment, is rooted in the type of structure exemplified by the Pythagorean Basilica at Porta Maggiore, which, like the Book of Wisdom, was a first-century work.

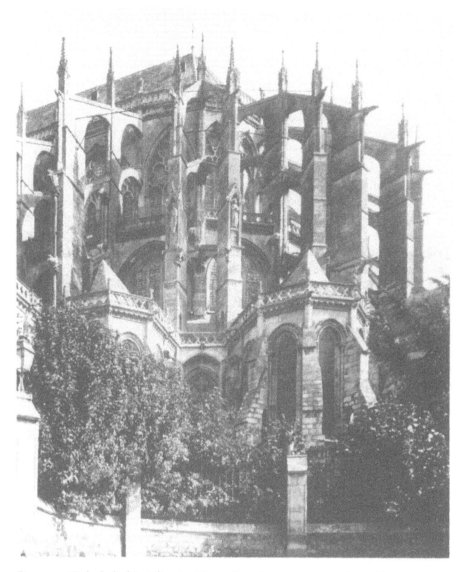

Figure 52. Cathedral of St. Julien, Le Mans, eleventh century–1254, chevet. Photo courtesy of Bildarchiv Foto Marburg (Art Resource, NY)

▲

A second striking feature of Gothic ecclesiastical architecture is the attention paid to number, proportion, and geometry. This interest was well noted and discussed by the modern scholars Emile Mâle and Otto von Simson.[38] Their observations came close to acknowledging that the role of number in Gothic church architecture is Pythagorean.

The attention to number in Gothic architecture presumed that numbers had symbolic qualities and that they were used to demonstrate religious "truths" in the same way that medical doctors used numbers to demonstrate the state of an individual's personal health. Thus in Gothic religious architecture did numbers have a quality of mystical, magical, association that can be called what Pythagorean writers in late Antiquity termed a theology of arithmetic. These arithmological concepts appear to have influenced, if not directed, the distribution of component elements and thus their proportion in the design of religious buildings.

While it is arguable that the intricately devised conjoining of ribs, vaults, buttresses, walls, and windows into a sublimely unified plan reflects the monad (which, as Nicomachus explained, coincides with God), and while the sense of the dyad may apply to the idea of symmetry or the inherent balance suggested by contrasting concepts such as north and south or Old and New Testaments, the number three is, without doubt, of paramount importance for Gothic religious architecture. Most Gothic churches have tripartite elevations—that is, interior walls that are divided into three sections, each treated differently from the structural point of view (fig. 53). The three facades of almost every major Gothic church each have three portals, centered on the middle portal, which, as developed in Romanesque churches, is the largest and the highest. Many facades have three registers, separated by moldings, or stringcourses (fig. 53). In each case they compose a facade that is further articulated by three large stained glass windows surmounted by a single rose window, which is one of three rose windows that characterize French Gothic type. Although every church posed a different problem, the implied reference to the Trinity is inescapable. Cohesive and unificatory, they form an indivisible harmony as did the three perfect (Pythagorean) consonances in medieval music.[39]

Regard for other numbers, such as four (the four evangelists, four Church Fathers, the four directions), five (the five wounds of Christ), seven (the Seven Liberal Arts, seven virtues and seven vices, seven sacraments, seven deadly sins), eight (the eight beatitudes), nine (the number of choirs of angels), ten (the Decalogue, or Ten Commandments), twelve (the number of apostles and of the prophets, the labors of the months, the tribes of Israel, the signs of the zodiac), and twenty-four (the elders of the church) may well have affected the thoughts of those who laid out plans and organized corresponding decorative schemes. Referring to the importance of Saint Augustine (who, as we have seen, was sympathetic to Pythagoreanism) for transmitting the idea that numbers were thoughts of God, Mâle cites Augustine's insistence that the definition of all things by number is a reflection of Divine Wisdom.[40]

Consistent with this view, von Simson attributes to Saint Augustine the advice that number is the source of all aesthetic proportion. This advice was, von Simson explains, derived from Augustine's reading of the Book of Wisdom: "You have set all things in order by measure and number and weight."[41] It was further elaborated by Boethius, who attributed this knowledge to Pythagoras.

Together Augustine and Boethius, von Simson proposes, laid the foundation for the "perfect" ratios of Pythagorean mysticism as it came to be viewed in medieval art.[42] The result of this admiration for number was the important place assumed by harmony and proportion in the ecclesiastical structures of the Christian West.

Abbot Suger is explicit on this topic. For example, he tells us that twelve columns, representing the number of the twelve apostles, were raised in one part of his church and set off by twelve corresponding columns signifying the number of prophets.[43] In another passage, he reports that he decreed that seven lamps should burn in perpetuity in his choir and that two should forever burn before the altar of St. Denis.[44] We may never know if the number of chapels (apsidioles) of his beautiful new chevet (seven) was chosen to accommodate the desire to build seven chapels for symbolic reasons—perhaps related to the seven candles designed to burn in perpetuity on his altar (the Cathedral at Amiens also has seven apsidioles)—or if this number of chapels, resulting from the construction of the outer ambulatory, was accidental. The answer to this mystery died with Suger.

In his manual on the design and ornamentation of churches, written in about 1280, Gulielmus Durandus has more to say on the subject of numerical symbolism. His many counsels include admonitions that the four sides of a church symbolize the four evangelists and the four cardinal virtues; the four sides of the altar signify the four quarters of the world; the great piers of a church be arranged in groups of seven to symbolize the seven gifts of the Holy Ghost (perhaps exemplified in the seven bays of the naves at Chartres [fig. 51] and Amiens), while the seven recommended candlesticks symbolize the seven lights of Moses. The fifteen steps that, ideally, lead to the altar signify fifteen virtues, he held, while twenty-four elders make an appropriate arrangement around the image of the Savior. The twelve apostles are so numbered, he explained, because they preached the Trinity to the four corners of the world ($3 \times 4 = 12$). Sheep may be used to represent the apostles, so long as they are twelve, just as twelve crosses (or stations) will remind us of the twelve apostles. He also informs us that two candles on the altar symbolize Jews and Gentiles, and that reliquaries ought to contain three grams of frankincense to symbolize the Trinity. For Gulielmus, number also figures in liturgy and ceremony: In the Hours observed by priests, they are required to praise God seven times; in honor of the twelve apostles church bells are rung twelve times during the twelve hours of the day, and in honor of the evangelists, four times each hour. In dedicating an altar, the priest is urged to circumvent it seven times to signify the seven meditations, the seven virtues, and the seven gifts of the Holy Ghost. In one ceremony, the priest must, he added, anoint the altar with oil five times to symbolize the five wounds of Christ. Two other ceremonial altar anointings bring the total times an altar is anointed to three, which, Gulielmus summarized, symbolized the three theological virtues, Faith, Hope, and Charity.

Gulielmus also reminds us of the Pythagorean insistence on white garments

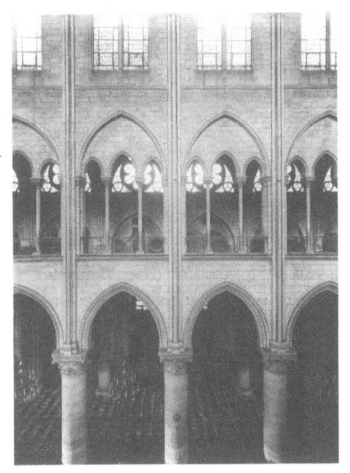

Figure 53. Cathedral of Notre-Dame, Paris, ca. 1163–1250, interior, south side of nave.
Photo courtesy of Bildarchiv Foto Marburg (Art Resource, NY)

and cloths by repeatedly stipulating that all altar cloths should be white be-
cause this color alone symbolizes pureness of living. His description of holy
water (which drives away evil demons) awakens our memory of the
Pythagorean practice (seen in the Basilica at Porta Maggiore) of purification in
a small pool of water before entering the basilica itself.[45]

Although some historians have attempted to analyze in detail the symbol-
ism of numbers in Gothic church architecture (Wilhelm Vöge, for example, the
first to study the west facade of Chartres Cathedral as a coherent composition
based on number and arrangement), this task is difficult, dangerous, and, be-
cause of our lack of knowledge in each particular situation, probably impossi-
ble. Yet there appears to be an unmistakably deliberate order in the plans of
the designers of Chartres and other Gothic structures.

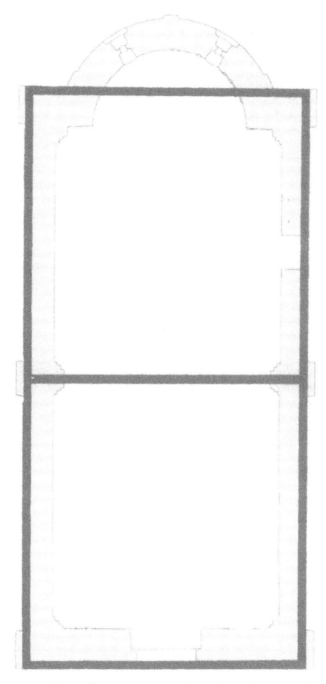

Figure 54. San Nicola di Trullas, Semestene (Sardinia), eleventh century, plan. Photo from Massimo Rassu, *La geometria del tempio* (Dolianova, 2002)

Suger makes this point eloquently: "The admirable power of one unique and supreme reason equalizes by proper composition the disparity between things human and Divine; and what seems mutually to conflict by inferiority of origin and contrariety of nature is conjoined by the single, delightful concordance of one superior, well-tempered harmony."[46] He speaks of the "continual controversy of the similar and dissimilar" as "litigant parties." It would seem that his passion for order, which, he claims, suggests "eternal wisdom," shows that the Pythagorean idea of the reconciliation of opposites into a harmonious unity was alive and well in his thinking, even if he failed to credit its originator. The concord and harmony Suger aims for in the design of his church reminds him of the concord and harmony that he hears in the music of the Mass that will be celebrated in his church. "Concordantly," and with "unified harmony," this music will join the "material with the immaterial, the corporeal with the spiritual, the human with the Divine."[47]

Backed up by the symbolism of numbers, the concept of harmony inevitably leads us to the importance of geometry in medieval ecclesiastical architecture. This importance is exemplified in the equilateral triangle, square, pentagon, and other polygons that can be deduced from the plans, facades, and elevations of medieval churches not only in the major centers but also in remote and isolated areas such as Sardinia (fig. 54) and Cyprus.[48] The square, especially, was useful as a module. The use of geometrical ratios also determined proportions.[49] During the crucial years (ca. 1180–1220) in the genesis of Gothic cathedral planning, the tools of quadrature and pentagonal construction, although experimental, were well known.[50] A rare surviving model book illustrated by the thirteenth-century French architect Villard de Honnecourt (fl. 1225–50) contains a number of drawings that pay tribute to the importance of geometry for architectural design.[51] This importance was no doubt signified by the representation of Geometry as the centerpiece of the Seven Liberal Arts in the Cathedral at Clermont-Ferrand (see fig. 30). Surely, the significance of geometry at this time is related not only to its usefulness for uniting number and form in order to achieve proportion. It is also most certainly related to the birth of "modern" (or post-Boethian geometry) in the second half of the eleventh century. The efflorescence of original geometrical treatises at this time did not, however, obfuscate the importance of Pythagoras for this field.[52]

The linear diagrams on which rose windows, the centralizing element of the facades of Gothic cathedrals, were based well illustrate the importance of geometry to medieval builders and designers (fig. 55). These schematic designs can be traced back to the wheel-like constructions of Isidore of Seville and ultimately to late Antique cosmological ideas. Positioned aloft on the facade of a church, the rose window brings to mind the cosmological character of the Pythagorean sphere, which has a consistent history throughout medieval times. So, also, other orderly geometrical schemes in medieval manuscripts, such as wheels of fate and mystical paradise illustrations, suggest the complex self-inclusive system of the universe (fig. 56).[53] The design of the rose window

of the facade at Chartres, for example, expands into a double design of twelve, an arrangement similar to that of the twelve sections seen in mystical paradise illustrations. Indeed the rose window is the ideal combination of the three characteristics of geometry listed in the thirteenth century by Hugh of St.-Victor: planimetry (which measures the plane), altimetry (which measures the height), and cosimetry (which measures the sphere).[54]

▲

One of the practical purposes of the rose window, as of all stained glass windows, was to illuminate the interior of the ecclesiastical space. But the character of the resulting luminosity was more transformative than practical. The various arrangements of colored glass provided a lucid and translucent light, which, depending on the position of the sun, flickered and vibrated throughout the holy space, giving it a radiance that suggested the immateriality and perfection of God.

Unlike Greek temples and most of their Roman successors, which existed in and were surrounded by light, the oldest surviving Pythagorean buildings (the Basilica at Porta Maggiore and the Pantheon) proposed that light should play a dramatic role in uplifting darkness into light, that is, in the creation of a spiritual interior space. Entering from above, the light of the sun illuminates the cavernous place below; thus the dazzling light of the upper world facilitates the ascent of the soul to receive truth and knowledge (as described by Plato in the *Timaeus*).[55] So too does the light in a Gothic cathedral enter the interior space and transform it in this way. As for the Pythagoreans (who honored above all the light of the sun, and who admonished the faithful not to discuss Pythagorean matters without a light),[56] Gothic light, engendered by the sun, is the true light that illuminates the darkness. To obtain the purest light from the greatest heights, Gothic builders undertook the extraordinary and hazardous task of supporting the soaring vaults with elaborate and daring systems of flying buttresses.

Reflecting Pythagorean thought, and much admired by medieval authors such as Dante, who called him an "astonishing mortal man . . . who pondered the celestial realms," Dionysius the Areopagite had explained that celestial light helps the worshipper to be elevated to God and to obtain wisdom: "illuminated with the knowledge of visions, we shall be able to become . . . purified and purifiers; images of Light . . . perfected and perfecting."[57] God is the source of all light, he explained, and the "Divine Ray" of wisdom from the Father of Lights illuminates the worshipper with its immaterial enlightenment. Illumination, he elucidated, is the source of all perfection.[58] Even so austere an intellect as Saint Thomas of Aquinas was compelled to agree, saying that proportion and harmony were best seen in the clarity of light and color, as is the son of God who is the light and splendor of the intellect.[59]

Abbot Suger describes with great care the stained glass windows of his new chevet, which were made by specially selected masters from different places.

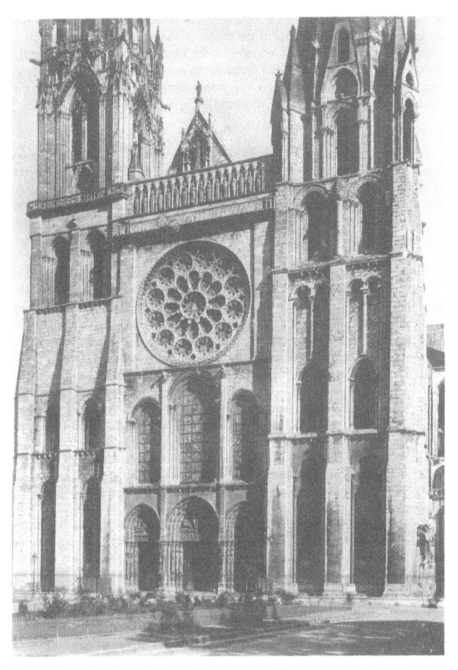

Figure 55. Cathedral of Notre-Dame, Chartres, ca. twelfth century, west facade. Photo courtesy of Bildarchiv Foto Marburg (Art Resource, NY)

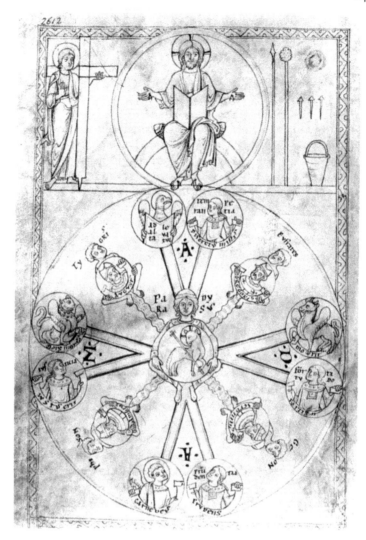

Figure 56. Mystical Paradise. From *Cod. Lat.14159* (*Dialogus de laudibus sanctae crucis*), fol. 5v, ca. 1170–85 (from Ratisbon), Staatsbibliothek, Munich. Photo courtesy of Bildarchiv Foto Marburg (Art Resource, NY)

His church, he exults, shines with the brightness of the new light that pervades its spaces. Here the worshipper is transported from an inferior to a higher and immaterial world, which Suger calls the fountain of eternal wisdom. For him, wisdom has both an aesthetic and a theological dimension: together with the glow of the seven lamps that perpetually burned on his altar, these lights miraculously transformed his interior into the "elevated place" and immaterial "Heavenly Kingdom" that he triumphantly described.[60]

The connection of light with wisdom is poignantly made by Dante, who ex-

plained that when light is shed on things, they can be perceived by the intellect. Thus, he argued, does heaven signify knowledge. Dante ascribed to the sun the characteristics of arithmetic and the property of number:

> The heaven of the Sun may be compared to Arithmetic, on account of two properties: the first is that it is from the Sun's light that all the other stars draw theirs; the other is that the eye cannot gaze on it. These two properties are found in Arithmetic, too, for by its light all the sciences are illuminated . . . progress in the study of these subjects is always made with the help of numbers. It is not only the ensemble of these principles that is characterized by number, but each of them individually, as careful reflection reveals; that is why Pythagoras . . . held that the fundamental principles of natural things . . . consisted of number. The second property of the Sun is also found in number, whose science is Arithmetic; the eye of the intellect cannot gaze on this, because number . . . is infinite, and this we human beings cannot directly apprehend.[61]

In so doing Dante was, like Pythagoras, "measuring heaven."

▲

Although we are without explicit expositions on the practice of architecture in the Middle Ages in the form of treatises, instructions, or rules, nonetheless it is clear from the circumstantial evidence that survives—in the form of records, references, drawings, and known intellectual preoccupations, not to mention the surviving structures themselves—that Pythagorean themes of number, proportion, and balance dominated medieval religious building. By orienting their holy sanctuaries to the east, while giving symbolically appropriate roles to the north, south, and west, these builders showed they had one goal in common, the cosmological orientation of the church. At the same time, they were avid experimenters in the art of the geometric interlocking of spaces and solids. No doubt they "remembered" from Iamblichus that Nicomachus had described perfect proportion as musical; certainly they knew from Plato's *Timaeus* that, through arithmetic means, God had made a harmonic world.

As late as the year 1400, the architect of the Cathedral of Milan recorded his belief that art and science go hand in hand.[62] In its broadest sense, the term *art* referred to artful construction, while *science* meant proportional arrangement and articulation. As the architect of the universe, the God of Plato's *Timaeus,* a work of supreme interest to medieval scholars, was engaged in both, and therefore the cathedral was a symbol of God's complete knowledge. Although the methods of medieval architects appear to have been secret (not unlike Pythagorean knowledge), the aesthetically dazzling Gothic cathedrals they created were cosmological structures based on the perfection of mathematical forms. Inside, the illumination of the heavens motivated men to seek God's wisdom.

Even if Pythagoras was not directly credited by Gothic builders, his inspira-

tion was important, particularly in the authority of the quadrivium—arithmetic, geometry, music, and astronomy—and through Boethius's enlightened counsel concerning harmony, not to mention that of the modern geometry born in the mid-eleventh century. Bishop Fulbert, who built the first cathedral at Chartres and inspired there the efflorescence of mathematical and musical studies, was in his own time compared with Pythagoras.[63] As the modern scholar Jacques Le Goff suggests, the thirst for knowledge in medieval times was so great that famous figures from the past, known through Greco-Arab as well as from Latin sources, were exalted and popularized.[64] Thus, especially in France, could men hope, using the language of Pythagoras that had long been familiar on French soil, to create perfect proportions through the use of number, symbols, geometry, and light in bringing into ordered existence an immaterial world modeled after the divine rule of the universe.

CHAPTER 13

CONCLUSIONS

The first information we have about Pythagoras is that he was kind to animals. From this simple fact, an extraordinary intellectual and social history unfolds. His compassion for animals extended to his "discovery" of the soul and the staggering revelation, new in his time, of its immortality. Although he made this wondrous idea intelligible by explaining that the soul passed from one being to another—an assumption that was to be debated and ultimately rejected in the far distant future—the brilliance of Pythagoras as a master imaginer and a master inspirator began with this modest account of his saving a little dog from being beaten. Thus is his "humble wisdom" established early on.

The impact of Pythagoras on his own time and for later centuries is hard to define if one attempts to do so with pedantic precision, for surviving reports vary in terms of their reliability. However, a survey of his reputation, which was transformed imperceptibly from Pythagoras the historical figure to Pythagoras the mythical figure, and of the dissemination of his influence, which likewise was transformed imperceptibly from what appear to have been his original ideas into a plethora of purported doctrines, tells us his impact was, in its consistency and duration, nothing short of dazzling.

More facts about Pythagoras emerge in his own lifetime. These early bits of objective reality provide evidence of the deep wisdom behind his apparent humility. We learn much from his contemporaries and from those in the next generation who appear to have been deeply affected by him. To Philolaus and

Empedocles, Pythagoras was not obscure and perplexing, as he may be to us in the twenty-first century; on the contrary, he was the recently deceased wise man from Samos who they deeply admired as a man of prodigious learning.

Thereafter we learn of his belief that a single cause regulates the universe. We learn that all things, considered in terms of their opposites, invite the inevitable result of balance, which in turn leads to harmony. We also learn of the importance of number and, especially, of the tetrad. Those who claim to have preserved Pythagoras's teachings tell us that he imagined, and believed, the universe was made up of the four elements. Represented by the cube as the most perfect harmonic form, they tell us further, the earth took its place, in his thinking, as the center of the universe, a universe that was harmonically unified as a sphere. Last but not least among these early facts, his contemporaries inform us that Pythagoras was very famous in his day and that he was regarded as a polymath—a man of comprehensive knowledge. For most of those who had direct knowledge of him, he was a massive genius who was admired for his wisdom and humility; at the same time he was held in awe for his (believed) special power to perform enchantment, a skill that for some inspired censure and even ridicule. Taboos were attributed to him. It is at this point that we begin to lose track of the "real" Pythagoras.

A bit later we learn, from Aristotle, that Pythagoras worshipped primarily one god and that that god was Apollo. From Aristotle we also learn that Pythagoras was related to this god, for he was worshipped at Croton as Apollo Hyperboreus, and we learn that Pythagoras had a thigh of gold. Although Aristotle has great respect for Pythagoras as a mathematician, he notes Pythagoreans' practice of silence and secrecy, practices that were now believed to have been taught by Pythagoras himself. Aristotle, who was a rigorous and scientifically minded scholar, reports a series of miraculous events that were associated with Pythagoras. Evidently Aristotle had sources of information from earlier scholars (of the sixth or fifth century BC) that are lost to us.

This early knowledge about Pythagoras corresponds with the first manifestations of what appears to be the influence of those who were affected by him and his teachings on the history of art. A remarkable number of sixth-century temples dedicated to Apollo, the first of their kind in Magna Grecia, or southern Italy, appear in the very centers associated with Pythagoras's life and teachings. Although normally one temple might be dedicated to a given god in a given town, in the case of Metapontum two Doric temples dedicated to Apollo existed, while in Croton there were three. This is not to mention the one Pythagoras's earthly father is reputed to have built on Samos in honor of his birth. Underlined by the many surviving fragments relating to the cult of Apollo that have been found in the adjacent areas of Croton and Metapontum, the fact that the temples dedicated to Apollo that were built there appear to have been constructed in Pythagoras's lifetime suggest strongly that the cult of Apollo was widely practiced in this area. Both offer strong evidence that the worship of Apollo was brought to Magna Grecia by Pythagoras. Certainly, at

the very least, the introduction of Apollo in Magna Grecia coincides with the presence of Pythagoras in Italy. Although the physical superstructures of these temples have all perished, their surviving ruins, lingering in the landscape of southern Italy, hauntingly corroborate their former life and approximate dating with a time when Croton and Metapontum were both lively centers of Greek culture.

It is during this time that the first surviving portraits of Pythagoras appear in Abdera, a Greek coastal city near Thrace. On different silver coins, from about 430 BC, the same man is represented, his head framed by short wavy hair. He has a prominent nose and high cheekbones, and he wears a short beard. The representation of a philosopher on silver coins at this moment in history is stunning. It may well be the first time a philosopher was chosen for representation on Greek coinage, an event, at the very least, extremely rare at this time.

More important, perhaps, is how he is represented. Framed by a (four-sided) square, his head is centered in the circular shape of the coin. Although imagined in three dimensions, the coin with its two-dimensional language suggests the cube (of the earth) inscribed within the sphere (of the universe), one of the earliest known Pythagorean teachings believed to have originated with the master himself. (Later, Sextus Pythagoricus would demonstrate, in the first century AD, that inscribing the square within the circle was an "old" Pythagorean tradition, although he did not say, or did not know, how old.) Even more significant is the fact that both of these earliest known images of Pythagoras appear on tetradrachmae, that is, on coins worth four drachmas or units of weight, substantial and valuable silver coins and a clear reference to the important early symbolism of the number four in Pythagorean thought.

It is alluring to consider the possible role the early Pythagorean philosopher Democritus of Abdera might have played with respect to the design and production of these coins. Although the prolific writings of this most influential of pre-Socratic philosophers who later would be highly regarded by Aristotle are now almost entirely lost, numerous ancient sources testify to the quality and quantity of his writings. These writings covered a wide range of topics in the natural sciences, mathematics, and astronomy as well as rhythm and harmony, diet, medicine, and last but not least, Pythagoras himself, who, it appears, Democritus admired enormously. Most interesting for us, however, are Democritus's reported overlapping interests in geometry and art. As the author of a treatise on painting, he must have had a serious interest in art. His expertise in art and design emphasizes, in a manner directly recognizable to modern readers, the wide-ranging nature of his interests and aptitudes. Thus can we entertain the likely possibility that this remarkable and influential citizen of Abdera, who was very much alive there at the time these coins were made and who happened to be an expert on Pythagoras, would have been invited (or ought to have been invited) to design these coins, if indeed he was not the instigator of the idea. What more logical and honorific way could Democritus have trans-

lated his very clear idea than into the precious coins most perfectly appropriately issued as the tetradrachmae?

During the years that Pythagoras was commemorated on the coins of Abdera, the worship of Apollo reached Rome. Here in 431 BC, because of the new status of this god, Rome's first temple dedicated to this "foreign deity" was constructed outside the city walls; although he had been introduced to the Italic peninsula in Magna Grecia, Apollo had not previously had a building dedicated to him in Rome. Significant also is the fact that it was dedicated to Apollo as healer, in thanks for a halt to an outbreak of the plague; this suggests that the cult of the "new" Apollo had reached northward. At the time Pindar, who worshipped at the same altar as Pythagoras, and who had invented the idea that Apollo was a gentle god and a friend and helper to mankind rather than the avenging terrifying deity of older Greek tradition, had just died. It is to his new Apollo that the Italic world was attracted. As the Romans began to feel at home under Apollo's protection, the populace dedicated their public games to him, while the oligarchy sought advice from his oracles. Apollo had become a god for everyone.

As the fourth century BC dawned, the threads of Pythagoras's biography began to multiply as his life slowly began to turn into legend. At the same time, the tentacles of Pythagoreanism begin what was to develop into their inexorable spread. It is during this time that, with a rationality born of historical respect if not tinged by religious fervor, the Roman Senate decreed that a statue of Pythagoras should be erected not just within the city walls but in the center of Rome, which was both a city and an empire as well as the center of the world. This piece of public sculpture was the result of an oracle of Apollo that had advised those in power to erect this sculpture because, we are told, Apollo decreed that Pythagoras was the wisest of all Greeks.

This account corresponds with the fourth-century fascination with Pythagoras as the inventor of philosophy, miracle worker, and, by now, brilliant mathematician. It was he who had discovered, and extolled, the properties of number, and it was he who had first imagined the entire universe as the creator's unified composition based on number. Plato, who had established the Academy at Athens, journeyed to the land of Pythagoras, Magna Grecia, to study; there he tried, in the face of their persecution, to collect writings by Pythagoreans. His *Timaeus* explicated the philosophical belief attributed to the Pythagoreans that the value of geometry is not so much practical as it is speculative in that it leads the soul to truth. He explained the geometrical solids, also inherited from the Pythagoreans, as particles of the four elements that could be arranged so as to construct the regular solids, each of which was made up of triangles and could be fitted into a sphere, which represented the universe. The idea of concords and contraries that balance each other was basic to the function of this universe.

Pythagoras, who had coined the word *philosopher*, was admired for more practical reasons—for his politics and his advocacy of social benevolence and

justice. These multifaceted revelations must have been inspirational after the collapse of Etruscan power in central Italy. Although Romans still looked forward to defeating the Etruscans to the north, they were at the same time slowly beginning to open the world of political power to plebeians, an event that was beginning to have the effect of expanding the guarantees of Roman law. In this world, the inspiration of Pythagoras, who functioned as the example of example, could be honored not only because Apollo had decreed it but because Pythagoras was acceptable to the oligarchy and plebeians alike as one who advocated the practical application of justice and the social good in every day life.

Expanded to include his moral teachings, and particularly his admonitions to abandon luxury and pursue simplicity, Pythagoras's third-century BC persona was so humanized that people must have wondered how he died. Thus did the first accounts of his death surface at this time. Although the descriptions of how he died are not in accord, they are all in agreement that, persecuted by tyrants throughout his life, Pythagoras had died a martyr's death. From this century, when Pythagoreans experienced such persecution as to diminish their presence in the Roman world, no examples of works of art inspired by the memory of their inspirator appear to have survived.

During the next century, however, things seem to have improved, at least in the city of Rome. There a second temple, this one within the city walls, was dedicated to Apollo. At the same time, the magistrates of the city commissioned a series of precious golden statues dedicated to Apollo. Correspondingly, it was at this time that the legend emerged, reported as fact by Diodorus Siculus, that Pythagoras had been the teacher of the beloved early king of the Romans, Numa, who was also believed to have been the first Roman to revere Apollo. By now, Apollo and Pythagoras had become intertwined inspirational icons in Roman culture.

Thus the sage and polymath from Samos had become more than the originator of a coherent body of wisdom that, incorporating arithmetic, number, geometry, and music—the future quadrivium—explained the harmony of the cosmos. His close association with Apollo was clear as was proven by his golden thigh. First reported by Aristotle, the legend of Pythagoras's golden thigh had a long life that served, like a crestless wave, to continuously elevate the status of Pythagoras to that of superhuman. Correspondingly, the connective tissue that joined the varied elements of his educational background was now expanded to include not only his tutelage in Egypt, Persia, and Babylon but also the belief that he had a Jewish education and a connection with Moses, as first suggested in the third century BC and reaffirmed in the second century BC.

A third temple, and the most lavish of all those in Rome, was dedicated by the first emperor, Augustus, to Apollo in the first century BC. Together with Augustus's library, which adjoined the temple and also was dedicated to Apollo, this temple was founded on a site distinctly marked off by a miracle. In

undertaking to rescue and rebuild Rome's first temple to Apollo and adorn it with a special cult statue, Augustus demonstrated that he shared with Pythagoras a unique piety for Apollo. In commissioning a public sculpture of Apollo for the city, he was, in a sense, going further. He was putting the city under the protection of this god, who, in a probably not unrelated gesture, he impersonated by dressing himself as Apollo. Among the many stories that circulated in Rome linking Augustus to Apollo were two that were particularly Pythagorean. The admiration of Augustus for the rising sun parallels some of the currently circulating injunctions of Pythagoras that required respect for the rising sun. Likewise the claimed constellation of seven birthmarks on his torso suggests the great respect Pythagoreans were expressing at this time for the number seven, described by Cicero as the most cosmologically important number because it represented the harmonic engagement of the seven planets in regulating (or, interpreted differently, ruling) the universe.

Indeed, it was in these years that this highly cultured Roman completed his *Somnium Scipionis,* a seminal work that describes the music of the spheres and their perfect concordant unity. Thus could the heavens be comprehended and measured through the (audible) relationships of the planets to the firmament. In his other works, Cicero admires Pythagoras and the devout Pythagoreanism of his own best friend, the astrologer Nigidius Figulus. Varro, another friend of Cicero's, was exploring Pythagorean numerology at this time, especially the symbolism of the number seven. When Varro's life ended, its significance was artfully demonstrated by his Pythagorean burial. It was in these years that Pythagoras was first described as a god. Diodorus of Siculus reported that large crowds of fervent believers had greeted Pythagoras as a god wherever he went. Thus, despite their earlier persecution, Pythagoreans appear to have survived for the better, so that by the end of the first century BC they were regarded as highly virtuous individuals who surveyed the heavens and combined civic, religious, and scientific concerns in their common aim to lead orderly lives.

Vitruvius was, in many ways, the consummate Pythagorean of this time in terms of his recommendations for architectural design. He advised that temples should face the east and the rising sun, and he expressed his high esteem for the cube, one of the earliest geometric forms associated with Pythagoras and a subject on which, he said, Pythagoras had written a book. For Vitruvius the cube was a perfect geometrical shape that had a divine character. Vitruvius, whose writings were preserved and would be highly influential in the Renaissance, has more to say respecting what he saw as his Pythagorean inheritance: He suggested ways in which buildings could be conceived in the spirit of the symbolism of number. He introduced the idea of architectural proportion. He found practical uses for the geometrical proof now known as the Pythagorean theorem, which, although first published by Euclid several centuries earlier, Vitruvius was the first to attribute to Pythagoras. And last but not least, he divided his text, as had Pythagoreans in the past, into ten

books. Ten was the number that Speusippus had first defined, and Aristotle after him, as symbolized by a triangle and a pyramid, which was the "complete thing" for Pythagoreans.

Although most of the Roman temples and sculptures just described have perished, and although no buildings designed by Vitruvius are known to survive, Pythagorean inspiration is not unknown in other surviving works from these centuries. Bronze coins issued at Samos, described in chapter 8, show Pythagoras, now in full figure, pointing to a sphere evidently symbolizing the universe. The contorniate now in Paris shows Pythagoras on one side and Apollo-Helios on the other, thus demonstrating their close relationship. Apollo-Helios is articulated by seven rays that frame his head.

The tradition of Greek portraiture of Pythagoras would continue through late Antique times, as exemplified by the honorific shield portrait from a school in Aphrodisias and the library mosaic now in Antalya, both described in chapter 8. Documented by inscribed works from the fifth century BC to the fifth century AD, the Greek image of Pythagoras would remain consistent. Yet the only known Roman representations of Pythagoras are lost. Perhaps these were based on Greek example. However, in a number of modern attributions, the Roman busts thought to represent him exhibit a wide variation. The lack of iconographical consistency in these purported portraits of Pythagoras suggests the possibility that as the centuries went by, there was no longer one way to represent Pythagoras. In any case, Pythagoras's elevation to the status of a god was accompanied by a gradual ablation, or erosion, of his actual (or Greek) physical image. New writings described him as having long hair and wearing trousers. Curiously, however, no known writings describe him as wearing a turban (as he does in some of these sculptures), and no sculptures represent him wearing trousers.

One characteristic of the Roman regard for Pythagoras that emerges quite clearly is that some Romans (Cicero and Varro, for example) were genuinely attached to the doctrines associated with him, whereas others (especially the emperors after Augustus) appear to have been, at least in their worship of Apollo, fashionably pseudo-Pythagorean at best. The exceptions are Hadrian and Septimius Severus. No doubt, many Roman emperors feigned an attachment to Pythagoras or Apollo, or both, as a way to ennoble their origins.

While Rome was transforming itself from a republic into an empire, a Celtic tribe that apparently had originated in Greece and then resided in Etruria was driven north in at least two campaigns. These were the Druids, as they came to be known north of the Alps. Both pagan writers (Greeks and Romans) and Christian writers at the time testify in abundance to their Pythagoreanism. A bishop of Rome even suggested they were direct descendants of Pythagoras himself. At any rate, the characteristics of Pythagoreanism survived in their philosophy and teachings as well as in their engagement in the arts of healing and divination.

It is from the years of the early empire that the oldest-known surviving

Pythagorean building dates. At the time this extraordinary vaulted building was built deep under the ground, the concept of Pythagoras had unfolded to reveal a much broader and realistic picture than that of a distant wise man and god. Although much of Ovid's information was based on older ideas, his picture of Pythagoras as a vegetarian sent by heaven to damn forever those who eat blood is unforgettable: "Life eating life to feed the devouring belly that never eats enough of flesh that dies!"[1] While always present, Pythagoras's mystical side now takes center stage. Ovid also brought to the forefront Pythagoras's abilities to heal, which, in the *Metamorphoses*—a work whose influence would survive through medieval times—were deeply interlocked with those of Apollo. Writing at the same time, the medical doctor Celsus admitted that Pythagoras was expert in medicine, while Quintilian described some of the techniques used by Pythagoras to calm frenzy through the practice of music therapy. Apollonius of Tyana, himself a medical man as well as a mystic, wrote, in these years, of medicine as a divine occupation and of Pythagoras's divine inspirations to help humankind.

In Egypt the Hellenic Jewish philosopher Philo, who would be so influential to Christianity, actively participated in the exergonic discussions of mysticism. His indebtedness to Pythagoreanism was expressed in his own kind of subjective analyses, for he believed that God and matter were interconnected. He also believed that arithmetic and theology were interlocked. The ecstasy and purity he sought is couched in the language of universal harmony and concord, whose characteristics can be explained by number. Number four is the source of eternal order, six is the first perfect number, seven is the most revered number, and so on, he demonstrated. No doubt remembering the "Jewish connection," he saw parallels between the life of Moses and that of Pythagoras. His argument for the immortality of the soul was powerful.

Different from the mystics was Pompeius Trogus, who chose, during this time, to focus on the social good that Pythagoras had accomplished. Pythagoras had delivered people from tyranny and shown them the path to sober lives, explained to them how to achieve virtue, and guided them in understanding their "brotherhood." For Pompeius Trogus the applied "political science" practiced by Pythagoras was far more important than the newly developing idea of his preeminence in mathematics. In other words, for him Pythagoras was more important as a practical and inspirational healer of public woe than as an intellectual or miracle worker.

In many ways, the Subterranean Basilica at Porta Maggiore reflects such contemporary concerns as these and those of the previous century. Although it is not known when Pythagoreans began to meet in groups, or brotherhoods, to perform a ritual in a liturgical setting, it is possible this practice was new at the time. The first century was clearly a time when mystical ideas and mystery religions flourished in the Roman world. The setting, deep underground, may well refer to Pythagoras's own preference to teach and study in dark caves, illuminated by a light. The single light source, an oculus, which allows light

from the upper, outside world to stream into the darkness below, recalls
Plato's imagery as well as suggesting the great monadic source of light that was
Apollo as the sun. Or it may refer to the possibility that Pythagoreans were
still somewhat ostracized, or that they needed a safe haven.

Oriented toward the rising sun, for which Pythagoras had advocated ut-
most respect, the altar of the Subterranean Basilica at Porta Maggiore is in the
east. The absence of color on its pure white walls and pavement, highly un-
usual in Roman times, suggests Pythagoras's preferred "color," while the im-
agery depicted in relief throughout the building refers to the life hereafter and
the immortality of the soul. Indeed the immortality of the soul appears to be
the exclusive theme of the interior space. Most significantly, on the apse be-
hind the altar, in view of all who enter from the west and see the altar in full
view, Apollo is representing playing his seven-string lyre while reaching out to
save Sappho, who, in the act of making her suicidal leap, is thereby guaranteed
immortality by him. It is tempting to think that the idea of dividing the aisles
leading to the altar into three (a nave and two side aisles) reflects the three
parts of the immortal soul, believed at the time to have been the doctrine of
Pythagoras.[2] Thus would the tripartite soul's journey to immortality be
demonstrated, or made complete, at the altar.

Other numerological concepts are evident, as discussed in chapter 9, in the
basilica. These appear to reflect emerging interests in the symbolism of num-
ber, such as those discussed by Philo, who had just died at approximately the
time the building was designed. Independent of other cultic structures in the
Roman world, this triple-aisled basilica with vaulted ceilings, apse in the east,
and primary iconographical symbol of immortality presented above the altar
prefigures the Christian church at a time when the design and structure of the
latter had not even yet been imagined. Although it is to be expected that other
such subterranean structures were constructed by Pythagoreans at this time,
no others—with the possible exception of at least one in France—have been
discovered to date.

Not long afterward, the temple of the Pantheon was built by Hadrian not as
a meeting place for the brotherhood of Pythagoreans but as a fourth temple to
Apollo in Rome—Apollo being, in this case, himself. Hadrian had a great deal
to prove to the Roman people; above all, he had to show them that when he
assumed the title of pater patriae in 128, he was the legitimate emperor of
Rome, even though he was in Syria at the time of his unilateral assumption of
power. He also had to demonstrate that his ascension was approved, if not dic-
tated, by Apollo, and that it was Apollo who had deified him. What better lan-
guage could he use in expressing his gratitude to Apollo—while at the same
time glorifying himself—than to build the most fabulously original temple the
world had ever seen, crowning it with gold, and expressing through its design
a contemporary language that, clearly understood by the initiated while con-
founding the uninitiated, would proclaim his authority, power, lineage, and
immortality.

That very language was available in the contemporary (or approximately contemporary) work of Nicomachus of Gerasa, who, in a world that had begun to stress the importance of mathematics, identified Pythagoras as the founder of this systematic science. Nicomachus was demonstrating that number was fundamental to the geometry and arithmetic with which the universe was constructed. Indeed, the Pantheon is a universe. Cosmologically, geometrically, numerologically, and possibly also astronomically, it is a universe created by a divine mind. Numbers relate to each other, and their symbology expresses an utterly perfect harmonious message—in a nucleus the same message that its builder was attempting to give in the vast building programs he undertook in the city of Rome and in the empire of Rome. Nicomachus left us a great deal of information not only about the constitution and meaning of numbers, but about the avenue to obtain perfect harmony, achieved through the commingling of number with geometric proportion. The ability to understand and express this perfect harmony, which is inherent in the nature of the universe, is, Nicomachus explains, true wisdom, or the path set forth by Pythagoras.

If, how, and where Hadrian and Nicomachus met we may never know. However, Hadrian's known Pythagoreanism, his frequent trips to Syria, and his long residence there, as well as Nicomachus's extensive travels in the Roman world, all open up the possibility. Nicomachus's dedication of one of his arithmetical works to a woman who may have been an empress gives us an idea of the kind of people he was in touch with, even if she was not Empress Plotina, and even if Hadrian had not been a mathematician/architect himself who sought the company of erudite mathematicians.

Not only were the works of Philo and Nicomachus new at this time, but so also were those of Aëtius, whose mystical views of mathematics paralleled those of Nicomachus. Aëtius took a special interest in defining the Platonic polyhedrons, which he explained had been first identified by Pythagoras, who was above all interested in the sphere because it enclosed the universe. The first and early second centuries (AD) were important centuries for the development of Pythagorean mathematics. The very contemporary doctrine of the essentiality of number in the construction of the universe, which was a sphere, must have been inspirational to such an astute practitioner of mathematics as Hadrian. It provided the perfect language for him, as a Grecophile emperor who believed in divination, astrology, and the immortality of his "little" soul, to unveil his power and immortality in an everlasting monument.

Two hundred years later, in the early third century, Septimius Severus paid a significant tribute to Pythagoras by creating a bronze statue depicting Pythagoras as "measuring heaven"; the work was located in the great gymnasium of Zeuxippos in ancient Byzantium. Septimius Severus's second wife, Julia Domna, a learned Syrian, was most likely a Pythagorean, for she was directly connected with Philostratus, the author of the *Life of Apollonius of Tyana,* who may have been the designer of the sculptural program at Zeuxip-

pos. His possible influence on the iconographical idea behind the building of the now-lost Septizodium at Rome may also be considered. It is thus tempting to believe that Septimius Severus was, during the second sophistic, also an admirer of Pythagoras.

It was during this time that in France Druidic culture appears to have slowly become subverted. Nonetheless the Druids continued to be active in the practice of divination and prognostication. As the educated elite of the Gauls, the Druids recalled their Pythagorean ancestors in Italy and, before that perhaps, in Greece through their cosmological philosophy as well as their educational system, which spanned a period of twenty years, equivalent to the period that Pythagoras had allotted to the education of young men. Transmitted secretly, Druidic doctrines appear to have been focused on the immortality of the soul, cosmology, the healing arts, and political justice. The Druids also played the lyre. Perhaps also, as they increasingly lost favor, they were obliged to conduct religious rites underground.

Examples survive of the bronze dodecahedrons with which the Druids appear to have practiced the art of prognostication. Indeed, they are sufficiently numerous as to allow us to ascribe to them characteristics held in common with those with which Plato described the dodecahedron of the universe in the *Timaeus*. This form was doubtless inspired by the writings of the first Pythagorean philosopher, Philolaus, who was reputed in Antiquity to have been the first to publish the doctrines of Pythagoras. Made up of twelve pentagons, the Pythagorean symbol of health, these dodecahedrons appear to have been used for medical prognostication and to have been connected with numerology. Beyond the fact that Christians and pagans alike describe the Druids as Pythagoreans who engaged in the medical arts, late Antique writers of this time such as Plutarch, Lucian, Apuleius, Theon of Smyrna, Numenius, and Sextus Empiricus emphasize the Pythagorean doctrines of immortality of the soul, numerology, divination, and Pythagoras's views of the principles that govern the universe.

Meanwhile, it was during the same time period that the first Christian churches, or basilicas, were constructed. These gradually evolved into the prototypical early medieval church, which is characterized by a rectangular space in which three (or more) aisles lead to a semicircular apse located in the east; a narthex in the west, which contained a fountain or source of holy water; a clerestory, which made light available from above; and iconographical concentration on the interior space—characteristics first apparent in the Pythagorean Subterranean Basilica at Porta Maggiore in Rome. As the Christian church developed, both numerology and geometrical proportion came to be important—elements first described as Pythagorean in the works of Theon of Smyrna, Anatolius, Porphyry, and Iamblichus, which had come to be well known. From its beginnings in a world of multiple mystical sects, Christianity, it appears, had allowed Pythagorean elements to help form its visible language. Too, Pythagoreanism had so expanded that it came to speak a similar mystical

language. Porphyry and Iamblichus had described the divine birth of Pythagoras, who was the son of god. His earthly mother and patient earthly father hovered in the background during the formation of his superhuman character. Eventually it became clear that the child prodigy inclined to teach the masses who surrounded him had access to God because he was God and had a divine mission on earth. By now the legend of Pythagoras developed by his followers evoked the image of a great teacher who idealized purity, secrecy, morals, and wisdom and who had supernatural powers.

At the same time early Christian authorities, such as Clement of Alexandria, Eusebius, Saint Augustine, and later Isidore of Seville, to name only a few, spoke of Pythagoras with respect, accepting his authority as a guide to the holy and virtuous life. Thus admired by Christians, Pythagoras honored the east, the land of the rising sun, as the land of his god, Apollo, who, playing the seven-string lyre, had inspired him to discover the laws of harmony in the universe. Saint Jerome held Pythagoras in particularly high esteem as the first to have presented the dogma of the immortality of the soul.

As Christians accepted, and honored, Pythagoras, they portrayed him often, even sometimes representing him as a bishop. Macrobius and Boethius, who were of the greatest importance for the Middle Ages, emphasized the authority of Pythagoras in number and proportion, a factor that came to be of the greatest importance in the development of the Gothic cathedral. Just as Pythagoras's invention of number had given men the tools with which to measure heaven and comprehend the harmony that governs the universe, so also, at the same time, did the prestige of geometry in the quadrivium grow in tandem with the beginnings of original studies that modernized this field, in the eleventh century. In going beyond the precedent set by Boethius, these "modern" geometers retained, at the same time, respect for the authority of Pythagoras in this field. In concept the Gothic cathedral, which took the words of Boethius and the modern geometers seriously, aimed to present a celestial city governed by geometry and numbers, which together produced proportion and—as Dionysius the Areopagite had also inspired its builders—light. Thus was the Gothic cathedral a cosmology in itself, paralleling the cosmologies William of Conches, Hugh of St. Victor, and others of their time had sought to define in philosophical terms, a universe of knowledge based on the preeminence of the quadrivium in the Seven Liberal Arts.

While the appeal of Pythagoras was very democratic in that it survived in less high-minded endeavors, such as geomancy and alchemy, the magic side of Pythagoras, which had a long history going back to Antiquity, does not appear to have been as inspirational for the visual arts as it was for the literature of experimental science.

By the fourteenth century, on the eve of the Renaissance, Dante saw Pythagoras as a prophet and the first great authority on order in the universe. Like his contemporaries Petrarch and Walter Burley, Dante appreciated—even venerated—the brotherly love practiced by Pythagoras. Petrarch went so far as

to equate the authority of Pythagoras with that of Saint Peter and the Church. Yet neither he nor Dante overlooked what was perhaps the most important characteristic of Pythagoras known from the beginning, his humility.

▲

The idea of Pythagoras, in the imaginations of his followers, was gradually transformed from a humble animal lover to a wise man to a god (in Antiquity), and from a pagan god to a prophet of Christianity (in the Middle Ages, which had its own god). Yet he was always a sage. These changing ideas were undoubtedly a major source of inspiration. From the beginning, he appealed to common folk as well as to intellectuals, a double-sided appeal—in which one side fed the other in perfect demonstration of the balance he would have approved—which lasted the entire course of Antiquity and the Middle Ages. In this sense, although no writings by him are known, or perhaps because no writings by him are known, he was the greatest personality of ancient Greece. He could be interpreted according to the interests of later generations. Plato, one of his most famous disciples, understood his mystery, his genius, and the unity of thought inherent in his idea of harmony. Unlike other forms of Antique thought that faded away, to be retrieved in the Renaissance, the legacy of Pythagoras in fact grew steadily throughout Antiquity, blossoming in medieval times, and creating as the Middle Ages came to a close a stunning and powerful language that formed the background of a tremendous inspiration for the Renaissance. It was, ironically, through the longevity of the influence of Pythagoras and its transformation from reality into legend that such a venerable ancient could, in ever later centuries, inspire the creation of forms of modernity.

NOTES

Introduction

1. See Christiane L. Joost-Gaugier, *Raphael's Stanza della Segnatura: Meaning and Invention* (Cambridge, 2002).

2. Christodorus of Thebes in Egypt, *Description of the Statues in the Public Gymnasium called Zeuxippos* (trans. W. R. Paton, in *The Greek Anthology*, ed. W. R. Paton [Cambridge and London, 1939], 1:69).

3. See, e.g., the work of Salvator Rosa (1615–1673) titled *Pythagoras Emerging from the Underworld* (1662), at the Kimball Museum, Fort Worth, Texas.

4. Karl Menninger (*Number Words and Number Symbols,* [1958; Cambridge, MA, and London, 1966]), for example, tells readers that Pythagoras, having discovered his famous hypotenuse theorem, made a sacrificial offering of one hundred cattle in gratitude to the gods. We do not know that Pythagoras, whose opposition to killing animals is well attested in Antiquity, sacrificed a hundred cattle; nor can we say for sure that Pythagoras, who was known for his worship of only one God (Apollo), sacrificed to multiple gods. Although it is not unreasonable for the history of mathematics to credit Pythagoras with the discovery of the theorem attributed to him (which was first published by Euclid in *Elements,* I.xlvii, without mention of Pythagoras), it should be acknowledged that the name of Pythagoras was not associated with this theorem until four centuries after his death. Thus can some claims, which were the subject of considerable controversy in Antiquity, appear to be misleading.

5. That is to say, a work of specialized scholarship such as Marshall Clagett, ed., *Archimedes in the Middle Ages* (Madison, WI, 1964).

6. Cornelia de Vogel, *Pythagoras and Early Pythagoreanism* (Assen, 1966).

7. François Lenormant, *La grande Grèce, paysages et histoire* (Paris, 1881), esp. 1–75.

8. See esp. Franz Cumont, *Les religions orientales dans le paganisme romain* (1905; Paris, 1929); idem, *Astrology and Religion among the Greeks and Romans,* trans. J. B. Baker (New York, 1912); idem, *Recherches sur le symbolisme funéraire des romains* (Paris, 1942); idem, *Lux Perpetua* (Paris, 1949); and Joseph Bidez and Franz Cumont, *Les mages hellénisés: Zoroastre ostanès et hystaspe* (Paris, 1938).

9. See Peter Kingsley, *Ancient Philosophy, Mystery, and Magic* (Oxford, 1995); and idem, *In the Dark Places of Wisdom* (Inverness, CA, 1999).

10. See Isidore Lévy, *Recherches sur les sources de la légende de Pythagore* (Paris, 1926); and idem, *La légende de Pythagore de Grèce en Palestine* (Paris, 1927).

11. Jérôme Carcopino, *De Pythagore aux Apôtres: Études sur la conversion du monde romain* (Paris, 1956); and Jean Gagé, *Apollon romain* (Paris, 1955).

12. Paul Zanker, *The Mask of Socrates: The Image of the Intellectual in Antiquity*, trans. Alan Shapiro (Berkeley, Los Angeles, and Oxford, 1995).

13. See S. K. Heninger Jr., *Touches of Sweet Harmony* (San Marino, 1974); and idem, *The Cosmological Glass: Renaissance Diagrams of the Universe* (San Marino, 1977).

14. George L. Hersey, *Pythagorean Palaces: Magic and Architecture in the Italian Renaissance* (Ithaca and London, 1976).

15. On this see Gersohm Scholem, "The Curious History of the Six-Pointed Star," *Commentary* 8 (1949): 143–51.

Chapter 1. Pythagoras in the Greek World

1. Regarding the history of Samos, see esp. Ludwig Bürchner, *Das jonische Samos* (Amberg, 1892); and Graham Shipley, *A History of Samos, 800–188 BC* (Oxford, 1987). Its rich store of antiquities, including temples, statues, and Egyptian and oriental bronzes, is outlined (with bibliography) by Licia Vlad Borrelli, "Samos," in *Enciclopedia dell'arte antica classica e orientale* (Rome, 1965), 6:1091–1101, and idem, "Samos," in *Princeton Encyclopedia of Classical Sites,* ed. Richard Stillwell (Princeton, 1976), 802–3. A fascinating new interpretation of Samos as a center of long-distance trade and cultural exchanges between East and West, and as a pivotal source of the early influence of Babylonian ideas on Pythagoras, is presented in Kingsley, *Dark Places of Wisdom,* 17ff.

2. Kingsley, *Dark Places of Wisdom.*

3. See Herodotus, *History,* III.125–27; also the descriptions of Croton and its history in Strabo's *Geography,* VI.I.3–13, passim. The temple to Hera (at Capo Colonna, about six kilometers south of Crotone) is described by Livy in *Ab urbe condita libri* XXIV.3–11. Cf. François Lenormant, "Crotone et le Pythagorisme," in *La grande Grèce,* 2:1–103; W. K. C. Guthrie, *A History of Greek Philosophy, I: The Earlier Presocratics and the Pythagoreans* (1962; Cambridge, 2000), 341–59; W. D. E. Coulson, "Kroton," in *Princeton Encyclopedia of Classical Sites,* ed. Richard Stillwell (Princeton, 1976), 470–71; and Jonathan Barnes, *Early Greek Philosophy* (London and New York, 1987), 89–92.

4. See fragment in Diogenes Laertius, *The Lives and Opinions of Eminent Philosophers,* IX.1. See also Geoffrey S. Kirk, John E. Raven, and Malcolm Schofield, *The Presocratic Philosophers,* 2nd ed. (1957; Cambridge, 1999), 181. On Heraclitus of Ephesus see John Burnet, *Early Greek Philosophy* (1892; New York, 1930), 130–68; and esp. Geoffrey S. Kirk, ed., *Heraclitus, the Cosmic Fragments* (Cambridge, 1954), 181–212.

5. Regarding the dates of Xenophanes' life, see Holger Thesleff, *On Dating Xenophanes* (Helsinki, 1957). For his writings and influence, see Eduard Zeller, *Die Philosophie der Griechen in ihrer geschichtlichen Entwicklung* (Leipzig, 1876), 1:486–508; Hermann Diels, *Die Fragmente der Vorsokratiker* 5th rev. ed., ed. Walther Kranz (1903; Berlin, 1934), 1:113–39 (hereafter Diels-Kranz); Cecil M. Bowra, *Early Greek Elegists* (Cambridge, MA, 1938), 106–35; and esp., Guthrie, *History of Greek Philosophy,* 1:360–402. See also James H. Lesher, *Fragments: Xenophanes of Colophon* (Toronto, 1992). Xenophanes' idea of a single god, not like mortals or like cows and horses, is stated in several fragments (14, 15, and 23) recorded in Clement of Alexandria's *Stromateius* (ca. AD 200), V.xiv. On his "theology," see Werner Jaeger, "Xenophanes' Doctrine of God," in *The Theology of the Early Greek Philosophers,* ed. W. Jaeger (Oxford, 1947), 38–54. Regarding anthropomorphism in pre-classical Greece,

see Walter Burkert, *Homer's Anthropomorphism: Narrative and Ritual* (Washington, DC, 1991).

6. *The Greek Anthology*, VII, epigram 120 (trans. W. R. Paton, *The Greek Anthology* [London and New York, 1917], 2:71). For this poem see also Thomas F. Higham and Cecil M. Bowra, eds., *The Oxford Book of Greek Verse* (Oxford, 1938), 226.

7. On the life-soul and Pythagoras's doctrine of transmigration of the soul, see Jaeger, "Xenophanes' Doctrine of God," 83–89.

8. Evidence regarding the life of Alcmaeon is presented together with his few surviving fragments in Diels-Kranz, *Fragmente der Vorsokratiker*, 1:210–16. See also Zeller, *Philosophie der Griechen*, 1:452–56. In regard to the fragment, see Barnes, *Early Greek Philosophy*, 89–90.

9. Aristotle, *Metaphysics*, I.v.7–8.

10. For the fragment ("Most human things come in pairs"), see Barnes, *Early Greek Philosophy*, 89. Aristotle's comment is in the *Metaphysics*, I.986a.30–34.

11. This was stated by Aristotle in *On the Soul*; see the quoted passage in Barnes, *Early Greek Philosophy*, 90.

12. Aristoxenus of Tarentum (not far from Croton) stated in his work *On Pythagoras and His School* (as cited by Diogenes Laertius, *Lives and Opinions of Eminent Philosophers*, I.11.118) that Pythagoras buried Pherecydes of Syros. Later sources take it for granted that finding him ill with lice, Pythagoras cared for Pherecydes in his last days. On this see, e.g., Diodorus Siculus, *Bibliotheke Historika*, X.3.4. Regarding the confusion of Pherecydes as a sage with Pythagoras as a sage, see Kirk, Raven, and Schofield, *Presocratic Philosophers*, 52–53 and 223. Regarding the life and writings of Pherecydes, see Diels-Kranz, *Fragmente der Vorsokratiker*, 1:43–49.

13. *The Greek Anthology*, VII, epigram 93 (trans. Paton, 2:57). This fragment is that of Duris of Samos from the second book of Horae, according to its later quote by Diogenes Laertius (*Lives and Opinions of Eminent Philosophers*, I.120).

14. On this subject see the discussion of Kirk, Raven, and Schofield, *Presocratic Philosophers*, 52.

15. For the life and works of Heraclitus, see Diels-Kranz, *Fragmente der Vorsokratiker*, 1:139–90.

16. Heraclitus, frag. 81. The translated term is that of W. K. C. Guthrie, *History of Greek Philosophy*, 1:417. Quotation is from Heraclitus, frag. 126 (trans. Barnes, *Early Greek Philosophy*, 111).

17. Diogenes Laertius, *Lives and Opinions of Eminent Philosophers*, VIII.1.6 (trans. R. D. Hicks [Cambridge, MA, and London, 1942], 325). Cf. Kenneth S. Guthrie, comp., *The Pythagorean Sourcebook and Library*, ed. David Fideler (1929; Grand Rapids, 1988), 142; and Barnes, *Early Greek Philosophy*, 111.

18. Heraclitus, frag. 40 (trans. Barnes, *Early Greek Philosophy*, 105).

19. On this see esp. Kingsley, *Ancient Philosophy, Mystery, and Magic*, 294n16; also Kirk, Raven, and Schofield, *Presocratic Philosophers*, 181–82.

20. On this see W. K. C. Guthrie, *History of Greek Philosophy*, 1:157, 412, 417, and esp. 448.

21. Regarding the life of Ion of Chios and for his surviving fragments, see Diels-Kranz, *Fragmente der Vorsokratiker*, 1:377–81.

22. Ion of Chios, frag. 2. Cf. Clement of Alexandria, *Stromateius*, I.xxi, passim; and Diogenes Laertius, *Lives and Opinions of Eminent Philosophers*, VIII.1.8. See also Barnes, *Early Greek Philosophy*, 82; Kirk, Raven, and Schofield, *Presocratic Philosophers*, 221; and W. K. C. Guthrie, *History of Greek Philosophy*, 1:158.

23. Ion of Chios, frag. 4. The passage was quoted by Diogenes Laertius, *Lives and*

Opinions of Eminent Philosophers, I.11.120 (trans. Barnes, *Early Greek Philosophy*, 83). See also W. K. C. Guthrie, *History of Greek Philosophy*.

24. For the life of Empedocles and his surviving fragments, see Diels-Kranz, *Fragmente der Vorsokratiker*, 1:276–375. See also W. K. C. Guthrie, *History of Greek Philosophy, II: The Presocratic Tradition from Parmenides to Democritus* (1965; Cambridge 2000), 122–265.

25. Empedocles, frag. B 129, from Porphyry, *Life of Pythagoras*, 30 (trans. Barnes, *Early Greek Philosophy*, 199); cf. Kirk, Raven, and Schofield, *Presocratic Philosophers*, 218–19; and Cornelia J. de Vogel, *Greek Philosophy* (Leiden, 1957), 1:11.

26. This is one of the main themes of Kingsley, *Ancient Philosophy, Mystery, and Magic*.

27. Regarding Empedoclean miracle stories, including the raising of a dead woman, the purification of marshes, and his death, see de Vogel, *Greek Philosophy*, 1:52. See also Kingsley, *Ancient Philosophy, Mystery, and Magic*, passim.

28. This approach is that of Kingsley, *Ancient Philosophy, Mystery, and Magic*, 250–316; also see ibid., 233–34.

29. The passage from Empedocles, frag. B 137, is quoted from Barnes, *Early Greek Philosophy*, 200. Other examples can be found in frags. B 115, 1–2 (trans. Barnes, 195); and B 136 (trans. Barnes, 200). Regarding the eating of meat in Antiquity and its relation to animal sacrifice, see Johannes Haussleiter, *Der Vegetarismus in der Antike* (Berlin, 1935); also Gillian Clark, introduction to Porphyry of Tyre, *On Abstinence from Killing Animals*, ed. Gillian Clark (Ithaca, 2000), esp. 1–8. Cf. Porphyry, *De abstinentia* [French and Greek texts], 3 vols., ed. Jean Bouffartigue and Michel Patillon (Paris, 1977–79).

30. Empedocles, frag. B 141, as quoted in Barnes, *Early Greek Philosophy*, 201.

31. Cf. Herodotus, *History*, IV.95.

32. Isocrates, *Busiris*, 28 (trans. Larue Van Hook [Cambridge, MA, and London, 1945], 3:119). Cf. the doubts expressed by W. K. C. Guthrie, *History of Greek Philosophy*, 1:173. Guthrie speculates that Isocrates, out of respect for Egyptian wisdom, may have said Pythagoras made a journey to Egypt, and that the statement was not based on fact.

33. Cf. the comments of David C. Lindberg, *The Beginnings of Western Science: The European Scientific Tradition in Philosophical, Religious, and Institutional Context, 600 BC to AD 1450* (Chicago, 1992), 13, which appear to be a mistake or derived from a fabrication: "Herodotus . . . reported that Pythagoras travelled to Egypt, where he was introduced by priests to the mysteries of Egyptian mathematics." This is simply not true. The tradition is established by Isocrates, who is the first to propose an Egyptian visit for Pythagoras. He says that Pythagoras went to Egypt in order to study religion.

34. Regarding the information concerning Damo and her complicity in her father's secrecy, see the letter from a certain Lysis (whose dates are unknown but who was probably an early follower of Pythagoras himself) quoted in Diogenes Laertius, *Lives and Opinions of Eminent Philosophers*, VIII.l.42. For the testimonia about Lysis, see Diels-Kranz, *Fragmente der Vorsokratiker*, 1:420–21. Regarding the letter, see Burkert, "Hellenistische Pseudopythagorica," *Philologus* 105 (1961): 16–43.

35. Plato, *The Republic*, X.600A–B.

36. On Eudoxus of Cnidus and his works, see Friedrich Gisinger, *Die Erdbeschreibung des Eudoxos von Knidos* (Berlin, 1921); and Eudoxus of Knidos, *Die Fragmente des Eudoxos von Knidos*, ed. François Lasserre (Berlin, 1966). The fragment discussed here (no. 36) is from Porphyry, *Life of Pythagoras*, 6–7. It is discussed in Gisinger, *Die*

Erdbeschreibung, 116–19. Other ancient sources for quotations from Eudoxus are in Aristotle and Simplicius. On their discussions of the movements of the planets, see Samuel Sambursky, *The Physical World of the Greeks,* trans. Merton Dagut (1954; London, 1956), 59–62.

37. On Andron, see *Paulys Real-Encyclopädie der Classischen Altertumswissenschaft* (Stuttgart, 1894), 1:2160–61. Eusebius's comments are contained in *Praeparatio evangelica,* X.464 (see J.-P. Migne, ed., *Patrologia Graeca* [Paris, 1857], XXI [21]: 774).

38. A Renaissance Latin translation of the fragment reads as follows: "Subsecurus hos Pythagoras Mnesarchi F. principiò mathematib. ac numeris animum intendit. Postea verò, Phereydis etiam praestigijs non abstinuit. Nam Pontij naue adueniente mercib. onusta, & ijs qui aderant optantib, vt salua portum intraret propter merces, adstas ipse: Ergo, inquit exiguum vobis apparebit corpus, hanc ducens nauim. Rursum in Caulonia (vt ait Aristoteles, scribens de eo etiam multa alia) in Etruria serpétem qui morsu necabat, iste mordés interfecit Seditionem enim orientem suis indi cauit discipulis: ideoqúe Metapontum transijt, nemini visus. Et fluuium qui infra Samum est transiens, vocem humana maiorem audiuit, quae diceret: Salue Pythagora, vnde summus comitib. incidit pauor. Visus est aliquando Crotone & Metaponti eadem die atq; hora. Aliqúado in theatro sedés vt Aristoteles refert, surrexit, & sessoribus demonstrauit femur suum aurem. Feruntur de eo etiam alia mirabilia. Nos autem nolentes trásscriptorum munere fungi, hic finem facimus" (Apollonius, second century BC, from a Greek and Latin Renaissance edition in *Apollonii historiae mirabiles,* in *Antonini liberalis transformationum congeries,* ed. Thomam Guarinum [Basel, 1568], 106). On this passage see also Barnes, *Early Greek Philosophy,* 85. On Aristotle's lost work, originally two monographs later reedited as one, and the kinds of information collected in it, see J. A. Philip, "Aristotle's Monograph *On the Pythagoreans,*" *Transactions and Proceedings of the American Philological Association* 94 (1963): 185–99.

39. Diogenes cites a passage from Aristotle's now-lost *Constitution of Delos,* which said that the only altar at which Pythagoras worshipped was Apollo's at Delos, and that he offered only flour meal and cakes there, no animal sacrifices. (Aristotle is associated with the compilation of the constitutions of 158 Greek states, of which only that of Athens survives.) See Diogenes Laertius, *Lives and Opinions of Eminent Philosophers,* VIII.1.13. For the second fragment, see Aelian, *Varia historia,* II.26. For the collected fragments from Aristotle's lost works (mainly derived from later commentators such as Diogenes Laertius and Aelian), see *Aristotelis Fragmenta,* 2nd ed., ed. Valentino Rose (Leipzig, 1886); and *Aristotelis Fragmenta Selecta,* ed. William D. Ross (Oxford, 1955).

40. For the fragments of Aristoxenus of Tarentum, see Fritz R. Wehrli, *Die Schule des Aristoteles: Texte und Kommentar: II, Aristoxenos* (Basel, 1945). On his elements of harmonics, see esp. *The Harmonics of Aristoxenus* [Greek and English ed.], ed. Henry S. Macran (Oxford, 1902). See also Louis Laloy, *Aristoxène de Tarente et la musique de l'antiquité* (Paris, 1904); *Aristoxeni: Elementa Harmonica,* ed. Rosetta da Rios (Rome, 1954); and *Aristoxenus Elementa Rhythmica: The Fragment of Book II and the Additional Evidence for Aristoxenean Rhythmic Theory,* ed. Lionel Pearson (Oxford, 1990). Aristoxenus's position between the Pythagorean and Peripatetic school is the subject of the astute analysis of Arnaldo Momigliano, *The Development of Greek Biography,* expanded ed. (Cambridge, MA, and London, 1993), 74–78; cf. an earlier work, idem, *Second Thoughts on Greek Biography* (Amsterdam and London, 1971), esp. 14–15. See also Kirk, Raven, and Schofield, *Presocratic Philosophers,* 223–25; and Kurt von Fritz, *Pythagorean Politics in Southern Italy* (New York, 1940).

41. It appears that the later Greek writers Diogenes Laertius, Porphyry, and Iamblichus had access to Aristoxenus's biography of Pythagoras, for they all refer to it (Diogenes Laertius, *Lives of Eminent Philosophers*, I.11.118 and VIII.l.1; Porphyry, *Life of Pythagoras*, 9; and Iamblichus of Chalcis, *Vita Pythagorica*, 35). On this work, see Johannes Mewaldt, *De Aristoxeni Pythagoricis sententiis et vita Pythagorica* (Weimar, 1904); also Lévy, *Recherches sur les sources de la légende de Pythagore*, 44–49. Regarding other such works, see W. K. C. Guthrie, *History of Greek Philosophy*, 1:169.

42. The skill of Chaldeans in prophecy was known as far back as the fifth century BC. On this see Gilbert Murray, *Five Stages of Greek Religion* (Oxford, 1925), 175–77.

43. The information concerning the age of Pythagoras (also referred to later by Porphyry in *Vita Pythagorica*, 9) as analyzed by Apollodorus enables us to calculate the birth date of Pythagoras as being about 570 BC. On this see Wehrli, *Die Schule des Aristoteles*, 2:59; *Apollodors Chronik, Eine Sammlung der Fragmente*, ed. Felix Jacoby (1902; reprint, New York, 1973), 39–47; and Alden A. Mosshammer, *The Chronicle of Eusebius and Greek Chronographic Tradition* (Lewisburg, PA, and Leiden, 1979), 122, 278, 283–89. Aristoxenus's *Life of Pythagoras* was Clement of Alexandria's source for the claim that Pythagoras was Tuscan born (*Stromateius*, I.xiv). Regarding Aristoxenus's assertion that Pythagoras studied with Zoroaster in Chaldea, see Hippolytus as cited in W. K. C. Guthrie, *History of Greek Philosophy*, 1:253. On this subject see Heinrich Dörrie, "Pythagoras als Schüler des Zoroaster—Ein Modell für platonische Legenden," in *Der hellenistische Rahmen des kaiserzeitlichen Platonismus* (Stuttgart, 1990), 2:458–65. Regarding Pythagoras's departure from Croton and the other information mentioned here, see the fragment (frag. 18) quoted by Iamblichus. For its text, see Kirk, Raven, and Schofield, *Presocratic Philosophers*, 222–23. An excellent historical, cultural, and geographical description of ancient Metapontum is contained in François Lenormant, "Metaponte," in *La grande Grèce*, 1:115–63. See also D. Adamesteanu, *Metaponto* (Naples, 1973). An excellent recent history of the origins and historical development of the territory and city of Metapontum (which was later destroyed by Hannibal) and its architectural and artistic production is contained in Ettore M. De Juliis, *Metaponto* (Bari, 2001). Cf. Strabo, *Geography*, 6.I.15. On the possible reasons for Pythagoras's move from Croton to Metapontium, see de Vogel, *Pythagoras and Early Pythagoreanism*, 58–60. On the burning of the Pythagorean synedrion at Croton, see Polybius, *The Histories*, II.39.1–3.

44. Aulus Gellius (*Noctes Atticae*, IV.xi.5), quoting from Aristoxenus's (now lost) book about Pythagoras, as translated by Barnes, *Early Greek Philosophy*, 206.

45. Aulus Gellius (see *Noctes Atticae*, IV.xi.11) paraphrasing Aristoxenus's text. Regarding Pythagoras's enthusiasm for beans, pigs, and suckling kids, see also W. K. C. Guthrie, *History of Greek Philosophy*, 1:188–90.

46. See n. 43 *supra*.

47. Regarding frag. 23 from Aristoxenus, preserved by Stobaeus, see Wehrli, *Die Schule des Aristoteles*, 2:14. The translation here is that of W. K. C. Guthrie, *History of Greek Philosophy*, 1:177.

48. Regarding Lyco, see Diogenes Laertius, *Lives and Opinions of Eminent Philosophers*, V.65–74. His lost work on Pythagoras is mentioned by Zeller, *Philosophie der Griechen*, 2:922–23, esp. n. 3. On Heraclides Ponticus, a predecessor of Aristarchus who believed that a divine force moved the universe with the earth as its center, see Thomas Heath, *Aristarchus of Samos . . . A History of Greek Astronomy to Aristarchus* (Oxford, 1913), 249–83; and Fritz R. Wehrli, *Die Schule des Aristoteles: Texte und Kommentar: VII, Herakleides Pontikos* (Basel, 1953).

49. See Heraclides Ponticus, frag. 40, in W. K. C. Guthrie, *History of Greek Philosophy*, 1:163–64. See also de Vogel, *Pythagoras and Early Pythagoreanism*, 3–4; also (on the Academy and Pythagoras) Werner Jaeger, *Aristotle: Fundamentals of the History of His Development*, 2nd ed., trans. Richard Robinson (1934; Oxford, 1968), 431–32.

50. Callimachus, frag. 191.60–63 (trans. C. A. Trypanis, *Aetia, Iambi, Lyric Poems, . . . and Other Fragments* (Cambridge, MA, and London, 1965), 109. The fragments, hymns, and epigrams of Callimachus are published in *Callimachus*, ed. Rudolfus Pfeiffer, 2 vols. (Oxford, 1949–53). Despite the fame of his lengthy poem *Aetia* (*Causes*), now known only through extant fragments, comparatively little has been written on this important and highly productive Alexandrian poet. See Émile Cahen, *Callimaque et son oeuvre poétique* (Paris, 1929); Giovanni Perrino, *La poetica di Callimaco e i suoi influssi* (Naples, 1982); and Alan Cameron, *Callimachus and His Critics* (Princeton, 1995).

51. Callimachus, frag. 191.60–63 (trans. Trypanis, *Lyric Poems* 109–10).

52. Callimachus, frag. 553 (trans. Trypanis, 265).

53. Aulus Gellius, *Noctes Atticae*, IV.xi.1–13. On the early controversies over whether Pythagoras ate meat and beans, see the commentary of W. K. C. Guthrie, *History of Greek Philosophy*, 1:188–91; also Barnes, *Early Greek Philosophy*, 201 and 205–7. This discussion may, as John Burnet suggests (*Early Greek Philosophy*), simply reflect differences between more and less taboo-observant sects of the same order. In any case it leaves us with some degree of uncertainty as to whether Pythagoras himself established such a practice. On this see also de Vogel, *Greek Philosophy*, ll.

54. This fragment from Timon of Phliasios is quoted in Plutarch, *Life of Numa*, VIII.5 (trans. Bernadotte Perrin, in *Plutarch's Lives*, ed. B. Perrin [London and New York, 1914], 1:333).

55. For the fragment from Hippobotus (and Empedocles, whom he quotes), see Diogenes Laertius, *Lives and Opinions of Eminent Philosophers*, VIII.22. See also the section on the family of Pythagoras according to Diogenes Laertius, in K. S. Guthrie, *Pythagorean Sourcebook and Library*, 152–53.

56. See fragment from Dicaearchus (quoted by Porphyry) in Kirk, Raven, and Schofield, *Presocratic Philosophers*, 226–27.

57. For texts of these fragments by Neanthes, see Lévy, *Recherches sur les sources de la légende de Pythagore*, 60–64.

58. Ibid., 64–65.

59. See esp. Kingsley, *Ancient Philosophy, Mystery, and Magic*; and idem, *Dark Places of Wisdom*.

60. Diogenes Laertius, *Lives and Opinions of Eminent Philosophers*, VIII.40. Cf. Lévy, *La légende de Pythagore de Grèce en Palestine*, 63–78.

61. Hermippus's story is reported by Diogenes Laertius, *Lives and Opinions of Eminent Philosophers*, VIII.41. Cf. chap. 3, n. 23.

62. This is discussed in the first century AD by the Roman Jewish priest and historian Flavius Josephus, in *Against Apion*, I.164–65, and reaffirmed by the Christian theologian Origen in his third-century AD work *Contra celsum*, at I.15. (See the edition of the latter work by Henry Chadwick [Cambridge, 1953], at 17–18.)

63. See esp. Aristobulus, frags. 3–5. For the collected fragments of Aristobulus, see Albert-Marie Denis, *Fragmenta pseudepigraphorum graeca*, in *Pseudepigrapha veteris testamenti graece*, ed. A.-M. Denis and M. de Jonge (Leiden, 1970), 217–28; an excellent commentary and English translation of the fragments can be found in A. Yarbro Collins, "Fragments of Lost Judeo-Hellenistic works: Aristobulus," in *The Old Testa-*

ment Pseudepigrapha, ed. James H. Charlesworth (New York, 1983), 2:831–43. The writings of Aristobulus and their Pythagorean character are discussed in Zeller, *Philosophie der Griechen,* 3(2): 256–64; and also Emile Schürer, *Geschichte des jüdischen Volkes in Zeitalter Jesu Christi* (Leipzig, 1909), 3:512–22 (with bibliography). Though some have questioned the authenticity of these fragments, most experts agree that they are genuine (on this see esp. Schürer, *Geschichte des jüdischen Volkes*; and Nikolaus Walter, *Der Toraausleger Aristobulos* [Berlin, 1964], esp. 73 and 166–71). The most significant of the fragments are reported or quoted by Eusebius in *Praeparatio evangelica,* VII.14 and 32.16–18, VIII.10, IX.6.6–8, and XIII.12–13; also by Clement of Alexandria in *Stromateius,* I.xv, xxii, and V.xiv. On the beginning of Jewish Pythagoreanism in the writings of Aristobulus, see esp. Walter, *Der Toraausleger Aristobulos,* esp. 166–71. See also Roberto Radice, *La filosofia di Aristobulo* (Milan, 1994), passim. Joseph Bidez and Franz Cumont discuss the origins of the notion (in Antiquity) that Pythagoras was a disciple of Moses, in *Mages hellénisés,* 41–43, with further bibliography. On Pythagoras and Alexandrian Judaism, see Lévy, *Légende de Pythagore de Grèce en Palestine,* esp. chap. 3 and 211–31.

64. See Diogenes Laertius's vita of Pythagoras in *Lives and Opinions of Eminent Philosophers,* VIII.1.1–50; Porphyry, *Life of Pythagoras*; and Iamblichus of Chalcis, *Vita Pythagorica.* See also Barnes, *Early Greek Philosophy,* 206 (regarding Xenophillus) and 245 (on Democritus); W. K. C. Guthrie, *History of Greek Philosophy,* 1:163 (regarding Heraclides Ponticus); and Fritz R. Wehrli, *Die Schule des Aristoteles: Texte und Kommentar: I, Dikaiarchos* (Basel, 1944).

65. Lévy, *Recherches sur les sources de la légende de Pythagore,* 60–67.

Chapter 2. Pythagoras in the Roman World

1. Diodorus Siculus, *Bibliotheke historika,* X.3.2–3 and X.9.9 (trans. C. H. Oldfather, in *Diodorus of Sicily,* ed. C. H. Oldfather [Cambridge, MA, and London, 1946], 1:55 and 71). On Diodorus and his uncritical compilation of world history from its mythical beginnings to the time of Julius Caesar, written in forty (partially preserved) books, see the fundamental study of Johann T. Bader, *De Diodori rerum Romanarum auctoribus* (Leipzig, 1890); also the excellent summary of his life and work in E. Schwartz, "Diodoros von Agyrion," in *Paulys Real-Encyclopädie der classischen Altertumswissenschaft* (Stuttgart, 1903), 9:663–704.

2. Diodorus Siculus, *Bibliotheke historika,* VIII.13.14 and X.1.2–10.2.

3. Marcus Tullius Cicero, *De re publica,* II.28–29. A vast bibliography exists on the scope and depth of the learnedness of this public figure, who had a literary and philosophical career as well as a political one. His interest in history is but one example of his concern for establishing cultural values (especially as seen in the appreciation of Greek authority for Roman intellectual thought) for the Roman world. On his life, world, and works (some of which are wholly lost and some of which survive in fragmentary state), see Ernest G. Sihler, *Cicero of Arpiniumum: A Political and Literary Biography* (London and New Haven, 1914); Emanuele Ciaceri, *Cicerone e i suoi tempi,* 2 vols. (Milan, Rome, and Naples, 1926); Hartvig Frisch, *Cicero's Fight for the Republic* (Copenhagen, 1946); and Pierre Grimal, *Cicéron* (Paris, 1986).

4. The first great Latin historian, Livy, was a Roman patriot who had a deep interest in and respect for the traditions and destiny of the city of Rome. Although his work parallels, in many ways, that of Dionysius of Halicarnassus, his emphasis—on Rome as a Roman city rather than Rome as a Greek city—is quite different. On his historical method see esp. Henri Bornecque, *Tite-live* (Paris, 1933); Erich Burck, *Die Erzäh-*

lungskunst des Titus Livius (Berlin, 1934); and Patrick G. Walsh, *Livy: His Historical Aims and Methods* (Cambridge, 1961). Regarding the legacy of the A*b urbe condita libri,* see Giuseppe Billanovich, "Petrarch and the Textual Tradition of Livy," *Journal of the Warburg and Courtauld Institutes* 14 (1951): 17–28. On the birth of Latin historiography, see Antonio La Penna, *La cultura letteraria a Roma* (Bari, 1986), esp. 37–80.

5. Titus Livius, A*b urbe condita libri,* I.xviii.1–4 and XL.xxix.8–9.

6. The careful research and literary criticism of Dionysius of Halicarnassus, who taught literary theory in Rome, are studied by Stanley F. Bonner in *The Literary Treatises of Dionysius* (Cambridge, 1939). On his enthusiasm for Roman subject matter, see Moses Hadas, *A History of Greek Literature* (New York, 1950), 234–36.

7. Dionysius of Halicarnassus, *Roman Antiquities,* II.lix.1–3 (in *The Roman Antiquities of Dionysius of Halicarnassus,* ed. Earnest Cary, vol. 1 [London and Cambridge, MA, 1937]).

8. On this Greek tradition see D. R. Hicks, *Early Greek Astronomy to Aristotle* (1970; Ithaca, 1985), esp. 62–92 and 174–75.

9. Much interesting work has been done on this subject in the twentieth century, beginning with the work of Franz Cumont; see esp. *Les religions orientales dans le paganisme romain* (1905); *Astrology and Religion among the Greeks and Romans* (1912); *Recherches sur le symbolisme funéraire des romains* (1942); and *Lux Perpetua* (1949). Among more recent works see Walter Burkert, *Lore and Science in Ancient Pythagoreanism,* trans. Edwin L. Minar Jr. (1962; Cambridge, MA, 1972); idem, *Orphism and Bacchic Mysteries* (Berkeley, 1977); idem, *Ancient Mystery Cults* (Cambridge, MA, 1987); Kingsley, *Ancient Philosophy, Mystery, and Magic* (1995); and idem, *In the Dark Places of Wisdom* (1999).

10. Cicero, *Tusculanae disputationes,* I.62.

11. Ibid., V.8–10.

12. Cicero, *De re publica,* III.22; idem, *Tusculanae disputationes,* V.8–10; and idem, *De legibus,* I.34.

13. Regarding Pythagoras's teachings about the soul, see Cicero, *Tusculanae disputationes,* I.20,38–39. On Pythagoras as an augur, see Cicero, *De divinatione,* I.5. There appears to be no evidence that Pythagoras applied systematic or scientific principles to divination; for him the practice appears to have been above all a religious one, related to his sacerdotal connection with Apollo. On this see Auguste Bouché-Leclercq's monumental work, *Histoire de la divination dans l'Antiquité,* 4 vols. (Paris, 1879), esp. vol. 1, passim.

14. Cicero, *De natura deorum,* II.88; and idem, *De legibus,* II.26.

15. Cicero, *De natura deorum,* I.74; and idem, *Tusculanae disputationes,* I.61–62.

16. Cicero, *De divinatione,* II.119.

17. Cicero, *De finibus bonorum et malorum,* V.50 and 87; and idem, *Tusculanae disputationes,* IV.44.

18. Cicero, *De re publica,* I.16.

19. Strabo, *Geography,* XIV.I.16.

20. Cicero, *De re publica,* I.16; and idem, *Tusculanae disputationes,* I.38 and IV.2–3.

21. Cicero, *De natura deorum,* I.10.

22. Cicero, *De finibus bonorum et malorum,* V.4.

23. Cicero, *Tusculanae disputationes,* I.20 and 38–39; idem, *Academica,* II.118; and idem, *De re publica,* I.16.

24. Cicero, *De re publica,* VI.12 and 17–19.

25. Ibid., VI.9–29. For an overview of the history of the concept of the harmony of

the spheres, see Ferdinand Piper, *Mythologie der christlichen Kunst* (Weimar, 1847), 2:245–76.

26. In late 1493, a group of manuscripts was discovered at the Badia of Bobbio, near Pavia. This was one of the most important ancient literary finds of the Quattrocento, occurring several decades after an important find at Lodi. Among the books found at Bobbio (listed by Giacomo Aurelio Questenberg, in a pre-1503 codex, *Hannover.Bib.XLII.1845,* and by Raffaelle Maffei in *Commentaria Urbana* [Rome, 1506], fol. LVIr) was the *De re publica* of Cicero, a work that had been lost during the Middle Ages except for its last section, which, known as the *Somnium Scipionis,* survived throughout medieval times largely because Macrobius had written a commentary on it. The discovery of this only remaining lost work of major importance by Cicero made the Ciceronian corpus complete. It was brought to Rome by Tommaso Inghirami, then in the service of Pope Alexander VI and future librarian of Pope Julius II. On the Bobbio find, see O. von Gebhardt, "Ein Bücherfund in Bobbio," *Centralblatt für Bibliothekswesen* 5, no. 8 (1888): 343–62; Remegio Sabbadini, *Le scoperte dei codici latini e greci ne'secoli XIV e XV,* ed. Eugenio Garin (1905; Florence, 1967), 158–60; and M. Ferrari, "Le scoperte a Bobbio nel 1493: Vicende di codici e fortuna di testi," *Italia Medioevale e Umanistica* 13 (1970), esp. at 162–63. Still very fragile, the manuscript was rediscovered in 1820 by the eminent nineteenth-century scholar Cardinal Angelo Mai in the Vatican Library as part of a palimpsest containing Saint Augustine's *Commentary on the Psalms.* On this rediscovery and its ramifications, see Joost-Gaugier, *Raphael's Stanza della Segnatura,* 184n21.

27. On the life and works of Varro, see Gaston Boissier, *Étude sur la vie et les ouvrages de M. T. Varron* (Paris, 1861). For the opinion of Pythagoras, as described by Varro in a work probably included in his *Antiquitates rerum humanarum et divinarum,* see Censorinus, *De die natali liber ad Q. Caerellium* (AD 238), in *Edizioni e saggi universitari di filologia classica,* vol. 47, ed. Carmelo Rapisarda (Bologna, 1991).

28. The influence of Vitruvius's *De architectura* on the development of Western architecture, which began in the Renaissance when this work became the standard that inspired architects from Alberti onward, is the subject of Ingrid Rowland and Thomas N. Howe's introduction to Vitruvius, *Ten Books on Architecture: Vitruvius,* ed. I. Rowland and T. N. Howe (Cambridge, 1999).

29. Vitruvius Pollio (hereinafter Vitruvius), *De architectura,* V.Pref., 3–4 and IX.Pref. Not only is the importance of Pythagoras for Vitruvius clear here; Vitruvius's importance for Pythagoreanism is discussed in chap. 5 of this volume. On the Pythagoreanism of Vitruvius, see Hersey, *Pythagorean Palaces,* passim.

30. Vitruvius, *De architectura,* IX.3.

31. Ibid., VIII.Pref. and IX.Pref.; also IX.18.

32. Ibid., IX.Pref. Cf. Euclid, *Elements,* I.xlvii.

33. Cicero, *De natura deorum,* I.10.

34. Cf. Publius Ovidius Naso (Ovid), *Metamorphoses,* XV, ll. 80–100 and 455–66. On Ovid, who has inspired an extensive literature, and his major work the *Metamorphoses,* a work of great importance through medieval and Renaissance times, see Brooks Otis, *Ovid as an Epic Poet,* 2nd ed. (1966; Cambridge, 1970); and Walther Ludwig, *Struktur und Einheit der Metamorphosen* (Berlin, 1965).

35. Ovid, *Metamorphoses,* XV, ll. 214–374.

36. Ibid., XV, ll. 143–44, 418–22, and 625–90.

37. Ibid., XV, ll. 530–40.

38. Celsus, *De medicina,* Proemium, 8.

39. Pliny's discussion of Pythagoras as an astronomer is contained in *Historia natu-*

ralis, II.vi. In explaining the history of magic, he says that Pythagoras, Empedocles, Democritus, and Plato went on distant journeys to learn it and considered it one of their most treasured secrets (ibid., XXX.ii). His discussion of Pythagoras's interest in magical plants is contained in XXIV.xcix and that on the squill in XIX.xxx. For his reference to Pythagoras as "vir sagacis animi," see II.xx.83–84. Commenting on Pliny's linking of such eminent scholars with magic, Aulus Gellius finds such claims absurd (*Noctes Atticae,* X.xii).

40. Regarding the Pythagorean sage of the first century AD who was immortalized later by Philostratus, and his letters, see Robert J. Penella, ed., *The Letters of Apollonius of Tyana: A Critical Text with Prolegomena, Translation, and Commentary* (Leiden, 1979). According to his biographer Philostratus (b. ca. AD 172), Apollonius emerged from seven days at the oracle of Apollo with a volume containing the "tenets" of Pythagoras, a volume that was later to be collected, together with the letters of Apollonius, by the Roman emperor Hadrian. Philostratus claimed to have this collection of letters (from which he quotes). In the early fifth century Stobaeus included twenty-two letters of Apollonius in his anthology. The letters included in Penella's volume are largely from Stobaeus though a few are from other sources. See Philostratus, *Life of Apollonius of Tyana,* VII.20. We are told by a later writer that Apollonius wrote a biography of Pythagoras (which he consulted). See Porphyry, *Life of Pythagoras,* 2.

41. See, e.g., Apollonius of Tyana, letter no. 50, in Penella, *Letters of Apollonius.*

42. Ibid., letter no. 23. Regarding Ovid's comment, see n. 37 *supra.* On Pythagoras and his peculiar interests in medicine, see Jackie Pigeaud, *La maladie de l'âme: Étude sur la relation de l'âme et du corps dans la tradition médico-philosophique antique* (Paris, 1981), passim; and idem, *Folie et cures de la folie chez les médecins de l'Antiquité greco-romaine* (Paris, 1987), 154–60. See also de Vogel, *Pythagoras and Early Pythagoreanism,* 232–44.

43. Apollonius of Tyana, letter no. 48(2), in Penella, *Letters of Apollonius.* The passage quoted here is translated by F. C. Conybeare, in Philostratus, *The Life of Apollonius of Tyana/The Epistles of Apollonius of Tyana,* ed. F. C. Conybeare (London and New York, 1921), 445.

44. Valerius Maximus, *Facta et dicta memorabilia,* VIII.7 passim and VIII.15 (External).

45. Pompeius Trogus's *Historiae Philippicae* is known through an *Epitome* written two centuries later by Marcus Junian Justinus. For the relevant text and commentary, see de Vogel, *Pythagoras and Early Pythagoreanism,* 247–48 and 60–64.

46. Marcus Fabius Quintilianus (Quintilian), *Institutio oratoria,* I.x.32.

47. Martial, *Epigrams,* IX.47.

48. On Antonius Diogenes, see Bruno Lavagnini, *Studi sul romanzo greco* (Messina and Florence, 1950), 181–82. For the citation, see Porphyry, *Life of Pythagoras,* 12.

49. Later scholars (such as Apuleius of Madaura, Boethius Severus, Porphyry, Proclus, and Isidore of Seville) revered Nicomachus as the representative in his time of Pythagoras himself. Proclus, a Greek fifth-century philosopher and scientist who was head of the Platonic Academy at Athens until his death in 484, claimed, on the authority of a dream, to have miraculously received the soul of Nicomachus (according to his student Marinus of Samaria [b. ca. 440] in his *Vita Procli,* cited further in chap. 3, n. 94). Much of the work of Nicomachus is known through extracts that were made by Photius, a ninth-century Byzantine scholar and patriarch of Constantinople. For the Greek text of the *Introduction to Arithmetic,* see *Nichomachi Geraseni Pythagorei introductionis arithmeticae libri II,* ed. Richard Hoche (Leipzig, 1866). The best modern biography and commentary on the works, philosophy, and critical fortune of Nico-

machus of Gerasa is Martin Luther D'Ooge's introduction to *Nicomachus of Gerasa: Introduction to Arithmetic,* ed. M. L. D'Ooge, Frank E. Robbins, and Louis C. Karpinski (New York, 1926), 3–180. Regarding the *Manual of Harmonics,* see Flora R. Levin's introduction to *The Harmonics of Nicomachus and the Pythagorean Tradition,* American Philological Association (University Park, PA, 1975); and *The Manual of Harmonics of Nicomachus the Pythagorean,* ed. F. Levin (Grand Rapids, MI, 1994), 13–27. Regarding the preservation of the *Theologoumena arithmetica,* see the works cited in chap. 6, n. 42. The many translators and commentators on Nicomachus's works are discussed in D'Ooge, *Nicomachus of Gerasa,* 124–67; and Levin, *Harmonics of Nicomachus,* 14–15.

50. D'Ooge, *Nicomachus of Gerasa,* 79. Regarding the works of Nicomachus, see n. 49 *supra.*

51. Nicomachus of Gerasa, *Introduction to Arithmetic,* bk. I.I.1; also bk. I passim.

52. Ibid., bk. II, passim.

53. Ibid., bk. II.xvii.

54. On the primary opposition of limited/unlimited and the pairs of contraries unity/odd and duality/even, which are inherent in the One, see James A. Philip, *Pythagoras and Early Pythagoreanism* (Toronto, 1966), 46–53. Both Plato and Aristotle distinguished what makes a number odd, even, odd-even, odd [multi] odd, etc. On these views and the various examples of their possible classification, see Edward A. Maziarz and Thomas Greenwood, *Greek Mathematical Philosophy* (New York, 1968), 18–20.

55. Nicomachus of Gerasa, *Introduction to Arithmetic,* bk. II.XIX.1 (trans. D'Ooge, 259–60).

56. Ibid., bk. II, passim.

57. Nicomachus, *The Manual of Harmonics,* title page (see in Levin, *Manual of Harmonics of Nicomachus the Pythagorean,* 33). For the Greek text of this work, see Nicomachus, "Manuale harmonicum," in *Musici scriptores graeci,* ed. Carolus Janus (Karl von Jan) (1895; reprint, Hildesheim, 1962), 37–65.

58. Nicomachus of Gerasa, *Introduction to Arithmetic,* bk. I.V.2. On Aristoxenus's view of music, see H. S. Macran, "On Aristoxenus and His Extant Works," in Macran, *Harmonics of Aristoxenis,* 86–93.

59. Nicomachus of Gerasa, *Manual of Harmonics,* chaps. 1 and 2.

60. Ibid., chap. 3.

61. Ibid., chap. 4.

62. Ibid., chap. 5.

63. Ibid., chap. 6 (trans. Levin, *Manual of Harmonics of Nicomachus the Pythagorean,* 83). Although Pythagoras's conclusion was correct in principle, it would not be the weight of the hammers that would determine the musical pitch but the size of the anvils.

64. Nicomachus of Gerasa, *Manual of Harmonics,* chaps. 8–12.

65. Levin, *Manual of Harmonics of Nicomachus the Pythagorean,* 177–79. See also n. 58 above.

66. Cf. Macrobius, *Commentary on the Dream of Scipio,* II.I.9, where the story is the same. See also the comments of Levin in *Manual of Harmonics of Nicomachus the Pythagorean,* 86–87.

67. Aëtius, *Placita philosophorum,* passim, esp. I.7.18, I.15.2, I.24.3, I.25.2, II.4.1–2, II.6.5, II.25.14, II.30.1, III.1.2, and III.14.1. Often erroneously attributed to Plutarch, this work was preserved in the translation of Qostà ibn Lùqà. (For text in Arabic and German, see *Aëtius Arabus,* ed. Hans Daiber [Wiesbaden, 1980].) Cf. Plutarch, *Opinions des philosophes,* ed. Guy Lachenaud (Paris, 1993).

68. Plutarch, *Isis and Osiris*, 354D–F.

69. Ibid., 354F–355A.

70. Ibid., 354F.

71. Plutarch, *Table Talk*, VIII.8, 729A.

72. Ibid., VIII.7, 727B–C; and VIII.8, 728F–729A.

73. Plutarch's description of these calculations by Pythagoras appears in a fragment from a lost *Life of Heracles* (in Plutarch, *Moralia,* ed. F. H. Sandbach [Cambridge, MA, and London, 1969], XV.81). It is also reported by Aulus Gellius, in *Noctes Atticae*, I.i.1–3.

74. Plutarch, *A Pleasant Life Impossible,* 1094B; and idem, *Table Talk,* VIII.2, 720A.

75. Plutarch, *A Pleasant Life Impossible,* 1094B; and idem, *Table Talk,* VIII.2, 720A.

76. Plutarch, *A Pleasant Life Impossible,* 1105E; frag. 200 in idem, *Moralia,* ed. Sandbach, 369; and idem, *On the Eating of Flesh,* 997E.

77. Plutarch, *The Cleverness of Animals,* 964E–F.

78. Plutarch, *Table Talk,* VIII.8, 729D–E; and idem, *How to Profit by One's Enemies,* 91C–D.

79. Plutarch, *Life of Numa,* VIII.4–5; idem, *On the Sign of Socrates,* 580C.

80. Plutarch, *Life of Numa,* VIII.5.

81. Plutarch, *On the Sign of Socrates,* 580C.

82. Plutarch, *How to Tell a Flatterer,* 70F.

83. Plutarch, *On the Fortune or Virtue of Alexander,* 328A.

84. Plutarch, *Is "Live Unknown" a Wise Precept?* 1128F; idem, *How to Study Poetry,* 35F; idem, *The Education of Children,* 12D; idem, *On Listening to Lectures,* 44E; idem, *On Having Many Friends,* 96A; and idem, *On Curiosity,* 519C.

85. Plutarch, *On Music,* 1147A and 1144F–45A; and idem, *On Moral Virtue,* 441E.

86. Plutarch, *On the Education of Children,* 2B–C (trans. Frank Cole Babbitt, in Plutarch, *Moralia,* ed. F. C. Babbitt [Cambridge, MA, and London, 1949], 1:9).

87. Regarding this author see the study of Rudolf Helm, *Lucian und Menippus* (1906; reprint, Hildesheim, 1967). On the textual tradition of Lucian's works in Latin manuscripts (until the Greek original came to be widely known after a Greek manuscript of its text was brought to Italy from Constantinople in 1423) and early printed books, see E. P. Goldschmidt, "The First Edition of Lucian of Samosata," *Journal of the Warburg and Courtauld Institutes* 14 (1951): 7–20. For an example of the popularity of Lucian's comments about Pythagoras in the seventeenth century, see Antonio Enriquez, *El siglo pitagorico y vida de Don Gregorio Guadaña* (Madrid, 1991).

88. Lucian of Samosata, *Hermotimus,* 48.

89. Lucian, *The Dialogues of the Dead,* 415.

90. Lucian, *Alexander the False Prophet,* 39–41. On Pythagoras's divinity, see also idem, *A Slip of the Tongue in Greeting,* 5.

91. Lucian, *A Slip of the Tongue in Greeting,* 5.

92. Apuleius of Madaura, *Metamorphoses,* XI.1. For a complete edition of this work, see idem, *Apulei Platonici Madaurensis metamorphoseon libri XI,* ed. Rudolfus Helm (Leipzig, 1907).

93. Thomas Heath, *A History of Greek Mathematics* (Oxford, 1921), 97. No primary source is cited.

94. An incisive discussion of the philosophy of this poet, rhetorician, and philosopher, renowned in his own time, is contained in John M. Dillon, "Apuleius of

Madaura," in *The Middle Platonists* (1977; reprint, Ithaca, 1996), 306–38. The cited passage is from Apuleius of Madaura, *Florida*, 15.12–15. (For a complete edition of the *Florida*, see *Apulei Platonici Madaurensis florida,* ed. Rudolfvs Helm (Leipzig, 1921.) On this passage, see also Menahem Stern, ed., *Greek and Latin Authors on Jews and Judaism* (Jerusalem, 1980), 2:205n. For Apuleius's comment regarding the appearance of Pythagoras, see Apuleius, *Apologia*, 4 (most recently published in *L'Apologia, o, La Magia, Florida,* ed. Giuseppe Augello [Turin, 1984]).

95. See the complete work in Theon of Smyrna, *Expositio rerum mathematicarum ad legendum Platonem,* ed. Eduard Hiller (Leipzig, 1878); quotation at idem, *Mathematics Useful for Understanding Plato* (trans. R. Lawlor and D. Lawlor [San Diego, 1979], 98). On Theon, see Heath, *History of Greek Mathematics,* 1:112–14, 2:238–44.

96. Theon of Smyrna, *Mathematics Useful for Understanding Plato,* 38.

97. Ibid. (trans. Lawlor and Lawlor, 62).

98. Ibid. (trans. Lawlor and Lawlor, 65).

99. For insights on the ideas and background of Numenius of Apamea, who though probably not a Jew had wide and diverse interests in religious philosophy, including interests in Zoroastrianism as well as in Jewish doctrine, see Dillon, "Numenius of Apamea," 361–79. Eusebius of Caesarea offers us a direct quote from Numenius of Apamea's *On the Good.* For the Greek text, see Eusebius of Caesarea, *Preparatio evangelico,* IX.vii.i, in *Patrologia Graeca,* ed. J. P. Migne (Paris, 1857), 21: 694–95. Eusebius also quotes passages from another of Numenius's works, *The Secrets of Plato,* in the same work. For the compiled fragments (Greek and French texts) of this author, see Numenius of Apamea, *Numenius: Fragments,* ed. and trans. Édouard des Places (Paris, 1973), where the fragment discussed here is frag. 1. On Numenius see also Bidez and Cumont, *Mages hellénisés,* passim.

100. The description of the Magi of Persia is based on that of Diogenes Laertius, *Lives and Opinions of Eminent Philosophers,* Prologue I.6–10. Regarding the comments of Numenius, see frags. 7, 24, 29, 32, 35, 52, and 54 in Numenius of Apamea, *Numenius: Fragments.*

101. Pausanias, *Description of Greece: Corinth,* II.13.1 and 17.1.

102. Sextus Empiricus, *Against the Arithmeticians,* in *Against the Professors,* IV.1–10.

103. Clement of Alexandria (Titus Flavius Clemens), *Stromateus,* I.xiv and xv, I.xxi, and II.xviii; also idem, *Exhortation to the Greeks,* VII.

104. Clement of Alexandria, *Exhortation to the Greeks,* VI.

105. Ibid.

106. Clement of Alexandria, *Paedagogus,* I.X.94 (trans. mine). See text in Clement of Alexandria, *Le pédagogue,* ed. Henri-Irénée Marrou (Paris, 1960), vol. 1.

107. In the *Philosophumena (Refutation of All Heresies),* a work attributed to Hippolytus, its author seems sympathetic to the doctrines of Pythagoras while admitting that heresies could result from following them too assiduously. See Hippolytus, *Philosophumena, ou réfutation de toutes les hérésies,* ed. A. Siouville (Paris, 1928), 2 vols., esp. I.2, IV.7, V.13, VI.Pref. and 2, and IX.14.

108. Plutarch, *On Music,* 1132, 1135–36. Cf. the earlier fourth Homeric hymn, the *Hymn to Hermes,* which contains an eloquent passage describing the shaping of the first lyre (by Hermes) from the back of a tortoise and the transformation of its gut into strings. Hermes later shared this invention, the unknown author tells us, with Apollo (IV.30–530). Pausanias, on the other hand, presents evidence that would dispute this claim for he describes a bronze statue on Helicon as representing Apollo fighting with Hermes for the lyre (*Description of Greece: Boeotia,* IX.30.1).

NOTES TO PAGES 44-45

Chapter 3. Pythagoras in the Late Pagan and Early Christian Worlds

1. Both Varro and Cornelius Nepos were friends of Cicero's, and all three were pioneers in the composition of collected, or group, biographies intended to memorialize the deeds of famous men. Suetonius's *Lives of the Caesars* is closely related to the work of these, while Plutarch's *Parallel Lives* is a famous later example. On this tradition see Christiane Joost-Gaugier, "The Early Beginnings of the Notion of Uomini Famosi and the De Viris Illustribus in Greco-Roman Literary Tradition," *Artibus et Historiae* 23, no. 6 (1982): 97–116.

2. The identity of Constantine's new capital city as the "new Rome" and its function as a second Rome equal but not superior to the original city are analyzed in Richard Krautheimer, *Three Christian Capitals: Topography and Politics* (Berkeley, Los Angeles, and London, 1983), esp. 41–50. On the background for this idea of the state vis-à-vis Byzantine history and its effects on the inhabitants of Constantinople, see Cyril Mango, *Byzantium: The Empire of New Rome* (London, 1980), passim.

3. This refers to Philon, commonly known as Philo of Alexandria, or Philo Judaeus (ca. 30 BC– AD 45), who is discussed in chap. 6.

4. For more information on Flavius Philostratus and this unusual work, see Moses Hadas and Morton Smith, *Heroes and Gods: Spiritual Biographies in Antiquity* (Freeport, NY, 1970), 196–259; Ferdinando Lo Cascio, *La forma letteraria della vita di Apollonio Tianeo* (Palermo, 1974); Graham Anderson, *Philostratus, Biography, and Belles Lettres in the Third Century* AD (London and Dover, NH, 1986); and Jaap-Jan Flinterman, *Power, Paideia, and Pythagoreanism: Greek Identity, Conceptions of the Relationship between Philosophers and Monarchs, and Political Ideas in Philostratus's Life of Apollonius of Tyana*, Dutch Monographs on Ancient History and Archaeology 23 (Amsterdam, 1995).

5. Philostratus, *The Life of Apollonius of Tyana*, passim. The idea of Pythagoras as a mystic in the work of Philostratus is discussed in Johannes Geffcken, *The Last Days of Greco-Roman Paganism*, trans. Sabine MacCormack (1929; Amsterdam, New York, and Oxford, 1978), 40–41.

6. Nothing is known of the life or exact time of the elusive Greek author Diogenes Laertius. On the basis of the contents of his major surviving work, which does not mention Neoplatonism, it appears that he lived in the early third century. His mysterious name, origins, time, and audience are discussed in Arnaldo Momigliano, "Ancient Biography and the Study of Religion," in *On Pagans, Jews, and Christians* (Middletown, CT, 1987), 170–77. For a significant effort to reconstruct his literary life and influences, see Jorgen Mejer, *Diogenes Laertius and His Hellenistic Background* (Wiesbaden, 1978). Two examples of Renaissance texts of this work are *Diogenes Laertius, Vita et sententiae philosophorum*, ed. Bernardinus Celerius (Venice, 1480); and *Diogenis Laertij De uita et moribus philosophorum libri X*, ed. Seb. Gryphium (Lugduni, 1541). For the Greek text with Latin translation and various commentaries, see *Diogenes Laertius, De vitis, dogmatis et apophthegmatis clarorum philosophorum libri decem*, 4 vols., ed. Henricus Gustavus Huebnerus (Hildesheim, 1981). For a recent publication of the Greek text, see *Diogenes Laertius, Vitae philosophorum*, ed. Miroslave Marcovich (Stuttgart, 1999).

7. The medieval tradition for this work is extensive. Byzantine authors such as Stephanus, Suidas, and Photius (ninth century) cite it; by the early fourteenth century this tradition came to be established in the West in the work of Walter Burley (Walter de Burleigh), a disciple of Duns Scotus, discussed in chapter 4. In the fifteenth century a manuscript tradition of this work was firmly implanted in Italy. In 1433 Ambrogio

Traversari completed a Latin translation of the work in Florence. This edition circulated in later manuscript form until the invention of printing, when, after further editing by others, it was published many times in the sixteenth century. On this long tradition for this work, see esp. Robert D. Hicks, introduction to Diogenes Laertius, *Lives of Eminent Philosophers*, ed. R. D. Hicks (Cambridge, MA, and London, 1942), 1:ix–xii; R. R. Bolgar, *The Classical Heritage and Its Beneficiaries* (1954; reprint, Cambridge, 1977), 472, 512–13; Eugenio Garin, *La cultura filosofica del Rinascimento italiano* (Florence, 1961), 75–78, 398n; Marcello Gigante, "Ambrogio Traversari interprete di Diogene Laerzio," in *Ambrogio Traversari nel VI centenario della nascita*, ed. Gian Carlo Garfagnini (Florence, 1988), 367–459; and Jill Kraye, "Philologists and Philosophers," in *The Cambridge Companion to Renaissance Humanism*, ed. J. Kraye (Cambridge, 1996), 153–54.

8. Diogenes Laertius, *Lives and Opinions of Eminent Philosophers*, VIII.1.1; Prologue, I.13–15; and VIII.1.46.

9. Ibid., VIII.1.2.

10. Ibid., VIII.1.3.

11. Ibid., VIII.1.2.

12. Ibid., VIII.1.3.

13. There are several references to (Pythian) Apollo in the text. Ibid., VIII.1.5, 13, and 21–22.

14. Ibid., VIII.1.11.

15. Pythagoras, says Diogenes Laertius (in agreement with Nicomachus of Gerasa, *Manual of Harmonics*, X), played the monochord, and it was on this instrument that he discovered the musical intervals. On this and Pythagoras's favorite instrument, the lyre, see *Lives and Opinions of Eminent Philosophers*, VIII.1.12 and 24. On Apollo's connection with the lyre, see chap. 2, n. 108. Regarding the long tradition in Greek Antiquity of the word *apollo*, meaning the monad, see Plato, *Cratylus*, 404E–406C. This was repeated by Plutarch in *The E at Delphi*, 393C and 394A; idem, *Isis and Osiris*, 354F and 381F; and again by Plotinus in the *Fifth Ennead*, V (esp. at V.6), where he discusses the concept of Apollo as meaning the negation of plurality or the repudiation of the multiple and connects it with Pythagoreanism. True unity, he argues, has a divine nature that is incompatible with multiplicity.

16. Diogenes Laertius excoriates those who thought that Pythagoras left no writings; indeed he calls Heraclitus to his defense in the belief that Pythagoras did in fact leave writings and then proceeds to name them. See *Lives and Opinions of Eminent Philosophers*, VIII.1.6–8, but cf. chap. 1, n. 17, in this volume.

17. Diogenes Laertius, *Lives and Opinions of Eminent Philosophers*, VIII.1.17. Regarding Posidonius and his interest in the sun, see Geffcken, *Last Days of Greco-Roman Paganism*, 38–39. No complete text of his survives. His fragments are collected in *Posidonius of Apamea and Rhodes: I. The Fragments*, 2nd ed., ed. L. Edelstein and I. G. Kidd (1972; Cambridge, 1989). Those regarding the shape, course, and characteristics of the sun are from Diogenes Laertius, *Lives and Opinions of Eminent Philosophers*, VII.1.144; Macrobius, *Saturnalia*, I.23.2; Strabo, *Geography*, III.i.5; Pliny the Elder, *Historiae naturalis*, II.21.85–87; and others. On the profound religious mysticism and influence of Posidonius, see Umberto Fracassini, *Il misticismo greco e il Cristianesimo* (Città di Castello, 1922), 258–62; Karl Reinhardt, *Kosmos und Sympathie: Neue Untersuchungen über Poseidonios* (Munich, 1926); and Poseidonios of Apamea, *Die Fragmente*, ed. Willy Theiler (Berlin, 1982), vol. 2 (commentary). Regarding Diogenes' discussion of the sun, the following article is relevant: Gilbert Heuten, "Le 'soleil' de Porphyre," in *Mélanges Franz Cumont*, Annuaire de l'Institut de Philologie et

d'Histoire Orientales et Slavs 4 (Brussels, 1936), 253–59. On Posidonius's identification of the "world soul," see Philip Merlan, *From Platonism to Neoplatonism* (The Hague, 1953), 32–52.

18. Diogenes Laertius, *Lives and Opinions of Eminent Philosophers*, VIII.1.9, 10, and 22–23.

19. Ibid., VIII.1.10, and 14.

20. Ibid., VIII.1.22–23, and 35.

21. Ibid., VIII.1.30–32.

22. Ibid., VIII.1.44, and 15 (respectively). On Cicero's visit to Pythagoras's house at Metapontum, see *De finibus bonorum et malorum*, V.4 (cf. chap. 2, n. 22 above).

23. Diogenes Laertius's description of how Pythagoras's golden thigh was revealed varies slightly from earlier accounts. As transmitted by Diogenes Laertius, Hermippus's third-century BC account of Pythagoras's alleged journey into Hades and back strongly resembles Herodotus's fifth-century BC account of a fraud perpetrated by Pythagoras's former slave Salmoxis: Pythagoras built an underground chamber and went there to live, enjoining his mother to keep a log recording daily events, dates, and times; after an extended stay underground he emerged, looking like a skeleton, and told his followers that he had been down to the land of Hades. Regarding these events see Diogenes Laertius, *Lives and Opinions of Eminent Philosophers*, VIII.1.11, and 41. On Hades as a symbol of immortality, see Burkert, *Lore and Science in Ancient Pythagoreanism*, 359–63.

24. On Aelian and his *Varia historia,* see N. G. Wilson, introduction to *Aelian: Historical Miscellany,* ed. N. G. Wilson (Cambridge, MA, and London, 1997), 1–23. Aelian's identity as a Roman is self-proclaimed: see *Varia historia,* XII.25.

25. Aelian, *Varia historia,* III.17 and IV.17.

26. Ibid., XII.32, specifies "trousers," *anaxyridas.* On trousers as an Iranian (rather than Greek) item of clothing in the time of Pythagoras, see Kingsley, *In the Dark Places of Wisdom,* 14; Burkert, *Lore and Science in Ancient Pythagoreanism,* 112n16, 165; and Henry G. Liddell and Robert Scott, *Greek Lexicon,* 9th ed. (Oxford, 1940), 114, which identifies *anaxyrides* as a word of Persian origin and says that such trousers were worn by "eastern nations," including the Scythians and the Sacae.

27. Aelian, *Varia historia,* XII.59 and XIII.20.

28. A student of Longinus in Athens and a devoted follower of Plotinus, Porphyry of Tyre is the author of numerous works that are regarded as scholarly although frequently thought to be unoriginal. The earliest known biography of him is Eunapius, *Lives of the Philosophers,* 456–57. The primary modern study of his life and works is Joseph Bidez, *Vie de Porphyre, le philosophe néo-platonicien, avec les fragments des traités* (Leipzig, 1913). His scholarship has been the subject of several recent studies. See esp. Andrew Smith, *Porphyry's Place in the Neoplatonic Tradition: A Study in Post-Plotinian Neoplatonism* (The Hague, 1974); Francesco Romano, *Porfirio di Tiro: Filosofia e cultura nel III secolo D.C.* (Catania, 1979); Giuseppe Girgenti, *Il pensiero forte di Porfirio: Mediazione fra henologia platonica e ontologia aristotelica* (Milan, 1996); and Gillian Clark, introduction to *Iamblichus: On the Pythagorean Way of Life* (Liverpool, 1989), ix–xxi. The sources used by Porphyry are discussed in Hans Jaeger, *Die Quellen des Porphyrius in seiner Pythagoras-Biographie* (Zurich, 1969).

29. Porphyry, *Life of Pythagoras,* 2. The standard edition of this work is *De vita Pythagorae,* in *Porphyrii philosophi platonici opvscula tria,* ed. Augustus Nauck (Leipzig, 1860), 14–39. An excellent modern edition is now available in Édouard des Places, ed. and trans., *Vie de Pythagore/Lettre à Marcella* [Greek and French texts] (Paris, 1982). For an English translation, see Hadas and Smith, *Heroes and Gods,*

105–28. See also "The Life of Pythagoras," in K. S. Guthrie, *Pythagorean Sourcebook and Library,* 123–35.

30. Porphyry, *Life of Pythagoras,* 16, 26, 32, 51. For Plutarch's discussion of Apollo as the apex of a triangle, see *Isis and Osiris,* 374A, 375F, and 381F. Cf. the description of Plotinus in *Sixth Ennead,* V.

31. Porphyry, *Life of Pythagoras,* 16, 28.

32. Ibid., 6, 12, 21, 41. See the citation from Hippolytus in W. K. C. Guthrie, *History of Greek Philosophy,* 1:253. See also similar references from Clement of Alexandria, Plutarch, and Apuleius in the same volume. The idea of Pythagoras as a disciple of Zoroaster in Babylon is discussed in Bidez and Cumont, *Mages hellénisés,* 32–43, 102–3.

33. Porphyry, *Life of Pythagoras,* 18, 20, 31–32, 34; Diogenes Laertius, *Lives and Opinions of Eminent Philosophers,* VIII.9.

34. Porphyry, *Life of Pythagoras,* 10, 20, 23–29.

35. Ibid., 33, 39, 46–47, 49. On the Muses as symbolizing harmony, see Pierre Boyancé, *Le culte des muses chez les philosophes grecs* (Paris, 1936). The Greek tradition of the harmony of the spheres, according to which these bodies are believed to produce a sound as they whirl around the earth in accord with each other, is discussed in Heath, *Aristarchus of Samos,* esp. 98–115.

36. Porphyry, *Life of Pythagoras,* 20, 36, 38, 49.

37. Ibid., 56–57.

38. The previous authors cited by Diogenes Laertius include Hermippus, Herodotus, Arignota, Antiphon, Heracleides of Pontus, Heracleides son of Serapion, Heraclitus of Ephesus, Aristoxenus of Tarentum, Sosicrates, Timaeus, Auticlides, Apollodorus the Logician, Favorinus, Parmenides, Aristotle, Aristippus of Cyrene, Hieronymus, Alexander, Timon, Xenophanes, Cratinaus, Mnesimachus, Austophon, Dicaearchus of Messina, Lysis, and Hippobotus. Those cited by Porphyry include Neanthes of Cyzicus, Arignota, Apollonius of Tyana, Duris of Samos, Lycus, Exodus, Aristippus of Cyrene, Timaeus, Antiphon, Antonius Diogenes, Dionysophanes, Dicaearchus of Messina, Nicomachus of Gerasa, Empedocles, Aristoxenus of Tarentum, Moderatus of Gades, Hippobotus, and Aristophon. The names in common to both include Antiphon, Dicearchus of Messina, Aristoxenus of Tarentum, Hippobotus, Arignota, Aristippus of Cyrene, and Timaeus. Regarding these authors and their (lost) works, see Holgar Thesleff, *An Introduction to Pythagorean Writings of the Hellenistic Period* (Abo, 1961); idem, *The Pythagorean Texts of the Hellenistic Period* (Abo, 1965); and the anthology of Felix Jacoby, *Die Fragmente der griechischen Historiker* (1923–58; reprint, Leiden, 1993).

39. The first biographer of Iamblichus of Chalcis was Eunapius (*Lives of the Philosophers,* 458–62). On the problematic birth date of Iamblichus, see Alan Cameron, "The Date of Iamblichus's Birth," *Hermes* 96 (1968): 374–76. Regarding this pagan scholar as a "philosophical theologian" in the Platonic tradition, see Dillon, *Middle Platonists,* chap. 7. On the understanding of "opposites" and "sameness and otherness" in Iamblichus, see Steven Gersh, *From Iamblichus to Eriugena: An Investigation of the Prehistory and Evolution of the Pseudo-Dionysian Tradition* (Leiden, 1978), esp. 57–66. On the life, works, and approach of Iamblichus and the relation of his pagan religiosity to the emerging Christian religion, see Joseph Bidez, "Le philosophe Jamblique et son école," *Revue des Etudes Grecques* 32 (1919): 29–40; de Vogel, *Pythagoras and Early Pythagoreanism,* esp. chap. 6, and 70–147; Bent Dalsgaard Larsen, *Jamblique de Chalcis, exétète et philosophe* (Aarhus, 1972); John M. Dillon, *Iamblichi Chalcidensis I Platonis dialogos commentariorum fragmenta* (Leiden, 1973); and Clark, introduction to *Iamblichus: On the Pythagorean Way of Life,* ix–xxi.

40. An example of the latter is the repetition of Nicomachus's story about Pythagoras's discovery of the intervals in musical harmony by hearing the hammers of a blacksmith (*Vita Pythagorica*, 26).

41. This fact was well noted by Clark, introduction to *Iamblichus: On the Pythagorean Way of Life*, xv.

42. The standard modern text of this work is Iamblichus, *De vita Pythagorica liber*, rev. ed. addendis et corrigendis adiunctis curavit Udalricus Klein, ed. Ludovicus Deubner (1937; Stuttgart, 1975). An excellent English edition is now available in Clark, *Iamblichus: On the Pythagorean Way of Life*. For other English editions see *Iamblichus's Life of Pythagoras, or Pythagoric Life; Accompanied by Fragments of the Ethical Writings*, trans. Thomas Taylor (1818; reprint, Rochester, VT, 1986); also "The Life of Pythagoras," in K. S. Guthrie, *Pythagorean Sourcebook and Library*, 57–122. On Iamblichus's sources, see Erwin Rohde (who sees a dependence of Iamblichus on Nicomachus and Apollonius), "Die Quellen des Jamblichus in seiner Biographie des Pythagoras," *Rheinisches Museum für Philologie* 26 (1871): 554–76, and 27 (1872): 23–61; Philip (who argues that Iamblichus's work derives from that of Porphyry), "The Biographical Tradition—Pythagoras," *Transactions and Proceedings of the American Philological Association* 90 (1959): 185–94; and de Vogel (who argues that Iamblichus used many sources that go back to fourth-century BC sources, and perhaps earlier), *Pythagoras and Early Pythagoreanism*, passim, but esp. 299–303. Cf. the comments of Clark, introduction to *Iamblichus: On the Pythagorean Way of Life*, ix–xii. Regarding the composition and plan of the larger work, Iamblichus's encyclopedia of Pythagoreanism, see Dominic J. O'Meara, *Pythagoras Revived: Mathematics and Philosophy in Late Antiquity* (Oxford and New York, 1989), 30–105.

43. See, e.g., Bolgar, *Classical Heritage*, 165, 477.

44. Writing shortly after his subject's death, Eunapius, Iamblichus's first biographer, reports a number of miracles that caused students to be impressed by Iamblichus's sagacity and to flock to him for divine inspiration as well as knowledge. Eunapius also confirms what is apparent even to the modern reader, that Iamblichus's writing style was more irritating than graceful and more obscure than lucid. See Eunapius, *Lives of the Philosophers*, 458–59.

45. De Vogel, *Pythagoras and Early Pythagoreanism*, 124.

46. Ibid., 6.

47. Iamblichus, *Vita Pythagorica*, 1–2 (trans. Clark, *Iamblichus: On the Pythagorean Way of Life*, 4–5).

48. Ibid., 19 (trans. Clark, 41).

49. Ibid., 28 (trans. Clark, 60).

50. The supernatural aspect of Pythagoras as Apollo is a recurrent theme in Iamblichus's biography. For the passages summarized here, see esp. *Vita Pythagorica*, 10, 23, 27, 29, 35. The tradition of calling Pythagoras "the divine" is undoubtedly an old one, as de Vogel suggests. She also suggests that Iamblichus's immediate source for this was Apollonius of Tyana (de Vogel, *Pythagoras and Pythagoreanism*, 130).

51. Iamblichus, *Vita Pythagorica*, 6, 8.

52. Ibid., 2–6.

53. Ibid., 6–12.

54. Ibid., passim. On his political science, see esp. 21.

55. Ibid., 16, 21, 24, 31.

56. Ibid., 24. Other forbidden foods were the heart (the center of life) and the brain (the center of wisdom), and beans. Ibid., 24, 31.

57. Ibid., passim.

58. Ibid., 28–29.

59. Ibid., e.g., 6, 12, 5.

60. Ibid., 26.

61. Ibid., passim, esp. 14 and 34.

62. Ibid., 28, 29. Cf. Porphyry, *Life of Pythagoras*, 16.

63. Iamblichus, *Vita Pythagorica*, 28.

64. Ibid., passim. Regarding the injunction to adore the rising sun, 33; regarding the long life of Pythagoras, 36.

65. On Eusebius of Caesarea, see the vita authored by Saint Jerome, in *Hieronymus liber de viris inlustribus/Gennadius liber de viris Inlustribus*, ed. Ernest C. Richardson, *Texte und Untersuchungen zur Geschichte der altchristlichen Literatur* 14:43. The comprehensive study Timothy D. Barnes, *Constantine and Eusebius* (Cambridge, MA, 1981), esp. 81–244, is particularly attentive to Eusebius's historical context as well as to his voluminous writings, especially the theological, exegetical, and apologetic works. See also Hendrikus Berkhof, *Die Theologie des Eusebius von Caesarea* (Amsterdam, 1939); Jean Sirinelli, *Les vues historiques d'Eusèbe de Césarée durant la période prénicéenne* (Paris, 1961); Friedhelm Winkelmann, *Euseb von Kaisareia: Der Vater der Kirchengeschichte* (Berlin, 1991); and Édouard des Places, *Eusèbe de Césarée, commentateur: Platonisme et écriture sainte* (Paris, 1982). The works of Eusebius are collected in *Eusebii pamphili Caesareae Palestinae Episcopi, opera omnia quae exstant*, in Migne, *Patrologia Graeca* (Turnholt, 1857), vols. 20–22. On the times of Eusebius, see Momigliano, *On Pagans, Jews, and Christians*, passim.

66. Eusebius, *The Ecclesiastical History*, II.iv and IV.vii.

67. "Mosem vero quis est qui pro merito laudare possit? . . . Pythagoras certe sapientiam ejus oemulatus, modestiae causa tantopere celebratus est, ut Plato vir modestissimus, abstinentiam illius velut exemplum sibi ad imitandum proponeret." This passage is from Eusebius, *Constantini imperatoris oratio quam inscripsit "Ad Sanctorum Coetum,"* XVII (Latin trans. Migne, *Patrologia Graeca*, 20[2], sec. 590).

68. Eusebius, *Contra Hieroclem*, XII (sec. 520 Migne), XIII (sec. 521 Migne), XVI (sec. 522 Migne), XLIV (sec. 540 Migne), XLV (sec. 542 Migne), and XLVI (sec. 544 Migne).

69. On this see Mosshammer, *Chronicle of Eusebius and Greek Chronographic Tradition*, esp. 282–83; cf. with ibid., 122, 278, 283–89. Mosshammer has attempted to reconstruct the original Greek text of this work.

70. The setting is described in two excellent studies: Arnaldo Momigliano, *The Conflict between Paganism and Christianity in the Fourth Century* (Oxford, 1963), esp. 88–95; and Wayne Meeks, *The First Urban Christians* (New Haven, 1983). See also Rebecca Lyman, *Christology and Cosmology: Models of Divine Activity in Origen, Eusebius, and Athanasius* (Oxford, 1993), esp. 82–124; Richard N. Longenecker, *The Christology of Early Jewish Christianity* (Naperville, IL), 1970. On the relationship of Christian writers to pagan sources and the shaping of Christianity by the assimilation of pagan practices, see Ramsay MacMullen, *Christianity and Paganism in the Fourth to Eighth Centuries* (New Haven, 1997). The literature on syncretism and mystery religions of this time is vast. See, e.g., Cumont, *Les religions orientales dans le paganisme romain*; Fracassini, *Il misticismo Greco*; Richard Reitzenstein, *Die Hellenistischen Mysterienreligionen*, 3rd. rev. ed. (1910; Darmstadt, 1977); Jean Doresse, *The Secret Books of the Egyptian Gnostics: An Introduction to the Gnostic Coptic Manuscripts Discovered at Chenoboskion* (London, 1960); and Geffcken, *Last Days of Greco-Roman Paganism*.

71. See Philip, "Biographical Tradition," which compares these points of view, es-

pecially that of Porphyry with that of Iamblichus, and offers sensible conclusions. Cf. Lévy, *Recherches sur les sources de la légende de Pythagore*; and idem, *Légende de Pythagore de Grèce en Palestine*. Lévy suggests that the history of Pythagoras was replaced by the myth of Pythagoras, and that its hero came to be a Hebraic-Christian ideal.

72. On Saint Jerome see his autobiography, the last entry in his *De viris illustribus* before the continuation of Gennadius begins, in Jerome, *Hieronymus liber de viris inlustribus*, 55–56. On his legacy in medieval and Renaissance times, see Eugene F. Rice, *Saint Jerome in the Renaissance* (Baltimore, 1985).

73. Saint Jerome, letters LII and LX; translation of a passage from the latter is by F. A. Wright, *Select Letters of Saint Jerome*, ed. F. A. Wright (London and New York, 1933), 273.

74. Saint Jerome, letter CVII.

75. Decimus Magnus Ausonius, *Letter to Herculanus, My Nephew, Grammarian of Bordeaux*, in *Ausonius*, ed. Hugh G. Evelyn White (London and New York, 1919), 117.

76. Ausonius, *The Eclogues*, in *Ausonius*, 167.

77. From the vast bibliography on Saint Augustine of Hippo, a few relevant works may be cited here. On Saint Augustine's relation to Platonic thinking and traditions (which would have included Pythagoras), see M. F. Sciacca, *Saint Augustin et le néoplatonisme* (Louvain and Paris, 1956); Henri I. Marrou, *Saint Augustin e la fin de la culture antique* (Paris, 1958); John J. O'Meara, "Augustine and Neo-Platonism," *Recherches augustiniennes* 1 (1958): 91–111; and Peter Brown, *Augustine of Hippo* (Berkeley and London, 1967). The chronology of his writings has been the subject of several studies; on this see esp. Max Wundt, "Zur Chronologie augustinischer Schriften," *Zeitschrift für neutestamentliche Wissenschaft und die Kunde der älteren Kirche* 21 (1922): 128–35. Saint Augustine frequently uses number symbolism to express religious concepts. Beyond the obvious example of the Trinity are his discussions of the "perfection" of the number six and the meaning and use of the number seven in *De civitate Dei*, XI.30 and 31.

78. On the soul see esp. Augustine, *De civitate Dei*, XIII.2, 8–13, 17, and 23.

79. The works of Augustine are collected in *Sancti aurelii Augustini hipponensis episcopi opera omnia*, in *Patrologia Latina*, ed. J.-P. Migne (Paris, 1886–1900), vols. 32–47; *De civitate Dei* is in vol. 41. Augustine's references to Pythagoras occur in VI.5, VII.35, VIII.2, XVIII.26, VIII.4, VIII.10, XVIII.37 (in the order discussed).

80. For the complete *De Trinitate*, see *De Trinitate libri Quindecim*, in Migne, *Patrologia Latina*, 42:819–1098. See also a later edition (with bibliography) in *De Trinitate libri XV*, ed. W. J. Mountain (Turnholt, 1968). The passages referred to here are, respectively, XIV.l and XII.15.

81. The reader is referred to a modern edition of this work in *Orosio: Le storie contro i pagani* [Latin and Italian], 2 vols., ed. Adolf Lippold, trans. Aldo Bartalucci (Milan, 1976). On the close friendship between teacher and pupil notwithstanding the more negative ideas of Orosius toward the classical past, see Theodor E. Mommsen, "Orosius and Augustine," in *Medieval and Renaissance Studies*, ed. Eugene F. Rice Jr. (Ithaca, 1959), 325–48.

82. The nationality of this early fifth-century polymath (who may have been a Christian, though if so not a devout one) has not been firmly established. He appears more comfortable using Latin than Greek, and he does not share the mystical outlook typical of Syrians in his day; many scholars believe that his devotion to the persistence of paganism suggests that he was closely connected to the classical world of the West.

The Macrobius writings have been tentatively attributed to two contemporary figures with the same name: a prefect in Spain and (rather more plausibly) a proconsul in Africa. On this see esp. William Harris Stahl, introduction to *Macrobius: Commentary on the Dream of Scipio*, ed. W. H. Stahl (1952; reprint, New York, 1990), 3–9; and Alan Cameron, "The Date and Identity of Macrobius," *Journal of Roman Studies* 56 (1966): 25–38. The latter strongly suggests that, on the basis of literary evidence, Macrobius was active between 390 and 426.

83. Regarding manuscript editions and early printed editions of the *Commentary*, see Stahl, *Macrobius: Commentary on the Dream*, 59–63. See also Albrecht Hüttig, *Macrobius im Mittelalter* (Frankfurt, 1990).

84. For a complete edition of this work, see *Macrobii Ambrosii Theodosii Commentari in Ciceronis Somnium Scipionis*, vol. 1, ed. Ludovicus Ianus (Quedlinburg and Leipzig, 1848); or *Macrobio, Commento al Somnium Scipionis* [Latin and Italian texts], 2 vols., ed. and trans. Mario Regali (Pisa, 1983). For the cited passages, see I.ii,21; vi, 4l; xii, 3; xiv, 19; II.i.8–15; and xvii, 8.

85. For an edition of the *Saturnalia*, see *Ambrosii Theodosii Macrobii, Macrobivs Conviviorvm Primi diei satvrnaliorvm*, ed. Franciscvs Eyssenhardt (Leipzig, 1893). An English edition exists in Macrobius, *The Saturnalia*, trans. and ed. Percival Vaughan Davies (New York and London, 1969). The passage referred to in the text is in I.13.5 (regarding the length of the year).

86. An excellent discussion of Iohannes Stobaeus is contained in Otto Hense, "Ioannes Stobaeus," in *Paulys Real-Encyclopädie der classischen Altertumswissenschaft* (Stuttgart, 1916), 9:2549–86. See the critical Stobaean texts in *Ioannis Stobaei Anthologium*, 5 vols., ed. Cvrtivs Wachsmvth and Otto Hense (Berlin, 1884–1912).

87. Trans. Vincent L. Wimbush in *Ascetic Behavior in Greco-Roman Antiquity*, ed. V. L. Wimbush (Minneapolis, 1990), 172 (no. 11) and 173 (no. 26). Concerning the virtue of *enkrateia*, or the practice of continence or self-restraint to control the passions of the body, see Aristotle, *Ethics*, VII, passim, esp. 1146a–b.

88. On the naming of numbers by Pythagoras, see Stobaeus, *Anthology*, in *Ioannis Stobaei Anthologium*, I.l.10.

89. One of the "verses" refers to the command to have reverence for the oath (on the *tetraktys*), while another refers to swearing on the quaternary (the *tetraktys*). For the discussion by Diogenes Laertius about the writings of Pythagoras that were known to him, see *Lives and Opinions of Eminent Philosophers*, VIII.1.5 and 6–7 (cf. preceding note).

90. Armand DeLatte, in *Études sur la littérature pythagoricienne* (Paris, 1915), 44–79, considers these "verses" to be a compilation from the mid third to early fourth century by an anonymous author who used old fragments, or perhaps a copy of *The Mystical Discourse* then attributed to Pythagoras. Or, he suggests, the maxims could have been transmitted orally at first and subsequently put in writing, in which case they could have been considered to go back to Pythagoras. (Cf. the following note.) In an excellent study of the School of Alexandria and the sources of the influences on Hierocles of Alexandria, Noël Aujoulat suggests that Hierocles may have felt the influence of Christianity, which may have tempered the mysticism of Iamblichus; he also suggests that his friendship with Ammonios Sakkas, a Pythagorean with whom he studied, may have helped him to obtain this information, which was thought to have been conserved by the disciples of Pythagoras (Noël Aujoulat, *Le néo-Platonisme Alexandrin: Hiéroclès d'Alexandrie* [Leiden, 1986], passim). On Hierocles see also Theo Kobusch, *Studien zur Philosophie des Hierokles von Alexandrien* (Munich, 1976). The "Golden

Verses" and Hierocles' commentary on them exist in several modern annotated editions, including *Les vers d'or: Hiéroclès. Commentarie sur les vers d'or des Pythagoriciens*, ed. Mario Meunier (Paris, 1931); *Hieroclis in aureum Pythagoreorem carmina*, ed. Friedrich G. A. Mullach (Hildesheim, 1971); and Hieroclis in *Avrevm Pythagoreorvm Carmen Commentarivs*, ed. Friederich W. Koehler (Stuttgart, 1974). Regarding Hierocles' understanding that Pythagoras is the inventor of the *tetraktys*, see *Hieroclis Philosophi commentarius in aurea Pythagoreorum carmina*, ed. Joan Curterio (London, 1654), 216–24.

91. William H. Stahl, *Martianus Capella and the Seven Liberal Arts*, vol. 2 (New York, 1977–91), contains (in English translation by Stahl and Richard Johnson) the *De nuptiis philologiae et mercurii*. For the original text, see Martianus Capella, *De nuptiis philologiae et mercurii*, ed. Franciscus Eyssenhardt (Leipzig, 1866).

92. Although this entire work, which "explains" the numerical magic of the Seven Liberal Arts and its relation to the trivium and quadrivium (3 + 4 = 7), may be considered to reflect the ideas of Pythagoras as previously expounded by Nicomachus, Iamblichus, and others, the parts in which Pythagoras is included as an actor include the following: II.106, 125; VII.728–31; VIII.803 and 882.

93. On this important but difficult author and his didactic fantasy, see Stahl, *Martianus Capella and the Seven Liberal Arts*, vol. 1.

94. On Proclus Diadochus, see Laurence J. Rosán, *The Philosophy of Proclus: The Final Phase of Ancient Thought* (New York, 1949); the introduction to Proclus, *Théologie platonicienne*, 6 vols., ed. H. D. Saffrey and L. G. Westerink (Paris, 1968–97), 1:i–cxcii, which is especially informative on Academy of Athens in the fourth and early fifth centuries; Annick Charles-Saget, *L'architecture du divin: Mathematique et philosophie chez Plotin et Proclus* (Paris, 1982); and Dominic J. O'Meara, *Pythagoras Revived*, 142–230. Among the extant works by this voluminous author are scientific works as well as works of prose and poetry, including *Platonic Theology, Elements of Theology, Elements of Physics, Commentary on the Timaeus, Commentaries on Euclid, Nicomachus, and Ptolemy, Outline of Astronomical Theories*, and *Hymns* (one of which is "Hymn to the Sun"). For his earliest biography, by his disciple Marinus of Samaria, written in about 486, the year after his death, see Marinus of Samaria, *Marini vita procli*, ed. J. F. Boissonade (Leipzig, 1814). On the influence of Proclus, which was important in medieval, and especially Renaissance, times, see G. Boss and G. Seel, eds., *Proclus et son influence* (Zurich, 1987).

95. For these and other details of the life of Proclus, and including reports of the miracles associated with his birth and life as well as the portents that foretold his death, see Marinus of Samaria, *Marini vita procli*, esp. 20–53.

96. See Proclus, *Platonic Theology*, esp. I.4–5, and 24–26.

97. Dominic J. O'Meara, *Pythagoras Revived*, esp. 147–48, 152–53.

98. Ibid., 149. See also Leendert Westerink, "Proclus commentateur des Vers d'or?" in Boss and Seal, *Proclus et son influence*, 61–78.

99. Although Boethius is not a source of new biographical information on Pythagoras, nonetheless his approach reflects the critical fortune of Pythagoras in the early fifth century. On Boethius and his approach, see Oscar Paul, *Boetius und die griechische harmonik* (Leipzig, 1872); and Edmund Reiss, *Boethius* (Boston, 1982). The major importance of Boethius lies in the fact that his works established a tradition that persisted through the Middle Ages and into the Renaissance. On this see the fundamental work of Howard R. Patch, *The Tradition of Boethius: A Study of his Importance in Medieval Culture* (1935; New York, 1970). See also Boethius, *The Consolations of Music, Logic, Theology, and Philosophy*, ed. Henry Chadwick (Oxford, 1981).

100. Boethius, *De institutione arithmetica*, I.1. For text, see *Institution arithmé-tique* [French and Latin texts], ed. Jean-Yves Guillaumin (Paris, 1995).

101. Boethius, *De institutione arithmetica*, II.41.

102. Ibid., II.40–54.

103. Boethius, *De institutione musica*, I.1. A different version of the first incident was reported in Iamblichus, *Vita Pythagorica*, 25. Although the "Phrygian" mode was one that induced excitement, the Greek word *spondeios* refers to ceremonious songs that were sung at libations. Technically, it signifies two sustained measures. Such a pair of long beats, or a heavy double beat, was considered a soothing rhythm, as Quintilian informs us in the first century AD (*Institutio oratoria*, I.x.32). Boethius tells us that Pythagoras used this "beat" to accomplish a curative (or balancing) purpose or, in other words, to alter mental states.

104. Boethius, *The Consolation of Philosophy*, I.141–43. For Latin text see *Boethii philosophiae consolationis libri quinque*, ed. Guilelmus Weinberger, Corpus Scripto-rum Ecclesiasticorum Latinorum 67 (Leipzig, 1934). Aristoxenus's description of Pythagorean concepts (including "Follow God") is discussed in chap. 5.

105. On the closing of the Platonic Academy at Athens in 529 by Justinian, see Alan Cameron, "The Last Days of the Academy at Athens," *Proceedings of the Cam-bridge Philological Society*, n. s., 15 (1969): 7–29; Johannes Glucker, *Antiochus and the Late Academy* (Göttingen, 1978); and Polymnia Athanassiadi, "Persecution and Response in Late Paganism," *Journal of Hellenic Studies* 113 (1993): 1–29.

Chapter 4. Pythagoras in Medieval Memory

1. Regarding the Alexandrian school in late Antiquity, see the introduction to *Olympiodorus, Commentary on Plato's Gorgias*, ed. Robin Jackson, Kimon Lycos, and Harold Tarrant (Leiden, 1998), esp. 5–15. On Olympiodorus of Alexandria (some-times called the Younger, to distinguish him from the fifth-century alchemist Olympi-odorus of Thebes), see Friedrich Ueberwegs, *Grundriss der Geschichte der Philosophie*, ed. Carl Praechter (Basel, 1953), 1:637 and passim.

2. The literature on the legacy of these pagan authors is vast. The work of Simplicius is studied in Ilsetraut Hadot, ed., *Simplicius, Sa vie, son oeuvre, sa survie* (Berlin and New York, 1987). See esp. Simplicius's *Commentary on Aristotle's Categories*, in Simplicius of Cilicia, *Commentaire sur les catégories*, ed. I. Hadot (Leiden, 1990). On the great library at Alexandria, which, although it was partially destroyed during the invasion of Julius Caesar in 48 BC and sacked by Caracalla in the third century AD, was to survive until its ultimate destruction in the seventh century; see Roy Macleod, ed., *The Library of Alexandria* (London and New York, 2002). See also Jackson, Lycos, and Tarrant, *Olym-piodorus, Commentary*. On the production of early Christian texts, see Harry Y. Gam-ble, *Books and Readers in the Early Church: A History of Early Christian Texts* (New Haven and London, 1995). See also Dominic J. O'Meara, *Pythagoras Revived*, passim; Leighton D. Reynolds and Nigel G. Wilson, *Scribes and Scholars: A Guide to the Trans-mission of Greek and Latin Literature* (Oxford, 1991), 1–122, esp. 99–101 (regarding the monastic collections such as those at Richenau and St. Gall and that at Bobbio).

3. On the survival of Aristotelian texts in the Middle Ages, see Amable Jourdain, *Recherches critiques sur l'âge et l'origine des traductions latines d'Aristote et sur les commentaires grecs ou arabes employés par les docteurs scolastiques*, 2nd ed. (1843; New York, 1960); also Fernand Van Steenberghen, *Aristotle in the West: The Origins of Latin Aristotelianism*, trans. L. Johnson (Louvain 1955); and *Pseudo-Aristotle, The Se-cret of Secrets: Sources and Influences*, ed. Charles B. Schmitt and W. F. Ryand (London,

1982). On the influence of Plato in the Middle Ages, see Raymond Klibansky, *The Continuity of the Platonic Tradition in the Middle Ages* (1939; Millwood, NY, 1982); James Hankins, "Plato in the Middle Ages," in *Dictionary of the Middle Ages* (New York, 1987), 9:694–704, for further bibliography; and Stephen Gersh, *The Platonic Tradition in the Middle Ages* (Berlin and New York, 2002). Regarding Plato's *Timaeus,* see Cicero, *M. Tvlli Ciceronis Timaevs,* ed. Franciscus Pini (Milan, 1965); Porphyry, *Porphyrii in Platonis Timaeum commentariorum fragmenta,* ed. A. R. Sodano (Naples, 1964); and Chalcidius, *Platonis Timaeus interprete Chalcidio cum eiusdem commentario,* ed. Iohannes Wrobel (Leipzig, 1876); also idem, *Timaeus a Calcicio translatus commentarioque instructus,* ed. J. H. Waszink (London and Leiden, 1962). See also Proclus's commentary on this work in *Commentaire sur le Timée,* ed. A. J. Festugière (Paris, 1966). Regarding medieval legends and popular cults pro and con Plato ("superb," and "impatient") and Aristotle ("perfect" and "son of the devil"), see Arturo Graf, *Roma nella memoria e nelle immaginazioni del Medio Evo* (Turin, 1923), esp. 508–20.

4. See Edward K. Rand, *Ovid and His Influence* (Boston, 1925); and Franco Munari, *Ovid im Mittelalter* (Zurich, 1960).

5. See W. Fortunat, *Étude sur un dernier représentant de la poésie latine dans la Gaule mérovingienne* (Paris, 1927). On medieval libraries, see esp. Theodor Gottlieb, *Mittelalterliche Bibliotheken* (Leipzig, 1890); George H. Putnam, *Books and Their Makers during the Middle Ages* (New York, 1896), vol. 1; Reynolds and Wilson, *Scribes and Scholars;* and Dominic J. O'Meara, ed., *Neoplatonism and Christian Thought* (Albany, 1982). On the organization of early medieval libraries, essentially rooms lined with cupboards or *armarii* that contained books, see J. O. Ward, "Alexandria and Its Medieval Legacy," in Macleod, *Library of Alexandria,* 163–79; and Gamble, *Books and Readers in the Early Church,* esp. 144–203.

6. On the influence of Macrobius for the Middle Ages, see esp. Hüttig, *Macrobius im Mittelalter;* also Pierre Paul Courcelle, "La posterité crétienne du 'Songe de Scipion,'" *Revue des Études Latines* 36 (1958): 205–34.

7. See Patch, *Tradition of Boethius;* and Boethius, *Consolations of Music, Logic, Theology and Philosophy* (ed. Chadwick). The strain of Provençal literature that regarded Boethius as a saint and martyr is discussed in Karl Utti, "Provençal Literature to 1200," in *Dictionary of the Middle Ages* (New York, 1988), 10:159–73. Other legends about Boethius are discussed in Graf, *Roma nella memoria,* 615–49.

8. Cassiodorus, *Cassiodori satoris institutiones,* II.iii (ed. R. A. B. Mynors [Oxford, 1937], 132–33). On this influential scholar, his dates, and his scriptorium, see Putnam, *Books and Their Makers,* esp. 22–27; James J. O'Donnell, *Cassiodorus* (Berkeley, Los Angeles, and London, 1979) (with bibliography); and Gamble, *Books and Readers in the Early Church,* 164–65, 198–201. For the surviving works of Cassiodorus, see Migne, *Patrologia Latina* (Paris, 1865), vols. 69–70.

9. On the library of Isidore, reputed to be the largest in seventh-century Europe, see Putnam, *Books and Their Makers,* 152–54. Isidore's sources are discussed in Jacques Fontaine, *Isidore de Seville et la culture classique dans l'Espagne Wisigothique,* 3 vols. (Paris, 1959), esp. vol. 1.

10. Isidore of Seville, *Etymologiae,* III.ii. The scientific writings of Apuleius are lost, although several mathematical and astronomical treatises are attributed to him.

11. For the relevant passages (in order of discussion), see Isidore of Seville, *Etymologiae,* I.iii.6, III.ii.1, III.xvi.1, VIII.vi.2–5 and 19–20, XIV.vi.31, and III.xxii.1–8. The full text is contained in *Sancti Isidori etymologiarum libri XX,* in Migne, *Patrologia Latina* (Paris, 1878), vol. 82. For an annotated edition, see *Isidori hispalensis episcopi etymologiarvm sive originvm libri XX,* 2 vols., ed. W. M. Lindsay (Oxford, 1911).

12. Little is known, however, about the many rare texts that survived in the Greek East before the time of Photius. As a result of his activity, a continuous tradition of classical studies developed in Byzantium. The literature on the importance of Constantinople as a literary center in early and middle Byzantine times is vast. Regarding scholars and copies of ancient texts made in early and middle Byzantine times, see Reynolds and Wilson, *Scribes and Scholars,* esp. 62–79. For a good general background, see Cyril Mango, *Byzantium: The Empire of New Rome* (London, 1980). Regarding texts, their writers, and readers, see Guglelmo Cavallo, ed., *Libri e lettori nel mondo bizantino* (Bari, 1982).

13. The entire text of Photius's major work is published in Photius, *Bibliothèque,* 9 vols., ed. René Henry (Paris, 1959–91); the text of the anonymous biography appears in vol. 7, no. 249. The Greek text was previously published in Otto Immisch, ed., *Agatharchidea* (Heidelberg, 1919), 27–36. An English translation can be found in K. S. Guthrie, *Pythagorean Sourcebook and Library,* 137–40.

14. Graf quotes the entire epitaph in *Roma nella memoria,* 501–2.

15. The passage is quoted ibid, 515–16.

16. For the Arabic text and translation, see Ibn at-Tayyib (d. 1043), *Proclus' Commentary on the Pythagorean Golden Verses* [Arabic text with translation], trans. Neil Linley (Buffalo, 1984).

17. See excerpts from this work (via a text by the Byzantine excerptor Michael Psellus), with translation, in Dominic J. O'Meara, *Pythagoras Revived,* appendix 1. See also the author's discussion at 230–31.

18. Thierry de Chartres, *Commentum super Boethii librum de Trinitate,* II.7; see Latin text in Thierry de Chartres, *Commentaries on Boethius by Thierry of Chartres and His School,* ed. Nikolaus Häring (Toronto, 1971), 70.

19. *Glosarum super Timaeum Platoni,* in William of Conches, *Glosae super Platonem,* ed. Édouard Jeauneau (Paris, 1965), 91.

20. William of Conches, *Liber de eodem secundus,* 14; see text in *La doctrine de la création dans l'École de Chartres,* ed. J. M. Parent (Ottawa, 1938), 210–11.

21. Hugh of St. Victor, *Didascalicon,* passim. See *The Didascalicon of Hugh of St. Victor,* ed. Jerome Taylor (New York and London, 1961).

22. On the decline of Church schools and the rise of communal schools, see Paul F. Grendler, *Schooling in Renaissance Italy: Literacy and Learning, 1300–1600* (Baltimore and London, 1989).

23. Dante, *Convivio,* II.xiii.

24. Ibid., II.xv.

25. Ibid., III.v and xi.

26. Ibid., IV.i and xxi.

27. Dante, *De monarchia,* I.xv; and *Eclogue* I (response, l. 34).

28. Cicero and Valerius Maximus mentioned having visited the house of Pythagoras at Metapontum. As discussed in chapter 3, Diogenes Laertius was the earliest source to tell us that Pythagoras's house had (in his time) been converted into a full-fledged temple. Burley's use of the word *temple* suggests that he may have been acquainted with the writings of Diogenes Laertius—possibly through a Latin manuscript translation—well before their "rediscovery" in early fifteenth-century Italy. On Burley, see Connor Martin, "Walter Burley," in *Oxford Studies Presented to Daniel Callus* (Oxford, 1964), 194–230; and Augustin Uña-Juarez, *La filosofia del siglo XIV: Contexto cultural de Walter Burley* (Madrid, 1978). A review of Burley's text (see next note) does not support the contention of Herbert S. Long, in his introduction to Diogenes Laertius, *Lives of Eminent Philosophers,* rev. ed., trans. R. D. Hicks (1925; Cambridge, MA, 1972), that Burley drew on Diogenes Laertius "extensively."

29. For printed editions of this work, see Gualterus Burlaeus, *De vita et moribus philosophorum e poetarum,* ed. Arnold ter Hoernen (Cologne, 1472); idem, *De vita e moribus philosophorum e poetarum,* ed. Johannem de Westfalia (Louvain, 1479); and idem, *Vita omnium philosophorum e poetarum* (Paris, 1500). In all editions, the vita of Pythagoras is no. 17. The extensive manuscript tradition of this work was studied by John O. Stigall, "The Manuscript Tradition of the *De vita et moribus philosophorum e poetarum* of Walter Burley," *Medievalia et Humanistica* 2 (1957): 44–57.

30. Petrarch, *On His Own Ignorance,* trans. in *The Renaissance Philosophy of Man,* ed. Ernst Cassirer, Paul Oskar Kristeller, and John Hermann Randall Jr. (Chicago, 1948), 94. For the passage in Chalcidius, see his *Platonis Timaeus interprete Chalcidio,* xiii.295.

31. Petrarch, *Trionfo della fama,* III.8–9; and idem, *De viris illustribus,* II.12–13.

32. See *Epistolae metricae,* 3, 32, in *Petrarchae poëmata minora* (Milan, 1831), 2:150, 12–13; see also Theodor E. Mommsen, "Petrarch and the Story of the Choice of Hercules" in Mommsen, *Medieval and Renaissance Studies,* ed. Eugene F. Rice (Ithaca, 1959), 188.

33. Petrarch, *Familiarium rerum libri,* III.12.5, VII.17.1, and XII.3.6. On this subject see the comments of Mommsen in "Petrarch and the Story of the Choice of Hercules," 186–89.

34. Petrarch, *De vita solitaria,* ed. Jacob Zeitlin (Westport, CT, 1978), 286.

35. Petrarch, *Familiarium rerum libri,* I.2.6, IV.3.6, and IX.13.13.

36. Ibid., X.3.8–9; quoted passage translated by Carolyn P. Tuttle.

37. Ibid., XIII.12.2–3, XVII.1.38 and 8.5, and XXIV.12.9.

38. Petrarch, *Itinerarium de Janua usque in Hierusalem et Alexandriam,* 13. See original text in Petrarch, *Viaggio in Terrasanta,* ed. Antonio Altamura (Naples, 1979), 75.

39. On Marchettus of Padua, see Nancy G. Siraisi, *Arts and Sciences at Padua: The Studium of Padua before 1350* (Toronto, 1973), 100–103.

40. Guillaume de Lorris and Jean De Meun, eds., *The Romance of the Rose,* 3rd ed., trans. Charles Dahlberg (Princeton, 1995), 105.

41. One of the major theses in Paolo Casini, *L'antica sapienza italica: Cronistoria di un mito* (Bologna, 1998), is that the image of Pythagoras took on new forms in medieval times. Although this may be true of Pythagoreanism and of the ways in which Pythagoras was portrayed (as will be seen in chap. 11), it does not appear to be true in the case of the reputation of Pythagoras.

42. The literature on the occult sciences in the Middle Ages is vast. Although these practitioners were not necessarily Pythagoreans, the texts they consulted frequently cited Pythagoras as an authority in the particular field. See, e.g., Paul Tannery, "L'introduction de la géomancie en Occident," in *Mémoires scientifiques: IV. Sciences exacts chez les byzantins,* ed. Johann Ludwig Heiberg (Toulouse and Paris, 1920), 318–33. The connection of so eminent a scholar as Albertus Magnus with such practices is discussed in Lynn Thorndike, *A History of Magic and Experimental Science* (New York, 1929), 2:118.

Chapter 5. Pythagoreanism in Greek and Roman Antiquity

1. The first modern comprehensive study of Pythagorean philosophy was that of Anthelme E. Chaignet, *Pythagore et la philosophie pythagoricienne,* 2 vols. (Paris, 1873), which attempted to reconstruct Pythagorean doctrine. Shortly thereafter Eduard Zeller published his seminal work on Greek philosophy, of which a substantial section was dedicated to reconstructing the Pythagorean movement through consideration of

materials that are eminently philosophical (*Die Philosophie der Griechen*, 1:254–463). Among the most important subsequent works is a series of research essays published in 1881 by François Lenormant, "Tarente," and "Metaponte," in *La grande Grèce*, 1:1–115 and 115–63, respectively, and "Crotone et le Pythagorisme," ibid., 2:1–103 (a brilliant trilogy of basic studies that defines Pythagorean thought as an underlying unity, born in southern Italy, that incorporates various intellectual ideas and modes of behavior); Burnet, *Early Greek Philosophy* (1892 ed.) (which distinguished between various components of Pythagorean thought, including aspects of mathematics and primitive religion); Diels-Kranz, *Fragmente der Vorsokratiker* (1903 ed.) (a monumental accomplishment that brought together in an orderly way ancient testimony and quotations that helped to establish a body of work for the pre-Socratic philosophers, many of whom were connected with Pythagoreanism); Paul Tannery, "Sur l'arithmétique pythagoricienne," *Bulletin des Sciences Mathématiques* 9 (1885): 69–88, and in a series of studies in *Mémoires scientifiques: I. Sciences exactes dans l'Antiquité*, ed. Johann Ludwig Heiberg (Toulouse and Paris, 1912), was the first to study seriously Greek arithmeticians, whom he connected with Pythagoras; Heath, *Aristarchus of Samos* (which attempted to describe the astronomical system of the Pythagoreans); Augusto Rostagni, "La vita e l'opera di Pitagora secondo Timeo," *Atti dell'Accademia di Scienze di Torino* 40 (1914): 373–95 (which attempted to lay the chronological foundations of the life of Pythagoras); DeLatte, *Études sur la littérature pythagoricienne*; and idem, *Essai sur la politique pythagoricienne* (Paris, 1922) (these two important studies proposed that Pythagoreanism was so broadly conceived and broadly dispersed that its ingredients formed a heterogeneous mix that lacked unity).

These works were followed by a period of attention (from the 1920s to the 1950s) to the religious component and eastern connections of Pythagoreanism, primarily in the various works of Franz Cumont, many of which have been cited in earlier chapters of this volume. In addition, the works of Isidore Lévy and Jérôme Carcopino (also cited above) focused on these interesting aspects of Pythagoreanism. The most active period of interest in the scholarship of Pythagoreanism was in the 1960s, and most of this interest focused on philosophy. These works include the following: Thesleff, *Pythagorean Writings of the Hellenistic Period* (1961), and *Pythagorean Texts of the Hellenistic Period* (1965) (works that provided a distinctly scholarly approach to the study of a group of philosophical texts); Walter Burkert, *Weisheit und Wissenshaft: Studien zu Pythagoras, Philolaos und Platon,* translated as *Lore and Science in Ancient Pythagoreanism* (which considers astronomy, musical theory, and number theory in the setting of primitive religion and early science, attributing the beginnings of these "disciplines" to Philolaus), was first issued in 1962; W. K. C. Guthrie, *History of Greek Philosophy* (1962) (an excellent and lucid study of earlier Pythagorean philosophy from the point of view of the history of religion, which, however, takes little account of other Pythagorean "strands"); and de Vogel, *Pythagoras and Early Pythagoreanism* (1966) (a scholarly work that discusses the early philosophical writers and their relation to Pythagoras); and Philip, *Pythagoras and Early Pythagoreanism* (1966) (a study that focuses on certain issues considered to be Pythagorean: cosmology, number, and harmony of the spheres). The 1970s saw one important work that considered Pythagoreanism in a very different way: Hersey, *Pythagorean Palaces* (1976), made the bold suggestion that certain early Renaissance architects were fascinated by Pythagoreanism. In more recent years there has appeared Barnes, *Early Greek Philosophy* (1987) (which contains a brief and readable summary of the thought of pre-Socratic philosophers, including Pythagoreans, together with numerous extracts); and K. S. Guthrie, *Pythagorean Sourcebook and Library*. This latter compendium, together with its useful

foreword by Joscelyn Godwin and introduction by David Fideler, attempted to define Pythagorean philosophy in readable terms supported by extracts from the works of ancient authors in English translation. Two years later Dominic J. O'Meara published a work of fundamental importance, focusing on Pythagorean arithmetic and geometry in late Antiquity, *Pythagoras Revived: Mathematics and Philosophy in Late Antiquity* (1989). The year 1999 saw the publication of Charles H. Kahn, *Pythagoras and the Pythagoreans: A Brief History* (Indianapolis, 1999), a small volume that offers only a summary survey of Pythagorean philosophy from Philolaus to Kepler. Pedro Miguel González Urbaneja's *Pitágoras: El filósofo del número* (Madrid, 2001) is more useful as an explanation of the types of mathematics associated with Pythagoras than it is as a biography or as a discussion of Pythagoras in the history of art, both of which contain defects. Most recently, Christoph Riedweg, *Pythagoras: His Life, Teaching, and Influence,* trans. Steven Rendall (2002; Ithaca, 2005), relying on a medley of later biographies, assumes that Pythagoras lived for eighty years from about 570 to 480 BC. It offers a concise reconstruction of the philosophical world of the early Pythagorean societies and their development into Hellenistic times.

2. See, e.g., the catalogue of all the members of the early Pythagorean "school" (based on Iamblichus), followed by Pythagoreans cited in later sources, such as Aristotle, as constructed in Diels-Kranz, *Fragmente der Vorsokratiker,* 1:446–78.

3. See Plutarch, *On Music,* 1132–33 and 1136.

4. Important ancient sources on the lyre, including fragments and works by Aristoxenus, Euclid, Nicomachus, Alypius, Gaudentius, Bacchius, Aristide Quintilianus, and Martianus Capella, are contained in Plutarch, *On Music,* and esp. in *Antiquae musicae auctores septem,* ed. Marcus Meibom (Amsterdam, 1652). Among the numerous modern sources who discuss the history of this instrument are François Auguste Gevaert, *Histoire et théorie de la musique de l'antiquité* (Ghent, 1875–81); Karl von Jan, *Die griechischen Saiteninstrumente* (Leipzig, 1882); Théodore Reinach, *La musique grecque* (Paris, 1894); Gabrielle Battaglia, "Lira," in *Enciclopedia italiana* (Rome, 1934), 21:249–50; James F. Mountford and Reginald P. Winnington-Ingram, "Music in Greek Life," in *The Oxford Classical Dictionary,* ed. N. G. L. Hammond et al. (Oxford, 1972), 705–13; and Solon Michaelides, *The Music of Ancient Greece* (London, 1978). On the development of the number of strings, see esp. Battaglia, "Lira."

5. Sappho mentions the lyre in her own poetry. On the Aeolian lyre, see Plutarch (who has consulted an older authority, Duris of Samos), *On Music,* 1133; and Horace, *Odes,* I.i.34, who refers to the "lesbian lyre." In *Odes,* II.xiii.25, Horace describes the Aeolian lyre as Sappho's instrument.

6. Menander, frag. 312. This fragment is from a lost play, possibly called the "Lady of Leucas." For this fragment see *Menander, the Principal Fragments,* ed. Francis G. Allinson (London and New York, 1930), 1:401–3.

7. Ovid, *Heroides,* XV.164–65 (trans. and ed. Grant Showerman [Cambridge, MA, and London, 1947], 193).

8. Ibid., XV.178–84 (trans. Showerman).

9. The remains of the Temple of Apollo still survive. For Strabo's description, see his *Geography,* X.2.8–9. On the immortality signified by this place, see E. Janssens, "Leucade et le pays des morts," *Antiquité Classique* 30, no. 2 (1961): 381–94.

10. Carcopino, *De Pythagore aux Apôtres,* 9–81. On Sappho's love for Apollo, see also Pierre Boyancé, "Leucas," *Revue Archéologique* 3 (1929): 211–19.

11. Douglas E. Gerber, ed. and trans., *Greek Elegiac Poetry from the Seventh to the Fifth Centuries* BC (Cambridge, MA, and London, 1999), 83.

12. David A. Campbell, ed. and trans., *Greek Lyric* (Cambridge, MA, and London, 1991), 3:417.

13. Trans. Campbell; ibid., 1:99. Regarding the idea of astral immortality, which involved people becoming stars after death, see Burkert, *Lore and Science in Ancient Pythagoreanism,* 1:359–63.

14. *The Love Songs of Sappho,* trans. Paul Roche (Amherst, NY, 1998), 127. The attribution to Sappho of these lines and those in the next two translations is not unanimously accepted, but even if the words are (as some believe) paraphrases by early commentators, they appear to represent Sappho's own sentiments.

15. Ibid., 104.

16. Aristotle, *Rhetoric,* 1398b (trans. Campbell, *Greek Lyric,* 1:99).

17. Pliny the Elder, *Historia naturalis,* XXII.ix.20–21.

18. On the evidence for the life and activities of Hippasus of Metapontum, see the brief vita of Diogenes Laertius (*Lives and Opinions of Eminent Philosophers,* VIII.6). For information on the traditions associated with him, see Zeller, *Die Philosophie der Griechen,* 1:456–63; Diels-Kranz, *Fragmente der Vorsokratiker,* 1:107–10 (which offers a collection of references from Diogenes Laertius, Iamblichus, Apollonius, and others); Thesleff, *Pythagorean Texts of the Hellenistic Period,* 91–93; and esp. Philip, *Pythagoras and Early Pythagoreanism,* 26–32. For Iamblichus's rather romantic interpretation of Hippasus, see *Vita Pythagorica,* 18 and 34.

19. See the statement of Iamblichus in *Vita Pythagorica,* 36. On Aristeas of Proconnesus, see James D. P. Bolton, *Aristeas of Proconnensus* (Oxford, 1962); also Eric R. Dodds, *The Greeks and the Irrational* (1951; Boston, 1957), 143–44.

20. See, e.g., Pindar, *Isthmian Odes,* II.17–18; and idem, *Olympian Odes,* II.12–15. Regarding Apollo as the god of the sun and of light and his direction of celestial phenomena, see Stefos Anastase, *Apollon dan Pindare* (Athens, 1975), esp. 258–59. On Apollo in Pindar's work, see also Maurice Bowra, *Pindar* (Oxford, 1964), passim.

21. On the meaning of the name Apollo, see Plato, *Cratylus,* 404E–406C. Subsequently, Plutarch explained that the name means "denying the many," or "unity." Thus, Plutarch held, Apollo and the sun are the same, an argument that would be taken up by Plotinus and other Pythagoreans. See Plutarch, *The E at Delphi,* 393C and 394A, where he defines the name as meaning the abjuration of multiplicity and symbolizing one and one alone or unity pure and simple. See also idem, *Isis and Osiris,* 381F; and Plotinus, *Fifth Ennead,* V, where Plotinus discusses the Pythagorean concept of Apollo as meaning the negation of plurality or the repudiation of the multiple. True unity, Plotinus argues, has a pure divine nature and is not composed of accidents or multiplicities.

22. Pindar describes Apollo as shining down over man in many places. See, e.g., *Olympian Odes,* VII.55–78; *Pythian Odes,* IV.55–56; and *Paean,* VI and IX.

23. Zeus, the great thunderbolt, begins to become drowsy (when listening to the music of the golden lyre of Apollo) and eventually falls asleep. Thus is the stern god of war soothed by the grace of Apollo (and the Muses). See Pindar, *Pythian Odes,* I.8–13.

24. The order evoked by the power of music is set forth in the opening phrases of this ode, when harmony and peace prevail. This passage, in the first *Pythian Ode* (esp. ll. 1–5), provides a stunning contrast to the chaos and horror described later.

25. Pindar, *Pythian Odes* I, passim.

26. On the birth of Apollo see Hesiod, *Works and Days,* 770–71. Regarding this tradition and the important role of the number seven in the mythology of Apollo, see Anastase, *Apollon dan Pindare,* 21 and 256.

27. Aeschylus, *The Seven against Thebes,* 800–801.

28. Plutarch, *The E at Delphi,* 391F.

29. Pindar, *Pythian Odes,* II.70–71; and idem, *Nemean Odes,* V.23–25. On Apollo's gift to the dying, see Anastase, *Apollon dan Pindare,* 259.

30. In *Paean,* VI, Pindar describes Apollo's shrine at Delphi as his own spiritual home. Indeed Pausanias underlines the time Pindar spent there when he describes a famous relic he saw near the hearth of the temple—the very chair in which Pindar sat while composing his songs to Apollo (Pausanias, *Description of Greece,* IX.17.2 and 23.3). On Pythagoras's visit to this shrine, see Porphyry, *Life of Pythagoras,* 16.

31. See frag. 205 ("The Birth of Pindar"). Regarding Pindar's record of his birth and the Pythian Festival at Delphi with which it coincided, see John Sandys, introduction to *The Odes of Pindar including the Principal Fragments,* ed. J. Sandys (London and New York, 1919), vii. The naming of Pythagoras was described by Diogenes Laertius, relying on older sources, and Iamblichus, as discussed in chap. 3.

32. An example of Pindar's elated and triumphant notion of immortality can be found in *Olympian Odes,* II; also in the *Dirges,* where he describes the soul relieved of toil following the death of the body, and its glistening in the "super sunlight" for all time, as it begins its new life (*Dirges,* frags. 131–37). See also *Nemean Odes,* I.70, which describes the eternal tranquility that rewards the heroic life.

33. In *Platonic Questions,* 1007B, Plutarch explains that Pindar had the same point of view as Pythagoras. Also in the second century AD, Clement of Alexandria explains that like Pythagoras, Pindar had great respect for the sweetness of silence (*Stromateius,* I.x).

34. See fragments of Parmenides' major work preserved by the later Antique writers Sextus Empiricus, Simplicius, and Stobaeus, in Barnes, *Early Greek Philosophy,* 129–42 (quoted passage, trans. Barnes, is at 136). For the suggestion that Parmenides was lying, see ibid., 130.

35. Although Timaeus's work is lost, fragments are known through the works of other writers. See frag. 14 and discussion in Truesdell S. Brown, *Timaeus of Tauromenium* (Berkeley, 1958), 53. Cf. Diogenes Laertius, *Lives and Opinions of Eminent Philosophers,* VIII.2.53–54; and Iamblichus, *Vita Pythagorica,* 23.

36. For more on the "Pythagoreanism" of Empedocles, see Joseph Bidez, *La biographie d'Empédocle* (Paris, 1894); Ettore Bignone, *Empedocle: Studio critico* (Florence, 1916); W. K. C. Guthrie, *History of Greek Philosophy,* 1:266–67 and 2:122–265; and Kingsley, *Ancient Philosophy, Mystery, and Magic,* passim.

37. Empedocles, frags. B 112.4–5; B 21, 111, and 130; B 117, 126, 127, and 146; and B 89 and 109 (trans. Barnes, *Early Greek Philosophy*).

38. Empedocles, frags. B 17, 21, 26, 96, and 122 (trans. Barnes).

39. See Diogenes Laertius, *Lives and Opinions of Eminent Philosophers,* VIII.2.61. See also Empedocles, frags. B 111; B 40 and 134; B 114; and B 136, 137 (where he argues that as a result of transmigration of the soul, a person might unwittingly eat his own kin), and 139 (trans. Barnes, *Early Greek Philosophy*).

40. Empedocles' passion for the sun is evident in a number of his fragments. On the fire at the center of the earth as a source of sun-like light for Empedocles, see Kingsley, *Ancient Philosophy, Mystery, and Magic,* 49–68.

41. Cf. Diogenes Laertius, *Lives and Opinions of Eminent Philosophers,* VIII.1.41. See also Lucian, *Dialogues of the Dead,* 415–17.

42. See esp. "Sandals of Bronze and Thighs of Gold," in Kingsley, *Ancient Philosophy, Mystery, and Magic,* 289–316 (chap. 19). Kingsley's argument is potent: Empedocles was clearly a magician who considered the visualization of his own immortalization a fundamental prerequisite of the demonstration of his divinity. This visualization,

Kingsley points out, reflects older strata of the interplication of myth and folklore in ancient Greece, something that came to be obscure to future scholars.

43. Although he visited Samos, Herodotus shows no special interest, beyond his usual historian's curiosity, in Pythagoras. The dates of Herodotus's life are unknown, but on the basis of the events he reports he is presumed to have been born in the 480s BC and to have died before 420 BC. He has had many biographers, old and modern. See, e.g., Terrot R. Glover, *Herodotus* (London, 1924).

44. Herodotus, *History,* II.81 (trans. A. D. Godley [London and New York, 1931], 1:367).

45. See W. K. C. Guthrie, *History of Greek Philosophy,* 1:284–85. See the vita of Philolaus, in Diogenes Laertius, *Lives and Opinions of Eminent Philosophers,* VIII.7. For the surviving fragments of Philolaus, see Diels-Kranz, *Fragmente der Vorsokratiker,* 1:398–419.

46. See Plutarch, *On the Sign of Socrates,* 583A. The Roman writer is a certain Demetrius (probably Demetrius of Troezen); on this see Diogenes Laertius, *Lives and Opinions of Eminent Philosophers,* VIII.7.

47. On the life, writings, and authenticity of the fragments of Philolaus, see Carl A. Huffman, *Philolaus of Croton, Pythagorean and Presocratic* (Cambridge, 1993). The various reasons for the doubts of authenticity regarding many Philolaun extracts are discussed (with bibliography) in W. K. C. Guthrie, *History of Greek Philosophy,* 1:329–33.

48. For the life, teachings, and fragments of Philolaus, see Diels-Kranz, *Fragmente der Vorsokratiker,* 1:398–419. For the full texts of frags. 2–7 in English, see Barnes, *Early Greek Philosophy,* 216–19. See also K. S. Guthrie, *Pythagorean Sourcebook and Library,* 168–75. Diogenes Laertius cited Philolaus as the first to describe the governance of all things by harmony (VIII.1.84). Regarding the revolution of the earth around a central fire in the thinking of Philolaus, see the discussion in Heath, *Aristarchus of Samos,* 97.

49. See Barnes, *Early Greek Philosophy*; also Kirk, Raven, and Schofield, *Presocratic Philosophers,* 327; and, for the Greek text, de Vogel, *Greek Philosophy,* 32b.

50. Philolaus, frag. 4 (trans. [from Stobaeus] Barnes, *Early Greek Philosophy,* 217). For the Greek text see de Vogel, *Greek Philosophy,* 15 at 32a.

51. Philolaus, frag. 7 (trans. [from Stobaeus] Barnes, *Early Greek Philosophy,* 218). Philolaus's description of the five regular solids is quoted by Proclus (*Commentary on Euclid,* I.36) and that praising the cube by Nicomachus (*Introduction to Arithmetic,* II.xxvi). These quotes refer to works that have not survived.

52. See the conclusions of Kirk, Raven, and Schofield, *Presocratic Philosophers,* 328.

53. See the vita of Democritus of Abdera by Diogenes Laertius (*Lives and Opinions of Eminent Philosophers,* IX.7). Regarding his life, teachings, and fragments, see Diels-Kranz, *Fragmente der Vorsokratiker,* 2:81–230; also the extracts published in Barnes, *Early Greek Philosophy,* 244–88.

54. The oldest extant biography of Archytas of Tarentum is that of Diogenes Laertius (*Lives and Opinions of Eminent Philosophers,* VIII.4). Diogenes explains that on one occasion Archytas saved the life of Plato; he also quotes from their correspondence. Elsewhere, Diogenes Laertius (ibid., VIII.1.79) tells us that Aristoxenus wrote about Archytas. So also, apparently, did Aristotle (W. K. C. Guthrie, *History of Greek Philosophy,* 1:334n1). For testimony about Archytas (who was commemorated by Aristotle, Strabo, Ptolemy, Quintilian, Theon of Smyrna, Aulius Gellius, Iamblichus, Proclus, Suidas, Boethius, and others) and the fragments, see Diels-Kranz, *Fragmente der*

Vorsokratiker, 1:421–40; also Thesleff, *Pythagorean Texts of the Hellenistic Period,* 2–48.

55. For these passages see Diels-Kranz, *Fragmente der Vorsokratiker,* 1:431–32 and 435–36, respectively. For the English translation (from a quote of Porphyry in his *Commentary on Ptolemy's Harmonics*), see Ivor Thomas, ed. and trans., *Greek Mathematical Works* (Cambridge and London, 1951), 1:5 and 113.

56. This is according to the report of Diogenes Laertius, in *Lives and Opinions of Eminent Philosophers,* VIII.4.

57. Ocellus (whose works are lost to us) is quoted by Diogenes Laertius in *Lives and Opinions of Eminent Philosophers,* VIII.4. On Plato's trips to Italy, see Strabo, *Geography,* VI.280. In his vita of Archytas, as mentioned in the preceding notes, Diogenes Laertius quotes from their correspondence (ibid., VIII.4.80–82). On this see W. K. C. Guthrie, *History of Greek Philosophy,* 1:333–36 and esp. 334n1. Plato's intentions in visiting Italy are explained in Valerius Maximus, *Facta et dicta memorabilia,* VIII.7 (External 3). See also Guy C. Field, *Plato and His Contemporaries,* 3rd ed. (1930; London, 1967), 21–14, 186–87.

58. Aelian tells us that Lysis of Tarentum was a disciple of Pythagoras and, as well, that he was tutor to Epaminondas (*Varia historia,* III.17). On Lysis see Diogenes Laertius, *Lives and Opinions of Eminent Philosophers,* VIII.7, 39, and 42; de Vogel, *Pythagoras and Early Pythagoreanism,* 24 and 26; and Albin Lesky, *A History of Greek Literature,* trans. J. Willis and C. de Heer (1957; London, 1966), 797–99.

59. See the comments of Diodorus Siculus (*Bibliotheke historika,* X.11.2) and the vita of Epaminondas of Thebes by Cornelius Nepos in *De viris illustribus* (a work that was to be well known in the Renaissance). For the Latin text see Cornelius Nepos, *Gli uomini illustri,* ed. Luca Canali (Bari, 1983), 152–67.

60. The reports of Aristoxenus, Nicomachus, and Apollonius are quoted and extensively discussed by Iamblichus in *Vita Pythagorica,* 35.

61. Plato, *The Republic,* X.600.A–B.

62. Aristotle, *Metaphysics,* I.vi.

63. On Cicero's (incomplete) translation of Plato's *Timaeus,* see Remo Giomini, *Ricerche sul testo del Timeo Ciceroniano* (Rome, 1960) (with text); on that of Chalcidius, see *Platonis Timaeus interprete Chalcidio cum Eiusdem commentario,* ed. Iohannes Wrobel (Leipzig, 1876); and John M. Dillon, ed., *Iamblichi Chalcidensis in Platonis dialogos commentariorum fragmenta* (Leiden, 1973); and for the commentary of Proclus, see *Commentaire sur le Timée,* ed. Festugière. Skeptical views on Plato's "Pythagoreanism" have been voiced by several twentieth-century writers, including Erich Frank, *Plato und die sogenannten Pythagoreer* (Halle, 1923); Paul Shorey, "Recent Interpretations of the *Timaeus,*" *Classical Philology* 23 (1928): 343–62, esp. 347–49; and Field, *Plato and His Contemporaries,* passim. However, Cicero is adamant that Plato was a Pythagorean and, he insists, specifically went to southern Italy to study the discoveries of Pythagoras, which Socrates had repudiated, and to learn from Archytas. Cicero even goes so far as to claim that Plato obtained the notes of Philolaus. Cicero holds that indeed Plato learned "all" Pythagorean doctrines. See Cicero, *De re publica,* I.16; *De finibus bonorum et malorum,* V.87; and *Tusculanae disputationes,* I.39. Thus did this "certainty" pass into medieval and Renaissance times. Plato's birth date (and death date, which was the same), May 7, is discussed by Plutarch in *Table Talk,* VIII.717B–E. Plutarch explains that Plato's birth on the seventh day of May, during a festival of Apollo, caused some to attribute his parentage to Apollo. On the meaning of the seventh of the month, see n. 26 in this chapter.

64. Plato, *The Republic,* VII.530D. Regarding the history of the Pythagorean con-

cept of the harmony of the spheres, from Philolaus to Plato to Aristotle to Cicero, see
Heath, *Aristarchus of Samos*, 105–15. Cf. n. 25 *supra* regarding Pindar's first intuitions
about this concept.

65. Plato, *The Republic*, X.617B.

66. Ibid., VII.524E–526B; and idem, *Philebus*, 17.E.

67. Plato, *Timaeus*, 21–23.

68. Ibid., passim (the immortality of the soul is specified at 11.43 and 37.69). Re-
garding the possibility of oriental influences on these ideas, especially during the last
years of Plato's life, see Édouard des Places, "Platon et l'astronomie chaldéene," in
Mélanges Franz Cumont, 129–42.

69. Plato, *Gorgias,* passim.

70. Plato, *Epinomis*, 977E–978A; idem, *The Laws* V.737e.

71. Plato, *Epistle XIII*, 360B–C.

72. For the testimonia and fragments of Speusippus, see *De Speusippi academici
scriptis*, ed. Paul Lang (1911; Frankfurt, 1964); and in the more recent study of him by
Leonardo Tarán, *Speusippus of Athens: A Critical Study* (Leiden, 1981). See the refer-
ences to him by Pseudo-Iamblichus (who quotes at length from Speusippus's lost work
On the Pythagorean Numbers) in *The Theology of Arithmetic*, X. As regards his work
on the theory of number, see Dillon, *Middle Platonists*, 11–22, esp. 21–22.

73. This passage (from Pseudo-Iamblichus's *Theology of Arithmetic*) is quoted from
Thomas, *Greek Mathematical Works*, 1:75.

74. See Diogenes Laertius, *Lives and Opinions of Eminent Philosophers*, IV.1.1–5.

75. The Speusippus fragment was preserved by Pseudo-Iamblichus. For translation,
see Thomas, *Greek Mathematical Works*, 1:77.

76. Xenocrates of Chalcedon is mainly known through the reports of others, espe-
cially that of Diogenes Laertius (*Lives and Opinions of Eminent Philosophers*, IV.2.6–
14), who lists over seventy works by him. On Xenocrates see *Xenokrates: Darstellung
der Lehre und Sammlung der Fragmente*, ed. Richard Heinze (1892; Hildesheim,
1965); and Dillon, *Middle Platonists*, esp. 22–24.

77. On the various intellectual interests of Aristotle, see esp. Jaeger, *Aristotle*. On
Aristotle and the early development of the Peripatetic school, see Zeller, *Die Philoso-
phie der Griechen*, passim.

78. Aristotle, *Metaphysics*, I.v.985b; idem, *Physics*, III.203a; idem, *Posterior Ana-
lytics*, I.10, 76a, and I.6,206b–207a.

79. Aristotle, *Metaphysics*, I.v.985a–986b and XIII.1080b, 1083b, and 1090a. Re-
garding Aristotle's observation that for Pythagoreans all things are numbers, see Geof-
frey E. R. Lloyd, *Magic, Reason and Experience: Studies in the Origin and Develop-
ment of Greek Science* (London, 1979), 145–46.

80. Aristotle, *Metaphysics*, XIV.vi.1093a; idem, *Magna moralia*, I.1182a.

81. Aristotle, *Physics*, III.204a and IV.213b.

82. Regarding Aristotle's interest in the Odd and the Even, the Limited and the Un-
limited, see esp. *Metaphysics*, I.iv.

83. Ibid., I.v.968a, and 986a and b.

84. Aristotle, *Meteorologica*, I.vi.342b, I.viii.345a; and idem, *Posterior Analytics*,
II.xi.94b.

85. Aristotle, *De caelo*, II.284b and I.268a, respectively; also II.284b–290b.

86. Ibid., II.233a, and 293a–294b.

87. Aristotle, *Metaphysics*, III.996a, 1001a, X.1053b, XII.1072b; and idem, *Nico-
machean Ethics*, I.vi.7.

88. Aristotle, *Metaphysics*, I.986b.

89. Ibid., I.989b.

90. Aristotle, *Magna moralia*, I.1182a; and idem, *Nicomachean Ethics*, I.vi.7 and V.v.1.

91. Aristotle, *On the Soul*, I.404a and 407b.

92. Aristotle, *On Sense and Sensible Objects*, V.445a.

93. Iamblichus refers to this in *Vita Pythagorica*, 28 (without crediting Aristoxenus in this case). Cf. Diels-Kranz, *Fragmente der Vorsokratiker*, 1:468, D.2. On this subject see the discussion in W. K. C. Guthrie, *History of Greek Philosophy*, 1:199 and 210.

94. See on this subject esp. Heath, *Aristarchus of Samos*, 105–15. See also C. Abdy Williams, *Aristoxenian Theory of Musical Rhythm* (Cambridge, 1911).

95. Theocritus, poem XIV, *The Love of Cynisca*, 5 (trans. and ed. J. M. Edmonds, *The Greek Bucolic Poets* [London and New York, 1928], 167).

96. See, e.g., Jaeger, *Aristotle*, 455–59.

97. See Rohde, "Die Quellen des Iamblichus in seiner Biographie des Pythagoras," in *Kleine Schriften,* ed. Fritz Schöll (Tübingen, 1901), 2:102–4; also Jaeger, *Aristotle,* 455. Cf. collected examples ("Pythagoristen in der mittleren Komödie,") in Diels-Kranz, *Fragmente der Vorsokratiker*, 1:478–80.

98. Diodorus Siculus, *Bibliotheke historika*, X.3.5, 4.3, 4.5, and 6.7; and XII.20.1–21.3.

99. Strabo, *Geography*, VI.I.12.

100. On this period see Burkert, "Hellenistische Pseudopythagorica," 16ff. and esp. 232ff. The roots of Kabbalah are largely fragmentary and unclear, but there is good reason to believe, as Gershom Scholem explains in *Major Trends in Jewish Mysticism*, 3rd rev. ed. (1941; New York, 1961), 40–43; and idem, *Origins of the Kabbalah*, trans. Allan Arkush (1962; Princeton, 1987), 18–24, that they existed in Palestinian tracts that can be traced back to the first century AD but whose first conceptions may date from as early as the first century BC. On this subject see also idem, *Jewish Gnosticism, Merkabah Mysticism, and Talmudic Tradition*, rev. ed. (1960; New York, 1965); and Ithamar Gruenwald, *Apocalyptic and Merkavah Mysticism* (Leiden, 1980). On the so-called Wisdom of Solomon of the Apocrypha, written by an unknown but learned Jew of Alexandria, perhaps Philo, see Schürer, *Geschichte des jüdischen Volkes*, 3:508–12; C. Larcher, *Études sur le "Livre de la sagesse"* (Paris, 1969); Édouard des Places, "Le *Livre de la sagesse* et les influences grecques," *Biblica* 50 (1969): 536–42 (review of Larcher); David Winston, *The Wisdom of Solomon* (New York, 1979), esp. 1–61; and Georg Luck (who describes Solomon as king, scientist, and occultist), *Arcana Mundi, Magic, and the Occult in the Greek and Roman Worlds* (Baltimore and London, 1985), 27–28.

101. See the dedication in Cicero, M. *Tvlli Ciceronis, Timaevs*, ed. Franciscus Pini (Milan, 1965).

102. Cicero, *Epistulae ad Atticum*, II; and *Epistulae ad familiares*, IV.xiii. On Publius Nigidius Figulus, who was widely respected by others in the Roman world, and his reputation, see the testimonia and fragments published in Hyginus Funaioli, *Grammaticae romanae fragmenta* (Leipzig, 1907), 1:158–79.

103. Cicero, *De oratore*, II.154; and idem, *Tusculanae disputationes*, IV.3 and V.9.

104. Cicero, *Tusculanae disputationes*, IV.3; idem, *Academica*, II.118; and idem, *De divinatione*, I.62 and 119.

105. See Aulus Gellius, *Noctes Atticae*, III.x; and, regarding the *Hebdomades*, see Kurt Weitzmann, *Ancient Book Illumination* (Cambridge, MA, 1959), 116.

106. Pliny the Elder, *Historia naturalis*, XXXV.160.

107. The seminal work on the subject of the Pythagoreanism of Vitruvius and its influence is that of Hersey, *Pythagorean Palaces*.

108. Vitruvius, *De architectura,* III.i.8.

109. Ibid., IV.v.l.

110. Hersey, *Pythagorean Palaces,* passim.

111. See, for example, the summary of Pythagoreanism in Aristotle's times offered by Jaeger in *Aristotle,* 455–59. The biggest problem with this interpretation of Pythagoreanism as referring to two "entirely different groups of men" is the view of two incompatible extremes that it presents. Much of the supporting material is drawn from Porphyry and Iamblichus, who of course lived about six centuries after Aristotle. Essentially relying on the discussion of Rohde ("Die Quellen des Iamblichus"), Jaeger does not present a picture drawn from literary sources of Aristotle's times and previous centuries that would support his argument. Regarding the literature of this period in general, see esp. Burkert, "Hellenistische Pseudopythagorica," 16–43 and 226–46.

Chapter 6. Neopythagoreanism

1. On the assimilation of Pythagoreanism into Platonism, see esp. Dillon, *Middle Platonists,* passim.

2. On the history and scope of the Apocryphal work known as the Book of Wisdom or the Wisdom of Solomon, and the possibility that it was written by Philo, see Winston, *Wisdom of Solomon,* esp. 1–61. The quoted passage is from *Wisdom,* 11:21. On its Pythagoreanism see Lévy, *Légende de Pythagore,* 225–26. Eusebius speaks admiringly of Philo's zeal for the study of Plato and Pythagoras in *The Ecclesiastical History,* II.iv. For an early vita of Philo of Alexandria, see the *Viris illustribus* of Saint Jerome, where the life of Philo is the last vita authored by Jerome (preceding his autobiography, with which his part ends before the additions of Gennadius begin) as "Philo Iudeus," in *Hieronymus Liber de viris inlustribus/Gennadius Liber de Viris Inlustribus,* XI.14–15. Regarding the life and works of Philo, see Zeller, *Philosophie der Griechen,* 3(2):338–418. The recent (and vast) literature on Philo before 1986 is catalogued by Roberto Radice and David Runia, *Philo of Alexandria: An Annotated Bibliography, 1937–1986,* 2nd ed. (Leiden and New York, 1992).

3. See, e.g., Philo Judaeus (Philo of Alexandria), *De opificio mundi,* 48, 50–52, and 109–10; idem, *De decalogo,* 21–25; and idem, *Quaestiones in Genesis Supp. 1,* II.5–7 and 12.

4. See, e.g., Philo Judaeus, *De opificio mundi,* 47–56.

5. See, e.g., ibid., 13–14.

6. Philo Judaeus, *De decalogo,* 102 and 106; idem, *De opificio mundi,* 111–29; idem, *De specialibus legibus,* II.56–72; and idem, *De vita Mosis II,* 210–20 and 263–69. On the building of the tabernacle, see *De vita Mosis II,* 71–109.

7. Philo Judaeus, *De decalogo,* passim, esp. 20–32.

8. Philo Judaeus, *De vita Mosis I and II,* passim. Philo in several places describes the many virtues of Moses as a priestly ruler. See, e.g., *De vita Mosis II,* 185–86. On Philo's presentation of Moses, see esp. Wayne Meeks, *The Prophet King: Moses Traditions and the Johannine Christology* (Leiden, 1967), esp. 100–131.

9. See Lévy, *Recherches sur les sources de la légende de Pythagore;* idem, *Légende de Pythagore*

10. See Clement of Alexandria, *Stromateius,* I.xv. On this see also Lévy, *Légende de Pythagore,* 223–24.

11. Lucius Anneus Seneca, *Epistle CVIII: "On the Approaches to Philosophy,"* 17–23.

12. Regarding the life of Apollonius, see Philostratus, *The Life of Apollonius of Tyana,* an early third-century work.

13. According to Philostratus, the most complete and pure philosophical text, the tenets of Pythagoras, was kept by Hadrian together with a collection of letters of Apollonius. On these collections, which Hadrian kept in his palace at Antium, see Philostratus, *The Life of Apollonius of Tyana,* VIII.20. Evidence of Hadrian's Pythagoreanism can also be found in his early biographies. See the vita of Hadrian authored by Aelius Spartianus in *Scriptores historiae augusta,* and Aurelius Victor, *Liber de Caesaribus,* XIII. (Hadrian's collection of Apollonius's letters is mentioned in chaps. 2 and 10 of the present volume.)

14. On Hadrian's many active and varied intellectual interests and his association with philosophers, teachers, and intellectuals, see the biographies of Dio Cassius, Aelius Spartianus, Aurelius Victor, and Orosius. On Hadrian's rewards to intellectuals, providing them with membership in the Museum at Alexandria, see Philostratus, *Lives of the Sophists,* VIII (Favorinus) and XXXV (Polemo). Hadrian was especially fond of the Greek-speaking East. On this see chap. 10, n. 41, of this volume. In 112 or 113 he received the honor of being elected archon in Athens. Hadrian enlarged Athens and covered it with sumptuous monuments, including a grand gymnasium and a magnificent library. On his trips to Athens and his activities there, and regarding statues and inscriptions of him there, see Paul Graindor, *Athènes sous Hadrien* (1934; reprint, New York, 1973). On Hadrian's devotion to the sun, see Aelius Spartianus's vita of Hadrian in *Scriptores historiae augusta,* XIII, XIV, and XIX. For Hadrian's verse "Dying Farewell to His Soul," see John Wight Duff and Arnold M. Duff, eds., *Minor Latin Poets* (Cambridge, MA, and London, 1934), 445. On the ascent of the soul as the central teaching of Jewish Gnosticism, see Scholem, *Origins of the Kabbalah,* 22–23.

15. Pliny the Elder, *Historia naturalis,* II.xx.83–84.

16. Nicomachus of Gerasa, *Introduction to Arithmetic,* passim. On Nicomachus's views of the relation between Pythagoras and Plato, and between mathematics and philosophy, see D. J. O'Meara, *Pythagoras Revived,* 14–18.

17. This lost work of Nicomachus survives in great part through the review of it by Photius (Photius, *Bibliothèque,* ed. René Henry [Paris, 1967], codex 187).

18. See Nicomachus, *Theologoumena arithmetica,* in Photius, *Bibliothèque,* III, no. 187. Photius's epitome is discussed in great detail in Frank E. Robbins and Louis C. Karpinski, "The Works of Nicomachus" and "The Philosophy of Nicomachus," in Nicomachus, *Introduction to Arithmetic,* trans. M. L. D'Ooge, 82–110 (New York, 1926). See also Pseudo-Iamblichus, *The Theology of Arithmetic: On the Mystical, Mathematical, and Cosmological Symbolism of the First Ten Numbers,* ed. and trans. Robin Waterfield, with an introduction by Keith Critchlow (Grand Rapids, MI, 1988). Cf. Heath, *History of Greek Mathematics,* 1:97–112.

19. Photius, *Bibliothèque,* III, no. 187; or, for English translation, see Karpinski, "Philosophy of Nicomachus," 110.

20. See Plutarch, *On the Sign of Socrates,* 583A.

21. On embracing each other before sunset, see Plutarch, *On Brotherly Love,* 488C. Regarding shaking the bed clothes and avoiding fish and swallows, see idem, *Table Talk,* VIII.727B–731A. On the orderly symphony of the universe in motion, see idem, *Platonic Questions,* VIII.1007B; and idem, *On Music,* 1147A.

22. See, e.g., the following works by Plutarch: *The Education of Children,* 12E–F; *On Having Many Friends,* 96A; *The Greek Questions,* 300C; *The Roman Questions,*

288D–E and 290E; *The E at Delphi,* 368B–F, 389A–F, and 390E–391A; *Isis and Osiris,* 354F, 381F, and 384A; *On the Sign of Socrates,* 579D; and *Life of Numa,* XIV.3–5.

23. Regarding the number seventeen, see Plutarch, *Isis and Osiris,* 367F. Pythagorean superstitions are discussed by Plutarch, ibid., 370E; *On Compliancy,* 532B–C; *Table Talk,* VIII.729C–E; and *On the Eating of Flesh,* 993A–B, 997E–F, and 998A.

24. Plutarch, *Life of Numa,* XIV.4. Cf. Vitruvius, *De architectura,* IV.v.1.

25. See Clement of Alexandria, *Paedagogus,* passim, esp. bks. II and III.

26. The passage from Clement of Alexandria occurs at the end of book VI in the *Exhortation to the Greeks.* That of Lucian can be found in *The Lover of Lies,* 29.

27. See Lucian, *The Dance,* 70; and idem, *Lexiphanes,* 19.

28. On the pentagram as the symbol of Pythagoreans, see Lucian, *A Slip of the Tongue in Greeting,* 5. On the wider symbolism of the pentagram and its probable derivation from Babylonian sources, see de Vogel, *Pythagoras and Early Pythagoreanism,* 46–48. For the description of his friend, see Aelian, *Varia historia,* IX.22 and XIV.23.

29. Justin Martyr, *Dialogue with Trypho,* II.

30. Eusebius has a great deal of praise for Anatolius, who, as he explains, was his predecessor as bishop of Caesarea before the latter became bishop of Laodicea. See Eusebius, *Ecclesiastical History,* VII.xxii.5–23. On possible sources for the work of Anatolius, see Gerhard Borghorst, *De Anatolii fontibus* (Berlin, 1904). Regarding the place of Anatolius in Pythagorean mathematics of the second and third centuries, and the unlikely possibility that there may have been two mathematicians with the same name, see D. J. O'Meara, *Pythagoras Revived,* 23–25.

31. Anatolius's work would be important for the Renaissance humanist Giorgio Valla, for example, in the *De expetendis et fugiendis rebus,* III, x–xx.

32. See a citation from Anatolius (which discusses the origin of mathematics) in Heron's *Definitions,* quoted in Thomas, *Greek Mathematical Works,* 1:3.

33. For the text of this work, see Paul Tannery, "Anatolius: Sur la décade et les nombres qu'elle comprend," in *Mémoires scientifiques: III. Sciences exactes dans l'Antiquité* (Toulouse and Paris, 1915), 12–28.

34. This is from Diogenes Laertius, *Lives and Opinions of Eminent Philosophers,* VIII.1.27. Regarding this, see especially the discussions in Cumont, *Astrology and Religion among the Greeks and Romans,* 194–99; and idem, *After Life in Roman Paganism* (1922; reprint, New York, 1959), 25, 78–82, and 96.

35. See Clark, introduction to Porphyry, *On Abstinence,* 1–2.

36. Plotinus, *Ennead,* II.7 (trans. Stephen MacKenna, in Plotinus, *The Enneads* [1930; London, 1991], 80–81). On the philosophy of Plotinus, see John Bussanich, *The One and Its Relation to Intellect in Plotinus* (Leiden, 1988).

37. Iamblichus, *Vita Pythagorica,* esp. 18.

38. Ibid., 21–34, passim.

39. Ibid., 18. On the Isles of the Blessed, see Burkert, *Lore and Science in Ancient Pythagoreanism,* 362–65; and Cumont, *Astrology and Religion among the Greeks and Romans,* passim.

40. Iamblichus, *Vita Pythagorica,* 15 and 35.

41. These issues are discussed in appropriate detail in D. J. O'Meara, *Pythagoras Revived,* 30–105.

42. Pseudo-Iamblichus, *Theologvmena arithmeticae,* ed. Victorivs de Falco (Stuttgart, 1975). See also idem, *Theology of Arithmetic.*

43. Pseudo-Iamblichus, *Theology of Arithmetic,* passim, esp. 79–86.

44. Jerome, *Letters,* passim. The quoted passage is from *Select Letters of Saint Jerome,* ed. and trans. F. A. Wright (London and New York, 1933), 247.

45. Regarding Saint Basil's comment about Pythagoreans, see letter XXI (to the Sophist Leontius) in Saint Basil, *The Letters,* trans. Roy J. Deferrari (Cambridge, MA, 1950, I). Our information on Emperor Julian (Flavius Claudius Julianus) is known primarily through his *Orations* and his *Letter to the Athenians.* His philosophy of revived Hellenism and his devotion to Iamblichus are discussed by Wilmer C. Wright in the introduction to *The Works of the Emperor Julian,* ed. W. C. Wright (London and New York, 1962–90). Julian's adulation of Pythagoras is stated in letter II (to Priscus), ibid., 3:5. His hymn to the sun (otherwise known as *Oration IV*) is titled *Hymn to Helios.* In it Julian describes the "middleness" of the sun, which is equally remote from the extremes with which it is associated, thus providing a link similar, he says, to Empedocles' concept of harmony. Plutarch explains the role of mediator as a Persian invention in *Isis and Osiris,* 369E.

46. See Eunapius, *Lives of the Philosophers.* Composed in about 396, when the first Christian martyrologies were probably already known, this still-extant work extols Neoplatonic and Neopythagorean philosophers of the fourth century.

47. See esp. Macrobius, *Commentary on the Dream of Scipio,* passim. Regarding the descent of souls from the Milky Way, see esp. I.XI.11–I.XII.13.

48. Boethius, *De institutione arithmetica,* I.1.

49. Ibid., passim.

50. Boethius, *De institutione musica,* I.1. On this see Boethius, *Consolations of Music, Logic, Theology and Philosophy,* 83.

51. Julius Caesar, *De bello Gallico,* VI.15–21.

52. Camille Jullian, *Histoire de la Gaule,* 8 vols. (Paris, 1909), 2:84–181 and 371n7. On the history of the Druids, see Giuseppe Zecchini, *I druidi e l'opposizione dei celti a Roma* (Milan, 1984), esp. the essay by Brogan on Gallia Transalpina. See also Christian J. Guyonvarc'h and Françoise Le Roux, *Les Druides* (Rennes, 1987). Although useful in some ways, Stuart Piggott, *The Druids* (London, 1968), offers a conventionally modern positivistic view that, debunking the views of contemporary historians of philosophy of the time, assumes that virtually all contemporaries who commented on the Druids of their time were either exaggerating or uninformed. This is despite the fact that some of them had personal contact with Druids, and the others (pagans and Christians alike, Alexandrians and Romans alike) are in agreement on the reputation of Druids in their own time (see nn. 53–56 below).

53. Diodorus Siculus, *Bibliotheke historika,* V.25.2–32.4; for the translation of V.28.6, see *Diodorus of Sicily,* ed. and trans. C. H. Oldfather (London and New York, 1933), 3:171.

54. Plutarch's and Clement's views on the origins of Pythagoras were discussed in chapter 2. For Polybius's description of the Celts in Italy, see his *Histories,* II.25–26.

55. Livy, *Ab urbe condita libri,* V.33–36. In this passage, Livy claims that Milan (Mediolanum) was founded by the Gauls, a claim that is corroborated on etymological grounds by Guyonvarc'h and Le Roux, *Les Druides,* 220 and 227. See also Valerius Maximus, *Facta et dicta memorabilia,* I.1.18, I.5.1, II.6.8, II.6.10–11, III.2.5, III.2.7, III.7.4, and III.7.ext.4.

56. Cicero, *De divinatione,* I.xli.90.

57. The work of Posidonius of Apamea is known through extensive fragmentary references. See Gerhard Dobesch, *Das europäische "Barbaricum" und die Zone der Mediterrankultur Ihre historische Wechselwirkung und das Geschichtsbild des Poseidonios* (Vienna, 1995), 11, 17, 24, 48–51, and 93–94.

58. Pomponius Mela, *De chorographia*, III.18–19. For an English translation see F. E. Romer, *Pomponius Mela's Description of the World* (Ann Arbor, 1998).

59. On Druidic medical practices according to Pliny, see *Historia naturalis*, XXIV.103 and XXIX.22–23; also Peter B. Ellis, *The Druids* (New York, 1994), 59–60 and 212.

60. Strabo, *Geography*, IV.4.4; cf. Clement of Alexandria, *Stromateius*, I.xv. Clement's source on Pythagoras having studied with the Gauls was Alexander Polyhistor, a first-century BC encyclopedist. Clement's words are "et vult praeterea Pythagoram Gallos audisse et Brachmanas." Evidently he viewed Pythagoras's teachers as being the wise men of the Gauls (the Druids) and the Brahmans.

61. Hippolytus, *Philosophumena*, I.22 (trans. Francis Legge, in Hippolytus, *Philosophumena*, ed. F. L. Legge [London, 1921], 1:62).

62. On this see Jullian, *Histoire de la Gaule*, 2:107 and n. 5; also Guyonvarc'h and Le Roux, *Les Druides*, esp. 205ff. and 263ff.

63. Diogenes Laertius, *Lives and Opinions of Eminent Philosophers*, I.6 (prologue). Cf. Pliny, *Historia naturalis*, XVI.250–51.

64. See bibliography in Jullian, *Histoire de la Gaule*, 2:108nn1–12.

65. Ausonius, *Commemoratio Professorum Burdigalensium*, XI.4.7–8. On the great invasions of the third century AD, see Édouard Salin, *La civilisation mérovingienne* (Paris, 1950), esp. 38–48. On the conquest of Gaul, see Jullian, *Histoire de la Gaule*, esp. vols. 5–8, passim.

Chapter 7. The Middle Ages: A New Pythagoreanism

1. This Sextus is known as Sextus Pythagoricus, or Sextus the Pythagorean. His name is recorded by Saint Jerome, *Die Chronik des Hieronymus/Hieronymi Chronicon*, in *Eusebius Werke*, vol. 7, ed. R. Helm (Berlin, 1984), XLIIII. Regarding him, and for an English translation of this work, see *The Sentences of Sextus: A Contribution to the History of Early Christian Ethics*, ed. Henry Chadwick (Cambridge, 1959). For the original Greek text, see *The Sentences of Sextus*, ed. Richard A. Edwards and Robert A. Wild (Chico, CA, 1981).

2. See H. Chadwick, introduction to *Sentences of Sextus* (ed. Chadwick).

3. Regarding the significance of the *Timaeus* in the Middle Ages, see esp. Klibansky, *Continuity of the Platonic Tradition*, passim; idem, "The School of Chartres," in *Twelfth-Century Europe and the Foundations of Modern Society*, ed. Marshall Clagett, Gaines Post, and Robert Reynolds (Madison, WI, 1961), 3–15; Margaret Gibson, "The Study of the *Timaeus* in the Eleventh and Twelfth Centuries," *Pensamiento* 35 (1969); and, generally, Gretchen J. Reydams-Schils, *Plato's "Timaeus" as Cultural Icon* (South Bend, IN, 2003). Also see chap. 4, n. 3, and chap. 5, n. 63, in this volume. On medieval number symbolism and its classical antecedents, see Edmund Reiss, "Number Symbolism and Medieval Literature," in *Medievalia et Humanistica*, ed. Paul M. Clogan (Cleveland and London, 1970), 161–75. See also the more general work of V. H. Hopper, *Medieval Number Symbolism* (New York, 1938).

4. Although Pseudo-Dionysius has been confused with a first-century follower of Saint Paul, it appears clear from the content of his work that this Dionysius in fact lived in the fifth or sixth century. Regarding him and his work, which is indebted to Proclus and to other late Antique authors in addition to Plato, see Ronald F. Hathaway, *Hierarchy and the Definition of Order in the Letters of Pseudo-Dionysius: A Study in the Form and Meaning of the Pseudo-Dionysian Writings* (The Hague, 1969); Pseudo-Dionysius, *La hiérarchie céleste*, ed. René Roque and Gunther Heil (1958; reprint,

Paris, 1970); and Gersh, *From Iamblichus to Eriugena.* For his works, see Pseudo-Dionysius, S. *Dionysii Areopagitae Opera Omnia quae extant,* in Migne, *Patrologia Graeca* (Paris, 1857), vol. 8; and for a translated text, Pseudo-Dionysius, *Pseudo-Dionysius: The Complete Works,* trans. Colm Luibheid, ed. Paul Rorem (New York, 1987).

5. This work, written in Greek, was made available in the West through the Latin translation of Duns Scotus (John the Scot, or Erigena Johannes Scotus, also known as Eriugena, ca. 810–ca. 877).

6. Photius, *Bibliothèque,* VII, no. 249.

7. Sacrobosco, *Sphaera mundi,* generally.

8. Dante's praise for Dionysius the Areopagite is expressed in *Paradiso* X.115–17, and XXVIII.130–32 and 136–37.

9. On the originality of Isidorian arithmetic, see Fontaine, *Isidore de Seville et la culture classique,* esp. vol. 1, chap. 2.

10. Isidore's medical writings, incorporated in the *Etymologiae,* include a work on man and monsters and another on general medicine. For English translations of these, see Isidore of Seville, *The Medical Writings,* ed. William D. Sharpe, in *Transactions of the American Philosophical Society* (Philadelphia, 1964).

11. See *The Letters of St. Isidore of Seville,* 2nd rev. ed., ed. Gordon B. Ford Jr. (Amsterdam, 1970), 43.

12. On the School of Chartres, see esp. Charles Homer Haskins, *The Renaissance of the Twelfth Century* (1927; New York, 1957); idem, "A List of Books from the Close of the Twelfth Century," *Harvard Studies in Classical Philology* 20 (1909): 75–94; and Brian Stock, *Myth and Science in the Twelfth Century: A Study of Bernard Silvester* (Princeton, 1972).

13. On this see Allen G. Debus, "Mathematics and Nature in the Chemical Texts of the Renaissance," in *AMBIX: The Journal of the Society for the Study of Alchemy and Early Chemistry* 15 (1968): 6–7.

14. William of Conches, *Glosae super Platonem,* 71.

15. William of Conches, *Glosarum super Timaeum,* 48E–49A, in *Glosae super Platonem;* and idem, *Philosophia Mundi,* ed. Gregor Maurach (Pretoria, 1974), passim.

16. Arabic translations of Nicomachus and interest in Pythagoras's theorem are discussed in Ali A. Al-Daff'a and John J. Stroyls, *Studies in the Exact Sciences in Medieval Islam* (Dhahran and New York, 1984), esp. 20–21.

17. "Nec minus Pythagoreis indulgebat fidibus." See the long poem quoted in Jules Alexandre Clerval, *Les écoles de Chartres au Moyen Âge* (1895; reprint (Frankfurt, 1965), 59–62; quotation at 60.

18. See Lynn Thorndike, *The Sphere of Sacrobosco and Its Commentators* (Chicago, 1949), 431.

19. Hugh of St. Victor, *De scripturis et scriptoribus sacris,* VI and XV, in Migne, *Patrologia Latina* (Paris, 1879), 175:15–16, 22–23. For translation, see John P. Kleinz, *The Theory of Knowledge of Hugh of St. Victor* (Washington, DC, 1944), 7. On this scholar, who was the master of Richard of St. Victor, see also Steven Chase, *Angelic Wisdom: The Cherubim and the Grace of Contemplation in Richard of St. Victor* (South Bend, IN, and London), 1995, esp. 142ff.

20. Hugh of St. Victor, *Didascalicon,* II.iv and v.

21. The first work is contained in *Cod.Vat.Lat.2148.* Regarding the second, see Walter Burley, *Questiones super librum posteriorum,* ed. Mary C. Sommers (Toronto, 2000), III.iv, 3.07.

22. On Albertus Magnus's disagreement with Pythagoreanism, see Benedict M.

Ashley, "St. Albert and the Nature of Natural Science," in *Albertus Magnus and the Sciences: Commemorative Essays,* ed. James Weisheipl (Toronto, 1980), 96.

23. Quoted from Proclus, *Commentary on Euclid's Elements,* in Douglas M. Jesseph, *Squaring the Circle: The War between Hobbes and Wallis* (Chicago and London, 1999), 17. On the future development of the quadrivium in the West, see esp. Pearl Kibre, "The *Quadrivium* in the Thirteenth Century Universities," in Kibre, *Studies in Medieval Science, Alchemy, Astrology, Mathematics and Medicine* (London, 1984), 1:176–91. On its development in the Byzantine world, see the discussion on Pachymeres that follows in text.

24. Kibre, "*Quadrivium* in the Thirteenth Century Universities," passim.

25. Jeauneau, *L'âge d'or des écoles de Chartres* (Chartres, 1995), 80; Josef Koch, ed., *Artes liberales von der antiken Bildung zur Wissenschaft des Mittelalters* (Leiden, 1959); Stahl, *Martianus Capella and the Seven Liberal Arts;* and Michael Masi, ed., *Boethius and the Liberal Arts* (Las Vegas, 1981). For background materials see Pierre Riché, *Education and Culture in the Barbarian West,* trans. John J. Contreni (1962; Columbia, SC, 1976).

26. Thierry of Chartres, *De septem diebus,* passim. For quoted passage see Stock, *Myth and Science in the Twelfth Century,* 245. On Thierry's Pythagoreanism and his *Heptateuchon* see Édouard Jeauneau, *L'âge d'or des écoles de Chartres,* esp. 70–71.

27. See passage quoted in Jeauneau, *L'âge d'or des écoles de Chartres,* 71.

28. Much has been written on medieval numerical symbolism. See especially for this discussion Adolf Katzenellenbogen, *Allegories of the Virtues and Vices in Mediaeval Art* (London, 1939), 31, 37, 49, and 68(2).

29. Michael Psellus, *Theologica,* ed. Paul Gautier, Bibliotheca Scriptorvm Graecorvm et Romanorvm (Leipzig, 1989), 1:312–21, 78–79. On Psellus's Pythagoreanism, see Christian Zervos, *Un philosophe neoplatonicien du Xième siècle Michel Psellos* (1920; reprint, New York, 1973). See also John Duffy, "Hellenic Philosophy in Byzantium and the Lonely Mission of Michael Psellos," in *Byzantine Philosophy and Its Ancient Sources,* ed. Katerina Ierodiakonou (Oxford, 2002), 139–51. Psellus expresses his disapproval to divulge a Pythagorean idea (on divination) in a letter, while a fragment records his appropriation of Diophantus as Pythagoras. On both these, see Paul Tannery, "Psellus sur Diophante," in Heiberg, *Mémoires scientifiques,* 4:275–79.

30. On this see Richard Reitzenstein, *Poimandres: Studien zur griechisch-ägyptischen und frühchristlichen Literatur* (Leipzig, 1904), 318–20. The evolution and development of the Hermetic texts are studied by Brian Copenhaver, *Hermetica: The Greek Corpus Hermeticum and the Latin Asclepius* (Cambridge, 1992).

31. Manuel Bryennius, Harmonica, in *The Harmonics of Manuel Bryennius* [English and Greek], ed. Goverdus Henricus Jonker (Groningen, 1970), passim. See also Thomas Mathiesen, "Aristides Quintilianus and the Harmonics of Manuel Bryennius," *Journal of Music Theory* 27 (1983): 31–49.

32. Georgios Pachymeres, *Quadrivium de Georges Pachymère* [Greek text], ed. Paul Tannery and R. P. E. Stéphanou (Vatican City, 1940). See esp. V. Laurent, introduction to ibid. On Pachymeres, see esp. Börje Bydén, *Theodore Metochites' Stoicheiosis Astronomike and the Study of Natural Philosophy and Mathematics in Early Palaiologan Byzantium* (Göteborg, 2003), 217 and passim. (For Photius's review of Nicomachus's *Theology of Arithmetic,* see Photius, *Bibliothèque,* III, no. 187.)

33. Theodore Metochites, *Stoicheiosis astronomike,* as quoted in Bydén, *Metochites' Stoicheiosis Astronomike,* at 217. On Metochites as a Platonist, see Christian Müller and Theophilius Kiessling, *Miscellanea philosophica et historica* (Leipzig, 1821), esp. 46, 56–62, 97–107, 298, and 466.

34. On this treatise see A. S. Saidan, "The Arithmetic of Abu'l-Wafa'," *Isis* 65, no. 228 (1974): 367–75.

35. On Islamic mathematical thought from the eleventh to the fourteenth centuries, see esp. George Sarton, *Introduction to the History of Science* (Washington, DC, 1931), vol. 2, pts. 1 and 2, esp. 1–12, 122–28, 204–15, 504–8, 611–28, 747–61, and 985–1023. See also Heinrich Suter, *Die Mathematiker und Astronomen der Araber und ihre Werke* (Leipzig, 1600); A. P. Juschkewitsch, *Geschichte der Mathematik in Mittelalter,* trans. from Russian by Viktor Ziegler (Leipzig, 1964); and the very readable summary discussion in Howard R. Turner, *Science in Medieval Islam* (Austin, TX, 1995), esp. 43–59.

36. See esp. Gershom Scholem, *Zur Kabbala und ihrer Symbolik* (Zurich, 1960); idem, *Kabbalah* (Jerusalem, 1974); idem, *Von der mystischen Gestalt der Gottheit* (Frankfurt, 1977); and Luck, *Arcana Mundi, Magic, and the Occult,* 28ff. Regarding the origins of Kabbalah see esp. Gershom Scholem, *Ursprung und Anfänge der Kabbala* (Berlin, 1962). In chapter 1 of that volume, Scholem discusses the possibility that the numerical/mystical system of the Sefiroth had its origin in Pythagorean sources such as Nicomachus.

37. This subject is discussed in Scholem, *Major Trends in Jewish Mysticism,* 241–43; respecting the term in Arabic for *transmigration,* see ibid., n. 133.

38. On this subject see the discussions of Luck, *Arcana Mundi, Magic, and the Occult,* 28; and Waterfield, introduction to Pseudo-Iamblichus, *Theology of Arithmetic,* 24–25.

39. See, e.g., Clement of Alexandria, *Stromateius,* I.xxviii.

40. See the discussion on this subject in Raphael Patai, *The Jewish Alchemists* (Princeton, 1994), passim.

41. On Maimonides (who is known by several other names, including the Arabic Musa Ibn Maimun), see esp. *Moses ben Maimon, sein Leben, seine Werke, und sein Einfluss,* 2 vols., ed. W. Bacher, M. Brann, and D. Simonsen (Leipzig, 1908–14).

42. Many editions of this work (several of them abridged) exist. See Maimonides, *The Guide for the Perplexed,* ed. Michael Friedländer (London, 1919).

43. The Tetragammaton is described in great detail by Maimonides, ibid., 1:lxii.

44. Leonardo da Pisa describes his education in the introduction to his most famous work, the *Liber abbaci* (ca. 1202), a work on mathematics and calculation (see trans. L. E. Sigler, in Leonardo Pisano, *The Book of Squares,* ed. L. E. Sigler [Boston, 1987], xvi–xvii). On his other works and his place in the theoretical tradition of the Greeks and the algebraic tradition of the Arabs, see Joseph Gies and Frances Gies, *Leonard of Pisa and the New Mathematics of the Middle Ages* (New York, 1969); and Heinz Lüneburg, *Leonardi Pisani Liber Abbaci* (Mannheim, 1993).

45. The full text of the *Liber quadratorum,* together with an extensive commentary, can be found in Leonardo da Pisa, "Il libro dei quadrati di Leonardo Pisano," ed. Ettore Picutti, *Physis* 19 (1979): 195–339. For an English translation, see Pisano, *Book of Squares* (trans. Sigler). See also Elena A. Marchisotto, "Connections in Mathematics: An Introduction to Fibonacci via Pythagoras," *Fibonacci Quarterly* 31 (1993): 21–27.

46. Pliny has a great deal to say on the marvelous powers of plants in *Historia naturalis, XXII–XXVI,* esp. XXIV. Eventually he checks himself by admitting that magical claims have been so exaggerated in his time as to endanger the trust people have in herbs (XXVI.9).

47. This was discussed in chap. 2.

48. On alchemy in Antiquity see the important monographic survey on this subject in Marcellin Berthelot, *Collection des anciens alchimistes grecs,* 2 vols. (Paris, 1883); also idem, *Les origines de l'alchimie* (Paris, 1885).

49. Pliny, *Historia naturalis*, XXIV.99 and 102. On this subject see also Thorndike, *History of Magic*, 1:65–67.

50. Hippolytus, *Philosophumena*, VI.pref., I.2, and IV.43–44 (ed. Siouville, *Philosophumena, ou réfutation de toutes les hérésies*). On this see also Thorndike, *History of Magic*, 1:370.

51. John of Damascus, *On Orthodox Faith*, II.xix.90. See in John of Damascus, *La fede ortodossa*, ed. Vittorio Fazzo (Rome, 1998).

52. This translation is based on the text presented in Ernst Wickersheimer, "Figures médico-astrologiques des IXe, Xe, et XIe siècles," *Janus: Archives Internationales sur l'Histoire de la Médecine et la Géographie Médicale* 19 (1914): 168. On the Sphere of Pythagoras, see also idem, *Les manuscrits latins de médecine du haut Moyen Âge dans les bibliothèques de France* (Paris, 1966); Henry E. Sigerist, "The Latin Medical Literature of the Early Middle Ages," *Journal of the History of Medicine and Allied Sciences* 13 (1958): 127–47; idem, "The Sphere of Life and Death in Early Mediaeval Manuscripts," *Bulletin of the History of Medicine* 11 (1942): 292–303; and Centre Jean Palerne, *Bibliographie des textes médicaux latins Antiquité et haut Moyen Âge*, ed. Guy Sabbah, Pierre-Paul Corsetti, and Klaus-Dietrich Fischer (St.-Etienne, 1987).

53. Sigerist, "Latin Medical Literature of the Early Middle Ages," 146; see also Charles Singer, "Early English Magic and Medicine," *Proceedings of the British Academy* 9 (1920), esp. 8–11.

54. Arnaldus de Villanova, *Regimen sanitatis*, ed. Mathias Huss (Lyon, 1486). See also, generally, other medical writings of this author in *Opera medica omnium*, 16 vols., ed. M. R. McVaugh (Granada, 1938).

55. From Paris, *Bib.Nat.Lat.1616* (IX–X cent.), fols. 12 and 14 (trans. Carolyn Tuttle).

56. For an abbreviated list of Egyptian Days in early medieval manuscripts, see Thorndike, *History of Magic*, 1:695–66; regarding Arnaldo de Villanova see *Opera medica omnium*, 2:856.

57. Paris *Bib.Nat.Lat.7028* (XI cent.), fol. 154 (illustrated in Wickersheimer, "Figures médico-astrologiques des IXe, Xe, et XIe siècles," 163).

58. Arnaldus de Villanova, *Liber de vinis*, in *The Earliest Printed Book on Wine*, ed. H. Sigerist (New York, 1943), 42.

59. Ramón Llull, *Ars compendiosa medicinae*, passim, esp. chaps. 7–11 in Llull, *Principes de médecine*, ed. Armand Llinares (Paris, 1992).

60. Thorndike, *History of Magic*, 2:111–12.

61. Ibid., 2:112–18.

62. The passage reads: "Pitagoras in libro romano sanguis vpupe illit' homini dormenti: demoniaca gignit fantasmata" (Vincent of Beauvais, *Speculum naturale*, ed. "Printer of the Legenda Aurea" [Strasbourg, 1481], XVII.clxviii).

63. Thorndike, *History of Magic*, 2:433–85, passim.

64. Petrus de Abano, *Conciliator differentiarvm philosophorvm*, ded. to Andrea Vendramino Duce (Venice, 1476), esp. secs. 49 and 105. Regarding the life of Pietro da Abano, see Alberico Benedicenti, introduction to *Il Trattato "De Venensis,"* ed. A. Benedicenti (Florence, 1949). On his Pythagoreanism see Siraisi, *Arts and Sciences at Padua*, 68–71.

65. The medical doctor was Ebn Abi Ossaïbiah. On him see Lucien LeClerc, *Histoire de la médecine arabe* (Paris, 1876), 1:197–99.

66. See, e.g., the rich holdings of the Cambridge University Library in this area in *Hebrew Manuscripts at Cambridge University Library*, ed. Stefan C. Reif (Cambridge, 1997), esp. 322–56.

67. The most thorough studies of ancient alchemy are Berthelot, *Collection des anciens alchimistes grecs;* and idem, *Origines de l'alchimie.* Regarding the development of medieval alchemy, see idem, *Introduction a l'étude de la chimie des Anciens et du Moyen-Âge* (Paris, 1938); and idem, *La chimie au Moyen Âge,* 3 vols. (Paris, 1893). See also Luck, *Arcana Mundi, Magic, and the Occult;* and Carlos Gilly and Cis van Heertum, eds., *Magia, alchimia, scienza dal '400 al '700* (Florence, 2002), 2 vols.

68. See, e.g., Paris *Bib.Nat.Grec.* 2419 (a collection of such works); and the so-called *Book of Alums and Salts* (ninth to the eleventh centuries), which exists in several Arabic and Hebrew versions. On this see the discussion in Patai, *Jewish Alchemists,* 57–58, 119–24.

69. On a major category of medieval works of alchemy, known collectively as Hermetic books, see Thorndike, *History of Magic,* 2:214–28. For a Greek text of the *Turba Philosophorum* see *Turba Philosophorum,* ed. Julius Ruska (1931; reprint, Berlin, 1970). An English translation is available in *The Turba Philosophorum . . . Called Also the Book of Truth in the Art and the Third Pythagorean Synod,* ed. Arthur E. Waite (1896; London, 1970).

70. On this subject see the useful discussion in Patai, *Jewish Alchemists,* 35–36.

71. "Pythagoras saith: Those who, in conjunction with us, have composed this book which is called the *Turba . . .*"; *Turba Philosophorum* (trans. Waite, 66).

72. Berthelot, *Chimie au Moyen Âge,* vol. 1, esp. 252–58.

73. Thorndike, *History of Magic,* 3:57, 637. An example of the popularity of the *Turba* in the fifteenth century can be seen in a French manuscript from that century, now in Paris (*Bib.Nat.MS.Fr.19978*), which includes adaptations from the *Turba* in addition to adaptations of the *Practica* of Llull and the *Rosary* sometimes ascribed to Arnaldo da Villanova.

74. See Fideler, introduction to K. S. Guthrie, *Pythagorean Sourcebook and Library,* 30 and 43.

75. See, e.g., the discussion of Albertus Magnus on Boethius's Pythagorean doctrine in *Metaphysicorum Libri XIII,* 1.32 (in *B. Alberti Magni Ratisbonensis . . . Opera Omnia,* ed. August Borgnet [Paris, 1890], VI). On this see Pearl Kibre, "The Boethian *De Institutione Arithmetica* and the *Quadrivium* in the Thirteenth Century University Milieu at Paris," in Kibre, *Studies in Medieval Science,* esp. 78–79.

Chapter 8. Pythagoreanism in Ancient Art and Architecture

1. See Porphyry, *Life of Pythagoras,* 19–20; on the "Apollo religion" of the Pythagoreans in southern Italy, see von Fritz, *Pythagorean Politics in Southern Italy,* 1, 91–93.

2. On the Pythagoreanism of the finds in Velia (in Campagnia), see Marco Fabbri and Angelo Trotta, *Una scuola-collegio di età Augustea* (Rome, 1989), passim. See also Kingsley, *Ancient Philosophy,* 322–23.

3. Concerning these coins see esp. Karl Schefold, *Die Bildnisse der antiken Dichter, Redner und Denker* (Basel, 1997), 106–7 and figs. 37 and 38; Gisela M. A. Richter and R. R. R. Smith, *The Portraits of the Greeks* (Ithaca, 1984), 193 and fig. 153. See also Charles T. Seltman, *Greek Coins,* 2nd ed. (1933; London, 1955), 142–45 and pl. XXVIII.II; J. M. F. May, *The Coinage of Abdera,* 510–345BC (London, 1966), 137–67, no. 218; Colin M. Kraay, *Archaic and Classical Greek Coins* (Berkeley and Los Angeles, 1976), 155 and fig. 535; and J. S. Morrison, *Pythagoras of Samos* (Athens, 1983), n.p., with reproduction.

4. Euclid, *Elements,* IV.6–9; and Pseudo-Iamblichus, *Theology of Arithmetic,* 20.

The latter stresses the importance of the tetrad as the discovery of Pythagoras and a symbol to which Pythagoreans were devoted.

5. Most of our information on Democritus comes from Diogenes Laertius (*Lives of the Eminent Philosophers*, IX.36–49); on his life and interests, see Barnes, *Early Greek Philosophy*, 244–46. The monetary traditions of Abdera, an important center of coin types, is discussed in Seltman, *Greek Coins*, 142–44; and May, *Coinage of Abdera*, passim.

6. On these examples see esp. Schefold, *Die Bildnisse der antiken Dichter*, 412–13, figs. 290 and 291; Richter and Smith, *Portraits of the Greeks*.

7. On this contorniate, see Schefold, *Die Bildnisse der antiken Dichter*, 424 and fig. 309; also Richter and Smith, *Portraits of the Greeks*. The relation between the obverse and the reverse is discussed in K. A. McDowell, "A Portrait of Pythagoras," *Papers of the British School at Rome* 3 (1906), esp. 309–10.

8. The dimensions of the whole are 65.5 cm high and 56 cm wide. It was first discovered, and published, with the head broken off and missing from the shield frame, in R. R. R. Smith, "Late Roman Philosopher Portraits from Aphrodisias," *Journal of Roman Studies* 80 (1990), esp. 127–56. It was published again, after the missing head was found, in idem, "A New Portrait of Pythagoras," Aphrodisias Papers II, *Journal of Roman Archaeology*, suppl. ser. 2 (1991): 159–67.

9. The grouping is noted in Zanker, *Mask of Socrates*, 313. Respecting the character of the philosophers in relation to the nature of the building that housed them, R. R. R. Smith speculates that the structure was the school of a famous master teacher at Aphrodisias, a certain Asklepiodotos (Smith, "Late Roman Philosophers Portraits," esp. 153–54).

10. Morrison, *Pythagoras of Samos*, passim (with reproductions). Cf. de Vogel, *Pythagoras and Early Pythagoreanism*, 52–57.

11. Pliny, *Historia naturalis*, XXXIV.26.

12. On this (now lost) herm, see Cornelius C. Vermeule III, *Greek Sculpture and Roman Taste* (Ann Arbor, 1977), 70–71. On the Piazza d'Oro of Hadrian's villa at Tivoli, see Salvatore Aurigemma, *Villa Adriana* (Rome, 1996), 154–63.

13. On the turbaned man (Museo Capitolino, Sala dei Filosofi no. 80), see McDowell, "Portrait of Pythagoras," esp. 307–14; also see H. Stuart Jones, *A Catalogue of the Ancient Sculptures Preserved in the Municipal Collections of Rome: The Sculptures of the Museo Capitolino* (Rome, 1969), 1:251 and pl. 59. Regarding the man with the curly pointed beard (Museo Capitolino, Sala dei Filosofi no. 27), see ibid., 1:230 and pl. 57. The iconography of Pythagoras is discussed in Richter and Smith, *Portraits of the Greeks*.

14. Giovanni Becatti, "Ritratto di un vate antico," *Bollettino d'Arte* 24 (1949): 97–110; and idem, "Pitagora," in *Enciclopedia dell'arte antica classica e orientale*, ed. Ranuccio Bandinelli (Rome, 1965), 6:197–99.

15. Jean C. Balty, "Pour une iconographie de Pythagore," *Bulletin des Musées Royaux d'Art et d'Histoire*, ser. 6, no. 48 (1976): 5–33.

16. This head, from the Villa of the Papyri at Herculaneum, was published as Pythagoras in Schefold, *Die Bildnisse der antiken Dichter*, 152–53 and fig. 69.

17. Balty, "Pour une iconographie de Pythagore."

18. Christodorus of Thebes in Egypt, *Description of the Statues in the Public Gymnasium called Zeuxippos* (trans. Paton, 69). On this see Johann Jacob Bernoulli, *Griechische Ikonographie mit Ausschluss Alexanders und der Diadochen* (Munich, 1901), 1:75.

19. Julianus Prefect of Egypt, "On a Statue of Pythagoras," (*Anthologia Graeca,*

XVI.325) in *The Greek Anthology*, ed. W. R. Paton (London and New York, 1926), 5:353 (trans. Paton).

20. The mosaic formed part of a larger design that centered on Homer; it was surrounded by sixteen panels, each containing a portrait. Among the ten surviving panels is that of Pythagoras and those of Diogenes, Pherecydes, Demosthenes, Hesiod, Thucydides, and Solon. *Antalya Museum Guide* (Istanbul, 1990), 93–96, and figs. 89–90; also Jale Inan, *Toroslar' da bir Antik kent/Eine Antike Stadt im Taurusgebirge: Lyrbe? Seleukeia?* (Istanbul, 1998), 15, 86, and figs. 78, 82, 83. Fatih Onur suggests, based on peculiarities of the inscription, that its dating belongs to the fourth century (letter to the author). On this mosaic see also Smith, "Late Roman Philosopher Portraits," 151; and idem, "A New Portrait," 164–65.

21. Iamblichus, *Vita Pythagorica*, 2. The temples of Samos are discussed in L. Vlad Borrelli, "Samos," in *Princeton Encyclopedia of Classical Sites*, ed. Richard Stillwell (Princeton, 1976), 802–3.

22. On these temples see D. Adamesteanu, "L'agora di Metaponto," in *Scritti di archeologia ed arte in onore di C. M. Lerici* (Stockholm, 1970), 39–43; idem, "Argoi Lithoi a Metaponto," in *Adriatica praehistorica et antiqua* (Zagreb, 1970), 307–24; idem, "Il santuario di Apollo e urbanistica generale," in *Metaponto*, 1:15–311 (Naples, 1975); D. Adamesteanu, D. Mertens, and Antonio De Siena, "Metaponto, Santuario di Apollo, tempio D . . . Rapporto preliminare," as cited in De Juliis, *Metaponto*, esp. 138–51 and 221–22. On the cult of Apollo in Metapontum, see De Juliis, 60–61.

23. This temple, near the modern town of Cirò, whose ruins (which contained numerous gold laurel crowns as well as two large statues of Apollo, one of marble and the other of bronze, and two smaller statues of him, one of gold and the other of bronze) were discovered in 1924, has been published fragmentarily. See Randall MacIver, *Greek Cities in Italy and Sicily* (Oxford, 1931), 68–69; Paolo Orsi, "Templum Apollinis Alaei," *Atti e memorie della Società Magna Grecia* (1932): 9–15 (with reconstruction and plan); William B. Dinsmoor, *The Architecture of Ancient Greece*, 3rd ed. (1927; London, 1950), 84, 267; Luigi Rocchetti, "Cirò," in *Enciclopedia dell'arte antica, classica, e orientale* (Rome, 1959), 2:693–94; Maria Grazia Aisa, "Storia delle ricerche sul santuario di Apollo Aleo a Cirò Marina," in *Santuari della Magna Grecia in Calabria*, ed. Elena Lattanzi (Naples, 1996), 286–89; Madeleine M. Horn, "Resti di due grandi statue di Apollo ritrovati nel santuario di Apollo Aleo di Cirò," in Lattanzi, *Santuari della Magna Grecia*, 261–64; and Luigi La Rocca, "Cirò Marina, I rinvenimenti nel Santuario di Apollo Aleo," in Lattanzi, *Santuari della Magna Grecia*, 266–69. On the topography of this site, see Roberto Spadea, "Note di topografia da Punta Alice a Capo Colonna," in Lattanzi, *Santuari della Magna Grecia*, 247–51. On the cult of Apollo in Croton, see Alfonso Mele, "I culti di Crotone," in Lattanzi, *Santuari della Magna Grecia*, 235–39.

24. On the temples to the Muses and to Apollo in Croton, see Carmelo G. Severino, *Crotone* (Bari, 1988), 12 and n. 28. For the comments attributed to Aristotle, see "On Marvellous Things Heard," 840a, in *Aristotle: Minor Works*, ed. W. S. Hett (Cambridge, MA, and London, 1936), 289.

25. This is suggested by Livy, who reports that in about 510 BC the king of Etruria went to great trouble to consult Apollo's oracle at Delphi (Livy, *Ab urbe condita libri*, I.56–57). On this see Gagé, *Apollon romain*. On the tradition of Apollo in the oracles and riddles in Etruria, see Kingsley, *In the Dark Places of Wisdom*, passim.

26. Regarding the origins and early settlement of Rome, see Einar Gjerstad, *Early Rome, Acta Instituti Romani Regni Sueciae* (Lund, 1953–66), 1 (1953), 2 (1956), 3

(1960), 4 (1966); Léon Homo, *L'Italie primitive et les débuts de l'impérialisme romain* (Paris, 1925); idem, *Rome impériale et l'urbanisme dans l'antiquité* (1951; Paris, 1971), esp. 28–78; Raymond Bloch, *The Origins of Rome* (New York, 1960); and Ernest Nash, "Roma," *The Princeton Encyclopedia of Classical Sites*, ed. Richard Stillwell, 763–67; and Angelo Brelich, *Tre variazioni romane sul tema delle origini* (Rome, 1955).

27. Romulus, the first king of Rome, is traditionally regarded as the founder of the city. On Servius and his accomplishments, see Livy, *Ab urbe condita libri*, I.42–45; and Ovid, *Fasti*, VI.569–73. On the tradition attributing the enrichment of Rome to Servius, see Brelich, *Tre variazioni romane*, esp. 28–31, and 42.

28. As the first of the Greek gods to enter the system of Roman worship, Apollo is known in Rome from the fifth century BC, when he was regarded primarily as a healer. This subject, and its relation to the construction of the first Roman temple in his honor, is studied in Georges Dumézil, *La religion romaine archaïque* (Paris, 1987), esp. 441–43 and 448. The larger aspect of the history of the cult of Apollo in Rome is the subject of the important study of Gagé, *Apollon romain*. Regarding the temple, which contained a square interior space equal to the width of its six-columned entrance porch, of which only a trace remains today, see Richard Delbrück, *Das Apollotempel am Marsfeld* (Rome, 1903); and Giuseppe Lugli, *Roma antica: Il centro monumentale* (Rome, 1946), 538–45.

29. On the receiving of advice from oracles by the Roman oligarchy as a sarcedotal experience, see W. Warde Fowler, *Roman Festivals of the Period of the Republic* (Port Washington, NY, 1969), 181; and idem, *The Religious Experience of the Roman People from the Earliest Times to the Age of Augustus* (1911; New York, 1971), 326.

30. Livy, *Ab urbe condita libri*, III.63–64.

31. Pliny the Elder, *Historia naturalis*, XXXIV.26. On the *comitium* of Rome, located to the east of the forum, see Paolo Carafa, "Il comizio di Roma dalle origini all'età di Augusto," *Bullettino della Commissione Archeologica Comunale di Roma* (Supplemento 5, 1998).

32. Cicero, *Brutus*, 53 and 78. Regarding the former, Cicero says that the Consul Lucius Brutus was devoted to Apollo. See also *De natura deorum*, II.69 and III.55.

33. Regarding these *ludi Apollinares*, see Gagé, *Apollon romain*, esp. 224–26.

34. Livy, *Ab urbe condita libri*, V.13.

35. Ibid., V.20–23.

36. Ibid., VII.20 and X.8.

37. Ibid., IV.25–30.

38. Ibid., XL.37.

39. Gagé, *Apollon romain*, 224–96; "Apollon, dieu de Numa: Les 'gentes' pompiliennes et les débuts de la propagande Pythagorisante," 313–47; and 685–93. Regarding this "dogma," discussed in chap. 2 of this volume, see e.g., Livy, *Ab urbe condita libri*, I.17–18.

40. Suetonius Tranquillus, vita of *Augustus*, 29 and 52, in *De vita Caesarum* (*Lives of the Twelve Caesars*). For a description of the temple (which suffered severe damage in the great fire during Nero's reign), which consisted of a closed interior space preceded by an entrance bay six columns wide, and its sculptures, see Lugli, *Roma antica*, 434–41 and 449. Regarding the library, which consisted of two large rooms, see ibid., 436–37 and 475–79. Both buildings are noted in various works by ancient writers. Cf. the discussion of both in Paul Zanker, *Augustus und die Macht der Bilder* (Munich, 1987), 73–79.

41. The bringing to Rome of the cult statue, made of cedar wood, is reported by

Pliny (*Historia naturalis,* XIII.53). Regarding the rebuilding of the temple (now lost save for fragments of its frieze) and its dating, see Diana E. E. Kleiner, *Roman Sculpture* (New Haven and London, 1992), 84–86.

42. Suetonius Tranquillus, *Augustus,* 57.

43. Ibid., 70.

44. Ibid., 94.

45. Ibid., 78 and 80.

46. Aristotle attributed this cosmological system to the Pythagoreans, in *De caelo,* 293A–B. The positioning of the mausoleum is discussed in Claude Nicolet, *Space, Geography and Politics in the Early Roman Empire* (Ann Arbor, 1991), 16–18.

47. The Mausoleum of Augustus is described by Strabo in his *Geography,* V.39. The present dilapidated condition of the exterior makes it difficult to ascertain the details of its original entrance. On this building see Giuseppe Lugli, *I monumenti antichi di Roma e suburbio* (Rome, 1930–38), 2:35–36, and 3:194–204; William MacDonald, *The Architecture of the Roman Empire* (1965; New Haven, 1982), 1:11; Ernest Nash, *Pictorial Dictionary of Ancient Rome,* rev. ed. (London, 1968), 2:38–43 (with bibliography); L. Duret and J.-P. Néraudau, *Urbanisme et métamorphoses de la Rome antique* (Paris, 1983), esp. 240 and 329–30; and Romolo A. Staccioli, *Guida di Roma antica* (1986; Milan, 1994), 350–55. On the *tumulus* as an architectural form see André Pelletier, *L'urbanisme romain sous l'empire* (Paris, 1982), 172.

48. See Suetonius, vitae of *Tiberius* (74), *Caligula* (21), and *Nero* (25 and 53), respectively.

49. On this see Gagé, *Apollon romain,* 692–93.

50. On the Severan Septizodium, which, dedicated in AD 203, formed a splendid entrance to the emperor's palace on the Palatine, see esp. Theodor Dombart, *Das Palatinische Septizonium zu Rom* (Munich, 1922). See also Andrea Augenti, "Il Palatino nel medioevo, archeologia e topografia," *Bullettino della Commissione Archeological Comunale di Roma* (1996), esp. 95–99. For further bibliography see Nash, *Pictorial Dictionary of Ancient Rome,* 2:302.

Chapter 9. The Oldest Surviving Pythagorean Building

1. An entire literature has developed around the discovery of this building. See esp. E. Gatti and F. Fornari, "Brevi notizie relative alla scoperta di un monumento sotterraneo presso Porta Maggiore," in *Notizie degli Scavi* (Rome, 1918), 30–52; Franz Cumont, "La basilique souterraine de la Porta Maggiore," *Revue Archéologique* 8 (1918): 52–73; Rodolfo Lanciani, "Il santuario sotterraneo recentemente scoperto," *Bullettino della Commissione Archeologica Comunale di Roma* 46 (1918): 69–84; Salamon Reinach, "Une grande découverte dans la banlieu de Rome," *Revue Archéologique* 7 (1918): 185–95; C. Densmore Curtis, "Sappho and the 'Leucadian Leap,'" *American Journal of Archaeology* 24 (1920): 146–51; Goffredo Bendinelli, "Il mausoleo sotterraneo altrimenti detto basilica di Porta Maggiore," *Bullettino della Commissione Archeologica Comunale di Roma* 49 (1922): 85–126; Jérôme Carcopino, "Encore la basilique de la 'Porta Maggiore,'" *Revue Archéologique* 18 (1923): 1–23; Eugenia Strong and Norah Jolliffe, "The Stuccoes of the Underground Basilica," *Journal of Hellenic Studies* 44 (1924): 65–111; Emily L. Wadsworth, "Stucco Reliefs of the First and Second Centuries Still Extant in Rome," *Memoirs of the American Academy in Rome* 4 (1924): 9–102; Goffredo Bendinelli, "Il monumento sotterraneo di Porta Maggiore in Roma," *Monumenti Antichi* 31 (1927): 601–859; Jérôme Carcopino, *La basilique pythagoricienne de la Porte Majeure* (Paris, 1927); Boyancé, "Leucas," 211–19; Lugli, *I*

monumenti antichi di Roma e suburbio, 3:495–515; Salvatore Liberti and Vittorio Per-
rone, "Note sulle condizioni della Basilica sotterranea di Porta Maggiore," *Bollettino
dell'Istituto Centrale del Restauro* (Rome), nos. 3–4 (1950): 122–43; Salvatore Au-
rigemma, *La basilica sotterranea neopitagorica di Porta Maggiore in Roma* (Rome,
1961). See also, generally, Nash, *Pictorial Dictionary of Ancient Rome,* 1:169ff.

2. See Ovid, *Metamorphoses,* XV.112; and Porphyry, *Life of Pythagoras,* 36. See
also the discussion of Carcopino on this subject in "Encore la basilique," 11–12.

3. Carcopino, *Basilique pythagoricienne de la Porte Majeure,* 218. This structure
has been carefully described by a number of archaeologists, as cited in n. 1. See esp.
ibid., passim.

4. On the Pythagoreanism of this concept, see Kingsley, *In the Dark Places of Wis-
dom,* passim, esp. 70–89.

5. "They took a morning walk, alone, and in places where peace and quiet were appro-
priate, where there were shrines or sacred groves. . . . only after the . . . walk did they meet
each other, preferably in sanctuaries." Iamblichus, *Vita Pythagorica,* 21 (trans. Clark).

6. The tradition that Pythagoras descended into Hades was discussed in chapters 1
and 3. Its long history begins with Herodotus's fifth-century BC description that a slave
of Pythagoras's built an underground chamber based on the instructions of Pythagoras,
from which the slave emerged after three years, claiming he had risen from the dead. In
the third century BC Hermippus said that Pythagoras had constructed an underground
apartment where he spent considerable time, eventually emerging into the light. This
description of his stay in Hades persisted into late Antiquity and was later described in
detail by Diogenes Laertius.

7. Porphyry, *Life of Pythagoras,* 27; Iamblichus, *Vita Pythagorica,* 5; and Diogenes
Laertius, *Lives of the Most Eminent Philosophers,* VIII.I.3.

8. Carcopino, *Basilique pythagoricienne de la Porte Majeure,* esp. 218–22.

9. Plato, *The Republic,* VII, esp. 514A–B. Cf. Homer, *The Odyssey,* XIII.101–112;
and Empedocles, frag. B 120 (trans. Barnes, *Early Greek Philosophy,* 197).

10. Porphyry, *De antro nympharum,* 5–8 (trans. John M. Duffy, in Porphyry, *The
Cave of the Nymph in the Odyssey* [Greek and English texts] [Buffalo, 1969]), at 8.

11. Iamblichus, *Vita Pythagorica,* 23 (trans. Clark).

12. Porphyry, *De antro nympharum,* 3.

13. Plutarch, in *Life of Numa,* XIV.4, had explained the importance, for
Pythagorean worshippers, to not turn their backs to the sun. Regarding the injunction
to pray to the sun as it rises, see Iamblichus, *Vita Pythagorica,* 35 (trans. Clark). See
also Diogenes Laertius, *Lives of the Most Eminent Philosophers,* VII.I.15; also
Iamblichus, *Vita Pythagorica,* 21.

14. Iamblichus, *Vita Pythagorica,* 21.

15. Homer, *The Odyssey,* XIII.101–12; and Porphyry, *De antro nympharum,* 1–2,
and 23.

16. Iamblichus, *Vita Pythagorica,* 28; see also Carcopino, *Basilique pythagorici-
enne de la Porte Majeure,* 226–27.

17. Carcopino, *Basilique pythagoricienne de le Porte Majeure,* 231.

18. Porphyry, *Life of Pythagoras,* 42; and Iamblichus, *Vita Pythagorica,* 18, 21 and
28. On this see also Carcopino, *Basilique pythagoricienne de la Porte Majeure,* 232–33.

19. Iamblichus (*Vita Pythagorica,* 21) describes the evening meal as consisting of
these foods, together with meat from sacrificial animals. This suggests either that not
all Pythagoreans were vegetarians or that some sects made exceptions in the case of sac-
rificial animals. He also describes the clothing worn by the faithful and the ritual of
reading after the meal. According to this ritual, the eldest member selected a text,

which was then read by the youngest. The subjects of these texts were focused on respect for plants and animals, piety to god, and virtuous behavior. On the tables, their arrangement, and their function, see Carcopino, *Basilique pythagoricienne de la Porte Majeure*, 247–57, passim.

20. On the size of dining groups, see Iamblichus, *Vita Pythagorica*, 21. Carcopino's analysis is contained in *Basilique pythagoricienne de la Porte Majeur*, esp. 220–63.

21. Strong and Joffiffe clearly state that in their opinion the number of original portraits, twelve, was significant ("Stuccoes of the Underground Basilica," 102).

22. Plato, *Timaeus*, 55.

23. The tripartite soul is discussed by Diogenes Laertius (*Lives and Opinions of the Eminent Philosophers*, VIII.30). His source is a Hellenistic scholar, Alexander Polyhistor (b. 105 BC), a Greek who lived in Rome and who would have been recently dead at the time the basilica was built. On these numbers see, e.g., Pseudo-Iamblichus, *Theology of Arithmetic*, passim.

24. See the essential bibliography in n. 1. On the Neopythagoreanism of the discernible subjects in the reliefs, see esp. Cumont, "La basilique souterraine"); Carcopino, "Encore la basilique,"; and Aurigemma, *La basilica sotteranea neopitagorica*, esp. 14–15.

25. See esp. Cumont, "La basilique souterraine," passim; and Carcopino, "Encore la basilique," esp. 293.

26. See Boyancé, "Leucas."

27. Pliny, *Historia naturalis*, XXII.20.

28. Regarding the tradition that says Pythagoras included consideration of women in his lectures, see esp. Iamblichus, *Vita Pythagorica*, 11. On this see the discussion in Boyancé, "Leucas," 218–19.

29. See, e.g., Leslie Brubaker, "Basilica," in *Dictionary of the Middle Ages* (New York, 1983), 2:123–25.

30. The transition from the basilica of the initiated to that of the Christian religion is postulated in Gabriel Leroux, *Les origines de l'édifice Hypostyle* (Paris, 1913), passim, and enthusiastically accepted by Carcopino in "Encore la basilique," 12–13. On early Christian religious architecture, see esp. Richard Krautheimer, *Corpus Basilicarum Christianarum Romae*, 5 vols., Monumenti di antichità cristiana (Vatican City, 1937–77). See also F. Deichmann, *Frühchristliche Kirchen in Rom* (Basel, 1948); and J. Davies, *The Origin and Development of Early Christian Church Architecture* (London, 1952). The geography of pagan cultic structures is studied in L. Michael White, *Building God's House in the Roman World* (Baltimore and London, 1990).

Chapter 10. The Pythagoreanism of Hadrian's Pantheon

1. Vitruvius, *De architectura*, IV.v. On Roman circular temples, known in limited number in the Republican age and the first age of the empire, see Louis Hautecoeur, *Mystique et architecture: Symbolisme du cercle et de la coupole* (Paris, 1954), 76–100; and Luigi Crema, "L'architettura romana," in *Enciclopedia classica III: Archeologia e storia dell'arte classica* (Turin, 1959), 12(1): 375–81.

2. For a basic bibliography on this structure, see Nash, *Pictorial Dictionary of Ancient Rome*, 2:170–71; also Kjeld De Fine Licht, *The Rotunda in Rome* (Copenhagen, 1968); William MacDonald, *The Pantheon: Design, Meaning and Progeny* (London, 1976); Henri Stierlin, *Hadrian et l'architecture romaine* (Fribourg, 1984); Mary Taliaferro Boatwright, *Hadrian and the City of Rome* (Princeton, 1987); Flaminio Lucchini, *Pantheon* (Rome, 1996); Susanna Pasquali, *Il Pantheon: Architettura e antiquaria nel Set-*

tecento a Roma (Modena, 1996); and Christiane Joost-Gaugier, "The Iconography of Sacred Space: A Suggested Reading of the Meaning of the Roman Pantheon," *Artibus et Historiae* 38 (1998): 21–42, where the ideas presented in this chapter were first offered.

3. For recent discussions of Hadrian's building activity see Stierlin, *Hadrian et l'architecture romaine;* Boatwright, *Hadrian and the City of Rome;* and William MacDonald and John A. Pinto, *Hadrian's Villa and Its Legacy* (New Haven and London, 1995). Regarding the herm of Pythagoras commissioned by Hadrian for the Piazza d'Oro of his villa at Tivoli, see Vermeule, *Greek Sculpture and Roman Taste.*

4. Regarding the forecourt of Hadrian's Pantheon, whose dimensions are unknown, see the proposed reconstruction in the model in the Museo della Civiltà Romana. See also Emma Marconcini, "La costruzione della Fontana," and "La piazza nelle immagini e nei documenti," both in *La fontana del Pantheon,* ed. Luisa Cardilli (Rome, 1993), 49–57 and 31–49, respectively.

5. On this see George M. Hanfmann, *Roman Art* (Greenwich, CT, 1964), 72.

6. The gilded bronze tiles were removed in 663. The golden dome of the Pantheon was already legendary in the late twelfth century, when the *Mirabilia Urbis Romae* was composed; however, it seems that traces of the gold still remained: "On top of the Pantheon, that is to say Santa Maria Rotonda, stood the golden Pine Cone that is now in front of the door of Saint Peter's. The church was all covered with tiles of gilded brass, so much so that from afar it seemed to be a mountain of gold. *The beauty of this is still discerned in part* [italics mine]. And on top of the front of the Pantheon stood two bulls of gilded brass." *The Marvels of Rome,* 2nd ed., ed. and trans. F. M. Nichols (New York, 1986), 37; cf. ibid., 22, which refers to a gilded image set at the top of the temple above the oculus and the roof of gilded brass.

7. In both previous instances of the use of the oculus in composing a large circular space dominated by a domed rotunda (the so-called Temple of Mercury at Baia and the octagon of Nero's Domus Aurea) it is possible, particularly in the latter case because of Nero's identification with the sun, that devotion to Apollo was involved.

8. See Photius's summary of Nicomachus, *Theologoumena arithmeica,* in Photius, *Bibliothèque,* 187, according to which Nicomachus described the universality of the unity expressed by the monad as symbolized by the god Apollo. See also subsequent writers who echo this, e.g., Anatolius, as published by Tannery ("Anatolius," 13). In referring to the authority of Nicomachus of Gerasa, the later Pythagorean Iamblichus explains the monad as the most authoritative of numbers because it is the sun that rules (Pseudo-Iamblichus, *Theology of Arithmetic,* esp. 37–38). Authors as late as Macrobius use this traditional language in describing the number one (Macrobius, *Commentary on the Dream of Scipio,* VI.7). Cf. Nicomachus, *Introduction to Arithmetic,* II.xvii. For the comments of Numenius, who said that Pythagoreans gave the name of monad to (their) god, who was Apollo, see *Numenius: Fragments,* 52. See also Plutarch, *Isis and Osiris,* 354F. Pythagoras's identification of the monad with god or Apollo is also reported by other contemporaries such as Aëtius and Philo, as discussed in this text. Excerpting from earlier authors in the fifth century AD, Stobaeus would also report this.

9. On the origins of Apollo's assimilation with the sun, master of the universe (which occurred in Hellenistic times), see Cumont, *Recherches sur le symbolisme funéraire,* 259–60, esp. n. 7. Apollo's role in the divine structure of the universe was central, a fact that leads in turn to his other role as a unifier, a role implicit in the Pythagorean explanation of the etymology of his name, *a–pollo,* or *alpha* (denying) and *pollo* (multiplicity). As Plato explained in the *Cratylus* and Plutarch later reaffirmed, the name Apollo refers to Oneness and Unity. The fact that Apollo was the god central

to Pythagoreanism is connected with the Pythagorean belief that Pythagoras was named after Pythian Apollo. See Plato, *Cratylus*, 404E–406C; cf. Plutarch, *The E at Delphi*, 393C and 394A, where he defines the name Apollo as meaning the abjuration of multiplicity and symbolizing one and one alone or unity simple and pure; also idem, *Isis and Osiris*, 381F; and Plotinus, who in the *Fifth Ennead* (at V) discusses the Pythagorean concept of Apollo as meaning the negation of plurality or the repudiation of the multiple. The descent of Pythagoras from Pythian Apollo was discussed in chapter 3. Concerning Apollo as the father of Pythagoras, see Cumont, *Recherches sur le symbolisme funéraire*, 197, esp. n. 4.

10. Concerning this "nuptial" number cited by Plato, see *The Republic*, VIII.546B. See Michael J. B. Allen, *Nuptial Arithmetic: Marsilio Ficino's Commentary on the Fatal Number in Book VIII of Plato's "Republic"* (Berkeley, Los Angeles, and London, 1994), 79. Cf. Pseudo-Iamblichus, *Theology of Arithmetic*, 65–66. Cf. also Macrobius, *Commentary on the Dream of Scipio*, VI.6.

11. On the unusual numerical combination represented by the coffer rows (five) and the vertical divisions (twenty-eight), see De Fine Licht, *Rotunda in Rome*, 140 and 200–201; Giangiacomo Martines, "Argomento di geometria antica a proposito della cupola del Pantheon," *Quaderni dell'Istituto di Storia dell'Architettura*, n. s., 13 (1989): 8; and Lucchini, *Pantheon*, 109. Regarding the circularity of the number five, see Theon of Smyrna, *Expositio rerum mathematicarum ad legendum platonem utilium*, 100–102 (Theon was, by his own admission, a Pythagorean). On this number as the marriage number, see Burkert, *Lore and Science in Ancient Pythagoreanism*, 467; Heninger, *Touches of Sweet Harmony*, 242; and Allen, *Nuptial Arithmetic*, 66.

12. Regarding the number seven, Apollo was believed (by Pythagoreans) to have been born on the seventh day of the month. His principal feast days fell on the seventh day of every month. On the birth of Apollo (on the seventh), see Hesiod, *Works and Days*, 770–71. On the tradition of Apollo's birthday and its symbolism in the number seven, see Nicomachus, *Manual of Harmonics*, 74. On this tradition generally, see Stefos Anastase, *Apollo dans Pindare*, esp. 21 and 256. The trigon derives from *tri* (three) + *gonia* (angle). On its circularity, see Theon of Smyrna, *Exposition rerum mathematicarum ad legendum platonem utilium*, 38. On the number three in other Pythagorean texts, see Allen, *Nuptial Arithmetic*, 65.

13. On Apollo as the apex of the triangle, see chap. 3, n. 30. The perfection of the triad was explained by Anatolius and elaborated by Nicomachus, both cited in Pseudo-Iamblichus, *Theology of Arithmetic*, 51–52. Apollo is, of course, number one in the triangular formation of the tetraktys.

14. Hadrian sat on a bench in the Pantheon to administer justice, we are told by his biographers; indeed, they emphasize his interest in judicial matters and his activity as a judge and legislator. See Dio Cassius, *Roman History*, LXIX.7; and Aelius Spartianus (considered to be one of the more reliable authors of the compilation known as the *Scriptores historiae augustae*), Hadrian, XVII and XXII.

15. On the symbolism of the numbers three and four, see Nicomachus, *Theologoumena arithmetica*. Known throughout Antiquity, the Pythagorean principle of the four elements is explained by Vitruvius (*De architectura*, VII.Pref.1). This tradition was affirmed by Theon of Smyrna in *Expositio rerum mathematicarum ad legendum platonem utilium*, 93–99.

16. Following Theon, Macrobius would soon note the tradition of the dual power of binding possessed by the number seven in that it inherits the qualities of three and four (Macrobius, *Commentary on the Dream of Scipio*, VI.34); on this see Heninger, *Touches of Sweet Harmony*, 151.

17. On the significance of the number seven and the birthday of Apollo, see n. 12. On this see also Christiane Joost-Gaugier, "Sappho, Apollo, Neopythagorean Theory, and Numine Afflatur in Raphael's Fresco of the Parnassus," *Gazette des Beaux-Arts* 121 (1993): passim. Pythagorean belief in the "magic" of the number 64 is reported in Pseudo-Iamblichus, *Theology of Arithmetic*, 87. Although the attic story originally contained 64 panels, in the mid-eighteenth century it was remodeled for unknown reasons; as a result, its design was changed and its present blind windows were incorporated. An early sixteenth-century pen drawing of the Pantheon interior by Raphael (Uffizi 164A) shows the original distribution of the pilasters. A later drawing by Palladio records the same arrangement (Andrea Palladio, *The Four Books of Architecture* [1570; 1738, ed. Isaac Ware; reprint, New York, 1965], plates LVII and LVIII); whereas in the seventeenth century Antoine Desgodetz records the number of pilasters as sixty-four (*Les édifices antiques de Rome dessinés et mesurés très exactement par Antoine Desgodetz architecte* [Paris, 1682], plates VI and VII). An engraving by Piranesi, which confirms the above, is reproduced in De Fine Licht, *Rotunda in Rome*, fig. 129. A section of the attic story, restored in the 1930s in accordance with Raphael's drawing, is visible today.

18. On the number four and the cosmos, see Heninger, *Touches of Sweet Harmony*, 160. On sixteen as a "prime" cube, see Allen, *Nuptial Arithmetic*, 60–62. On the significance of sixty-four as the great unifier, see Anatolius, in Tannery, "Anatolius," 20; and Boethius, *De institutione musica*, I.X and XLIII, and esp. II.XXVII.

19. On this see Pseudo-Iamblichus, *The Theology of Arithmetic*, annotated edition, ed. Peter Gravinger (Athens, 1983), 20–21, 86–90, and 108. Regarding the cube, see preceding note.

20. Aristotle noted that Antiphon had tried in vain in the fifth century BC to square the circle; Hippocrates of Chios, on the other hand, had falsely thought, in the following century, that he had achieved this goal. Also in about the fourth century BC, Bryson of Heraclea inscribed a square around the circle and a square within a square in order to prove that the circle is intermediate between two squares. He was thought to have achieved the goal of demonstrating the quadrature of the circle, an idea that would be powerfully developed by Archimedes. Later Pythagoreans, e.g., Simplicius, believed that the solution to the problem of the squaring of the circle had been discovered by Pythagoreans "of the past" who had "received" the method from "earlier" traditions. On these, see Aristotle, *Physics*, I.II.185A; Philoponus, *Commentary on Aristotle's Physics*, in Thomas, *Greek Mathematical Works*, 1:235; and Alexander Aphrodisiensis, *Commentary on Aristotle's Sophistic Refutations*, in Thomas, *Greek Mathematical Works*, 1:315–17. Archimedes is the author of a work titled *Measurement of a Circle*. For this he was praised by Proclus (Thomas, *Greek Mathematical Works*, 1:317). For Simplicius's explanation of the Pythagorean discovery of squaring the circle (in his *Commentary on Aristotle's Categories*), see Thomas, *Greek Mathematical Works*, 1:335. In the first century AD Sextus Pythagoricus claimed that the square inscribed in the circle was an "old" tradition of Pythagoreans (Heath, *History of Greek Mathematics*, 1:220–21). On the importance of various concepts of squaring the circle to Pythagoreans, see Heninger, *Cosmographical Glass*, 184–86.

21. The Pythagorean view of the number eight as Justice (it is the product of equals: $2 \times 2 \times 2$) is described by Macrobius (*Commentary on the Dream of Scipio*, V.15) and Pseudo-Iamblichus, *Theology of Arithmetic*, 102. On eight as the number of egalitarian justice in Pythagoreanism, see Allen, *Nuptial Arithmetic*, 69. The number eight as symbolizing universal harmony is discussed by Heninger (*Touches of Sweet Harmony*, 179–87, passim).

22. Nicomachus, *Manual of Harmonics*, 99–106.

23. The pavement of the Pantheon was severely damaged by water from the overflowing Tiber in 1598 (which rose to 6.58 meters in the Pantheon); this damage was not to be repaired until the nineteenth century, when it appears it was repaired following its original design, and not rebuilt anew. Although there is no evidence of any change in its present design, both Lanciani and MacDonald assure us that the pavement is Hadrian's original one. See Rodolfo Lanciani, *The Ruins and Excavations of Ancient Rome* (Boston and New York, 1897), 11 and 482–83, which emphasizes that the pavement is Hadrian's circular one and not the previous pavement, which was rectangular; the marbles of which it is made were used "only under the Empire," this eminent archaeologist declares. Also to be considered is the fact that the pavement was repaired during Lanciani's lifetime, in 1873, whereas Lanciani's described report dates from 1897. See also MacDonald, *Pantheon*, 35, who considers that despite its having been repaired, "the effect is genuinely Hadrianic." The design of the Pantheon's pavement is discussed in Tons Brunés, *The Secrets of Ancient Geometry and Its Use* (Copenhagen, 1967), 2:38–56.

24. The various attempts to solve the problem of the quadrature of the circle (according to the arguments of some, e.g., the late fourth-century mathematician Bryson, a square could be inscribed and circumscribed to a circle in order to determine the geometric mean between the two) are discussed in n. 20. Heath, *History of Greek Mathematics*, 1:220–21, discusses the Pythagoreans' claim to have solved this problem as originating with a certain "Sextius the Pythagorean," who lived in Augustan times but got his information from 'early traditions. Cf. Simplicius of Cilicia, *Commentaire sur les catégories*, who, writing several centuries later, got his information from "the divine Iamblichus."

25. The perfect correspondence of the height and breadth of this structure was admired by both Serlio and Palladio. The diameter of the vault at its base is 142 (English) feet, exactly the same as the height of the oculus from the center of the pavement. On this see MacDonald, *Architecture of the Roman Empire*, 103–4. Vitruvius notes the special interest of Pythagoreans in the cube, in *De architectura*, V.Pref.3–4; he also recommends that architects take note of Pythagorean instructions (ibid., X.Pref.6). Cf. Hersey, *Pythagorean Palaces*, passim. On the geometry of the space, and the cube as the key figure in the design of the Pantheon, see Kim Williams, *Italian Pavements: Patterns in Space* (Houston, 1997), fig. 48.

26. Vitruvius, *De architectura* 3.2. See also Theon of Smyrna, *Expositio rerum mathematicarum ad legendum platonem utilium*, 114. The number four, important in Pythagorean arithmology for the various reasons cited above, also signified justice, as did eight. According to this tradition, four is justice because it is equal × equal; on this see Burkert, *Lore and Science in Ancient Pythagoreanism*, 467. On the number eight as Justice, see n. 21.

27. On number four as representing a complete "egality" when squared, see Anatolius, *On the Decad* (in Tannery, "Anatolius," 16). Crediting Anatolius, Nicomachus in his *Manual of Harmonics* refers to the number sixteen as the double octave in harmonics (153–56). For Euclid's reference to twenty-eight as a perfect number, see *Elements*, IX. On the number twenty-eight as perfect in relation to its parts, see Pseudo-Iamblichus, *Theology of Arithmetic*, 90. Regarding Boethius's comment on this as a perfect number, see *De institutione arithmetica*, I.XIX–XXI. The perfect nature of this number forms the centerpiece of Martines's argument ("Argomento di geometra antica," 8) that the cupola is a unique example of ideal geometry.

28. For the statement about "earlier Pythagoreans," see Pseudo-Iamblichus, *Theology of Arithmetic*, passim.

29. Porphyry and Iamblichus both acknowledge their debt to Nicomachus; see e.g., Porphyry, *Life of Pythagoras*, 20; and Iamblichus, *Vita Pythagorica*, 26, 35; also Pseudo-Iamblichus, *Theology of Arithmetic*, 35–37, 51, 74, 88.

30. On this see D'Ooge, introduction to *Nicomachus of Gerasa*, 77.

31. On Hadrian's many active and varied intellectual interests and his association with philosophers, teachers, and intellectuals, see the biographies of Dio Cassius, *Roman History*, and Aelius Spartianus, as cited earlier; also that of Aurelius Victor (in *Liber de Caesaribus*, XIII). On Hadrian's rewards to intellectuals, see Philostratus, *Lives of the Sophists*, VIII (Favorinus) and XXV (Polemo). On the preparation of an architect, see Vitruvius, *De architectura*, I.I.1–17.

32. For the text of the dedication, see the Levin edition, 33.

33. Philostratus, *The Life of Apollonius of Tyana*, VIII.XX. According to Philostratus, Hadrian owned "the most complete and pure philosophical text," the tenets of Pythagoras. Evidence of Hadrian's Pythagoreanism can also be found in his early biographies.

34. Plotina is frequently mentioned by Dio Cassius, *Roman History*, and in the compilation of Trajan's life associated with Aelius Spartianus. Without doubt, she was important for Hadrian and appears to have been responsible for the fact that he succeeded her husband as emperor. When she died (in 122), Hadrian dedicated a basilica at Nimes in her honor as well as a building in Rome. The rumor that Plotina was the paramour of Hadrian was started by Dio Cassius (*Roman History*, LXIX.1 and 10). See also Aelius Spartianus (attr.), "Trajan" in *Lives of the Later Caesars*. trans. and ed. Anthony Birly (Harmondsworth, 1976), 38–53.

35. On the history of oracles, divination, the interpretation of dreams and associated rituals in classical Antiquity, see Bouché-Leclercq, *Histoire de la diviniation dans l'Antiquité*, esp. IV.III.

36. Dio Cassius, *Roman History*, passim.

37. See Auguste Bouché-Leclercq, *L'astrologie grecque* (1899; Darmstadt, 1979), esp. 5; also, generally, idem, *L'astrologie dans le monde romain* (Paris, 1897). Foreign astrologers and "impostors" were frequently put to death. Regarding this see Guillaume Libri, *Histoire des sciences mathematiques en Italie* (Bologna, 1966), 1:54.

38. Aelius Spartianus, Hadrian, passim. On the death of Hadrian and events accompanying the bitter end of his life, see esp. Anthony Birly, *Hadrian* (London and New York, 1997), 279–300.

39. Aelius Spartianus (Hadrian, XXV) quotes a poem that Hadrian wrote as he lay dying. It describes the flight of his immortal soul from his mortal body. For Hadrian's address to his "little soul," see Duff and Duff, *Minor Latin Poets*, as cited in chap. 6, n. 14. Similarities between Hadrian's view of the soul and Jewish Gnostic tradition are noted in chapter 6.

40. Aurelius Victor, *Liber de Caesaribus*, XIII. Among the modern biographies of Hadrian, several merit citation here: Bernard W. Henderson, *The Life and Principate of the Emperor Hadrian* (London, 1923); Boatwright, *Hadrian and the City of Rome*; and Birly, *Hadrian*.

41. Hadrian had a great affection for the Greek-speaking East. His passion for Greek culture is well documented by his biographers from his youth, when he was known as Graeculus (Greekling), to the end of his life. His artfully curled beard formed a contrast with his predecessors, who had been clean shaven for some time and constituted part of his Hellenizing image (on this see Zanker, *Mask of Socrates*, 202, 217–26). In 112 or 113 he was honored by being elected archon in Athens. Hadrian enlarged Athens and covered it with sumptuous monuments. On his trips to Athens and

his activities there, and regarding statues and inscriptions of him there, see esp. Paul Graindor, *Athènes sous Hadrien* (1934; reprint, New York, 1973). Toward the end of his life, Hadrian founded the Athenaeum at Rome, considered by some to be the first seed that would later develop into the Sapienza. On this see Boatwright, *Hadrian and the City of Rome,* esp. 207–8. See also chap. 6, esp. n. 14.

42. Romans first came into contact with this pseudo-science when it arrived in the Latin world ca. 250 BC. Although not all emperors were interested in astrology, astrologer-advisers became popular between the time of Augustus and Domitian. Roman interest in this is documented by Vitruvius (*De architectura,* IX.VI). On the rise of astrology in the Hellenistic world, the conversion of Republican Rome to astrology, and the interest in astrology among certain emperors, see esp. Frederick H. Cramer, *Astrology in Roman Law and Politics,* Memoirs of the American Philosophical Society 37 (1954; reprint, Chicago, 1996). The diffusion of astrology that accompanied the decline of the ancient world has been studied, more generally, in a number of important works. See esp. Paul Tannery, *Recherches sur l'histoire de l'astronomie ancienne* (Paris, 1893); Bouché-Leclercq, *L'astrologie grecque,* esp. 3–14; idem, *L'astrologie dans lemonde romain;* Cumont, *Les religions orientales dans le paganisme romain,* esp. chapt. VII; idem, *Astrology and Religion among the Greeks and Romans;* idem, *Lux Perpetua* (esp. useful for relation of astrology to Pythagoreanism); Franz Boll, Carl Bezold, and Wilhelm Gundel, *Sternglaube und Sterndeutung* (Stuttgart, 1966) (with excellent bibliography on Greek and Roman astrology); Luck, *Arcana Mundi,* 309–58; and André Le Boeuffle, *Le ciel des romains* (Paris, 1989). These authors discuss Pythagorean aspects of cosmic order in the setting of classical astrological interests. Regarding the relation of this subject to the Near East and its dissemination and development in the Antique world, see esp. Franz Cumont, *Le mystères de Mithra,* 3rd ed. (Brussels, 1913), esp. 197–98; E. Baldwin Smith, *The Dome: A Study in the History of Ideas* (Princeton, 1950), esp. 70–93; and Hans P. L'Orange, *Studies on the Iconography of Cosmic Kingship in the Ancient World* (Oslo, 1953).

43. On Nero's relations with the astrologer Balbillus, see Franz Cumont, "Astrologues romains et byzantins," *Mélanges d'Archéologie et d'Histoire* 37 (1918), esp. 33–38; for a description of Nero's Domus Aurea, see Suetonius, *Nero,* XXXI and XXXVI. On the relation of Egyptian and Greek solar mythology to the development of the quadriga, see Armand DeLatte and Philippe Derchain, *Les intailles magiques grécoegyptiennes* (Paris, 1964).

44. On this subject cf. Hetty Joyce, "Hadrian's Villa and the 'Dome of Heaven,'" *Römische Mitteilungen* 97 (1990): 347–81. An example of a Greek solar temple is the Sanctuary of Sabazios in Thrace.

45. The text of this papyrus fragment, found in Egypt, was published in Greek (with German translation) in Ernst Kornemann, "Papyrus Gissenis No. 20," *Klio: Beitraege zur alten Geschichte* 7, no. 2 (1907): 278–88. Subsequently, it was published in Franz Cumont, *Études syriennes* (Paris, 1917), 98 and n. 3; see also idem, *Lux Perpetua,* 292.

46. On the Pythagorean view of the monad as symbolizing Apollo, see also Bouché-Leclercq, *L'astrologie grecque,* 7 and n. 1.

47. Kornemann ("Papyrus Gissenis No. 20," 282) dates the papyrus at 117–18. This corresponds with the time the Pantheon was planned. Given Hadrian's literary interests and writing abilities, and given the fact that Aelius Spartianus reports (Hadrian, XIV) that the Roman people suspected Hadrian of authoring the oracles he claimed to receive, it is certainly possible that Hadrian—about whose "adoption" by Trajan there was much doubt, as is discussed in the text below—and possibly in complicity with Plotina, authored this "oracle" himself. In regard to the natal horoscope, see Aelius

Spartianus, Hadrian, II. See also Cramer, *Astrology in Roman Law and Politics,* 153 and 163.

48. See Cramer, *Astrology in Roman Law and Politics,* 162–64 and nn. 121a and 121b. Hadrian's devotion to Apollo is exemplified in his building of at least two temples to Apollo in Greece. See Pausanias, *Description of Greece,* I.xlii.5, and X.xxxv.4.

49. The early second-century horoscope is known through at least three manuscripts, as cited in Cramer, *Astrology in Roman Law and Politics,* 164n136. It is the only imperial horoscope authored by Antigonus of Nicea that has survived, because it was excerpted and copied by Hephestion of Thebes in the fourth century. On this see ibid., 164–65; also Wilhelm Kroll, "Antigonus," in *Paulys Real-Encyclopaedie der classischen Altertumswissenschaft* (Stuttgart, 1931), suppl. 5, col. 2. The horoscope was published (with photographs of the original text in figs. 15a, b, and c) in Cramer, *Astrology in Roman Law and Politics,* 162–78; also in Otto Neugebauer and H. B. van Hoesen, *Greek Horoscopes,* Memoirs of the American Philosophical Society 48 (Philadelphia, 1959), 1 and 90–91. Both Cramer and Neugebauer–van Hoesen offer English translations (essentially the same) of its contents as well as useful scholarly commentaries. See also the discussion of Hadrian's birth in Jean Richer, *Géographie sacrée dans le monde romain* (Paris, 1985), 179–80.

50. See Cramer, *Astrology in Roman Law and Politics,* 164–70; and Neugebauer and van Hoesen, *Greek Horoscopes,* 91, including the comparative diagram of W. Kroll showing the computation from the text. On Hadrian's horoscope as a good example of practical astrology see Luck, *Arcana Mundi,* 314. Regarding the conjunction of the sun and the moon resulting in the birth of a ruler of the world, Emperor Julian, who was a devotee of Pythagoras, claimed in AD 362 that it was such an occasion that caused the soul of Romulus to descend upon the earth. See Julian, *Hymn to King Helios,* 154D. On Julian's Pythagoreanism see idem, *Letter No. 2 (to Priscus),* in *The Works of Emperor Julian,* in which he expresses his reverence for Pythagoras above all others.

51. Cumont discusses the orthodox answer to the eternal Pythagorean question (as posed and answered in Iamblichus, *Vita Pythagorica,* 18) regarding where the immortal soul goes after death. To the question "What are the Isles of the Blessed?" the orthodox answer is "the sun and the moon." For discussion of this important concept, see Franz Cumont, *After Life in Roman Paganism* (New Haven, 1922), 96–99; idem, *Lux Perpetua,* 146; and Burkert, *Lore and Science in Ancient Pythagoreanism,* 363.

52. The assumption is in accord with the comments in Cramer, *Astrology in Roman Law and Politics,* 169. Aelius Spartianus, Hadrian, XIII.

53. Aelius Spartianus, Hadrian, XIV.

54. Ibid., XIX.

55. Ibid., VIII.

56. Cf. Dio Cassius, *Roman History,* LXIX.8; and Suetonius, who (in *Domitian I*) tells us that Domitian converted the house of Hadrian's birth into a temple. Aelius Spartianus, Hadrian, VII and XIX.

57. Both these incidents are reported in Aelius Spartianus, Hadrian, XXVI.

58. Dio Cassius, *Roman History,* LXIX.3.

59. Aelius Spartianus, Hadrian, XIII, XVI, and XX. Two temples (those at Cyzius and at Ephesus) are discussed in Margaret Lyttleton, "The Design and Planning of Temples and Sanctuaries in Asia Minor in the Roman Imperial Period," in *Roman Architecture in the Greek World,* ed. S. Macready and F. H. Thompson (London, 1987), 39 and 44–45. See also Dio Cassius, *Roman History,* LXIX.12; and Paulus Orosius, *Historiae adversum paganos,* VII.13.

60. Aelius Spartianus, Hadrian, XIV.

61. Ibid., IV.

62. Ibid., VI. Dio Cassius reports that he was told by his father that Plotina signed the letter(s) sent to the Senate (*Roman History*, LXIX.1). See on this Auguste Bouché-Leclercq, *Les pontifes de l'ancienne Rome* (1871; reprint, New York, 1975), 365–66.

63. Dio Cassius suggests that Plotina, being in love with Hadrian, secured his appointment (*Roman History*, LXIX.1). Aelius Spartianus holds that it was through Plotina that Hadrian was appointed in that he was—after the death of Trajan—supposedly adopted by Trajan through a person impersonating the dying emperor "in a tired voice" (Aelius Spartianus, Hadrian, IV). Aurelius Victor notes that Hadrian achieved his position through the manipulations of Plotina (*Liber der Caesaribus*, 13). On this subject see the discussion in Bouché-Leclercq, *Les pontifes de l'ancienne Rome*.

64. On this Dio Cassius and Aelius Spartianus are in agreement: Dio Cassius, *Roman History*, LXIX.23; and Aelius Spartianus, Hadrian, XXVII. On the lack of deification in the case of Hadrian, see Birly, *Hadrian*, 294.

65. See the extensive description of Hadrian's plans to gain popularity in Rome in Aelius Spartianus, Hadrian, XXVII.

66. Plato, *The Republic*, VIII.546B. Plato's account of how "perfect" conception dates are to be calculated is particularly obscure and has given rise to controversy going back at least as far as Cicero (whose *Ad Atticus*, VII.13, refers to Plato's "dark number"). See Allen, *Nuptial Arithmetic*, 79.

67. Hadrian appears with the quadriga on numerous coins. See, e.g., Gisela Foerschner, *Die Muenzen der Roemischen Kaiser in Alexandrien* (Frankfurt, 1988), esp. nos. 347, 361, 457, and 458.

Chapter 11. Pythagoreanism in Medieval Art

1. This manuscript (Wolfenbüttel, *Herzogl.B.Gud.Lat.8.334*, fols. 1v–2r) is published in Tilman Seebass, *Musikdarstellung und Psalterillustration im früheren Mittelalter* (Bern, 1973), 1:91 and 187, and vol. 2, pl. 79.

2. Paris, *Bib.Nat.Lat.7211*, fol. 133v. The suggestion that this image of Pythagoras was intended to refer to his cosmological discoveries was made in Charles de Tolnay, "The Music of the Spheres: Notes on a Painting by Bicci di Lorenzo," *Journal of the Walters Art Gallery* 6 (1943): 87.

3. Reims, *Bibliothèque MS.672*, fol. 1v. This manuscript is published in Seebass, *Musikdarstellung und Psalterillustration im früheren Mittelalter*, 1:95 and 184–85, and vol. 2, pl. 82; on it see also Tolnay, "Music of the Spheres," 88–89.

4. Although this instrument might be thought to resemble a kinnor (an interesting suggestion for which thanks are due to George Hersey), this Greco-Hebrew instrument does not figure in the legends connected with Pythagoras, in which the monochord came to be the instrument made venerable by his efforts. Although the kinnor was played with a plectrum, here Pythagoras appears to hold a little knife in his hand. This would be appropriate for making the careful adjustment he was reputed to have made on the monochord.

5. Adolf Katzenellenbogen, *The Sculptural Programs of Chartres Cathedral* (Baltimore, 1959), esp. 15–19; and idem, "The Representation of the Seven Liberal Arts," in Clagett, Post, and Reynolds, eds., *Twelfth-Century Europe and the Foundations of Modern Society*, 39–55.

6. See Thomas Aquinas, *An Exposition of the "On the Hebdomads" of Boethius*, ed. Janice Schultz and Edward Synan (Washington, DC, 2001).

7. See esp. Katzenellenbogen, *Sculptural Programs of Chartres Cathedral*, 16–21 and nn. 60–66.

8. Personifications of the Seven Liberal Arts are thought to have been employed in a cycle of wall decorations for a palace of Charlemagne in the ninth century; they are known in several tenth- and eleventh-century manuscripts, and on mosaics of church floors where they were often complemented by other cycles, e.g., the Virtues, the twelve months, the signs of the zodiac, etc. They were also represented in the early twelfth century in stained glass windows of the cathedral at Laon. On these see Paolo d'Ancona, "Le rappresentazioni allegoriche delle arti liberali nel medio evo e nel Rinascimento," *Arte* 5 (1902): 137–56, 211–28, and 269–89; Ernst R. Curtius, *European Literature and the Latin Middle Ages* (New York, 1953), 36–42; Katzenellenbogen, *Sculptured Programs of Chartres Cathedral,* esp. nn. 43–45 for further bibliography; idem, "Representation of the Seven Liberal Arts," passim; and Lucien Broche, *La cathédrale de Laon* (1926; reprint, Marseille, 1979), 75 and 104. After referring to Pythagoras's doctrine of silence, Ernst Dümmler ("Gedichte aus dem elften Jahrhundert," *Neues Archiv: Gesellschaft für ältere deutsche Geschichtskunde zur Beförderung* 1 [1896]: 182), quotes an eleventh-century poem whose seventh verse is composed of seven lines describing each of the Seven Liberal Arts.

9. The instrument that looks like an upside-down violin next to this figure was pointed out to me by George Hersey. It appears to be an early form of the lira da braccia, a type of lyre and an ancestor of the violin (which was not invented until the sixteenth century).

10. See José Peña Martínez, *Catedrals de España* (Madrid, 1998), 123–24. Thanks are due to Francisco LaRubia-Prado for bringing this example to my attention.

11. Boethius, *De musica,* Cambridge, *Univ.Lib.Ms. Ii.3.12,* fol. 61v. The dating is that of Katzenellenbogen, "Representation of the Seven Liberal Arts," 46–48. On this manuscript see Claus M. Kauffmann, *Romanesque Manuscripts, 1066–1190* (London, 1975), 113.

12. Munich, *Staatsbib.Cod.Lat.2599* (Sammelband aus Kloster Aldersbach), fols. 103r and 96v, respectively (in order of discussion here). This manuscript is published in Elisabeth Klemm, *Die illuminierten Handschriften des 13 Jahrhunderts deutscher Herkunft in der Bayerischen Staatsbibliothek* (Wiesbaden, 1998), vol. 4, no. 73, 92–93. Among the other subjects in this manuscript are Varro and Plautus, Statius and Terence, Rhetoric and Cicero, Dialectic and Aristotle, Arithmetic and Boethius, Grammar and Priscianus, Virgil and Lucan, Horace and Ovid, Ennius and Flaccus, Pliny and Macrobius, and Cicero (again) and Martianus Capella.

13. This dating was suggested to me by Michael T. Davis and is in line, generally speaking, with that proposed in Anne Courtillé, *La cathédrale de Clermont* (Nonette, 1994), 89, who dates it from the beginning of the fourteenth century. See also the complete study of Michael T. Davis, "The Cathedral of Clermont-Ferrand: History of Its Construction, 1248–1512," 3 vols., PhD diss., University of Michigan, 1979 (in which the north portal is discussed at 1:268–73). For an earlier history of this building, see Henri du Ranquet, *La cathédrale de Clermont-Ferrand* (1913; Paris, 1928).

14. Emile Mâle, *The Gothic Image: Religious Art in France of the Thirteenth Century,* 3rd ed., trans. Dora Nussey (1913; New York, 1958), 83 and 89. On this see also Courtillé, *Cathédrale de Clermont,* 84–89.

15. Formerly a Roman city (Augustonemetum), Clermont was the major city of Auvergne after its Christianization. After a number of politically turbulent centuries, the city, with the bishop in charge, was placed under royal control until it was joined administratively with nearby Montferrand in the early seventeenth century. The history of this city is described in the elegant book of Ambroise Tardieu, *Histoire de la ville de*

Clermont-Ferrand, 2 vols. (1871; reprint, Marseille, 1976). See also André G. Manry, *Historie de Clermont-Ferrand* (Clermont-Ferrand, 1975). On the historical background of thirteenth-century Clermont, see also Davis, "Cathedral of Clermont-Ferrand," 1:1–53.

16. Oxford, *Bod.Lib.Digby 46(1),* fol. 67b. Respecting the contents of this manuscript see Bodleian Library, *Catalogi Codicum Manuscriptorum Bibliothecae Bodleianae Pars nona Codices a Viro clarissimo Kenelm Digby* (Oxford, 1883), 42.

17. This work is discussed and its preface reproduced in Mirella Savonelli, "Un manuale di geomanzea presentato da Bernardo Silvestre da Tours (XII secolo): *L'Experimentarius,*" *Rivista Critica di Storia della Filosofia* 14 (1959): 29–42.

18. Wolfgang Wolters reproduces the inscriptions in *La scultura veneziana gotica, 1300-1460* (Venice, 1976), 1:174.

19. Antonio Manno, *Il poemo del tempo: I capitelli del Palazzo Ducale di Venezia* (Venice, 1999), 123–24.

20. D'Ancona, "Rappresentazioni allegoriche delle arti liberali," 226–28.

21. These are discussed by d'Ancona, ibid., 137–56, 211–18, and 169–89. On these see also Raimond van Marle, *Iconographie de l'art profane au Moyen-Age et à la Renaissance* (1931; reprint, New York, 1971), 2:203–28.

22. The contract for the execution of this fresco establishes the name of the painter and the date of its anticipated completion. See the bibliography in van Marle, *Iconographie de l'art profane,* 2:224n1; and Richard Offner and Klara Steinweg, *A Critical and Historical Corpus of Florentine Painting* (New York, 1930–84), 1:22–25.

23. The earliest inventory (with comparative descriptions), comprising forty-one known at the time of his writing, is that of Julien de Saint-Venant, *Dodécaèdres perlés en bronze creux ajouré de l'époque gallo romaine* (Nevers, 1907). For later additions, which bring the total close to eighty, see Robert Nouwen, "De Romeinse Pentagondodecaëder," in *Publikaties van het Provinciaal Gallo-Romeins Museum de Tongeren,* vol. 45 (Hasselt, Belgium, 1993). See also the summary in Dominique Tour-Clerc, "Le dodécaèdre," *Aventicum* 1 (1992): 3–8.

24. For additional descriptions of these objects, see Léonard Saint-Michel, "Situation des dodécaèdres celto-romains dans la tradition symbolique pythagoricienne," *Bulletin de l'Association Guillaume Budé* (suppl. Lettres d'Humanité 10) (Paris) 1951: 92–116; W. Deonna, "Des dodécaèdres gallo-romains en bronze, ajourés et bouletés," *Bulletin de l'Association Pro Aventico* (Lausanne) 16 (1954): 19–89; and G. Charrière, "Nouvelle hypothèse sur les dodécaèdres gallo-romains," *Revue Archéologique de l'Est et du Centre-Est* 16 (1965): 148–59.

25. Respecting Celtic Gaul metalwork, see Jullian, *Histoire de la Gaule,* 2:305–13; Felix Stähelin, *Die Schweiz in römischer Zeit,* 3rd ed. (Basel, 1948), passim; J. V. S. Megaw, "Les fragments de feuille de bronze décorés de Levrous (Indre)," *Gallia* 26 (1968): 33–41; and Olwen Brogan, "The Coming of Rome and the Establishment of Roman Gaul," in *France before the Romans,* ed. Stuart Piggott (London, 1974), esp. 205–6; also John Tavenor-Perry, *Dinanderie: A History and Description of Mediaeval Art Work in Copper Brass and Bronze* (London, 1910), esp. 6–7, 30, and 86; and Ernst G. Grimme, *Bronzebildwerke des Mittelalters* (Darmstadt, 1985), 1–10. Respecting the powers of bronze in purification rites, see bibliography in Victor Magnien, *Les mystères d'Éleusis* (Paris, 1950), 193 and n. 3.

26. These and other uses considered (and rejected) by those who have studied the dodecahedrons are discussed in Saint-Michel, "Situation des dodécaèdres celto-romains," 97.

27. This excludes the fact that some, found in modern times, were used as toys by those who found them. On the condition of these bronze dodecahedrons, see esp. Saint-Michel, "Situation des dodécaèdres celto-romains."

28. Philolaus's comments, preserved by Stobaeus, are published in Thomas, *Greek Mathematical Works,* 1:217. Regarding the five "regular solids" and what makes them so, see ibid., 216 at (a). Similar comments by Philolaus are quoted in Aëtius, *Placita,* ii.6.5; Nicomachus, *Introduction to Arithmetic,* II.xxvi; and Proclus, *Commentary on Euclid,* I.36.

29. Plato, *Timaeus,* 53c–55c.

30. Plato, *Phaedo,* 110B (trans. Hugh Tredennick, in *Collected Dialogues of Plato,* ed. Edith Hamilton and Huntington Cairns, Bollingen Series 71 [1961; reprint, Princeton, 1994], 91).

31. Ibid., 109 B–C (trans. Tredennick, 90).

32. Ibid., 111C–112A (trans. Tredennick, 92).

33. Ibid., 112B.

34. Euclid, *Elements,* xiii.18 (on the regular solids). See Thomas, *Greek Mathematical Works,* 1:473–77.

35. This work was attributed to Plutarch and published as *Opinions of the Philosophers* (see *Opinions des philosophes,* ed. Guy Lachenaud [Paris, 1993], 887B). However, it is now believed to have formed part of the *Placita* (*Opinions of the Philosophers*) by Aëtius, as discussed in chap. 2. Cf. *Aëtius Arabus,* ed. Hans Daiber (Wiesbaden, 1980).

36. Diogenes Laertius, *Lives and Opinions of Eminent Philosophers,* VIII.1.25–26, 35, and 48.

37. Iamblichus mentions this twice (*Vita Pythagorica,* 18 and 34).

38. While Lucian (*Slip of the Tongue in Greeting,* 5) specifically says the pentagram was a secret password that, deriving from the "divine Pythagoras" signified "health" among Pythagoreans, Iamblichus (*Vita Pythagorica,* 33) refers to a secret sign (without saying exactly what form it took) that symbolized health, which was known to all Pythagoreans. On the Pythagorean pentagram see de Vogel (*Pythagoras and Early Pythagoreanism,* 44–47 and Appendix A), who explains the ancient Babylonian roots of this form.

39. Lucian, *Slip of the Tongue in Greeting,* 5. Also see n. 38.

40. See Allen, *Nuptial Arithmetic,* 71–72.

41. Guyonvarc'h and Le Roux, *Les Druides,* passim, esp. 200–204, 213–17, 226–31, 259, 263–66, and 351.

42. Jullian, *Histoire de la Gaule,* 2:371n7 and 394–97.

43. Diodorus Siculus, *Bibliotheke historika,* V.25.2–32.4.

44. Pliny, *Historia naturalis,* XXIX.55–57.

45. Mâle, *Gothic Image,* 84–85.

46. Diogenes Laertius, *Lives and Opinions of Eminent Philosophers,* VIII.I.10; Julius Caesar, *De bello Gallico,* VI.15–21.

47. Iamblichus, *Vita Pythagorica,* 29.

48. On the marble baths, aqueducts, fountains, and sarcophagi—together with mosaics, capitals, drainage and fresco fragments, jewelry, and abundant pottery—that have been found there, see Tardieu, *Histore de Clermont-Ferrand,* 22–25. The abundant Gallo-Roman spolia found in the walls and foundations of the cathedral are described in Michael Greenhalgh, *The Survival of Roman Antiquities in the Middle Ages* (London, 1989), 53.

49. According to Sigerist ("Sphere of Life and Death," 292), the oldest text of the

Pythagorean Sphere is preserved in a fourth-century Greek papyrus. On this see also chapter 7 *supra*.

50. On the use of this device by priests, see Singer, "Early English Magic and Medicine"; and idem, *From Magic to Science* (New York, 1928), 146.

51. On these see Ernst Riess, "Sechepsonis et Petosiridis fragmenta magica," *Philologus*, suppl. 6 (1891–93): 325–94; see illustrations in Bouché-Leclercq, *L'astrologie grecque*, 539–40. See also Sigerist, "Sphere of Life and Death," 293. Cf. Democritus fragment reported in Plutarch, *On Common Notions*, 1079E.

52. Paris, *Bib.Nat.Lat.1141*, fol. 99. The folio was published in Heinrich Zimmer, "Neue Fragmente von Hisperica famina aus Handschriften in Luxemburg und Paris," *Nachrichten von der Königliche Gesellschaft der Wissenschaften zu Göttingen, philologisch-historische Klasse* (1895): 134–35; and Wickersheimer, *Manuscrits latins de médecine*, LXXVIII, 123.

53. St. Gall, *Stiftsbibl.Cod.752*, fol. 82; for illustration see Sigerist, "Sphere of Life and Death," 294–96, fig. 1.

54. This example (Vercelli, *Archiv.Cap.Cod.CLXXVII*, fol. 143r) is illustrated in Sigerist, "Sphere of Life and Death," 28, fig. 2.

55. See Sigerist, "Sphere of Life and Death," 294–303.

56. Paris, *Bib.Nat.Nouv.Acq.Lat. 1616*, fol. 7v. It was published in Wickersheimer, "Figures médico-astrologiques," 168–70 and 172–73; and idem, *Manuscrits latins de médecine*, XCII, 140.

57. Orléans, *Médiathèque.MS.276*, fol. 129. On this see Wickersheimer, "Figures médico-astrologiques," 171. The provenance of this folio indicates it came from St. Benoît sur Loire.

58. Ghent, *Universiteitsbibliotheek MS.92*, fol. 26r. Regarding this manuscript of the *Liber floridus*, an illustrated encyclopedia composed for the abbey of St. Bavo at Ghent (subsequently transferred to the cathedral Library), whose author was a certain Lambert, see Albert Derolez, *Lamberti S. Audomari canonici Liber floridus* (Ghent, 1968), 13–14 and 53. See also Katzenellenbogen, *Allegories of the Virtues and Vices*, 65.

59. Oxford, *Bodl.Lib.Digby 46*, fol. 106b. This was published in *Catalogi Codicum Manuscriptorum Bibliothecae Bodleianae*, 42.

60. Oxford, *Bodl.Lib.Digby 29*, fols. 193v and 194r. On these see *Catalogi Codicum Manuscriptorum Bibliothecae Bodleianae*, 26–27.

61. Other examples of manuscripts containing the Sphere of Pythagoras are listed in Thorndike, *History of Magic*, 1:692–94 and 2:117–18.

62. Iamblichus, *Vita Pythagorica*, 18, 28, 29, 30, and 34.

63. On the dating of this church and its sculptures, see Arthur Kingsley Porter, *Romanesque Sculpture of the Pilgrimage Roads* (Boston, 1923), 1:xxv, 234–37, and vol. 8, passim.

64. Saint Jerome, in letter CVII (*Select Letters of St. Jerome*, ed. F. A. Wright [London and New York, 1933], 355), speaks of the two roads and their connection with original sin and baptism.

65. Martianus Capella, *De nuptiis philologiae et mercurii*, 102 (Stahl ed., 2:35).

66. Remigius of Auxerre, *Commentum in martianum capellam*, ed. Cora E. Lutz (Leiden, 1962–65). The references are to 43.18 and 41.1, respectively. As Jane Chance suggests (*Medieval Mythography from Roman North Africa to the School of Chartres* [Gainesville, FL, 1994], 220–23 and 282–85), Remigius was most likely reworking the glosses on the Pythagorean Y, which he knew from the work of Servius, a fourth-century commentator whose work was well known from the ninth century onward. Servius had, in a commentary on the *Aeneid*, explained that Pythagoras divided human

life like the letter Y, with the vices forming its left branch and the virtues its right (*Aeneid,* 6.136, in *Servii Grammatici qui feruntur in Vergilii carmina commentarii,* ed. Georg Thilo and Hermann Hagen [1881–87; reprint, Hildesheim, 1961]).

67. Servius (as cited in n. 66), *In Aeneid,* 6.136 (cf. Virgil, *Aeneid,* VI).

Chapter 12. Sacred Siting

1. The quote is from Iamblichus, *Vita Pythagorica,* 2 (trans. Clark, 5). On the rise of the holy man, which coincides with the erosion of classical institutions, see Peter Brown, "The Rise and Function of the Holy Man in Late Antiquity," *Journal of Roman Studies* 61 (1971): 80–101.

2. On medieval manuscripts of the harmonic elements of Aristoxenus, see Macran, "On Aristoxenus and His Extant Works," in Aristoxenus, *Harmonics,* 86–93ff.

3. As mentioned in chapter 7, William of Conches recurrently used the metaphor of God as the wise craftsman who, acting like an architect, fashioned the cosmos as a beautiful work of art. See, e.g., William of Conches, *Glosae super Timaeum,* 48E–49A (in *Glosae super Platonem,* ed. Jeauneau).

4. In *De antro nympharum,* Porphyry comments on Homer's description of temples whose entrances for the most part face the east so that those who enter them look toward the west when they stand before the statues (see Porphyry, *Cave of the Nymph,* 3). This practice appears to have been reversed in the recommendations of Vitruvius. Perhaps because he was a Pythagorean, Vitruvius recommended that the altar in a temple be so placed as to allow the suppliant as well as those taking vows to face the eastern heaven. All altars, with the exception of those built on a problematic site, should, according to him, face the east (*De architectura,* IV.v). Writing a century later, Plutarch explains, in speaking of the olden days of Numa, that Pythagoreans turned around when they worshipped in order to face the east and the sun (*Vita Numa,* XIV.4). Subsequently, Iamblichus underlined the significance of this practice: Pythagoras taught that sunrise is more to be honored than sunset, as dawn is than evening. Pythagoreans rose before dawn so as to pray to the rising sun (Iamblichus, *Vita Pythagorica,* 8 and 31). In reporting on a Pythagorean precept that forbade urinating while facing the sun, Diogenes Laertius confirmed this very particular devotion of Pythagoreans to the sun (Diogenes Laertius, *Lives and Opinions of Eminent Philosophers,* VII.I.17).

5. On the beliefs of the various Eastern and Roman cults known in the first and second centuries, see especially Cumont, *Religions orientales dans le paganism romain;* idem, *Recherches sur le symbolisme funéraire des romains;* idem, *Textes et monuments figurés relatifs aux mystères de Mithra* (Brussels, 1899), vol. 2; and idem, *After Life in Roman Paganism.* On the structures associated with these cults, see esp. Richard Gordon, *Image and Value in the Graeco-Roman World* (Aldershot, 1966); and White, *Building God's House in the Roman World.*

6. A surviving example is in the underground chamber (crypt) below Sta. Maria in Cosmedin in Rome, which is divided into a nave and two aisles separated by colonnades. (See illustrations in Giovanni B. Giovenale, *La basilica di Sta. Maria in Cosmedin* [Rome, 1927], 35–36 and 322–23.) The origins, development, uses, and eventual abandonment of catacombs are discussed in Vincenzo Fiocchi Nicolai, Fabrizio Bisconti, and Danilo Mazzoleni, *The Christian Catacombs of Rome* (Regensburg, 1999). More generally, see Leonard V. Rutgers, *Subterranean Rome* (Leuven, 2000).

7. The custom of funeral banquets was to be abandoned by about the fifth century (Krautheimer, *Corpus Basilicarum Christianarum Romae,* 4:147). On this custom see also idem, *St. Peter's and Medieval Rome* (Rome, 1985), 15–16.

8. More information on the churches to be discussed in the following paragraphs may be found in Krautheimer, *Corpus Basilicarum Christianarum Romae,* vol. 5. See also the important essays in idem, *Studies in Early Christian, Medieval, and Renaissance Art* (New York and London, 1969), esp. 1–161; idem, *Rome, Profile of a City, 312–1308* (Princeton, 1980), esp. 3–202; idem, *Three Christian Capitals;* and idem, *St. Peter's and Medieval Rome.* Also useful is John Ward-Perkins, *The Shrine of St. Peter* (London, 1956).

9. See n. 4 *supra.*

10. Among the many who have theorized about the origins of the early Christian basilica are the following: Oskar Mothes, *Die Basilikenform bei den Christen der ersten Jahrhunderte* (Leipzig, 1865); Auguste Kempeneers, *Le type de églises bâties par et depuis l'Empereur Constantin* (Lièges, 1881); Leroux, *Origines de l'édifice Hypostyle;* Emerson H. Swift, *Roman Sources of Christian Art* (New York, 1951); and Georg Dehio and Gustav Bezold, *Kirchliche Baukunst des Abendlandes* (Hildesheim, 1969), vol. 1. See also the references to Krautheimer in n. 8 *supra.*

11. For an excellent survey of Carolingian and other pre-Romanesque religious architecture, see Kenneth J. Conant, *Carolingian and Romanesque Architecture,* 2nd rev. ed. (1959; Harmondsworth and Baltimore, 1974).

12. Willibald Sauerländer, "Première Architecture Gothique," in *Cathedrals and Sculpture* (London, 1999), 1:273–98. However, the ancestor of these quickly built structures, the Basilica at Porta Maggiore, was barrel-vaulted. Indeed, it appears that as Christianity came to be established, more attention was paid to constructing elaborate and permanent vaulting systems.

13. Sumner M. Crosby argues that Carolingian architects were aware of proportion and the relation of parts to each other (Crosby, *The Abbey of St. Denis, 475–1172* [New Haven, 1942]).

14. This connection was suggested, for example, in Marcel Joseph Bulteau, *Monographie de la cathédrale de Chartres* (Chartres, 1892), 1:27. Cf. *The Apostolic Constitutions,* in *Ante-Nicene Christian Library,* with an introduction and trans. James Donaldson (Edinburgh, 1870), 17:1–280. Donaldson points out that in medieval times the text was known only in two Greek copies and was not rediscovered until the mid-sixteenth century, when one of the copies, found in Crete, was published first in Ingoldstadt and then in Venice.

15. Speaking of the templum in describing the ideal church, Isidore says: "sed et locus designatus ad Orientem a contemplatione templum dicetabur. Cujus partes quator erant, antica ad Ortum, postica ad Occasum, sinistra ad Septentrionem, dextra ad Meridiem spectans. Unde et quando templum construebant, orientem spectabant" (*Etymologiae* XV.iv, in Migne, *Patrologia Latina,* vol. 82).

16. Olivier Beigbeder, *Lexique des symboles* (Saint-Léyer-Vauban, 1969), 222–23.

17. In addition to Conant (*Carolingian and Romanesque Architecture*), other sources fundamental to the study of Romanesque religious architecture include the following: Arthur K. Porter, *Medieval Architecture: Its Origins and Development,* 2 vols. (1909; reprint, New York, 1966); idem, *Lombard Architecture,* 4 vols. (1915–17; reprint, New York, 1967); and idem, *Romanesque Sculpture of the Pilgrimage Roads;* José Puig y Cadafalch, *La geografia e les orígens del primer art romànic* (Barcelona, 1930); Joan Evans, *Romanesque Architecture of the Order of Cluny* (Cambridge, 1938); idem, *Art in Medieval France* (1948; Oxford, 1969); and idem, *The Flowering of the Middle Ages* (New York, Toronto, and London), 1966.

18. The orderly planning and austere taste to which Cistercian buildings conformed is surveyed in Marcel Aubert, *L'architecture cistercienne en France,* 2 vols., 2nd ed. (1943; Paris, 1947).

19. The three "inventors" of the Gothic style were all prelates as well as personal friends who shared the same ideas: Bishop Henry of Sens, responsible for the design of the Cathedral of Sens, the first Gothic cathedral; Abbot Suger of St. Denis, who personally designed the Gothic abbey of that name north of Paris; and Bishop Geoffroy of Chartres, who first imagined the grand sculptural portals of that cathedral. (On these authors and their collaboration, see Otto von Simson, *The Gothic Cathedral*, 2nd rev. ed. [1956; Princeton, 1962], 64.) Suger's account of his intentions and the development of the building program at St. Denis is in three parts, the *Liber de Rebus in Administratione Sua Gestis* (hereinafter *De Administratione*), the *Libellus Alter de Consecratione Ecclesiae Sancti Dionysii* (hereinafter *De Consecratione*), and the *Ordinationes*.

20. Abbot Suger, *De Consecratione*, trans. and ed. Erwin Panofsky, in E. Panofsky, *Abbot Suger on the Abbey Church of St.-Denis and Its Art Treasures* (1946; Princeton, 1979), 101; and idem, *De Administratione*, ibid., 77 and passim.

21. Suger, *De Consecratione*, 107 (trans. Panofsky).

22. Suger, *De Administratione*, 75 (trans. Panofsky). Respecting the archaeology of St. Denis, see Crosby, *Abbey of St. Denis*.

23. Anne Prache, *Notre-Dame de Chartres image de la Jérusalem céleste* (Paris, 1993), passim.

24. Rev. 21:1-5. Here Saint John describes his vision of a new heaven on earth as the Holy City or new Jerusalem, which was made by God himself as the place where he could dwell among men. See also the discussion of this subject, in that scenes from the book of Revelation were actually represented in the sanctuaries of churches, in von Simson, *Gothic Cathedral*, 8-10.

25. On the representation of the "new" Jerusalem in medieval painting, see the guide to painting by the seventeenth-century Byzantine painter Dionysius of Fourna, *Manuel d'iconographie chrétienne grecque et latine*, with an introduction by Adolfe Napoléon Didron (1845; reprint, New York, 1963), vii-xii, 261. See also the important work of Prache, *Notre-Dame de Chartres*, passim; and von Simson, *Gothic Cathedral*.

26. Rev. 21:1-5, 15-28.

27. That this practice was not an absolute necessity from the structural point of view is suggested by the case at Amiens, where the nave of the cathedral, entirely rebuilt beginning in 1220 after a fire had destroyed the previous church, was built before its east end. On this cathedral see Henri Focillon, *Art d'occident*, 3rd ed. (1938; Paris, 1955), 174; and generally, Paul Frankl, "A French Gothic Cathedral: Amiens," *Art in America* 35 (1947): 295-99.

28. See, e.g., Malcolm Miller, *Chartres Cathedral* (New York, 1996).

29. On the early phases of Christian architecture at Chartres and the early history of its cathedral, see Bulteau, *Monographie de la cathédrale de Chartres*, 1:10-27; idem, *Description de la cathédrale de Chartres* (Paris, 1850), 12-17; also the abbreviated information in idem, *Petite monographie de la cathédrale de Chartres* (Cambrai, 1872), esp. 3-10; Harry H. Hilberry, "The Cathedral of Chartres in 1030," *Speculum* 34 (1959): 561-72; Louis Grodecki, *Chartres* (Paris, 1963), 12-15; and Robert Branner, ed., *Chartres Cathedral* (New York, 1969), 69-74. See also (with caution) the embellished account of this subject in Cecil Headlam, *The Story of Chartres* (n.d.; reprint, Liechtenstein, 1971).

30. Julius Caesar, *De bello Gallico*, VI.13. On the Druidic tribe known as Carnutes (the former inhabitants of present-day Chartres), see Louis Will, "Carnutes," in *La grande encyclopédie . . . des sciences, des lettres et des arts* (Paris, n.d.), 9:482-83 (with bibliography).

31. See Livy, *Ab urb condita* V.xxxiv; Strabo, *Geography*, IV.194C; and Pliny, *Historia naturalis*, IV.xviii.32; also Will, "Carnutes."

32. In that they underline traditional views respecting the area and its major holy site, some of the older histories of Chartres are useful: to some extent that of the humanist Sebastien Roulliard, *Parthénie, ou histoire de la très auguste église de Chartres* (Paris, 1609), reprinted in Branner, *Chartres Cathedral*, 104–7; but esp. that of Vincent Sablon, *Histoire de l'auguste et vénérable église de Chartres* (Chartres, 1671), reprinted in Branner, *Chartres Cathedral*, 107–14, esp. 107–10.

33. Sablon, *Histoire de l'auguste et vénérable église*, 109–10.

34. On Auxerre, see Jean Vallery-Radot and Marcel Aubert, "Auxerre," in *Congrès archéologique de France* CXVI (Paris, 1958), 26–96. See Remigius, *Commentum in martianum capellam*. On Remigius, see Georges Duby, ed., *Entretiens d'Auxerre: L'école carolingienne d'Auxerre* (Paris, 1991).

35. Gulielmus Durandus, *Rationale divinorum officiorum*, I:1.8 (trans. J. M. Neale and B. Webb, in William Durandus, *The Symbolism of Churches and Church Ornaments* [Leeds, 1843], 21). On this see Mâle, *Gothic Image*, 5.

36. Durandus, *Rationale divinorum officiorum*, IV:2.57.

37. Book of Wisdom, XVI.26.

38. Mâle, *Gothic Image*; and von Simson, *Gothic Cathedral*.

39. This is discussed in Von Simson, *Gothic Cathedral*, 191.

40. Mâle, *Gothic Image*, 10. On the symbolism of numbers in medieval thought, see Beigbeder, *Lexique des symboles*, esp. 311–35.

41. Book of Wisdom, XI.20.

42. See von Simson, *Gothic Cathedral*, 23–24.

43. Suger, *De Administratione*, 105 (trans. Panofsky).

44. Ibid., 131.

45. Durandus, *Rationale divinorum officiorum*, I, passim.

46. Suger, *De Administratione*, 83 (trans. Panofsky).

47. Ibid., 83 and 121.

48. On geometric measure and proportion in medieval architecture, see Nancy Y. Wu, ed., *Ad Quadratum: The Practical Application of Geometry in Medieval Architecture* (Aldershot, UK, and Burlington, VT, 2002). See also Massimo Rassu, *La geometria del tempio: Armonia e proporzione nelle chiese della Sardegna medievale* (Dolianova, 2002). Cf. Alpay Özdural, "The Church of St. George of the Latins in Famagusta: A Case Study on Medieval Metrology and Design Techniques," in Wu, *Ad Quadratum*, 217–42.

49. The importance of the square as a module in medieval plans and elevations is analyzed in von Simson, *Gothic Cathedral*, esp. 12–16.

50. An excellent example of this experimentation can be seen in the collegiate church of St. Quentin in France. On this see Ellen M. Shortell, "The Plan of Saint-Quentin: Pentagon and Square in the Genesis of High Gothic Design," in Wu, *Ad Quadratum*, 123–48.

51. See facsimiles in Hans R. Hahnloser, *Villard de Honnecourt: Kritische Gesamtausgabe des Bauhüttenbuches* (Vienna, 1935), e.g., pls. 18 and 39. The original model book, which contains sixty-three drawings, survives in an album in the Bibliothèque Nationale in Paris (*Ms.Fr.19093*).

52. The birth of original (non-Boethian) or "modern" geometry is the subject of two interesting studies by Tannery: "La géométrie au XIeme siècle," and "Une correspondance d'écolâtres du onzième siècle," in *Mémoires scientifiques: V. Science exactes au*

Moyen Âge, ed. Johann Ludwig Heiberg (Toulouse and Paris, 1922), 60–100 and 229–61, respectively.

53. See Wickersheimer, "Figures médico-astrologiques," 157–77 and illustrations. Wheels of fate and mystical paradise illustrations are discussed in Katzenellenbogen, "Representation of the Seven Liberal Arts"; and idem, *Allegories of the Virtues and Vices,* 70–72 and pls. 68–71. See also Jurgis Baltrusaitis, "Quelques survivances de symboles solaires dans l'art du Moyen Âge," *Gazette des Beaux-Arts* 17 (1937): 75–82; idem, "L'image du monde céleste du IXe au XIIe siècle," *Gazette des Beaux-Arts* 20 (1938): 137–48; and idem, "Roses des vents et roses de personnages a l'époque romane," *Gazette des Beaux-Arts* 20 (1938): 265–76.

54. Hugh of St.-Victor, *Didascalicon,* II.xiii.

55. Plato, *The Republic,* VII, passim.

56. Iamblichus frequently mentions the importance of light to Pythagoras (who was the son of Apollo, the god of the sun) and his followers. See, e.g., *De vita Pythagorica,* 8, 15, 18, 21, 23, 27, and 35.

57. Dante Alighieri, *Paradiso,* XXX.64–72, 106–7, and 124. Pseudo-Dionysius, *Ecclesiastical Hierarchy,* I (in *The Works of Dionysius the Areopagite,* trans. and ed. John Parker [1899; reprint, New York, 1976], 68).

58. Pseudo-Dionysius, *The Heavenly Hierarchy,* I and II; idem, *On Divine Names,* III.

59. Thomas Aquinas, *Summa theologica,* Q.39, art. 8 (in *The Summa Theologica,* trans. and ed. Laurence Shapcote (1950; rev. ed., Chicago, 1990), 211.

60. Suger, *De Administratione,* 51, 65, 71–77 (passim), 83, and 131 (trans. Panofsky).

61. Dante Alighieri, *Il convivio,* II.xiii.5–7 and 14–20 (trans. Christopher Ryan, in *The Banquet,* ed. C. Ryan [Stanford, 1989], 67–69, passim).

62. "Ars sine scientia nihil est" (Art without science is nothing). On this see James S. Ackerman, "Ars sine scientia nihil est: Gothic Theory of Architecture at the Cathedral of Milan," *Art Bulletin* 31 (1949): 84–111.

63. On this see von Simson, *Gothic Cathedral,* 189.

64. Jacques Le Goff, *Intellectuals in the Middle Ages,* trans. T. L. Fagan (Cambridge, MA, and Oxford, 1993), 48–50.

Conclusions

1. Ovid, *Metamorphoses,* XV, ll. 94–95 (trans. Horace Gregory [New York, 1958], 416).

2. Although this is discussed by Diogenes Laertius (as noted in chap. 9), who published roughly a century and a half later, he specifically notes his source as Alexander Polyhistor, who compiled a now-lost volume on philosophers, which Diogenes Laertius evidently read and from which he gained much of his information about Pythagoras. The scholarly Alexander Polyhistor's vast literary output dates from the first century BC, that is, shortly before the basilica was constructed.

BIBLIOGRAPHY

This bibliography contains both the primary and secondary sources that were useful for this work. Because I drew on various editions of many of the well-known primary sources, I sometimes cite no particular edition.

Primary Sources

Aelian (Claudius Aelianus). *Historical Miscellany.* Ed. N. G. Wilson. Cambridge, MA, and London, 1997.

——. *Varia historia.*

Aelius Spartianus. *Biography of Hadrian* (from *Scriptores historiae augustae*). In *Lives of the Later Caesars,* trans. and ed. Anthony Birly, 57–88. Harmondsworth, 1976.

——. (attr.) *Biography of Trajan* (a compilation). In *Lives of the Later Caesars,* trans. and ed. Anthony Birly, 38–53. Harmondsworth, 1976.

Aëtius. *Aëtius Arabus.* Hans Daiber, ed. Wiesbaden, 1980.

——. *Placita philosophorum* (*Opinions of the Philosophers*). In *Doxographi Graeci,* ed. Hermann Diels, 273–444. Berlin, 1879.

Albertus Magnus. *Metaphysicorum Libri XIII.* In *B. Alberti Magni Ratisbonensis . . . Opera Omnia,* ed. August Borgnet, VI. Paris, 1890.

Alexander. Author cited by Diogenes Laertius.

Alexander Aphrodisiensis. *Commentary on Aristotle's Sophistic Refutations.* In *Greek Mathematical Works,* ed. and trans. Ivor Thomas, 1:315–17. Cambridge, MA, 1951.

Anatolius. Fragment quoted from Heron's *Definitions.* In *Greek Mathematical Works,* ed. and trans. Ivor Thomas, 1:3. Cambridge, MA, 1951.

——. *On the Decad.* In Paul Tannery, "Anatolius: Sur la décade et les nombres qu'elle comprend," in *Mémoires scientifiques: III. Sciences exactes dans l'Antiquité,* ed. Johan Ludwig Heiberg, 12–28. Paris, 1912.

Antiphon. Author cited by Diogenes Laertius.

——. Author cited by Porphyry.

Antonius Diogenes. Author cited by Porphyry.

Apollodorus the Logician. Author cited by Diogenes Laertius.

——. *Apollodors Chronik, Eine Sammlung der Fragmente.* Ed. Felix Jacoby. 1902; reprint, New York, 1973.

Apollonius. From *Apollonii historiae mirabiles.* In *Antonini liberalis transformationum congeries,* ed. Thomam Guarinum. Basel, 1568.

Apollonius of Tyana. Author cited by Porphyry.

——. *The Letters of Apollonius of Tyana: A Critical Text with Prolegomena, Translation, and Commentary.* Ed. Robert J. Penella. Leiden, 1979.

Apuleius of Madaura. *Apulei Platonici Madaurensis metamorphoseon libri XI.* Ed. Rudolfus Helm. Leipzig, 1907.

——. *Florida.* In *Apulei Platonici Madaurensis florida.* Ed. Rudolfus Helm. Leipzig, 1921.

——. *L'Apologia, o, La Magia, Florida.* Ed. Giuseppe Augello. Turin, 1984.

Arignota. Author cited by Diogenes Laertius.

——. Author cited by Porphyry.

Aristides Quintilianus. Author cited by Plutarch (*On Music*).

Aristippus of Cyrene. Author cited by Diogenes Laertius.

——. Author cited by Porphyry.

Aristobulus. Fragments. In *Die Philosophie der Griechen in ihrer geschichtlichen Entwicklung,* ed. Eduard Zeller, 3(2): 277–83. Leipzig, 1876.

——. Fragments. In A. Yarbro Collins, "Fragments, of Lost Judeo-Hellenistic Works: Aristobulus," in *The Old Testament Pseudepigrapha,* ed. James H. Charlesworth. 2 vols., New York, 1983.

Aristophon. Author cited by Porphyry.

Aristotle. *Aristotelis fragmenta.* Ed. Valentino Rose. Leipzig, 1886.

——. *Aristotelis fragmenta selecta.* Ed. William D. Ross. Oxford, 1955.

——. *Aristotle: Minor Works.* Ed. W. S. Hett. Cambridge, MA, and London, 1936.

——. *Constitution of Delos* [now lost]. Described by Diogenes Laertius.

——. *De caelo.*

——. *Ethics.*

——. *Magna moralia.*

——. *Metaphysics.*

——. *Meteorologica.*

——. *Nicomachean Ethics.*

——. *On Marvellous Things Heard.* In *Aristotle: Minor Works,* ed. W. S. Hett, 289–90. Cambridge, MA, and London, 1936.

——. *On Sense and Sensible Objects.*

——. *On the Soul.*

——. *Physics.*

——. *Posterior Analytics.*

——. *Rhetoric.*

Aristoxenus of Tarentum. Author quoted in Aulus Gellius, *Attic Nights,* IV.xi.1–13.

——. Author cited by Diogenes Laertius.

——. Author cited by Plutarch (*De musica*).

——. Author cited by Porphyry.

——. Fragments. Preserved by Stobaeus.

——. *Aristoxeni: Elementa harmonica.* Ed. Rosetta da Rios. Rome, 1954.

——. *Aristoxenus Elementa Rhythmica: The Fragment of Book II and the Additional Evidence for Aristoxenean Rhythmic Theory.* Ed. Lionel Pearson. Oxford, 1990.

——. *The Harmonics of Aristoxenus.* Ed. Henry S. Macran. Oxford, 1902.

Arnaldus de Villanova. In *Opere medica omnium,* ed. M. R. McVaugh. Granada, 1938.

——. *Regimen sanitatis.* Ed. Mathias Huss. Lyon, 1486.

Augustine of Hippo. *De civitate Dei.*

——. *De Trinitate libri XV.* Ed. W. J. Mountain. Turnholt, 1968.

——. *De Trinitate libri quindecim.* In *Patrologia Latina,* ed. J.-P. Migne, vol. 42.

——. *Sancti Aurelii Augustini Hipponensis episcopi opera omnia*. In *Patrologia Latina*, ed. J.-P. Migne, vols. 32–47.

Aulus Gellius. *Noctes Atticae*.

Aurelius Victor, Sextus. *Liber de Caesaribus*.

Ausonius (Decimus Magnus Ausonius). *The Eclogues*.

——. *Letter to Herculanus, My Nephew, Grammarian of Bordeaux*. In *Ausonius*, ed. Hugh Evelyn White, 117. London and New York, 1919.

Austophon. Author cited by Diogenes Laertius.

Auticlides. Author cited by Diogenes Laertius.

Bacchius. Author cited by Plutarch.

Basil. *The Letters*. Trans. R. J. Deferrari. 4 vols. Cambridge, MA, 1950.

Boethius Severus. *Boethii philosophiae consolationis libri quinque*. Ed. Guilelmus Weinberger. Corpus Scriptorum Ecclesiasticorum Latinorum 67. Leipzig, 1934.

——. *The Consolations of Music, Logic, Theology, and Philosophy*. Ed. Henry Chadwick. Oxford, 1981.

——. *De institutione arithmetica*.

——. *De institutione musica*.

Bryennius, Manuel. *Harmonica*. In *The Harmonics of Manuel Bryennius*, ed. Goverdus Henricus Jonker. Groningen, 1970.

Burlaeus, Gualterus. *Questiones super librum posteriorum*. Ed. Mary C. Sommers. Toronto, 2000.

——. *De vita et moribus philosophorum e poetarum*. Ed. Arnold ter Hoernen. Cologne, 1472.

Caesar, Julius. *De bello Gallico*.

Callimachus of Cyrene. *Aetia*.

——. Fragments. In *Aetia, Iambi, Lyric Poems, . . . and Other Fragments*, ed. C. A. Trypanis. Cambridge, MA, 1975.

——. Works. In *Callimachus*, ed. Rudolfus Pfeiffer. Oxford, 1949–53.

Cassiodorus (Flavius Magnus Aurelius Cassiodorus). *Cassiodori satoris institutiones*. Ed. R. A. B. Mynors. Oxford, 1937.

——. All texts. In *Patrologia Latina*, ed. J.-P. Migne, vols. 69–70.

Censorinus. *De die natali liber ad Q. Caerellium*. In *Edizioni e saggi universitari di filologia classica*, ed. Carmelo Rapisarda, vol. 47. Bologna, 1991.

Chalcidius (Calcidius). *Platonis Timaeus interprete Chalcidio cum eiusdem commentario*. Ed. Iohannes Wrobel. Leipzig, 1876.

——. *Timaeus a Calcidio translatus commentarioque instructus*. Ed. J. H. Waszink. London and Leiden, 1962.

Christodorus of Thebes in Egypt. *Description of the Statues in the Public Gymnasium called Zeuxippos*. In *The Greek Anthology*, vol. 1, ed. W. R. Paton. Cambridge and London, 1939.

Cicero (Marcus Tullius Cicero). *Academica*.

——. *Brutus*.

——. *De divinatione*.

——. *De finibus bonorum et malorum*.

——. *De legibus*.

——. *De natura deorum*.

——. *De oratore*.

——. *De re publica*.

——. *Epistulae ad Atticum*.

——. *Epistulae ad familiares*.

——. *In somnium Scipionis.*

——, trans. Plato's *Timaeus.* In *M. Tvlli Ciceronis Timaevs,* ed. Franciscus Pini. Milan, 1965.

——, trans. Plato's *Timaeus.* In *Ricerche sul testo del Timeo Ciceroniano,* ed. Remo Giomini. Rome, 1960.

——. *Tusculanae disputationes.*

Clement of Alexandria (Titus Flavius Clemens). *Exhortation to the Greeks.*

——. *Pedagogus.* In *Le pédagogue,* ed. Henri-Irénée Marrou. Paris, 1960.

——. *Stromateius.*

Cratinaus. Author cited by Diogenes Laertius.

Dante Alighieri. *Convivio.*

——. *De monarchia.*

——. *Divina comedia.*

——. *Eclogue I.*

Democritus of Abdera. Fragments. In Jonathan Barnes, *Early Greek Philosophy,* 245–88. Harmondsworth, 1987.

Dicaearchus of Messina. Author cited by Diogenes Laertius.

——. Author cited by Porphyry.

Dio Cassius (Cassius Dio Cocceianus). *Roman History.*

Diodorus Siculus. *Bibliotheke historika.*

——. *Diodorus of Sicily.* Ed. C. H. Oldfather. Cambridge, MA, and London, 1946.

Diogenes Laertius. *Diogenes Laertius, vita et sententiae philosophorum.* Ed. Bernardinus Celerius. Venice, 1480.

——. *Diogenis Laertij De uita et moribus philosophorum libri X.* Ed. Sebastin Gryphium. Lugdoni, 1541.

——. *The Lives and Opinions of Eminent Philosophers* (*Lives of Eminent Philosophers*).

Dionysius the Areopagite. See Pseudo-Dionysius.

Dionysius of Fourna. *Manuel d'iconographie chrétienne grecque et latine.* With an introduction by Adolfe Napoléon. 1845; reprint, New York, 1963.

Dionysius of Halicarnassus. *Roman Antiquities.*

Dionysophanes. Author cited by Porphyry.

Duff, John Wight, and Arnold M. Duff, eds. *Minor Latin Poets.* Cambridge, MA, and London, 1934.

Durandus, Gulielmus, *Rationale divinorum officiorum.* Trans. J. M. Neale and B. Webb. In William Durandus, *The Symbolism of Churches and Church Ornaments,* 19–25. Leeds, 1843.

Duris of Samos. Author cited by Diogenes Laertius.

——. Author cited by Plutarch (*On Music*).

——. Author cited by Porphyry.

Edmonds, J. M., ed. and trans. *The Greek Bucolic Poets,* by Theocritus. London and New York, 1928.

Empedocles. Author cited by Porphyry.

——. Fragments. In Jonathan Barnes, *Early Greek Philosophy.* Harmondsworth, 1987.

Euclid. *Elements.*

——. Fragment cited by Plutarch (*On Music*).

Eudoxus of Knidos. *Die Fragmente des Eudoxos von Knidos.* Ed. François Lasserre. Berlin, 1966.

Eunapius. *Lives of the Philosophers.*

Eusebius of Caesarea. *Eusebii pamphili Caesareae palestinae episcopi, opera omnia quae exstant.* In *Patrologia Graeca,* ed. J.-P. Migne, vols. 19–24.

Exodus. Author cited by Porphyry.

Favorinus. Author cited by Diogenes Laertius.

Gaudentius. Author quoted by Plutarch (*On Music*).

Gerber, Douglas E., ed. *Greek Elegiac Poetry from the Seventh to the Fifth Centuries* BC. Cambridge, MA, and London, 1999.

Greek Anthology. Ed. W. R. Paton. V. London and New York, 1926.

Hebrew Manuscripts at Cambridge University Library. Ed. Stefan C. Reif. Cambridge, 1997.

Heraclides Lembus. Author cited by Diogenes Laertius.

Heraclides Ponticus. Author cited by Diogenes Laertius.

——. Fragments. In W. K. C. Guthrie, *A History of Greek Philosophy, I: The Earlier Presocratics and the Pythagoreans,* 163–64. 1962; reprint, Cambridge, 2000.

Heraclitus of Ephesus. Author cited by Diogenes Laertius.

——. Fragments. In Jonathan Barnes, *Early Greek Philosophy,* 100–26. Harmondsworth, 1987.

——. *Heraclitus, the Cosmic Fragments.* Ed. Geoffrey S. Kirk. Cambridge, 1954.

Hermippus. Author cited by Diogenes Laertius.

Herodotus. *History.*

Heron. *Definitions.* Quoted in *Greek Mathematical Works,* ed. and trans. Ivor Thomas, 1:3. Cambridge, MA, 1951.

Hesiod. *Works and Days.*

Hierocles of Alexandria. *Avrevm Pythagoreorvm carmen commentarivs.* Ed. Friederich W. Koehler. Stuttgart, 1974.

——. *Hieroclis philosophi commentarius in aurea Pythagoreorum carmina.* Ed. Joan Curterio. London, 1654.

——. *Les vers d'or: Hiéroclès. Commentaire sur les vers d'or des Pythagoriciens.* Ed. Mario Meunier. Paris, 1931.

Higham, Thomas F., and Cecil Maurice Bowra, eds. *The Oxford Book of Greek Verse.* Oxford, 1938.

Hippasus of Metapontum. Author described by Diogenes Laertius.

——. Fragments. In Hermann Diels, *Die Fragmente der Vorsokratiker,* 5th ed., ed. Walther Kranz, vol. 1. 1903; Berlin, 1934.

Hippobotus. Author cited and quoted by Diogenes Laertius.

——. Author cited by Porphyry.

Hippolytus. *Philosophumena, ou refutation de toutes les hérésies.* Ed. A. Siouville. Paris, 1928.

——. *Philosophumena.* Ed. F. L. Legge. London, 1921.

Homer. *The Odyssey.*

Homeric hymns. In *Hesiod, the Homeric Hymns, and Homerica,* ed. H. G. Evelyn-White. London and New York, 1914.

Horace. *Odes.*

Hugh of St. Victor. *The Didascalicon of Hugh of St. Victor.* Ed. Jerome Taylor. New York and London, 1961.

——. *De scripturis et scriptoribus sacris. Patrologia Latina.* Ed. J.-P. Migne, vol. 175.

Hyginus Funaioli, ed. *Grammaticae romanae fragmenta.* Vol. 1. Leipzig, 1907.

Iamblichus of Chalcis. *De vita Pythagorica liber.* Rev. ed. Ed. Udalricus Klein. 1937 (ed. L. Deubner); Stuttgart, 1975.

——. Fragment about Speusippus. In *Greek Mathematical Works,* ed. and trans. Ivor Thomas, vol. 1. Cambridge, MA, 1951.

——. *On the Pythagorean Way of Life (Vita Pythagorica)*. Ed. Gillian Clark. Liverpool, 1989.

Ibn at-Tayyib, *Proclus' Commentary on the Pythagorean Golden Verses.* Trans. Neil Linley. Buffalo, 1984.

Ion of Chios. Fragments. In Hermann Diels, *Die Fragmente der Vorsokratiker,* 5th ed., ed. Walther Kranz, 1:377–81. 1903; Berlin, 1934.

Isidore of Seville (Isidorus Hispalensis). *Etymologiae/Sancti Isidori etymologiarum libri XX.* In *Patrologia Latina,* ed. J.-P. Migne, vol. 82.

——. *Isidori hispalensis episcopi etymologiarvm sive originvm libri XX.* Ed. W. M. Lindsay. Oxford, 1911.

——. *The Letters of St. Isidore of Seville.* 2nd rev. ed. Ed. Gordon B. Ford. Amsterdam, 1970.

——. *The Medical Writings.* Ed. William D. Sharpe. In *Transactions of the American Philosophical Society.* Philadelphia, 1964.

Isocrates. *Busiris.* In *Isocrates,* ed. Larue Van Hook, vol. 3. Cambridge, MA, and London, 1945.

Jacoby, Felix, ed. *Die Fragmente der griechischen Historiker.* 1923–58; reprint, Leiden, 1993.

Jerome. *Die Chronik des Hieronymus/Hieronymi Chronicon.* In *Eusebius Werke,* ed. R. Helm, vol. 7. Berlin, 1984.

——. *Hieronymus liber de viris inlustribus/Gennadius Liber de viris inlustribus.* Ed. Ernest C. Richardson. In *Texte und Untersuchungen zur Geschichte der altchristlichen Literatur,* 14. Leipzig, 1896.

——. *Letters.*

John of Damascus. *La fede ortodossa.* Ed. Vittorio Fazzo. Rome, 1998.

Josephus (Flavius Josephus). *Against Apion.*

Julian (Flavius Claudius Julianus). *The Works of Emperor Julian.* Ed. Wilmer C. Wright. London and New York, 1952–90.

Justin Martyr. *Dialogue with Trypho.*

Justinus (Marcus Junian Justinus). *Epitome,* in Pomponio Trogus, *Historiae philippicae.* In Cornelia de Vogel, *Pythagoras and Early Pythagoreanism,* 60–64. Assen, 1966.

Leonardo da Pisa. "Il libro dei quadrati di Leonardo Pisano." Ed. Ettore Picutti. *Physis* 19 (1979): 195–339.

Livy (Titus Livius). *Ab urbe condita libri.*

Lorris, Guillaume de, and Joan De Meur, eds. *The Romance of the Rose.* 3rd ed. Trans. Charles Dahlberg. Princeton, 1995.

Lucian (Lucian of Samosata). *Alexander the False Prophet.*

——. *The Dance.*

——. *The Dialogues of the Dead.*

——. *Hermotimus.*

——. *Lexiphanes.*

——. *The Lover of Lies.*

——. *A Slip of the Tongue in Greeting.*

Llull, Ramón. *Ars compeniosa medicinae.* In Llull, *Principes de médecine,* ed. Armand Llinares. Paris, 1992.

Lyco of Troas. Author cited by Diogenes Laertius.

Lycus. Author cited by Porphyry.

Lysis. Author cited by Diogenes Laertius.

Macrobius (Ambrosius Theodosius). *Ambrosii Theodosii Macrobii, Macrobius conviviorvm primi diei saturnaliorvm.* Ed. Franciscvs Eyssenhardt. Leipzig, 1893.

———. *Commentary on the Dream of Scipio.*

———. *Macrobi Ambrosii Theodosii commentari in Ciceronis somnium Scipionis.* Vol. 1. Ed. Ludovicus Lanus. Quedlinburg and Leipzig, 1848.

———. *Saturnalia.*

Maffei, Raffaelle. *Commentaria urbana.* Rome, 1506.

Maimonides (Musa Ibn Maimun). *The Guide for the Perplexed.* Ed. Michael Friedländer. London, 1919.

———. *Moses ben Maimon, sein Leben, seine Werke, und sein Einfluss.* 2 vols. Ed. Wilhelm Bacher, Marcus Brann, and David Simonsen. Leipzig, 1908–14.

Marinus of Samaria. *Life of Proclus* (*Vita Procli*). Ed. David Fideler. Grand Rapids, 1986.

———. *Marini vita procli.* Ed. J. F. Boissonade. Leipzig, 1814.

Martial (Marcus Valerius Martialis). *Epigrams.*

Martianus Capella. *De nuptiis philologiae et mercurii.* Ed. Franciscus Eyssenhardt. Leipzig, 1866.

———. *Martianus Capella and the Seven Liberal Arts.* Ed. William Harris Stahl. New York, 1977.

The Marvels of Rome. 2nd ed. Ed. and trans. F. M. Nichols. New York, 1986.

Meibom, Marcus, ed. *Antiquae musicae auctores septem.* Amsterdam, 1652.

Menander. *Menander, the Principal Fragments.* Ed. Francis G. Allinson. London and New York, 1930.

Migne, Jacques-Paul, ed. *Patrologia Graeca.*

———, ed. *Patrologia Latina.*

Mimnermus. Fragments. In *Greek Elegiac Poetry from the Seventh to the Fifth Centuries* BC, ed. Douglas E. Gerber. Cambridge, MA, and London, 1999.

Mnesimachus. Author cited by Diogenes Laertius.

Moderatus of Gades. Author cited by Porphyry.

Neanthes of Cyzicus. Fragments. In Isidore Lévy, *Recherches sur les sources de la legende de Pythagore.* Paris, 1926.

Nepos, Cornelius. *De viris illustribus.* In *Gli uomini illustri,* ed. Luca Canali. Bari, 1983.

Nicomachus of Gerasa. *Introduction to Arithmetic.* In *Nicomachus of Gerasa: Introduction to Arithmetic,* trans. Martin Luther D'Ooge; with essays by Frank E. Robbins and Louis C. Karpinski. New York, 1926.

———. "Manuale harmonicum" [Greek text]. In *Musici scriptores graeci,* ed. Carolus Janus [Karl van Jan]. 1985; reprint, Hildesheim, 1962.

———. *Manual of Harmonics.* In *The Manual of Harmonics of Nicomachus the Pythagorean,* ed. Flora R. Levin. Grand Rapids, MI, 1994.

———. *Nichomachi Geraseni Pythagorei introductionis arithmeticae libri II.* Ed. Richard Hoche. Leipzig, 1866.

———. *Theologoumena arithmeticae.* Described in Photius, *Bibliothèque,* ed. René Henry. Vol. III, Codex 187. Paris, 1962.

Numenius of Apamea. *De bono.* Quoted in Eusebius of Caesaria, *Preparatio evangelica.*

———. *Numenius: Fragments.* Ed. and trans. Édouard des Places. Paris, 1973.

Olympiodorus of Alexandria. *Commentary on Plato's Gorgias.* Ed. Robin Jackson, Kimon Lycos, and Harold Tarrant. Leiden, 1998.

Origen. *Contra celsum.*

Orosius, Paulus. *Historiae adversum paganos.*

——. *Orosio: Le storie contro i pagani.* 2 vols. Ed. Aldo Bartalucci. Milan, 1976.

Ovid (Publius Ovidius Naso). *Fasti.*

——. *Heroides.*

——. *Metamorphoses.*

Pachymeres, Georgios. *Quadrivium de Georges Pachymère* [Greek text]. Ed. Paul Tan-
nery and R. P. E. Stéphanou. Vatican City, 1940.

Palladio, Andrea. *The Four Books of Architecture.*

Parmenides. Author quoted by Diogenes Laertius.

——. Author quoted by Sextus Empiricus.

——. Author quoted by Simplicius.

Parmenides of Elea. Author cited by Diogenes Laertius.

Paton, W. R., ed. *The Greek Anthology.* 5 vols. Various editions. London and New York.

Pausanias. *Description of Greece.*

Petrarch. *De viris illustribus.*

——. *De vita solitaria.*

——. *Epistolae.*

——. *Familiarium rerum libri.*

——. *Itinerarium de Janua usque in Hierusalem et Alexandriam.* Orig. text in *Viaggio
in Terrasanta,* ed. Antonio Altamura. Naples, 1979.

——. *On His Own Ignorance.* Trans. in *The Renaissance Philosophy of Man,* ed. Ernst
Cassirer, Paul Oskar Kristeller, and John Herman Randall Jr. Chicago, 1948.

——. *Trionfo della fama.*

Petrus de Abano. *Conciliator differentiarvm philosophorvm.* Ed. Gabriel de Grassis.
Pavia, 1490.

Philo Judaeus. *De declogo.*

——. *De opificio mundi.*

——. *De specialibus legibus.*

——. *De vita Mosis I–II.*

——. *Quaestiones in Genesis.*

——, attributed. *Wisdom of Solomon.*

Philolaus of Croton. Fragments. In Jonathan Barnes, *Early Greek Philosophy,* 216–23.
Harmondsworth, 1987.

Philoponus. *Commentary on Aristotle's Physics.* In *Greek Mathematical Works,* ed.
and trans. Ivor Thomas, 1:235. Cambridge, MA, 1951.

Philostratus (Flavius Philostratus). *Life of Apollonius of Tyana/The Epistles of Apollo-
nius of Tyana,* ed. F C. Conybeare. London and New York, 1921.

——. *Lives of the Sophists.*

Photius. *Bibliotheca* or *Myriobiblion.* In *Bibliothèque,* vols. III and VII, ed. René
Henry. Paris, 1962 and 1967.

Pindar. *Dirges.*

——. Fragment 205 ("The Birth of Pindar"). In *The Odes of Pindar including the Prin-
cipal Fragments,* ed. John Sandys, vii. London and New York, 1919.

——. *Isthmian Odes.*

——. *Nemean Odes.*

——. *Olympian Odes.*

——. *Paeans.*

——. *Pythian Odes.*

Pisano, Leonardo. *The Book of Squares.* Ed. and trans. L. E. Sigler. Boston, 1987.

Plato. *The Collected Dialogues*. Ed. Edith Hamilton and Huntington Cairns. Trans. Hugh Tredennick. Bollingen Series 71. 1961; reprint, Princeton, 1994.

——. *Cratylus*.

——. *Epinomis*.

——. *Epistle XIII*.

——. *Gorgias*.

——. *The Laws*.

——. *Phaedo*.

——. *Philebus*.

——. *The Republic*.

——. *Timaeus*.

Pliny the Elder (Gaius Plinius Secundus). *Historia naturalis*.

Plotinus. *The Enneads*.

Plutarch (Plutarch of Chaeronea). *The Cleverness of Animals*.

——. *The E at Delphi*.

——. *The Education of Children*.

——. Fragments. In *Moralia*, ed. F. H. Sandbach. Cambridge, MA, and London, 1969.

——. *The Greek Questions*.

——. *How to Profit by One's Enemies*.

——. *How to Study Poetry*.

——. *How to Tell a Flatterer*.

——. *Is "Live Unknown" a Wise Precept?*

——. *Isis and Osiris*.

——. *Life of Numa*.

——. *On Brotherly Love*.

——. *On Compliancy*.

——. *On Curiosity*.

——. *On Having Many Friends*.

——. *On Listening to Lectures*.

——. *On Moral Virtue*.

——. *On Music*.

——. *On the Eating of Flesh*.

——. *On the Education of Children*.

——. *On the Fortune or Virtue of Alexander*.

——. *On the Sign of Socrates*.

——. *Opinions des philosophes*, ed. Guy Lachenaud. Paris, 1993.

——. *Parallel Lives*.

——. *Platonic Questions*.

——. *A Pleasant Life Impossible*.

——. *The Roman Questions*.

——. *Table Talk*.

Polybius. *The Histories*.

Pompeius Trogus. *Historiae Philippicae*.

Pomponius Mela. *De chorographia*.

Porphyry of Tyre. *De abstinentia*. Ed. Jean Bouffartigue and Michel Patillon. Paris, 1977–79.

——. *De antro nympharum*. In *The Cave of the Nymph in the Odyssey*, ed. John M. Duffy. Buffalo, 1969.

——. *De vita Pythagorae*. In *Porphyrii philosophi Platonici opvscvla tria*, ed. Augustus Nauck. Leipzig, 1860.

——. "Life of Pythagoras." In *The Pythagorean Sourcebook and Library*, comp. Kenneth S. Guthrie, ed. David Fideler. Grand Rapids, MI, 1987.

——. *On Abstinence from Killing Animals*. Ed. Gillian Clark. Ithaca, 2000.

——. *Porphyrii in Platonis Timaeum commentariorum fragmenta*. Ed. A. R. Sodano. Naples, 1964.

Posidonius of Apamea. *Die Fragmente*. Ed. Willy Theiler. 2 vols. Berlin, 1982.

——. *Posidonius of Apamea and Rhodes: I. The Fragments*. 2nd ed. Ed. L. Edelstein and I. G. Kidd. 1972; Cambridge, 1989.

Proclus Diadochus. *Commentaire sur le Timée*. Ed. A. J. Festugière. Paris, 1966.

——. *Commentary on Euclid*.

——. *Elements of Physics*.

——. *Elements of Theology*.

——. *Hymns*.

——. *Platonic Theology*.

——. *Théologie Platonicienne*. Ed. H. D. Saffrey and L. G. Westerink. 6 vols. Paris, 1968–97.

Psellus, Michael. *Theologica*. Ed. Paul Gautier. Bibliotheca Scriptorvm Graecorvm et Romanorvm. Leipzig, 1989.

Pseudo-Aristotle. *The Secret of Secrets: Sources and Influences*. Ed. Charles B. Schmitt and W. F. Ryand. London, 1982.

Pseudo-Dionysius. *S. Dionysii Areopagitae opera omnia quae extant*. In *Patrologia Graeca*, ed. J.-P. Migne, vols. 3–8.

——. *Pseudo-Dionysius: The Complete Works*. Trans. Colm Luibheid, Ed. Paul Rorem. New York, 1987.

——. *The Works of Dionysius the Areopagite*. Trans. and ed. John Parker. 1899, reprint, New York, 1976.

Pseudo-Iamblichus of Chalcis. *Theologvmena arithmeticae*. Ed. Victorivs de Falco. Stuttgart, 1975.

——. *The Theology of Arithmetic*. Ed. Peter Gravinger. Athens, 1983.

——. *The Theology of Arithmetic: On the Mystical, Mathematical, and Cosmological Symbolism of the First Ten Numbers*. Ed. and trans. Robin Waterfield. With a foreword by Keith Critchlow. Grand Rapids, MI, 1988.

Questenberg, Giacomo Aurelio. *Codex Hannover.Bib.XLIII.1845*.

Quintilian (Marcus Fabius Quintilianus). *Institutio oratoria*.

Remigius of Auxerre. *Commentum in martianum capellam*. Ed. Cora E. Lutz. Leiden, 1962–65.

Sacrobosco, John. *Sphaera mundi*.

Sappho. Fragments. In *Greek Lyric*, ed. and trans. David A. Campbell, vol. 3. Cambridge, MA, and London, 1991.

——. Fragments. In *The Love Songs of Sappho*, ed. Paul Roche. Amherst, NY, 1998.

Seneca (Lucius Anneus Seneca). *Epistle CVII: "On the Approaches to Philosophy."*

Sextus Empiricus. *Against the Arithmeticians*. In *Against the Professors*.

Sextus Pythagoreus. *The Sentences of Sextus*. Ed. Richard A. Edwards and Robert A. Wild. Chico, CA, 1981.

——. *The Sentences of Sextus: A Contribution to the History of Early Christian Ethics*. Ed. Henry Chadwick. Cambridge, 1959.

Simonides. Fragments. In *Greek Lyric*, ed. and trans. David A. Campbell, vol. 3. Cambridge, MA, and London, 1991.

Simplicius. Fragment of *Commentary on Aristotle's Categories*. In *Greek Mathematical Works*, ed. and trans. Ivor Thomas, vol. 1. Cambridge, MA, 1951.

——. *Commentaire sur les catégories.* Ed. I. Hadot. Leiden, 1990.

Sosicrates. Author cited by Diogenes Laertius.

Speusippus. Fragments. In *De Speusippi academici scriptis,* ed. Paul Lang. 1911; Frankfurt, 1964.

——. Fragment preserved by Iamblichus. In *Greek Mathematical Works,* ed. and trans. Ivor Thomas, vol. 1. Cambridge, MA, 1951.

Stobaeus (Iohannes Stobaeus). *Ioannis Stobaei Anthologium.* 5 vols. Ed. Cvrtivs Wachsmvth and Otto Hense. Berlin, 1884–1912.

Strabo. *Geography.*

Suetonius (Suetonius Tranquillus). *Lives of the Twelve Caesars.*

Theocritus. *The Love of Cynisca.* In *The Greek Bucolic Poets,* ed. and trans. J. M. Edmonds. London and New York, 1928.

Theon of Smyrna. *Expositio rerum mathematicarum ad legendum platonem utilium.* Ed. Eduard Hiller. Leipzig, 1878.

——. *Mathematics Useful for Understanding Plato.* Ed. R. Lawlor and D. Lawlor. San Diego, 1979.

Thierry de Chartres. *Commentum super Boethii librum de Trinitate.*

——. *Commentaries on Boethius by Thierry of Chartres and His School.* Ed. Nikolaus Häring. Toronto, 1971.

——. *De septem diebus.* Extensive quoted passages in Brian Stock, *Myth and Science in the Twelfth Century: A Study of Bernard Silvester.* Princeton, 1972.

Thomas Aquinas. *An Exposition of the "On the Hebdomads" of Boethius.* Ed. Janice Schultz and Edward Synan. Washington, DC, 2001.

——. *Summa theologica.*

Timaeus. Author cited by Diogenes Laertius.

——. Author cited by Porphyry.

Timon. Author cited by Diogenes Laertius.

Timon of Phliasios. Quoted in Plutarch, *Life of Numa,* in *Plutarch's Lives,* ed. Bernadotte Perrin, vol. 1. London and New York, 1913.

Turba philosophorum. Ed. Julius Ruska. 1931; reprint. Berlin, 1970.

Turba philosophorum . . . Called Also the Book of Truth in the Art and the Third Pythagorean Synod. Ed. Arthur E. Waite. 1896; London, 1970.

Valerius Maximus. *Facta et dicta memorabilia.*

Valla, Giorgio. *De expetendis et fugiendis rebus.*

Varro (Marcus Terrentius). *Antquitates rerum humanarum et divinarum.*

Vincent of Beauvais. *Speculum Naturale.* Strasbourg, 1481.

Vitruvius (Vitruvius Pollio). *De architectura.*

——. *Ten Books on Architecture: Vitruvius.* Ed. Ingrid Rowland and Thomas N. Howe. Cambridge, 1999.

William of Conches [Guillaume de Conches]. *Glosae super Platonem, Texte critique.* Ed. Édouard Jeanneau. Paris, 1965.

——. *Liber de eodem secudus.* In *La doctrine de la création dans l'école de Chartres,* ed. J. M. Parent, 210–11. Ottawa, 1938.

——. *Philosophia mundi.* Ed. Gregor Maurach. Pretoria, 1974.

Xenokrates of Chalcedon. *Xenokrates: Darstellung der Lehre und Sammlung der Fragmente.* Ed. Richard Heinze. 1892; Hildesheim, 1965.

Xenophanes of Colophon. *Fragments: Xenophanes of Colophon.* Ed. James H. Lesher. Toronto, 1992.

Xenophilus. Author cited by Aulus Gellius.

Secondary Sources

Ackerman, James. "Ars sine scientia nihil est: Gothic Theory of Architecture at the Cathedral of Milan." *Art Bulletin* 31 (1949): 84–111.

Adamesteanu, Dinu. "L'agora di Metaponto." In *Scritti di archeologia ed arte in onore di C. M. Lerici,* 39–43. Stockholm, 1970.

——. "Argoi Lithoi a Metaponto." In *Adriatica praehistorica et antiqua,* 307–24. Zagreb, 1970.

——. "Il santuario di Apollo e urbanistica generale." In Adamesteanu, *Metaponto,* 1:15–311. Naples, 1975.

Aisa, Maria Grazia. "Storia delle ricerche sul santuario di Apolo Aleo a Cirò Marina." In *Santuari della Magna Grecia in Calabria,* ed. Elena Lattanzi, 286–89. Naples, 1996.

Allen, Michael J. B. *Nuptial Arithmetic: Marslio Ficino's Commentary on the Fatal Number in Book VIII of Plato's "Republic."* Berkeley, Los Angeles, and London, 1994.

Anastase, Stefos. *Apollo dans Pindare.* Athens, 1975.

d'Ancona, Paolo. "Le rappresentazioni allegoriche delle arti liberali nel medio evo e nel Rinascimento." *Arte* 5 (1902): 137–56, 211–28, and 269–89.

Anderson, Graham. *Philostratus, Biography, and Belles Lettres in the Third Century AD.* London and Dover, NH, 1986.

Ashley, Benedict M. "St. Albert and the Nature of Natural Science," in *Albertus Magnus and the Sciences: Commemorative Essays,* ed. James Weisheipl. Toronto, 1980.

Athanassiadi, Polymnia. "Persecution and Response in Late Paganism." *Journal of Hellenic Studies* 113 (1993): 1–29.

Aubert, Marcel. *L'architecture cistercienne en France.* 2 vols. 2nd ed. 1943; Paris, 1947.

Augenti, Andrea. "Il Palatino nel medioevo, archeologia e topografia." *Bullettino della Commissione Archeologica Comunale di Roma* (1996): 90–99.

Aujoulat, Noël. *Le néo-platonisme alexandrin: Hiéroclès d'Alexandrie.* Leiden, 1986.

Aurigemma, Salvatore. *La basilica sotterranea neopitagorica di Porta Maggiore in Roma.* Rome, 1961.

——. *Villa Adriana.* Rome, 1996.

Babbitt, Frank Cole, ed. *Plutarch's Moralia.* Cambridge, MA, and London, 1949.

Baltrusaitis, Jurgis. "L'image du monde céleste du IXe au XIIe siècle." *Gazette des Beaux-Arts* 20 (1938): 137–48.

——. "Quelques survivances de symboles solaires dans l'art du Moyen Âge." *Gazette des Beaux-Arts* 17 (1937): 75–82.

——. "Roses des vents et roses de personnages a l'époque romane." *Gazette des Beaux-Arts* 20 (1938): 265–76.

Balty, Jean C. "Pour une iconographie de Pythagore." *Bulletin des Musées Royaux d'Art et d'Histoire,* ser. 6, no. 48 (1976): 5–33.

Barnes, Jonathan. *Early Greek Philosophy.* London and New York, 1987.

Barnes, Timothy D. *Constantine and Eusebius.* Cambridge, MA, 1981.

Battaglia, Gabrielle. "Lira." In *Enciclopedia italiana,* 21:249–50. Rome, 1934.

Becatti, Giovanni. "Pitagora." In *Enciclopdia dell'arte antica classica e orientale,* 6:197–99. Rome, 1965.

——. "Ritratto di un vate antico." *Bollettino d'Arte* 24 (1949): 97–100.

Beigbeder, Olivier. *Lexique des symboles.* Saint-Léyer-Vauban, 1969.

Bendinelli, Goffredo. "Il mausoleo sotterraneo altrimenti detto basilica di Porta Mag-

giore." *Bullettino della Commissione Archeologica Comunale di Roma* 49 (1922): 85–126.

———. "Il monumento sotterraneo di Porta Maggiore in Roma." *Monumenti Antichi* 30 (1927): 601–859.

Benoit, Fernand. *Le symbolisme dans les sanctuaires de la Gaule.* Brussels, 1970.

Berkhof, Hendrikus. *De theologie des Eusebius von Caesarea.* Amsterdam, 1939.

Bernoulli, Johann Jacob. *Griechische Ikonographie mit Ausschluss Alexanders und der Diadochen.* Munich, 1901.

Berthelot, Marcellin. *La chimie au Moyen Âge.* 3 vols. Paris, 1893.

———. *Collection des anciens alchimistes grecs.* Paris, 1883.

———. *Les origines de l'alchimie.* Paris, 1885.

Bidez, Joseph. *La biographie d'Empédocle.* Paris, 1894.

———. "Le philosophe Jamblique et son école." *Revue des Études Grecques* 32 (1919): 29–40.

———. *Vie de Porphyre, le philosophe néo-platonicien, avec les fragments des traités.* Leipzig, 1913.

Bidez, Joseph, and Franz Cumont. *Les mages hellénisés: Zoroastre ostanès et hystaspe.* Paris, 1938.

Bignone, Ettore. *Empedocle: Studio critico.* Florence, 1916.

Billanovich, Giuseppe. "Petrarch and the Textual Tradition of Livy." *Journal of the Warburg and Courtauld Institutes* 14 (1951): 17–28.

Birly, Anthony. *Hadrian.* London and New York, 1997.

Bloch, Raymond. *The Origins of Rome.* New York, 1960.

Boatwright, Mary Taliaferro. *Hadrian and the City of Rome.* Princeton, 1987.

Bodleian Library. *Catalogi Codicum Manuscriptorum Bibliothecae Bodleianae Pars nona Codices a Viro clarissimo Kenelm Digby.* Oxford, 1883.

Boissier, Gaston. *Étude sur la vie et les ouvrages de M. T. Varron.* Paris, 1861.

Bolgar, R. R. *The Classical Heritage and Its Beneficiaries.* 1954; Cambridge, 1977.

Boll, Franz, Carl Bezold, and Wilhelm Gundel. *Sternglaube und Sterndeutung.* Stuttgart, 1966.

Bolton, James D. P. *Aristeas of Proconnensus.* Oxford, 1962.

Bonner, Stanley F. *The Literary Treatises of Dionysius.* Cambridge, 1939.

Borghorst, Gerhard. *De Anatolii fontibus.* Berlin, 1904.

Bornecque, Henri. *Tite-live.* Paris, 1933.

Borrelli, L. Vlad. "Samos." In *Princeton Encyclopedia of Classical Sites,* ed. Richard Stillwell et al., 802–3. Princeton, 1976.

Boss, G., and G. Seel, eds. *Proclus et son influence.* Zurich, 1987.

Bouché-Leclercq, Auguste. *L'astrologie dans le monde romain.* Paris, 1897.

———. *L'astrologie grecque.* 1899; Darmstadt, 1979.

———. *Histoire de la divination dans l'Antiquité.* Paris, 1879.

———. *Les pontifes de l'ancienne Rome.* 1871; reprint, New York, 1975.

Bowra, Cecil Maurice. *Early Greek Elegists.* Cambridge, MA, 1938.

———. *Pindar.* Oxford, 1964.

Boyancé, Pierre. *Le culte des muses chez les philosophes grecs.* Paris, 1936.

———. "Leucas." *Revue Archéologique* 3 (1929): 211–19.

Branner, Robert, ed. *Chartres Cathedral.* New York, 1969.

Brelich, Angelo. *Tre variazioni romane sul tema delle origini.* Rome, 1955.

Broche, Lucien. *La cathédrale de Laon.* 1926; reprint, Marseille, 1979.

Brogan, Olwen. "The Coming of Rome and the Establishment of Roman Gaul." In *France before the Romans,* ed. Stuart Piggott. London, 1974.

Brown, Peter. *Augustine of Hippo.* Berkeley and London, 1967.

———. "The Rise and Function of the Holy Man in Late Antiquity." *Journal of Roman Studies* 61 (1971): 80–101.

Brown, Truesdell S. *Timaeus of Tauromenium.* University of California Publications in History no. 55. Berkeley, 1958.

Brubaker, Leslie. "Basilica." In *Dictionary of the Middle Ages,* 2:123–25. New York, 1983.

Brunés, Tons. *The Secrets of Ancient Geometry and Its Use.* Trans. Charles Napier. Copenhagen, 1967.

Bulteau, Marcel Joseph. *Description de la cathédrale de Chartres.* Paris, 1850.

———. *Monographie de la cathédrale de Chartres.* Chartres, 1892.

Bürchner, Ludwig. *Das jonische Samos.* Amberg, 1892.

Burck, Erich. *Die Erzählungskunst des Titus Livius.* Berlin, 1934.

Burkert, Walter. *Ancient Mystery Cults.* Cambridge, MA, 1987.

———. "Hellenistische Pseudopythagorica." *Philologus* 105 (1961).

———. *Homer's Anthropomorphism: Narrative and Ritual.* Washington, DC, 1991.

———. *Lore and Science in Ancient Pythagoreanism.* Trans. Edwin L. Minar Jr. 1962; Cambridge, MA, 1972.

———. *Orphism and Bacchic Mysteries.* Berkeley, 1977.

Burnet, John. *Early Greek Philosophy.* 1892; New York, 1930.

Bussanich, John. *The One and Its Relation to Intellect in Plotinus.* Leiden, 1988.

Bydén, Börje. *Theodore Metochites' Stoicheiosis Astronomike and the Study of Natural Philosophy and Mathematics in Early Palaiologan Byzantium.* Göteborg, 2003.

Cadafalch, José Puig y. *La geografia e les origens del primer art romànic.* Barcelona, 1930.

Cahen, Émile. *Callimaque et son oeuvre poétique.* Paris, 1929.

Cameron, Alan. *Callimachus and His Critics.* Princeton, 1995.

———. "The Date and Identity of Macrobius." *Journal of Roman Studies* 56 (1966): 25–38.

———. "The Date of Iamblichus's Birth." *Hermes* 96 (1968): 374–76.

———. "The Last Days of the Academy at Athens." *Proceedings of the Cambridge Philological Society,* n. s., 15 (1969).

Campbell, David A., ed. and trans. *Greek Lyric.* Cambridge, MA, and London, 1991.

Carafa, Paolo. "Il comizio di Roma dalle origini all'età di Augusto." *Bullettino della Commssione Archeologica Comunale di Roma* (1998).

Carcopino, Jérôme. *La baslique pythagoricienne de la Porte Majeure.* Paris, 1927.

———. *De Pythagore aux Apôtres: Études sur la conversion du monde romain.* Paris, 1956.

———. "Encore la basilique de la 'Porta Maggiore.'" *Revue Archéologique* 18 (1923): 1–23.

Cardilli, Luisa, ed. *La fontana del Pantheon.* Rome, 1993.

Casini, Paolo. *L'antica sapienza italica: Cronistoria di un mito.* Bologna, 1998.

Cassirer, Ernst, Paul Oskar Kristeller, and John Herman Randall Jr., eds. *The Renaissance Philosophy of Man.* Chicago, 1948.

Cavallo, Guglielmo, ed. *Libri e lettori nel mondo bizantino.* Bari, 1982.

Centre Jean Palerne. *Bibliographie des textes médicaux latins Antiquité et haut Moyen Âge.* Ed. Guy Sabbah, Pierre-Paul Corsetti, and Klaus-Dietrich Fischer. St.-Etienne, 1987.

Chaignet, Anthelme E. *Pythagore et la philosophie pythagoricienne,* 2 vols. Paris, 1873.

Chance, Jane. *Medieval Mythography from Roman North Africa to the School of Chartres.* Gainesville, FL, 1994.

Charles-Saget, Annick. *L'architecture du divin: Mathematique et philosophie chez Plotin et Proclus.* Paris, 1982.

Charrière, G. "Nouvelle hypothèse sur les dodécaèdres gallo-romains." *Revue Archéologique de l'Est et du Centre-Est* 16 (1965): 148–59.

Chase, Steven. *Angelic Wisdom: The Cherubim and the Grace of Contemplation in Richard of St. Victor.* South Bend, IN, and London, 1995.

Ciaceri, Emanuele. *Cicerone e I suoi tempi.* Milan, Rome, and Naples, 1926.

Clagett, Marshall, Gaines Post, and Robert Reynolds, eds. *Twelfth-Century Europe and the Foundations of Modern Society.* 1961; Madison, WI, 1966.

Clerval, Jules Alexandre. *Les écoles de Chartres au Moyen Âge.* 1895; reprint, Frankfurt, 1965.

Conant, Kenneth J. *Carolingian and Romanesque Architecture.* 2nd rev. ed. 1959; Harmondsworth and Baltimore, 1974.

Copenhaver, Brian P. *Hermetica: The Greek Corpus Hermeticum and the Latin Asclepius.* Cambridge, 1992.

Coulson, W. D. E. "Kroton." In *Princeton Encyclopedia of Classical Sites,* ed. Richard Stillwell et al. Princeton, 1976.

Courcelle, Pierre Paul. "La posterité crétienne du 'Songe de Scipion.'" *Revue des Études Latines* 36 (1958): 205–34.

Courtillé, Anne. *La cathédrale de Clermont.* Nonette, 1994.

Cramer, Frederick H. *Astrology in Roman Law and Politics.* Memoires of the American Philosophical Society 37. 1954; reprint, Chicago, 1996.

Crema, Luigi. "Architettura romana." In *Enciclopedia classica III: Archeologia e storia dell'arte classica,* 12(1): 375–81. Turin, 1959.

Crosby, Sumner M. *The Abbey of St. Denis, 475–1172.* New Haven, 1942.

Cumont, Franz. *After Life in Roman Paganism.* New Haven (1922), reprint, New York, 1959.

——. "Astrologues romains et byzantins." *Mélanges d'Archéologie et d'Histoire* 37 (1918): 13–40.

——. *Astrology and Religion among the Greeks and Romans.* Trans. J. B. Baker. New York, 1912.

——. "La basilique souterraine de la Porta Maggiore." *Revue Archéologique* 8 (1918): 52–73.

——. *Études syriennes.* Paris, 1917.

——. *Lux Perpetua.* Paris, 1949.

——. *Les mystères de Mithra.* Brussels, 1913.

——. *Recherches sur le symbolisme funéraire des romains.* Paris, 1942.

——. *Les religions orientales dans le paganisme romain.* 1905; Paris, 1929.

——. *Textes et monuments figurés relatifs aux mystères de Mithra.* Brussels, 1899.

Cumont, Franz, and Joseph Bidez. *Les mages hellénisés: Zoroastre ostanes et hystaspe.* Paris, 1938.

Curtis, C. Densmore. "Sappho and the 'Lucadian Leap.'" *American Journal of Archaeology* 24 (1920): 146–51.

Curtius, Ernst R. *European Literature and the Latin Middle Ages.* New York, 1953.

Daff'a, Ali A. al-, and John J. Stroyls. *Studies in the Exact Sciences in Medieval Islam.* Dhahran and New York, 1984.

Davis, Michael T. "The Cathedral of Clermont-Ferrand: History of Its Construction, 1248–1512." PhD diss., University of Michigan, 1979.

Debus, Allen G. "Mathematics and Nature in the Chemical Texts of the Renaissance." *AMBIX: The Journal of the Society for the Study of Alchemy and Early Chemistry* 15 (1968): 6–7.

De Fine Licht, Kjeld. *The Rotunda in Rome.* Copenhagen, 1968.

Dehio, Georg, and Gustav Bezold. *Kirchliche Baukunst des Abendlandes.* Vol. 1. Hildesheim, 1969.

Deichmann, F. *Frühchristlche Kirchen in Rom.* Basel, 1948.

De Juliis, Ettore M. *Metaponto.* Bari, 2001.

DeLatte, Armand. *Essai sur la politique pythagoricienne.* Paris, 1922.

———. *Études sur la littérature pythagoricienne.* Paris, 1915.

DeLatte, Armand, and Philippe Derchain. *Les intailles magiques gréco-egyptiennes.* Paris, 1964.

Delbrück, Richard. *Das Apollotempel am Marsfeld.* Rome, 1903.

Denis, Albert-Marie, and M. de Jonge, eds. *Fragmenta pseudepigraphorum graeca.* In *Pseudepigrapha veteris testamenti Graece.* Leiden, 1970.

Deonna, W. "Des dodécaèdres gallo-romains en bronze, ajourés et bouletés." *Bulletin de l'Association Pro Aventico* (Lausanne) 16 (1954): 19–89.

Derolez, Albert. *Lamberti S. Audomari canonci liber floridus.* Ghent, 1968.

Desgodetz, Antoine. *Les edifices antiques de Rome dessinés et mesurés très exactement par Antoine Desgodetz architecte.* Paris, 1682.

des Places, Édouard. *Eusèbe de Césarée, commentateur: Platonisme et écriture sainte.* Paris, 1982.

———. "Le *Livre de la sagesse* et les influences grecques." *Biblica* 50 (1969): 536–42.

———. "Platon et l'astronomie chaldéene." In *Mélanges Franz Cumont,* 129–42. Annuaire de l'Institut de Philologie et d'Histoire Orientales et Slavs 4. Brussels, 1936.

———, ed. and trans. *Vie de Pythagore/Lettre à Marcella.* Paris, 1982.

de Vogel, Cornelia J. *Greek Philosophy.* Vol. 1. Leiden, 1957.

———. *Pythagoras and Early Pythagoreanism.* Assen, 1966.

Diels, Hermann. *De Fragmente der Vorsokratiker.* Ed. Walther Kranz. 1903; Berlin, 1934.

———. *Doxographi Graeci.* Berlin, 1879.

Dillon, John M., ed. *Iamblichi Chalcidensis I Platonis dialogos commentariorum fragmenta.* Vol. 1. Leiden, 1973.

———. *The Middle Platonists.* 1977; reprint, Ithaca, 1996.

Dinsmoor, William B. *The Architecture of Ancient Greece.* 3rd ed. 1927; London, 1950.

Dobesch, Gerhard. *Das europäische "Barbaricum" und die Zone der Mediterrankultur Ihre historische Wechsel Wirkung und das Geschichtsbild des Poseidonius.* Vienna, 1995.

Dodds, Eric R. *The Greeks and the Irrational.* 1951; Boston, 1957.

Dombart, Theodor. *Das Palatinische Septizonium zu Rom.* Munich, 1922.

D'Ooge, Martin Luther, with Frank E. Robins and Louis C. Karpinski, eds. *Nicomachus of Gerasa: Introduction to Arithmetic.* New York, 1926.

Doresse, Jean. *The Secret Books of the Egyptian Gnostics: An Introduction to the Gnostic Coptic Manuscripts Discovered at Chenoboskion.* London, 1960.

Dörrie, Heinrich. "Pythagoras als Schüler des Zoroaster—Ein Modell für platonische Legenden." In *Der hellenistische Rahmen des kaiserzeitlichen Platonismus.* Stuttgart, 1990.

Duby, Georges, ed. *Entretiens d'Auxerre: L'école carolingienne d'Auxerre.* Paris, 1991.

Duffy, John. "Hellenic Philosophy in Byzantium and the Lonely Mission of Michael

Psellos." In *Byzantine Philosophy and Its Ancient Sources*, ed. Katerina Ierodiakonou, 139–51. Oxford, 2002.

Dumézil, Georges. *La religion romaine archaïque*. Paris, 1987.

Dümmler, Ernst. "Gedichte aus dem elften Jahrhundert." *Neues Archiv: Gesellschaft für ältere deutsche Geschichtskunde zur Beförderung* 1 (1896): 180–83.

Duret, L., and J.-P. Néraudau. *Urbanisme et métamorphoses de la Rome antique*. Paris, 1983.

Ellis, Peter. *The Druids*. New York, 1994.

Evans, Joan. *Art in Medieval France*. 1948; Oxford, 1969.

——. *The Flowering of the Middle Ages*. New York, Toronto, and London, 1966.

——. *Romanesque Architecture of the Order of Cluny*. Cambridge, 1938.

Fabbri, Marco, and Angelo Trotta. *Una scuola-collegio di età Augustea*. Rome, 1989.

Ferrari, M. "Le scoperte a Bobbio nel 1493: Vicende di codici e fortuna di testi." *Italia Medioevale e Umanistica* 13 (1970): 150–65.

Field, Guy C. *Plato and His Contemporaries*. 3rd ed. 1930; London, 1967.

Flinterman, Jaap-Jan. *Power, Paideia, and Pythagoreanism: Greek Identity, Conceptions of the Relationship between Philosophers and Monarchs, and Political Ideas in Philostratus' Life of Apollonius of Tyana*. Dutch Monographs on Ancient History and Archaeology 13. Amsterdam, 1995.

Focillon, Henri. *Art d'occident*. 3rd ed. 1938; Paris, 1955.

Foerschner, Gisela. *Die Muenzen der Roemischen Kaiser in Alexandrien*. Frankfurt, 1988.

Fontaine, Jacques. *Isidore de Seville et la culture classique dans l'Espagne Wisigothique*. Paris, 1959.

Fowler, W. Warde. *The Religious Experience of the Roman People from the Earliest Times to the Age of Augustus*. 1911; New York, 1971.

——. *Roman Festivals of the Period of the Republic*. Port Washington, NY, 1969.

Fracassini, Umberto. *Il misticismo greco e il Cristianesimo*. Città di Castello, 1922.

Frank, Erich. *Plato und die sogenannten Pythagoreer*. Halle, 1923.

Frankl, Paul. "A French Gothic Cathedral: Amiens." *Art in America* 35 (1947): 295–99.

Frisch, Hartvig. *Cicero's Fight for the Republic*. Copenhagen, 1946.

Gagé, Jean. *Apollon romain*. Paris, 1955.

Gamble, Harry Y. *Books and Readers in the Early Church: A History of Early Christian Texts*. New Haven and London, 1995.

Garfagnini, Gian Carlo. *Ambrogio Traversari nel VI centenario della nascita*. Florence, 1988.

Garin, Eugenio. *La cultura filosofica del Rinascimento italiano*. Florence, 1961.

Gatti, E., and F. Fornari. "Brevi notizie relative alla scoperto di un monumento sotterraneo presso Porta Maggiore." In *Notizie degli Scavi*, 30–52. Rome, 1916.

Gebhardt, Oskar von. "Ein Bücherfund in Bobbio." *Centralblatt für Bibliothekswesen* 5, no. 8 (1888): 343–62.

Geffcken, Johannes. *The Last Days of Greco-Roman Paganism*. Trans. Sabine MacCormack. 1929; Amsterdam, New York, and Oxford, 1978.

Gersh, Stephen. *From Iamblichus to Eriugena: An Investigation of the Prehistory and Evolution of the Pseudo-Dionysian Tradition*. Leiden, 1978.

——. *The Platonic Tradition in the Middle Ages*. Berlin and New York, 2002.

Gevaert, François Auguste. *Histoire et théorie de la musique de l'antiquité*. Ghent, 1875–81.

Gibson, Margaret. "The Study of the *Timaeus* in the Eleventh and Twelfth Centuries." *Pensamiento* 35 (1969).

Gies, Joseph, and Frances Gies. *Leonard of Pisa and the New Mathematics of the Middle Ages.* New York, 1969.

Gigante, Marcello. "Ambrogio Traversari interprete di Diogene Laerzio." In *Ambrigio Traversari nel VI centenario della nascita,* ed. Gian Carlo Garfagnini. Florence, 1988.

Gilly, Carlos, and Cis van Heertum, eds. *Magia, alchimia, scienza dal '400 al '700.* Florence, 2002.

Giovenale, Giovanni B. *La basilica di sta. Maria in Cosmedin.* Rome, 1927.

Girgenti, Giuseppe. *Il pensiero forte di Porfirio: Mediazione fra henologia platonica e ontoligia aristotelica.* Milan, 1996.

Gisinger, Friedrich. *Die Erdbeschreibung des Eudoxos von Knidos.* Berlin, 1921.

Gjerstad, Einar. *Early Rome. Acta Instituti Romani Regni Sueciae.* Lund, 1953–66. Vols. 1 (1953), 2 (1956), 3 (1960), 4 (1966).

Glover, Terrot R. *Herodotus.* London, 1924.

Glucker, Johannes. *Antiochus and the Late Academy.* Göttingen, 1978.

Goldschmidt, E. P. "The First Edition of Lucian of Samosata." *Journal of the Warburg and Courtauld Institutes* 14 (1951): 7–20.

González Urbaneja, Pedro Miguel. *Pitágoras: El filósofo del número.* Madrid, 2001.

Gordon, Richard. *Image and Value in the Graeco-Roman World.* Aldershot, 1966.

Gottlieb, Theodor. *Mittelalterliche Bibliotheken.* Leipzig, 1890.

Graf, Arturo. *Roma nella memoria e nelle immaginazioni del Medio Evo.* Turin, 1923.

Graindor, Paul. *Athènes sous Hadrien.* 1934; reprint, New York, 1973.

Greenhalgh, Michael. *The Survival of Roman Antiquities in the Middle Ages.* London, 1989.

Grendler, Paul F. *Schooling in Renaissance Italy: Literacy and Learning, 1300–1600.* Baltimore and London, 1989.

Grimal, Pierre. *Cicéron.* Paris, 1986.

Grimme, Ernst G. *Bronzebildwerke des Mittelalters.* Darmstadt, 1985.

Grodecki, Louis. *Chartres.* Paris, 1963.

Gruenwald, Ithamar. *Apocalyptic and Merkavah Mysticism.* Leiden, 1980.

Guthrie, Kenneth Sylvan, comp. *The Pythagorean Sourcebook and Library.* Ed. David Fideler. 1929; Grand Rapids, MI, 1988.

Guthrie, William K. C. *A History of Greek Philosophy, I: The Earlier Presocratics and the Pythagoreans.* 1962; reprint, Cambridge, 2000.

——. *A History of Greek Philosophy, II: The Presocratic Tradition from Parmenides to Democritus.* 1967; reprint, Cambridge, 2000.

Guyonvarc'h, Christian J., and Françoise Le Roux. *Les Druides.* Rennes, 1987.

Hadas, Moses. *A History of Greek Literature.* New York, 1950.

Hadas, Moses, and Morton Smith. *Heroes and Gods: Spiritual Biographies in Antiquity.* Freeport, NY, 1970.

Hadot, Ilsetraut, ed. *Simplicius, Sa vie, son oeuvre, sa survie.* Berlin and New York, 1987.

Hahnloser, Hans. *Villard de Honnecourt: Kritische Gesamtausgabe des Bauhüttenbuches.* Vienna, 1935.

Hanfmann, George M. *Roman Art.* Greenwich, CT, 1964.

Hankins, James. "Plato in the Middle Ages." In *Dictionary of the Middle Ages,* 9:694–704. New York, 1987.

Haskins, Charles Homer. "A List of Books from the Close of the Twelfth Century." *Harvard Studies in Classical Philology* 20 (1909): 75–94.

——. *The Renaissance of the Twelfth Century.* 1927; New York, 1957.

Hathaway, Ronald F. *Hierarchy and the Definition of Order in the Letters of Pseudo-Dionysius: A Study in the Form and Meaning of the Pseudo-Dionysian Writings.* The Hague, 1969.

Haussleiter, Johannes. *Der Vegetarismus in her Antike.* Berlin, 1935.

Hautecoeur, Louis. *Mystique et architecture: Symbolisme du cercle et de la coupole.* Paris, 1954.

Heath, Thomas. *Aristarchus of Samos . . . A History of Greek Astronomy to Aristarchus.* Oxford, 1913.

——. *A History of Greek Mathematics.* 2 vols. 1921, reprint, New York, 1981.

Helm, Rudolf. *Lucian und Menippus.* 1906; reprint, Hildesheim, 1967.

Henderson, Bernard W. *The Life and Principate of the Emperor Hadrian.* London, 1923.

Heninger, S. K., Jr. *The Cosmographical Glass: Renaissance Diagrams of the Universe.* San Marino, CA, 1977.

——. *Touches of Sweet Harmony: Pythagorean Cosmology and Renaissance Poetics.* San Marino, CA, 1974.

Hense, Otto. "Ioannes Stobaeus." In *Paulys Real-Encyclopädie der classischen Altertumswissenschaft,* 9:2549–86. Stuttgart, 1916.

Hersey, George L. *Pythagorean Palaces: Magic and Architecture in the Italian Renaissance.* Ithaca and London, 1976.

Heuten, Gilbert. "Le 'soleil' de Porphyre." In *Mélanges Franz Cumont,* 253–59. Annuaire de l'Institut du Philologie et d'Histore Orientales et Slavs 4. Brussels, 1936.

Hicks, D. R. *Early Greek Astronomy to Aristotle.* 1970; Ithaca, 1985.

Hicks, Robert D. "Introduction" to Diogenes Laertius, *Lives of Eminent Philosophers,* Cambridge, MA, and London, 1942.

Hilberry, Harry H. "The Cathedral of Chartres in 1030." *Speculum* 34 (1959): 561–72.

Homo, Léon. *L'Italie primitive et les débuts de l'impérialsme romain.* Paris, 1925.

——. *Rome impériale et l'urbanisme dans l'antiquité.* 1951; Paris, 1971.

Horn, Madeleine M. "Resti di due grandi statue di Apollo ritrovati nel santuario di Apollo Aleo di Cirò." In *Santuari della Magna Grecia in Calabria,* ed. Elena Lattanzi. Naples, 1996.

Huffman, Carl A. *Philolaus of Croton, Pythagorean and Presocratic.* Cambridge, 1993.

Hüttig, Albrecht. *Macrobius im Mittelalter.* Frankfurt, 1990.

Immisch, Otto, ed. *Agatharchidea.* Heidelberg, 1919.

Inan, Jale. *Toroslar'da bir Antik kent/Eine Antke Stadt im Taurusgebirge: Lyrbe? Seleukeia?* Istanbul, 1998.

Jaeger, Hans. *Die Quellen des Porphyrius in seiner Pythagoras—Biographie.* Zurich, 1969.

Jaeger, Werner. *Aristotle: Fundamentals of the History of His Development.* Trans. Richard Robinson. 1934; Oxford, 1968.

——. "Xenophanes' Doctrine of God." In *The Theology of the Early Greek Philosophers,* ed. Werner Jaeger. Oxford, 1947.

Jan, Karl von (Carolus Janus). *Die griechischen Saiteninstrumente.* Leipzig, 1882.

Jeauneau, Édouard. *L'âge d'or des écoles de Chartres.* Chartres, 1995.

Jesseph, Douglas M. *Squaring the Circle: The War between Hobbes and Wallis.* Chicago and London, 1999.

Jones, H. Stuart. *A Catalogue of the Ancient Sculptures Preserved in the Municipal Collections of Rome: The Sculptures of the Museo Capitolino.* Rome, 1969.

Joost-Gaugier, Christiane L. "The Early Beginnings of the Notion of Uomini Famosi and the *De Viris Illustribus* in Greco-Roman Literary Tradition." *Artibus et Historiae* 23, no. 6 (1982): 97–116.

———. "The Iconography of Sacred Space: A Suggested Reading of the Meaning of the Roman Pantheon." *Artibus et Historiae* 38 (1998): 21–42.

———. "Pindar on Parnassus." *Gazette des Beaux-Arts* 127 (1996): 65–80.

———. *Raphael's Stanza della Segnatura: Meaning and Invention*. Cambridge, 2002.

———. "Sappho, Apollo, Neopythagorean Theory, and Numine Afflatur in Raphael's Fresco of the Parnassus." *Gazette des Beaux-Arts* 121 (1993): 123–34.

Jourdain, Amable. *Recherches critiques sur l'âge et l'origine des traductions latines d'Aristote et sur les commentaires grecs ou arabes employés par les docteurs scolastiques*. 2nd ed. 1843; New York, 1960.

Joyce, Hetty. "Hadrian's Villa and the 'Dome of Heaven.'" *Römische Mitteilungen* 97 (1990): 347–81.

Jullian, Camille. *Histoire de la Gaule*. 8 vols. 2nd ed. Paris, 1909.

Kahn, Charles H. *Pythagoras and the Pythagoreans: A Brief History*. Indianapolis, 1999.

Katzenellenbogen, Adolf. *Allegories of the Virtues and Vices in Mediaeval Art*. London, 1939.

———. "The Representation of the Seven Liberal Arts." In *Twelfth-Century Europe and the Foundations of Modern Society*, ed. Marshall Clagett, Gaines Post, and Robert Reynolds. 1961; Madison, WI, 1966.

———. *The Sculptural Programs of Chartres Cathedral*. Baltimore, 1959.

Kauffmann, Claus M. *Romanesque Manuscripts, 1066–1190*. London, 1975.

Kempeneers, Auguste. *Le type de églises baties par et depuis l'Empereur Constantin*. Liéges, 1881.

Kibre, Pearl. *Studies in Medieval Science: Alchemy, Astrology, Mathematics and Medicine*. London, 1984.

Kingsley, Peter. *Ancient Philosophy, Mystery, and Magic*. Oxford, 1995.

———. *In the Dark Places of Wisdom*. Inverness, CA, 1999.

Kirk, Geoffrey S., ed. *Heraclitus, the Cosmic Fragments*. Cambridge, 1954.

Kirk, Geoffrey S., John E. Raven, and Malcolm Schofield. *The Presocratic Philosophers*. 2nd ed. 1957; Cambridge, 1999.

Kleiner, Diana E. *Roman Sculpture*. New Haven and London, 1992.

Kleinz, John P. *The Theory of Knowledge of Hugh of St. Victor*. Washington, DC, 1944.

Klemm, Elisabeth. *Die illuminierten Handschriften des 13.Jahrhunderts deutscher Herkunft in der Bayerischen Staatsbibliothek*. Vol. 4. Wiesbaden, 1998.

Klibansky, Raymond. *The Continuity of the Platonic Tradition in the Middle Ages*. 1939; Millwood, NY, 1982.

Kobusch, Theo. *Studien zur Philosophie des Hierokles von Alexandrien*. Munich, 1976.

Koch, Josef, ed. *Artes liberales von der antiken Bildung zur Wissenschaft des Mittelalters*. Leiden, 1959.

Kornemann, Ernst. "Papyrus Gissenis No. 20." *Klio: Beitraege zur alten Geschichte* 7, no. 2 (1907): 278–88.

Kraay, Colin M. *Archaic and Classical Greek Coins*. Berkeley and Los Angeles, 1976.

Krautheimer, Richard. *Corpus Basilcarum Christianarum Romae*. 5 vols. Monumenti di antichità cristiana. Vatican City, 1937–77.

——. *Rome, Profile of a City, 312–1308*. Princeton, 1980.

——. *St. Peter's and Medieval Rome*. Rome, 1985.

——. *Studies in Early Christian, Medieval, and Renaissance Art*. New York and London, 1969.

——. *Three Christian Capitals: Topography and Politics*. Berkeley, Los Angeles, and London, 1983.

Kraye, Jill. "Philologists and Philosophers." In *The Cambridge Companion to Renaissance Humanism*. Cambridge, 1996.

Kroll, Wilhelm. "Antigonus." In *Paulys Real-Encyclopaedie der classischen Altertumswissenschaft*, suppl. 5. Stuttgart, 1931.

Laloy, Louis. *Aristoxene de Tarente et la musique de l'antiquité*. Paris, 1904.

Lanciani, Rodolfo. "Il santuario sotterraneo recentemene scoperto." *Bullettino della Commissione Archeologica Comunale di Roma* 46 (1918): 69–84.

——. *The Ruins and Excavations of Ancient Rome*. Boston and New York, 1897.

La Penna, Antonio. *La cultura letteraria a Roma*. Bari, 1986.

Larcher, C. *Études sur le "Livre de la sagesse."* Paris, 1969.

La Rocca, Luigi. "Cirò Marina, I rinvenimenti nel Santuario di Apollo Aleo." In *Santuari della Magna Grecia in Calabria*, ed. Elena Lattanzi. 266–69. Naples, 1996.

Larsen, Bent D. *Jamblique de Chalcis, exétète et philosophe*. Aarhus, 1972.

Lattanzi, Elena, ed. *Santuari della Magna Grecia in Calabria*. Naples, 1996.

Lavagnini, Bruno. *Studi sul romanzo greco*. Messina and Florence, 1950.

Le Boeuffle, André. *Le ciel des romains*. Paris, 1989.

LeClerc, Lucien. *Histoire de la médecine arabe*. Paris, 1876.

Le Goff, Jacques. *Intellectuals in the Middle Ages*. Trans. T. L. Fagan. Cambridge, MA, and Oxford, 1993.

Lenormant, François. *La grande Grèce, paysages et histoire*. 3 vols. Paris, 1881.

——. *Chaldean Magic: Its Origin and Development*. Trans. 1878. London and New York, 2004.

Leroux, Gabriel. *Les origines de l'édifice Hypostyle*. Paris, 1913.

Lesher, James H., ed. *Fragments: Xenohanes of Colophon*. Toronto, 1992.

Lesky, Albin. *A History of Greek Literature*. Trans. J. Willis and C. de Heer. 1957; London, 1966.

Levin, Flora R. *The Harmonics of Nicomachus and the Pythagorean Tradition*. University Park, PA, 1975.

Lévy, Isidore. *La légende de Pythagore de Grèce en Palestine*. Paris, 1927.

——. *Mélanges Isidore Lévy*. Brussels, 1955.

——. *Recherches sur les sources de la légende de Pythagore*. Paris, 1926.

Liberti, Salvatore, and Vittorio Perrone. "Note sulle condizioni della basilica sotterranea di Porta Maggiore." *Bollettino dell'Istituto Centrale del Restauro* (Rome), nos. 3–4 (1950): 122–43.

Libri, Guillaume. *Histoire des sciences mathematiques en Italie*. Bologna, 1966.

Lloyd, Geoffrey E. R. *Magic, Reason and Experience: Studies in the Origin and Development of Greek Science*. London, 1979.

Lo Cascio, Ferdinando. *La forma letteraria della Vita di Apollonio Tianeo*. Palermo, 1974.

Longenecker, Richard N. *The Christology of Early Jewish Christianity*. Naperville, IL, 1970.

L'Orange, Hans P. *Studies in the Iconography of Cosmic Kingship in the Ancient World*. Oslo, 1953.

Lucchini, Flaminio. *Pantheon*. Rome, 1996.

Luck, Georg. *Arcana Mundi, Magic, and the Occult in the Greek and Roman Worlds.* Baltimore and London, 1985.

Ludwig, Walther. *Struktur und Einheit der Metamorphosen.* Berlin, 1965.

Lugli, Giuseppe. *I monumenti antichi di Roma e suburbio.* 3 vols. Rome, 1930–38.

——. *Roma antica: Il centro monumentale.* Rome, 1946.

Lüneburg, Heinz. *Leonardi Pisani Liber Abbaci.* Mannheim, 1993.

Lyman, Rebecca. *Christology and Cosmology: Models of Divine Activity in Origen, Eusebius, and Athanasius.* Oxford, 1993.

Lyttleton, Margaret. "The Design and Planning of Temples and Sanctuaries in Asia Minor in the Roman Imperial Period." In *Roman Architecture in the Greek World,* ed. Sarah Macready and F. H. Thompson, 30–46. London, 1987.

MacDonald, William. *The Architecture of the Roman Empire.* Vol. 1. 1965; New Haven, 1982.

——. *The Pantheon: Design, Meaning and Progeny.* London, 1976.

MacDonald, William, and John Pinto. *Hadrian's Villa and Its Legacy.* New Haven and London, 1995.

MacIver, Randall. *Greek Cities in Italy and Sicily.* Oxford, 1931.

MacKenna, Stephen. *Plotinus, The Enneads.* 1930; London, 1991.

MacLeod, Roy, ed. *The Library of Alexandria.* London and New York, 2002.

MacMullen, Ramsay. *Christianity and Paganism in the Fourth to Eighth Centuries.* New Haven, 1997.

Macready, Sarah, and F. H. Thompson, eds. *Roman Architecture in the Greek World.* London, 1987.

Magnien, Victor. *Les mystères d'Éleusis.* Paris, 1905.

Mâle, Emile. *The Gothic Image: Religious Art in France of the Thirteenth Century.* 3rd ed. Trans. Dora Nussey. 1913; New York, 1958.

Mango, Cyril. *Byzantium: The Empire of the New Rome.* London, 1980.

Manno, Antonio. *Il poemo del tempo: I capitelli del Palazzo Ducale di Venezia.* Venice, 1999.

Manry, André G. *Histoire de Clermont-Ferrand.* Clermont-Ferrand, 1975.

Marchisotto, Elena A. "Connections in Mathematics: An Introduction to Fibonacci via Pythagoras." *Fibonacci Quarterly* 31 (1993): 21–27.

Martin, Connor. "Walter Burley," *Oxford Studies Presented to Daniel Callus,* 194–230. Oxford, 1964.

Martines, Giangiacomo. "Argomento di geometra antica a proposito della cupola del Pantheon." *Quaderni dell'Istituto di Stora dell'Architettura,* n. s., 13 (1989).

Martínez, José Peña. *Catedrals de España.* Madrid, 1998.

Masi, Michael, ed. *Boethius and the Liberal Arts.* Las Vegas, 1981.

Mathiesen, Thomas. "Aristides Quintilianus and the Harmonics of Manuel Bryennius." *Journal of Music Theory* 27 (1983): 31–49.

May, John M. F. *The Coinage of Abdera, 510–345 BC.* London, 1966.

Maziarz, Edward A., and Thomas Greenwood. *Greek Mathematical Philosophy.* New York, 1968.

McDowell, K. A. "A Portrait of Pythagoras." *Papers of the British School at Rome* 3 (1906): 309–10.

Meeks, Wayne. *The First Urban Christians.* New Haven, 1983.

——. *The Prophet King: Moses Traditions and the Johannine Christology.* Leiden, 1967.

Megaw, J. V. S. "Les fragments de feuille de bronze décorés de Levrous (Indre)." *Gallia* 26 (1968): 33–41.

Mejer, Jorgen. *Diogenes Laertus and His Hellenistic Background.* Wiesbaden, 1978.

Mele, Alfonso. "I culti di Crotone." In *Santuari della Magna Grecia in Calabria,* ed. Elena Lattanzi, 235–40. Naples, 1996.

Menninger, Karl. *Number Words and Number Symbols.* 1958; Cambridge, MA, and London, 1969.

Merlan, Philip. *From Platonism to Neoplatonism.* The Hague, 1953.

Mewaldt, Johannes. *De Aristoxeni Pythagoricis sententiis et vita Pythagorica.* Weimar, 1904.

Michaelides, Solon. *The Music of Ancient Greece.* London, 1978.

Miller, Malcolm. *Chartres Cathedral.* New York, 1996.

Momigliano, Arnaldo. *The Conflict between Paganism and Christianity in the Fourth Century.* Oxford, 1963.

——. *The Development of Greek Biography.* Cambridge, MA, and London, 1993.

——. *On Pagans, Jews, and Christians.* Middletown, CT, 1987.

——. *Second Thoughts on Greek Biography.* Amsterdam and London, 1971.

Mommsen, Theodor E. "Orosius and Augustine." In *Medieval and Renaissance Studies,* ed. Eugene F. Rice Jr., 325–48. 1953; Ithaca, 1959.

Morrison, J. S. *Pythagoras of Samos.* Athens, 1983.

Mosshammer, Alden A. *The Chronicle of Eusebius and Greek Chronographic Tradition.* Lewisburg, PA, and Leiden, 1979.

Mothes, Oskar. *Die Basilikeform bei den Christen der ersten Jahrhunderte.* Leipzig, 1865.

Mountford, James F., and Reginald P. Winnington-Ingram. "Music in Greek Life." In *The Oxford Classical Dictionary,* ed. N. G. L. Hammond and H. H. Scullard, 705–13. Oxford, 1972.

Müller, Christian, and Theophilius Kiessling. *Miscellanea philosophica et historica.* Leipzig, 1821.

Munari, Franco. *Ovid im Mittelalter.* Munich, 1960.

Murray, Gilbert. *Five Stages of Greek Religion.* Oxford, 1925.

Nash, Ernest. *Pictorial Dictionary of Ancient Rome.* 2 vols. London, 1968.

——. "Roma," *The Princeton Encyclopedia of Classical Sites.* Ed. Richard Stillwell, 763–67. Princeton, 1976.

Neugebauer, Otto, and H. V. van Hoesen. *Greek Horoscopes.* Memoirs of the American Philosophical Society 48. Philadelphia, 1959.

Nicolai, Vincenzo Fiocchi, Fabrizio Bisconti, and Danilo Mazzoleni. *The Christian Catacombs of Rome.* Regensburg, 1999.

Nicolet, Claude. *Space, Geography, and Politics in the Early Roman Empire.* Ann Arbor, 1991.

Nouwen, Robert. "De Romeinse Pentagon-dodecaëder." In *Publikaties van her Provinciaal Gallo-Romeins Museum de Tongeren,* vol. 45. Hasselt, Belgium, 1993.

O'Donnell, James J. *Cassiodorus.* Berkeley, Los Angeles, and London, 1979.

Offner, Richard, and Klara Steinweg. *A Critical and Historical Corpus of Florentine Painting.* New York, 1930–84.

O'Meara, Dominic J., ed. *Neoplatonism and Christian Thought.* Albany, 1982.

——. *Pythagoras Revived: Mathematics and Philosophy in Late Antiquity.* Oxford, 1989.

O'Meara, John J. "Augustine and Neo-Platonism." *Recherches Augustiniennes* 1 (1958): 91–111.

Orsi, Paolo. "Templum Apollinis Alaei." *Atti e memorie della Società Magna Grecia* (1932): 9–15.

Otis, Brooks. *Ovid as an Epic Poet.* 2nd ed. 1966; Cambridge, 1970.

Panofsky, Erwin. *Abbot Suger on the Abbey Church of St.-Denis and Its Art Treasures.* 1946; Princeton, 1979.

Parent, J. M., ed. *La doctrine de la création dans l'école de Chartres.* Ottawa, 1938.

Pasquali, Susanna. *Il Pantheon: Architettura e antiquaria nel Settecento a Roma.* Modena, 1996.

Patai, Raphael. *The Jewish Alchemists.* Princeton, 1994.

Patch, Howard R. *The Tradition of Boethius: A Study of His Importance in Medieval Culture.* 1935; New York, 1970.

Paul, Oscar. *Boetius und die griechische harmonik.* Leipzig, 1872.

Pelletier, André. *L'urbanisme romain sous l'empire.* Paris, 1982.

Philip, James A. "Aristotle's Monograph *On the Pythagoreans.*" *Transactions and Proceedings of the American Philological Association* 94 (1963): 185–99.

——. "The Biographical Tradition—Pythagoras." *Transactions and Proceedings of the American Philological Association* 90 (1959): 185–94.

——. *Pythagoras and Early Pythagoreanism.* Toronto, 1966.

Pigeaud, Jackie. *Folie et cures de la folie chez le médecins de l'Antiquité greco-romaine.* Paris, 1987.

——. *La maladie de l'âme: Étude sur la relation de l'âme et du corps dans la tradition médico-philosophique antique.* Paris, 1981.

Piggott, Stuart. *The Druids.* London, 1968.

Porter, Arthur Kingsley. *Medieval Architecture: Its Origins and Development.* 2 vols. 1909; reprint, New York, 1966.

——. *Romanesque Sculpture of the Pilgrimage Roads.* 10 vols. Boston, 1923.

——. *Lombard Architecture.* 4 vols. 1915–17; reprint, New York, 1967.

Prache, Anne. *Notre-Dame de Chartres image de la Jérusalem céleste.* Paris, 1993.

Putnam, George H. *Books and Their Makers during the Middle Ages.* Vol. 1. New York, 1896.

Radice, Roberto. *La filosofia di Aristobulo.* Milan, 1994.

Radice, Roberto, and David Runia. *Philo of Alexandria: An Annotated Bibliography, 1937–86.* 2nd ed. Leiden and New York, 1992.

Rand, Edward K. *Ovid and His Influence.* Boston, 1925.

Rassu, Massimo. *La geometria del tempio: Armonia e proporzione nelle chiese della Sardegna medievale.* Dolianova, 2002.

Reinach, Salamon. "Une grande découverte dans la banlieu de Rome." *Revue Archéologique* 7 (1918): 185–95.

Reinach, Théodor. *La musique grecque.* Paris, 1894.

Reinhardt, Karl. *Kosmos und Sympathie: Neue Untersuchungen über Poseidonios.* Munich, 1926.

Reiss, Edmund. "Number Symbolism and Medieval Literature" in *Medievalia et Humanistica,* ed. Paul Clogan. 161–75. Cleveland and London, 1970.

Reitzenstein, Richard. *Die Hellenistischen Mysterienreligionen.* 3rd rev. ed. 1910; Darmstadt, 1977.

——. *Poimandres: Studien zur griechisch-ägyptischen und frühchristlichen Literatur.* Leipzig, 1904.

Reynolds, Leighton D., and Nigel G. Wilson. *Scribes and Scholars: A Guide to the Transmission of Greek and Latin Literature.* Oxford, 1991.

Rice, Eugene F., Jr., ed. *Medieval and Renaissance Studies.* 1953; Ithaca, 1959.

——. *Saint Jerome in the Renaissance.* Baltimore, 1985.

Riché, Pierre. *Education and Culture in the Barbarian West.* 1962; trans. John J. Contreni. Columbia, SC, 1976.

Richer, Jean. *Géographie sacrée dans le monde romain.* Paris, 1985.

Richter, Gisela M. A., and R. R. R. Smith. *The Portraits of the Greeks.* Ithaca, 1984.

Riedweg, Christoph. *Pythagoras: His Life, Teaching, and Influence.* Trans. Steven Rendall. 2002; Ithaca, 2005.

Riess, Ernst. "Sechepsonis et Petosiridis fragmenta magica." *Philologus,* suppl. 6 (1891–93): 325–94.

Rocchetti, Luigi. "Cirò." In *Enciclopedia dell'arte antica, classica, e orientale,* 2:693–94. Rome, 1959.

Rohde, Erwin. "Die Quellen des Iamblichus in seiner Biographie des Pythagoras." In *Kleine Schriften,* ed. Fritz Schöll, 2:102–5. Tübingen, 1901.

——. "Die Quellen des Jamblichus in seiner Biographie des Pythagoras." *Rheinisches Museum für Philologie* 26 (1871): 554–76 and 27 (1872): 23–61.

Romano, Francesco. *Porfirio di Tiro: Filosofa e cultura nel III secolo D.C.* Catania, 1979.

Romer, F. E. *Pomponius Mela's Description of the World.* Ann Arbor, MI, 1998.

Rosán, Laurence J. *The Philosophy of Proclus: The Final Phase of Ancient Thought.* New York, 1949.

Rostagni, Augusto. "La vita e l'opera di Pitagora secondo Timeo." *Atti dell'Accademia di Scienze di Torino* 40 (1914): 373–95.

Rutgers, Leonard. *Subterranean Rome.* Leuven, 2000.

Sabbadini, Remegio. *Le scoperte dei codici latini e greci ne'secoli XIV e XV.* Ed. Eugenio Garin. 1905; Florence, 1967.

Saidan, A. S. "The Arithmetic of Abu'l-Wafa'," *Isis* 65(228), 1974, 367–75.

Saint-Michel, Léonard. "Situation des dodécaèdres celto-romains dans la tradition symbolique pythagoricienne." *Bulletin de l'Association Guillaume Budé* (suppl. Lettres d'Humanité 10) (Paris) 1951: 92–116.

Saint-Venant, Julien de. *Dodécaèdres perlés en bronze creux ajouré de l'époque gallo romaine.* Nevers, 1907.

Sambursky, Samuel. *The Physical World of the Greeks.* Trans. Merton Dagut. 1954; London, 1956.

Sarton, George. *Introduction to the History of Science.* Vol. 2, pts. 1 and 2. Washington, DC, 1931.

Sauerländer, Willibald. *Cathedrals and Sculpture.* Vol. 1. London, 1999.

Savonelli, Mirella. "Un manuale di geomanza presentato da Bernardo Silvestre da Tours (XII secolo): *L'Experimentarius.*" *Rivista Critica di Storia della Filosofia* 14 (1959): 29–42.

Schefold, Karl. *Die Bildnisse der antiken Dichter, Redner und Denker.* Basel, 1997.

Scholem, Gershom. "The Curious History of the Six-Pointed Star." *Commentary* 8 (1949): 243–51.

——. *Jewish Gnosticism, Merkabah Mysticism, and Talmudic Tradition.* Rev. ed. 1960; New York, 1965.

——. *Kabbalah.* Jerusalem, 1974.

——. *Major Trends in Jewish Mysticism.* 3rd rev. ed. 1941; New York, 1961.

——. *Origins of the Kabbalah.* Trans. Allan Arkush. 1962; Princeton, 1987.

——. *Von der mystischen Gestalt der Gottheit.* Frankfurt, 1977.

——. *Zur Kabbala und ihrer Symbolik.* Zurich, 1960.

Schöll, Fritz. *Kleine Schriften.* Tübingen, 1901.

Schürer, Emile. *Geschichte des jüdischen Volkes in Zeitalter Jesu Christi*. Vol. 3. Leipzig, 1909.

Sciacca, M. F. *Saint Augustin et le néoplatonisme*. Louvain and Paris, 1956.

Seebass, Tilman. *Musikdarstellung und Psalterillustration im früheren Mittelalter*. 2 vols. Bern, 1973.

Seltman, Charles T. *Greek Coins*. 2nd ed. 1933; London, 1955.

Severno, Carmelo G. *Crotone*. Bari, 1988.

Shipley, Graham. *A History of Samos, 800–188 BC*. Oxford, 1987.

Shorey, Paul. "Recent Interpretations of the *Timaeus*." *Classical Philology* 23 (1928): 343–62.

Sigerist, Henry E. "The Latin Medical Literature of the Early Middle Ages." *Journal of the History of Medicine and Allied Sciences* 13 (1958): 127–47.

———. "The Sphere of Life and Death in Early Mediaeval Manuscripts." *Bulletin of the History of Medicine* 11 (1942): 292–303.

Sihler, Ernest G. *Cicero of Arpinium: A Political and Literary Biography*. London and New Haven, 1914.

Singer, Charles. "Early English Magic and Medicine." *Proceedings of the British Academy* 9 (1920): 6–12.

———. *From Magic to Science*. New York, 1928.

Siraisi, Nancy G. *Arts and Sciences at Padua: The Studium of Padua before 1350*. Toronto, 1973.

Sirinelli, Jean. *Les vues historiques d'Eusèbe de Césarée durant la période prénicéenne*. Paris, 1961.

Smith, Andrew. *Porphyry's Place in the Neoplatonic Tradition: A Study in Post-Plotinian Neoplatonism*. The Hague, 1974.

Smith, E. Baldwin. *The Dome: A Study in the History of Ideas*. Princeton, 1950.

Smith, R. R. R. "Late Roman Philosopher Portraits from Aphrodisias." *Journal of Roman Studies* 80 (1990): 127–56.

———. "A New Portrait of Pythagoras." *Aphrodisias Papers II. Journal of Roman Archaeology*, suppl. ser. 2 (1991): 159–67.

Spadea, Roberto, "Note di topografia da Punta Alice a Capo Colonna." In *Santuari della Magna Crecia in Calabria*, ed. Elena Lattanzi, 247–51. Naples, 1996.

Staccioli, Romolo A. *Guida di Roma antica*. 1986; Milan, 1994.

Stähelin, Felix. *Die Schweiz in römischer Zeit*. 3rd ed. Basel, 1948.

Stahl, William Harris, ed. *Macrobius: Commentary on the Dream of Scipio*. 1952; reprint, New York, 1990.

———, ed. *Martianus Capella and the Seven Liberal Arts*. New York, 1977.

Stern, Menahem, ed. *Greek and Latin Authors on Jews and Judaism*. Jerusalem, 1980.

Stierlin, Henri. *Hadrian et l'architecture romaine*. Fribourg, 1984.

Stigall, John O. "The Manuscript Tradition of the *De vita et moribus philosophorum e poetarum* of Walter Burley." *Medievalia et Humanistica* 2 (1957): 44–57.

Stillwell, Richard, ed. *The Princeton Encyclopedia of Classical Sites*. Princeton, 1976.

Stock, Brian. *Myth and Science in the Twelfth Century: A Study of Bernard Silvester*. Princeton, 1972.

Strong, Eugenia, and Norah Jolliffe. "The Stuccoes of the Underground Basilica." *Journal of Hellenic Studies* 44 (1924): 65–111.

Swift, Emerson. *Roman Sources of Christian Art*. New York, 1951.

Tannery, Paul. "Anatolius: Sur la décade et les nombres qu'elle comprend." In *Mémoires scientifiques: III. Sciences exactes dans l'Antiquité*, ed. Johann Ludwig Heiberg, 12–28. Toulouse and Paris, 1915.

———. "Sur l'arithmétique pythagoricienne," *Bulletin des Sciences Mathématiques,* IX, 1885, 69–88.

———. "Une correspondance d'écolâtres du onzième siècle." In *Mémoires scientifiques: V. Sciences exactes au Moyen Âge,* ed. Johann Ludwig Heiberg. Toulouse and Paris, 1922.

———. "La géométrie au Xieme siècle." In *Mémoires scientifiques: V. Sciences exactes au Moyen Âge,* ed. Johann Ludwig Heiberg. Toulouse and Paris, 1922.

———. "L'introdction de la géomancie en Occident." In *Mémoires scientifiques: IV. Sciences exactes chez les byzantins,* ed. Johann Ludwig Heiberg. Toulouse and Paris, 1920.

———. "Psellus sur Diophante." In *Mémoires scientifiques: IV. Sciences exactes chez les byzantins,* ed. Johann Ludwig Heiberg. Toulouse and Paris, 1920.

———. *Recherches sur l'histoire de l'astronomie ancienne.* Paris, 1893.

Tarán, Leonardo. *Speusippus of Athens: A Critical Study.* Leiden, 1981.

Tardieu, Ambroise. *Histore de la ville de Clermont-Ferrand.* 1871; reprint, Marseille, 1976.

Tavenor-Perry, John. *Dinanderie: A History and Description of Mediaeval Art Work in Copper Brass and Bronze.* London, 1910.

Thesleff, Holgar. *An Introduction to the Pythagorean Writings of the Hellenistic Period.* Abo, 1961.

———. *On Dating Xenophanes.* Helsinki, 1957.

———. *The Pythagorean Texts of the Hellenistic Period.* Abo, 1965.

Thomas, Ivor, ed. and trans. *Greek Mathematical Works.* 2 vols. Cambridge, MA, 1951; London, 1957.

Thorndike, Lynn. *A History of Magic and Experimental Science.* Vols. 1–3. New York, 1923–34.

———. *The Sphere of Sacrobosco and Its Commentators.* Chicago, 1949.

Tolnay, Charles de. "The Music of the Spheres: Notes on a Panting by Bicci di Lorenzo." *Journal of the Walters Art Gallery* 6 (1943): 83–88.

Tour-Clerc, Dominique. "Le dodécaèdr." *Aventicum* 1 (1992).

Turner, Howard R. *Science in Medieval Islam.* Austin, TX, 1995.

Ueberwegs, Friedrich. *Grundriss der Geschichte der Philosophie.* Ed. Carl Praechter. Basel, 1953.

Utti, Karl. "Provençal Literature to 1200." In *Dictionary of the Middle Ages,* 10:159–73. New York, 1988.

Vallery-Radot, Jean, and Marcel Aubert. *Congrès archéologique de France CXVI.* Paris, 1958.

van Marle, Raimond. *Iconographie de l'art profane au Moyen-Âge et à la Renaissance.* Vol. 2. 1931; reprint, New York, 1971.

Van Steenberghen, Fernand. *Aristotle in the West: The Origins of Latin Aristotelianism.* Trans. L. Johnson. Louvain, 1955.

Vermeule III, Cornelius C. *Greek Sculpture and Roman Taste.* Ann Arbor, 1977.

von Fritz, Kurt. *Pythagorean Politics in Southern Italy.* New York, 1940.

von Simson, Otto. *The Gothic Cathedral.* 2nd rev. ed. 1956; Princeton, 1962.

Wadsworth, Emily L. "Stucco Reliefs of the First and Second Centuries Still Extant in Rome." *Memoirs of the American Academy in Rome* 4 (1924): 9–102.

Walsh, Patrick G. *Livy: His Historical Aims and Methods.* Cambridge, 1961.

Walter, Nikolaus. *Der Toraausleger Aristobulos.* Berlin, 1964.

Ward-Perkins, John. *The Shrine of St. Peter.* London, 1956.

Wehrli, Fritz R. *Die Schule des Aristoteles: Texte und Kommentar:* vol. 1, *Dikaiarchos;* vol. 2, *Aristoxenos;* vol. 7, *Herakleides Pontikos.* Basel, 1944–45.

Weitzmann, Kurt. *Ancient Book Illumination.* Cambridge, MA, 1959.

White, L. Michael. *Building God's House in the Roman World.* Baltimore and London, 1990.

Wickersheimer, Ernst. "Figures médico-astrologiques des IXe, Xe, et XIe siècles." *Janus: Archives Intenationales sur l'Histoire de la Médecine et la Géographie Médical* 19 (1914): 162–68.

——. *Les manuscits latins de médecine du haut Moyen Âge dans les bibliothèques de France.* Paris, 1966.

Will, Louis. "Carnutes," in *La grande encyclopédie . . . des sciences, del lettres et des arts.* Paris (n.d.) 9: 482–83.

Williams, C. Abdy. *Aristoxenian Theory of Musical Rhythm.* Cambridge, 1911.

Williams, Kim. *Italian Pavements: Patterns in Space.* Houston, 1997.

Wimbush, Vincent L., ed. *Ascetic Behavior in Greco-Roman Antiquity.* Minneapolis, 1990.

Winkelmann, Friedhelm. *Euseb von Kaisareia: Der Vater der Kirchengeschichte.* Berlin, 1991.

Winston, David. *The Wisdom of Solomon.* New York, 1979.

Wolters, Wolfgang. *La Scultura veneziana gotica, 1300–1460.* Venice, 1976.

Wu, Nancy, ed. *Ad Quadratum: The Practical Application of Geometry in Medieval Architecture.* Aldershot, UK, and Burlington, VT, 2002.

Wundt, Max. "Zur Chronologie augustinischer Schriften." *Zeitschrift für neutestamentliche Wissenschaft und die Kunde der älteren Kirche* 21 (1922): 128–35.

Zanker, Paul. *Augustus und die Macht der Bilder.* Munich, 1987.

——. *The Mask of Socrates: The Image of the Intellectual in Antiquity.* Trans. Alan Shapiro. Berkeley, Los Angeles, and Oxford, 1995.

Zecchini, Giuseppe. *I druidi e l'opposizione dei celti a Roma.* Milan, 1984.

Zeller, Eduard. *Die Philosophie der Griechen in ihrer geschichtlichen Entwicklung.* 3 vols. Leipzig, 1876.

Zervos, Christian. *Un philosophe neoplatonicien du Xieme siècle Michel Psellos.* 1920; reprint, New York, 1973.

Zimmer, Heinrich. "Neue Fragmente von Hisperica famina aus Handschriften in Luxemburg und Paris." *Nachrichten von der Königliche Gesellschaft der Wissenschaften zu Göttingen, philologisch-historische Klasse* (1895): 132–35.

INDEX

Abaris, 53
Abu'l-Wafa', 124
Adam, 218–19, 221
Aelian (Claudius Aelianus), 48, 50, 64–65, 107
Aelius Hadrianus, 178
Aelius Spartianus, 177–79
Aeschylus, 85
Aëtius, 36, 206, 255
Albertus Magnus, 76, 121, 132–33
Alcmaeon of Croton, 12–14, 94
Alexander Neckham, 120
Alexander the Great, 142
Allah, 70
Allen, Michael J. B., 169, 207
Anatolius of Laodicea, 52, 105, 107–8, 110, 117, 159, 170, 175–76, 256
Anaxagoras, 131
Anaximander, 53, 131
d'Ancona, Paolo, 199
Andrea di Bonaiuto (Andrea da Firenze), 200, 202–3
Andrea Pisano, 199
Andron of Ephesus, 18
Antonius Diogenes (author cited by Porphyry), 32
Apollo, 4, 6, 18–19, 23, 27, 30, 37, 43–44, 46–47, 49, 52–56, 60–61, 64, 81, 84–86, 98, 105–6, 110, 119, 129, 137, 140, 143, 145, 148, 150–54, 156, 161–62, 164, 167–68, 172, 177–80, 224, 247–52, 254, 257
Apollodorus of Athens, 19, 38, 47, 57, 83, 87
Apollonius of Alexandria, 18, 90
Apollonius of Tyana, 30–31, 42, 45, 49, 52, 103–4, 142, 145, 152, 154, 176, 253, 255
Apostles, 122
Apuleius of Madaura, 39–40, 42–43, 50, 68, 71, 73, 128, 211, 256
Archimedes, 174
Archippos, 22

Archytas of Tarentum, 17–18, 61, 69, 73, 88–90, 96, 99, 111, 115, 121, 124
Arion, 183
Arisleus, 131–32
Aristeas of Croton, 83–84, 148
Aristeas of Proconnesus, 84
Aristippus of Cyrene (author cited by Diogenes Laertius), 46
Aristobulus, 22–23, 92, 97, 103, 125
Aristophon (author cited by Porphry), 24
Aristotle, 1, 12, 18, 20, 24, 27, 34–36, 46–47, 52, 63, 66, 69, 70–72, 75–76, 83, 90, 93–96, 99, 122, 127, 133, 137, 142, 150, 188, 196, 199, 207, 247–48, 250, 252
Aristoxenus of Tarentum, 19–22, 24, 28, 32, 35–36, 41, 49, 64, 80, 83, 89–90, 95, 99, 123, 222
Arnaldo de Villanova, 128–29, 132
Athena, 37, 60, 62
Augustine, Saint, Bishop of Hippo, 58–59, 67, 69, 73, 102, 116, 133, 223, 236–37, 257
Augustus Caesar (C. Octavius), 29, 152–53, 250–52
Aulus Gellius, 21, 98
Aurelius Victor, Sextus, 177
Ausonius (Decimus Magnus Ausonius), 58, 68, 74, 114, 218
Austremoine, Saint, 209

Basil, Saint, 110
Benedict, Saint, 117
Bernard of Chartres, 120
Bernard Silvester of Tours, 199
Bidez, Joseph, 49
Boethius Severus, 7, 31, 33, 36, 61–65, 67–71, 73, 76, 87, 93, 95, 110–11, 114–15, 119–24, 130, 133, 190–94, 196, 201, 219, 220, 223, 234, 236–37, 240, 245, 257

Boyancé, Pierre, 162
Bryennius, Manuel, 123–24
Burkert, Walter, 3
Burlaeus, Gualterus, 72–73, 75, 121, 257
Burley, Walter. *See* Burlaeus, Gualterus

Caligula. *See* Gaius
Callimachus of Cyrene, 20
Camillus (Marcus Furius Camillus), 151
Carcopino, Jérôme, 4, 81, 83, 156–59,
 161–62
Cassiodorus (Flavius Magnus Aurelius Cas-
 siodorus), 67–69, 76, 87, 119, 223
Celsus (Aulus Cornelius Celsus), 30, 127, 253
Censorinus, 29
Chalcidius (Calcidius), 36, 67, 74, 90, 206
Christ, 1, 129, 189–91, 222, 231, 237
Christodorus of Thebes in Egypt, 2, 144, 146
Cicero (Marcus Tullius Cicero), 26–29, 31,
 35, 40, 42–43, 46–47, 67–70, 73, 75–76,
 85, 89–90, 92, 97, 98–101, 111, 113, 120,
 151–52, 154, 172, 196, 199, 206–7,
 251–52
Claudius (Tiberius Claudius), 154
Clement of Alexandria, 41, 67, 69, 85, 103,
 106–7, 112–13, 116, 133, 221, 223, 257
Clinias, 107
Constantine (the Great), 224–25
Cumont, Franz, 4, 22, 27, 49, 108, 161–62
Cylon, 19

Damo, 17
Dante Alighieri, 72, 119, 241, 243–44,
 257–58
David, King, 191, 194–95
Demeter, 47
Democritus of Abdera, 24, 88, 138, 211,
 248
de Vogel, Cornelia, 4, 52
Dicaearchus of Messana (author cited by
 Diogenes Laertius), 21–22, 24, 26, 50, 65
Dio Cassius (Cassius Dio Cocceianus), 177,
 179
Diodorus Siculus, 26, 42, 89, 96–97, 112,
 208, 250–51
Diogenes Laertius, 13–14, 19, 24, 45–51, 55,
 57, 60, 64, 75, 80, 83, 86, 92, 95, 108,
 113, 156, 159, 206, 208
Dionysas (magistrate), 138
Dionysius, 138
Dionysius of Halicarnassus, 26
Dionysius the Areopagite. *See* Pseudo-Diony-
 sius
Diophantus, 123
Divitacus, 113

Domna, Julia, 145, 255
Durandus, Gulielmus, 234, 237
Duris of Samos (author cited by Diognes
 Laertius), 80

Empedocles, 14–15, 20–21, 27, 52, 84,
 86–87, 90, 125, 158, 247
Epaminondas of Thebes, 89
Epicurus, 88
Euclid, 29, 33, 62, 119, 138, 196, 199, 206
Eudoxus of Cnidos, 18, 20, 37
Eunapius, 52, 110
Eunomus, 46
Euphorbus, 20, 26, 46, 75, 145, 158
Eusebius of Caesarea, 18, 57, 69, 107, 257
Evangelists, 122
Eve, 218–19, 221
Ezekiel, 41

Fibonacci. *See* Leonardo da Pisa
Ficino, Marsilio, 119, 123
Fideler, David, 133
Fulbert, Bishop, 231, 245

Gagé, Jean, 4, 151
Gaius Julius Caesar Germanicus ('Caligula'),
 153
Galen, 31
Gerard of Cremona, 120
Gilbert of England, 130
Giotto, 200
Giovanni Pisano, 199
Grosseteste, Robert, 130
Guillaume de Conches. *See* William of
 Conches

Hadrian (Publius Aelius Hadrianus), 30,
 104–5, 143, 154, 165–67, 172, 176–81,
 252, 254–55
Hannibal, 28, 113
Heath, Thomas, 3
Helios, 110
Heninger, S. K., Jr., 4
Hera, 11
Heracles (Hercules), 37
Heraclides Ponticus, 20, 24, 26–27
Heraclitus of Ephesus, 13, 15, 21, 24, 42, 65,
 127, 207
Hermes, 43
Hermes Trismegistus, 123, 131
Hermippus of Smyrna (author cited by Dio-
 genes Laertius), 22, 24, 32, 48, 51, 86, 89,
 125
Hermodamas, 46, 49
Herodotus, 16, 22, 37, 46, 87, 148

Hersey, George L., 4, 98
Hesiod, 12, 13
Hierocles of Alexandria, 60, 64
Hippasus of Metapontum, 83, 207
Hippobotus (author cited and quoted by Dio-
 genes Laertius), 21, 24, 41
Hippocrates, 31
Hippolytus, Bishop, 41, 113, 116, 127, 208
Homer, 54, 145, 147, 158–59
Huffman, Carl, 87
Hugh of St. Victor, 71, 121–22, 190, 219,
 241, 257

Iamblichus of Chalcis, 24, 36, 51–57, 61,
 63–66, 70, 80, 84, 86, 90, 92–93, 95,
 107–10, 117, 127, 148, 156, 159, 161,
 207–8, 215, 224, 256–57. See also Pseudo-
 Iamblichus
Ion of Chios, 14–15
Isidore of Seville (Isidorus Hispalensis,
 Bishop), 36, 68–69, 119–20, 133, 220,
 223, 227, 240, 257
Isocrates, 16, 21, 32

Jerome, Saint, 57–58, 67–69, 74, 110,
 116–17, 127, 133, 218, 223, 257
John, Saint, 231
John of Damascus, 127
Josephus (Flavius Josephus), 97
Julian (Flavius Claudius Julianus or Emperor
 Julian), 110
Julianus Prefect of Egypt, 146
Julius, consul of Rome, 151
Julius II, Pope, 2
Julius Caesar (Gaius Julius), 112, 203, 233
Jullian, Camille, 112
Justin Martyr, Saint, 107
Justinian (Flavius Petrus Justinianus), 7,
 65–66

Kahn, Charles H., 3
Katzenellenbogen, Adolf, 190
Kingsley, Peter, 4, 22, 48, 86, 156

LeGoff, Jacques, 245
Lenormant, François, 4
Leonardo da Pisa (or Fibonacci), 126
Levin, Flora R., 3, 36
Lévy, Isidore, 4, 22, 24, 103
Livy (Titus Livius), 26, 112, 150–52
Llull, Ramón, 129, 132
Lucian of Samosata, 39, 42, 86–87, 107, 207,
 256
Lyco of Troas (author cited by Diogenes
 Laertius), 20

Lycurgus, 37
Lysis of Tarentum (author cited by Diogenes
 Laertius), 17, 22, 89

Macrobius (Ambrosius Theodosius), 7, 28,
 36, 59–60, 63–64, 67, 69, 76, 85, 87,
 110–11, 114, 130, 220, 223, 257
Maimonides (Musa Ibn Maimun). See Moses
 Maimonides
Mâle, Emile, 198, 208, 235–36
Mamarcus, 45
Marchettus, 75
Marinus of Samaria, 61
Martial (Marcus Valerius Martialis), 32, 42,
 50, 64
Martianus Capella, 60–61, 67, 69, 76, 111,
 122–23, 201, 219, 223, 234
Mary (Virgin), 122, 189
Menahem of Recanati, 125
Menander, 81
Menelaus, 20, 46
Metochites, Theodore, 124
Mimnermus, 82
Mnesarchus, 13–14, 16, 19, 21, 45, 49, 52,
 148, 247
Moses, 22–23, 57, 102–3, 123, 237, 250
Moses Maimonides (Moyses of Cordova),
 126
Muses, the, 29, 50, 54, 56, 60, 64, 82, 148
Myscellus, 11

Neanthes of Cyzicus, 21–22, 24, 51
Nepos, Cornelius, 44
Nero (Nero Claudius Caesar), 153–54, 177
Nicolo Pisano, 199
Nicomachus of Gerasa, 32–36, 39, 42–43,
 46, 51, 56, 61–63, 66, 68, 71, 73, 76,
 87–90, 104–5, 109–11, 114–15, 117, 119,
 120, 122–24, 126–27, 159, 161, 166, 168,
 172, 176, 183, 191–92, 194, 236, 244,
 255
Nigidius Figulus, 67, 97, 99, 101, 152, 154,
 251
Numa Pompilius, 26, 38, 74, 152, 250
Numenius of Apamea, 40–41, 46, 168, 256

Ocellus, 89
Oenuphis, 37
Olympiodorus of Alexandria, 66
O'Meara, Dominic, 62
Orosius, Paulus, 59
Orpheus, 14, 124, 183
Ovid (Publius Ovidius Naso), 29–31, 42, 67,
 69–70, 76, 81, 101, 120, 127, 152–54,
 253

Pachymeres, Georgios, 124
Pacioli, Luca, 126
Parmenides of Elea (author cited by Diogenes Laertius), 85, 91
Pausanias, 41
Peter, Saint, 75, 258
Petosiris, 211
Petrarch (Francesco Petrarca), 72, 74–76, 219, 257
Petrus de Abano, 130
Phaon, 81, 83, 162
Pherecydes of Syros, 13, 19, 21–22, 46, 48–49, 53, 57, 74, 80, 147
Philo Judaeus (Philo of Alexandria), 23, 57, 97, 102–3, 117, 125–26, 159, 172, 234, 253–55
Philolaus of Croton, 27–28, 34, 87–88, 90–92, 94, 105, 111, 125, 206, 246, 256
Philostratus (Flavius Philostratus), 44–45, 103–4, 145, 176–77, 255
Photius, Patriarch of Constantinople, 32, 68–69, 104–5, 118–19, 124
Pico della Mirandola, 130
Pindar, 23, 54, 84–86, 108, 142–43, 249
Plato, 1–2, 6–7, 18, 22, 27–28, 33–34, 37–38, 40–41, 46, 57–58, 61–63, 66–72, 74–76, 85, 88–97, 99–102, 104–5, 110–11, 114, 117–123, 125–26, 131, 133, 142, 158, 161, 168–69, 172, 180, 191–92, 206, 208, 223, 241, 244, 249, 254, 256, 258
Pliny the Elder (Gaius Plinius Secundus), 30, 42, 65, 83, 98, 104, 113, 120, 127, 151, 162, 207–8
Plotina, Empress, 176–79, 255
Plotinus, 46, 48–49, 102, 108, 110
Plutarch (Plutarch of Chaeronea), 37–39, 42, 46–47, 51, 66, 76, 80, 85, 87, 105–6, 117, 150, 152, 168, 170, 224, 256
Poliziano, Angelo, 81
Polybius, 19, 112
Polycrates, 19
Pompeius Trogus, 31, 65, 137, 253
Pomponius Mela, 113
Pontenien, Saint, 233
Porphyry of Tyre, 15, 24, 32, 36, 48–53, 56–57, 63–65, 67, 80, 90, 95, 110–11, 127, 137, 156, 158–59, 206, 256–57
Poseidon, 37
Posidonius of Apamea, 47, 113
Priscianus, 196, 199
Proclus Diadochus, 61–62, 64–67, 69–70, 90, 114, 121, 176
Psellus, Michael, 51, 109, 123

Pseudo-Dionysius (or Dionysius the Aere-opagite), 118–19, 223, 241, 257
Pseudo-Iamblichus of Chalcis, 32, 105, 110, 117, 176
Ptolemy, 196, 199
Pythais, 49
Pythagores (magistrate of Abdera), 138

Quintilian (Marcus Fabius Quintilianus), 31–32, 63, 152, 253

Raphael, 2
Remigius of Auxerre, 219, 233
Robert of Anjou, 199

Sacrobosco, John, 118–19, 121
Salmoxis (Zalmoxis), 16, 22, 46, 113
Samian Sibyl, 68
Sappho, 80–83, 85, 162, 224, 254
Satyrus Ponticus, 21–22, 24
Savinien, Saint, 233
Scholem, Gershom, 125
Scipio Africanus, 28, 59, 67
Seneca (Lucius Anneus Seneca), 103
Septimius Severus, 2, 144, 153, 252, 255
Servius (Maurus Servius Honoratus), 219
Servius Tullius, 150
Sextus Empiricus, 41–42, 256
Sextus Pythagoricus, 117, 174, 203, 218, 248
Simonides, 82
Simplicius of Cilicia, 66, 223
Simson, Otto von, 235–37
Smith, R. R. R., 140, 142
Socrates, 5, 22, 38, 69, 74, 131, 142, 151
Solomon, King, 102, 199, 234
Solon, 37
Sophia. See Wisdom
Sotion, 103
Spartianus. See Aelius Spartianus
Speusippus, 20, 92–93, 95, 99, 110, 252
Stobaeus (Iohann Stobaeus), 60, 63, 66, 87
Strabo, 27, 81, 97, 113
Suetonius (Suetonius Tranquillus), 44, 152
Suger, Abbot, 228, 231, 237, 240–41, 243

Telanges, 21
Terpander, 124
Thales of Miletus, 37, 45, 53
Theano, 21
Theocritus, 96
Theon of Smyrna, 39–43, 107, 111, 117, 161, 172, 256
Theophrastus, 36
Thierry de Chartres, 70, 120, 122, 190, 199

Thomas Aquinas, Saint, 71, 127, 133, 190, 200, 202, 241
Thorndike, Lynn, 130
Tiberius (Tiberius Julius Caesar Augustus), 153
Timaeus of Locri, 73, 91
Timaeus of Tauromenium (historian cited by Porphyry), 86, 137
Timon of Phlius (or Phliasios, quoted by Plutarch), 21, 38
Trajan (Marcus Ulpius Traianus), 176, 178–79
Triopas, 49
Tubalcain, 199
Turba philosophorum (unknown authors), 131
Tyrrhenus, 46

Valerius Maximus, 31, 42, 47, 73, 89, 113
Varro (Marcus Terrentius), 28–29, 44, 61, 75, 98, 251–52

Villard de Honnecourt, 240
Vincent of Beauvais, 130, 132
Virgil (Publius Vergilius Maro), 68–70, 219
Vitruvius (Vitruvius Pollio), 29, 38, 42, 47, 98–100, 106–7, 111, 126, 150, 166, 173–74, 176, 224, 251–52
Vöge, Wilhelm, 238

William of Conches, 70–71, 120, 190, 223, 257
Wisdom, Lady (Sophia), 63, 125

Xenokrates of Chalcedon, 93, 99
Xenophanes of Colophon, 12, 15, 27
Xenophillus (author cited by Aulus Gellius), 24, 95

Zalmoxis. *See* Salmoxis
Zanker, Paul, 4
Zeus, 84
Zoroaster, 19, 21, 23, 49, 131